WESTON

CHARLOT

ART & FRIENDSHIP

Lew Andrews

UNIVERSITY OF NEBRASKA PRESS

LINCOLN AND LONDON

Art credits and source acknowledgments
are found on pp. xxiii and 361, which
constitute an extension of the copyright page.

© 2011 by the Board of Regents of the
University of Nebraska. All rights reserved.
Manufactured in the United States of America

Publication of this volume was assisted by a
grant from the Atherton Family Foundation.

∞

Library of Congress
Cataloging-in-Publication Data
Andrews, Lew. Weston and Charlot: art
and friendship / Lew Andrews.
p. cm. Includes bibliographical
references and index.
ISBN 978-0-8032-3513-7 (cloth: alk. paper)
 1. Weston, Edward, 1886–1958—
Correspondence. 2. Charlot, Jean, 1898–1979—
Correspondence. 3. Photographers—
United States—Correspondence. I. Title.
 II. Title: Art and friendship.
TR140.W45A4 2011
 770.92'2—dc23 2011021295

Set in Ehrhardt by Bob Reitz.
Designed by Nathan Putens.

for Laura

Write me please. There are so few people who *live* for art.

JEAN CHARLOT TO EDWARD WESTON, AUGUST 15, 1927

CONTENTS

ILLUSTRATIONS

PREFACE

In the summer of 1923 the photographer Edward Weston arrived in Mexico. He quickly immersed himself in the art world of Mexico City, and on November 28, 1923, he met a young artist named Jean Charlot, to whom he took an immediate liking. During the next several years the two men saw each other quite often and forged a strong and enduring friendship. After Weston left Mexico for good in 1926, he and Charlot were rarely in the same place at the same time again, but they remained in contact, writing letters and exchanging news and ideas. The letters were often more matter-of-fact than reflective. In many cases, they speak of mundane concerns—about print sales or small presents and favors. They speak of recent developments, of plans and accomplishments, but they also occasionally address larger questions and include remarks on art and photography that are quite revealing. Although they tell us a good deal about the day-to-day concerns of these two men, about the texture of their lives, they also speak to the profound links between them, personal and artistic.

Fortunately, many of these letters have survived; they are divided between archives in Honolulu, Hawai'i, and Tucson, Arizona. Weston's letters to Charlot, from the 1930s to the 1950s, are now in the Jean Charlot Collection in Hamilton Library at the University of Hawai'i at Mānoa, while Charlot's letters to Weston are in the Center for Creative Photography at the University of Arizona, where Weston's archives are housed.[1] Taken altogether, these letters tell a compelling story, or series of stories, starting in the 1920s and

continuing until Weston's death almost thirty-five years later, on January 1, 1958. These are the stories I recount in this book.

My initial idea, after first seeing the letters in the Jean Charlot Collection, was to write a relatively short article focused on Weston. As my work progressed, it soon became clear that these letters would make the most sense if they were matched with Charlot's responses and considered in a broader context. Accordingly, I set about linking the letters together, filling in the gaps between them, and incorporating related material as needed. As a result, what began as a short discussion grew into a much longer one and eventually into a book. So too the focus has shifted somewhat, as Charlot became an increasingly important part of the story. While the book is still very much about Weston, it is also about Charlot; most of all, it is about the interconnections between them and about those close to them, including Tina Modotti, Charis Wilson, and Zohmah Charlot. I have tried to weave these different threads into a coherent account. This is not an edition or compilation of the letters in any strict sense but rather a multivalent narrative, extracted from the letters, that sheds new light on a number of aspects of Weston's career, on Charlot, and on the era in which the two of them lived.

Although the Weston-Charlot correspondence forms the backbone of this study, I have relied heavily on other primary sources, published and unpublished, as well. Of course Weston's daybooks remain an important source, especially for the earlier part of the story, when there are few letters to go on. The daybooks are so rich that they are a little like a Rorschach test; it is possible to paint many different pictures, depending on what one chooses to emphasize or ignore, on which excerpts one selects or passes over. It is possible to focus on Weston's romantic entanglements, on his photographic work, or on a host of other matters. In what follows, especially in the early chapters, I have largely confined myself to those passages—and there are quite a few of them—in which Charlot plays a significant role, that provide necessary background information, or that serve as substitutes for missing letters. Weston often mentioned Charlot's letters in the daybooks, frequently treating their arrival as a special occasion and adding a response; in lieu of his lost letters back to Charlot, these entries give at least some idea of Weston's reaction to what his friend had to say.

I have also made use of Charlot's small diary volumes—of the sort still used for pocket calendars (about 4 in. x 2½ in.)—that are now housed in the Jean Charlot Collection. They run from 1922 until 1979; the volume for

1945 is missing and presumed lost. The diaries, which cover almost his entire career, are relatively terse and matter-of-fact and extremely frustrating to use, especially in comparison with Weston's colorful daybooks. For the most part—especially early on—Charlot wrote in an obscure form of shorthand that in many cases is difficult, if not virtually impossible, to decipher. Charlot himself described it as "a French professional shorthand that I learned around 1910 from a lady who had been a stenographer for the government."[2] After an assiduous effort, Peter Morse (who compiled the catalogue raisonné of Charlot's prints and was the first curator of the Jean Charlot Collection) initially decided that it was probably the Fayet system used by government agencies in France, but he later concluded that it was a modified form of the Aimé Paris system.[3] Fortunately, in later years Charlot increasingly wrote out many of the entries, or at least parts of them, in longhand and mostly in English, and they remain a noteworthy guidepost. That has been true, for example, when it comes to reconstructing the visits Charlot and Weston made to one another in the 1940s and 1950s, when there are no letters on which to rely and little other documentation.

In addition to the diaries and Weston's letters, I have made use of a great deal of other material in the Jean Charlot Collection. In particular, there is extensive correspondence between Zohmah Charlot and her friends Prudence and Owen Plowe, which not only provides much detail about the lives of the Charlots but often touches upon Weston and his doings. Zohmah's other papers—letters, diaries, and reminiscences—have been helpful as well, along with scrapbooks and photo albums. The Center for Creative Photography also contains a wealth of documents and photographs in addition to Weston's archive. I have made use, for example, of Henrietta Shore's letters to Weston, which frequently mention Charlot, speaking of their encounters in Mexico and subsequent connections. I have also had the opportunity to look at the Ansel Adams papers (which include numerous letters from Charlot), the Nancy and Beaumont Newhall archive, and the Sonya Noskowiak archive, among others. The Center's photograph collection includes, in addition to a vast holding of Weston's photographs, Noskowiak's portraits of both Jean and Zohmah, which complement those in the Jean Charlot Collection at the University of Hawai'i. All of this material has helped to fill out the story.

As much as possible, I have tried to let the documents themselves control the narrative. Although I have not been able to include everything contained in

the letters, I have tried to stay as close to them as I can, to present things as set down in the original texts, and to let the protagonists speak for themselves, in their own voices. Of course, the letters often mask as much as they reveal, requiring decoding or explanation, and naturally my own biases inevitably creep into the process—in what I chose to include or exclude, in the emphasis I put on certain matters at the expense of others, or in the context in which I placed each episode. But I have tried not to impose a particular agenda or conception. Rather than marshaling evidence to make the case for a particular characterization of Weston, or of Charlot for that matter, I have tried to let the documents lead the way, adding only what is necessary to make the exchanges intelligible. Generally speaking, in his letters Weston comes across as a loyal and generous friend—not only to Jean but to Zohmah as well; Charlot too emerges as an attentive and supportive friend as well as an incisive critic who, together with Zohmah, played a more important role in Weston's life than is commonly acknowledged. But that is not so much a starting point as a conclusion or summation.

There are many aspects to both artists that are not considered here. I have made no attempt to provide a detailed account of their artistic development or to cover most of their best-known images, but rather I have discussed those works that in one way or another figure into the story spelled out in the letters—the works they discussed among themselves or about which they corresponded. So too the discussion of other artists or of aesthetic concerns grows out of what Weston and Charlot mention in their letters or related documentation. As a result, this is a selective account, but one that nevertheless fills in many gaps in more familiar discussions and clears up certain chronological tangles and misunderstandings—especially starting in the mid-1930s, after Weston put aside his daybooks.

Of the two main protagonists, Charlot has been studied relatively little—although that has begun to change. Weston, on the other hand, has been studied a great deal; his life and work have been rehearsed in many forms. But very few of these studies explore the interconnections between Weston and Charlot at any length, if at all. In the Weston literature, Charlot is rarely discussed beyond mention that he was one of Weston's acquaintances in Mexico and that he was the subject of a number of Weston's and Modotti's photographs. Similarly, the studies on Charlot do not dwell on Weston or on the links between them. There are, of course, some noteworthy exceptions,

especially in some of the Weston material. Amy Conger, for example, discusses Charlot a good deal, in more than one context. In *Edward Weston in Mexico*, for example, she describes him as one of the people to whom Weston was closest during his Mexico years, as someone who stirred Weston's interest in local art forms and introduced him to a number of key figures, perhaps including Anita Brenner, the subject of one his best-known images from that period.[4] Later on, in her catalog of Weston photographs in the collection of the Center for Creative Photography, one of the most valuable sources of information on Weston's work, she goes further; indeed, Charlot crops up quite frequently among the individual entries and in the biographical essay at the end as Conger, in effect, outlines many of the contacts between Weston and Charlot, in Mexico and beyond.[5]

Meanwhile, in the fall of 1984 the Honolulu Academy of Arts held an exhibition of the Charlot Collection of Weston Photographs, organized by Van Deren Coke. It featured photographs by Weston that Jean and Zohmah had acquired over the years, in exchange for other artwork or as presents. The slim catalog included a reminiscence by Zohmah of the visits she and Jean made to Carmel in the 1930s, as well as an essay Jean wrote about Weston, reprinted from the first monograph dedicated to Weston's photographs, edited by Merle Armitage in 1932.[6] In the foreword to the catalog, James Jensen, then curator of western art at the Academy (and now deputy director of exhibitions and collections at the Contemporary Museum in Honolulu), wrote of the friendship between Weston and Jean and Zohmah Charlot: "Over a period of thirty-five years, they enriched each other's lives and expanded one another's outlooks and vision."[7] Charis Wilson, in her memoir of her years with Weston, also devoted attention to the Charlots, especially Zohmah.[8]

On a more theoretical plane, the photo historian Mike Weaver has written about Charlot's influence on Mexican art and on Weston, describing Charlot as the intellectual leader of the Mexican muralists.[9] More recently, Leslie Furth has likewise written of the photographer's links to Charlot in her insightful discussion of Weston's Mexican work. Describing the metamorphosis that Weston's work underwent during that period, inspired in part by European modernism and local traditions, she calls attention in particular to Weston's still lifes of Mexican folk art, including toys. She also makes clear how Charlot's approach to landscape had an impact on Weston.[10]

Furth, Jensen, and others have taken note of the letters that Charlot and Weston exchanged over the years, but the correspondence has not been explored

fully. Although some of the letters have occasionally been cited or quoted, they have not been studied in a systematic fashion or linked together into an extended account. Individual letters—interesting or useful as they may be—often reveal relatively little, leaving many questions unanswered; taken as a whole, as an ongoing dialogue or conversation, the situation is quite different. When the gaps between letters are filled in or explained, and when they are placed in a larger context, personal correspondence can tell us a good deal more about day-to-day concerns, specific incidents, and personal feelings and artistic issues. Such is the raw material of more than one biography.

In the process of constructing this account, I have of course covered some familiar ground, especially with regard to Weston, but there is also much that is new, including a number of episodes that have not received much attention. And even the most commonly discussed episodes and incidents are presented here from a different perspective: much of the information on Weston is here filtered through the eyes of Jean, Zohmah, or both. We also see Charlot from Weston's point of view. Consequently, there is much information here that does not appear in more familiar sources.

The final result is a little hard to characterize or categorize. This is not a biography in the ordinary sense, nor a monograph on either Weston or Charlot, but rather a number of interconnected and overlapping biographies or microhistories, stressing those moments when the lives of Weston and Charlot, and those close to them, came together or intersected. It describes shared experiences and visits, correspondence and other writings, paintings and photographs, artistic exchanges and mutual influences. Relying mainly on primary sources, my intention is to explore the impact these characters had on one another, artistically and otherwise. The story of these interconnections not only illuminates the everyday life of those involved but also represents an important chapter in the history of twentieth-century art and photography, seen at close range.

ACKNOWLEDGMENTS

This book would not have been possible without help from many quarters, in Honolulu and elsewhere. I would like to thank, first of all, Nancy Morris, former curator of the Jean Charlot Collection (JCC) at Hamilton Library at the University of Hawai'i at Mānoa. It was Nancy who first steered me to Weston's letters to Charlot in the JCC; once I decided to go forward with this project, she assisted me in innumerable ways. Bronwen Solyom, her successor, has likewise been of enormous help on many fronts; Ellen Chapman, also of the JCC, has made my research go more smoothly. For preparation of the illustrations, I am grateful to Lynn Davis, head of the Preservation Department at the University of Hawai'i at Mānoa, and to the late DeeDee Acosta. As the book neared completion I received valuable assistance from Christine Takata of the Preservation Department and Ryan James of the External Services Program; Cheryl Ernst, director of External Affairs and University Relations–Creative Services, and R. David Beales, university photographer, were also most helpful. My thanks as well to Leilani Ng at Colorprints in Honolulu.

In addition, I am deeply grateful to John Charlot, Jean and Zohmah Charlot's son, a professor of religion at the University of Hawai'i, who has written a considerable amount about his father. John was encouraging from the start and generously shared his vast knowledge and insights all along the way; he has saved me from many mistakes. His brother, the artist Martin Charlot, also kindly shared his recollections of Weston with me. Prudence and Owen Plowe, old friends of the Charlot family, provided useful information as well.

I owe special thanks to the Center for Creative Photography for granting me an Ansel Adams Fellowship, which enabled me to travel to Tucson to work with the Edward Weston Archive, where the Charlots' letters to Weston are now housed. The Center is, of course, an incredible resource, and its staff were welcoming and helpful; my visit there was a memorable experience. I would especially like to acknowledge archivist Leslie Calmes, as well as Shaw Kinsley, who guided me through the material and patiently put up with my many questions and requests. I am grateful to Amy Rule, then acting director, for her encouragement, for useful suggestions and corrections, and for assistance with permissions. My thanks as well to Diane Nilsen, Marcia Tiede, Jeanne Courtemanche, and many others. More recently, for help with pictures and permissions, I am indebted to Tammy Carter and her graduate assistant Marianna Pegno, who expedited a complicated order.

I would like to thank noted photo-historians Anne Hammond and Mike Weaver for their encouragement and suggestions. Anne, whose work on Ansel Adams is of fundamental importance, read my manuscript at an earlier stage and made numerous useful and insightful comments. Thanks, too, to Amy Conger, a leading authority on Weston, who read part of the manuscript and made useful suggestions. I am likewise grateful to my old classmate and friend Chama Armitage Rogate for her interest and help; her family extended their hospitality to my wife and me on recent visits to Milan, and she graciously granted permission to quote from her father's letters.

I would also like to acknowledge Caroline Klarr, who has written an excellent dissertation on Charlot; Steve Murin, one of the stalwarts of the Jean Charlot Foundation, who cooks up an outstanding omelet; Becky Boom; Laura Ruby; and Joseph Martin. Thanks, too, to Clemente Orozco V, son of the painter, for a thought-provoking evening; and to Joe and Cathy Silveira, especially for an unforgettable trip to Weston Beach.

For permission to quote from previously unpublished material, I am indebted to Professor Arthur Noskowiak, Sonya's brother, to Tish Rosales of the Ansel Adams Publishing Rights Trust, and to David Scheinbaum of the Beaumont and Nancy Newhall Estate. I especially appreciate the assistance of Rachel Fern Harris, who not only granted me permission to quote her mother's letters and cards but generously provided me with additional material as well. I also appreciate the assistance of Jennifer Riley of the Boston Museum of Fine Arts and the support of Chun, Kerr, Dodd, Beaman & Wong.

When it comes to the publishing process, I am indebted to many people. My thanks, first of all, to William H. Beezley, professor of history at the University of Arizona, for initiating the process that led to the present publication. At the University of Nebraska Press, Heather Lundine, editor in chief and acquisitions editor, shepherded this project along and did a great deal to tighten my text; her heroic efforts have made this a much better and more readable book. I am grateful to Bridget Barry, associate acquisitions editor; and to Erika Kuebler Rippeteau, grant and development specialist, who provided valuable assistance in my quest for funding. I would also like to thank Ann Baker, project editor, who kept things moving; Joy Margheim, copyeditor, who rescued me from numerous errors and made significant improvements; and Nathan Putens for the book design. So too I would like to express my gratitude to the outside readers for their supportive comments and constructive criticism.

Most of all, endless thanks to my wife, Laura Warfield, to whom this book is dedicated. Without her help and patience this book would never have happened.

Grateful acknowledgment is made for permission to reprint the following material:

Quotations from Jean Charlot's and Zohmah Day Charlot's letters, diaries, and other unpublished writings by permission of the Jean Charlot Estate LLC.

Quotations from Edward Weston's letters by permission of the Arizona Board of Regents, Center for Creative Photography, University of Arizona, © 1981.

Quotations from Charis Wilson's letters by permission of Rachel Fern Harris.

Quotations from Sonya Noskowiak's letters by permission of Arthur F. Noskowiak.

Quotations from Merle Armitage's letters by permission of Chama Armitage Rogate.

Quotations from Beaumont Newhall's writings © Beaumont Newhall, © 2010, the Estate of Beaumont Newhall and Nancy Newhall, courtesy of Scheinbaum & Russek, Ltd., Santa Fe, New Mexico.

Quotations from Nancy Newhall's writings © Nancy Newhall, © 2010, the Estate of Beaumont Newhall and Nancy Newhall, courtesy of Scheinbaum & Russek, Ltd., Santa Fe, New Mexico.

Quotations from Ansel Adams's letters by permission of the Ansel Adams Publishing Rights Trust, © 2010.

INTRODUCTION

In many ways Edward Weston and Jean Charlot were an unlikely pair. Weston was the older of the two: born March 24, 1886, he was in his late thirties and already an established photographer when he first came to Mexico. Originally from the Midwest, he was the son of a physician whose forebears hailed from New England (and earlier on, from England). He was born in Highland Park, Illinois, but his family soon moved to Chicago, where he was raised. His mother, about whom there seems to be little information, died when he was five, and his older sister, May, played an important role in his upbringing. When he was about twenty, in 1906, he followed her to Tropico (now Glendale), California, where he settled. Three years later he married Flora Chandler, who was part of a prominent Los Angeles family, with whom he had four sons (Chandler, Brett, Neil, and Cole). Two years after his marriage, with relatively little professional training, Weston started his own photo studio, and in the years that followed he began to thrive as a professional portrait photographer. In 1913 he met the photographer Margrethe Mather, who was a significant factor—as he himself acknowledged—in his artistic development; she became his model, lover, and professional collaborator. She introduced him to a world of bohemians, many of whom became the subjects of his photographs. They advanced challenging ideas on politics, on sexual relationships, and on art, radical thinking that broadened his vision considerably and pushed him further into the world of serious photography—in which he soon would distinguish himself, garnering numerous awards. In the early years he worked

in a pictorialist idiom, producing soft-focus, romantic imagery, in some cases with literary or historical overtones. Initially his work harked back to the turn of the century, to the work that had appeared in the pages of *Camera Work* a decade earlier, but soon he began to incorporate new elements in his imagery; although still operating within the context of pictorialism, he increasingly began to experiment with more modernist ideas, influenced by cubism and other contemporary trends.[1]

In 1921, or perhaps a little earlier, he had another fateful encounter, with a young woman ten years his junior named Tina Modotti. Originally from Udine, in Friuli, Italy, Modotti spent some of her early years in Austria before emigrating to California at age sixteen. She settled first in San Francisco and then moved to Los Angeles, where she worked as an actress in Hollywood. In 1920 she gained some recognition for her role in a film called *The Tiger's Coat*. The following year Modotti came to Weston's studio to be photographed, and she soon became his lover. Before long, the two of them had decided to move together to Mexico, where she had already spent some time. It was, of course, to be a romantic adventure, but there was also a more pragmatic aspect: Edward was going to teach Tina photography, and Tina would serve as his assistant and interpreter. She was hoping to learn a new profession, and Weston was trying to jump-start his career; he had high hopes that the move to Mexico would not only improve his professional fortunes but also stimulate his photographic art.

Before leaving the United States, Weston made a trip to Middletown, Ohio, to visit his sister, May, and her family, who had moved there from Tropico not long before. While there, he made a number of photographs of the Armco steel plant that, with their stark realism and bold composition, heralded things to come.[2] His commitment to serious photography led him to continue on to New York City, where he met with the photographer and tastemaker Alfred Stieglitz—a meeting that stayed in Weston's mind long afterward. Although he did not understand everything Stieglitz had to say and did not agree with all of his comments, Weston came away feeling encouraged; he believed that the venerable Steiglitz had, in effect, sanctioned the changes starting to take place in his art, and he returned to California determined to go further.[3] By the time Edward arrived in Mexico in 1923, not only with Tina, but also with his eldest son, Chandler, he was already in the process of shedding his pictorialist skin and starting to embrace a more direct approach. Although this transformation had already begun, his Mexican adventure

would prove pivotal to his artistic development. Over the next three years in Mexico, Weston gradually emerged as a paragon of straight photography and modernism. Charlot was one of those who cheered him on.

Charlot was twelve years younger than Weston (and two years younger than Modotti). Born February 8, 1898, he was in his mid-twenties when they all first met, and he had already been in Mexico for a few years. Charlot was born in Paris and was of mixed ethnic background: French, Russian, Spanish, Jewish, and Aztec Indian. His father was a free thinker (and a Freemason), his mother, a pious Roman Catholic, and he became a devout Catholic himself. A precocious artist, as a boy he had haunted the Louvre, where he admired the work of Uccello and Poussin, David and Ingres, among many others. He studied for a time at the École des Beaux-Arts in Paris and as a teenager was a member of the Gilde Notre-Dame, a Catholic liturgical arts group. While Weston had relatively little formal training, Charlot had a thorough grounding in traditional art.

During World War I Charlot served in the French army as an artillery officer, and after the armistice he was stationed in Germany. There he managed, despite adverse conditions, to produce a series of fifteen woodcuts of *Chemin de Croix* (Way of the Cross or Via Crucis), which reveals the continuing influence of the symbolist painter Maurice Denis and his attenuated forms. Soon after, a civilian once again, Charlot began to experiment with cubism. Once he moved with his mother to Mexico, in 1921, he started to forge a less attenuated style, still tinged with cubism, combining modernist tendencies with local elements and classical tradition.

In his first years in Mexico he shared a studio at the San Carlos Academy with the painter Fernando Leal and was soon introduced to Diego Rivera, whom he assisted on the mural *Creation* (in encaustic), in the auditorium of the Escuela Nacional Preparatoria (now the Antiguo Colegio de San Ildefonso), along with Xavier Guerrero, Carlos Mérida, and Amado de la Cueva. So too Charlot provided illustrations for the publications of the Estridentistas (the strident ones), a group of avant-garde writers and artists, and his woodcuts were exhibited in the Café de Nadie in Mexico City, where the group often met. His efforts sparked a new interest in the woodcut among his fellow artists. It was also in this period that he became acquainted, probably through Leal, with Julia Jiménez González, also known as Luciana (or Luz). Originally from the Nahuatl community of Milpa Alta, south of Mexico City, Luz modeled for many of Charlot's Mexican images, starting as early as 1922, and became

a lifelong friend (he was godfather to her daughter). She would also model for Weston, for Modotti, and for Rivera, among others.[4]

In early 1923 Charlot completed the first true fresco painted in Mexico since colonial times, *The Massacre in the Main Temple* in the stairwell of the Preparatoria, a depiction of a brutal episode in the Spanish conquest of Mexico that calls to mind the battle paintings of Paolo Uccello and Piero della Francesca. After that, he painted murals in the Secretaría de Educación. In those years Charlot also began to write about Mexican art, in French and Spanish, and by the time Weston arrived on the scene the young artist had already played a key role as a participant and chronicler of what would become known as the Mexican Renaissance, or, thanks to Charlot himself, the Mexican Mural Renaissance. In the 1920s Mexico was experiencing a period of considerable artistic ferment, and Charlot was in the middle of it. He was in a good position to help ease Weston into the local art scene.

It was probably around the time of Charlot's first meeting with Weston and Modotti, or shortly thereafter, that he also met a young woman named Anita Brenner, with whom he formed a close attachment. Brenner had been born in Mexico but later moved with her family to San Antonio, Texas, where she went to high school. After graduating from high school she briefly attended the University of Texas at Austin before returning to Mexico in the fall of 1923, at the age of eighteen, to pursue her studies further. She enrolled in the University of Mexico and got a job teaching English at the Presbyterian Mission School for Girls (Escuela Normal de San Angel). In the coming years she would model not only for Charlot but also for Weston and Modotti. She also would write extensively, sometimes with Charlot, about Mexican art, a subject on which she became an authority; her book *Idols behind Altars* included a discussion of Charlot's work and photographs by Weston and Modotti, as well as artwork by Charlot.[5]

Weston's daybooks tell of the frequent contact among Jean, Edward, and Tina during the mid-1920s. By early 1924 Charlot had already become a regular visitor to Edward and Tina's dwelling at Calle Lucerna and later at the Boat House in Mexico City. They often encountered one another at parties and gatherings, and they went on outings together, visiting well-known sites and other artists, such as Diego Rivera or the woodcarver Manuel Martínez Pintao. More than once Edward came to the Charlots' home, where Mme Charlot, Jean's mother, served memorable meals—partly Mexican and partly French.

Charlot followed Weston's work quite closely and was very supportive; he helped to arrange for Weston's participation in more than one exhibition. Weston, for his part, considered Charlot to be among the most important contemporary artists—on a par with Rivera or even more significant. As the daybooks indicate, they admired each other's work and frequently exchanged views on art and other matters; so too they worked with some of the same models and subjects.

In the first years after Weston returned to California for good, he moved about quite a bit, from the Los Angeles area to San Francisco and then to Carmel. Charlot, meanwhile, stayed on in Mexico until 1928, dividing his time between Chichén Itzá in the Yucatán and Mexico City, and then moved, together with his mother, to New York. Throughout this period Jean and Edward wrote one another and exchanged news and artwork; Weston was full of praise for what Charlot sent along, and Charlot, in turn, responded to Weston's latest work (his pictures of shells, his most recent nudes, and his vegetables, including green peppers, which became one of his best-known subjects) and offered advice on practical matters and art more generally. There were numerous exchanges, about Stieglitz and Atget, about Weston's photographs, and about many other topics. Moreover, Weston and Charlot continued on occasion to act as each other's agent or promoter. Unfortunately, their correspondence from this period can be reconstructed only partially; although many of Charlot's letters to Weston have survived, none of Weston's replies have been preserved. (Charlot destroyed all of his correspondence before he married in 1939.) Nevertheless, much can be pieced together on the basis of the daybooks and other sources, including Charlot's diaries.

For the 1930s there is more to go on—especially after Charlot and his future wife, Zohmah Day, visited Weston in Carmel in 1933. Charlot was having an exhibition there, which Weston had arranged. During their stay in Carmel, Jean and Zohmah met Sonya Noskowiak, who was living with Weston and who, like Edward, photographed the visitors. Charlot also selected the prints for Weston's exhibit at the Increase Robinson Galleries in Chicago later that year. Soon after, Charis Wilson entered the picture, and the letters proliferate. Edward spent the rest of the thirties in Los Angeles and Carmel, much of it with Charis; Jean, for his part, traveled back and forth between New York and California, while Zohmah spent time in Los Angeles, London, and New York, among other places. Jean wrote to Edward; Edward wrote to Jean and to Zohmah (sometimes together and sometimes separately); Charis

and Zohmah exchanged letters as well. Indeed, while Jean and Charis were never entirely comfortable with each other, Charis and Zohmah became good friends, and in the later part of the decade—after Edward won a Guggenheim grant (with Jean's help)—Zohmah spent much time, on her own, with both Edward and Charis, in Los Angeles and in Carmel. And she played a role, hitherto unnoticed, in the preparation of some of Weston's articles on photography. Thankfully, much of the correspondence from these years has been preserved (it seems likely that Zohmah played an important role in that regard), and it is quite revealing. Since Weston eventually stopped making regular entries in his daybooks in 1934, the surviving letters add a considerable amount of detail and precision to existing accounts.

At the end of the decade Edward and Charis were married in Elk, California; Jean and Zohmah were married about a month later, in San Francisco. The newly wed Charlots spend their honeymoon in Carmel with the Westons, and it was at that time that Edward photographed them sleeping on the rocks. Weston made use of this image so often that it became a running joke between them—one version ended up as Weston's sole entry in the well-known *Family of Man* exhibition at the Museum of Modern Art in New York.

In the 1940s the Westons and the Charlots grew somewhat apart. They spent about a week together in Athens, Georgia, in 1941, just after the attack on Pearl Harbor, when Edward and Charis were on the East Coast in conjunction with a series of photographs Weston was making for an illustrated edition of Walt Whitman's *Leaves of Grass*, but they saw little of each other after that. Following the Athens visit Edward and Charis hurried back to California, where they spent the war years. The Charlots left Georgia in 1944, partly because of their discomfort with segregation, and by the time Weston visited New York in 1946 for his retrospective at the Museum of Modern Art, they were in Mexico. From there they moved on to Colorado and then to Hawai'i. Although the correspondence becomes more sporadic at this point, the Westons and the Charlots remained in contact. Even after Weston separated from Charis and his health began to deteriorate, he continued to write to the Charlots. At every step of the way, Edward kept Jean and Zohmah apprised—about progress on his book *California and the West*, about Charis, about his wartime activities, his backyard setups, his pictures of cats, and more. And the Charlots promptly responded, with comments, encouragement, and news of Mexico and other matters. It was during this period that Jean and Zohmah urged Edward to do something more with his

daybooks, and at one point Zohmah even arranged for someone to type a portion of them.

Weston saw the Charlots for the last time in 1951, when the Charlots, with their children in tow, passed through Carmel. By then Edward was quite ill with Parkinson's disease, which would eventually kill him. Nevertheless, surrounded by family and friends, he still had a sparkle in his eye, which Zohmah captured on film. These old friends perhaps sensed that it was the last time they would see each other, but they continued to exchange letters and little gifts—and those final letters from the 1950s also tell a moving story.

In many respects, Jean's and Edward's lives took rather different paths. After Weston left Mexico he enjoyed increasing recognition for his photographic work; Charlot has not yet become as well known, but he had a distinguished and productive career, not only as an artist but also as a critic, art historian, and teacher. Initially, in Mexico, the two artists depicted some of the same models (Tina Modotti, Anita Brenner, and Luz Jiménez, among others), and they tackled some of the same subjects, such as Mexican toys; they sometimes even employed some of the same compositional motifs. But even during this period of close contact, their work was quite different, and with time their imagery increasingly diverged. On the whole, over the years, there are few obvious similarities in their work: while Weston concentrated on still lifes, nudes, and landscapes, Charlot continued to draw inspiration from Mexico, devoted considerable attention to liturgical art, and in later years turned his attention to Hawaiian subjects and related themes, in a variety of media—which, in some respects, set him on a different path than Weston.

Nevertheless there was a strong bond between them, both personal and artistic, a fundamental kinship in their thinking and in their artwork. In the 1920s both artists proceeded along parallel tracks, distancing themselves from past styles and stylizations toward a more direct kind of vision. During the late 1930s and on into the 1940s Weston flirted with surrealism, which made Charlot—who looked upon surrealism with considerable suspicion—somewhat uneasy. And Weston, for his part, was uncomfortable with Charlot's emphasis on geometry. But despite occasional or temporary disagreements, throughout their careers they shared a concern for honest and direct seeing, free of affectation. They moved in an analogous direction all along, each one reinforcing the other. And while they differed on various specific matters—religion, geometry, surrealism—there was a good deal of common ground, as the following chapters will reveal.

WESTON AND CHARLOT

1

CABALLITO DE CUARENTA CENTAVOS

Edward Weston had been in Mexico less than two months when he had his first exhibition at the Aztec Land Gallery. Along with his lover, Tina Modotti, and his eldest son, Chandler, age thirteen, Weston had arrived in Mexico City in August 1923; the exhibition opened October 17. It is not certain how many or which photographs Weston put on view, but he provided some indication in his daybook.[1] There were a number of nudes of Margrethe Mather, sharp and detailed, taken at Redondo Beach just before Weston left for Mexico; there were also some recent pictures of Tina, including one of her wearing a black tailored suit and holding an ebony cane, seen through a doorway; and there were three pictures of Elisa Guerrero (Xavier Guerrero's sister) and one of Chandler.[2] In all likelihood the show also included *The Great White Cloud of Mazatlán*, a spectacular formation, and perhaps *Pipes and Stacks* (fig. 1), a print of which Edward had brought along with him to Mexico and which he displayed on the wall of their first dwelling, in Tacubaya. With a few exceptions, the pictures in the exhibition reflected Weston's increasingly direct, modernist approach, as he continued to distance himself from the misty romanticism of his pictorialist past. All in all, it was a good overview of his imagery at a watershed moment in his career.

Although not a financial success—he sold eight photographs altogether, mostly nudes of Mather—the show did attract a lot of attention. Visitors included Ricardo Gómez Robelo, an art critic and archeologist Weston had met a few years earlier in Los Angeles, and Adolfo Best-Maugard, the art

educator. Diego Rivera, whom Edward and Tina had already met, came with his wife, Lupe (Guadalupe Marín de Rivera). The influential artist and art historian Dr. Atl (Gerardo Murillo) also appeared, along with his mistress, the writer and painter Nahui Olín, who would soon become the subject of one of Weston's best-known portraits.[3] Another visitor who signed the guestbook was a young artist originally from France named Jean Charlot.[4] Although Charlot did not meet Weston at the show, they would soon become good friends.

Soon after the show closed Weston found himself at a gathering at the palatial home of Tomás Braniff, a wealthy Mexican who liked to surround himself with artists and writers. Weston had already met many of those present, but on that occasion he met Charlot for the first time and took an immediate liking to him. Weston described the scene in his daybook: "Today again to the Braniff mansion of gold leaf and alabaster; the whole 'Painters' Union' was there, some of them, most likely, to get a square meal and a drink. Rivera an animated cartoon, with his two chins, two bellies, and inevitable smile. Lupe with her 'Por Dios' and 'Caramba.' Jean Charlot, a French boy, whom I like immensely, and who gave me one of his excellent wood cuts."[5]

The following day Jean visited Edward and Tina at their new quarters in Calle Lucerna, in the heart of Mexico City, and he was soon part of Weston's growing circle of friends.[6] Charlot also became the subject of some of Modotti's portraits. She photographed him on at least three occasions; the earliest may have been at the end of 1923, shortly after they first met. The resulting portrait shows Jean straight on, seated on a painted chest in a relaxed pose. He leans forward, toward the camera, his elbows resting on his thighs, with hands together. He seems to have donned his finest clothes, down to the spats, and looks very dapper, a little as if he had stepped out of a P. G. Wodehouse novel.[7]

Jean encountered his new friends again on New Year's Eve, when Edward and Tina held a party. The party had been planned by Lupe Rivera, who dominated the festivities. Also present were Diego, Senator Manuel Hernández Galván, the Spanish painter Rafael Sala and his wife, Monna, along with several Germans who had recently arrived in Mexico. Weston took the opportunity to show some of his work, notably *Pipes and Stacks* (fig. 1), which he had just printed in platinum; it was well received. The Salas considered it to be Weston's best, and Charlot liked it as well.[8] Compared to much of his work to date, *Pipes and Stacks*, although taken more than a year before, represented a fresh and unfiltered way of seeing. Edward's new friends perhaps recognized and appreciated that, and he was clearly encouraged by their response.[9]

The New Year's celebration was such a success that Edward and Tina decided to hold weekly gatherings at their Calle Lucerna abode, in place of the Braniff parties, which had been discontinued because of concerns about the current political climate. By the third party, two weeks later, the couple had attracted a growing group of guests, including many new faces. Jean was there along with his mother—whom Edward described as "the refined Madame Charlot"—as were a number of politicians, generals, and many others. It was an odd and potentially combustible mix, and Jean offered a kind of warning, based on his own experience (and that of his mother): "'When we first came here,' said Charlot, 'we attempted to have open house as you are doing, but we gave it up. Some of the guests were sure to end the party by shooting out our light bulbs.'" Nothing untoward happened that evening, but Edward seemed to take Jean's words to heart: "Already I sense an end to these gatherings under the present plan. It is too much of a mixture; it may be an amusing contrast, the refined Madame Charlot along with Mexican generals comparing bullet holes in their respective anatomies, but it is sure to end disastrously. As Diego put it—rearranged in my own phraseology—'I want either one thing or the other, a party where I go with the avowed intention of getting drunk, or one with a more subtle prospectus.'"[10]

It may have been soon afterward that Modotti photographed Charlot again; one of the resulting portraits shows Jean perched on the edge of a bed or couch, facing to one side, with a pencil poised on a sheet of paper (fig. 2). As before he wears a dark suit, but in this case he is wearing heavier, rather worn boots and a pince-nez. A soft light comes in from the right, highlighting his face, his right hand, and a portion of the drawing paper, along with the creases in his trousers and his shoes. It is an evocative, almost romantic image of a pensive and inspired artist absorbed in art making.[11]

Around the same time or shortly afterward, it would seem that Jean returned the favor and made a drawing of Tina. The drawing shows Modotti with her head turned toward the left, with mane-like hair swept back dramatically (fig. 3). She has a rather far-off expression, as if she were looking beyond her present situation to the future. Despite the delicacy of the line drawing, Charlot transformed his subject into something of a visionary, foreshadowing the political commitment of her later years.[12]

One of the artists who attracted considerable attention in Mexico at the time was the woodcarver Manuel Martínez Pintao, who specialized in bas reliefs of

religious subjects. On January 22 Jean joined Edward, Tina, and Rafael Sala in paying him a visit. Charlot had recently written a brief article on Pintao in which he spoke of the sculptor's work as an effective blend of religious subject matter and everyday life, rendered with geometric precision: "Without recurring to the picturesque or exquisite, with such humble vocabulary as leaves, a stump with nestling birds, a spindle, monastic robes, Pintao recreates in terms of God the everyday spectacle."[13] For his part, Weston was struck by the contrast between Pintao's carefully crafted wood carvings and the mass-produced calendars on the wall of his little room, with its cheap brass bed; he was also impressed with Pintao himself: "What a personality too! I did not need to understand each word he uttered to feel the import of his prophetic gestures. One knew the man must be as great as his work—or greater. Pintao is Spanish, but he has lived most of his life in Mexico. His motives are usually religious, but never sentimental. Too bad he has not the opportunity to apply his art, for instance in the carving of some impressive door."[14]

About two weeks later, one morning early in February, Pintao returned the visit, and Edward photographed him as he was talking with Tina. One of the resulting pictures depicts a mustachioed Pintao, wearing a cap, with a cigar jutting upward from his mouth; he is shown close-up and from an odd angle (below and slightly to the side). His head appears slanted, as he looks up and toward the right; the cigar provides a diagonal accent that answers the tilt of his head.[15] Weston seemed almost taken aback by what he had done: "Some of the heads are rather intense characterizations."[16]

During the visit Weston showed Pintao some of his photographs, and he was happy with Pintao's enthusiastic response, perhaps in part because he saw a kinship between Pintao's approach to art making and his own. "The approach to his own work is entirely intuitive—hence its great vitality, profundity. He is impatient with geometrically calculated work. With his knife and a block of wood he starts, his mind free from formulae. As he cuts away, the vision—if you will—comes naturally, the form grows unstudied." And he was quick to bring out the relative spontaneity of his own efforts: "I told him that my photographs were entirely free from premeditation, that what I was to do was never presented to me until seen on the groundglass, and that the final print was usually an unchanged, untrimmed reproduction of what I had felt at the time of exposure."[17] Although certain choices necessarily preceded the act of taking the picture or of studying a given scene or subject in the ground glass (and that required a little more premeditation than Weston

allowed), the photographic act was largely an intuitive one, not unlike Pintao's approach to carving, which was free of any formula or geometric planning.

Weston was in Mexico for six months before he visited the National Museum of Anthropology (Museo Nacional de Antropología), but when he finally did so, what he saw greatly surpassed his expectations. He was especially struck by the simplified, abstract forms and the decorative patterns of the work on view there.[18] Yet Weston felt strongly that the future of photography, and of his own work, led in a rather different direction—away from abstraction and toward a heightened realism—and he sensed a growing dichotomy in his own recent work. He had been making relatively abstract images, like his picture of a circus tent, which pleased many of his friends, but at the same time he was also creating images of greater immediacy, a group of portraits in which he captured life in a way no other medium could match. For him, the abstractions were interesting enough, but the portraits were of greater significance.

It was during the early part of 1924 that Weston made some of the most powerful portraits of his Mexican years—his pictures of Modotti, Lupe Rivera, and Manuel Hernández Galván. These, along with his earlier portrait of Nahui Olín, reflect a changing approach to such imagery; not only are the images noticeably sharper and more detailed than before, but Weston comes in close and fills the frame with the head, which in itself adds a degree of immediacy. Weston had begun to move in this direction before arriving in Mexico, but in 1923 and 1924 he moved forward with increasing boldness, coming in closer and focusing more sharply. He seemed to sense that his recent portraits were his most important work to date and that the new portraits represented the direction in which photography, or at least his own work, should now go. Unlike the abstractions that grew out of his pseudo-cubist efforts in California, the new work represented the path of realism, which he favored because it involved photography's inherent strength: "I shall let no chance pass to record interesting abstractions, but I feel definite in my belief that the approach to photography is through realism—and its most difficult approach."[19]

On March 9, a couple of days after his visit to the National Museum, Edward and Tina held a Mardi Gras party at their house, and once again Jean and his mother were in attendance. Judging from Edward's own account it was a rather wild affair, in which Lupe Rivera came dressed as Diego, with much padding, and Edward and Tina exchanged clothes and roles:

The Mardi Gras party went off with a bang! Many funny and some quite beautiful costumes. Masking, costuming, and drink loosens up the most sedate. Tina and I exchanged clothes, to the veriest detail. I even squeezed into a pair of mannish shoes which she had just bought. She smoked my pipe and bound down her breasts, while I wore a pair of cotton ones with pink pointed buttons for nipples. We waited for the crowd to gather and then appeared from the street, she carrying my Graflex and I hanging on her arm. The Ku Klux Klan surrounded us and I very properly fainted away. We imitated each other's gestures. She led me in dancing, and for the first few moments everyone was baffled. After awhile I indulged in exaggerations, flaunted my breasts and exposed my pink gartered legs most indecently.[20]

There is a photo of this gathering, taken by Chandler, that shows Edward, in the lower right-hand corner, reclining in a plaid dress that he coyly pulls up to reveal his stockinged legs and garter. Standing farther back is Tina, wearing a shirt and tie, and seated in a row in front of them is the Ku Klux Klan, including Monna and Rafael Sala and, surprisingly, Jean.[21] To us now the evocation of the Klan is in poor taste, to say the least, but with their skeleton faces the costumes probably had more to do with local traditions such as the Day of the Dead than with the destructive history of the Klan. In any case, the costumed figures were an important and prominent part of the festivities, and Jean was very much in the thick of things.

Several days after the party Jean came over to Calle Lucerne and Edward photographed him sketching Tina again.[22] The next day Weston busied himself with printing. He seems not to have returned to the Charlot portraits, but he reprinted some nudes of Margrethe Mather that he had sold at the Aztec Land exhibition, and he printed one of the nudes of Tina lying on the *azotea* (roof terrace), which he described in his daybook as one of the best nudes he had ever done. It is not entirely clear which of the nudes of Tina he was referring to at this point, but for Weston it must have represented something of a breakthrough, a more direct kind of seeing.[23] It was in striking contrast to the nudes he had done before coming to Mexico: instead of the pictorialist haze that had typified his earlier imagery, Weston's latest nudes were shown with greater clarity, and he was excited by the result.

Not long after there was another party at Calle Lucerna, and Weston brought out one of the new prints of Tina on the azotea. Much to his surprise, it was

not as well received as he might have liked. In particular, some of those present criticized it "because of the 'incorrect drawing.'" The apparent distortion of the body, the odd foreshortening resulting from the unusual, overhead vantage point, did not correspond with the ideal proportions of traditional nudes. But Jean did not have the same objections; on the contrary, he tried to reassure Edward by pointing out that Picasso had drawn inspiration from precisely that sort of photographic effect.[24] Edward seems to have taken some comfort from Jean's words.

As usual, the party also involved much merrymaking. Edward had been preoccupied with family problems—with thoughts of his sons—and dancing provided a needed distraction. So too there was boxing, and Edward and Jean fought each other. We ordinarily do not associate either one with such activities, but that night they went at it. Jean had more experience than one might have expected—he had been boxing champion of his lycée and artillery regiment in France—and seems to have prevailed. The next day Edward was still feeling the after effects: "A bad head: it was considerably jarred last night, boxing with Charlot. He was once an amateur champion in France and certainly knocked me around rather roughly."[25]

In the following days Dr. Leo Matthias, who had been one of the guests at the Mardi Gras party, became a frequent caller at Calle Lucerna—so frequent that he sometimes had to be turned away. It quickly become obvious that he was obsessed with Tina, who found his attentions annoying, and before long the doctor became the object of considerable ridicule, especially on the part of Jean and Federico Marín, Lupe Rivera's brother. Edward clearly took less kindly to the attention, writing in his daybook, "I wish I could assume the attitude of Charlot and Féderico, who had great fun at the Goldschmidts, showering Tina with mock attention in the style of the Doctor whose infatuation is so profound he cannot disguise it, or else does not care to."[26] Jean's mockery also extended to a cartoon he drew on the wall of Edward and Tina's azotea, which showed Dr. Matthias kissing Tina on the hand while she turns her head away to kiss somebody else.[27]

The same humorous spirit is evident in a photo by Weston that shows Charlot starting a drawing on Tina's upper back as Federico Marín looks on (fig. 4); Weston's own shadow appears below.[28] Although playful in intention, the photo is also carefully composed. Charlot's jacket, which has slipped down his back, creates a sweeping curve leading up to his hand and Tina's

shoulder, and that curve is answered by the rounded backs of the chairs on either side. In this way Weston focuses our attention on Charlot's gesture, and as a result, subject and object are blended together in a kind of visual joke (which looks forward to some of the backyard setup pieces he would do years later). It is a picture about picture making.

In April Charlot and Weston participated in a group show in Mexico City, at El Café de Nadie on the Avenida Jalisco, the meeting place of the Estridentistas. It was organized by the poet Manuel Maples Arce, with whom Charlot was well acquainted, and Charlot may have been responsible for having Weston included in the exhibit. Also included were Rafael Sala, Fermín Revueltas, Máximo Pacheco, and others. By this time the Estridentistas enjoyed considerable influence among Mexican artists, and as Amy Conger has pointed out, Weston's involvement in this show helped shape his reputation in avant-garde circles in Mexico City.[29]

Charlot may also have helped arrange an exhibit of Weston's work in Guadalajara that comprised forty pictures. Although Edward was reluctant to part with so many prints all at once, Jean and Federico forced the issue, and on April 11 they took the pictures off to Gaudalajara. They urged Edward and Tina to come along with them, holding out the prospect of good times at relatively little expense, but Weston demurred. He did not want to spend the money or take time away from his work, and he clearly had mixed feelings about the whole enterprise.[30] Despite his misgivings, however, all went well. Less than two weeks later Jean and Federico returned, bringing with them the proceeds from the sale of eight of the prints—280 pesos—more than Weston had expected. Among the prints sold were *Pipes and Stacks* and two views of the Pyramid of the Sun.

Weston was frankly amazed with the result and flattered: "And then to actually spend money for them! To not only admire them, but to desire to possess them! Los Angelenos would have said, perhaps some few of them, 'Yes, they are nice, but so expensive and I need a new tire for the auto; otherwise, we cannot go to the beach Sunday,' or, 'I must have a new hat for Easter.' The Mexicans, impoverished from the revolution, complained of the prices, yet they bought."[31] For Weston, the Mexicans in Guadalajara were willing to spend money on art that truly meant something to them, despite the disruptions caused by the revolution. In the United States, by contrast, bourgeois gallery-goers paid only lip service to the importance of visual art, preferring

to spend money on more ordinary or more frivolous goods. Weston, though moved, was rather caustic: his pleasure was laced with bitterness, and he indulged himself in the kind of social criticism that would resurface on more than one occasion in later years.

In mid-May Edward and Tina moved from Calle Lucerna to Avenida Vera Cruz, to a house they called El Barco, the boat, because of its triangular shape. A few days later Tina and Edward were at home in their new abode, both engrossed in Jakob Wasserman's novel *The World's Illusion*, when Dr. Matthias came calling. Although the doctor had been making a nuisance of himself with his obsessive attention to Tina, this time his manner had changed. Edward attributed the change to Jean's humor: "The door bell rang; it was Dr. M., or perhaps his ghost, for Charlot and Federico had assured us they had killed him! I am sure Charlot's sarcastic wit, his subtle ridicule, did kill something, for he did not seem quite the same hand-kissing enraptured admirer as before, or it may be he has changed his method of attack, or it may be that I have changed and am indifferent as to the turn of the tide."[32] The conversation was wide ranging. They spoke of Wasserman, whom the doctor dismissed as derivative; they spoke of pyramids; and they spoke of the prevalence of guns in Mexico, at all levels of society, and the disregard of life that went along with it. Then the conversation turned to more practical concerns, and they discussed the possibility of Weston having a show in Berlin, which Matthias seemed willing to undertake. Weston, however, was hesitant: he did not want to devote the time and effort unless he could feel assured of a financial reward. At that point the exposure alone, even if it would boost his reputation abroad, was apparently not enough.

That night Weston had a strange dream, perhaps prompted in part by the prospect of exhibiting his work in Berlin: "If dreams have any symbolic significance, the one I had last night must be of great import. I only have a thread to go on, I cannot recall nor reconstruct the whole dream. It was this, someone, and it is impossible to remember who, said to me, or rather I understood them to say, 'Alfred Stieglitz is dead.' 'Alfred Stieglitz dead!' I exclaimed. 'No,' said the person, referring to a newspaper, 'not dead but dying.'" As Weston himself realized, the dream perhaps referred to the changes taking place in his own work. Stieglitz had been a touchstone of sorts, but now he felt as if he was moving on, doing work that had little to do with Stieglitz's example and that the more senior photographer would not necessarily have approved

of: "The obvious way to interpret the dream, if dreams are to be interpreted, would be in the forecast of a radical change in my photographic viewpoint, a gradual 'dying' of my present attitude, for Stieglitz has most assuredly been a symbol for an ideal in photography towards which I have worked in recent years. I do remember the pain and shock of this news."[33] Weston clearly felt that his sojourn in Mexico was taking him in a new direction, away from earlier efforts inspired in part by Stieglitz, and in that he was not far from the truth. Yet he would continue to photograph subjects—most notably, clouds—that inevitably invited comparison with Stieglitz's then-recent work.

As Weston pondered the direction in which his work was going, his thoughts turned to Charlot and to the importance of their friendship: "As time passes and one gradually eliminates and unconsciously classifies people, the number is reduced to a small group of acquaintances and a still smaller handful of friends. Among these, Jean Charlot remains as the one whom I am most strongly drawn towards, and this despite a slight separation through difference in tongue, albeit his English is usually sufficient." Even religious differences did not stand in the way: "Because of his devout Catholicism, a superficial barrier is presented; though this barrier is not impassible as it might be if he were devoted to Christian Science or Methodism, for at least I can admire the beauty of his religion. Charlot is a refined, sensitive boy, and an artist."[34] Weston had little interest in organized religion; if religion had ever played a role in his life, he made scant mention of it in his daybooks and correspondence. Charlot, although he was deeply committed to his religion throughout his life, never tried to impose his beliefs on Weston.

Weston and his friends, Charlot included, continued their regular Saturday night gatherings, but by this time Edward and Tina had stopped hosting them. At one of these gatherings toward the end of June, at the home of Dr. and Frau Alfons Goldschmidt, those still left at midnight decided to go dancing. According to Weston, Frances Toor, editor of *Mexican Folkways*, suggested the Salón Azteca. "'It's a tough joint; we'll have fun.' There were Anita [Brenner], Frances, Tina, and there were Charlot, Federico, a couple of Americans, and myself who went to the 'Gran Salón Azteca.'" Weston went on to describe the lively scene:

> It was as tough as promised. Logically then it was colorful. Since no restraints of style and method were placed upon the dancers, one saw an unrestricted exhibition of individual expression, desires, passions, lusts,

mostly crude unvarnished lusts—though that French cocotte was subtle indeed and beautiful too. One could not but wonder why she was in such a place among cheap and obvious whores. On her arm were tattooed "Pas de chance." Jazz took a popular place in the music, but the danzón best revealed the temperament of the Spanish-Indian mixture. It is a dance from tierra caliente—tropic earth,—a slow, langorous sensuous dance of hip movements, the feet scarcely leaving one spot.[35]

The following week there was another of these gatherings, probably involving many of the same people, and again held at the Goldschmidts' home. This time the emphasis seems to have been on politics, and the discussion led to the formation of a new communist group. Weston was on hand, but when asked to join he declined, saying simply that he did not want to complicate his life any further.[36] Many of Weston's friends were engaged in radical politics, and although he respected them for their passionate beliefs, he tended to keep his distance. Indeed, he seemed to view such activities with a strange combination of admiration and detachment; his sympathies were more left than otherwise, but he shied away from organized political activity, and he was strangely unaffected by much of the turmoil around him (unless it threatened to disrupt his routine).

It is not clear whether Charlot was present that night at the Goldschmidts', but like Weston, he would not have joined the new group. Charlot probably thought more in terms of an art for the people than did Weston, and he had been an active participant in the Syndicate of Technical Workers, Painters, and Sculptors, a group of radical-minded artists, but he stopped short of any kind of overt propaganda or dogmatic political expression. His religious beliefs may have encouraged him to seek a kind of mass expression, and his interest in mural painting was a reflection of that. But his religious faith also precluded a wholehearted embrace of Communism, at least in any formal sense. In Charlot and Weston's circle, radical politics and avant-garde art making coexisted and often intersected. Charlot was familiar with both but not fully committed to either, and the same was true for Weston—that was probably one of the bonds between them.

By early summer Weston was thinking of leaving Mexico. The uncertainty of his financial situation was taking its toll, and he was increasingly concerned about his family. Although his son Chandler was happy to stay on in Mexico,

Weston was eager see his other sons again. As the days went by he agonized over what to do, but before long he was making travel plans, and everyone prepared to say their good-byes. On July 31 the Salas gave him a farewell supper (at which Charlot and his mother were both present), and he received many farewell presents, including a watercolor from Charlot; it represented a serape-wrapped Indian, and Weston considered it to be one of Charlot's best.[37] Then, at the last minute, after rushing to finish all his work, Weston changed his mind about leaving and decided to stay on: "Well, by remaining I can more completely realize Mexico in my work. Time is required for a new land to sink deep into one's consciousness. Also I can go on with my collecting of Indian craft work. An occasional small expenditure, and now and then a gift, has already brought me many lovely objects and recuerdos. I must make the best of my time while in exile!"[38]

Less than a week later, as a lark (and perhaps as a form of celebration), Edward and Tina had their portrait taken at a professional studio. Weston was amused by the variety of backdrops and props—changing the setting from a church to a rustic scene, a spring landscape.[39] It was also around this time that Charlot made a portrait drawing of Weston, of which there is more than one version. One is a red chalk drawing in which Edward is shown close-up, in profile (fig. 53); Jean emphasizes Weston's high forehead and extends his remaining hair in a way that further elongates the head, as do the rather stylized, pointy ears, adding a degree of severity. So too the absence of pupils makes him seem relatively remote, almost impersonal, something of a mustachioed Vulcan.[40] In another version, yet more stylized, the top of the head is flattened out and the bone structure is accentuated; Jean added shoulders and an open shirt as well (fig. 5). This second drawing Charlot gave to Weston, inscribing it "To Edward / his friend / Jean Charlot / 8-24."[41]

In mid-August 1924 Edward and Tina traveled to Cuernavaca for several days of vacation with Jean, Federico Marín, Anita Brenner, and her sister Dorothea (Dorothy). While there, Weston was drawn to a towering palm tree in the garden of the art collector and dealer Fred Davis, and he lost no time in making a photograph (fig. 6). In his daybook Weston described the "towering palm which, seen through my short focus lens with the camera tilted almost straight up, seemed to touch the sky. I have already printed from the negative and those who have seen it respond with exclamations of delight. It's a great cylindrical, almost white trunk, brilliant in the sun, topped by

a circle of dark but sungleaming leaves; it cuts the plate diagonally from a base of white clouds."[42]

As Weston suggested, the tree trunk seems to rise up from the clouds at the bottom of the picture, which are balanced at the top by the palm fronds that project downward, like darkened rays of light. It is at once direct and novel, and it is no wonder that Weston's traveling companions—Charlot no doubt among them—were delighted by what he had done. Weston said nothing more about his friends' reactions, but after he returned to Mexico City he showed the new photograph to Monna Sala and found her response especially intriguing: "'Ah, Edward, that is one of the finest things you have ever done. Aesthetically it has the same value as your smoke stacks.' Monna's opinion is always of interest to me."[43] He evidently liked the parallel Sala made between the new image of the palm and earlier industrial views of the Armco plant in Ohio, like *Pipes and Stacks*. She seemed to be suggesting that in terms of form or of basic seeing all these images were comparable and that a fundamental similarity overshadowed any superficial difference in subject.

At the same time, however, Edward was somewhat puzzled by what he had just done. Although he was clearly gratified by Monna's response, and presumably by Jean's as well, there was something in his new picture that he did not understand. He sensed that there was something significant about the new image, that it was beyond the ordinary, but—in a moment of uncertainty—he could not articulate how or why: "Just the trunk of a palm towering up into the sky; not even a real one—a palm on a piece of paper, a reproduction of nature: I wonder why it should affect one emotionally—and I wonder what prompted me to record it. Many photographs might have been done of this palm, and they would be just a photograph of a palm—Yet this picture *is* but a photograph of a palm, plus something—something—and I cannot quite say what that something is—and who is there [to] tell me?"[44]

Like Magritte, he understood that his photograph was a mere representation, and like Stieglitz, he understood how such representations could be conduits of emotion; nevertheless, he remained somewhat puzzled by what he had done.

In late September Weston went on an expedition with Chandler and the cinematographer Roberto "Tito" Turnbull to the Santuario de Nuestra Señora de los Remedios, outside of Mexico City. But it was not the church itself that interested him most; he was more impressed by a seventeenth-century

aqueduct nearby, with its simple, elegant lines.[45] He made two exposures of the impressive structure, taken from below, looking up. In both, the slender arches are set against the sky in a way that recalls a woodcut of a viaduct by Charlot, published two months earlier.[46]

That evening, back in the city, Weston browsed among the *puestos*, the market stalls in his neighborhood, where he purchased some painted clay animals; they included a bull as well as a horse for which he paid forty centavos. He would call it the "caballito de cuarenta centavos"—the little forty-cent horse.[47] Weston likened it to a Chinese ceramic: "The horse is Chinese in feeling—a 7th century porcelain perhaps!"[48] When Jean first saw it, he hurried off to get one for himself; unfortunately, he was unsuccessful, and after that he often pretended to steal Edward's.

One day, unable to print because of the cloudy weather, Weston decided to photograph his new acquisitions, making a series of still lifes, including one of the little horse in which the sweeping curve of the horse's neck and head stands out against the zigzag pattern of a *petate* (woven mat) (fig. 7).[49] He also made one of two fish and a bird and another of *chayotes* (vegetable pears) in a wooden bowl. Such subjects may not seem to be a radical departure, but surprisingly enough, *Caballito de cuarenta centavos* and the other negatives he made that day were Weston's first real attempts at still life. In a modest way they represented a new direction, as Weston seemed to understand, and feeling quite satisfied with the result, he also came to another significant realization: "and feeling quite sure they number among my best things, I would comment on how little subject matter counts."[50]

What Weston thus came to understand was that the strength of the picture was not necessarily a function of subject matter alone, or at all; it did not arise solely from the beauty of a particular body or the fascination of a given individual, object, or scene but was instead a matter of form and composition, of inspired seeing. Before he even printed his new negatives he realized that they opened many new possibilities, setting the stage for much of what he would do in the years to come.

When he showed the results, including the *Caballito*, at a spaghetti supper, his friends—Jean among them—received them with enthusiasm.[51] Meanwhile, Jean remained as interested in the little horse itself as in Edward's new photograph of it. Eventually Edward made him a present of it, writing that "Charlot's desire for it was so great that I could not be comfortably selfish any longer, and sent the caballito to fresh pastures."[52]

By mid-October Weston was ready for his second show at the Aztec Land Gallery. It comprised seventy to one hundred images in all, including a number of nudes, some portraits, pictures of the Pyramid of the Sun, the *Circus Tent*, as well as the new still lifes, among them *Caballito de cuarenta centavos*.[53] If the first show at the gallery represented his work at a watershed moment, this one summarized his first year in Mexico. Although Weston did not sell many prints from the show, it was well received, and many of his artist friends came to see it. Diego Rivera, who came with Lupe, paid special attention to certain pictures, including the *Caballito*, although he liked the *Circus Tent* best of all.[54]

Charlot, of course, also came by, and more than once. On one occasion he expressed an interest in analyzing Weston's compositions in geometric terms, explaining that they were "so exact as to appear calculated.'" Weston, however, was not interested and told Charlot that "to stop and calculate would be to lose most of them."[55] Although Weston carefully considered his compositions and pre-visualized his images, it was in large measure an instinctive process and not a matter of geometric planning and plotting: it involved seeing and finding as much as making. Charlot, by contrast, schooled as he was in French classical tradition (which for him included Cézanne and cubism), set greater store by geometry, and his pictures reflect careful planning.[56]

One day when Modotti was tending the gallery alone, an unwelcome visitor, a certain Sr. Silva, appeared on the scene, behaving rather irrationally:

> That mad Mexican photographer came yesterday, tells Tina, and after raving and waving and tearing his hair went up to a certain "Torso," exclaiming, "Ah, this is mine—it was made for me—I could—" and with that he clawed the print from top to bottom with his nails, utterly ruining it. Tina was horrified and furious, but it was too late. "I will talk to Sr. Weston," said Silva. "The print is mine, I must have it!" Tina was called away and later found that the mount had been signed—"Propriedad de Silva." I don't know whether Silva is really mad or only staging pretended temperament; if the latter, I could quite graciously murder him. Either way the print is ruined.[57]

That night Charlot came by with a watercolor of the little horse Weston had just given him, to reciprocate for his friend's recent act of kindness. As Weston noted in his daybooks: "Charlot's pleasure [on receiving the caballito] was expressed concretely—he wandered in last night with a water-color

sketch under his arm. 'To Edward, my first Boss—Horsie.' It was a humorous thing, and I told Charlot that either he had fed horsie too well on beef-steak or else 'he' had become a wee bit pregnant!"[58] To make light of the recent incident involving the deranged photographer Silva and to make Edward feel a little better about the ruined print, Jean added a humorous flourish: he signed the painting "Fot. Silva." Jean also painted a small oil of the horse shortly afterward, in November 1924.[59]

As the exhibit was about to close, Charlot, looking rather dejected, came again to the gallery:

> Jean Charlot wandered into the exhibit at evening, rather woebegone and discouraged: that is Mexico, it either raises one to ecstasy or dumps one into depths. We took him out to dine, Tina and I, prosaically filling him with hotcakes. Nahui Olín joined us, we met her on the way; then all four of us went to Nahui's house. Jean, who knows her well, defined Nahui as genius opposed to talent. At times brilliant in the extreme both in writing and painting, she is again commonplace, without discrimination, discounting her own best work, insisting on her worst. We spent two hours listening to her poems and prose and satires written in both French and Spanish.[60]

As Weston indicated, Charlot was already well acquainted with Olín; he went out with her for a while and made a number of drawings of her, a portrait head and a few nudes, but he obviously had mixed feelings about her work.[61]

No sooner had the Aztec Land Gallery show come down than Weston participated in another exhibition, an extensive group show at the Palacio Minería under the auspices of the Secretaría de Educación Pública. Modotti was also included, along with Rafael Sala, the bibliophile Felipe Teixidor, and Charlot, among others.[62] One night in November while the exhibition was going on, Jean and Edward went to the Teatro Hidalgo, where they saw a performance of an old Spanish play, *Don Juan Tenorio*. Tina came too, together with Pepe Quintanilla, with whom she was having an affair at the time. Although he sometimes strayed as well, Tina's involvement with other men made Edward very jealous. On this occasion, however, the tensions remained under the surface; during the intermission Edward and Pepe went out for a smoke—and talked about the weather.

The next night Edward—without Tina—went to Jean's home, where "Madame Charlot served Jean and me one of her delectable suppers—

'Mexican,' she called the meal, but methinks it had a marked French accent!"[63] Many years later Edward still remembered his dinners with Jean and his mother: "For those dinners at Charlot's I have very fond memories! They were French no matter if the food, the dishes, the recipes were Mexican: the expression, the 'air'. was entirely French!"[64] On this occasion they talked of having an exhibition together in New York; the possibility interested Weston greatly, and the next day, while reporting on the previous night's meal, he expressed his admiration for his friend: "Jean is a prolific worker. 'I am never happy unless I am working,' he said; he is a tireless, never satisfied experimentalist. I note a tremendous growth in his work since the year ago I met him. He renders the quintessence of Mexico . . . For me he is the most important artist—aside from Diego and Pintao—whose work I have known in Mexico, and I somehow sense that someday he will be the greatest of the three."[65]

Jean and Edward saw a fair amount of each other in the coming days. One day they went to visit Rivera's new murals on the walls of the Secretaría de Educación stairway. Charlot had worked in the same building, painting three murals in the second court in the spring and summer of 1923, including *Danza de los listones* (Dance of the ribbons), which would later be destroyed to make way for a work by Rivera.[66] Although they presumably stopped to look at Charlot's frescoes, Weston made no mention of it; the focus was on Rivera's latest work, which Weston judged to be his finest to date. Afterward, Jean and Edward headed back to Edward's place, armed with a bottle of vermouth: "We set the table and poured a glass for the unknown guest as well as ourselves; the unknown one came—it was Tina!"[67]

Less than a week later Jean showed up again with a group of friends—Nahui, Federico and Anita (with whom Jean was spending a lot of time); they came bearing several bottles of wine to celebrate the fact that Weston had won first prize and 150 pesos for photography at the recent exhibit at the Palacio Minería. Weston was surprised, and he was happy to be receiving that amount of money, but he downplayed the importance of the award, since his friend Rivera was on the jury.[68] But as it turned out, he would not actually receive the money for some time.

A few days later, on November 24, Weston went again to the Secretaría de Educación Pública. This time he came armed with his Graflex and photographed Rivera, seated on a packing crate in front of his murals.[69] Looking

over the proofs some days later, Weston was somewhat dissatisfied with the results. Charlot, however, expressed his admiration: "Jean thinks they are the most interesting set of proofs from a sitting that I have done in Mexico. Well—I do like some of them, yes, a number of them, yet I could wish, especially with Diego, that I had made something to be very enthusiastic over. In each proof I find a fault, granted a minor one, and I had hoped for a quite perfect negative from this sitting, not just because Diego is a big artist, rather because he is especially interested in my work."[70]

As it turned out, the sitter too was satisfied: "Diego was pleased with his proofs. They are, I will say, well seen. His choice was one in which his huge bulk was exaggerated, and his face expressed a cynical sadness."[71] The image Rivera singled out shows him seated on the crate leaning back against the wall, head down, cigarette in hand; the emphasis is on the sitter and his expression. Weston himself was not happy with the lack of definition in the picture; as a result he could not use it for himself, but it was nonetheless one of his favorites from the session, too.[72]

Jean was scheduled to sit for his portrait the next day, but if the sitting did take place, no pictures from it are known. It would be strange if, of all his friends, Jean was the only one Edward did not photograph, but no pictures of Jean from Weston's first stay in Mexico seem to have survived, aside from the one with Federico and Tina. A week later, looking over his most recent efforts, Weston said nothing about photos of Jean, but he mentioned how Jean and Tina were enthusiastic about one of his newest prints, a still life of two swan gourds, his *Pajaritos*, painted to look like herons.[73] The image is an elegant composition in which the necks of the birds incline toward each other very gracefully and with implied affection.

Two days afterward Edward and Tina went with Jean to the festival at Guadalupe, although they soon lost Jean in the crowd heading into the church. While they were there they made a number of purchases, including a strange plant that looked like a hand or a claw.[74] It would eventually become the subject of one of Modotti's better-known images. Its bizarre form obviously appealed to them and perhaps matched their unsettled mood. By this time Edward was again thinking in terms of leaving Mexico. He wanted to see his other three sons again, even if it meant being parted from Tina.

As the year came to a close and Weston prepared to leave, he and Charlot exchanged artwork. The process was a rather complicated one, which Edward

recorded in detail: "Last evening I tried to select one of his paintings. It was difficult! Hardly one that I could not have been happy with, yet he had several in reserve which I wanted and probably might have chosen from. Finally I took the hand of an Indian girl holding a bouquet of flowers."[75] Charlot had painted the work earlier that year, in May. It is a small (14 x 10¾ in.), vertical image of a hand holding a bouquet, in which the flowers fill the frame (fig. 21). Weston did not explain why that image in particular appealed to him; he had not spoken of it earlier, but perhaps he saw a connection to his own recent experiments with still life.[76]

Jean also offered Edward some drawings of Luz Jiménez, who had modeled frequently for Charlot. Jean had dozens of sketches of her on hand, and therefore Edward was faced with a difficult choice: "He handed me a number of ink sketches of 'Luziana', maybe thirty or more for my choice. It narrowed down to four. 'Now I shall see how our taste agrees,' said Jean. I chose the one he would have indicated!"[77] It is not known which one he chose, but Weston was greatly pleased to have made a judicious choice, demonstrating the extent to which he and Charlot had the same taste in art.

Then it was Charlot's turn to choose from Weston's prints: "Charlot has reserved several prints from which to choose two, in exchange for one of his paintings. The selection interests me so I will record it. First of all, and with no further question, he chose 'Bomba en Tacubaya'; the others are 'Lupe Marín' — 'Two Bodies' — 'Caballito de Cuarenta Centavos' — 'Circus Tent' — 'Hands against Kimono.'"[78] It is not surprising that Charlot would have chosen *Caballito de cuarenta centavos*, given that he had so much admired the horse itself. *Bomba en Tacubaya*, by contrast, is a relatively complicated scene, taken in front of Weston's first dwelling in Mexico; it focuses on the pump, a utilitarian form of great beauty. Of all of the pictures of Tina, it is interesting that Jean singled out *Hands against Kimono*, which is perhaps the most abstract and which, unbeknownst to Charlot at this point, especially recalls some of the images Stieglitz had made of Georgia O'Keeffe not long before. *Circus Tent* is likewise quite abstract and dynamically composed. Indeed, most of Charlot's choices are distinguished by relatively bold designs, some fairly simple, others more complex. That would include even the head of Lupe, which, in terms of its basic conception, echoes some of Charlot's own earlier woodcut portraits. All in all Charlot chose quite a varied assortment, a representative sample of Weston's work in Mexico over the prior year. Although *Bomba* seems to have been his first choice, it is not known which

of the group he ended up selecting, and Weston did not indicate whether he approved of Charlot's selection in the same way Charlot had agreed with his.

Less than a week later, a few days after Christmas 1924, Weston was on the train, heading back to California. As was to be expected, parting with Tina had been especially difficult: "We faced each other speechless at the parting—a hand clasp—tear filled eyes—a last kiss—."[79] Jean too came to the station, even though Edward had told him not to, and afterward he accompanied Tina back home.[80] Meanwhile, as the train made its way north, Weston reflected on what he had just left behind: "I seemed to realize that I was leaving not only Tina but dear friends and the land of my adoption too."[81]

2

"I'LL KISS TINA FOR YOU"

Edward and Chandler arrived back in Los Angeles by January 3, 1925, traveling through El Paso along the way. After having been away in Mexico for almost a year and a half, Weston felt strangely like a foreigner and not a little gloomy. His mood soon improved as he spent more time with his sons and began to reconnect with old friends—including Margrethe Mather and Ramiel McGehee, a dancer and devotee of Asian art and philosophy. He also began an affair with Miriam Lerner.[1] In those years Lerner was active in the Young Socialist League while also working as executive secretary to the prominent California oil magnate Edward Doheny. Weston had known Lerner for quite some time, but upon his return from Mexico their friendship blossomed into something more passionate.[2] Weston's new flame also became the subject of nude photographs, some of which would later win the approval of Modotti, Diego Rivera, and Charlot.[3]

But Weston did not stay put for long. As intense as his relationship with Lerner may have been, he felt compelled to pull up stakes yet again, and after only about a month in Los Angeles, he headed north to San Francisco, taking his third son, Neil, age eight, with him. (Neil would later return to Los Angeles with Edward's sister, May, while Edward himself stayed on.) In San Francisco he shared a studio with a friend, the photographer Johan Hagemeyer; they rented it from Dorothea Lange. In February the two of them exhibited their work at Gump's Department Store. Weston was excited by the prospect of showing his work in the city, but in the end the show was a

disappointment, at least in terms of sales. As a result, Weston found himself almost broke and wishing he had never left Mexico.[4]

The following month he received a letter from Charlot, who was still in Mexico, urging him—in no uncertain terms—to come back: "What is the matter with you! You have to return. Everybody is waiting for you." Charlot was thinking not only in personal terms but also in terms of art; if Weston returned to Mexico not only would his friends be glad to see him, but his photography would benefit: "Professionally I think you can do better work here than in the States. Many tried to get by photograph the spirit of mecanic modern life, but you would be the first to try the spirit of simpleness and primitiveness by this medium. Your last things (birds, horse) were full of promise. Think of that twenty minutes and see that I am right." In these years many artists, including the Estridentistas, were investigating the machine aesthetic and industrial subjects. Weston himself had done likewise before coming to Mexico (as did Paul Strand at around the same time). But Mexico had afforded him the opportunity to do something different, to use the machinery of photography to record something more basic, more fundamental (Charlot uses the word *primitive*), as in pictures like the *Pajaritos* and the *Caballito de cuarenta centavos*. To pursue that further, Charlot was suggesting, Weston would be better off back in Mexico, whether he realized it yet or not.

In the same letter Charlot also provided some news. Weston had left Mexico without collecting the prize money he had won for the exhibition at the Palacio de Minería toward the end of the previous year, but Charlot had some encouraging information on that front: "The famous prize money *is going to be paid*. I am arranging the things and I'll tell Tina when she can ask for it." Meanwhile Tina, as Jean went on to report, had been making some good photographs; he especially liked the one she had recently made of the plant that looked like a claw, the *flor de manitas* that she and Edward had obtained at the festival at Guadalupe. Jean also reported that Diego and Lupe Rivera, whose marriage had deteriorated, were not yet divorced.

Turning to his own situation, Charlot reported a mixed outlook. He had not managed to get a government post, as he had been hoping, and as a result he was very poor; nevertheless, he was continuing to paint, which was, of course, the most important thing. Moreover, he was hoping to be invited to participate in an upcoming exhibition of Latin American paintings in Los Angeles. Then, in closing, he spoke again of Modotti: "I'll kiss Tina for you, but on the cheek. It is all what my hate for women can allow me to do—." Jean

does not explain further, but his rather curious remark may have reflected recent romantic difficulties or disappointments—perhaps involving Anita Brenner, to whom he was greatly attached. Whatever the case may have been, something had aroused Jean's ire and left him bitter and angry, and—partly in jest and partly in earnest—he extended those feelings to all women (although Tina seemed to be an exception).

After signing off, Jean added a postscript, inquiring, with a bit of humor: "Shall I get the prints before the Last Judgment?!"[5] The prints in question may have been the ones he had selected shortly before Weston had left for California, or perhaps they were the results of his portrait sitting a few weeks before that, or both. Weston's response is not recorded, and it is not known when, if ever, Charlot finally received his prints.

Weston remained in San Francisco for several more months, during which he produced relatively little, aside from some portraits of Hagemeyer and nudes of Neil. By July he was again in Los Angeles. There he had an exhibition at the Japanese Club, which, in contrast to the show at Gump's, was quite successful. Indeed, it was enough of a success that Weston could again contemplate returning to Mexico. Soon he was making preparations, and on August 20 he set sail for Manzanillo, this time bringing with him his second son, Brett, age thirteen.[6]

Edward and Brett arrived in Mexico at the end of the summer of 1925; after stopping at Mazatlán and then Puerto Vallarta, they finally landed at the port of Manzanillo. From there they took the train to Colima and on to Guadalajara, where Tina met them along with Elisa, their *criada* (housekeeper), who had been with them for close to two years. Tina had arranged for a joint Weston-Modotti exhibition at the state museum in Guadalajara, which was scheduled to open a few days after they arrived, so they were immediately immersed in preparing for it. A photograph taken by Weston shows the installation of the show, which evidently was quite extensive.[7]

Unfortunately, the show, like the one at Gump's, was not a financial success. Only six of Weston's pictures sold—purchased by the governor, Sr. Zuno, for the museum itself—and none of Modotti's sold. The press notices, however, were positive, and much to Weston's amusement he was hailed as "Weston the Emperor of Photography, who, notwithstanding his birth in North America, has a Latin Soul."[8] The artist David Alfaro Siqueiros reviewed the show for *El Informador* and spoke in more serious terms, praising the work as a pure

kind of photographic expression. Weston was so pleased with what Siqueiros had to say that he quoted a portion of it in his daybooks: "In Weston's photographs, the texture, the physical quality, of things is rendered with the utmost exactness: the rough is rough, the smooth is smooth, flesh is alive, stone is hard."[9] What Siqueiros seemed to admire most about the images was the detail and texture, qualities that endowed the objects represented with a physical presence specific to photography. The beauty of the images was a function of their photographic quality, of the very fact that they were photographs; they were not imitations of other media: "In one word, the beauty which these photographs of Weston's possess is Photographic Beauty!"[10] That sort of thinking heralded some of Weston's own remarks about the medium, about pure photography, in subsequent years.

In Guadalajara, while the exhibit was going on, Edward, Tina, and Brett had Sunday dinner with Lupe Rivera's family. They also attended a masquerade party at the home of the painter Carlo Orozco Romero, and as they had done at the Mardi Gras party the year before, Edward and Tina exchanged clothes; Brett came as a California bathing beauty.[11] After the exhibit came down they went on several expeditions. One day they hiked to La Barranca de los Oblatos (the Valley of Forgotten Men) with Diego Rivera, among others. They spent another day in Tonalá, where they visited the potter Amado Galván, who would later become the subject of one of Edward's photographs.[12]

Soon after, they departed Guadalajara and proceeded by train to Mexico City. Tina insisted on traveling second class, even though Edward and Brett already had first-class tickets. Edward must have realized by then, if not before, that Tina's political commitment had deepened considerably in his absence. Although Tina would not join the Mexican Communist Party until 1927 and her work had not yet become explicitly political, she was already immersing herself more and more in left-wing activity. Edward ended up shuttling back and forth between Tina in second class and Brett, with his camera equipment, in first.[13]

By the middle of September Weston was again in Mexico City and in his old studio. In coming weeks, despite suffering from a cold and fever, he met many old friends, including Charlot, who must have been glad to see that his friend had come to his senses and was now back where he belonged. Weston may have shown him new photographs, perhaps including the nudes of Miriam Lerner; Charlot likewise lost no time in showing Weston the work he had done over the previous several months.[14] One of the things Weston might have seen

at that time was a small canvas, *Church Patio,* Cuernavaca, a view through an archway to a patio beyond, which Charlot had done several months earlier.[15] Weston might also have seen *The Round Tree,* which he would later come to own, but the piece that seemed to interest him the most was *Arches and Mountains,* Cuernavaca, another image in which arches played a prominent role.[16] Indeed, Edward was so taken with it that Jean made him a present of it: "Charlot seeing my delight in his new oil, said, 'Take it, you have many photographs I want to choose from.' It is simple, this painting,—two terra cotta [arches?] over a base of Mexican pink, surmounted by a mountain- top and sky of deep blue-grey,—a subtle thing in color and construction,—aesthetically satisfying."[17] Weston displayed Charlot's canvas in his room (Edward and Tina had always had separate rooms), along with his old chest, an orange and black serape, and a drawing by Rivera; on the shelves of a yellow *trastero* (whatnot) he placed his recently acquired *juguetes* (toys)—in which he, along with Jean and Tina, had developed a strong interest.[18]

At around the same time Weston also looked at Rivera's latest murals at the Secretaría and noted, "Diego has painted a self-portrait into one of his murals in the Secretaría, copied quite exactly from one of my photographs of him, one which I could not use because of poor definition, though it was my favorite as well as his."[19] Rivera had used the photo as the basis for a self-portrait in the scene by the stairway depicting the arts. In that portion of the mural Rivera presented himself as an architect, accompanied by a sculptor and a painter (a muralist seated on a scaffold). The sculptor too is recognizable: it is a portrait of Pintao, whom Rivera, like Charlot, evidently admired. The painter, meanwhile, is shown from behind; the face is not visible, but it may have been painted with Charlot in mind, or so Rivera—who was not always truthful about such things—assured him.[20]

Charlot had used Luz Jiménez as a model on numerous occasions. Indeed, according to Anita Brenner, it was because of his paintings that she became "a 'classic' native female in modern Mexican paintings."[21] In the fall of 1925 Charlot devoted much attention to her in his prints and paintings, creating a number of powerful images. Luz is present, for example, in his lithograph *Temascal* (fig. 8), which he created in early October.[22] *Temascal* is Nahuatl for *steam bath,* and as Charlot later explained, every Indian village had such a communal bath house.[23] In his depiction there are echoes of Ingres's Turkish baths, or of Renoir's bathers, but it is filled with monumental, sculptural

forms that are the antithesis of the classical ideal (or contemporary chic). Indeed, in his carefully orchestrated composition, Charlot combined classical principles and non-classical, more primal, figure types. At the same time, Charlot added a religious dimension by inserting a view of Calvary, topped with three empty crosses, through the window in the back wall.[24]

Luz was also the model for several large canvases painted at around the same time, including *Great Nude, Chalma I*.[25] Here an imposing deep-terracotta-colored figure—more sculpture than flesh and blood—looms up before an eerie moonlit landscape with part of a dark building in the corner. The drapery that the figure clutches around her waist and thighs calls to mind classical statuary, but her aspect refers more to local traditions; once again, Charlot integrates contrasting types and styles.[26] And Weston, as we shall see, was paying close attention.

At this time Weston was creating some of the best-known images of his Mexican years. On October 21 he reported in his daybooks that he had been photographing his toilet, and within a few days he had shown one of the resulting images to some of his friends, whose reaction was very positive. Charlot, for one, thought it was one of Weston's most keenly observed pictures. Rivera was likewise impressed; upon seeing it, he exclaimed, "In all my life I have not seen such a beautiful photograph."[27] Several weeks later Weston made his famous pear-like nude of Anita Brenner, seen from behind; it was taken the day before she was seriously injured in an automobile accident.[28] Very different from Charlot's *Great Nude*, it calls to mind Brancusi in its simplified, almost abstract form, and in that respect it builds on some the of nudes of Miriam Lerner done earlier the same year. The nudes of Lerner had been well received by Weston's Mexican friends, but this new one caused even more of a stir, and even the subject herself seemed pleased.[29] Although not entirely satisfied with it himself, Weston nevertheless considered it to be one of his best, as he explained a few months later: "Reviewing the new prints, I am seldom so happy as I am with the pear-like nude of A. I turn to it again and again. I could hug the print in sheer joy. It is one of my most perfect photographs. If (the saddest of words) if I had not needed to remove the spots in that patterned background, so carelessly used, I might be almost satisfied."[30]

Another one of his well-known images from this period was produced soon after, in Cuernavaca, where Weston had gone once more as a guest of Fred Davis. On his earlier visit to Cuernavaca he had photographed a palm in Davis's

garden. Now he tried again, photographing the same tree but with different results, producing a simpler, more reductive image.[31] The earlier picture had included palm fronds at the top, but now it was just the trunk, without leaves, set against a cloudless sky—making it more difficult to recognize the tree for what it was. Like the new nude, it was a rather radical image, testing the limits of realism and abstraction. After he printed it he pondered what he had done. The previous year, when he wondered what it was that made the earlier palm-tree picture special, he had found no answer. Having come back to the same theme—even to exactly the same tree—he still had no answer, but he now seemed to know why he had expended time on it. He had no choice: "Why should a few yards of white tree trunk, exactly centered, cutting across an empty sky, cause such real response? And why did I spend my hours doing it? One question is simply answered—I had to!"[32]

Later that fall Charlot submitted *Great Nude, Chalma I* to the Pan-American Exhibition in Los Angeles.[33] Rivera also submitted work, and it was he who came away with the first prize, three thousand pesos. Needless to say, Charlot was disappointed that he had not won anything—and so was Weston: "All we 'Mexicans' are happy, though for my part I wish Jean might have won, if for no other reason than his actual financial need. I think Jean is quite in distress, his demeanor indicates worry."[34] Later on, after he had returned to California, Weston reiterated his preference: "Jean and Diego both showed at the Pan American Exhibit here [in Los Angeles]. Diego won the grand prize,—but—Jean's canvas was the finer."[35]

Despite his disappointment and his financial woes, Jean joined in the festivities at a farewell party for Mercedes Modotti, Tina's sister, in early December 1925. Mercedes had been visiting for two months and was about to return to San Francisco. Many of Edward's old friends were also present; Diego and Lupe Rivera were there, as were the journalist Carleton Beals, Frances Toor, and the Salas, among others. Even Anita Brenner, only partly recovered from her injuries, was on hand; it was her first fiesta since her accident, and she had to be carried in. The assortment of guests reminded Edward of the gatherings at Calle Lucerna during his first stay in Mexico.[36]

Brenner cited Charlot's description of the general mood in her journal: "Charlot remarks that we 'the *familia*' had become so accustomed to certain things and certain attitudes—simplicity and naivete, a certain infantile direct-ness, that we can hardly conceive of how strange we must look to outsiders.

We even have our own language and certainly an etiquette that is original and unmatched. One does what one wants but who wants to promenade in fashion? Etc. etc. Scorn for sentimentals, humanitarians, reformers, moralists, and authorities & or not exactly scorn but surprise at their stupidity. It is indeed comfortable in spite of the undeniable family atmosphere."[37]

Sometime during the evening Edward seems to have brought out his new print of the palm in Cuernavaca to show everyone—and perhaps it was on this occasion that Rivera, echoing Monna Sala's remarks about Weston's earlier image of a palm, likened the new photograph to one of Weston's smokestack images. Rivera regarded the picture as modern even though the subject was only a tree. Weston was struck by Rivera's reaction: later, when countering criticism from Stieglitz, he would invoke Rivera's comment in his own defense.[38]

Shortly afterward Tina received a telegram that her mother was not well, and she left abruptly for San Francisco. While Tina was away Edward was left to his own devices, and one day he went to Jean's for chocolate, bringing along reproductions of the Pan-American Exhibition that had appeared in the catalogue and in the newspaper. Weston was not impressed with what he saw, and neither was Charlot. Edward described his friend's reaction: "'Really though,' he said, 'I am so angry with painters and 97% of paintings, I get to hate them,' and turning over the newspaper, 'Now look at this, it is something fine'—a news photo of a football player in action!" Clearly Edward was struck with the originality of Jean's response, and he went on to explain: "One can always expect to find a fresh new attitude in Jean's work, or rather he has no 'attitude,' is continually experimenting, changing. I spent three hours going over his new drawings and paintings with the greatest interest and pleasure. He is growing into an important figure, while Diego, unless he gets out of his rut, has reached his limit; he is going around in circles, repeating successes, but cold and calculated in their formulization. Charlot has no mannerisms, not in colour, brush-work, arrangement, subject nor medium."[39] Edward did not cite specific works, but Jean had recently completed a painted version of *Temascal* (in November) and portraits of Manuel Pintao (in November) and Anita Brenner (probably in December), among other things.[40] These images are stylized to some degree, but what impressed Weston most was Charlot's directness, the absence of any artificiality or mannerisms in his work. The same honesty was something that Charlot often saw in Weston's photography as well.

The following week, Edward celebrated Christmas in style: "La Noche Buena was spent with the Salas, Carleton [Beals] and friends. Gayety forced with habanero and vino rioja, an immense guajalote—turkey, dancing and games until 4:00." The next day, there was another party, at which Luz Jiménez's little daughter, Conchita, was the center of attention: "Up at 9:00 to keep a date with Anita. Luziana cooked a tasty meal—real Mexican. ¡Que bravo la chile! . . . Conchita in her inevitable pink bonnet was the important guest. She was handed in turn to each, down the table's length, always bright and cooing. Charlot swears she said '¡Ay Mama!' at two months."[41] Charlot's observation was made with a kind of fatherly pride—and for good reason: he was Conchita's godfather, an important responsibility in Mexico.[42] Indeed, Jean had become quite close to Luz and her family, and he would stay in contact with them until the end of his life.

One evening in January Diego Rivera came by Weston's place for a visit, and as might be expected, their conversation soon turned to photography; predictably, he expressed his admiration for Weston's work, but he did so in rather interesting terms, invoking Picasso and Marcel Duchamp: "All the modernists are sentimental. Picasso is, except in his cubism. I like the work of Marcel Duchamp, but I like your photographs better."[43] A few days later, over lunch, Weston reported to Charlot—whom he characterized in his daybooks as "another admirer of photography"—on his conversation with Rivera. Not surprisingly, Charlot was of a similar opinion, saying, "I too like the painting of Duchamp, but your photographs mean more."[44] Although Dada had less currency in Mexico than other avant-garde tendencies, such as futurism, Duchamp was already reasonably well known, and he was among the Dada artists cited by Estridentista leader Maples Arce in his manifesto *Actual no. 1*. Indeed, the Estridentistas had much in common with the iconoclastic spirit of Dada embedded in Duchamp's ready-mades and other works.[45] In comparing Weston and Duchamp, Charlot was speaking in particular of Duchamp's paintings, but he, like Rivera, may also have been thinking about Duchamp's famous *Fountain* (the urinal recorded in photographs by Alfred Stieglitz). Both Charlot and Rivera must have sensed that Weston's toilet image had arisen from a rebellious impulse not unlike Duchamp's, but at the same time they seem also to have recognized the greater emphasis the photographer had placed on formal beauty. Weston's image was not merely a conceptual or iconoclastic gesture or a celebration of everyday objects, it

was also an act of seeing; it was about not only the lines and forms of the toilet itself but also Weston's own ability to express them, and in that respect it went beyond Duchamp.

With the coming of the new year, Charlot left Mexico City for the Yucatán. He had been hired for the spring season as an artist on the archaeological staff of Dr. Sylvanus G. Morley at Chichén Itzá, an ancient Mayan site. Charlot's job was to copy reliefs and murals in the Temple of the Warriors and related structures that could not be effectively photographed. Although it was not the sort of creative work Charlot would have preferred, it was a good opportunity, and he was glad to have steady employment (at least for half of the year). In some ways—given not only his artistic abilities but also his long-standing interest in Mexican archaeology—he was ideally suited for the task.[46]

Charlot had been interested in Mexican archeology since he was a little boy. Growing up in Paris he had been well acquainted with Désiré Charnay, the archeologist, photographer, and author of the pioneering work *Ancient Cities of the New World*.[47] Charnay had been a neighbor and close friend of Jean's maternal grandfather, Louis Goupil (who, a long time before, had accompanied Charnay on one of his expeditions). And he was a frequent guest at Charlot family dinners, where he regaled everyone—including the young Jean—with stories of his Mexican adventures. On at least one occasion Jean and his mother went to dinner at Charnay's apartment, and it was likely at that time that the aged archaeologist allowed the young Jean to leaf through portfolios of his photographs of ancient sites in Mexico, including Chichén Itzá. Charnay also presented Jean—on the occasion of his first communion—with a clay whistle in the form of a coyote, originally from an ancient grave site in Mexico, a present that he treasured for many years.[48] As Charlot later explained, Charnay had found the whistle alongside a child's mummy in a tomb, together with another ancient toy, a clay dog on wheels. Charnay included an illustration of the dog on wheels in *Ancient Cities of the New World* and was derided for suggesting that pre-Hispanic cultures possessed the wheel—although years later, after his death, he was vindicated.[49]

In subsequent years Charlot made an active study of ancient Mexico, going to extraordinary lengths to seek out source material. His great-uncle Eugène Goupil had been an avid collector of pre-Hispanic antiquities and codices; upon his death in 1895 these materials had been given to the Trocadero (Musée de l'Homme) and to the Bibliothèque Nationale in Paris.

When Jean was sixteen years old, already immersed in his studies, he made a special effort to see some of his great-uncle's collection and applied to the Bibliothèque Nationale for special permission to inspect the codices firsthand, which was eventually granted.[50] It was experiences like these that sparked Charlot's enduring interest in the art of ancient Mexico, a topic about which he knew a great deal. Clearly he was well prepared—almost destined—for the challenges ahead.

When Charlot left for the Yucatán in January 1926, Weston recorded his reaction in his daybooks: "Even knowing Jean is to be vastly benefitted by his change, it was sad to view the breaking up of 'Independencia 50,' so long his home. He leaves today for Yucatán and I question if I shall ever see him again."[51] Jean had been one of Edward's closest friends in Mexico as well as an important contact; during the photographer's two sojourns in Mexico, he and Jean had spent a good deal of time together, in close conversation, at parties and on excursions. But Edward was already contemplating a return to California and did not expect to be in Mexico by the time Jean returned from the Yucatán—so their parting was more fraught than might otherwise have been the case. And indeed, it would be many months before they would see each other again.

In the days following Charlot's departure Weston continued to work with the Mexican toys. As he considered his results, he expressed satisfaction with his subjects: "I have made the juguetes, by well considered contiguity, come to life, or I have more clearly revealed their livingness. I can now express either reality, or the abstract, with greater facility than heretofore."[52] In speaking of abstraction Weston was no doubt thinking of such pictures as his pear-shaped nude of Anita or the palm at Cuernavaca—or possibly his pictures of clouds, which, like Stieglitz's Equivalents, also verged on abstraction. In these examples the original forms were simplified to the point of being hard to recognize, and he justly felt that he had attained a degree of mastery over that process. But his pictures of juguetes seemed to fall into a different category, one in which the challenge was to accentuate the actuality of his subjects, not to strip it away; in these new images he had been attempting to animate the little figures, to make them seem to move and interact, and he felt that he had succeeded in that respect.

One day in February Dr. Mayorga, a friend who was an optometrist and amateur photographer, came to see Weston's work. Weston showed him some

recent still lifes, and Dr. Mayorga was enthusiastic; he was especially amazed with the way in which Weston had managed to endow his subjects with personality and spirit. The doctor told Weston, "'You are a god—for you make these dead things come to life!'"[53] Weston obviously did not consider himself to be a god, but the optometrist's response seemed to confirm his own thinking about the new pictures and about the potential of still life. He was clearly elated.

The following day, however, financial reality intruded when the electricity in Weston's dwelling was turned off because he had been unable to pay the bill. That circumstance inspired him to write a rather savage lament about the pitfalls of modern life: "They came to cut off our lights for nonpayments. Next it will be telephone—that instrument of torture with which undesirables can invade one's privacy at any hour of the day or night. The telephone is the special joy of all the busy-bodies, live-wires, Rotarians, who lacking brains, want action. . . . And phones and Fords will help them. But I want to simplify life—my life. Christ! what a lot of excess baggage and blah we civilized moderns carry. We pay a pretty price for these extras, sweating to support supposed necessities which are superfluities."[54]

That night Tina arrived back in Mexico City after having been away for more than two months (her mother had recovered).[55] Edward did not make note of it in his daybook until March 4—when he described it as a big moment for all concerned, including X., his most recent lover, who was in tears at the prospect of being displaced. But his excitement was short lived for soon after, he became sick with influenza, and it took close to two weeks before he felt like himself again. His recovery came just in time for his fortieth birthday, on March 24, a milestone that made him rather sad—not so much because he felt old but because he missed the sons who were not there. He spent the day working, and that night there was a birthday party with many of his friends. Charlot, still in Yucatán, was not present.[56]

In the coming weeks Weston became increasingly restless; still concerned about his sons, he was contemplating a return to California. But at that point Anita Brenner approached him with a possible commission. She wanted to hire him to make photographs of Mexican decorative art for a book she was writing. Weston was excited about the idea; it gave him a good reason to remain, at least for a time, in Mexico. He envisioned traveling around taking pictures for four months if the deal went through and only after that returning to California. It took more than a month for all parties to come to terms, and both Tina and Brett would participate as well.[57]

Meanwhile, in the Yucatán, Charlot was still busy with his archaeological work; so too he was trying to find a way to have Weston join him there on the Chichén Itzá project. In particular, he had it in mind that Morley might hire Weston to replace his current photographer, and to that end he encouraged Morley to pay Weston a visit. In response to a postcard from Weston (which has not survived), Jean wrote to Edward about the possibility: "Morley is in Guatemala. Return by Mexico City. He has a word of introduction for you. Don't miss him. He is intelligent and can appreciate your work. . . . and his actual photograph [current photographer] is not so good as you and extremely lazy." He also asked Edward to give Morley a "Mexican Toy" for him: "I need it," he said, "being here only with Americans."[58] As we have seen, earlier Edward had given Jean the cuarenta centavos horse from which he had made several images; evidently Jean had not brought it along with him and wanted something to take its place during his stay in the Yucatán. Perhaps too he was thinking of Charnay and the coyote-shaped clay whistle. Charlot may have wanted to link the modern toys to more ancient ones for the benefit of his American associates on the expedition.

Charlot then went on to speak of his disagreements with Frances Toor. Charlot had been the first art editor of Toor's publication, *Mexican Folkways*, which showcased Mexican popular art and culture and was aimed primarily at foreign audiences. He had supplied cover designs for the first issue and for a poster promoting it; so too he had written articles for it.[59] But after Charlot's departure for the Yucatán Toor replaced him with Diego Rivera and seems to have insulted Charlot in the process. Charlot had been preparing some Mayan material for the magazine at the time (presumably based on his activities in the Yucatán), so from his standpoint, Toor's timing was especially unfortunate. Nevertheless, Jean's spirits were good, and he seemed to be enjoying his new job. Indeed, in the same letter, he also spoke of the virtues of copying: "Have very little time for me but great profit in *copying* maya things. One gets out of the individual. It is like opening the window. New air."[60] Although potentially dry and routine, copying became a way for Charlot to get out of himself; not only did it allow him to arrive at a better understanding of Mayan art but it also allowed him to engage in a form of artistic activity in which the ego was suppressed. Charlot would always look with suspicion on artists who put themselves on display in their work; he himself was more self-effacing, and his views on copying are a reflection of that.

Always interested in what Weston was doing, Jean concluded his letter

by asking Edward to send him some samples of his current work—not good prints, not platinum prints, but something like proofs, which would give him some idea of the photographer's latest efforts.

Soon after, Dr. Morley arrived in Mexico City and called upon Weston, bearing the letter of introduction Charlot had mentioned. "He said that Jean was the 'find' of the year for them. After seeing my work, he asked what amount I would consider for my services next season."[61] Weston did not record his response, and no definite offer was made at that moment. Presumably Morley needed time to work out the details, and Weston, for his part, had to mull the matter over. He was clearly intrigued by the possibility of joining Jean on the Chichén Itzá project but was held back by thoughts of his family; he had not seen his sons, except Brett, for close to a year and was contemplating a return home. If he went back to California he would not necessarily return by the following year, or at all.

Afterward Charlot wrote to convey Morley's offer. Morley, Jean reported, liked Weston's work and wanted him to come to the Yucatán for two months during the following season. All expenses, travel, and materials, were to be paid by the Carnegie Institution, and in addition he would receive $250 (500 pesos) for his work. By way of persuading Edward to accept the offer, Jean added, "There is here a photographic studio and Morley is intelligent enough to let you work *as you want*." And he signed off with kisses for Tina ("Besitos to Tina").[62]

Weston recorded his response in his daybooks: "I have had a definite offer from Morley to join the Chichén-Itzá project next season in Yucatán. The salary small—250 pesos a month—but all expenses paid and R. R. fare. I asked however for fare from the States, for I surely will be there." By this time Weston had decided to return to California, but he was willing to consider coming back to join the expedition the following year if Morley would cover his travel from the states. Weston was not impressed with the basic salary, but the fact that his expenses would be covered was an inducement, as was Charlot's continuing presence there: "Jean will join the expedition again, and to be in Yucatán with Jean would be jolly indeed."[63]

In June a brief article by Weston appeared in *Mexican Life*; it was his first formal statement on photography since arriving in Mexico. Above all else he emphasized the unique qualities of photography as distinct from painting.

While painting should not seek to rival the realism of photographic imagery, he argued, photography too should not imitate painting. And in that context, to reinforce his position, he invoked some of his artist friends: "I have noted the never failing interest in photography of several great painters; to name those in Mexico, whose 'Art Interpretations' have recently appeared in *Mexican Life*—Diego Rivera, Jean Charlot and Carlos Merida. But these painters would consider with due contempt a photograph overstepping its limitations; to explain, a photograph purposely blurred, or printed in some medium allowing of 'arty' presentation or hand manipulation; further to indicate, attempted painting with a camera." He went on to speak of photography's special strengths: "Photography is of today. It is a marvellous extension of our own vision; it sees more than the eye sees; it renders as can no other medium the most subtle nuances of light and shade, the most delicate of textures."[64]

Weston had spoken of a purist approach to the medium more than once; in the spirit of the British photographer Frederick Evans, he had long eschewed any kind of painterly manipulation. He sounded those same notes yet again here, but these remarks, reflecting the significant changes that had taken place in his work over the previous several years, signaled a deeper commitment to a more direct and precise mode of seeing.

By the time the article appeared in *Mexican Life*, Edward, Brett, Anita Brenner, and Tina had departed on an expedition to Puebla, Oaxaca, and other parts of Mexico in search of artwork to be included in Anita's book. It had taken some time to work out all the details, but they were on their way at last, and Weston had a great deal to do. Although much of the photography involved was straightforward copy work, Weston approached his new job with great diligence, discipline, and patience—an attitude not unlike Charlot's approach to his efforts in the Yucatán. As Amy Conger has indicated, it afforded him the opportunity to work further with still life, as he had been doing already with the juguetes, and this in turn set the stage for the still-life work he would do in the coming years with shells, fruit, and vegetables, after he returned again to California.[65]

One of Weston's images that does not quite fall into the category of still life is the luminous *Arcos, Oaxaca*, which shows a succession of arches, one seen through another. Modotti had photographed a similar scene sometime before, on a visit to the Convent of Tepotzolán.[66] Weston may have been thinking of that picture here—the basic structure is quite similar—but he

may also have been thinking of the small oil that Charlot had given him not long before, *Arches and Mountains,* Cuernavaca: there too arches had been used to good effect.[67] Weston may have had in mind Charlot's *Church Patio/ Patio rosa* as well.[68] On the face of it, Weston's photography generally bore little relationship to Charlot's paintings, but the two artists did sometimes explore similar motifs and compositional devices, and in a few instances they even depicted the same objects. Modotti had obviously been investigating similar terrain as well, even earlier.

During the second leg of the journey, Edward and Tina returned to Guadalajara, where they were welcomed by the Marín family, who had entertained them on their previous visit. The Maríns told them of the death of Manuel Hernández Galván, the senator who had been the subject of one of Weston's best-known portraits; Weston described his death as "a monstrous tragedy."[69] While in Guadalajara Weston made many negatives, in the museum and elsewhere; he worked in the colonial home of Governor Zuno (who had bought some of Weston's photographs the previous summer) and photographed frescoes by Siqueiros and Amado de la Cueva at the university. But Guadalajara, at that moment, was anything but calm, and the ongoing struggles threatened to interfere with their work, as Weston explained: "Guadalajara was not gay. What city could be during this crisis! Black prevailed, — the Catholics in mourning. A boycott of all luxuries, all pleasures, emptied the streets and stores. Street fighting between soldiers and Catholics, — the majority women, armed with bricks, clubs, machetes, — resulted in bloodshed and death. To work in such a belligerent atmosphere was embarrassing. Every movement out of the ordinary was noted. Setting up my camera in front of a church was next to training a gun upon it. I wished that instead of puttees and leather breeches, I had the most conventional suit."[70]

In the beginning of August they went to Tonalá and again visited the potter Amado Galván. Charlot, now back from the Yucatán, joined them there, as did Rivera. This time Weston thought that Galván, because of his growing renown, had begun to repeat himself; he considered the more recent work beautiful yet cold. But that did not prevent him from making his well-known picture of Galván's hand holding a pot aloft, against the sky, a photograph that Brenner would later use in *Idols behind Altars.*[71] During the same visit Rivera sketched Galván as he worked; according to Charlot, Rivera's portrait of Galván, included in his fresco in the first court of the Ministry of Education, was based on the sketches he made during this visit.[72]

After almost two weeks in Gaudalajara, Weston and his companions continued on to Guanajuato and then to Querétaro before heading home.[73] By the end of August they were again back in Mexico City, and soon after Edward paid a visit to Jean, who showed him his latest work, which Edward had not yet had much opportunity to see. As Weston noted, a good deal had changed: "His new work from Yucatán in contrast to the sombre, heavy painting done here, sparkled with delicate, but brilliant, jewellike color. I loved his old work and I love the new equally, if differently."[74] Among the works Weston may have seen was *Builder on Ladder, Yucatán*, a paradoxical combination of realism and stylization, reflecting Jean's familiarity with Mayan imagery. The relatively light palette was a departure from the deep reds and blacks of some of Charlot's earlier paintings.[75] Weston may also have seen *Great Malinches*, based on drawings that Jean made while staying at the Hacienda de la Llave in San Juan del Rio. Charlot made a number of variations on this lively theme, one he would continue to explore in later years.[76]

Weston concluded by praising Jean's amusing portrayal of a certain Mrs. Nuttal (Zelia Nuttal), presumably *Lady with Hat* (fig. 22), which Weston described as "a delicious caricature."[77] It shows, in profile, a rather regal dowager, looking a little like a Mayan ruler or deity; she wears an elaborate, feathered purple hat, pearl earrings, and a pearl necklace with a medallion depicting the crucifixion in relief, all set off by the swirls of her fur stole; the rouge on her cheek matches the red of her hair. It is indeed an impressive caricature, both humorous and savage.[78] In coloring it is more somber than some of the other works that attracted Edward's attention, but he enjoyed it nonetheless, especially its humor.

In the following months, Edward was much occupied with the pictures for Anita Brenner. He photographed a terracotta statuette of a *tortillera* (tortilla-maker) that belonged to Charlot and was produced by the Panduro family from Tlaquepacque.[79] Weston also photographed some of Charlot's own work, including drawings of a nude woman, an Indian mother and child, and a seated Indian woman in a serape.[80]

Then, one Sunday in early October, Edward and Jean went out to photograph *pulquería* paintings, and Brett went along with them. Pulquerías were bars that served *pulque*, a drink distilled from the maguey (or agave) plant; their exteriors were usually adorned with lively paintings of popular themes, such as *toreros* (bullfighters) or *charros* (cowboys), which served as

both decoration and publicity. Edward had been fascinated with such paintings since first arriving in Mexico, and he had photographed them at least once before, with Diego Rivera and Frances Toor, to illustrate an article Rivera was doing for *Mexican Folkways*.[81] This time he had different companions, and as he reported in his daybooks, he approached the task with a certain amount of trepidation: "I dreaded the day, — even the day before. The pulquerías are always in crowded sections; closed Sundays, yet in their shadow the habitués linger perhaps because some small side door may be ajar, or perhaps from habit. It seemed difficult to find just the right ones to illustrate the point. One week a fine example is noted, the next week it is gone, — repainted or painted out, or covered with posters. These fine examples of popular art are treated with scant respect."[82]

Among the pictures Weston took that day was one depicting the wall of an establishment called El Charrito, which boasted exquisite pulque from the best haciendas of Los Llanos de Apan (fig. 9). In this case, a myriad of detail—word and image—is locked into a carefully controlled geometric pattern. The main image shows a cowboy standing by his horse in a landscape framed by illusionistic curtains and a decorative border, the forms of which are echoed in the lettering. In addition to the painted figure, Weston included actual people, who nicely complement the painted image. One looks out of a window in the upper right, surrounded by birdcages; a seated figure, wearing a hat and holding a cane, seems almost to be snoozing at the lower left. Touches like these make this picture one of the most interesting of Weston's pulquería photographs; Brenner used it in a somewhat cropped version in *Idols behind Altars*.[83]

The same day, as Weston continued to photograph pulquerías, a little trouble developed from an unexpected quarter. A bourgeois gent, who apparently thought Weston intended to make Mexico look bad, abruptly interrupted their efforts. "Nothing untoward happened for a time, but just as I heaved a sigh of relief that we were out of the crowded, tough districts, and set up in a quite respectable, quiet street, an unpleasant incident took place. A Mexican of the middle class really quite a fifí, accosted us. He was boiling with hardly suppressed anger. We were to use such pictures to ridicule Mexico, to show her worst side to the North Americans, — and so on." Charlot felt the need to respond: "Words with such people are futile, but Jean argued, then became sarcastic. 'You think the Teatro Nacional is a finer expression?' — which naturally he did! I thought he would use personal violence, but he hurried half

running away,—'to get a gendarme,' so I hastened the exposure and we were off. But such people form the mass, the world over—except, in Mexico, they seem a bit more touchy."[84]

The Mexican gentleman obviously looked down upon such paintings and was concerned that the pictures Weston was taking would be used to embarrass Mexicans, to make them appear primitive or degraded. He did not understand how anyone could see any merit in them. But Weston and Charlot were both admirers of such paintings, and Charlot in particular was determined to convince their nemesis that these paintings were of an importance equal to that of more established monuments and more widely recognized examples of high art. Like the juguetes, the pulquería paintings represented a clear manifestation of vernacular culture—an important source of inspiration for the artists who participated in what Charlot would characterize as the Mexican Mural Renaissance.

Like Diego Rivera, Charlot wrote an article about pulquería painting around this time; it appeared in *Forma*, and Charlot used the occasion to say something about art in general: "Such wine shops, butcher shops or bakeries with façades and interiors excitingly frescoed are a practical answer to queries as to the whys of art. A writer proved the use of poetry by declaiming to his cook; moved by the verses, the cold hearted woman had to yield. In the same way does the picture invite its public. More patrons will get drunk in a wine shop well adorned, thus proving the reality of art. Nor is it by pleasant subject matter that the charm is woven, but by line and color." In Charlot's view the pulquería paintings demonstrated that art was not done for its own sake; it needed a purpose, but at the same time the subject in itself was of less importance than form, than line and color. Composition went hand in hand with meaning and even took the lead—and Weston would certainly have agreed. So too he would have appreciated the humor of the example Charlot provided to reinforce his point: "The story itself remains incidental, may even be of a disquieting nature, as in a butcher shop of la Piedad, on whose walls cows and pigs busy themselves with quartering, cooking and eating the customers of the establishment." Charlot concluded his article by emphasizing the value of pulquería paintings and related imagery, remarks that seem almost aimed at the middle-class critic who had accosted Edward, Brett, and Jean: "It is too bad that people of good taste will not take notice of the art show in the streets. More than museums and art galleries, the streets of Mexico are an index to its culture."[85]

In a similar spirit, Weston celebrated family daguerreotypes in an article published in the same issue of *Forma*. There, he spoke of such images as straightforward documents without artistic pretense: "They are documents, 'family memories', nothing more. They were made in the days before 'artistic photographs,' and 'light effects,' and theatrical 'posing.'" As Weston explained it, daguerreotypes were, despite their technical limitations, visually compelling, like pulquería paintings: "Although rigid, those photographs of our ancestors have a rigid dignity. Since the exposures lasted for minutes, they did not allow for calculated poses. In this manner we have inherited today the first epoch of photography, the most genuine, the most honest expression."[86] The statement was illustrated with three daguerreotypes, perhaps belonging to Weston himself or at least selected by him, which seem to have been made in Mexico.

On November 5, 1926, Weston recorded in his daybooks that Charlot had given him several drawings to take to Los Angeles to sell. These might have been some of the images that Weston had photographed back in September. Whichever ones they were, Weston was much taken with them: "they are so fine that I almost hope they do not sell!"[87] Charlot, for his part, expressed his admiration for one of Weston's new photographs, a picture taken in Xochimilco of cactus and rock; Rivera, who also showed up that day, shared Charlot's view.[88] As Amy Conger suggests, this was probably the picture of the Mexican artist Francisco Goitia's patio taken on October 17, while Weston was still making photographs for Anita Brenner's book.[89] The cactus, in harsh sunlight, is set against the dark rocks immediately behind it; the texture of the former complements the pattern of the latter.

On the same day, Weston made a number of portraits of Charlot: "In the afternoon Jean sat to me."[90] Weston had spoken of photographing Charlot once before, but the pictures from that earlier session, if they were ever taken, are not known. This time the portraits have survived, and they fall into several distinct groups, each with a different backdrop. First, Edward photographed Jean standing against a low wall, on a roof, looking rather dapper in a pinstripe suit (although, oddly, his belt does not go through the belt loops); he made several variations in this location as Charlot shifted position. In one case, he leans back against the wall, turning to the right and staring off into space; in another, he turns away completely and looks out over the rooftops in the background; and in yet another, taken from almost the same angle but closer

in, he turns back to the left, resting one arm on the wall, and looks past the photographer.[91] All of them project a fairly confident image, quite different from what Tina had done a few years earlier. Unlike Modotti's romantic depiction of a young artist at work, Charlot now seems more assertive, bolder, more active, and there is no indication of his profession.

During the same session Weston also photographed Charlot a little closer, standing against a relatively plain, textured wall; here, too, he tried a number of different poses. In one of them Jean, wearing the same suit as before, is shown standing in a casual pose, facing the camera, with his thumbs in his belt; in another one, quite similar to the first, he has one hand on his hip and the other behind his back. In yet another variant, Jean, with both hands in his trouser pockets, turns his head to the left. In each case the dark silhouette of the figure, shown in three-quarter length, fills the frame and stands out against the relatively light, textured background.[92]

Lastly, Weston made a few photographs of Charlot standing in front of a brick wall, including one in which he is shown with his back once more against the wall, with both hands wedged in the waistband of his trousers, looking off to the left (fig. 10).[93] There is also a related view, made at much closer range, in which Charlot is shown from the chest up, looking off rather soulfully to the side (fig. 11).[94] As in the fuller view, the bricks in the wall create a grid-like pattern behind the subject, and in that respect it differs considerably from Weston's better-known portraits from the Mexico years. In his portraits of Nahui Olín or Manuel Hernández Galván, for example, the heads are set against a neutral backdrop—often the sky—which does not call attention to itself. Here, by contrast, the pattern of the bricks is relatively busy and quite prominent: textures and patterns are combined to a greater degree.

A few days after these portraits were taken, as Edward prepared to leave Mexico, Jean and Madame Charlot gave him a little farewell supper. Edward presented Jean with a print of his new image of a maguey; Jean reciprocated with an oil painting, with which Edward was delighted.[95] Before they parted Edward showed Jean the proofs of the recent portrait session, and as he reported in his daybooks, Jean was pleased with them: "Jean was happy with the proofs, especially one head against a brick wall, a perfectly fine negative and a strong likeness."[96]

The following morning Edward woke up with a bit of a hangover, which did not prevent him from recording his experiences and making final preparations

for his trip. Shortly afterward he left Mexico for good. On the train his thoughts were mostly about Tina: although their romantic relationship had long since broken down, they remained attached to one another, and upon leaving, Edward was beset by a deep sense of loss.

After Edward departed Jean made a painting of the pottery bull that Anita Brenner had recently acquired at a street stall (fig. 23).[97] Weston had already photographed the same bull more than once: in one instance, he photographed the bull from the side, against a patterned textile, and in another the bull appears with a pig, a horse, and a decorated plate featuring a bird.[98] Charlot's depiction differs from both of Weston's images—the bull is shown fairly close-up and from an angle—but Charlot must have been thinking of his photographer friend. Without quite realizing it, perhaps, he was marking the end of an era.[99]

3

BACK IN CALIFORNIA

By the end of January 1927 Weston was back in Glendale, in his old studio. Soon after he was given a show at the University of California at Los Angeles, together with his son Brett, who at age fifteen was already emerging as a photographer in his own right. The exhibition comprised about a hundred prints by Edward and twenty by Brett.[1] Even before the formal opening, Edward's friend the painter and sculptor Peter Krasnow came to see it, and he brought along fellow artists Marguerite Zorach and Henrietta Shore. Edward was already familiar with Zorach's work but not Shore's. During the 1920s, the Canadian-born Shore was enjoying considerable success in New York as well as Los Angeles, where she was living at the time, but Weston knew her only by name.[2] That was soon to change.

Later the same day Weston had the opportunity to see a selection of Shore's work: "Now I know her very well, for they [presumably Krasnow and Zorach] took me to her home and there I saw fine painting." Then he added, in a rather sexist vein, "Women as creative artists soar in my half contemptuous estimation when I see such work."[3] Weston was obviously impressed with what he saw, and in due course it became clear that Shore felt the same way about his pictures. Soon after their first encounter she seems to have gone back to Weston's exhibition on her own and, after looking closely at the photographs, recorded her response in the exhibition register: "I spent an hour enjoying the sheer beauty of your work—free from mussiness or effect."[4] Clearly pleased,

Weston proudly quoted Henrietta's remarks in his daybooks. Their meeting would turn out to be a rather fateful one.

Charlot too would eventually meet Shore, but not until somewhat later. When Edward first encountered Henrietta, Jean was working again in the Yucatán, where he had returned for a second season. He had hoped that Weston might be able to join him as a part of Morley's team, but the job that Morley had offered the previous year had fallen through, apparently because of budget cuts. Weston wrote to Charlot about it (the letter has not been preserved), and Charlot wrote back, somewhat apologetically: "I am extremely sorry of what happened with Morley but *it is true* that they cut salaries. He even suppressed the boy who was going to help me though indispensable for my work. Please if another opportunity is offered to you to come here don't refuse because of that. I would like *so much* to have you here and it is all so beautiful."

Although Charlot was still hoping that, somehow or another, he and Weston would spend more time together, he added, rather hesitantly, a few more words, which sounded a little like a farewell: "I am pretty sure we shall meet again, Edward; I learned much from you about painting and if you want to send me from time to time some bad prints of your best negatives, I could still learn something. Your friend Jean."[5] By this time Edward had no doubt given up on any idea of joining Jean in the Yucatán, but he must have relished the idea that his own work had an impact on Jean's.

In early March Weston began photographing Bertha Wardell, a dancer he had known for some years; after seeing the UCLA show, she had offered herself as a model, and over the next few months he would make quite a few photographs of her posed in the nude, including a number of well-known and often-reproduced examples (such as fig. 12). In contrast to the images of Tina on the azotea or the pear-shaped form of Anita Brenner (or even his recent nudes of his friend Christel Gang), the new nudes are fragments: the heads, and in some cases other parts of the body, are cut off in a way that recalls ancient statuary. Yet, although posed, the new nudes are more dynamic than earlier examples; instead of sleeping or sitting, the figure is seemingly in motion. There is a muscular tension, a tautness not evident before, which is reinforced by the dark outlines created by the cast shadows.[6]

As work on the nudes progressed, he received a packet of drawings by Máximo Pacheco from Tina; he was to sell them, on commission, but he

decided, as a kind of birthday present to himself—he was just turning forty-one—to keep one of them. He described the drawing he chose as "a deep sea fantasy" that had for him a special kind of "transcendental force." But in order to buy it, he had to part with another artwork. He weighed whether it would be his Picasso drypoint or one of the Diego Rivera drawings he had brought back from Mexico, and making such a choice quickly led him to give some thought to the current state of Mexican art more generally. While he acknowledged that Rivera was the most highly acclaimed artist working in Mexico, he personally preferred others: "I have before this placed Jean Charlot ahead of Diego, now I place Pacheco also ahead: and there is Siqueiros to consider, no minor figure—and Orozco of great importance. No, not with less admiration for Diego, I say he is now overrated, or better the others are underrated, that there are several his equal or greater,—Jean and Orozco are surely greater."[7] In the same context, Weston also recalled the Pan-American Exhibition in which Charlot's *Great Nude, Chalma I* had been eclipsed by a work by Rivera that Weston did not like as much.

Meanwhile, Anita Brenner came to visit Charlot at Chichén Itzá, along with her roommate, Lucy Knox, who worked in Mexico City for the publication *Revista de revistas*.[8] A photograph records the visit: Jean and Anita are in a hammock, looking much at ease with one another. They were obviously on very good terms. To the right are Knox and Lowell Houser, another artist who had been brought in to help with the archaeological copying.[9] A second photograph shows Charlot hard at work (fig. 13).[10] All during this time, Charlot was busy making the precise renderings that would later appear in the final report of the expedition, and when time permitted he made more informal sketches of Mayan motifs and of the local scene.[11] The task of copying may have been tedious, but it would give Charlot a deep understanding of Mayan art, which would in turn have a lasting impact on his own work, on his style and his choice of subject matter.

Back in California, as Weston continued to work on the nudes, he also began photographing shells. Shore had asked him to sit for a portrait, and while he was there, she encouraged him to photograph some of her shells, which she herself had used in her own imagery. Weston noted, "I am stimulated to work with the nude body, because of the infinite combinations of lines which are presented with every move. And now after seeing the shells of Henrietta

Shore, a new field has been presented."[12] On some level this would be a continuation of the still-life work—of toys, pottery, and the like—that he had done in Mexico, but now, with less emphasis on a recognizable subject, it was turning back toward a more abstract realm.[13] In any event, Weston became absorbed with this new subject, and over the next few months he produced some notable images. Soon he was also working with bananas and other fruits and vegetables. His experiments with still life, begun in Mexico, had started to bear fruit (so to speak) and had become a dominant force in his work.

Not all of this work was well received; even some of his friends had reservations. One day, as Henrietta (or Henry, as she was often called) continued to work on Weston's portrait, he showed her a series of his latest nudes of Wardell. She was quite critical; although she had liked some of the earlier ones she was not impressed with what Weston now showed her: "I had a direct, plain-spoken reproof. 'I wish you would not do so many nudes,—you are getting *used* to them, the subject no longer amazes you,—most of these are *just* nudes.' (I knew she did not mean they were *just naked*, but that I *had* lost my 'amazement.')"[14] Weston appreciated her bluntness but wondered whether her response had to do with the fact that he had showed her a whole group of pictures, not just the best. This led him to an extended meditation on his method of work, which he addressed to Shore:

> You see, Henrietta, with the Graflex I cannot possibly conceive my complete, final result in advance,—as you can. I hold to a *definite attitude* of *approach*, but the camera can only record what is before it, so I must await and be able to grasp the right moment when it is presented on my ground glass. To a certain point I can, when doing still-life, feel my conception before I begin work, but in portraiture, figures, clouds,—trying to record ever changing movement and expression, everything depends upon my clear vision, my intuition at the important instant, which if lost can never be repeated. This is a great limitation and at the same time a fascinating problem in photography.
>
> Imagine if you had to create in, at the most a few seconds of time, without the possibility of pre-visioning, a complete work, supposed to have lasting value. Of course my technique is rapid, and serves me if coordinated at the time with my perception.[15]

When working with a large-format camera, photographing inanimate objects such as the shells, it is possible to imagine the image before the fact—to

pre-vision it, as he says. But when working with the Graflex, photographing moving objects, taking pictures becomes a more rapid and intuitive process, and that in turn means that not all of the resulting images can be successful; this was a limitation as well as a challenge. Less than a week after he first showed Henry his new nudes, however, Edward showed her more—presumably a more select group this time—and her response was positive.[16] Weston, for his part, once again expressed his admiration for Shore and his desire to write something about her and her work: "I want to write about her work,—yet to find words?—It would be a difficult subject, maybe beyond my ability."[17] He did not make the attempt at this point, in the daybooks or elsewhere, but he would eventually write an admiring essay on her work, and so would Charlot.[18]

At around the same time Weston's work came under criticism from Alfred Stieglitz as well. In April the photographer Consuela Kanaga had gone to New York and taken some of Weston's prints to show to Stiegtliz, among others.[19] In May Weston received a letter from her reporting that "Stieglitz seemed disappointed. He thought your technique was very fine but felt the prints lacked life, fire, were more or less dead things not a part of today."[20] Stieglitz had been an important force in the fight for recognition of photography as a fine art and later a strong champion of straight photography, and all that had had an impact on Weston. For that reason, Stieglitz's criticism must have stung, and not surprisingly, Weston quickly launched into a lengthy and combative defense. Most of all he took exception to the idea that his subjects—shells, nudes, and clouds—were not modern or contemporary enough. After all, although Stieglitz showed little interest in still life, he himself was photographing clouds extensively (the Equivalents) and thus appeared to be contradicting himself:

> If I had sent my toilet, for instance, how then would he have reacted? And must I do nothing but toilets and smokestacks to please a Stieglitz! Is his concern with subject matter? Are not shells, bodies, clouds as much of today as machines? Does it make any difference what *subject matter* is used to express a feeling toward life! And what about Stieglitz' famed clouds? Are they any more today than my subject matter? He contradicts himself!
>
> Great art of any period may portray, use, contemporary subject matter,—but the spirit of art is ageless,—it may have national characteristics but the appeal is universal. If it is not universal it is no better than propaganda, and as such must die.[21]

Kanaga's letter also made Weston recall a dream he had had about Stieglitz two years earlier, in Mexico, a dream "—that Alfred Stieglitz was dead. If dreams are symbolic—this was an important dream to me——."[22] The dream was significant in the sense that, although Stieglitz was very much alive, as far as Weston was concerned he was already dead. Stieglitz may have been disappointed with Weston, but Weston was also disappointed with him, disillusioned by one of his heroes.

The next day Weston awoke still fuming over what Stieglitz had said and added, "I am one who has always been keenly alive to the life of today: never have I mourned for the past of 'Greek glory' or any other period. I have protested whenever it was obvious that a contemporary artist had merely gone to the past either in technique or subject matter and assumed a pose,—but, to avoid using a palm, or Mexican pottery or what not because it does not belong to our day is merely silly!"[23]

In the same context, Weston also recalled a conversation in which Charlot had passed along something that Rivera had said about Weston's latest photographs, in particular his photograph of a palm tree (*Tronco de palma*): "I recall what Diego once said to Jean, 'I like Weston's new smoke-stack better than his old;' the new smoke-stack was the trunk of a palm! So much for aesthetic reaction to subject matter."[24] Perhaps he was also thinking of Monna Sala's response to his earlier image of the palm at Cuernavaca. For Rivera and Sala the palm was clearly as modern as a smokestack, and that seemed to underscore the absurdity of Stieglitz's criticism; Stieglitz may not have liked it, but Rivera did, as did Charlot (who would own a print of this picture).

Although Weston had made his farewells to Tina when he left Mexico the previous year, he was still in close contact with her and from time to time sent her examples of his latest work. Toward the end of June he sent her a batch of his shell pictures. Unlike Shore, she was effusive in her response: "nothing before in art has affected me like these photographs—I just cannot look at them a long while without feeling exceedingly perturbed—they disturb me not only mentally but physically—There is something so pure and at the same time so perverse about them—They contain both the innocence of natural things and the morbidity of a sophisticated distorted mind—They make me think of lilies and of embryos at the same time—They are mystical and erotic." Later that day she added, "Now then since the creations of an artist is the result of his state of mind and soul at the time of the creation

these last photographs of yours very clearly demonstrate that you at present are leaning toward mysticism—but since the life of the senses is there too your photographs are at the same time very sensuous also and that is why in the note of this morning I said that they are both mystical and erotic."[25] Modotti's increasing political involvement clearly did not prevent her from responding to Weston's relatively nonpolitical imagery.

About a week later Tina showed the pictures to Rivera, and he too had a strong reaction, stressing the physical, sensual qualities of the images—as she reported in another letter:

> At last D saw your photographs! Do you remember his typical exclamation "Ah!" whenever a new photograph was laid before him? The same this time as I slowly held up one print after the other—after the first breadth taking impression was over however, and after a long silent scrutiny at each print he abruptly asked me: "Is Weston sick at present?" . . . Then he went on: "These photographs are biological—beside the aesthetic emotion they disturb me physically—see, my forehead is sweating—" then: "Is Weston very sensual?" then: "Why doesn't Weston go to Paris? Elie Faure [the art critic] would go wild over these things"—and so on.

Unfortunately Jean was not in town, so Tina was unable to show him the pictures at that point, as Edward would have liked: "There is one more *important* person whose opinion I know you anxiously await. Charlot—he is due in a day or two—in the meantime I send this on—."[26] Tina clearly recognized that Jean's opinion would mean a great deal to Edward.

Weston had also been sending along his nudes of Bertha Wardell, and these Modotti showed to José Clemente Orozco:

> Last evening Orozco was here—It had not occurred to me to show him your shell photographs—but we were talking about some of his latest frescos and he explained to me all the drawings a certain leg (in one of the frescoes) represented—he was saying that he makes twenty thirty quick one minute drawings instead of one carefully finished—so I offered to show him all the Graflex nudes you have been sending—They interested him intensely—he said—"they are just like carbon drawings, yet, if an academic painter had made them they would be bad—as photographs they are not only good but strong and bold—they convince."

Orozco's response, as well as Modotti's impulse to show the photographs to him in the first place, are very much in line with Weston's explanation to Henrietta Shore. For both the photographs had the spontaneity of rapid sketches, unlike Weston's larger format work.

Then Tina showed Orozco the shells, to which he reacted very positively: "Well, in few words he liked them better than *all* your other collection put together—of one he said: 'This suggests much more "The Hand of God" than the hand Rodin made'—it is the one arrangement that has made everybody, including myself, think of the sexual act."[27]

Weston duly noted the responses of his Mexican friends, but he was surprised:

Why were all these persons so profoundly affected on the physical side? For I can say with absolute honesty that not once while working with the shells did I have any physical reaction to them: nor did I try to record erotic symbolism. I am not sick and I was never so free from sexual suppression,—which if I had, might easily enter into my work, *as it does* in Henry's painting.

I am not blind to the sensuous quality in shells, with which they combine the deepest spiritual significance: indeed it is this very combination of the physical and spiritual in a shell like the Chambered Nautilus, which makes it such an important abstract of life.[28]

As would be the case later on, in relation to his pictures of green peppers, many viewers saw his imagery in erotic terms, but Weston resisted such interpretations. Although he acknowledged the sensual aspect of the shells, his intentions were more complex, as the physical merged with the mystical—which Tina, at least, seemed to have intuited.

Charlot's response did not come until August, after he had returned to Mexico City. His judgment was very different from Orozco's: "Tina showed me your photographs. Of course the shells are beautiful, perhaps finer than best *in that style* made in Mexico, but I prefer the studies of legs. The shells are symbols (sex etc. . . .) or abstract shapes while the legs are legs described in function of their utility. There is perhaps the same evolution from your abstract photographs to those legs as from your ladies sunspotted smelling orchids to the abstract photographs. I express badly a thought I think is right."[29]

Like Modotti and the others, Charlot sensed a sexual component to the shell pictures, but he also saw them as further experimentation with abstraction,

an extension of what Weston had started to do in such images as the toilet or the palm, or perhaps the nude of Anita Brenner. The legs, by contrast, pointed in a new direction. They were more grounded, more about what legs are, or do, and hence more real. Summarizing Weston's overall development, Charlot saw the legs representing as big a step away from the relatively abstract imagery of the Mexican years as the Mexican work did from the pictorialist images with which Weston had begun. In Charlot's view, Weston had been evolving toward an increasingly direct way of seeing, and the legs went further in that regard than the more symbolic and suggestive shells. For Weston, the shells held out the hope of reconciling two opposing tendencies in his work: realism and abstraction. For Charlot they were, on the contrary, something of a dead end; it was the legs that represented the way forward. Although the leg imagery might strike us now as artificial or even forced, for Charlot it was just the opposite: it was the closest Weston had yet come to complete and honest naturalism.

In the same letter Charlot also spoke of his work in the Yucatán. By this time he had grown tired of the copying, which left him little energy for more creative work. Indeed, he was rather discouraged, feeling as if he was forced to renounce being an artist in order to support his creative work. Weston must have sent along additional prints from the portrait session done shortly before his departure from Mexico, for Charlot went on to acknowledge them. And then he provided some news about their mutual acquaintances: "Tina goes hard on social work. I incidentally peek at Anita over the shoulders of crowds of her admirators. Nahui had an artistic photograph 'en desnudo' published in a suspicious magazine." Evidently Jean was feeling neglected by Anita, which contributed to his gloomy mood and the rather disheartened tone of the letter. Meanwhile, Tina was increasingly immersed in politics—she would become a member of the Mexican Communist Party at the end of the year—which was overshadowing her concern with art. Feeling a little out of his element, Jean added in closing, "Write me please. There are so few people who *live* for art."[30]

Soon after, Edward spoke of Jean's latest letter in his daybook: "He is weary, and discouraged by the hard work in Yucatan. He thought the shells were my finest expression of their kind: but prefers the series of dancing legs." Edward obviously found Jean's reaction noteworthy and thought-provoking, but he did not feel the same way. After quoting a few lines from Jean's letter,

he added, "I cannot say that I agree with Jean. I certainly like the legs, but the shells, I believe, are so far my most important work."[31] Although he always took his friend's opinion seriously, he did not see his own development in quite the same terms.

In late August Henrietta Shore prepared to take a trip to Mexico (where she had been once before), and since she was closing her studio, she offered to loan Edward anything he might be able to use in her absence. Not surprisingly, he took some shells, along with books, records, and one of her paintings, *Semi-Abstraction No 3*. At the same time, as a parting gift, she gave him a copy of P. D. Ouspensky's *Tertium Organum*, which she was in the process of reading at the time; she wanted to feel that while she was away Edward would be reading it along with her. Meanwhile, he had been working more with shells and with peppers, which seemed to him to have a good deal of potential.[32]

Not long after Henry arrived in Mexico, Tina organized a tea for her. Jean and his mother were there for a short time (he was not well), as were others of Edward's old friends. Tina showed her work. Afterward Henry wrote Edward about the gathering: she liked Modotti's work but felt that it lacked structure, and she took an immediate liking to Charlot, about whom she had already heard a good deal—mostly, of course, from Weston.[33] The following Tuesday Henry went to the Charlot home to see Jean's latest work. Tina came too, as did Orozco. Unfortunately, there is no record of what transpired, but later, after a chance encounter with Madame Charlot in a shop one morning, Henry expressed a desire to see Jean again.[34]

Back in California, Weston had his hands full caring for his son Cole, now age eight, who had recently fallen from a walnut tree and broken both wrists; Edward was immediately taken up with tending to him. He also devoted considerable energy to making prints for an upcoming exhibition with Brett at the Los Angeles Museum. Somehow he also found time to send more pictures to Tina in Mexico, in particular more of his nudes. On October 20 Jean wrote to Edward about them: he first of all thanked Edward for sending the pictures and then said that one day soon he would go over to Tina's again, make sketches of those he preferred, and send them along.

Charlot then turned to Henrietta Shore, and her work, which he had been hesitant to discuss. He liked it up to a point, he said; he considered her to be a very important painter, but he also had reservations, as he explained at some

length: "I have seen her photographs [of her work] and the drawing (nude). I think the drawing very beautiful. Of the pictures it is difficult to judge because the colour and actual size must be an important factor. I like them as being quite adequate to her idea or esthetic impulse. What is incompatible with my own conception is anyhow the idea of infinity or infinite complexity."

Charlot's reservations stemmed from what he regarded as Shore's emphasis on the infinite, the symbolic aspect of her work. For him, in Shore's imagery the object seemed to lead in all directions, to extend without limit, becoming a symbol of something more, which was also true of some of Weston's shells: "In your last photographs (Tina's shells and another shell that she has [he adds a thumbnail sketch of one with the shell sticking out of the mouth of a jar]) I find the same effect. The frame or rectangle of the picture is broken down in all directions (profundity also) and the object itself is not defined 'per se' but a sort of symbol of an indefinite much more."[35]

By breaking down the boundaries of the frame and letting the image seep out, the subject seemed to allude not to itself but to something beyond itself, to the idea of the infinite, to a complex and mysterious universe. One would perhaps think that any suggestion of the infinite would be welcome to someone of as strongly religious a bent as Charlot, but not so. For Charlot, in fact, the opposite was true, and that was because the idea of the infinite does not bring one closer to the essence of things or to the absolute; instead it takes the artist away from the tangible nature of the object in question, from its mathematical properties or its thing-ness, which in itself is evidence of divine purpose. It is by bringing out that very thing-ness that an artist necessarily reveals the divine, without the need for the symbolic allusions embodied in Shore's paintings and in Weston's shells. The universe is not about mystery but about an order and design that is ultimately the result of God's creation:

It seems to me that the spiritual universe is just as simple as the physical one and could be translated in two or three simple formulaes. So that instead of a sense of mystery I have a sense of security (the work of Pintao is a very exact plastic translation of it.) The idea of infinite in the sense of unimeaserable [unmeasurable], unknowable, does not exist for me. Perhaps it is a Latin attitude and the mystery one a Saxon attitude. This I don't know. The only sensation of mystery comes to me of seeing things in perfect equilibrium and in *order*. This is why I enjoy much more your perfectly definite representations (legs, maguays) than the last ones.

Charlot then took his argument one step further, speaking of humanity's small place in the cosmos: "The real effort for one who has my conception of universe is to put oneself at the scale, this is see oneself as its own small size but measurable anyhow, being part of a limited whole. This is the exact definition of what we call humanity." And, presumably, art must reflect such humanity.

Jean was apologetic about his comments ("Now Edward excuse this long 'baby-talk'"), but he felt they needed to be said, and on that broad a level, in order to explain the underlying distinction he made between his own approach and that of Shore (or even Weston, for that matter).[36] However much he admired what Shore was doing, he did not share her basic philosophy and could not reconcile her sense of mystery with his own faith in cosmic equilibrium. For him, the work of Pintao, whose portrait he had painted more than once, came closest to expressing his own sense of security, as did Weston's photographs of legs or the maguey.

Edward might have been bewildered by some of Jean's remarks—they are not so easy to grasp—but, unfortunately, his letter back to Jean did not survive and he did not comment on the subject in his daybook. Weston no doubt understood the elemental distinction that Charlot had in mind, but he did not share Charlot's basic assumptions. While he sometimes spoke of life's rhythms, suggesting that specific objects could convey universal structures and relationships, he had more of an appetite for mystery than did Charlot. His interest in Blake, for example, is indicative of that, as is his willingness even to consider Ouspensky in serious terms. There is a kind of irony in the fact that Weston, who showed little interest in religion, was more attuned to such things than Charlot, a practicing Catholic.

Soon after writing the letter, Jean called on Henry. As she later reported to Edward, she took Jean up to the roof of her hotel and then down to Aztec Land, the gallery in which Weston had exhibited on several occasions. She described Jean as "an artist *in his* judgment and in his feeling."[37] Before parting they agreed to get together the following Thursday, when Jean had promised to take Henry to the Museo Nacional and to arrange to have her see work that was not normally on view. After their visit to the museum Henry again wrote to Edward, reporting on what had transpired: "I had a delightful time with Charlot at the museum and later at his home for dinner. He is nice and very kind. I think he really loves Anita Brenner—I hope she cares for him."[38]

She did not comment on Charlot's work at this point, but in almost motherly fashion she expressed her concern about Jean's emotional well-being; she seemed to sense that there were problems between Jean and Anita, as in fact there were. Their relationship was a complicated one, and Jean often seemed ambivalent; he blew hot and cold by turns. The issue for him was not so much the difference in their religious backgrounds—she was Jewish, while he was Catholic—indeed, Jean encouraged Anita in her study of Judaism. Instead, his hesitation resulted from a complex blend of devotion and principle: he was held back not only by his beliefs about sex and marriage, grounded in his Catholic faith, but also by practical considerations compounded by his artistic calling.[39] Henry made no specific mention of any of that, but obviously she sensed that something was amiss.

While Charlot and Shore were getting acquainted, Weston was having another show in Los Angeles, at the Los Angeles Museum. It opened on October 4, and Weston was pleased with the result: "Brett is showing with me, and a fine showing it is. He has hung 18 prints, I have 102,—all on one line, well-spaced, and in rooms well-suited to photographs. It is the finest exhibit I have ever given, both in general appearance and individual prints."[40]

In his statement for the show, he spoke again about the special qualities of photography. Harking back to what Siqueiros had written about his work years before, Weston began by declaring his intentions: "I herewith express my feeling for Life with Photographic Beauty; present objectively the rhythm, and form, and texture of nature." He then made a point of distancing himself from pictorialism and the like, which he derided as "anemic impressionism" and "incoherent emotionalism." He went on to stress how important it was that photography instead be honest and direct: "Photography can take its place as a creative expression only through sincerity of purpose, and a definite understanding of the finest usage of the medium."[41] Building on what he had already said (and thinking perhaps of Charlot as well), Weston sounded the notes that he would repeat throughout his career: he strongly embraced a straightforward, purist approach that at the same time focused on the rhythms of nature, on the underlying essence of things rather than their superficial appearance.

While the show was still on, some tension suddenly developed between Edward and his son Brett, who had apparently decided to travel north, seeking adventure, and left without any good-bye to his father—who was somewhat

hurt as a result. Brett's adventure came to an abrupt end, however, when he was picked up by the Modesto police for underage driving. Edward, together with Chandler and his friend and model Christel Gang, quickly drove to Modesto to rescue him and then continued on to San Francisco.[42] By the time they reached San Francisco tensions must have dissipated considerably, and Edward was able to focus his attention on other matters. In particular, after arriving in the city he sold some of Charlot's drawings that he had brought along on the trip. When Jean heard about it, he was delighted and quickly wrote to acknowledge Edward's efforts on his behalf: "A man who was a greater writer and a beggar said he believed only in friends that gave him money. Well I even knew before that you were a real friend. Thanks for the check."[43] As Jean well knew, Edward had acted on his behalf more than once in the past—although not always with equal success—and Jean had done the same for Edward.

In the same letter, Charlot also had something to say about Shore. By this time he had gotten to know her better and had revised his estimation of her work somewhat. Indeed, he felt a little sheepish about his previous comments: "I feel my letter to you was a little silly and I didnot expected you to answer on that. I know Henrietta more now and I like her very much. She painted three things since she is here. One (a corrida de toza) is a very precious painting. She grasped with an amazing quickness the essentials of Mexico. She is one of the very rare individuals that give an impression of security." And then he added, "I am thinking of painting her portrait."[44]

Soon after Jean again had dinner with Henry and spoke of Weston's efforts on his behalf, as she then reported to Edward: "Charlot says you sold some of his drawings. . . . It is like you Edward to do things for your friends. He was delighted." During their evening together Henry and Jean also spoke of portraits, and Shore reported on this too in her letter to Weston: "Looks as though I were going to be busy with portraits. Charlot & Orosco [Orozco] were here for dinner yesterday & Charlot wants to know when I am going to paint his portrait. He insists on painting my portrait—a large one (Heavens, it would need to be large!)—willy nilly, yes or no! I don't want to be painted. Then I will also paint a portrait sketch of Orosco."[45] Charlot too spoke of Shore's plans to paint his portrait, in a brief note to Weston written around the same time. In that context, Henry had mentioned to Jean that she had already painted Edward's portrait, and Jean expressed an interest in seeing what it

looked like: "Do you have a photograph of the portrait she made of you and could you send it to me."[46] Perhaps he wanted to see what he was up against.

The portraits were begun about a week later. Weston had apparently written to Shore that, possibly as a result of his recent show, a good number of commissions were coming his way, and she wrote back to congratulate him. She also spoke of the portraits: "Today I commenced Orosco's portrait. He is interesting but I am hampered by my lack of Spanish and his lack of English. On Saturday I commence Charlot's portrait and on Monday he will begin mine." She then went on to speak of a recent excursion to Chapingo: "I went with Helena [her studio-mate and traveling companion, Helena Dunlop] to Chapingo to see Diego Rivera frescoes. I prefer his earlier work—the earliest. It is most unfortunate that I am unable to fully appreciate his work. I grant its excellence—but am bored by it. Orosco and Charlot both interest me more by virtue of their work."[47] Shore evidently shared Weston's views on the relative merits of these artists.

Weston had not done any work of his own since before the exhibition at the Los Angeles Museum, but with the start of the new year—and now back in Los Angeles—the situation changed. He began again to make photographs for himself, concentrating initially on squash and cabbage: "My subject matter has been squashes. What an ugly word! Pumpkins may be better,—at least sounds humorous. I shall say pumpkins. They are really gorgeous: one exquisite as a Brancusi, another a human embryo,—another wartlike, malignant,—a little round one, quite jolly. I found also a cabbage of unusual shape, the leaves folded to a definite point: it is a beauty."[48] The new work seemed to renew his spirit, and as he became increasingly engrossed in it a letter came from Charlot, with New Year's greetings and news about an upcoming exhibition in New York: "You are going to be invited to the exhibit of Mexican Modern arts in N. York, Art Center by a Mrs Payne [Paine]. She has a very fine taste and of your photographs I have preferred your last palm-tree. This is to say her point of vue is plastic, not picturesque. Financially the exhibit is backed by the Rockefeller Foundation, all expenses paid by them."[49]

Frances Flynn Paine, a New York art dealer, worked with Mrs. John D. Rockefeller Jr. in connection with the planning of the Museum of Modern Art.[50] She played an important role in introducing Mexican artists to American audiences in the late 1920s and early 1930s, and the New York exhibition was a part of that process.[51] As Charlot explained to Weston, she was interested not

in picturesque views of Mexico but in more serious work, such as *Tronco de palma*. And, he added in a postscript, they also would probably like Weston's portraits of Lupe Rivera and Galván, both of which he would include in his selection when the time came.[52] The show promised to be a good opportunity, for it would provide Weston with exposure in New York, and at no expense to himself. In some ways it was too good to be true.

In the same letter Jean came back to Weston's photographs of dancing legs and, as he had earlier promised to do, he included a sheet with small drawings of the ones he liked best, the ones he would like to have. Judging from that drawing (fig. 14), he seemed to like quite a lot of them—including some of the best known, which he rendered in lively manner. He made no mention of the shells. Charlot also had more good words about Shore, who was preparing to leave Mexico soon and return to California: "Miss Shore is a very fine person and I do like her." Charlot's views on Shore were reiterated by his mother, who enclosed a brief note with the same letter: "So pleased to know Miss Shore. She is charming woman and good artist. Thank you to have send her to us."[53]

The New York exhibition that Charlot had described opened in January 1928, and as it turned out, Weston was not a part of it. It was an extensive exhibition under the patronage of the Mexican government, intended as a goodwill gesture toward the United States; it featured painting and sculpture but, in the end, no photographs. The show included work by Siqueiros, Charlot, Miguel Covarrubias, Pablo O'Higgins (Paul Higgins), Orozco, Pacheco, and Rivera, among others.[54] Charlot, who was still in the Yucatán, was represented by more pieces than anyone else: eighteen, as opposed to nine by Orozco and seven by Rivera. One of them, *The Great Malinches*, was used for the cover of the catalogue; also included was his *Temascal I*, as well as several individual images of Luz Jiménez.[55] A review in *Creative Art* singled out his work, although the comments were patronizing in tone: "The exhibition of Mexican Art left one with a sense of red hot sun and heavy, baking earth and the large and lumbering passions of untrained humans. Many of the canvases, notably those of Jean Charlot, were arresting in the power of their forms and the brutish simplicity of their manner."[56]

Orozco, who was in New York at the time, reported to Madame Charlot, expressing his disappointment in no uncertain terms.[57] The next day he wrote much the same to Jean:

The Art Center show—a total, absolute, and definitive failure. . . . The very few people who came just laughed and joked or felt/'disappointed.'/The serious art press, like The Arts, Art News, etc. didn't say a word, neither did the critics. . . . The newspapers and some /magazines/ just ridiculed it too and a number of them had some very harsh words to say (I sent a few clippings to your mother). . . . It seems only one picture was sold, I heard it was one of yours. I can tell you that the only purpose of the show is to sell trinkets of "Mexican folk art" (?), a commercial enterprise, for which our pictures have merely served as advertising posters.[58]

It is not clear why Weston was not included: perhaps it was because the organizers decided not to include photographs or because Weston was no longer in Mexico, or perhaps he was not deemed sufficiently Mexican, given the purpose of the show. Weston made no mention of it in his daybook; if he was hurt or disappointed, or angry with Jean, he said nothing at this point or afterward. In any event, new opportunities soon presented themselves when he encountered Merle Armitage, whom Edward had first met many years earlier, probably in 1923 or shortly before.[59] An impresario and book designer, Armitage was a man of many talents and connections; he was also an avid art collector. After seeing a couple of Weston's prints at the home of the critic Arthur Millier, Armitage expressed an interest in seeing more, and the photographer of course obliged; so too he took Armitage to see the work of Henrietta Shore, who had recently returned from Mexico. Armitage had been convinced that there was no great art being produced on the West Coast, but after seeing Weston's work and then Shore's, he quickly changed his mind.[60] Soon afterward he purchased two of Edward's prints for himself—a picture of ollas and a nude of Tina—and he also wrote a letter on Edward's behalf to Rockwell Kent, the editor of Creative Art, which Edward proudly quoted in his daybook: "There are a few artists on the Pacific Coast (not many) who are doing work of a character that I think warrants national attention. Two of them H. Shore, painter, and E. Weston photographer, I am certain of. Would you be interested in having some photographs of their work sent on with a view to your using articles on them in Creative Art?" To these words Edward then added: "This and a letter I wrote the Weyhe Gallery in view of an exhibit for next winter should start things in New York."[61] He was clearly hopeful that these efforts would help to launch him on the East Coast, and although things did not turn out quite as he expected, this was an important

moment. It would not be the last time that Armitage would intervene on Weston's behalf.

In April Jean wrote from the Yucatán; he had not written since he first mentioned the exhibition of Mexican art, and now, several months after it closed, he wrote to offer his apologies for what happened: "The last time I wrote you I spoke of the Mexican exhibit and your invitation to it but it seems that Mrs Paine changed her mind afterwards." Charlot offered no reason for Paine's change of heart but went on to suggest that, given how poorly the show was received, Edward was better off not having been a part of it. Judging from Orozco's comments, on which he was no doubt relying, Jean was not exaggerating the extent to which the show was a failure. Although he had been featured quite prominently and seems to have sold some of his work, he must have been discouraged. Moreover, Jean was clearly chagrined about having given Edward a false impression, especially given what had happened not long before, with Morley; he therefore offered a kind of apology: "I feel ashamed of always writing you things (like in the case of Morley) that don't happen. On the other hand I don't want to stop writing you, so excuse me for believing too readily my friends and let us proceed."

In the same letter Charlot also had apologies for Henrietta Shore. Because of a last-minute change of plans and a small mix-up, he had not been able to bid her a proper good-bye and asked Edward to convey his regrets to her. He also expressed his satisfaction with the portrait she had painted of him, which she had taken back to California with her; Jean was hoping that Edward would make a photograph of it and send it to him. At the same time, he spoke in less positive terms of Stieglitz: "I saw some Stieglitz fotographs lately and I lacked entirely the emotions the first ones had produced [in] me: I prefer your best last prints in Mexico to his—." It is not clear which Stieglitz photographs he had seen or how he came to see them in Chichén Itzá, but he was not impressed.

Charlot seemed to have mixed feelings about his own activities. Not only were there some tensions among the staff, but the work was no longer satisfying. After numerous discoveries—columns, paintings, and temples—the charm had worn off and the copying had become routine. Orozco had gone to New York, he reported, and he was hoping to do likewise by the end of the summer, if money permitted. Meanwhile, he was eager to learn more about what Weston was up to and, as he often had before, he asked to see any small

prints, proofs, with which Weston could easily part. In closing, he said, a little wistfully: "Good bye Edward. We'll probably meet again in Los Angeles, or New York or in the hall of fame, in busts."[62]

Weston's reply has not survived, but he noted Charlot's letter in his daybook, citing in particular what he wrote about Stieglitz: "This comment does not necessarily mean a thing, despite Jean's good judgment, — for who knows what prints he may have seen. Maybe even Stieglitz has prints out not up to standard."[63] He was no doubt gratified by Charlot's remarks about the relative merits of Stieglitz's work and his own, but he was willing to give Stieglitz the benefit of the doubt. Weston apparently bore no ill will about the Mexican art exhibition; he did not even mention it. It may have been around this time that a Los Angeles–based photographer named Fred R. Dapprich photographed Weston standing confidently in front of one of Charlot's lithographs, *Temascal* (a painted version of which had been included in the ill-fated show) (fig. 15).[64]

Meanwhile, Merle Armitage's efforts on Weston's behalf seemed to have paid off: at about the same time, Edward received a letter from Lee Simonson, who had recently succeeded Rockwell Kent as editor of *Creative Art*, requesting an article and photographs for the magazine. To celebrate, he went out dining and dancing with Christel Gang, along with Nahui Olín and her lover, the artist/caricaturist Matias Santayo, who were visiting Mexico, and the critic J. Nilsen Laurvik.[65] The *Creative Art* article appeared several months later and included excerpts from his daybooks, along with seven of his photographs: the pear-like nude of Anita Brenner and the maguey from his Mexico years as well as more recent images, including one of the shell photographs, one of the Bertha Wardell images, and a picture of swiss chard.[66] It was the first time a significant selection from his daybooks had been published, presaging later, fuller versions.

Then, in July 1928, Weston was included, along with Brett, in an exhibition in San Francisco at the East West Gallery in the Western Women's Club—where his work attracted a good deal of critical attention. The art critic Jehanne (Biétry) Salinger, in particular, was lavish in her praise; writing in the *San Francisco Examiner*, she stated, "If a book on the art of the western coast is ever to be written one name will stand out as of unusual significance—Edward Weston of L. A. is the man."[67] Later, in an extensive review, she would describe him as "this most selective of workers with the camera."[68] Salinger had first met Weston in 1926, and in the coming years

she would continue to be one of Weston's staunchest supporters and would also write about Charlot in positive terms.[69]

One of the visitors to the exhibition was a thoracic surgeon named Leo Eloesser, the chief of service at San Francisco General Hospital. Eloesser is best known for treating Frida Kahlo in the early 1930s and for later serving as a doctor with the Spanish Republican Army; but he was also an accomplished musician (he played viola) as well as an active patron of the arts, including photography. Although he did not meet Weston at the East West Gallery (Weston was probably still in Los Angeles), Eloesser purchased two prints from the show.[70]

The success of his San Francisco exhibition led Weston to think that a trip north might be a good idea, and later in the summer he made the move. Once he had settled in, on Post Street, he wrote to Jean, who by then had returned to Mexico City. For some reason the letter never reached him; Jean learned about it only inadvertently, from Tina, when she read him Edward's latest letter to her, in which he mentioned having also written to Jean). As Tina reported to Edward, Jean felt badly about not having gotten the letter but promised to write nonetheless.[71] He made good on his promise soon afterward: after first referring to the lost letter and how he came to know about it, Jean then spoke of his travel plans, about his intention to leave Mexico. Having returned from the Yucatán not long before, he reported, he was now on the verge of moving to New York. In fact, he would have left Mexico already but for some last-minute delays involving immigration formalities. He hoped to be able to depart soon.

Although he was about to leave Mexico, Charlot's focus was nevertheless still on the archaeological work he had been doing at Chichén Itzá: "For me my center of interest is now Yucatan. Archeologie is very absorbing as a job, but aside it [aside from that] I enjoyed esthetic contemplation of first hand material and this I hope with benefit in my own work. Art is aside [beyond] chronology: for me Maya art becomes a post-cubistic movement." His attitude seemed more positive than in his last communication, more like the attitude with which he had begun. For Charlot, Mayan art represented a way of going beyond cubism, incorporating aesthetic principles that could still prove useful; although created long ago, it showed the way forward.

In this context he turned once more to the recent exhibition of Mexican art: "It seems that the Mexican exhibit in New York was a terrible failure, through both lack of organization and lack of comprehension. To say the

truth the[y] are becoming here terribly conceited about the worst part of it: the nationalistic tendency and there is an arising of second-hand discoverers in this field." Given the diplomatic intentions of the exhibition, it was not surprising that many artists had hopped onto a nationalistic bandwagon, but for Charlot that was a false trail: for him the importance of Mayan art lay in its aesthetic basis, not its nationalistic implications. And artists like Rivera, who was incorporating Russian motifs in his latest imagery, and Orozco, who had moved to New York, were moving in a different, more international direction.

After speaking of Orozco's latest efforts in New York, Charlot added, "Please do an exhibit in New York while I am there. I would enjoy so very much to be with you again." Then Jean turned once more to Henrietta Shore; he still had not received a copy of her portrait of him and was growing impatient: "As to your friend H. Shore she disappeared from Mexico without a word to me. She had made a portrait of me and promised to send a photograph but never did either." His account differs a bit from that in his last letter, and he was no longer as apologetic as before, although he maintained his sense of humor and threatened to retaliate by turning his portrait drawing of Shore into something more elaborate: "I have, in revenge, a much worked drawing made from her that can become sometime a full length portrait."[72] As fate would have it, it took many months before Jean got around to painting Henry's portrait.

In the late summer or the early fall of 1928, shortly before Charlot left Mexico, he and Modotti worked together photographing Orozco's murals in the Preparatoria (Antiguo Colegio de San Ildefonso). Orozco was already in New York at the time, and he had been corresponding regularly with Charlot, specifying what he needed; Jean and Tina would then try to carry out his requests. Years later Jean described the process:

> In many a letter . . . Orozco stresses his pressing need for photographs of his murals, in the hope that American architects would give him the walls he had been denied at home. Tina Modotti and I attempted the task. . . . Easy to sketch from memory in his letters, Orozco's photographic directives posed substantial problems when weighed *in situ*. Tina's paraphernalia was old-fashioned even for that day, and it took much ingenuity to fit her bulky box camera and tripod along the staircases and under the low arches of the Colonial building. For days we worked throughout the

daylight hours, stopping only for a beer and sandwich brought by Tina's friend Julio Antonio Mella.[73]

It may have been around that time that Modotti photographed Charlot one last time, perhaps with his imminent departure in mind. The portraits this time are quite different from the ones Tina had done earlier, soon after they had first met. As before, Jean appears to be quite serious, lost in thought or looking off into space, but he is clearly a good deal older and less delicate. If in the early ones Jean had appeared—perhaps despite himself—as something of a dandy, an Edwardian aesthete, he is now presented as a kind of rugged academic, an archaeologist. He is wearing a heavy shirt, a knit tie, and a tweed jacket; instead of a pince-nez, he wears round, horn-rimmed glasses, which give him a more bookish demeanor. Although some of the poses appear somewhat forced, Jean seems more comfortable in his own skin.

In contrast with most of Tina's earlier efforts, the new portraits show Jean close-up. In one case, for example, he is shown from the chest up, in profile against a plain background, looking down (fig. 16). His expression is much the same as in the portrait taken in 1924 (fig. 2), in which he is absorbed in drawing, but now the view is closer in and there is no indication of what, if anything, he is doing. In another, similar close-up, Jean is shown slightly from the right and from below, against the sky.[74] He looks up with a rather intense, almost visionary expression. The image is oddly tilted, which reinforces the impression that he is wrestling with complex issues.[75]

Soon after Tina took her pictures, Jean and his mother finally departed from Mexico. They arrived in New York City in late September, and Anita Brenner and José Clemente Orozco were at the train station to meet them. Not having been in New York before, Jean and his mother were fascinated by their new home and somewhat daunted. In the coming days Orozco took it upon himself to serve as their guide: "Orozco did his best to help us make sense of this new world. We marveled at the sight of an automat, how the food on display could be ours by plugging nickels in a slot. We went sightseeing down the length of Fifth Avenue, seated on the top of an open two-decker bus, craning our necks."[76]

Shortly after their arrival in the city, Jean and his mother found a place to live at 12 Union Square, subletting the upper floor of the painter Morris Kantor's house.[77] Charlot was soon occupied with correcting proofs for his

portion of the expedition report for the Carnegie Institution.[78] He also became a frequent visitor to the salon of Madame Sikelianos, the widow of the Greek poet Angelo Sikelianos, in the apartment she shared with Alma Reed, where Orozco's paintings were always on view. The atmosphere there was a heady mix of Greek tradition together with Indian and other forms of mysticism, as Charlot later recalled with a kind of bemused irony:

I was invited to the Ashram, the *cénacle* presided over by Madame Sikelianos, née Cortland Palmer. In a vast room dimly lit, an abundance of carpets and sofas put at ease the many Indian guests. Over it all hovered the shade of Raymond Duncan [brother of Isadora], first among neo-Greeks. Shoes were out and sandals in. Though much was made of him, Orozco remained odd man in this choice stable of poets and mystics. Top man was Claude Bragdon [architect, philosopher, and devotee of Ouspensky], who, at the drop of a hat, seemed ready to ascend into a fourth dimension. His counterpart, or rather his counterweight, Madame Saronjini Naidu, plumped down her round body wreathed in seven veils so solidly that she became a cushion among cushions.

I missed a star guest, a Hindu guru who never said a word, in any language whatsoever, but allowed faithful female followers to nestle under his long thick beard for a spot of transcendental meditation. I was present, however, when a delegation of popes from the Greek Orthodox church, imposing in their ecclesiastical vestments, astonished Madame Sikelianos by offering her, in its enameled reliquary, a fragment of the True Cross, in thanks for what she had done for Greece. Either the popes were misinformed or very shrewd. The Greece that the Ashram revered was, up to then, more B.C. than A.D.[79]

Although Charlot made no mention of it, another regular at these gatherings was Mary Hambidge, the widow of Jay Hambidge, whose writings on art and geometry had widespread influence (and would later become the target of one of Weston's most satiric photographs). Charlot seems not to have gone to the ashram often, and he remained somewhat detached, even critical. Reed, for her part, remembered Charlot as something of an aesthete: "Delicate featured and of slender build, reticent but self-assured in manner, with a voice that was low-keyed yet richly modulated, he seemed to dominate even the noisiest group with a certain mystic authority. His quiet command of situations could be traced, perhaps, to his blue eyes, which looked out through

their bifocals with an expression that ceaselessly questioned hypocrisy and with a penetration that disturbed fatuous complacency."[80]

Charlot may have lived for art in many respects, but he might not have appreciated being described as an aesthete—even in appearance; the rest of the description does not differ greatly from the impression conveyed by Modotti's recent portraits.

On October 1, 1928, back in San Francisco, Edward and Brett found themselves as guests on the yacht of Dr. Eloesser. As Edward reported in his daybook, "Saturday night Brett and I sailed away on the yacht Flirt,—guests of Dr. Eloesser. We had never met the doctor,—he knew us only through the East West exhibit, where he purchased two prints. He took a chance, inviting strangers, and we likewise as guests of a stranger. However the night and day passed amicably enough."[81] Soon after Edward and Brett moved to new quarters on Union Street, and not long after that a letter from Jean arrived; it had been sent from Mexico City the previous month. "A letter from Jean Charlot, enclosing a new print, and a beauty. He will soon be in New York,—and hopes to see me there! Might as well hope to see me in Mexico!"[82]

By this time Charlot had already been in New York for a few weeks, and Weston would perhaps have enjoyed going there too. Edward and Jean had once discussed the possibility of exhibiting together in New York, but for the time being at least there seemed scant possibility of doing so: Weston had no money or time to make a trip, either to New York or back to Mexico. His evident sarcasm was directed not so much at Charlot as at circumstance; he had not yet established himself in San Francisco, and it was not the right moment to think in terms of going elsewhere. In any case, he would soon become involved with a young woman, identified only as A, about whom he spoke with great passion—at least until they went their separate ways toward the end of the year. Like many of his other loves, she became the subject of his photographs.[83]

At the same time, orders were starting to come in for portrait sittings, partly as a result of the article in *Creative Art*. In mid-October Weston made arrangements with the *Evening News* to do a series of portraits of prominent San Franciscans. One of his first subjects was Lt. George Norville, a transatlantic flier, and just after Election Day he photographed the newly reelected Florence Prag Kahn, the first Jewish woman to serve as a representative in the U.S. Congress.[84] His professional life was starting to go quite well, but

the presidential election had been a serious disappointment. Herbert Hoover had just defeated Al Smith, and Weston was not happy about it; he assessed the situation in rather cynical terms:

> I believe it was said last night that Hoover swept the country. A sad commentary upon the American people, indicating a smug conservatism, fear of change, lack of the spirit of adventure. Probably the Democrats would have thieved as readily as the Republicans have, but conditions could not be much worse. Al Smith represented danger, — radicalism to the mass mind, and fear was in the hearts and bellies! So they will go on, thankful to own a tin Ford, (the new ones are quite as tinny) have 10 cents for a "talkie," and drink synthetic gin. Smith could not have changed anything, but a vote for him symbolized desire![85]

Weston is often considered to have been apolitical, but already we see the strong opinions he held, about presidential politics as well as American society more generally—and he would express himself on such issues with increasing vehemence over the years.

After a brief trip to Carmel over the Armistice Day weekend with Brett and A., Weston was back in San Francisco and once again busy with portrait sittings, including those of Alfred Hertz, leader of the symphony; Thomas W. Hickey, a politician who had seconded Al Smith's nomination; and the labor leader William P. Stanton.[86] Soon after, in December, he was commissioned to photograph the same Dr. Eloesser who had entertained him and Brett aboard his yacht not long before; the plan was to show the doctor in action, at work in a hospital ward. The prospect intrigued him, but he was at the same time hesitant, and he seemed almost relieved when, as he was about to begin photographing, the weather interfered: "After a clear day, rain again,—which means a sitting postponed. I was to do Dr. Eloesser in the City Hospital, going the rounds of his ward, — or perhaps performing an operation. A commission which intrigues me, yet questioning whether I could go through with it. Fate has been kind to me, in bringing this rain storm: I needed another day on finishing more than a new sitting."[87]

It is not clear how long it was before Weston tried again, but he eventually managed to get a good result, as he reported to Johan Hagemeyer: "made a 'sitting' of Dr. Eloesser in the hospital ward—going the rounds—dressing wounds, etc.—the stench of disinfectants—the hopeless faces, the suffering—I

don't know how I worked—but got several I'll swear he will like—even I may."[88]

Weston left San Francisco after just three months, with the intention of moving to Carmel. He spent Christmas and New Year's in Glendale, and then on January 3, before heading north, he dined with the noted architect Richard Neutra, whom he had first met about a year before. On this occasion Neutra asked Weston to participate in an international exhibition of photography to be held in Stuttgart later in the year. The show, which would be called *Film und Foto*, would be an important compendium of modern photography in Europe and the United States, and Neutra wanted Weston not only to contribute some of his own work but also to organize a part of the exhibition and write a foreword to the catalogue. Weston quickly agreed; it was an important opportunity.[89]

By the end of January 1929 Edward, together with Brett, had settled down in Carmel, where he had taken over Johan Hagemeyer's studio. Before long he received rather startling news about Tina Modotti. Tina had been living in Mexico City with a young Cuban revolutionary named Julio Antonio Mella, and one night when they were walking home he was gunned down in her presence. Although the assassination was probably set in motion by the right-wing Machado government in Cuba, Tina was suspected of having been involved in some way, and she was questioned repeatedly. She eventually proved her innocence, but the incident caused quite a stir in Mexico and even in the United States. Upon hearing the news, Edward wrote about it in his daybooks: "Tina is featured in the headlines of every paper, even in California papers, as the only witness to the assassination of a young Cuban communist, Mellá. Indeed, she was more than witness, the boy's beloved it seems, and walking with him when he was shot. The murder may cause a break between the Cuban and Mexican governments. My name was brought in, but only as having gone to Mexico with Tina. Poor girl, her life is a stormy one."[90]

Edward evidently still cared enough about his former lover to appreciate how difficult her situation had just become. Meanwhile, things were also going badly for Jean. He had spent the holidays in New York, but in January his mother passed away, after suffering from pneumonia. Jean blamed himself for her illness: he felt responsible for the fact that they had been living in an unheated apartment, making her vulnerable to the winter cold. Charlot had been very close to his mother, and her death hit him very hard. Afterward he came close to having a breakdown and did not quite know what to do with

himself, but before long he resolved to leave New York (after living there for only a few months). Together with his friends the archaeologists Earl and Ann Morris, he pulled up stakes again and left for Washington DC.[91] Like Weston, he was moving about quite a bit.

Once settled in Washington, Charlot immersed himself in work; he and the Morrises concentrated on completing their report for the Carnegie Institution on the excavations at Chichén Itzá. That spring, as work on the report was nearing completion, Jean wrote to Edward about recent developments. "Bad news: Mother died the 15th of January and, as we had been so closely united all those last years, all my life is upset for the moment." In the same letter he mentioned Weston's recent article in *Creative Art*, adding, "I hope your work shall get the increasing understanding it deserves." Charlot also reported that while still in New York he had seen Stieglitz, who struck him as rather theatrical; he signed off, "Su amigo triste. Jean."[92]

In March, still occupying Johan Hagemeyer's studio in Carmel, Edward began photographing around Point Lobos, one of the places with which he would be most closely associated; there he photographed fragments of trunks and roots, including *Cypress Root*, 1929.[93] Weston was greatly excited by the results and hoped to pursue the subject further, but then Brett had an accident while out riding with Merle Armitage; his horse slipped and fell on him, and he broke his leg. Brett would be laid up for months, and Edward was forced to devote much time and attention to his recovery. It was during this time that he received Jean's letter, as he noted in his daybooks: "A letter from Jean Charlot, with sad news of his mother's death. A blow to him,—they were inseparable. Such a triste note!"[94] For Weston, the news must have brought back memories of his days in Mexico and companionable dinners with Jean and his mother.

A few weeks after Jean's letter arrived, Brett returned home from the hospital with a new cast, and by that time Edward had a new and important romantic attachment with a woman named Sonya Noskowiak.[95] Sonya had been a receptionist for Johan Hagemeyer, and it is through him that she and Edward first met. They soon became lovers, and she moved in with him; Edward was apparently starting to think of settling down again, and Sonya was evidently thinking in similar terms. Edward taught her about photography, and she soon became an accomplished photographer in her own right. They would remain together for close to five years, and Sonya would become

the subject of many of Edward's photographs from that period, including numerous nudes.[96]

In April 1929 Charlot returned to New York, where he rented an apartment in Chelsea. In the coming months he devoted a fair amount of time, together with Thomas Hart Benton, to organizing a retrospective of Orozco's work at the Art Students League. The exhibition included 112 works, in addition to photographs of the murals Orozco had painted in Mexico. According to Alma Reed, Charlot worked tirelessly to arrange the exhibition and then to promote it: "His painstaking efforts in the arrangement and hanging of the huge collection, his untiring zeal in creating interest in the event and his numerous lectures on the significance of Orozco's art during the exhibition, all attested to his generous spirit and to his capacity for loyal camaraderie."[97]

After returning to New York Charlot also resumed his own artwork, and one of the first things he painted was the long-planned portrait of Henrietta Shore. It was based on drawings he had done in Mexico. It showed Shore working on a canvas; part of a palette is visible in the lower-right corner.[98] After the Shore portrait was completed he turned his attention to Luz Jiménez, making five more paintings of her in the spring and summer.[99] Early that summer he wrote again to Weston. In the letter he expressed his good wishes for Brett, and then he once again spoke of Stieglitz, reiterating his rather negative assessment: "I saw Stieglitz and I saw his work and I dislike both—I can see how he could impress you *before* your mexican work but it is impossible that now you do not realize that you are far ahead of him."[100] Charlot was referring to the Stieglitz prints that had been donated to the Metropolitan Museum some months before, which included a range of recent work—portraits, nudes, and Equivalents, among other images.[101]

Stieglitz's work, and his Equivalents in particular, represented a significant milestone, in which the elder statesman of art photography sought to reconcile the realism of the photographic image and the expressive potential of abstraction and modernism. Weston had been struggling with related issues for some time, but so far as Charlot was concerned, his friend had moved well beyond the older photographer, even beyond Stieglitz's most recent creations. By this time Charlot was well aware of Weston's mixed feelings about Stieglitz—partly worshipful, partly skeptical—and he seemed eager to give his friend a boost.

Then, looking back over the months following his mother's death, Jean

talked about how painful it had been for him and how his grief was much like an illness—an illness from which he was only beginning to emerge. But he had at least enjoyed the work he had done on the color plates for the Carnegie Institution book: "They look like colored diagrams and I rather enjoy the unartistic, mathematic appearance of it all." That mathematical rigor perhaps had an impact on some of his own work, which was beginning to attract more attention. Meanwhile, in the wake of the exhibition at the Art Students League, Charlot's relationship with Orozco had become a little strained, at least from his standpoint. Orozco had attained considerable success by that point, thanks in part to the retrospective, and he seemed to have offended some his old friends in the process, as Jean explained: "You probably heard of Clemente Orozco and his 'triunfos.' It seems to have gone to his head a little and he stepped widely on the toes of his before-the-applauses friends, this is to say Anita and me. He returned last week to Mexico."[102]

By this time Weston had received his copy of the catalogue of the *Film und Foto* exhibition in Stuttgart, for which he had written a short statement about photography in America. Weston had organized the West Coast component of the exhibition, which included not only eight of his own pictures and four by Brett but also photographs by Imogen Cunningham and Roger Sturtevant. The East Coast was represented by Edward Steichen, Charles Sheeler and Paul Strand, among others. In the catalogue, however, only one image by an American was reproduced—Weston's portrait of Senator Galván. It appeared together with work by Hannah Hoch, Man Ray, and El Lissitsky, to name just a few. In that way, the catalogue selection exaggerated the difference between American and European modernism, contrasting direct seeing with photograms, photomontage, and the like. Indeed, Weston may have felt a little uncomfortable about being associated with so much imagery in which the boundaries of straight photography were often ignored, or at least strained. Also included—and looking not a little out of place—was Atget's image of a storefront with mannequins and suitcases (*Rue du petit Domal*), one of five prints by Atget that had been exhibited. *Film und Foto* provided a useful overview of contemporary photography, incorporating a variety of approaches, but like other publications of the time the catalogue glossed over many potential rifts.

Weston's written contribution was one of his clearest statements to date of his basic—essentially purist—position, partly reiterating ideas he had

begun to articulate in previous years, sometimes in a fragmentary way. He started by suggesting that, for the most part, American photography was in an anemic state. With the exception of a few outstanding figures, most of the work relied on trickery and posturing, on manipulation after the fact. His alternative involved a more direct kind of seeing, in which the final result is a function of clear vision and the final print is fully anticipated at the time of exposure: "The finished print is previsioned on the ground glass while focussing, the final result felt at that moment, — in all its values and related forms: the shutter's release fixes forever these values and forms, — developing printing becomes only a careful carrying on of the original idea." Although he does not quite use the word, he is speaking of what was later referred to as "pre-visualization," which would become one of the bywords of modernist photography, especially in California (and the basis for Ansel Adams's Zone System). The final image is visualized, in all its shades of gray, before the picture is even taken; by controlling exposure and development, the image is then brought to life.

A little further on, Weston invoked Van Gogh: "Vincent Van Gogh wrote: 'A feeling for things in themselves is much more important than a sense of the pictorial.'" He had cited this line before, and he would do so again; it not only carried the weight of authority but clearly encapsulated his purist doctrine — in strong opposition to pictorialism, which was still an important force in California and elsewhere. Instead of resorting to impressionistic blurs, the photographer should seek to record the thing itself, its essential qualities, in a clear, honest, and uncompromising fashion. Only in this way could photography become "a vital contemporary expression."[103]

A comparable modernist rigor is evident in Weston's photographic work from the same period, and in the second half of 1929 — after he received his copy of the *Film und Foto* catalogue — he began to work again, with increasing directness, with vegetables — eggplants and then peppers. So too he produced more images of cypress trunks and roots, including *Cypress Root, Seventeen Mile Drive*, as well as some striking, almost abstract images of eroded rocks, seen at very close range, such as *Eroded Rock*, 1929.[104] Some of these new photographs seem almost to be demonstrations of the principles set forth in his recent statements about photography, as he closed in on his subjects more and more in order to capture their essence. Meanwhile, his business had started to thrive again: he made several trips to the Bay Area for portrait sittings and did a series of pictures of the Berkeley campus for

California Monthly. He was not yet feeling the effects of the stock market crash of 1929.[105]

In the fall of 1929 Jean wrote to Edward with news of Anita Brenner, whose *Idols behind Altars* had just been published. The book was an extended study of the art and culture of Mexico over the centuries, from ancient times to the present. It included a section on Charlot, in which Brenner speaks of the important role he played in the history of Mexican art: "He revived woodcut; illustrated the poems of a leading *Estridentista* (literally strident) poet; wrote neatly scholastic reports of Mexican popular and modern art for Parisian revues, and for Mexican; fell in love with a gorgeous friend of the Syndicate [Nahui Olín]; discovered an Indian model [Luz Jiménez] who largely because of his paintings became a 'classic' native female in modern Mexican painting; and painted the first mural in the Preparatory School, which was also the first fresco." Brenner also characterized Charlot's basic approach and summarized his recent work: "Paradoxically Charlot, who stylizes to abstraction his subjects, is a realist, in the sense that his subjects are the frequent and familiar things that one sees.[106]

As seen by Brenner, the simplification of form in many of Charlot's pictures did not preclude a devotion to real life; on the contrary, form is tied to content, which is firmly anchored in the real world, directly seen. In that way, Charlot's approach comes close to that of Weston, although Weston's photographs—which combined clarity and detail with a degree of abstraction, in tightly composed images—look very different from Charlot's paintings. In Weston's imagery as well as in Charlot's, abstraction and realism were carefully balanced, albeit in different ways; Charlot's painting may not look anything like Weston's photography, but both arose from a comparable impulse. There was a kinship, so far as their basic thinking was concerned.

Idols behind Altars likewise included numerous photographs (many of which had been intended for her study of Mexican decorative art). In the acknowledgments section, Brenner spoke of the two photographers who worked with her on the project and shared the commission, Weston and Modotti. Since most of the individual photographs are not credited, it is difficult in some cases to know who was responsible for which images, but the book included Weston's striking picture of the hand of the potter Amado Galván, another of a maguey cactus, and a photograph of the Pyramid of the Sun at San Juan Teotihuacan, along with images of pulquería paintings, *ex-votos* (votive

paintings), *retablos* (devotional paintings), and the like.[107] These photographs were supplemented by pictures probably taken by Modotti later, after Weston had returned to California.[108] Charlot's work, of course, was also represented.

Jean thought *Idols* was quite a success and told Edward that Anita would send him a copy in the near future.[109] Then his tone abruptly shifted, as he ruefully informed Edward that Anita was to be married. Jean and Anita's relationship had often been intense, if uncertain, but during the summer Anita had become engaged to a doctor, David Glusker, and the news left Jean feeling shaken and lonely: "She was the only person I knew well in New York."[110] Although his professional prospects were starting to improve, his state of mind was not, and he was feeling more than a little glum. It would be some time before his spirits would revive.

4

AT THE HACIENDA

In January 1930 there was an exhibition at the Art Students League in New York of the work Charlot had done in Mexico.[1] It was quite comprehensive and featured numerous oil paintings, including *Burden Bearer*, *Steam-Bath*, and portraits of Anita Brenner and Pintao. So too there were watercolors, woodcuts, and quite a few drawings, including one of Tina Modotti. In addition, following the example of the Orozco show, the exhibition included studies and cartoons for, as well as photographs of, the frescoes Charlot had done in Mexico City. In the slim catalogue of the exhibition, Brenner supplied a brief foreword.[2]

The exhibition was respectfully received, and in the months that followed Charlot was included in group shows at the Museum of Modern Art in New York and the Harvard Society for Contemporary Art in Cambridge, Massachusetts.[3] As the latter exhibition was coming to an end, Jean wrote again to Edward, who had just sent him three photographs to show off some of his most recent work—probably *Eroded Rock* and *Cypress Root, Seventeen Mile Drive*, as well as *Kelp*, done just a few weeks before.[4] Charlot began by acknowledging the present: "Thanks very much for the three photographs. I think they are beautiful—and as much as I liked your Mexican work I think this one still deeper." Charlot indicated that he had just mailed three of his lithographs, to give Weston an idea of *his* 1929–30 style; he also mentioned the group shows in New York and Boston. Clearly things seemed to be looking up for him professionally, but on the personal front the situation was

somewhat different, and Jean was still feeling rather low: "As [an] individual I am not so well. Since mother's death and with Anita getting married in June, there is no one left near me of those I cared for. Even work, as you know is not enough to fill the gap."[5] Anita Brenner had married David Glusker on June 30, 1930, at the Spanish-Portuguese Synagogue in New York; Rabbi De Sola Pool officiated.[6]

In the same letter Jean asked for news of Tina. Since Mella's assassination, Tina had again gotten into difficulty with the Mexican authorities, and in February 1930 she had been deported from Mexico as an undesirable, for her political activity. Her deportation had been reported in the newspapers, and that is how Weston had first learned about what happened. In subsequent weeks, as she made her way to Germany, Tina wrote to Edward and filled him in on her situation, her movements, and her state of mind.[7] How much of all this Edward had passed along to Jean or how much Jean had already heard from his own sources is unclear, but he was concerned and eager to hear more. As it turned out, just after Jean's letter to Edward, Tina wrote to Edward again to let him know that she had finally arrived in Berlin, where she was thinking of staying.[8] If Edward passed this news along to Jean, the letter has not survived.

Jean wrote again soon afterward. He had recently seen a reproduction of Edward's 1923 portrait of Nahui Olín in a German publication, probably a discussion of the *Film und Foto* exhibition in which the portrait had been included, and it reminded him of the direct power of Weston's best work. At the same time, he worried that Weston might be heading off course: "I hope you never become a surrealist, Edward. Clean focussed vision seems best."[9] By this time surrealism had become an important force in the art world, and Charlot looked upon this new development with a good deal of suspicion. While rejecting pure abstraction and emphasizing the importance of content, he rejected the sort of literary or mythological associations underlying much symbolist or surrealist imagery. The subject mattered, but it had to be rendered directly, without visual tricks or symbolic twists and without being overshadowed by the artist's presence. Charlot, like Weston, was interested in revealing the essence of things, without calling attention to himself in the process or embracing the dreamworld of surrealism.

Edward may not have realized it, but for Jean such feelings were born of deep religious conviction. Speaking of the poetry his father wrote in his early

years, John Charlot has said, "By the true observation and depiction of nature, avoiding any egotistical imposition of the self, the artist makes God's plan visible even if he does not fully grasp that plan."[10] Revealing nature directly was a kind of religious observance, akin to prayer. Weston, of course, did not see things in the same religious terms, but he expressed similar sentiments.

In the same undated letter, Jean also responded to a question Edward must have asked in a recent communication (now lost). Sometime the previous year (late 1929), as he was preparing an exhibition of Atget's work at the Weyhe Gallery in New York, Carl Zigrosser, the director of the gallery, had written to Weston about how great a photographer Atget was—he felt that Atget was the greatest photographer of all time. Weston, who was not yet fully familiar with Atget's work, must have asked Charlot for his opinion. Charlot concurred with Zigrosser: "Atget seems to me a very great artist. His best work done in Paris, around 1900."[11] He also referred Weston to an article about Atget by Bernice Abbott that had appeared in *Creative Art* the previous year.[12]

Edward must also have asked about the various galleries in New York that might show his photographs and specifically about the Delphic Studios and Carl Zigrosser, for in the same letter Jean added a summary of the current possibilities, as he saw them: "I *do not like* the Delphic Studios—though there can be much of a personal element in it. They have shown already photographs of a pretty indifferent trend, and the atmosphere is too 'arty' for me. Did you think of Stieglitz with his gallery: 'An American Place,' though you are a dangerous man for him. Zigrosser has very good taste and his gallery good reputation. The place is well suited for a photographic show. If he could assure you of a show the following season it would perhaps be worth waiting."[13]

The Delphic Studios had been established by Alma Reed the previous fall, primarily to showcase the work of Orozco.[14] The ethos of the gallery—a carryover from the ashram of Madame Sikelianos—was obviously not to Charlot's liking, and he was trying to steer Weston toward other options. It is interesting, given his dislike of Stieglitz, that he suggested An American Place as a viable alternative. Despite Charlot's view that Weston posed an artistic threat to Stieglitz, he evidently thought the elder photographer might be receptive to Weston's work. Weston probably had mixed feelings about that possibility.

In June 1930 Weston made a series of photographs of an egg cutter. The first of these still lifes (fig. 17)—made in foggy weather—featured the egg cutter,

together with hard-boiled eggs and baking dishes, carefully arranged with an eye toward compositional balance: "The taut wire strings for slicing give it the appearance of a musical instrument, a miniature harp. I put the hard-boiled egg, stripped for cutting into it, a couple more eggs were commandeered to balance, and two aluminum baking dishes, the halved kind, made to fit together in a round steamer were used in back. Result, —excellent."[15] The next day he continued working with the egg cutter—in sunlight this time—playing off the object itself against its own shadow to create a dynamic interplay of lines and forms; the resulting efforts bring to mind the imagery of Albert Renger-Patzsch.[16]

Reflecting in his daybook on what he had just done, Weston not only expressed his satisfaction with the new work but also formulated, perhaps for the first time, what he would later call his theory of mass production:

It [photography] is a perfect medium for one whose mind is teeming with ideas, imagery, for a prolific worker who would be slowed down by painting or sculpting, for one who sees quickly and acts decisively, accurately.

It is an abominable medium for the slow-witted, or the sloppy worker: he, the slow one, cannot use the speed to advantage, or cannot grasp the passing moment quickly enough to record it in an instant, —or, if sloppy, the ease of execution tends to exaggerate his weakness. Now one does not think *during* creative work: any more than one thinks when driving a car. One has a background of years—learning—unlearning—success—failure—dreaming—thinking—experience—back it goes—farther back than one's ancestors; all this,—then the moment of creation, the focussing of all into the moment. So I can make—"without thought"—fifteen carefully-considered negatives one every fifteen minutes,—given material with as many possibilities.[17]

For Weston, one of the special advantages of the photographic medium is the relative speed with which a photographer can work. This rapidity enables an artist to realize ideas quickly, without being slowed down by laborious methods or materials. To work this quickly, of course, requires great technical mastery—something for which Weston was well known—but technique should never be allowed to interfere with the creative process, which, in Weston's view, is essentially intuitive. Indeed, technical control must be so complete, so thorough, as to be automatic, like driving a car. Once attained, it enables the photographer to explore visual ideas more fully than artists

working in other, more time-consuming media, and it allows him to sharpen his vision in new and unprecedented ways by varying and perfecting visual ideas. Such thinking is an offshoot of Weston's basic purism, which stressed the detailed realism of sharply focused images and disallowed extensive and time-consuming hand work; now he took his argument a step further and underscored what he regarded as another special advantage—beyond sharpness and detail—of the medium itself: because of its speed, photography paved the way for a special, heightened kind of seeing. Weston would come back to this idea on numerous occasions.

The following month, in July, Orozco and Reed came to Carmel for a visit. They may have been encouraged to do so by Charlot, who no longer harbored any ill will toward Orozco (and who knew of Weston's interest in the Delphic Studios). Weston, of course, showed the visitors his latest work, starting with an image of kelp, and they were duly impressed; ironically, what impressed them most was not the direct honesty of the imagery but rather its surreal quality. Indeed, Orozco reportedly told Weston that he should call himself the first surrealist photographer.[18] There is no indication of how Weston responded.

Orozco's positive comments were not just idle chatter, for the next day Reed offered Weston a show at the Delphic Studios in the coming fall. Since the Delphic Studios had been concentrating almost exclusively on the work of Orozco, for Weston to be featured in this way represented a significant exception, a profound compliment, and an important opportunity. Moreover, it would be his first major exhibition in New York. Despite any reservations Weston might have had about being classed as a surrealist, he immediately accepted.[19] On the same occasion Weston made portraits of the visiting painter, including one of his best-known portraits—with light reflecting off Orozco's thick glasses—which displays an intensity that surpasses that of earlier examples. Orozco was very pleased with the result.[20]

In the coming months, perhaps with the upcoming show in mind, Weston redoubled his efforts and continued his work with vegetables, sharpening his vision. In early August he made some of his most admired images of peppers, including *Pepper No. 30*, which he regarded as the culmination of all of his efforts up to that moment and an embodiment of his most exalted feelings: "It is a classic, completely satisfying,—a pepper—but more than a pepper: abstract, in that it is completely outside subject matter. It has no psychological attributes, no human emotions are aroused: this new pepper

takes one beyond the world we know in the conscious mind."[21] The pepper pictures were soon followed by photographs of cabbage and then squash. These pictures too seemed to have a special significance.[22]

Many of these recent images were among the prints selected for his New York exhibition, which opened on October 15 at the Delphic Studios. Altogether there were fifty photographs, mostly work he had done in the previous two years. There were images of kelp, peppers, and eroded rock, along with pictures of squash, bananas, and the egg cutter; so too there were the recent portraits of Orozco and of the poet Robinson Jeffers. Going back a little further, Weston also included a number of the shell photographs from 1927 and, from his Mexican period, the portrait of Galván that had been featured in the *Film und Foto* exhibition.[23] In conjunction with the show Weston wrote a statement about photography in which he brought together some of the ideas he had already expressed: he spoke again, for example, about how the speed of photography seems to match the tempo of modern life, and he reiterated his ideas about pre-visualization.[24]

Although Weston did not sell many prints the show was well received, and among the many visitors who came to see it was, of course, Charlot, who was still in New York at the time. Not surprisingly, Jean was greatly impressed with what he saw, but he also had some reservations, as he explained in a letter to Edward, written shortly after the show opened:

> I went to see your show and was very much taken by it. The things I like best were perhaps the rocks, including a print of foot print in mud. Given that I liked everything, if I had to criticize I would say: the pepper series looks more like photographs of sculpture than they exist as photographs alone. Others are perilously near the surrealist people, for example the egg-slicer with the egg would make a good "Orpheus playing the harp" in a Paris show. Others are perhaps too heavy with implications coming from the subject-matter like the red cabbage and artichoke (with the idea of growth etc. . . .) to know which of its beauty is in the print, which in the mental correlation. I hope critics will recognize fully what a great artist you are.[25]

Interestingly enough, he did not care for the peppers as much as many people did, and the egg cutter set off alarm bells: like Edward, Jean had noticed that the egg cutter resembled a harp, and partly because of that the picture struck him as too literary, as the sort of image that would have fit very well into an exhibition of surrealist art. Charlot likewise noted the surrealist

tendencies in some of Weston's other work, as had Orozco not long before; for Orozco, that aspect of Weston's work had been something positive, but for Charlot it was a cause for concern. Indeed, Charlot was quite worried about those images that smacked of symbolism or surrealism, in which the symbolic or literary associations distracted the viewer from the thing itself, in the most direct, photographic sense.

Weston referred to Charlot's letter in his daybook. He was pleased with Charlot's basic response and found the rest of what he had said very thought-provoking: "Ever faithful friend, Jean Charlot wrote: 'I hope critics will recognize fully what a great artist you are.' His comments, upon various avenues of approach in my work, were so interesting, intelligent, keen, that some morning I wish to devote to discussing them with myself, — if time for writing ever comes again!"[26] Several weeks later he was still thinking of Jean's remarks, and he responded to them in more detail in his daybooks:

—thinking of Jean's letter: I too felt that my peppers resemble sculpture: but not while doing them, — afterwards, maybe helped by others who have even thought I copied "modern" sculpture.

Well, a sculptor might have exactly copied a pepper, and been accused of realistic (photographic) viewpoint, or of taking liberties with Nature! I have only discovered unusually important forms in nature and presented them to an unseeing public. I have had time and again persons tell me, "I never go to a market now, without looking at the peppers, or cabbage, or bananas!" And even they bring me vegetables to work with, as the Mexicans used to bring me toys. So I have actually made others *see* more than they did. Is not that important?

When I work in the field with rocks, trees, what not, I think that this is my important way: then comes a period of "still-life" which excites me equally. So the best way is not to theorize, but do whatever I am impelled to do at the moment. I have always had the faculty of seeing two sides, positive and negative, to a question. No sooner do I say "no," than out pops "yes." Of this I am sure: the intimate "close-up" study of single objects has helped my work outside.

As to Jean's remark re implications of growth—If I get into my work that very feeling of growth—livingness—I am deeply satisfied.[27]

Edward was especially concerned with Jean's comments about the pepper pictures, which he seemed to feel called all of his still lifes into question.

Edward acknowledged that Jean had been right in seeing a connection to sculpture, but that was something that applied only after the fact. As far as Edward was concerned, he was merely recording the important forms of nature. Weston clearly shared Charlot's fundamental belief in direct seeing and in the importance of portraying the essence of things, the thing itself, but for Weston, his still lifes fulfilled that goal every bit as much as the pictures taken in nature, of rocks and other subjects. Weston did not remark upon Charlot's concerns about surrealism: if he was either worried or offended by such a label, he made no mention of it at this point.

In December Weston had a one-man exhibition at the Vickery, Atkins & Toorey Gallery in San Francisco.[28] When the show opened he was still in Carmel, but soon after he headed north, mostly to spend time in the gallery with the hope of drumming up more portrait sittings. While he was in town he had a sad encounter with Margrethe Mather, with whom he had once been very close. As he reported, "Margrethe Mather,—a fine renewal of an old friendship: but she seems as lost, or more so, than ever,—in her work. I have promised to help her if she will come to Carmel,—but it really seems futile."[29]

At around the same time Edward also saw Diego Rivera for the first time since Weston left Mexico four years before. Rivera was in San Francisco, together with Frida Kahlo, whom he had married a year before, to paint murals in the San Francisco Stock Exchange Luncheon Club (now the City Club of San Francisco) and the California School of Fine Arts (now the San Francisco Art Institute).[30] They all met at the home of the sculptor Ralph Stackpole, where Edward photographed Diego and Frida, individually and together. Afterward he described the encounter with considerable enthusiasm:

I met Diego! I stood behind a stone block, stepped out as he lumbered down stairs into Ralph's courtyard on Jessop Place,—and he took me clear off my feet in an embrace. I photographed Diego again, his new wife—Frieda—too: she is in sharp contrast to Lupe, petite,—a little doll alongside Diego, but a doll in size only, for she is strong and quite beautiful, shows very little of her father's German blood.

Dressed in native costume even to huaraches, she causes much excitement on the streets of San Francisco. People stop in their tracks to look in wonder. We ate at a little Italian restaurant where many of the artists gather, recalled old days in Mexico, with promises of meeting soon again in Carmel.[31]

It seems likely that Charlot's name would have come up, as Diego and Edward talked over old times and shared the latest news, but if Edward reported any of this to Jean, the letter has been lost.

During his stay in San Francisco Weston also met and photographed Timothy Pflueger, the architect who had designed the stock exchange where Rivera would paint a mural.[32] And it was around the same time that Kahlo became acquainted with Dr. Eloesser. Rivera had already met the doctor in Mexico in 1926, and Weston too had spent time with him. Kahlo first consulted Eloesser in December 1930, and for the rest of her life she relied on his medical advice; she would also paint him standing next to a sailboat (*Portrait of Dr. Eloesser*, 1931).[33] Eloesser seems to have enjoyed the company of artists a great deal, and soon after he would come into contact with Charlot as well.

On his return to Carmel, Weston had a chance to print for himself for the first time in several months; the new prints included recent images of cypress roots and the cross-section of an onion, and he was quite excited by the results.[34] A few days later Rivera and Kahlo wrote to thank him for the pictures he had just taken of them, which they thought marvelous.[35] And it was not long afterward that Edward also received a Christmas present from Jean, a recently published book of photographs by Eugène Atget.[36] Weston noted the gift in his daybook on Christmas morning.[37] Two days later, having had time to study the pictures more closely, Weston wrote about them in more detail. He was somewhat disappointed:

> Zigrosser wrote me last year that they were to have an exhibit of photographs by Atget, whom he considered one of the greatest photographers of all time. I was curious and excited over this new name to me,—and I know Zigrosser to have good taste,—since he chose my work as the most important art of the West!
>
> So when Jean sent the book of Atget—I prepared to be thrilled—or that's a cheap word, let's say deeply moved! Instead I was interested,—held to attention all through the book—but nothing profound—
>
> Atget establishes at once with his audience a sympathetic bond: for he has a tender approach to all that he does,—a simple, very understanding way of seeing, with kindly humor, with direct honesty, with a reporter's instinct for items of human interest.
>
> But I feel no great flame: almost, in plate 94 of tree roots,—if I had

seen it before doing my own I would have thought it great. How much it resembles my viewpoint.

Weston may not have been as impressed as he had expected, but he did recognize a kinship between Atget's work and his own. In particular, he mentions Atget's photograph of tree roots taken at Saint-Cloud, which excited him a good deal. Weston seemed to feel that his own pictures of the same sort of subject went further—and indeed he moved in closer—but he understood that his viewpoint and Atget's were closely related.

Weston was also critical of Atget's technique and composition, and he singled out specific images he thought particularly weak in that regard:

Unless the plates were poorly reproduced Atget was not a fine technician,—not always: halation destroyed much, and color correction not good. The poor man being dead he had no "say" in this book and perhaps would have omitted many plates. I can see no excuse for publishing 32,—for example. Too often he uses such poor judgment in lighting, getting messy, spotty results like plate 24. Certainly it has value as a record, but not as important photography. Again a plate like 48, his instinct for subject matter was keen, but his recording weak,—his construction inexcusable. Cut off the sky and present the wagon—and what he felt but did not get is there. So often one feels he just missed the real thing: for example 55 of the agave,—or the flowers 53, or the wagon, above-mentioned.

Of the examples just mentioned, the agave is once again close to the sort of image that Weston himself had made, but he felt that Atget's picture was poorly composed. At the same time, however, Weston greatly admired Atget's interiors, his store windows, his circus imagery, and the like, some of which anticipate photographs Weston would make in the coming decade: "his intimate interiors,—the bedrooms,—are as fine as a Van Gogh: and his store windows a riot,—superb. In these I find him at his best, and in such plates as his merry-go-round and circus or side show front."

Weston concluded on an increasingly positive note, having warmed to his subject as he went along:

Atget's importance is unquestioned. If I started out to criticize, it was from disappointment. I had expected a flame, and found but a warm glow. What I admire most of all is the man's simple honesty. He has no bag of tricks. He makes me feel ashamed in recalling certain prints—most all

destroyed now—in which I found myself trying to call attention with cleverness, or shall I say by a forced viewpoint—for I hope I have never been cheaply clever!

And recalling the usual "Photo Salon" of pretty trees, romantic nudes, sentimental postures, Atget stands out, so very far apart, in extraordinary dignity.[38]

There is a kind of irony, perhaps, in the fact that Atget, the darling of surrealists, should be considered in terms of his direct and honest sensibility—and that is no doubt part of the reason Charlot had sent along the book in the first place. For Charlot, Atget's photographs must have evoked memories of the Paris of his younger years, but at the same time his imagery clearly represented the sort of direct seeing Charlot most admired. He knew Weston wanted to know more about Atget's work, and on some level he was simply trying to satisfy his friend's curiosity, but like Weston, he recognized the simple directness of Atget's vision. In all likelihood Weston communicated his response to Charlot, perhaps in much the same form as it appeared in his daybooks.[39]

Early in 1931 Weston received a letter from Tina Modotti. Having been forced to leave Mexico, she had gone to Berlin, where she had trouble establishing herself and did little photography. Six months later she moved on to Moscow with the hope of making more of a contribution and began to work for International Red Aid (the International Organization for Aid to Revolutionaries).[40] In her letter Tina spoke of how busy she had been since arriving in Moscow, although she gave no specifics, and indicated that she felt as if she had embarked on a new and interesting life.[41]

Edward had sent her the announcement of his exhibition at the Delphic Studios, which Tina acknowledged in her letter. She then went on to speak of cameras, asking Edward if he knew anyone who might want to buy her Graflex for a reasonable price; she had been unable to get the right-sized film for it and planned to get a smaller camera, a Leica, instead. At the time she must have still been thinking of going forward with photography, but her political activity was already starting to crowd out her art; she was questioning the value of her photographic endeavors and soon would abandon them altogether.[42] Modotti's letter was the last communication Weston would receive from his former lover.[43] It is not known whether he ever responded.

In February Charlot had a small exhibition at the Denny-Watrous Gallery in Carmel, which Weston helped arrange; it consisted mostly of prints and drawings, to which were added a few paintings owned by local collectors, including Weston. For the occasion the local newspaper, the *Carmelite*, reprinted the essay Anita Brenner had written for Charlot's show at the Art Students League in New York the year before.[44] A week later the *Carmelite* also printed a piece by Weston about his friendship with Charlot, in particular the years they had spent together in Mexico. He recalled, for example, the excursions they went on together and the dinners at the Charlots', and he expressed fond memories of Jean's mother: "The violet laden table was presided over by his mother, a woman I consider a privilege to have known,—cultured, distinguished in bearing, with fine critical judgement, she undoubtedly held a significant place in Jean's growth as an artist. She has gone, I salute her memory."

In the same article Edward spoke of the artistic bond between Jean and himself. His feelings for his friend were closely bound up with his modernist views of photographic art: "one basis for the friendship which formed between Charlot and myself was his understanding and keen appreciation of photography as a contemporary expression. Photography has changed the world's eyesight, it is the great destroyer of bad painting, clearing the way for a new vision. A painter of today who does not recognize this—granting he has seen photography, can be dismissed as belonging to a decadent culture,—and photographers who imitate these myopic painters of Calender Art are equally unmentionable." Further on, Weston attempted to characterize his friend: "A finely balanced personality, sensitized, not merly [*sic*] sensitive,—Charlot—keen analyst and deep observer of life, may delicately ridicule, broadly chuckle, or create monumental form, but always with the surety of a technique which effaces all effort." Not only did Weston call attention to Charlot's acute powers of observation, but he also emphasized the importance of a technical mastery so thorough as to be automatic and unnoticed. He closed by saying, "World-wide overproduction applies to art. Thousands of 'artists' should turn to house painting. We need Charlot."[45]

When Jean saw the article from the *Carmelite*, he wrote Edward to express his thanks: "Your article was very nice. I appreciated specially your tribute to mother—and it is nice to hear of art in an unassuming way, related to life."[46] Charlot also sent a copy of the article to his sister, Odette, in Paris, along with a brief note in which he explained that he had had a little show, "en province," in conjunction with which Weston, whom he described as a

famous photographer, had written about his life with Maman in Mexico.[47] Jean was obviously pleased.

Weston rarely spoke about political matters in his daybooks, but one day in March he made an exception and wrote at some length about his political views. He had just seen himself described in a radical journal as a "Left-wing American Photographer" and, although amused by it, he felt compelled to clarify his position—at least privately. Indeed, he was at pains to explain how he felt about the possibility or desirability of revolution:

> A radical I have always been considered, but only in my work. Politically, my convictions are unformed, excepting to realize, to know, that a change must come, that the world, and these States are in a mess: what form the change should take—evolution or revolution—I leave to those who have given it a life study. For me evolution offers a stronger base for a unified future. Prohibition failed here because it was forced upon a people not ready, not evolved: they needed the escape drink offers. I cannot see the possibility of success in proletarian revolution here; too many workers hope to become bosses, or even President,—too many individuals out for hemselves, to get all they can at any cost.

Further on he considered the social role of art and the social significance of his own photographic work:

> One's work must have social significance, be needed,—to be vital. Art for art's sake is a failure: the musician cannot play forever to an empty house. There must be balance—giving and receiving—of equal import whether in sex or art. The creative mind demands an audience, must have one for fulfillment, to give reason for existence. I am not trying to turn the artist into a propagandist, a social reformer, but I say that art must have a living quality which relates it to present needs, or to future hopes, opens new roads for those ready to travel, those who were ripe but needed an awakening shock,—impregnation.

Then he offered the specific example of Orozco:

> Nor am I in any way suggesting that the artist consciously tries to put a message into his work—he may, as Orozco does—who, whipped into a flame by injustice, releases himself with scathing satire: but his work will

live, one might say, despite the social theme, as done by a creative mind, a visionary functioning positively, giving direction and meaning to life, which had been suffocating in sunless middle-class parlors, or falsified in "Bohemian" attics. The same theme, put down by a lesser artist, be he ever so fiery a radical would no more live than a skyscraper erected by a school boy.[48]

For the most part Weston was content to leave political matters to others, but he nevertheless had strong—almost cynical—feelings, which emerge here, and he felt strongly that the best art, including his own photography, had a kind of social significance, even if it did not address social issues directly. And political imagery must transcend the specifics with which it deals in order to be truly important or lasting, as was the case with Orozco's best work.

In the spring of 1931 Charlot's work gained considerable exposure; he had two solo shows in rapid succession. The first one was held at the John Levy Gallery on Fifty-seventh Street in New York City. It was the first of two exhibitions of Mexican art involving Charlot that were arranged and selected by Frances Flynn Paine. It focused on his paintings from the previous five years (1927–31), including work done in the Yucatán.[49]

Although the show received a good deal of critical attention, the reviews were somewhat mixed. Henry McBride of the *New York Sun*, for example, was rather negative: although he praised Charlot's natural use of the brush and his daring compositions, he was critical of what he regarded as an overemphasis on technique, and while he considered Charlot's palette to be appropriately Mexican, he seemed to feel that Charlot was benefiting unduly from the temporary popularity of Mexican art in the United States and would probably not outlast the passing fad.[50] Ralph Flynt, on the other hand, writing in the *Art News*, was more positive; he regarded Charlot's imagery as both powerful and original.[51] *New York Times* critic Edward Alden Jewell also expressed his admiration and underscored the uniqueness of Charlot's approach: "Charlot is first himself, then an exponent of Mexican painting. We get plenty of archaeology—in the strange head-dresses of the women, the popular customs, the notes on building Mayan temples, the life of patio and street—but what seems most essentially the artist's contribution resides in his personal statement of design as expressed in terms of line and color."[52]

Among those who came to see the exhibition was a young woman from

California called Zohmah Day, who had arrived in New York toward the end of the previous year with the intention of studying art. Zohmah had been born Dorothy Day in Brigham Young, Utah, on December 13, 1909. When she was a young girl her family had moved to Los Angeles, where she grew up. She had always disliked the name Dorothy, and as a teenager she adopted the name Zohmah instead. After graduating from Fairfax High School in 1927 she studied typing and shorthand, but she had always been more interested in art.[53] Indeed, it was her artistic interests that had led her to New York and to Charlot's exhibition. Zohmah did not meet the artist at the time, but she later recalled that she was impressed with what she saw: "At the time I thought his paintings looked the way I'd like to paint. I was annoyed that somebody else had already done it."[54]

The following month the second of the two shows opened, at the John Becker Gallery. Once again Frances Flynn Paine, who seemed to be taking an active interest in promoting Charlot's work, played an important role. This time the emphasis was on watercolors and drawings.[55] For the show's catalogue, Paul Claudel, the noted poet and French ambassador to the United States, wrote a brief foreword. Referring to the painter as *un constructeur* (a builder) and *un compositeur* (a composer), he praised the geometric rigor, the architectonic strength, of Charlot's imagery and spoke of how this was manifest in his many images of Mayan masons at work and related themes (some of which were included in the exhibition). So too he spoke of the artist's special interest in fresco and expressed the hope, in rather prophetic terms, that Charlot would have more spaces to fill in the future: "Charlot was born for fresco. His painting has the good smell of damp plaster. Copious though his groups are, they call for others more important to surround them. He should have wide spaces to fill. Why not the whole of this enormous panel between the Atlantic and the Pacific?"[56] Charlot worked in many media, two-dimensional and three-dimensional, but as Claudel well knew, he was always looking for a wall to paint.

In April Zohmah Day left New York and made her way to Mexico to join Ione Robinson, the daughter of one of her mother's acquaintances. Robinson, an aspiring painter, had already spent some time in Mexico, where she had been one of Diego Rivera's assistants and had shared an apartment with Tina Modotti. After a failed marriage to Joseph Freeman, a correspondent for the Soviet news agency Tass, she found herself in New York, where she met Zohmah. Soon after,

upon receiving a Guggenheim Fellowship to study art, Ione decided to move back to Mexico and invited Zohmah to follow her. Much to Ione's surprise, Zohmah took her up on the offer and likewise traveled to Mexico, moving into the house Ione had already rented in Coyoacán, next door to the radical journalist Carleton Beals (who had known both Weston and Modotti); Beals often dropped by for breakfast. Before long Zohmah became part of the expatriate community, immersing herself in the Mexican scene and meeting many of the luminaries of the Mexican art world. Along with Robinson, she even did some of the painting on one of Rivera's murals at the National Palace.[57]

After she had been in Mexico a little more than a month, the artist and educator Adolfo Best-Maugard stopped by looking for Ione, who was away at the time; he invited Zohmah to come with him to Tetlapayac, about eighty miles southeast of Mexico City, to a pulque hacienda where the Russian director Sergei Eisenstein was working on the ill-fated film *Qué viva México!*[58] The next day the two of them set out for the hacienda, together with Edouard Tisse, Eisenstein's main cameraman. When they arrived Eisenstein was there to greet them. Also on hand were Grigory (or Gregori) Alexandrov ("Grisha"), Eisenstein's chief assistant; don Julio Saldivar, the owner of the hacienda; and several other guests, cast members, and numerous workers.[59] Zohmah later recalled some of her experiences:

> Our meal routine was fairly regular. In the morning everybody got up early and had breakfast before going out to do filming. Lunch was at 2 p.m. or 3 p.m. We usually sat down to eat dinner about 10 p.m. and food was served, course after course, until about midnight. One dish came at a time: soup, rice, eggs, vegetables, various meats, a small sugary desert [*sic*] and then always finishing up with beans.
>
> Eisenstein always had me sit next to him at the dinner table and told everybody that I was crazy about vermouth. Although I didn't really like it he thought I did and insisted I drink it. I couldn't hurt his feelings. None of the Russians, or Tisse, the Norwegian, drank.[60]

Of all the residents and visitors, Zohmah seemed to have a special rapport with Eisenstein himself, as she later recalled: "While I was staying at the hacienda, Eisenstein was the quietest and most comfortable person there. I frequently took a book to his room to read. He liked me and didn't seem to mind. I became kind of a mascot. He gave me the Russian stamps off the letters he was reading and always showed me his latest drawings."[61]

Zohmah went on to speak of how rapidly Eisenstein made his drawings, seldom lifting his pencil from the paper; the drawings, as she recalled, were mostly studies of people from a variety of difficult angles, presumably in preparation for the filming then underway. But Zohmah not only watched Eisenstein planning the film, she also spent time on location and observed him in action, while directing; she was impressed with his quiet and methodical approach: "Eisenstein was a very quiet person whenever I watched him directing the picture. He had so thoroughly planned the scene beforehand that once the cameras started he really didn't have to say anything."[62]

Zohmah inevitably became the subject of some of Eisenstein's rapid drawings. While at the hacienda she often wore a pair of checked pajamas that looked like a taffeta dress, which Eisenstein seemed to find amusing; he made at least two drawings, on lined paper, of her wearing them. The surviving examples are quite comical. One of them simply shows Zohmah in the taffeta pajamas and a straw hat, the broad brim of which extends outward—almost like wings (fig. 18). At her side a large bottle of vermouth is held aloft by two birds, while another bird appears on the opposite side.[63] The other drawing is more complex and as odd as it is funny; it shows Zohmah in the same pajamas and hat, but in this case she is identified in a caption at her feet as Cyrano de Bergerac. To her right is a sinister-looking cupid-like figure with a hat and goatee, aiming a crooked arrow back toward Zohmah. And in the upper right a naked figure, perhaps Eisenstein himself, is madly playing an upright piano with every available part of his body.[64] The result is not only comical but enigmatic; whatever inside jokes are expressed here have been left unexplained, and the meaning of the drawing remains unclear.

Eisenstein also had his assistant, Alexandrov, take photographs of Zohmah, once again wearing the pajamas and the hat and standing in the courtyard of the hacienda: "He directed several shots and, for one of them, he got down on his stomach behind me and asked that I hold out the yards of taffeta for the photograph. When the picture was developed I was shown standing there with a sweet expression and Eisenstein was visible sticking out from behind. Grisha let me help him sort the photographs and I kept a few."[65] In the picture to which Zohmah refers, Eisenstein's head indeed sticks out between her legs and her pajamas are spread out like bat wings; the effect is quite comical.[66] Of those she kept, one shows her in the taffeta pajamas, looking happily toward the camera while she steadies her broad-brimmed straw hat with both hands.

In another she throws her head back and seems almost transported (fig. 19). The director himself is not visible in either one.[67]

It is not clear exactly how long Zohmah remained at the hacienda, but she was back in Coyoacán by June 8, when she wrote her friend Prudence Perry (later Plowe) about her experiences there.[68] The same day Eisenstein visited Charlot, who by that time had returned to Mexico for a several-month stay. Charlot had arrived in Mexico in May and was sharing a rooftop flat with fellow artist Pablo O'Higgins in Mexico City, which is where Eisenstein came to see him.[69] Eisenstein had not yet met Charlot, but he was already quite familiar with his work; he had read about Charlot in *Idols behind Altars* (which had inspired the basic structure of Eisenstein's film), and he must have heard a good deal more from other sources, including Best-Maugard.[70] Indeed, by the time of his visit, Eisenstein already looked upon Charlot as one of the important representatives of Mexican art, and in that spirit he had dedicated part of *Qué viva México!*—the section called "Sandunga"—to him.[71]

Qué viva México! was to comprise a chain of novellas representing different periods and regions, along with a prologue and an epilogue; each episode was dedicated to a different artist (Siqueiros, Goya, Rivera, Orozco, and Posada, in addition to Charlot).[72] "Sandunga," the most lyrical part of the film, is set in precolonial times in Tehuantepec, which is presented as a tropical paradise; it tells about the marriage of Concepción and Abundio and culminates in an extended wedding celebration, partly inspired by Charlot's imagery. The filming for the "Sandunga" episode had been completed earlier in the year; Charlot was still in New York at the time.[73]

Charlot's arrival in Mexico gave the Russian director the opportunity to meet the artist in person, see more of his work, and hear his thoughts about Mexico and Mexican art. They must have had a great deal to discuss, for they met again on the following day, when Best-Maugard was on hand as well.[74] Several days after that Eisenstein sent a telegram inviting Charlot to the hacienda, and the following week Charlot was on his way to Tetlapayac, arriving there in the middle of June; Ione Robinson, Zohmah's housemate, arrived on the scene around the same time.[75] During his stay Eisenstein showed Charlot many drawings, including a series on the stigmata, and like Zohmah, Jean was impressed with the director's fluid, almost automatic way of working; he was likewise intrigued that Eisenstein, an orthodox marxist, had been immersed in the study of mysticism, including the writings of Teresa of

Avila.[76] Eisenstein no doubt spoke about his plans for *Qué viva México!* and Charlot may even have watched some of the filming. (Eisenstein was working on the "Maguey" episode at the time.) In any event, the two men clearly hit it off, and they made contact with each other several more times over the course of the summer and then later in the United States.[77]

While at the hacienda Jean may have heard something of Zohmah and her recent visit; he may even have seen some of Eisenstein's drawings of her or some of the photographs, but he did not meet her there. The two of them met a little later, back in Coyoacán, at a dinner party Zohmah and Ione had organized at their house. Tisse and Alexandrov both came, and Ione invited some of her own artist friends as well—members of the expatriate community Zohmah had not yet met, including Emily Edwards, a painter from Texas and fellow student of Rivera's; Pablo O'Higgins; and of course, his roommate, Jean (whom Ione had just seen at Tetlapayac).[78] When they were first introduced, Jean, not realizing Zohmah was an American, asked her if she spoke English. For her part, Zohmah did not know at first who Jean was, but she soon remembered having seen his exhibition in New York, at the John Levy Gallery. As she later recalled, she immediately sensed he was attracted to her.[79] After dinner they went for a walk together, and in subsequent days Zohmah and Jean would see quite a lot of each other; over the course of the summer Jean painted several portraits of her, one of which they had photographed by Manuel Alvarez Bravo.[80] As Jean accustomed himself to the fact that Anita was beyond reach, a new and important relationship was blossoming.

That summer Charlot made the acquaintance of Dr. Eloesser. In August the two of them, together with Frida Kahlo and Diego Rivera, visited the Palacio de Cortés in Cuernavaca, where in 1930 Rivera had painted a series of frescoes depicting the history of Cuernavaca and the state of Morelos. Also present on that occasion were the art critic Elie Faure as well as Frances Flynn Paine. They were all photographed together, standing in front of one of Rivera's murals.[81]

Charlot left Mexico at the end of the summer and returned to New York, taking up residence in what had previously been the studio of Miguel Covarrubias. The following month, after he had settled in, he was the subject of an article by Lincoln Kirstein in *Creative Art*. Kirstein spoke of Charlot's work, first of all, in terms of three influences: Rubens, Goya, and El Greco. According to Kirstein, Charlot's imagery revealed something of Rubens's interest in

the human figure, along with a sense of irony comparable to Goya and an approach to light and color that recalled El Greco. Having said that, however, Kirstein was insistent that these were not superficial resemblances; rather, they were profound affinities, and Charlot forged these qualities into an original expression, balancing abstraction and human reference. Like Claudel, Kirstein spoke of Charlot's work in terms of its geometric rigor, drawing a distinction in that respect between his work and that of many of his contemporaries (and taking a potshot at those who believed in the mystical properties of the golden section):

> We never question a carpenter's ability to plane a board true. Yet when an artist makes it known that he understands the "mysteries" of asymmetrical balance, of the "golden" section as his A B C, then too usually we give him the credit for erudition. Charlot happens to be an unusually well-informed painter. He takes no stock in the parisian dogmas of miraculous surprises in naïviste spontaneity. His paintings are built like battleships to withstand the attack of looseness, disintegration, boredom and the facility of wit, that deals in the School of Paris consider the be-all and end-all of smart paint.

After characterizing Charlot in general terms he went on to speak of his most recent creations, done in Mexico: "This summer Charlot started exploring new directions. Turning to portraiture, his subjects are not, as formerly, tawny Mexicans, but synthetic Nordics of North America. Americans have never been crystalized in paint. Gibson and Sargent established a type which was more the artist than the girl. Charlot can afford anonymity. His analyses need no benison of 'attractiveness.' In Charlot's Americans one can expect the honesty and freshness which have so distinguished his Central Americans."[82] It would seem that Kirstein must have been referring, among other things, to the portraits of Zohmah that Charlot had done not long before, during the summer months in Mexico.

At about the same time, Charlot's thoughts turned once again to Atget, and he began working on a painting based on one of Atget's images. One of the plates in the book Charlot had sent Weston seems to have struck a chord: it was one of a series of pictures Atget had made of Parisian street vendors and tradesmen and showed a woman with a cart delivering bread on the streets of Paris (*La boulangère* or *La porteuse de pain*) (fig. 20). Taken around the turn of the century, Atget's picture brought back memories of Jean's Paris days, prompting him to make the painting; indeed, Jean must have liked that image

a great deal, for he acquired a print of it at about this time.[83] He started out by making small, painted studies, first of the head, then of the *boulangère en buste*, and finally of the wheels of the bread cart. Then he made the larger final painting, which he called *La grande boulangère. Hommage to Adget.*[84] The basic composition follows Atget's image quite closely, but Charlot simplified the background and added a piece of paper on the ground (in the immediate foreground, next to one of the wheels of the cart) as a visual accent (fig. 24). As John Charlot has noted, it was the first of his paintings in a long time, aside from portraits, that did not deal with a Mexican theme; if nothing else, it was an evocation of his boyhood.[85] Perhaps too it was a response to Weston's comments on Atget, a statement about the art of photography and the importance of direct seeing and unassuming imagery.

While Charlot was celebrating the direct realism of Atget, Weston was moving in a very different, almost opposite, direction. One day in October he took a spider conch shell out to Point Lobos, found a place for it on the rocks, and photographed it; he would call the resulting image *Shell and Rock—Arrangement* (fig. 25).[86] Shortly after he did much the same thing with a skull and the jawbone of a cow. Unlike the vegetable still lifes, which inevitably involved a degree of arranging or rearranging, his pictures of trees and rocks tended to present nature just as he found it—which is one of the reasons that some of his friends, like Charlot, preferred them to the rest. In these pictures, however, starting with *Shell and Rock*, he frankly manipulated the scene, in defiance of his critics and perhaps of his own apparently rigorous standards.

When he reflected on what he had done in his daybooks, he was defensive yet unapologetic:

> Artificial,—to place them? Not if they do not look placed, or if they are frankly placed. Since I ask this question, I must be having doubts. I have such violent reactions over faking, dishonesty in others,—half-nude flappers, holding water jars, obviously studio lighted and posed, called "The Greek Slave," that I have become more questioning about my own "arrangements." However I am by no means ready, or even expect to give up arrangements, thereby discrediting some of my most important work,—all the peppers, vegetables, etc. Selection in the field is only another form of arrangement,—the camera being moved instead of the subject.[87]

Weston was at pains to distinguish his work from that of photographers like Paul Outerbridge or William Mortensen, whose set-up images were overly literary and artificial for his taste. But at the same time he wished to validate the whole of his still-life imagery, which had been subject to considerable criticism. Although Weston had positioned himself as a purist, he found himself employing strategies more often associated with nonpurists—strategies he was unwilling to renounce. Whether he realized it or not, he was performing something of a theoretical balancing act, trying to reconcile potentially contradictory aims, and as a result his conclusion is somewhat forced. While even the most apparently straightforward image of nature involves a degree of manipulation—of the camera position, the angle, and the like—it is disingenuous to equate such decisions about how best to present an existing scene with the creation of a situation that would not have existed save for the intervention of the photographer. In making such assertions Weston was attempting to modify his purist standards in order to make room for his latest work—work that challenged those standards and that ultimately was not really about recording the natural scene in any literal way. In the end, Weston's concerns, both aesthetic and cosmic, were somewhat broader: "My own response in making it was one of emotion from contrasting scale,—the tiny shell in a vast expanse, yet the shell dominating."[88]

About two months later, toward the end of 1931, Weston had a large exhibition at the de Young Museum in San Francisco; it was the most comprehensive show he had yet had, comprising 150 photographs. It included many of the same images he had shown at the Delphic Studios the previous year—like the peppers and the egg slicer, the tree roots and the rocks—but there were also many more, most notably a large number of portraits, as well as *Steel* from 1922; the records are incomplete, but *Shell and Rock—Arrangement* seems not to have been shown at this time.[89] Ansel Adams, whom Weston had first met in 1928, wrote a review that appeared in the *Fortnightly* in December. As might be expected, Adams expressed considerable admiration for Weston's work; he praised the simplicity of his approach as well as his technical mastery. But he had serious reservations about at least some of the images in the exhibition.

Sounding rather like Weston himself, or even Charlot (whom Adams had not yet met), Adams started from the premise that photography should concern itself with direct seeing, with realism in the most fundamental sense: "Photographic conceptions must be unencumbered by connotations—philosophical,

personal, or suggestive of propaganda in any form. The representation of objects and materials must be convincing in their complete realism; the stylization of form and substance is utterly foreign to the function of pure photography." In Adams's view, Weston was unquestionably an artist working in the tradition of Atget and Stieglitz, Steichen and Strand—but he did not always uphold that tradition; he did not always live up to the strictest standard of pure photography, at least not in all of his work. Adams greatly admired the photographs of rocks or trees, but like Charlot he was less enthused about the vegetable imagery: "In the main, his rocks are supremely successful, his vegetables less so, and the cross-sections of the latter I find least interesting of all. But I return with ever-growing delight to his rocks and tree details, and to his superb conception of simple household utensils."[90]

For Adams it was the photographs of vegetables that were the most removed from direct observation. They were the most encumbered by extraneous connotations and hence overly symbolic. Although he took Weston at his word that no symbolic associations—pathological, phallic, or erotic—were intended, Adams seemed convinced that they were nonetheless present, even if only subconsciously, and that weakened the result.

Unlike Charlot's criticism that the peppers seemed too much like modern sculpture and therefore one step removed from real life, Adams felt that they introduced unnecessary psychological associations, which he deemed distracting or even false. Although these images are now among the best-known and most oft-reproduced of all Weston's work, they were not readily accepted when they were first made, as Adams's and Charlot's responses make clear.

Not surprisingly, Weston respectfully disagreed with both Adams and Charlot, and as he prepared for his second one-man show at the Delphic Studios in New York, he wrote to Adams with the intention of setting the record straight, especially with regard to the peppers: "The part you devoted to my vegetables provoked a trend of thought which I will try to put into words. Your [sic] are not the first to object to them: my good friend Charlot, whose opinion I value highly, also cared less for them than my rocks, thought they resembled sculpture too much or held other implications. Others have had similar reactions." Weston then launched into his defense, but at first he seemed almost to address himself more to Charlot than to Adams, speaking as much of sculpture as of symbolism:

No painter or sculptor can be wholly abstract. We cannot imagine forms not already existing in nature,—we know nothing else. Take the extreme

abstractions of Brancusi: they are all based upon natural forms. I have often been accused of imitating his work, — and I most assuredly admire, and may have been "inspired" by it, — which really means I have the same kind of (inner) eye, otherwise Rodin or Paul Manship might have influenced me! Actually, I have proved, through photography, that Nature has all the "abstract" (simplified) forms Brancusi or any other artist can imagine. With my camera I go direct to Brancusi's *source*. I find *ready to use*, select and isolate, what he has to "create." One might as well say that Brancusi imitates nature as to accuse me of imitating Brancusi, "Negro sculpture," or what not, — just because I found these forms first hand.

Addressing himself more specifically to Adams's criticism, he went on to say, "I have on occasion used the expression, 'to make a pepper more than a pepper.' I now realize that it is a carelessly worded phrase. I did not mean 'different' than a pepper, but a pepper *plus*, — seeing it more definitely than does the casual observer, presenting it so that the importance of form and texture is intensified."

In defending *Shell and Rock—Arrangement*, Weston had wanted to distance himself from the likes of Mortensen. Now he wanted to distinguish his approach from mere recording; his purpose was not documentary but revelatory: "No—I don't want just seeing—but a presentation of the significance of facts, so that they are transformed from things (factually) *seen*, to things *known*: a revelation, so presented—wisdom controlling the means, the camera—that the spectator participates in the revelation."[91] Weston was redefining himself somewhat as he moved away from the factual toward the transcendent. It might seem as if he was moving away from Charlot (and from Atget), but on another level, whether he realized it or not, he was actually edging closer to Charlot's general way of thinking. Although trying to articulate his differences with Charlot as well as with Adams, ultimately his last line of defense is distinctly spiritual—and in that respect he is not all that far from the more explicitly religious views of his friend Charlot, for whom direct seeing was akin to worship.

Zohmah, meanwhile, had arrived back in New York from Los Angeles, where she had been since leaving Mexico. Jean met her at the station, and she stayed at the Allerton, then a residence for women, a few blocks from Charlot's studio. In the ensuing months she and Jean were often together. Jean was teaching at

the Art Students League that fall, but he spent much of his spare time going to galleries and museums with Zohmah. On one occasion Jean introduced her to William Ivins Jr., the curator of prints at the Metropolitan Museum; on another occasion they went together to the private opening of a Matisse exhibition at the Museum of Modern Art, which they both liked immensely.[92] Zohmah found Jean to be an excellent guide; she was greatly impressed with her companion's apparently boundless knowledge of art and artists.[93]

During this period Zohmah busied herself with cataloguing Jean's pictures, presaging some of her activities in later years.[94] She also took it upon herself to promote Eisenstein's work; she went to the John Becker Galleries, where Charlot had had an exhibition the previous spring, and suggested that they should have a show of Eisenstein drawings. Much to her surprise, they were interested and asked her to arrange it.[95] Nothing more about Zohmah's participation is recorded, but the following October, about eight months after Zohmah had left New York, such a show did indeed take place at John Becker's gallery.[96] It is possible that in Zohmah's absence, Jean, who had likewise been impressed with Eisenstein's drawings, helped bring to fruition what she had set in motion—an unintended consequence of their visits to the hacienda at Tetlapayac.

Although there were obviously many distractions, during that fall and on into the winter Jean did more paintings of Zohmah: he painted her asleep, in profile, turning to the left and to the right.[97] Even when they were not actually together, he was concentrating on her image. Jean's relationship with Zohmah seemed to be deepening, but the exact nature of their relationship remained unclear—at least to Zohmah. As the winter wore on, she became troubled by the situation and apparently sought some sort of clarification. Despite whatever romantic feelings there may have been between them, they decided to treat each other more as friends than lovers, as Zohmah explained to Prudence (or Prue, as she was sometimes called): "My problems are settled for the present. I am busy, and Jean and I have decided to be each others favorite uncle. It works very well."[98] Shortly afterward Zohmah left New York, after having been there about four months, and returned to California; it would be more than a year before Jean would see her again.

Three days after Zohmah left New York, Weston's second one-man show at the Delphic Studios opened; at the time he considered it his best ever. With a small number of exceptions, it included only recent work, made since his

previous New York exhibition in 1930. There were images of cabbage leaves and fragments, toadstools and squash, along with numerous photographs of cypress trees and rocks in and around Point Lobos. In addition, he included *Shell and Rock—Arrangement*, which he had made the previous October and probably had not exhibited before.[99] Despite his initial defensiveness, in his statement for the New York show he said nothing about the image—although he began by emphasizing the importance of thinking irrationally, of avoiding the straightjacket of rules and theories. He may have been thinking about *Shell and Rock* in saying this; he may have had Charlot in mind, or even Adams, but he was careful not to be specific, and he did not write about the implications of his arrangement.

Further on in his statement, taking a rather different tack, he reiterated some of what he had written—in his response to Adams's review, for example—about the revelatory nature of the art of photography: "Fortunately, it is difficult to see too personally with the very impersonal lens-eye: through it one is prone to approach nature with desire to learn from, rather than impose upon, so that a photograph, done in this spirit, is not an interpretation, a biased opinion of what nature should be, but a revelation,—an absolute, impersonal recognition of the significance of the facts."[100] Neither Adams nor Charlot would have disagreed with him on that.

The following month, while his New York show was still running, Weston's friend Christel Gang showed him a copy of the left-wing journal *Experimental Cinema*, which included a selection of stills from *Qué viva México!*[101] At this point Weston seemed unaware of Charlot's contacts with Eisenstein (and he did not yet know of Zohmah), but Gang too had come to know Eisenstein quite well, before he left Hollywood for Mexico, and during that time she had shown him some of Edward's photographs. Eisenstein had been favorably impressed, and Christel had told him he could keep whichever one of the prints he liked most. As it turned out, he selected a relatively abstract image of a back—an image for which Christel herself had been the model.[102] Gang may also have helped to arrange for Brett Weston to take Eisensten's portrait during the same period; it was published in an earlier issue of *Experimental Cinema*, which featured Eisenstein's essay "The Cinematographic Principle and Japanese Culture."[103]

Since the new stills involved Mexico, Weston obviously had a special interest, and given Eisenstein's reputation, he must have been expecting a good

deal; but what he saw did not live up to his expectations. Weston was not as impressed with Eisenstein's imagery as Eisenstein had been with his. He took Eisenstein to task on technical as well as aesthetic grounds:

> Of course one cannot judge the film from a few stills, nor even the stills as a whole from several selections, but I was disappointed. The full page reproductions are very bad technically, with no excuse for bad focus when they could have been stopped down. I can forgive much when movement must be stopped, but these figures were obviously placed and static. Also they were picturesque to a degree,—a fault which permeated my first work there.

Despite his misgivings, or perhaps because of them, Eisenstein's images prompted Weston to reflect more directly on his own Mexican work. His earlier pictures now seemed to him to be too picturesque, like Eisenstein's stills, and in the end he felt he could have done better: "I admit my failure in Mexico,—not complete, I have some strong records,—but as a whole I now realize how much more profoundly I could have seen."[104]

In the photographs from his Mexican years, Weston had increasingly distanced himself from pictorialism; in that respect, the work of that period represented an important milestone for him (and Charlot would later underscore that fact). But looking back from the vantage point of the early 1930s—after he had already made some of his best-known modernist images of rocks, tree roots, and vegetables, and after having switched from platinum/palladium to gelatin silver paper, from matte finish to glossy—his work in Mexico, or at least some of it, seemed to Weston somewhat old-fashioned, too picturesque, and more about Mexican scenery than rigorous vision. As far as he was concerned, he had since gone beyond it, and beyond Eisenstein. That did not prevent him, however, from wanting to see more of Eisenstein's Mexican work and wanting to see the film itself.[105]

By the time Weston was musing over the stills in *Experimental Cinema*, Eisenstein's Mexican project had started to unravel. After his backer, the author Upton Sinclair, had withdrawn his support, Eisenstein's efforts to complete the filming of *Qué viva México!* had failed, and the director was heading home to the Soviet Union under a cloud. On his way he stopped off in New York, and in mid-April Charlot visited him in his hotel room at the Barbizon Plaza. During the visit Charlot made a drawing of him from life, which he later made

into a painting. The portrait shows Eisenstein very close-up, in profile, with a tiny piercing eye, pursed lips, and rather heavy five-o'clock shadow, wearing a checked sweater or scarf; his reddish hair extends upward on a diagonal, in an almost flame-like and mildly comical way (fig. 54). Charlot portrayed the Russian director as a somewhat disillusioned yet still fiery visionary.[106]

Eisenstein left New York soon after, on April 19; he was still hoping to receive the Mexican footage after he returned to the USSR and was confident that he would be able to make something worthwhile out of it, even though he had not done all the filming he would have liked. Unfortunately, after he arrived back in Moscow in early May he learned that Sinclair had decided to hold on to what there was of the film. Sinclair arranged for it to be cut in Hollywood and made into something profitable, without Eisenstein's further participation.[107] The director was understandably devastated. Tina Modotti came to visit him, along with Pablo O'Higgins, who was living in Moscow at the time on a one-year fellowship at the Moscow Art Academy. They found him in an almost suicidal state.[108] It would take several years for him to rebound from this disappointing experience, but he would eventually go on to make the films *Alexander Nevsky* and *Ivan the Terrible*. In subsequent years other films would be made from the remaining footage.[109]

Back in Carmel, Weston was debating with himself about art and revolution, a topic on the mind of many of his friends and acquaintances; although not known for being politically engaged, Weston devoted considerable thought to such matters. In his daybooks from the spring and summer of 1932, he comes back to these issues a number of times, as if groping for some sort of solution, trying to clarify his own position, or trying to work out an honest response. What, he asks himself, will be the fate of capitalism, and is communism the ultimate solution? These questions were hotly debated at the time, at least in certain circles, and Weston was trying to come to terms with them.

Weston admitted that he found some of the arguments for communism rather appealing, but in the end he remained skeptical and resistant:

> Despite the splendid arguments in its favor, many of which I can agree to, indeed have always held to, — equal opportunity for all, not admitting that all are born free and equal, — the destruction of money value, doing away with the *need* for making money, — the shortening of necessary working hours by collectively owned machines, leaving time for the individual

to develop himself: despite these undeniably fine ideals, which would benefit the capitalist even more than the proletarian, turning his exceptional capacities into finer channels than those of grubbing or grafting for money,—yet I draw back instinctively from communism, at least as I have seen it in the making.

His resistance stemmed largely from his distrust of the masses and of popular rule—which threatened individual liberty and led to the vulgarization of society. Such tendencies were already present to a dangerous degree in democracies but would become truly oppressive in more fully collective societies: "I realize that I have been so conditioned by my fight as an individual in a back-slapping, mob-spirited, intolerant, self-righteous, familiar, evangelistic, regulating, levelling 'democracy,'—that the very thought of collectivism, community ownership, of *one another* actually sickens me, literally."[110]

There is a note of elitism in Weston's position. As far as he was concerned, people were not all created equal, and only a select group of individuals, endowed with true discernment, rise above mass hysteria or bourgeois pretension. The vulgarization of contemporary society that Weston so abhorred was not so much a function of capitalism itself—although that was undoubtedly a factor—as the inevitable result of human nature left unchecked. Indeed, human nature being essentially flawed, Weston was skeptical about the possibility that communism would bring about a significant change for the better or ameliorate the human condition.

Of primary concern to Weston, of course, was the role of art and of the artist, and he categorically rejected the argument of those who felt that art had to be overtly political, evangelistic, or propagandistic, that moralistic considerations took precedence over aesthetic responses, and that art should be subservient to radical or revolutionary ideologies. In such thinking there was little room for the sort of imagery Weston was making; pictures of rocks and vegetables could not be a meaningful part of any revolutionary struggle. As his presumed interlocutors might say, "What has kelp got to do with the revolution?"[111]

In the end, Weston responded by invoking Trotsky:

What I am now, where I stand, in this epochal time, fast-changing world, I frankly don't know. I certainly am not for the capitalist, nor the sovereign mass. The communists I know are "mouthing Puritans." I do know where I stand re my work, though the "radicals" (political) don't think so. Funny,

I have always been considered a radical by academic artists, but the communists probably would damn me as "bourgeois liberal,"—because I do not portray the worker's cause.

Despite all criticism my work is functioning. I receive continued and growing response from sensitive persons from all walks of life—yes, I do know my work has revolutionary significance, despite its lack of literary connotations. Peter Steffens said that Trotsky believes that new and revolutionary art forms may be of more value in awakening a people, or disturbing their complacency, or challenging old ideals with constructive prophecy of a coming change. I am not quoting him, rather using my own ideas to explain his thought as given to me.[112]

Although his goals were not identical to Trotsky's, he liked the idea that art had the capacity to shake loose tired ways of thought without necessarily addressing social issues directly or literally. Art can bring about change on its own terms, simply by looking at the world afresh, by upsetting complacency and overturning accepted ways of seeing. He remained an advocate of modernism, even of art and beauty for its own sake, but at the same time he defended his role as an agent of change; he upheld the radical nature of his imagery while keeping revolution at arm's length. In this context even a photograph of kelp, if it is well seen, can be considered a political act, revelatory and radical. Weston may have rejected the moralistic posture of some left-wing ideologues, and he seems to have disdained ideology itself, yet he could not break from politics altogether. Weston's continuing preference for apolitical subject matter opened him up to the charge of being unconcerned or irrelevant, but that is not really the case. He espoused an individualistic ideology of his own, a relatively comfortable, aesthetic sort of radicalism.

In the summer of 1932 Charlot turned his attention to, among other things, nudes; in June and July he produced a small group of them, quite different from his earlier ones.[113] Earlier in the year he had done a number of remarkably sensual nudes, painted with a new looseness of handling and in brighter, harsher colors than before.[114] The new works, perhaps based on nude studies of Zohmah, made earlier, are more unsettling—strongly foreshortened and angular and challenging tradition more aggressively than ever. As before, they are loosely painted, but they are now muddier and earthier in tone, emphasizing grays and browns. One of the new paintings includes the hand

of the painter holding a brush and the corner of the canvas on which he is working, which adds a self-reflexive note not often found in Charlot's paintings. It anticipates the self-reflexive ink drawings of the artist and model that Matisse would do later on in the same decade (starting in 1935).[115] Shortly afterward, in a letter to Weston, Charlot spoke of his recent work, briefly and with tongue in cheek: "Wish you could see my last work. I am tackling the 'american scene' in a series of nudes—Think you would like them."[116] What Charlot had in mind when he referred to the American scene is not clear; perhaps he was referring to his models or perhaps to Kirstein's discussion of his recent portraits; but he was no doubt thinking of Weston as well. There is no direct resemblance to any of Edward's recent photographs, but perhaps Jean assumed that his friend would respond to their intensity.

Charlot had not exhibited a great deal of work since returning from Mexico the previous year, but his career got something of a boost when a small volume of his work, titled *Jean Charlot*, was published in France; it was part of a series on recent artists under the rubric Peintres Nouveaux that included books on Picasso, Matisse, Chagall, Rouault, and many more.[117] The Charlot volume featured a selection of his drawings and paintings from 1924 to 1931. The most recent nudes were not among them, but there was one portrait of Zohmah, painted the previous year, along with some of his fresco work, the *Petites Malinches*, the *Grandes Malinches*, and numerous others. The introduction by Charlot's friend Paul Claudel was taken from the John Levy exhibition catalogue. There was also an essay by Charlot himself, written almost a decade earlier, and a brief statement by Anita Brenner, extracted from what she had written for Charlot's exhibition at the Art Students League a few years before.

The book was a handy introduction to Charlot's art, and although the small black-and-white reproductions did not do justice to his achievements, the volume was nonetheless a feather in his cap. Charlot had often felt very much at odds with the latest trends in Paris, so he must have gotten some satisfaction from the publication of this collection in France, bringing his work to a wider audience and even, in a sense, bringing it back home. Like Weston's, his career seemed to be advancing, the Depression notwithstanding, and in the coming years Jean and Edward, working on opposite sides of the country, would both progress further despite the difficult times. Indeed, Edward would soon have an important book of his own, in which Jean played a small but not insignificant role.

5

VISITING CARMEL

In early July 1932 Merle Armitage approached Weston with the idea of doing a book of photographs; it was to be the first of many books devoted solely to Weston's imagery.[1] Almost immediately the photographer wrote to Charlot in New York and asked him if he would supply one of the introductory texts. Charlot readily agreed and then inquired, "I would like to know which photographs are included in the book."[2] Weston's immediate response is not known, but making the final selection proved to be a difficult task, one that took a considerable amount of time. Weston described the process in his daybooks: "Weeks passed, with prints under consideration strewn all over my room. The first dozen or so were easy to select, work that *had* to be included, prints that were epochal in my life. But after these, came the struggle to eliminate from amongst a hundred or more possibilities. To confine myself to the limit of thirty reproductions, lay aside dozens that I wanted to use, was a task which made me question my own decisive ability. Merle raised the number to thirty-six; but even then I wavered between my desires. Probably I will always regret certain omissions."[3]

Weston also struggled with his own written statement, which he reworked many times. Finally satisfied, he mailed it off in late October only to find that it had to be revised once more, at the very last minute, because it was a little too long; Charlot's contribution had been completed in early August. In early November the book went to press, and about a month later it was out, roughly five months after the project was initiated.[4] In the end there were

thirty-nine photographs by Weston, including some of the same pictures he had exhibited at the Delphic Studios in previous years; the vast majority of them, however, were relatively recent. The close-up images of vegetables were well represented, as were the eroded rock pictures. So too there were numerous portraits, and although a few of them were from Weston's Mexico days, most had been done within the last few years—including a double portrait of Diego Rivera and Frida Kahlo taken in San Francisco at the end of 1930 and *Shell and Rock—Arrangement* from 1931 (fig. 25). There were no photographs of Tina Modotti.[5]

In addition to Weston's text and Charlot's, there were essays by Armitage himself and Arthur Millier, the critic for the *Los Angeles Times*, and brief comments by Lincoln Steffens and Charles Sheeler. Some of them are more revealing than others, but Charlot's statement ("An Estimate and a Tribute to Weston from a Painter") stands out as one of the most valuable; although quite brief, it provides important insights into Weston's fundamental thinking and sheds considerable light on his development up to that point. Indeed, Charlot's concise analysis set the stage for many of the discussions to follow, including Weston's.

Charlot began by describing the familiar story of how Weston turned away from the "flou" effects of pictorialism toward a more straightforward approach. According to Charlot, the process was a gradual one that proceeded in stages; even as Weston moved away from the artificiality—"the subjective addenda"—of his early days, he at first continued to rely on questionable devices, like unusual angles, that call attention to the photographer and interfere with direct vision. Before long, however, even this sort of affectation was discarded, and Weston approached his subjects more directly; the presence of the photographer became less and less apparent: "it is evident that the increased effacement of the man behind his work has resulted in a deepening and a heightening of its aesthetic contents."[6]

For Charlot this process of self-effacement was crucial, for not only did it allow Weston to concentrate more fully on nature itself, devoid of artistic distractions, it also made it possible to go even further, to penetrate outward appearances and enter a more fundamental, spiritual realm. An increasingly straightforward representation of the natural world became a pathway to something higher or deeper—not just the expression of a passing mood but the revelation of some essential quality, previously unseen: "The very fact of the visibility of the outer world is proof that it has laws, rhythms and phrases

to which, both being attuned to the same diapason, the laws, rhythms and phrases of our spiritual world do answer. To describe physical biological phenomena, erosion, growth, etc., is to refer by image to similar happenings in our mental self. Thus is description apt to move us deeply."[7] In Charlot's view, there is no contradiction between the inner and the outer, as some might suppose, and no hierarchical relationship; rather, these two worlds answer one another, or coincide, which is why, in the ultimate analysis, visual imagery resonates with the beholder.

Weston, for his part, expressed comparable views in his written statement for the book, entitled "A Contemporary Means to Creative Expression," which he completed after he had seen and corrected Charlot's contribution. Not only did he too make a connection between objective depiction and the inner realm, as might be expected, but he spoke of photography as a kind of revelation, by which he meant "a fusion of an inner and outer reality, derived from the wholeness of life — sublimating things seen into things known."[8] The terminology is a little different from Charlot's, but the underlying thinking is much the same.

The book was well received — in his daybooks, Weston spoke of a good reaction — but there was also some criticism. Ansel Adams, for one, writing in *Creative Art*, gave it a rather mixed review. He admired the photographs themselves, but he was critical of some of the essays; although he did not single out any one in particular, he regarded some of them — and he was probably not thinking of Charlot's — as superficial. Moreover, Adams was unhappy with the design, which in his view did not show off the photographs to the best advantage. As he said, "Mr. Armitage's gesture of self-conscious altruism might have been convincing, had he permitted the photographs to speak for themselves. I sincerely advise all who are interested in the art of photography to get this book; the magnificent work of Edward Weston triumphs over the manner of its presentation."[9] Although Adams and Weston were good friends, Weston took exception to these remarks and came to Armitage's defense: "You certainly eulogized my work, if you did 'pan' Merle. I can understand, enjoy, believe in controversy — if it is creative argument. But when you label Merle with 'self conscious altruism' I take exception. For years others talked of a E. W. Book; Merle acted! And by the way, I have had dozens of letters congratulating me on the fine presentation of my work — and from important critics and artists."[10]

Perhaps the most vociferous criticism came from Ramiel McGehee, who had done some editing work on the book, and his partner, Bob Sanborn. They objected to the inclusion of *Shell and Rock—Arrangement*. Weston's manipulation of the natural scene distressed them, and they felt that Weston had been pressured into including it in the book against his better judgment.[11] Weston responded in a letter to McGehee, saying that the decision to add *Shell and Rock* to the book—which he did not expect to regret—was his own and that his friends' objections to the picture made little sense. For him, there was scant difference between his more familiar still lifes of shells or peppers, to which few objected, and this one, which was more controversial. The only distinction Weston could see was that, while the others were made indoors, *Shell and Rock* was made outdoors; in both cases, there was a good deal of manipulation.[12]

If Charlot had the same reservations, he refrained from saying so at this point; moreover, he approved of the book in general and the presentation in particular. After he received a copy from Weston he wrote back to say, "That was a beautiful book and thanks for sending it. The make-up is perfect and your dedication [inscription] really did get me."[13] Unlike Adams, Charlot was happy with the layout, or the "make-up," as he termed it; indeed, Charlot may have been one of the artists Weston had in mind when he spoke of the dozens of congratulatory letters he had received, and Charlot was evidently pleased, even moved, by the inscription that Weston had added. Unfortunately, the present whereabouts of Charlot's personal copy of the book are unknown, so we cannot know what Weston wrote in his inscription, but it must have been more than perfunctory to have elicited such a pronounced response.[14]

In the same letter, Charlot spoke of how he was thinking of heading for California and hoping to get a teaching job at the Chouinard School of Art, an art school in Los Angeles run by a woman named Nelbert Chouinard, where Siqueiros had been teaching fresco painting.[15] Charlot also announced his intention of paying Weston a visit: "Am eager to know this mythical Carmel. And it would be nice to be together anew. An abrazo de Jean."[16] About two months later, in April 1933, he wrote Weston to say that he would be heading for California in June. He had been unable to get a job at the Chouinard School but he was coming anyway, and he asked if perhaps Edward might be able to help him get some other work—teaching or painting murals—to cover his expenses. And then he added, "It will be nice to see you after such

long separation."[17] About two months after that Jean wrote once more: "I arrived Wednesday in L.A.—still a little dazed with everything. I thought Carmel was pretty near L.A. like xochimilco is to Mexico but found out it was much further indeed. Please tell me what would be a good time to go and I would make arrangements to stay about a week. I brought with me about 15 very small oils (6x8) that we could show in your Carmel gallery if you think it a good idea. I improvised a little show in Chicago, passing through and we could do the same in Carmel."[18]

The Chicago show to which Charlot referred was at the Increase Robinson Galleries; it included pictures on Mexican themes, such as *Mother and Child Standing with Toy* and *Two Bathers (Idols)*, which had been painted in May.[19] Apparently the photographer was able to oblige his friend, for it was arranged that Charlot would exhibit his paintings at the Denny-Watrous Gallery in Carmel later that summer.[20] Charlot also asked for Weston's assistance in a different matter: "there is somewhere in Carmel a lady with a Siqueiros picture (portrait of Zohmah Day) that she either bought or accepted in payment of some debt from Siqueiros—why would be a long story but I want that picture very much to return it to the model—If you know where it is tell the owner that I would exchange it for anyone of my pictures that she would like or even paint one specially for her, big or small, as she wants."[21]

Although Jean had met Zohmah several years before in Mexico and had spent a good deal of time with her since then, this may well have been the first time that he mentioned her name to Weston, even in passing. In his letter Jean gave no indication of who Zohmah was or what she meant to him; for that matter, he said nothing of the fact that she was one of the chief reasons for his trip to California, although Weston may nevertheless have sensed that there was something behind Charlot's eagerness to locate this particular portrait. If so he did not let on; it would be several months before he would learn anything more.

The portrait in question had been painted the previous year, in 1932, when Siqueiros was in Los Angeles teaching at the Chouinard School and working on a mural (*América tropical*). Zohmah's portrait was exhibited at the Stendahl Ambassador Galleries and afterward acquired by Bertha Hartmann de Lecuona. As Jean understood it, Mrs. de Lecuona either bought the painting from Siquieros or accepted it as payment for some debt, despite the fact that Zohmah had expected to buy it herself. Obviously there had been some sort of misunderstanding that Jean was hoping to resolve with

Edward's assistance. Unfortunately, in this instance Edward was unable to help, or at least Jean failed to retrieve the portrait; it is still in the possession of the family of the original owner, and it was shown in a recent exhibition of Siqueiros paintings.[22]

Charlot seems to have spent most of July in Los Angeles, where he met Merle Armitage, who in turn introduced him to Lynton Kistler, the printer who had done the Weston monograph the year before and with whom Charlot would collaborate on many projects in the coming years.[23] Toward the end of the month Jean wrote Edward again to say that he was on his way to Carmel. He was planning to spend the night in San Luis Obispo and start for Carmel the next morning. His arrival was timed to coincide with his exhibition at the Denny-Watrous Gallery, as he was slated to give a talk on contemporary Mexican art at the opening. Charlot also informed Weston—presumably for the first time—that he was bringing someone along: "I bring, though a 'woman hater,' a little girl from Los Angeles and you must find her a room somewhere—you'll like her, I do."[24] Although he did not give her name, Charlot was, of course, speaking of Zohmah, and this time he was more open about his attachment. He did not go into details and he made no mention of the portrait, but he did at least acknowledge a connection of some sort, which is more than he had done before.

In the same letter, Charlot added a postscript in which he indicated that he had just finished a portrait of Henrietta Shore. He had painted her portrait in May 1929, and now he was transposing his initial conception into a lithograph (fig. 55). It was intended for an upcoming book devoted to Shore's work that Armitage was planning for later that same year, following up his success with the book of Weston photographs. Charlot later recalled, "I was asked to do it by Armitage—kind of a last minute job. She really looked like that. She didn't like it much. I met her first when she went to Mexico. She had asked permission to do my portrait and that of Orozco—so I reciprocated. I did an article on her. She was a very good painter."[25] Jean asked Edward not to say anything to Henry about the portrait for fear that she would not like it, and his reservations were not unfounded; the portrait was not exactly flattering, and as it turned out, she was not very pleased with it. Nevertheless, it was included in the book as planned; later Henry politely inscribed Jean's copy and spoke of the integrity of his work.

Edward too was involved in this project. He had first of all been called

upon to photograph the artwork for the book, and he was also supplying one of the introductory texts, a task he had long contemplated and now looked upon with some trepidation. As he said, "Merle is to publish a book on Shore, which means I do all the copying of her work, for Henry is penniless, and would have none other anyway; besides I have been asked to write the forward, an even greater task, though a labor of love; I can only hope that this is to be my swan song as an art critic!"[26]

Weston's remarks on Shore are rarely mentioned; indeed, Shore's importance is generally overlooked, but some of what Weston had to say about her is of considerable interest. After speaking of his first encounter with Shore's work, soon after his return from Mexico, which immediately amazed and moved him, he went on to discuss her most recent efforts: "Emerging from the 'Semi-Abstractions', Shore has become identified more closely with nature, but nature freed from the non-essentials which diffuse an artist's early work. Retaining the free, sweeping rhythms, the grandly contrasted volumes achieved in her 'abstract' painting, Shore now realizes a fusion of her own ego with a deep universality. Approaching nature with reverence, using tools with knowledge and command, her work compels attention."[27]

Once again we hear of the sort of stripping away that Charlot had cited when characterizing Weston's development in *The Art of Edward Weston*, and here too there is discussion of how, once that stripping away has been achieved, the direct representation of nature provides access to something deeper and more universal. Indeed, much of what Weston wrote here could easily apply to his own work or derive from things that had been said about it. Interestingly enough, Charlot later wrote his own essay about Shore for the literary magazine *Hound and Horn*; in it he spoke of her "desire for self-effacement," echoing Weston's remarks about Shore and, more specifically, his own earlier observations about Weston.[28]

Jean and Zohmah arrived in Carmel on Saturday, August 5, 1933, and came upon a very lively scene. Zohmah described things as follows:

> We found the house full of people, including three tall sons. Jean and I were immediately made part of the gathering. A girl named Sonia was preparing dinner and was expertly rolling a freshly baked cake into a jelly role. As the evening progressed, Edward read aloud from *Look Homeward Angel*. There was talk of Edward's new series of still-life arrangements of

vegetables. I was surprised that sex seemed to intertwine with all other subjects; even photography got mixed up with the information that photographers could meet under their black capes. . . . Someone brought the food, light and delicious, with salads, artichokes and boiled carrots. We ate the masterpiece Pepper. Edward's subject matter often ended up on the supper menu.[29]

Actually, the well-known pepper pictures had been taken three years earlier; the peppers she saw may have been linked to their famous forbears, but they were not the same ones.

The girl named Sonia to whom Zohmah referred was of course Sonya Noskowiak; she and Edward had been together for several years. They all seemed to hit it off, although it would seem that Zohmah was mildly shocked by some of what was said, and they all passed a pleasant evening together. As Zohmah recalled, the days that followed were equally enjoyable, even idyllic: "we went out on Point Lobos: walking on the beach and hiking over rocks and through woods. While Edward took pictures and Jean drew in his sketchbook, I took sun baths, watched the big breakers, looked for sea urchins, wandered among cypresses, poked into termite-eaten logs and fed squirrels."[30]

In his diaries from that period, Jean supplied more details. There were drives along the coast, afternoons at the beach, and evenings with Lincoln Steffens or with Robinson and Uno Jeffers. The visitors spent a good deal of time with Henrietta Shore, and they looked at many pictures. One night there was a dance, and on another occasion they sang Mexican songs. Jean also seems to have done a good deal of work while he was in Carmel, on prints and on drawings, including landscapes, some of it in the studio and some of it, as Zohmah had indicated, outdoors.[31]

One of the drawings Charlot made during this time was of Monterey cypresses, which he later made into a print (fig. 26). A few years later he incorporated the same landscape motif into the background of an oil (*The Sacrifice of Isaac*). On August 17, 1933, he noted in his diaries: "Point Lobos. Good drawing of Cypress," and long afterward, he recalled, "I made drawings there from nature. I like my landscapes."[32] The drawing is indeed a striking one. The tree arcs across the top of the page, almost like a bird of prey or a pterodactyl, while the roots spread out beneath like veins or even lightning, and the image as a whole crackles with energy. Charlot did not devote a great deal of attention to landscape during his career, and his interest in cypresses

at this point no doubt reflected Weston's influence in a general sense—or even his contact with Henrietta Shore; the concern with the landscape at Point Lobos, with the trees and rocks, must have been infectious, but his image of a cypress bears only superficial resemblance to what Weston and Shore were doing with the same material.[33]

Charlot also made a drawing, first in pencil and then in ink, of Weston in his studio, which shows the lofty space, a spartan but pleasant setting with a number of light fixtures hanging down from the ceiling beams (fig. 27). Down below there is a simple bed and a stove with a teapot on it, and to the right of the stove is a toilet. On the wall we see three pictures—just dark rectangles—and farther to the right is a tall desk with a figure seated at it; although we see him only from behind, this no doubt represents Weston, busy writing letters or perhaps spotting prints. He almost blends into the desk and seems lost in the spacious surroundings.[34]

One day after Jean and Zohmah had been in Carmel for close to two weeks, they accompanied Edward and Sonya on an outing to Point Lobos; Henrietta Shore went along with them. At some point it seems that Henry ventured too far afield and could not get back up the cliff. She cried out for help and Jean went to her rescue; in the process he had a near-fatal mishap. The incident was later reported in the local newspaper:

> Jean Charlot, visiting Mexican painter, norrowly [sic] escaped death at Point Lobos one day last week when a rock gave way with him on the side of a steep cliff. He fell some distance down the side followed by a shower or [sic] rocks but fortunately escaped with minor cuts and bruises.
>
> Charlot was going to the help of Henrietta Shore, local artist, who had been lost for some hours and was unable to get back up the cliff to join the rest of the party which included Zoma [sic] Day and Sonya Noskowiak and Edward Weston. Miss Day brought help from the gate who helped Miss Shore and Charlot to safety.
>
> The party went to Point Lobos to work; Miss Noskowiak and Mr. Weston with cameras and Miss Shore and Mr. Charlot to sketch.[35]

Although the newspaper account did not mention it, Jean not only sustained minor injuries but also broke his eyeglasses—one of the sidepieces came off and could not be reattached. Sometime afterward Weston made portraits of him wearing the damaged glasses as if nothing had happened,

including one that was later used as an illustration for an article on portraiture in *Camera Craft* (fig. 28).[36] It shows Jean, with his hand on his chin, looking toward the right, apparently unconcerned about the precarious position of his glasses. At first glance we do not notice anything unusual, but after looking for a few moments we realize that something is missing, and once we do the picture becomes oddly comical, even surreal, despite the contemplative pose and mood.

Edward had not photographed Jean for many years—not since Mexico—and his approach was now quite different. As we have seen, in many of the early pictures Jean was shown at three-quarter length, leaning nonchalantly against a wall. Now we come in a good deal closer, and as in many of Weston's portraits from the early thirties, the design is simpler and tighter. At the same time, in the new sets of portraits Jean appears less jaunty, less the romantic dreamer, and more complicated and concerned.[37]

Edward also took several portraits of Zohmah that August, one of which (fig. 29) was later used in the same issue of *Camera Craft* that included the portrait of Jean. In this case we see Zohmah leaning on the arm of a chair, inclined toward the right and turning back toward the camera. The curved back of the chair, which is echoed in the line of her shoulder and the top of her head, adds considerable movement; Zohmah comes across as open and friendly.[38] Soon afterward Zohmah wrote, "At times it is fun having a goofy face, for Edward, for instance, likes mine and is taking lots of pictures of it. I'm slightly uneasy having seen his other portraits."[39] It is true that some of Weston's earlier portraits are severe and unflattering, but that is not the case here.

Perhaps the best known of the many portraits taken during this visit is the double portrait in which we see Zohmah nestling against Jean, who seems lost in thought (fig. 30); Zohmah's face cannot be seen at all, so we can only imagine her thoughts and emotions.[40] The photographer and critic Robert Adams singled this image out for special praise, calling attention to its warmth and eroticism.[41] Indeed, the result is romantic and tender; the two lovers are locked together—visually and emotionally—yet Jean's expression hints at complex feelings, even doubts, that go beyond tenderness in the ordinary sense, and it is tempting, therefore, to see in this image some foreshadowing of the difficulties, the separations and disappointments, the ups and downs that Jean and Zohmah would experience before they were finally married some six years later.[42]

Noskowiak also photographed Jean and Zohmah during their visit to Carmel, on several occasions, both together and separately. As might be expected, her approach was similar to Weston's in certain respects; she too favored very close-up views and bold designs, but the results are quite distinctive, and her portraits are likewise of considerable interest. She made, for example, a series of portraits of Jean at very close range, wearing a dark beret. Several of them are quite serious, but in one case the tone is more satirical: Jean wears two pairs of glasses—his broken ones and a pair of dark glasses—and stares at the camera with a slightly bemused expression; he looks more like a gangster or a gun runner than an artist or a friend (fig. 31). In a deadpan sort of way Sonya, and Jean, seem to be poking fun at stereotypical notions of the "artiste" that the beret might otherwise suggest. In a similarly humorous vein, Noskowiak showed Jean close-up and straight on, with a blank expression and a straw hat, in what appears almost to be a mug shot.[43] Since childhood, Charlot had enjoyed clowning for the camera, and Noskowiak seems to bring that out in these examples. Charlot's reaction to these portraits is not known, but Zohmah liked Sonya's work and found these pictures to be funny.[44]

Sonya's portraits of Zohmah, on the other hand, are more wistful; only rarely does Zohmah look directly at the camera, and she tends not to smile. One of the most striking shows her against a plain, light background, turning to the side (fig. 32). She is wearing a dark dress with a broad white collar that is nicely complemented by the curve of her hair and barrette. These forms impart a distinctly art deco flavor to the image. But despite the bold design the mood is oddly quiet, and the effect is quite different from what we find in Weston's photograph of Zohmah seated in a chair. In the Weston portrait Zohmah appears outgoing and engaging, but here she seems distracted and pensive, as indeed she does in many of Noskowiak's representations of her.[45]

In addition to his show at the Denny-Watrous Gallery, Charlot was also hoping to exhibit his work at the Ansel Adams Gallery in San Francisco. Adams had just leased space on Geary Street with the intention of establishing a showcase for contemporary art and photography, in the spirit of Stieglitz's gallery in New York, An American Place.[46] The first show, scheduled for the beginning of September, was to be devoted to Group f/64, a short-lived society of West Coast photographers dedicated to a purist aesthetic, including Adams himself, Noskowiak, and of course, Weston. The second show was Charlot's, which would follow in the latter part of the month and comprise

both paintings and lithographs. Before all this was settled, Weston also tried to arrange for Charlot to have yet another show in the Bay Area; with that in mind, he wrote to his friend Willard Van Dyke, another member of Group f/64, who had a small gallery in Oakland. Weston expressed the desire that Charlot and Van Dyke meet in the near future to see one another's work and suggested that perhaps Van Dyke would be interested in showing Charlot's paintings: "I want to have Charlot see your work, and you his exhibit. It would be a grand show for your 'gallery'; 6 x 8 oils. I have said nothing. Want you to meet first. But feel it could be arranged if you want it. Jean wants to show in S.F. probably first; that should not harm your showing."[47] Van Dyke seems not to have made it down to Carmel while Jean and Zohmah were there, but they would meet in Oakland a few weeks later, and Charlot would indeed have shows in San Francisco and Oakland, as Weston expected.

In the same letter Weston also spoke of his own upcoming show at the Increase Robinson Galleries in Chicago, where Charlot had shown not long before. Although Weston has credited his sister with making all the arrangements for the show, it is possible that Charlot laid the groundwork or set things in motion. In any case, Weston's exhibition was to comprise one hundred prints, and Weston wanted Charlot to choose them: "I am making Jean select it. Much fun, though I may change some of his selections." He gave a fuller account in his daybooks:

> With curiosity and desire to see which prints another would select for this show—such another as Jean—I handed him some 400 prints to choose from, holding a mental reservation that if he did not please me I would make my own changes. After several days the selecting was finished; several of my favorite prints had been left out, and many added which I would not have considered. Then I started in to make my corrections. Result, I left Jean's selections intact. I decided that it was as good an exhibition as one that I would have chosen and probably better balanced; my tendency being to overlook older work that I have wearied of. Jean gave me renewed interest in certain works I have neglected. But what a job his selections made me face; I had to reprint at least two-thirds of the total. In doing this I made the best set of prints of my life; so fine that many are like new work to me."[48]

After the selecting process was over, Zohmah reported to her friend Prue, everyone celebrated with ice cream and bananas. And Edward let Zohmah

choose any print she wanted: "I took a cactus, for it rhymed so well with my portrait."[49] It is not known which picture she selected, but it was the first of many she would acquire over the years. At the same time, Jean wrote a few words about Edward's photographs for the show announcement, following up on what he had written in 1932 in *The Art of Edward Weston* but speaking in somewhat different terms than before.

In this very short statement Charlot defends photography against those who might think less of it because it does not require the extended amount of time sometimes required of painting—especially the most realistic style. In doing so Charlot is careful to point out that the issue is not the amount of time that goes into the image but rather the spiritual passion, which can be expressed in a moment of heightened clarity, of exaltation, as is the case in Chinese brush painting. According to Charlot, the greatest masterpieces of Chinese painting were created very rapidly, with great fluidity, using only a broken reed or the like. In the same way, in Weston's photographs a moment of perception can express a great deal: "Under the stupendous concentration of the artist's mind, 1/35th of a second suffices to create the image that will perpetuate his spiritual passion."[50] In making this analogy Charlot takes for granted that technical mastery—in photography as in brush painting—is so complete that it does not interfere in any way in the creative process, which is instinctive and seemingly effortless. Weston himself had once spoken of how "technique must be as automatic as breathing."[51] Such attitudes were not at all uncommon at the time, but Charlot put them into a larger context.

Unfortunately, Weston was disappointed with the announcement and so was Charlot. As Weston wrote to Van Dyke, "My Chicago announcement didn't please me, nor Jean. Too many, trying to work 400 miles apart; and no time to see proof. Too bad—"[52] Presumably their unhappiness had to do with the design, not the content: Weston must have approved Charlot's comments, which after all were highly complimentary, and Charlot would use this material again on subsequent occasions.[53]

At the very end of August Charlot accompanied Weston on a brief trip to San Francisco in conjunction with the opening of Ansel Adams's new gallery. Chandler Weston did the driving, and Edward made photographs along the way. After traveling for four and a half hours, they arrived at Van Dyke's studio in Oakland, where Jean finally met Willard. That evening Jean and Edward had dinner with the architect Timothy Pflueger (whom Weston had

photographed three years before) at the Family Club in San Francisco before returning to their hotel.[54]

The next day, after visiting the Palace of the Legion of Honor, where he especially admired the work of Bronzino, Jean helped with the hanging of the Group f/64 show at Adams's gallery. Once the photographs were in place Jean and Edward accompanied Willard to Oakland, where they seem to have spent the night.[55] The following morning Charlot and Weston met again with Pflueger and went to the new stock exchange building (which Pflueger had designed), where they admired Diego Rivera's fresco; Charlot judged it to be "tres beau." After that they went to see Rivera's fresco at the California School of Fine Arts, in which Pflueger was depicted. That evening was the opening at Adams's gallery, and after that there was dinner at a fish place and a visit with noted art patron Alfred Bender.[56]

In anticipation of his upcoming exhibition at Adams's gallery, Charlot was interviewed by Jehanne Biétry Salinger for the West Coast French-language paper *Courrier du Pacifique*. In her article Salinger described an earlier encounter with Charlot—in New York in 1930 at the Delphic Studios—but after recounting Charlot's history at some length, including, of course, his association with the Mexican muralists, she went on to say, "C'est Edward Weston le photographe de génie dont l'influence va grandissant sur la Côte du Pacifique qui conduisit ver moi, ce vendredi dernier, pour une entrevue spéciale pour le 'Courrier du Pacificque', l'artiste Charlot." (It was Edward Weston, the photographer of genius whose influence on the West Coast is growing, who brought Charlot to me late Friday for a special interview for the *Courrier du Pacifique*.)[57] As we have seen, Salinger had long been an admirer of Weston's work, and she took this opportunity to praise him again. Around the same time, Weston provided Salinger with a portrait of Charlot, perhaps to be used as an illustration for her interview or for her subsequent reviews of Charlot's show, although in the end it was not actually used for either purpose.[58]

The day after the opening events took a somewhat unusual turn when Charlot witnessed breast-cancer surgery performed by none other than Dr. Leo Eloesser, who had attended the Group f/64 opening. Charlot had not seen the doctor since they met in Mexico in the summer of 1931, and the opening gave them the opportunity to become reacquainted. It was probably on that occasion that arrangements were made for Charlot to come to the hospital the following day. The name of the patient is not recorded, nor is it known what exactly Charlot intended to do during his visit, but the outcome was rather

unexpected: indeed, it seems that Charlot fainted during the operation. In a letter to Weston written shortly afterward, Van Dyke raised the question: "There is an amusing story around that Charlot fainted during the operation! Did he tell you?"[59]

The travelers all returned to Carmel later that same day; Wanda Van Dyke, one of Willard's sisters (who was staying in Carmel), drove them back. Two days later Jean and Zohmah returned to Los Angeles, having been gone for about a month.[60] Soon after Weston wrote about their time together in his daybooks: "The most important event of the summer was a visit from Jean Charlot who spent several weeks with us, bringing with him Zohmah Day, a strange little sprite of whom we became quite fond. As to Jean, I found that we were as close together, in friendship and work, as before, though seven years had separated us since Mexican days." He went on to speak of Charlot in very positive, complimentary terms:

> Jean is an artist who functions in work as easily as he breathes. He has none of the "artistic temperament" for he *is* an artist. He has clear, direct knowledge; intuition rather than reason. He has a subtle humor which comes through in his work and in most original and unexpected remarks. He has a quiet, strong reserve which made it possible for me to have him around at a time when almost any other person would have been quite impossible. Much as I wanted to see him, see more of him, most of the time I was too busy; we each had to go our way. There was never a demand, obvious or implied on his part.[61]

On September 16 Weston's exhibition opened in Chicago, and it was reportedly well received. Weston was of course gratified by the favorable response, but he was bemused by some of the specific reactions to the show, especially that of Chicago art critic C. J. (Clarence Joseph) Bulliet, who likened him to Man Ray—whose work Weston did not especially admire; he thought it too clever. Weston seemed especially bothered by the suggestion that his work was sentimental, more so than Man Ray's (which was more flinty). Although he vigorously denied that his work should be considered sentimental in any way, he attributed the response in part to Charlot's selection of prints: "Perhaps if I had selected Chicago show, more of the hard, stronger items would have been included. Jean's tendency was to select the more subtle work." He went on to say, "But just because a thing is subtle, or delicate, or 'poetical,' it need

not be sentimental. Is one to avoid nature when she elects to be unusual or even fantastic,—consider her sentimental?"[62]

Two days later Charlot's show opened at the Ansel Adams Gallery in San Francisco. Charlot was already back in Los Angeles at the time, having finally been given a class to teach at the Chouinard School.[63] Weston made no mention of the occasion in his daybooks, and he probably was not there either (although by this time the daybook entries had become rather sporadic). In any event Salinger, following up on her initial interview, gave Charlot's exhibition favorable reviews in both the *Examiner* and the *Courrier du Pacifique*. In the latter she cited Charlot's comments from the Chicago announcement about Chinese art and Weston's work, applying them to Charlot's own work: "C'est cette philosophie que l'artist a réalisé dans les peintures qu'il expose chez Ansel Adams." (It is this philosophy that the artist has realized in the paintings he is showing at the Ansel Adams Gallery.) Charlot's work looked very different from what Weston was doing during the same period—if anything, it recalled Weston's Mexican pictures more than his most recent efforts, such as the shells and peppers—but Salinger saw a similar sensibility at work. She went on to speak of "un réalisme qui depasse la réalité illusoire de ce qui se voit et l'expression d'une esthétique basée sur des valeurs spirituelles" (a realism that goes beyond the illusory reality of what one sees and the expression of an aesthetic based on spiritual values).[64] This too sounds much like the sort of things Charlot had just said about Weston.

Although well received, Charlot's show was not a financial success: sales were poor, which must not have been a surprise given the difficult economic climate in which it took place. Only two paintings and two lithographs sold. After deducting the cost of the announcement and the gallery commission, Adams sent Charlot a check for sixty dollars—not a large sum, although more significant by Depression-era standards than by current ones.[65] Dr. Eloesser bought one of the paintings in the exhibition; afterward Charlot made it into a Christmas card for him.[66] Of the remaining pictures, one was acquired by Merle Armitage, another ended up in the possession of Los Angeles art critic Arthur Millier, several went to Zohmah, and one to Sonya.[67] Some of these pictures were also shown at Willard Van Dyke's Oakland gallery after the San Francisco exhibition closed in October, as Weston had envisioned.[68]

Sometime in September Edward sent proofs of the Carmel portraits to Jean in Los Angeles; in the accompanying letter he wrote, "This is the first day

since you left, that I have had a breathing spell, in fact have had such a bad cold I could hardly breath! Here are the proofs. I like some of them very much—wish I had them ready for Chicago—You and Zohmah are to choose as many as you wish, and from group sittings too. Ones I especially like are marked, 'E',—which seems to be most of them." He went on to say, "It was so fine to renew our friendship, to have you here, and Zohmah too. I only wish that I had not been so preoccupied with exhibition, tourists, etc. I will try to be in Los Angeles in October. If impossible,—maybe you can come up here again before you leave. I hope so." And then he signed off: "Much love to you and Zohmah Daisy from Edward." Zohmah had already acquired the nickname that would be used a good deal in the coming years.[69]

It was Zohmah who wrote back; she had already started to write to Edward the day before to say what a good time she had had in Carmel, but she had been interrupted, and by the time she resumed the next day she had already seen Edward's letter and the proofs. As she wrote, "I'm sorry your cold was bad, and I'm glad you are so nice and make such marvelous pictures. Jean asked, when I was writing, to say which pictures he wanted, but then he forgot to say which ones he wanted. They are exceptionally good."[70]

Weston did not make it to Los Angeles that fall, but at the beginning of November he responded to Zohmah's letter:

Zohmah—daisy dear,

You no doubt think me "muy informal" because I have not answered your lovely letter, written months ago! No use my making excuses, going into detail; I will just say that I have been busier even than when you and Jean were here. Don't forget that, "he whom we call friend we treat with discourtesy",—find consolation in this!

I got off my tree-contest prints Monday. Tonight—I hang forty portraits at Denny-Watrous Gallery. Monday I must ship my exhibition of forty-five prints to Ansel Adams. And so it goes—

I have at last started printing some of your negatives,—yours and Jeans. You will have a first installment before many weeks. I am going to print from *all* the negatives that each of you liked,—eventually!

Well, I did not get to Los Angeles after all; and I really wanted to. Many things happened to prevent me. Besides the several shows to prepare, I had charge of Teddie [Chandler's three-year-old son] for awhile, while

Chan worked in S.F. Maybe it's lucky I didn't leave because I would have missed two important sittings.

Chan showed me the superb new litho that Jean sent him this morning. I felt—as I always do when seeing fine art—like doing new work for myself.

I hope that you and Jean can visit us again. I will not be so preoccupied next time. This letter is to greet Jean too, and carries much love to both of you[71]

After having helped Charlot get shows at the Denny-Watrous Gallery and at Adams's gallery in San Francisco, Weston was now getting his turn; as he indicated, the preparations for these exhibits had kept him very busy and made it difficult to work on anything else. But his response to the new lithograph that Charlot had sent to Chandler—an urge to do more work for himself—is noteworthy. It is not clear exactly which lithograph he had seen, but it probably was one of the images from the *Picture Book*, which Charlot had almost completed by that time. Intended as a compendium of Charlot's most important images and motifs—mostly Mexican subjects—up to that point, the *Picture Book* was a kind of *Liber Studiorium*, in the spirit of Turner, or of earlier medieval or Renaissance model books. It was to contain thirty-two lithographs by Charlot and inscriptions by Paul Claudel.[72]

The first installment of the promised prints soon arrived, and Charlot responded with a batch of lithographs, no doubt once again related to the *Picture Book* images, and they too were duly acknowledged. In December the *Picture Book* finally appeared, and Jean and Zohmah sent a complete copy of it to Edward and Sonya, along with a batch of special stationery for Sonya, for which Jean had created a little image of her under a black cloth, photographing (fig. 33).[73] Sonya, who confessed to being a poor letter writer, forced herself to respond with a long letter to Zohmah ("Dearest beloved Zohmah") acknowledging the prints—on her brand-new stationery:

The most delightful and desirable Christmas remembrance was your package of stationary. I cannot think of anything which has given me more pleasure than this. You are truly dear and sweet to think of me. I thank you and for Jean's part in creating the enchanting portrait of myself—a true likeness, indeed. Again a million gracias.

I had hoped that you and Jean could have been with us to celebrate the

Xmas holidays. We really could have had both of you to ourselves, and what fun we might have had. But you will come soon, won't you? Jean's book is completed and I am sure he needs a vacation. And Zohmah dear, aren't you proud of Jean?—his book is a marvel!—it is exquisite. Edward and I have looked through it many many times and always with increased pleasure and delight. What a joy this book exists.

Sonya went on to speak of some of their other activities:

We saw the Shan-Kar Dancers (a Xmas present from a friend) and enjoyed the performance tremendously. Shan-Kar was exquisite, almost too beautiful—though, strong. The other male dancer really thrilled me. The musical instruments I thought fascinating. Certainly made with more imagination than our own. Did you see them? The same day we saw the moving picture, "Thunder over Mexico." I was frankly disappointed—photographically and otherwise—mostly the otherwise. Too bad Eisenstein did not see the final result. If he is the artist I am led to believe he is, I do not think he would have been in sympathy and certainly horrified at the result shown and the butchering of his creation.[74]

The Shan-Kar (Shankar) dancers were an Indian troupe featuring Uday Shankar together with members of his family (including his younger brother Ravi); they were in the midst of an American tour organized by the impresario Sol Hurok following their success in Paris and Europe.[75]

Thunder over Mexico had been pieced together from the footage Eisenstein had shot in Mexico, but he had had no role in the editing of the film, as Sonya seemed to know. Edward's assessment of the film was similar to Sonya's; in a letter to Van Dyke he opined, "See 'Thunder Over Mexico', for the sake of discussion. I feel there has been to[o] much 'thunder' over it. I left 'let down.' Expected too much. May have been badly cut. But also the technique, not so hot. Double printing very bad, confusing,—in 'Cavalcade' it was better. There were a few superb shots, but that is not enough. The 'story' ordinary, in places melodramatic, almost on a par with some of our wildwest pictures." Like Sonya, he looked more favorably on the Shan-Kar Dancers, saying simply, "Shan Kar dancers worth seeing." Then, at the end of the letter, he added—referring to the *Picture Book*: "Charlot's book, superb."[76]

The ensuing months were unsettled ones for Weston and those around him. In January he began working for the Public Works of Art Project (PWAP) in

Southern California; Armitage had arranged it and was his boss. It was the first time in many years that he had worked on salary, and it came at an opportune moment. In the previous month he had had no portrait sittings at all. At first Weston remained in Carmel and had complete creative freedom: he took whatever pictures he wanted and made his own schedule. But then he had to make several trips to Los Angeles, where he was employed in photographing works of art.

The first trip must have been in mid-February, when he met with Jean on at least one occasion, in the company of Merle Armitage.[77] And it would seem that he was back again toward the end of March, by which time Jean had left Los Angeles and was on his way back to New York, by way of Rock Island, Illinois; he was having a show in nearby Davenport, Iowa. Zohmah, however, was still around, tending to her ill father and planning a trip to London. In the days before her departure she saw Edward on a number of occasions. On Monday, March 26, 1934, for example, she noted in her diary:

> To meet Edward
> He is wonderful
> I am happy he likes me
> a few peaceful moments
> wrote Jean a letter.[78]

The next day she saw him again, and it would seem that Edward began to press his attentions more strongly. He was attracted to Zohmah and apparently wanted to transform their friendship into something more; he continued to feel that way even after leaving Los Angeles a short time later. At the end of March or the beginning of April Weston resigned his job with the PWAP, which was jeopardizing his portrait business, and returned to Carmel. It must have been very soon after that that he wrote a rather impassioned letter to Zohmah:

> Zohmah Daisy Darling
>
> I too have thought of you—many times—of our few, but precious hours together. When can we meet again— or when will we? You see I think of this too. I wish it could be before you sail away,— or have you gone?—but how? We are hundreds of miles apart!
>
> I want you!—and you?
> Love and kisses,-many kisses-
> Edward[79]

As Weston suspected, Zohmah had already left on her trip by the time his letter arrived, and her immediate response to this declaration is not known. It is unlikely that anything physical ever developed between them, and she made no further reference to Weston's feelings in her letters to him. Of course, Zohmah liked Edward immensely—and that continued to be the case—but she was not moved by the same passion, and in romantic matters she was clearly more focused on Jean (who was a little uneasy about her attachment to Weston). For his part, Edward seems not to have been unduly upset by Zohmah's hesitation or rejection; indeed, it became a kind of private joke between them, and in subsequent years he sometimes referred to Zohmah in jest as his "Secret Sorrow."[80] Not one to dwell on the past, Edward soon turned his attention elsewhere: on Sunday afternoon, April 24, 1934, Charis Wilson came to pose for him, and his life changed dramatically.

Edward had met Charis at a concert in Carmel several months earlier; she was nineteen at the time, and he was forty-seven. Her father was Harry Leon "H. L." Wilson, the author of *Ruggles of Red Gap* and other books; her mother owned a dress shop in Carmel, the Carmelita. Not long before Charis had graduated from the Caitlin-Hillside School (now Caitlin Gabel) in Portland, Oregon, and after a brief stay in San Francisco, where she had tried her hand at acting while going to secretarial school and preparing to be a writer, she had returned to Carmel.[81] She had first posed for Weston in March of that year, at Sonya's suggestion; at the second session, in April, as Edward carefully noted at the end of his daybook, they became lovers. And it was at about this time that he turned away from still-life subjects—vegetables and the like—and began to concentrate more heavily on nudes; he lavished a great deal of attention on Charis, creating a new series of nudes, rendered close-up, in complex designs. Not surprisingly, Edward's relationship with Sonya—already in difficulty—deteriorated still further.

After Zohmah left Los Angeles she met Jean in Chicago, where they spent several pleasant days together. Then they traveled on to New York by bus, stopping off in Detroit to see Rivera's frescoes there. They arrived in New York on April 17, and the next day Zohmah boarded the ss *President Harding* and sailed for England, while Jean remained behind and immersed himself in the New York art world.[82] Zohmah arrived in London eight days later and stayed in a rooming house with her friend Sallie Phipps (Bernice Beutler), who had arrived there some time before. Phipps was involved with

spiritualism—mediums, séances, and the like—and even had her own special spirit named White Hawk.[83] Zohmah reluctantly participated in some of these activities but remained skeptical and soon tired of spirits.[84]

Eventually she got a job as a stenographer for "an old importing of lemon peel place at London bridge."[85] Some evenings she also worked for a man by the name of Paul Brunton, who rented a room in the same boardinghouse. Brunton had just published a book called *Search in Secret India*, which had attracted a good deal of attention, and he was at work on another; Zohmah typed the manuscript.[86] In her letters to Prue she referred to him as "The Yogi."

Sometime in July 1934 Zohmah's friend Tom Burns—a publisher then working for Sheed and Ward—introduced her to an old school chum, a Jesuit novice named Henry, "who wanted to meet a girl and find out what they are like."[87] This inquisitive young man, it turned out, was Henry "Elffin" John, the ill-fated son of the painter Augustus John; at the time he was seeking to be released from his religious vows.[88] One day Henry invited Zohmah to a tea party at his father's house and studio in Chelsea, thinking that the painter might want to do a portrait of her; Vaslav Nijinsky's daughter was also in attendance. No such portrait was ever done, it seems, but Zohmah had the opportunity to show Weston's book of photographs to Augustus John, who was greatly impressed. Indeed, as Zohmah later reported to Weston in a postcard, the famed painter thought the photographs were the best he had ever seen: "Edward dear, I wanted to tell you your book is much appreciated here, Yesterday I took it to show Augustus John who said the photographs are the best he has ever seen and he is England's most famed painter at this time. Also Dodgeson of the British Museum like them much, and everyone does, despight [*sic*] there [*sic*] being from America the wild. I like them too, and you. Love to Sonya & Henry [Shore], Zohmah"[89]

Sometime later an appreciative—and temporarily disabled—Edward wrote back:

Zohmah Daisy Darling

To you a hundred impolite squeezes. I had thought to write you long ago, but feared you had moved (since this address). Wrote Jean for your location but no answer. I hope this reaches you. If it does I'll write a better letter. Just now I'm a bit low physically & psychically, having spent the holidays

on crutches with a sprained knee. Now I hobble with a cane and resent the quesiton "have you rheumatism" [edge of paper slightly damaged]

But when are you returning? Have you not favored London long enough?

I am glad my book is well received especially by Augustus John, You are sweet and loyal to be my press-agent.

If this reaches you let me know and I'll send you a red-rose from my balcony,

and my love—
Edward[90]

There are still lingering traces of Edward's tenderness here, but the intensity of his earlier letter is gone. He speaks of impolite squeezes and a red rose, but after the first few lines his tone is more chatty than passionate. Whatever had transpired back in Los Angeles was no longer an issue and it did not prevent Edward from writing to Jean concerning Zohmah's whereabouts, even if he received no reply.

Soon after he returned to New York Charlot had begun to prepare designs to accompany Amelia Martinez Del Rio's *The Sun, the Moon, and a Rabbit*, a book of Mexican legends for young people that was published the following year.[91] In August he finally got himself another wall to paint: he was called in to coordinate work on a mural in the lobby of the Straubenmuller Textile High School (now Bayard Rustin High School of the Humanities), *The Art Contribution to Civilization of All Nations and Countries*. It was done under the auspices of the Federal Arts Project of the Works Progress Administration (WPA/FAP), and it occupied him and his collaborators for many months; in his diary he referred to it simply as the "mur."[92]

In addition to his other activities, Charlot continued to write about art. Sometime in the summer or fall of that same year he wrote an article titled "Art, Quick or Slow," in which he again referred to photography and expanded on what he had said earlier in relation to Weston; it appeared in the *Magazine of Art* in November 1934. Once again, as in the Increase Robinson Galleries announcement, Charlot began with the issue of technical mastery and speed of execution in painting and photography. He spoke first of all about how, from impressionism onward, a kind of artistic shorthand, a "shorthand method," became prevalent; this entailed a rejection of the laborious

execution of academic painting in favor of a looser, more freehand approach. The resulting images, Charlot explained, were often criticized by those for whom effort and craftsmanship were the only adequate measure of quality, but in his view that approach was misguided, for such "shorthand methods" can also be the language of passion or exaltation, at least when there is an underpinning of technical mastery. He cited Van Gogh (along with Orozco) as one example: "To such a master, the moment of work is what to the saint is the moment of ecstasy, nourished and developed by the slower process of meditation and mortification." Even an ostensibly precise and mechanical medium like photography could be understood in similar terms: "And when a great artist works with this the most objective of mediums, his work does not recall the so-called objective work of mediocre artist, but can only match the work of more subjective masters. Rare are the masters of photography as are those of painting; yet an Atget, a Weston, weld objective and subjective into one in their indubitable masterpieces."

Charlot then went on to speak of "Sesshou's" (Sesshu's) aesthetic testament, a splash of ink on silk which in a single, momentary gesture embodied years of art and thought. Like the work of Atget and Weston, Sesshu's example showed how a lifetime of experience and technical mastery can be distilled into a moment of revelation. Despite the apparent lack of effort and rapidity of execution, the artist captures a deeper reality, an underlying geometry and harmony that is a precondition for the greatest art: "Underlying all emotional painting, even unknown to the painter, is a system of co-ordinates through which rhythms and spaces could be translated into figures as mathematical as are the intervals of music."[93]

When Charlot speaks of coordinates and rhythms, it echoes his discussion of Weston in the 1932 monograph, and when he turns to the quickness of vision and the technical certainty required by photography, it is reminiscent of the Increase Robinson Galleries announcement. Here, in "Art, Quick or Slow," he brings these two notions more closely together and also links Weston and Atget. Weston did not feel as strongly about Atget as Charlot did, but despite any misgivings concerning the merit of Atget's work, Weston understood and appreciated the direct honesty of his approach, an attitude akin to his own.

Zohmah stayed on in London through the winter of 1934–35 and was still there the following spring when the noted sculptor Jacob Epstein had an exhibition that included a massive statue of Christ, *Behold the Man*, that

was clearly inspired by Mexican sculpture or other non-European styles. Epstein's unorthodox approach stirred up a great deal of controversy. Some of those who saw it were full of praise, but many critics denounced it as ugly and blasphemous; G. K. Chesterton, for example, considered it "an outrage," and another critic spoke, offensively, of "the debased, sensous, flat features of an Asiatic monstrosity."[94] The debate became so heated that Parliament even considered what measures might be needed to maintain public order.[95]

The fury and adulation, as Zohmah put it, aroused her curiosity; she resolved to see the work for herself. In order to do so she had to use the money she had been saving to see *The Painted Veil* with Greta Garbo (there was an admission charge at the gallery) but it must have been worth it, for she was so impressed that she wrote an admiring letter to Epstein that evening. Much to her surprise, Epstein responded, asking her to come see him the following Saturday.[96] It is not known exactly what the two of them discussed, but she later reported to Prudence that Epstein was "nuts about Mexican sculpture."[97] And she also must have spoken of Epstein's enthusiasms in her next letter to Weston (which is no longer extant).

Weston took a long time to respond to Zohmah's letter, but when he finally did he referred to Epstein—after reporting on the latest changes in his life:

Zohmah Daisy dear—If you could have seen my activities during the last few weeks you would forgive my long silence. Fact is I'm leaving Carmel. Sonya & Sibyl have taken over the studio, and Neil, Cole and I are living (?) in the basement of old house pending instructions from Washington. I am to be traveling for a year for the U.S. Dept. of Agriculture, Soil Erosion Service. I am to photograph the effects of wind & water erosion throughout the South West.

Neil *sails* for Japan June 1st on one of the old Alaska packers. We are both excited over the new life ahead.

So you are returning? And where will we next meet? I expect to make L.A. my headquarters, but not sure.

You have been sweet to think of me, to write me. I have thought of you, if I have not written!

I have a book on mexican sculpture which I will send to Epstein. I admire his work very much, so it is a pleasure to be of some aid to him in this small way.

I have not heard from Jean for many months.

Here are a few rose petals to remind you of Carmel,— and me.

Love & abrazos Edward[98]

Merle Armitage had offered Weston more work in Los Angeles, this time with the Federal Arts Project of the Works Progress Administration. And so Edward turned over his Carmel studio to Sonya and their friend Sibyl Anikeef (or Aniekeff), another Carmel photographer who had also modeled for Weston, and headed south with his son Brett. They stayed first in Glendale, with Flora—that is what Weston meant, it seems, when he spoke of the basement of the old house. His sons Neil and Cole, now age eighteen and sixteen, were already there. Although Edward and Flora had lived apart for many years (since he moved to Mexico with Tina Modotti), they remained married and Edward stayed with her from time to time. Since he expected to be traveling frequently, the old house would be a convenient home base. After the Washington project to which Weston referred fell through, however, he needed a more permanent residence and moved into a house on Mesa Road in Santa Monica Canyon, along with Brett. Charis remained behind in Carmel.[99]

Although Weston had not heard from him for many months, Charlot had been busy back in New York. While work continued on the "mur," he also began teaching at the Florence Cane School, a small, progressive art school, now defunct, that was located in Rockefeller Center and offered classes in lithography and fresco painting.[100] According to his diary entries from this period, his days were divided between teaching and work on the mural or on other projects. In his off hours, he spent his time at the Metropolitan Museum of Art and at various other museums and galleries, paying close attention to drawings and paintings by Botticelli, Grünewald, and Pontormo.[101] There were also other sorts of diversions. One day, it seems, he went to a ping-pong club with Raphael Soyer, and he frequented the Automat, Childs, and unspecified Chinese restaurants. On one occasion he went to see the film *Ruggles of Red Gap*, based on the book by H. L. Wilson, Charis's father. At this point, Jean, like Zohmah, was unaware of Charis or of the fact that she had already become an important part of Edward's life.

After the Textile High School mural was finished in May 1935, Charlot continued to teach at the Florence Cane School. It was at this time that he

began work on the *Stations of the Cross* (or *Way of the Cross*), a series of canvases illustrating the key incidents leading up to the Crucifixion, as Jesus made his way through Jerusalem to Golgotha. They would occupy him, off and on, for a number of years and ended up in a Catholic church in Illinois.[102] Later that summer Charlot also produced a new version of *Abraham Sacrificing Isaac*, a subject that he had done before and had included in the *Picture Book*.[103] In the earlier interpretation he had emphasized the figures, which were contained in a compact and tight composition; in the later one he pulled back and devoted more attention to the landscape, incorporating motifs based on a drawing he had made two years earlier at Point Lobos. Indeed, in his diary he referred to the painting simply as Point Lobos.

This new picture was not simply a traditional narrative, a reprise of a standard Old Testament subject that Charlot liked to represent. It also was associated with his visit to Carmel, or perhaps even with Zohmah. Zohmah had returned from London at the very end of May and had passed through New York, where she and Jean had spent almost two—mostly pleasant—weeks together, after not having seen each other for more than a year.[104] Jean wanted Zohmah to stay in New York, but she would agree only if they were to live together. He refused, and so she left for California.[105] As a result, his thoughts turned again to the West Coast, and by the time he began the new version of *Abraham Sacrificing Isaac* he may have been contemplating another trip across the country—although he would not make the journey for more than two years. Jean may not have been writing letters to Edward, and at this point Carmel may have seemed a long way away, but Edward and his world—which would increasingly include Zohmah—were evidently still on Jean's mind.

6

THE HONEYMOON PICTURE

Zohmah was back in Los Angeles by the beginning of July 1935 and once again sought employment as a stenographer or typist. Shortly after her return she went to visit Edward and renewed their friendship.[1] Weston had been living in the area since January, most of the time in a house in Santa Monica Canyon, and he was working for the Federal Arts Project (FAP); Charis was still in Carmel. In the weeks that followed Edward organized outings to the beach and evening dances, and he often invited Zohmah to participate. Edward would send postcards to Zohmah urging her—mock plaintively—to visit. In one case he wrote simply, in large letters, "Cuando?" (fig. 34). In another, "How about your tonsils? Come out for a sun-beach-bath-supper-dance. Charis will be here soon. Want you to meet."[2]

Finally, in late August Charis arrived, after not having seen Edward for eight months. Zohmah's visits continued during the fall of 1935 and on into the following year. By February 1936 she was spending a good deal of time with Edward and Charis (to whom she referred in her diaries as "the Westons," though they were not yet married). Although the three spent many enjoyable hours together, times were hard and the Westons were concerned about their finances. One day, for example, Zohmah reported, "The Westons are broke & feel blue> 'sit in sun and Plan.'"[3] A few days later Zohmah—who was struggling herself—sent them money she had just received from Jean.[4]

Getting out to Santa Monica was routine: when she didn't have a ride Zohmah would take the bus or streetcar. This was usually a simple matter, but

on one occasion sometime in late February there was some sort of mix-up. Zohmah had apparently set out to visit Edward and Charis, but after waiting an unusually long time for the bus to come she gave up and went home; Edward, unaware of the change of plans, was somewhat distraught and fired off a note to Zohmah:

Zohmah Daisy Darling

What *did* happen to you Sunday. I feel terribly. B [Brett?]—said that you would take a bus within 15 min. He should have gone after you anyway, should have insisted. He is thoughtless at times but never intentionally.

I had a nice supper cooked "for you." Sister, niece, Uncle were here too, and later in came Ramiel.

I would not sit down to eat without you, but went to the bus and waited for you almost an hour. No Zohmah, so I returned a sad and distressed Edward. What *did* happen? Write me, phone me, or come out soon. I have prints for you, abrazos for you, dances for you. And I have something (a piece of paper) to return to you.

Love & kisses
Edward[5]

In response Zohmah noted in her diary, "Special letter from Edward. I feel terribly sorry to inconvenience him." The next day she talked to him on the phone and straightened out the confusion. The significance of the paper to which he referred remains a mystery.[6]

In the ensuing months—all through the spring and summer of 1936—Zohmah continued to visit Edward and Charis in Santa Monica, often staying overnight on a couch or in a sleeping bag. In her diary entries from this period she again speaks of dancing in the evenings, breakfast with "the Westons," and mornings at the beach. By this time Zohmah and Charis had become good friends and also spent a good deal of time together on their own. As Charis later recalled, "For me you were not only a great original, but the first woman I ever felt a truly warm friendship for."[7]

Back in New York, Jean was still teaching at the Florence Cane School; starting in April he was also busy with a series of illustrations for Hilaire Belloc's *Characters of the Reformation*, an interesting complement to his work on the

Stations of the Cross (which was still incomplete).[8] In addition, in August 1936 he put the finishing touches on another article, "The Critic, the Artist, and the Problems of Representation," in which he commented on contemporary artistic trends and issues. It was written for *American Scholar* and appeared in the spring of 1937, the first of several articles he would do for the journal.[9] There is no specific discussion of photography or Weston, but it is revealing nonetheless. In essence, the article is a plea for a more serious consideration of subject matter and storytelling, for a more satisfactory integration of form and content. In Charlot's view impressionism and cubism waged war on subject matter, emphasizing form at the expense of content, considering the one apart from the other. For Charlot, however, the dichotomy between form and content was a false one: "The incompatability of story-telling and plastic equilibrium is an entirely fictitious creation, a scarecrow propped up by dealers to shush a dissatisfied public."[10] This may seem obvious now, but at the time it was not a widely held view; subject matter had long been downplayed or ignored and storytelling had often been considered anathema. In Charlot's view it was high time for a change, for a renewed emphasis on these aspects of art making.

Charlot acknowledged that the work of the surrealists represented a welcome return to storytelling, but he objected not only to the sort of stories they told, which he regarded as unpleasant and "devoid of logic," but also to the old-fashioned style they employed; he considered their academic realism to be a lifeless relic, not a genuine expression of the present. An effective comeback, he explained, would require a suitable artistic language, and that was something the surrealists, among others, failed to recognize. In this regard the Mexican muralists—with whom he had more than a passing acquaintance—represented a more promising solution. Like other artists of the day the muralists chose socially significant themes, but at the same time theirs was a public kind of art. And more importantly, "their plastic language, though fit for a descriptive purpose, was not a surrender to the past."[11]

Many people on the left looked on surrealism with suspicion. Charlot's old friend Anita Brenner, for example, in a short article on Giorgio de Chirico, drew a distinction between surrealism and proletarian art. For Brenner, the surrealist was an individualist in the most selfish sense while the proletarian artist remained engaged, part of a larger whole; the proletarian artist correctly acknowledged a collective responsibility.[12] Charlot too saw the need for a more public or communal kind of art, an art for the people, not just

for aesthetes or connoisseurs, but he spoke in less specifically political or ideological terms. Indeed, Charlot's engagement with the temporal world, his concern for ordinary people, grew out of a deep and abiding religious faith. John Charlot describes his position very well:

> This lifelong identification with the people, in whichever culture he found himself, is an essential characteristic of Charlot as an artist and a man. This attitude is, of course, part of the Christian emphasis on the poor in body and in spirit, an attitude emphasized by the French Catholic Renaissance of Charlot's youth, with its renewed interest in addressing social problems and in using liturgy, art and literature to bring the Christian message to the people. Charlot was an admirer of such writers as Léon Bloy and Jacques Maritain, who based their radical social reformism on a stringently interpreted Christianity.[13]

Weston, on the other hand, remained more of a formalist; even in the depths of the Depression he avoided social questions in his imagery, unlike his friend Dorothea Lange and the other photographers of the Resettlement Administration / Farm Security Administration (RA/FSA). He had no quarrel at all with those who embraced a more concerned, more documentary approach, but in his own work he continued to concentrate on nudes and landscapes, and he resisted any pressure to become more politically engaged. Inevitably, however, as the Depression deepened, he came to feel somewhat isolated and felt the need to justify that artistic stance; indeed, his defensive attitude is revealed quite poignantly in a letter to Ansel Adams: "I agree with you that there is just as much 'Social Significance in a rock' as in 'a line of unemployed.' All depends on the *seeing*. I must do the work that *I* am best suited for. If I have in some way awakened others to a broader conception of life,—added significance and beauty to their lives— and I know that I have—then I have functioned, and am satisfied—not satisfied with my work as it is, understand. Thank the gods we never achieve complete satisfaction. How terrible to contemplate Utopia: Contented Cows." And he went on to say, "I have the greatest sympathy, even understanding, for those who have gone sociological (politically). They had to,—granted they are honest. If I saw an interesting battle between strikers and police I might be tempted to photograph it,—if aesthetically moved. But I would record the fight as a commentator regardless of which side was getting licked."[14]

Weston remained aloof and detached. For him, aesthetic concerns clearly

took priority over any obvious political agenda. Nevertheless, in the coming years Weston moved away from the extreme formalism, the "semi-abstractions" — to borrow a term he himself had used in relation to Henrietta Shore — of the work of the last decade, and toward the more open and explicit approach that would define his later style. As John Szarkowski has said, "Little by little Weston's subjects became more and more specific — less universal, and more clearly a celebration of a particular experience in a particular place at one moment."[15] Charlot's article — which Weston would surely have read — helps us understand some of these changes.

Early in the fall of 1936 Edward and Charis moved from Mesa Road to a smaller place on East Rustic Road, on the other side of Santa Monica Canyon. In October Weston submitted his proposal for a Guggenheim Fellowship. Charlot was one of his sponsors, along with Armitage and several others, including Karl Nierendorf, the German art dealer who had published the photographer Karl Blossfeldt's *Urformen der Kunst*. Nierendorf had recently opened a gallery in New York City and planned to give Weston an exhibition. Charles Sheeler, who had written one of the introductory texts in *The Art of Edward Weston* in 1932, was another sponsor. The application included a "Plan for Work" that is extremely brief and sheds little light on his thinking at the time. Weston simply intended to continue making photographs of the West, with an eye on publication. The new work would include a broad range of subjects, "from satires on advertising to ranch life, from beach kelp to mountains."[16]

After the application had been sent in, Edward and Charis rewarded themselves with a trip to Oceano, California. It was on that trip, in November 1936, that Weston made his famous nudes of Charis in the sand as well as many of his best images of the dunes themselves.[17] In important respects these new pictures represent a shift away from the more hermetic imagery of just a few years before. Weston's first nudes of Charis were close-up and decontextualized. Now he pulled back, showing her entire body as well as some of the surrounding dunes. Similarly, the images of the dunes themselves became more accessible than some of his earlier still lifes. They remain highly abstract — in many ways they are comparable to Stieglitz's Equivalents — but they are also less concentrated and ambiguous and so presage the more open and explicit approach of much of the work to come. In Weston's Oceano photographs, form and content are subtly realigned — very much in accord with

the principles set forth in Charlot's recent article. Weston had not become more socially engaged, but he had moved away—albeit only slightly—from the relatively abstruse formalism of previous years.

After Edward and Charis returned from Oceano, Zohmah visited them in their new place, and her friendship with Charis deepened. Shortly after that, in the early days of December, Zohmah and Charis went to Carmel together, leaving a lonely and unhappy Edward back in Los Angeles. As Zohmah noted, "E sorry to have the beautiful Charis go away even for a week." Zohmah herself, on the other hand, was happy to be going and had a pleasant and leisurely time. One day she noted, "Charis's theory of being happy—a balance>We sit on pine slope & she dictates novel>Charis is beautiful & other conversation is dull after listening to hers." And then the next day: "Go to cove near Point Lobos . . . drink wine and swim naked in the blue water>It was all perfection."[18]

Edward apparently sent Charis a number of notes but received no word from her. In desperation he turned to Zohmah, writing her a humorous and plaintive letter:

Zohmah Daisy—

No word, no response from my concubine, so I turn to you, my secret sorrow. *You* would not keep me waiting five days for some little sign of life, some word from your gay world, *would you?* No! And again No! Ah well, I shall get even, I shall hold out news from that long legged blond hussey. Two old loves tried to commune with her this week; one by phone, one in person,—and I wont tell—she'll never know. So tell me how things go with you. Just a line you know. Five minutes worth of writing, or just about 1/300 of a day's time.

As for me, nothing exciting, just routine rush before xmas.[19]

Edward's desperation was short-lived, for Zohmah and Charis were soon back in Los Angeles; there was a feast at Christmas time, and a party after New Year's. Then, in mid-January, the photographer Frederick Sommer came for a visit; Charis recalled that he showed tiny prints—she describes them as postage-stamp sized—of leaves and twigs.[20] According to Zohmah, who was there for dinner, that night there was talk of such oddities as fireplugs in Arizona.[21]

Around the same time or shortly after, at the urging of friends, including Dorothea Lange and Paul Taylor, Weston decided to amend his original application to the Guggenheim Foundation; he sent a letter to Henry Allen Moe of the foundation explaining his intentions more fully than he had before. The letter, which Charis helped to write, is widely considered one of Weston's most complete statements on photography, at least from this period in his life. After speaking first of the "Straight Photograph" and its potential for individual expression—a familiar theme for him—he went on in more philosophical terms:

> My work-purpose, my theme, can most nearly be stated as the recognition, recording, and presentation of the interdependence, the relativity, of all things,—the universality of basic form.
>
> In a single day's work, within the radius of a mile, I might discover and record the skeleton of a bird, a blossoming fruit tree, a cloud, a smokestack; each of these being not only part of the whole, but each,—in itself,—becoming a symbol; for the whole, of life. So, the blossom of the fruit tree becomes more than a blossom, is the tree itself,—etc.
>
> And the recording of these becomes not just the documentation of a given subject matter, but its sublimation,—the revealing of its significance.[22]

It has been pointed out that passages like this reflect Weston's growing openness to more metaphysical approaches to art and photography.[23] His recent contact with Frederick Sommer, who is more closely associated with such thinking, would perhaps support that contention, but such views were not at all new to Weston. As early as 1929, for example, he had spoken of "the very quintessence and interdependence of all life" and of a fragment of nature "symbolizing life's rhythms."[24] In 1932, in *The Art of Edward Weston*, he had spoken of "sublimation"; in the same book Charlot had taken a similar stance, as we have seen. Even Henrietta Shore was quoted—in Reginald Poland's contribution—voicing a comparable view. According to Poland, "She [Shore] once said: 'The mountains are dynamic to me, a living part of the rhythm of all life.' When she emphasizes a detail more definitely than other parts of a composition, it is, for one thing, to suggest the ensemble, the universal rhythm."[25] Such pantheistic notions were common coin among the artists in Weston's circle. Perhaps these views received more emphasis in the revised fellowship application than before, but they were not a real departure. If anything is different here, it is that Weston speaks less of form, in the most

abstract sense, than he had before; the joy in formal juxtapositions that we hear of in the daybooks, for example, is absent here. Meaning or content in the deepest sense has taken center stage; in that respect he was moving along the same track as Charlot.

Back in Los Angeles, Edward and Charis awaited word about the Guggenheim Fellowship, but despite this uncertainty the merrymaking continued. Everyone was hard at work or seeking work, but there was time for music and dancing to the sound of the latest records. Edward, it seems, was especially partial to the rhumba. At one point someone, perhaps Zohmah, presented Charis and Edward with a new phonograph, which pleased Edward immensely; he spoke of the gift in one his frequent postcards: "Z Daisy—Come out & Rumba to my new 'portable' radio-phonograph. It's marvelous. A sweet girl gave it to me *or* the house or Westons—anyway she *is* sweet."[26] In her diary Zohmah simply noted, "the phonograph is nice."[27]

There were also other amusements: "To the beach>Edward tells us about living>Charis & Leon [Leon Wilson, Charis's brother] play games & I can't think of answers—decide to hurry back to Compton>but don't>Play pencil games on bus with Leon and on streetcar talk to sailor."[28]

In March Weston received news that he had received the Guggenheim Fellowship and that it was to begin April 1, 1937. He and Charis put many things in storage and soon moved out of the Rustic Road house; they arranged to stay with Chandler in Glendale when in Los Angeles and with Brett when their travels took them to San Francisco. On March 28, 1937, Zohmah noted in her diary, "go to see Edward-Charis at Glendale. He has the Guggenheim (—reporters come)." Then she added, in a matter-of-fact way, "I cut their hair."[29] Shortly afterward she told Prue, "Edward got the Guggenheim so they will be off on a grand tour of the deserts and mountains. They are so excited and happy."[30]

At about the same time the exhibition of Weston's photographs put together by Karl Nierendorf opened in New York, at Nierendorf's gallery.[31] Charlot was still in New York at the time; after having worked for many months on the *Stations of the Cross* series and bringing it almost to completion, he was again occupied primarily with Mexican subjects: among other things he was working on a series of pictures of *tortilleras* (tortilla makers), and another devoted to *lavanderas* (washerwomen). As work progressed on these series he went to see Weston's show and reported to him, "Your show is grand,

and *very well* presented. What a difference from the D. Studio! Thanks for offering me photos. Only I could not look on the back because the[y] were hung. I particularly remember a dead bird's bone, and two *very light* ones, one of sand and one of sky, as those I like best. I was glorified, hanging between Stravinski [Stravinsky] and Cagney!"[32] Interestingly, the pictures he singled out, aside from the portraits, were recent ones, taken in the previous year. In all likelihood he had not seen any of them before. The sand picture must have been one of the Oceano pictures taken the previous November; although it is difficult to pinpoint exactly, it was probably one of the more delicate and lyrical ones and not one of the more dramatic images with deep, swirling shadows. The sky picture also could have been among the ones Weston had taken at Oceano — or part of a group of cloud pictures taken earlier the same year in Santa Monica. The other picture Charlot singled out was probably *Bird Skeleton*, also from Oceano; it is an angular yet delicate image with a distinctly surreal edge — something Charlot did not mention — not unlike what Sommer was doing at about the same time.[33]

In his letter, Jean went on to ask Edward for a recent photo of Zohmah and offered one of his own works in exchange. Weston would have had ample opportunity to make more portraits of Zohmah — formal or informal — but it is not clear whether he did so; if he made such a picture, it has slipped out of sight. Nevertheless, Edward reported to Zohmah soon after that he went to the Stendahl Ambassador Galleries (Jean's gallery in Los Angeles) with the intention of "choosing a Charlot." He made no final selection at the time but saw many that he liked.[34]

As they prepared for their travels, Edward and Charis contracted with *Westways*, the official magazine of the Automobile Club of Southern California, to publish some of their results as they went along; Edward would supply eight to ten prints each month, and Charis would write a few paragraphs to set the stage as well as provide captions for the images. The extra money they expected to earn from this arrangement enabled them to purchase a new car, a Ford v-8 sedan, which they loaded with camping gear and camera equipment.[35] With Weston's son Cole, they left on their first Guggenheim expedition in April 1937; the trip took them to Death Valley and Red Rock Canyon, among other places. More trips followed in April and May. And early in June Charis asked Zohmah to join them on a trip to Antelope Valley, where Edward had gone a few years before. Zohmah quickly wrote to Prudence, "I am going

over to spend the night in a Weston sleeping bag. And in the morning Charis and Edward and I are going to Antelope Valley, so they say, whatever that is. Hope I don't meet a snake."[36]

On the morning of June 4 they departed, but Antelope Valley turned out to be a disappointment; it was more built up than Weston had remembered, so they ended up going back to Red Rock Canyon instead. Sometime later Zohmah wrote an account of the trip for Charis and mailed it to her; Charis included part of it in *California and the West* and quoted it at greater length in her more recent book *Through Another Lens*. Among other things, Zohmah recorded some of their dinner conversation: "Good dinner was ready in a moment and then slow leisurely eating & sipping of hot Weston special deluxe coffee and fun conversation all about, briefly, 'Yea gods, how can a writer write. How when he comes up against a place like the desert, how can he speak of it with words found alphabetically arranged in every dictionary.' E. [Edward] said when he used to write there were not enough words for beauty. C. [Charis] said maybe it is best not to try and tell about things but can really say only what things do to us."[37] Zohmah then added a few words by way of characterizing Charis: "Charis, though, besides being a sophisticate, a bohemian, is also 'a child of nature' and could walk about casually in the blackened world."[38] Charis would later say—in her introduction to the second edition of *California and the West*—that she was "secretly bewitched by Zohmah's description of me" and added, "it was how I saw myself."[39] Eventually the conversation turned to snakes: "When they had asked me come on this trip I knew I musn't speak of how snakes frighten me, but couldn't help mentioning them conversationally. C. said, 'sure there are lots of them & especially at night.' E. said, 'They won't bother you at all, but sleep in the middle and we will protect you.' We got into our sleeping bags."[40]

The next morning Edward set to work. On the previous trip to Red Rock Canyon his efforts had been hampered by the wind; he had also been somewhat overwhelmed by the beauty of the scene. As Charis reported about that occasion, "We walked around looking and Edward said, 'What can I do with it? It's all done. Photographing this stuff would be like copying a painting. Anyway, it's too damned pretty.'"[41] This time conditions were more favorable, and Edward worked quickly and well. Zohmah described the situation vividly: "E. in his pink shirt looked like a very bouncing bit of R.R.C. [Red Rock Canyon] as he went along the ft. of the cliffs looking. . . . C. went off to

find him more places, me trailing after. Up a side canyon, she found, there were perfect joshua trees. After E, happy to find so many things he liked, had been snapping pictures almost as quick as he could carry the heavy camera into position, we ate some breakfast and E. was again at work."[42] Edward evidently liked the Joshua trees, because he made a very striking photograph, with one of the trees in the foreground climbing up the side of the picture and bending over so that the pods seem almost to touch the cliffs behind them. The photograph was later included in one of the articles in *Westways* and in *Seeing California with Edward Weston*, where the caption—which Charis presumably authored, although her words were often altered—stated, "Against a background of softly rounded pink walls, the sharp green points of a Joshua tree show up in bold contrast. Joshua trees bring forth their fat greenish-gold seed pods in summer."[43]

Not surprisingly, Weston devoted most of his attention to the rock formations. In *Westways* Charis described them in rather fanciful terms: "Praying nun, gargoyles, a cerberus, temples and palaces of all kinds, heads of fabulous monsters, are all to be seen."[44] Later she likened them to a Gothic cathedral: "spires and buttresses, cloisters and choirstalls, were cut into cliffs brick-red to rosy pink."[45] It is hard to imagine that Weston would have accepted or welcomed these explicitly symbolic associations in relation to the photographs themselves, but there is a markedly architectural quality to many of the pictures of the rock walls of Red Rock Canyon made on this trip. Like the Oceano pictures, the vantage point is more distant now than had been the case in Weston's earlier work—the shells and vegetables. In some respects these photographs are still highly abstract and reflect Weston's longstanding concern with pattern and form, but at the same time they often recall Gothic or other forms of architecture. There is something more explicit about them and the rock formations are a bit more recognizable for what they are than is the case with much of the subject matter of Weston's earlier pictures. In that respect they represent a different approach and look forward to much of his work to come.

Later that same day they all went off to a petrified forest, which Zohmah described as "just a twisty desolation."[46] Edward found nothing to inspire him there, so they went back to Red Rock Canyon. The following day they drove to Mt. Wilson and had lunch at the top. Afterward they headed back to Los Angeles and arrived in Glendale in time for dinner; then Zohmah returned home via streetcar.[47]

Zohmah saw very little of Edward and Charis in the coming months; for much of the time they were traveling on a series of Guggenheim trips that took them to Yosemite National Park and Northern California. Weston was also taken up with preparations for his retrospective at the San Francisco Museum of Art.[48] They didn't return to Los Angeles until November. By that time Charlot too had returned to Los Angeles, where he stayed—with Zohmah—for about eight months. He had again been offered a job at the Chouinard School of Art, to begin in January.

On Thanksgiving, about ten days after their return, Edward and Charis joined Jean and Zohmah for a feast; in her diary Zohmah noted, "Turkey is good—we eat & eat then all fall asleep."[49] It may have been the first time that Jean and Charis met, but there is no mention of that or of their reaction to one another. In later years Jean expressed his disapproval of Charis—he thought that she put words into Edward's mouth and that she steered his art in the wrong direction—but if he had any of these feelings from the start, he must have kept them to himself. Charis, for her part, was never entirely comfortable with Jean and later spoke of his efforts to make Zohmah more conventional.[50]

At the dinner or very soon thereafter, a short-lived and abortive plan was hatched for the four of them to move in together; two days after the feast, Zohmah noted in her diary, "Meet Westons to see House. We think we will move there together."[51] But just one day later the situation changed and the idea was abandoned: "Weston phones all plans off > J and I are all turned around >."[52] What changed their plans is unknown. Perhaps Edward and Charis expected to be traveling too much to make it worthwhile or perhaps they were already thinking about returning to Carmel, which they did the following year. In any case, they were soon on the road again, to New Mexico, Arizona, and elsewhere. Jean and Zohmah—who had to leave the place in Compton where they had been living—made other arrangements.[53] There is no further mention of the episode, but in the coming months, whenever Edward and Charis were not traveling, there were many more dinners.

As the year drew to a close Charlot was much occupied with a series of illustrations devoted to the story of Carmen, based on Prosper Mérimée's classic tale about Spain and gypsies; they were for a deluxe edition of the text to be published by the Limited Editions Club (for whom Weston would later do his *Leaves of Grass* photographs). Charlot had approached George Macy, the

director of the firm, sometime in the previous year with the idea of doing a series of lithographs devoted to Carmen, and Macy apparently jumped at it; Merle Armitage had been designated as the designer. Nothing further was done for some time, but after arriving in Los Angeles Charlot began to make watercolor studies of Spanish costumes, taken from images he had seen in the Los Angeles Public Library; he also did a series of drawings in which he worked out the basic design for the illustrations and prepared a book dummy.[54]

The choice at this time of such a specifically Spanish theme—and one seen through French, not Spanish, eyes—was an interesting one. Of course, the Carmen story has strong links to French tradition—Bizet as well as Méri-mée—but it is hard to imagine that Charlot did not see a potential connection to the civil war that was, during that very period, starting to tear Spain apart. No doubt he was well aware of what was going on, and he may have known of the controversy unfolding in the French Catholic press concerning the events in Spain, an issue that pitted Charlot's old friend and collaborator Paul Claudel, a supporter of the rebels, against Jacques Maritain, a supporter of the loyalist government.[55] This rather bitter controversy even spilled over into the pages of *Commonweal*, for which Charlot was doing a good deal of artwork at the time. Charlot's own views are not known; no doubt he was somewhat torn, for he had long admired both Maritain and Claudel, but his sympathies were most likely with the Republican forces, and the *Carmen* project can perhaps be understood in that context.

Weston probably had some sympathy for the loyalists too, but there is no clear indication of that in the record. It would seem that there was little or no discussion of the situation in Spain at the dinners mentioned earlier and later accounts, like Charis's memoir, make no mention of it. For the most part it would seem that Weston's attention was directed elsewhere, but many of his old friends from the Mexico days were deeply involved, most notably Tina Modotti; whether he or Charlot knew it then or not, she had recently gone to Spain to support the Republican cause.

In January 1938 Jean began teaching at the Chouinard School as planned, and at the end of the month a writer by the name of Bradley King gave a big party at the Beverly Hills Hotel in his honor and in honor of Helene Mullins, whose book of poetry had just been published. Jean and Zohmah had first met Mullins some years before in New York through her sister, Marie McCall, also a writer; McCall, who had since moved to California, was also

at the party and later recalled that it was attended mostly by film people. Among those present were John Farrow, Maureen O'Sullivan, and Gypsy Rose Lee; Charlot and Mullins were "unusual celebrities for Hollywood" (fig. 35). Afterward, as McCall relates, Charlot introduced Mullins to Weston, who made portraits of her that were used for publicity purposes and, much later, for the dust jacket of another book of poems.[56]

In February Charlot had an exhibit at the Stendahl Ambassador Galleries, which mostly included examples from his *Tortillera* series and the *Lavanderas*.[57] By this time Charlot had also started work on another article for *American Scholar*, and Zohmah was assisting him, as she noted in her diary. The subject of this one was again surrealism; here he expands on what he said earlier and explains his position—which is a complex one—more fully. He makes it clear that he welcomes the return to storytelling; indeed, he is even more emphatic about that than he had been in the past: "In practice this meant that after a lapse of some 60 years during which the art-for-art slogan reigned, painting was to come back to its old purpose of telling stories. The public was by now fed up with sharing the personal failures and victories of the painter struggling within the intricacies of his craft, and sighed with relief when addressed by the painter of anecdotes who faced his public squarely, catered to the layman in his own language."[58] He again voices his criticism of the academic style that painters like Dali adopted; it seemed to Charlot to be at odds with the surrealists' emphasis on the irrational and the spontaneous or automatic. Charlot then goes on to speak more specifically about the nature of surrealism. As much as he appreciates some of the changes that surrealism brought about, he is wary of the excessive reliance on Freudian notions and dreamworld imagery, the more sensational or even calculated depiction of the subconscious: "The Viennese haze that settles between the surrealist's eye and the world, by bringing its diversity to a shameful common denominator, disintegrates actual objects and people to such a degree that painting them becomes an artificial exercise."[59]

Charlot, of course, devout Catholic that he was, had long stressed the importance of the spiritual aspects of art, but here he voices his concern about the vulgar mysticism and spiritualism, the world of séances and ouija boards that was so popular at the time (as Zohmah had experienced firsthand in London).[60] For Charlot, art—surrealist or otherwise—should not involve itself in that sort of thing. When he speaks of the spirit he is referring not so much to what is mysterious or irrational but rather to a kind of divine order.

Weston did not share Charlot's religious convictions, but he did share many aspects of Charlot's approach to art. He may have come at it all from a less pious point of view, but he too upheld the underlying order and interconnectedness of the natural world, as we have seen, and like Charlot he believed that art could reveal that deeper reality. In the coming years Weston would occasionally dabble in surrealism, venturing into the Viennese haze in ways that would make Charlot more than a little uncomfortable, but such experiments were halfhearted at best; by and large, although he made occasional references to mystics and mysticism, he shared Charlot's position on the essential purpose of art and photography.

In March Charis and Edward (who had just turned fifty-two) were in Death Valley when they learned that the Guggenheim grant had been renewed. As Charis reported, they were understandably elated at the prospect of another year of freedom, and they set about finding a suitable base of operations with an adequate darkroom where Edward would be able to print all his Guggenheim work.[61] Jean spoke with Edward—just back from Death Valley—a week later and learned the good news, which he noted in his diary.[62] In the meantime, Jean had been offered a teaching job at the Art Students League in New York beginning the following September and was thinking about leaving Los Angeles; he had the option of staying on through the summer and teaching at the Chouinard School but had not yet made up his mind about how soon to leave.

The possibility of Jean's departure set off something of a crisis with Zohmah. She wanted to go with him but Jean discouraged her and, as Zohmah reported, they quarreled:

> To church & take Jean's pants to weavers & walk on up to Hollywood Blvd & take bus to Edward's—I feel desperate and say to Jean that I will come to N.Y. with him or anywhere that I want to be with him> He says that isn't a good idea. I say then shoot me or go now and leave me> He says he can't shoot me but will move tomorrow. So we arrive at Edward's Brunswick place [Chandler's]— I guess it is justice> Charis gone to Carmel, her father sick> Get home tired & nothing good to eat> Go to bed to weep but get up & kiss Jean good night, then sleep.[63]

Evidently Zohmah was hoping to see Charis, who would perhaps have been able to comfort her. How much Edward got to hear or how much he was able

to help is not clear; it is not even clear from Zohmah's account whether Jean came along with her to Edward's, but whether he liked it or not, Edward was caught in the middle of it all. Soon after Jean moved out, as he had indicated he would, but he and Zohmah continued to spend time together; understandably, there appears to have been a good deal of tension, some ups and downs in their relationship, but nothing that prevented them from taking a train trip to San Francisco together. There they saw Sonya Noskowiak—whom they had not seen since their stay in Carmel—and ran into Jehanne Salinger at a local department store, City of Paris; Jean took Zohmah to see Diego Rivera's frescoes, which he had seen on his previous visit to the city, in 1933. They returned to Los Angeles in early May.[64]

By that time Charis and Edward were making plans to move back to Carmel, where Weston's third son, Neil, was to build them a house on land owned by Charis's father; they were preparing for more Guggenheim trips while the house was being built. Before they left they again joined Zohmah and Jean for dinner, and Edward showed pictures.[65] Less than two weeks later Edward and Charis left for a brief stay in Carmel, and after that they headed north to San Francisco. They also spent some time in Yosemite with Ansel Adams before returning to Carmel to await the completion of their new dwelling.[66]

Charlot, meanwhile, was getting ready to go back to New York; he had decided not to continue on at the Chouinard School and was expecting to leave California at the beginning of the summer. He left in the middle of June, but his last weeks in Los Angeles were very active ones. He was in the midst of giving a series of lectures at the Disney Studios, aimed primarily at Disney's animators, in which he again discussed issues such as composition, the representation of space, mural painting, and suitably enough, animation.[67] He was also painting a group of oil sketches in connection with his *Carmen* project.[68]

He also completed yet another article for *American Scholar*, "Cubism R.I.P."[69] As the title suggests, it was intended as a kind of eulogy for cubism. Charlot had criticized cubism in the past: he had been concerned with the de-emphasis or absence of significant subject matter, the emphasis on form as opposed to content. Here he took a more positive view, concentrating on the achievements of cubism. What interested him above all was the rationality of cubist pictures, the geometric or even classical order underlying cubist imagery, in the tradition of Piero della Francesca, Raphael, and Ingres, who all favored the ideal form over the accidental or specific. By contrast,

impressionist imagery was amorphous and emphasized transitory effects. Charlot did not invoke Weston here, but he surely could have.

After the cubism article was completed, with Zohmah's assistance, and the *Carmen* sketches were done, Charlot finally left Los Angeles and returned to New York where, soon after, he finally completed the *Stations of the Cross* series.[70] Not surprisingly, in the days following Jean's departure Zohmah was upset and blue. At this point her future with Jean seemed somewhat uncertain, and she was a little at loose ends. Coincidentally, her "Yogi," Paul Brunton, appeared in Los Angeles at that moment and presented her with an inscribed copy of the book she had worked on back in London, *A Hermit in the Himalayas*, which had been published in 1937; he also asked her to work for him again, and she agreed. This time, however, she found him difficult and soon quit. A little later she made the rounds of various employment agencies.[71]

By August Edward and Charis were ensconced in their new abode, and they wrote to Zohmah to let her know: "Zohmah Daisy—we have moved into our new home. Sounds very affluent! Always find a corner for you (but dont tell anyone) Want to see you! We go north in 2 wks. South in nov. Write: Rte 1, Box 162A Carmel. Jean's address? His new painting first to hang."[72]

Edward and Charis had been out of touch with Jean since he had left Los Angeles, but he was still on their minds, and so was his artwork. The painting to which they refer is probably *Gossip (Mestizas and Hammocks)*, which Charlot had painted in November of the previous year; he must have given it to them sometime before he left Los Angeles, perhaps as a belated Christmas present. The Mexican subject matter may have stirred memories of earlier days—at least for Edward. It recalls some of the imagery in Eisenstein's ill-fated Mexican film; perhaps it represented Jean's response to Edward's photograph of Charis in a hammock.[73]

Several weeks later Charis wrote once more, urging Zohmah—or "Zohmagon," as she now called her—to hurry up and pay a visit to "Maison Weston." She even included a map showing the way and a rudimentary diagram of the house, parts of which, it seems, she had painted blue. In order to entice Zohmah she also made reference to their feline friends—with photographic or surrealist names: "We have three kittens—Amidol, Negative, & Panic (Dali, Tivvy, & Nicky). You can ruffle them all up when you come up here. They don't mind & I dont." And Edward added, "Ruffle me too? E—" Further on,

Charis spoke of Edward's activities: "Edward has been printing and printing and experimenting and making better & better prints & doesn't seem to have hit the ceiling yet." After listing the people who had already visited the Carmel house—which included the Sommers—she concluded, "If all these people could come & see us certainly you can. You can swim in the pool & look at prints & lie in the sun & ruffle kittens and sleep in our loft. Come along in a hurry." At the bottom of the page Charis left a place for Edward to say a few more words; he added simply, "Zohmah Daisy—do you still love me?"[74]

It was more than a month before she took the Westons up on their invitation, but finally, on October 19, Zohmah arrived in Carmel, where she stayed several weeks. As we have seen, Zohmah had been in Carmel at least twice before, the first time with Jean, when Edward had been living with Sonya; at that time she came along as Jean's friend. Now the situation was quite different. Edward was living in a different house, with a different companion; Zohmah was there in her own right, and she had become more enmeshed in Edward's (and Charis's) activities than before.

The first days were relaxing ones. While Edward worked at Point Lobos, the others—Zohmah, Charis, and Charis's brother, Leon—spent pleasant days at the beach, rambling and conversing. A good deal of time was also spent looking at Edward's latest pictures. It all seems rather idyllic, but it was not long before Zohmah began to feel useless and thought about leaving. She probably would have done so had Charis not persuaded her to stay, asking for her help with typing. Soon Zohmah was busy with the preparation of negative lists and other tasks, and she felt more at ease; she wrote to Prue about her new situation: "Gosh the Westons live such a busy life that I can't keep track of the days. I'm enjoying myself muchly now that I am helping on the typing. Fun too before, with all the pictures to look at and Charis' log of trips to read, but it is nice to be a vague part of so much activity." A little further on she added, "Lots of reading of books and of course Charis and I are busy typing lists. Hundreds of negatives to know all about, where, why, or what happened to them. Then we all cook and play with the cats. We read 'The Dynamiter' aloud and now we are reading the new Richard Hughes' 'In Hazard' The Dynamiters made me think Leon and Charis would like 'The Woman in White'. Maybe I'll borrow it from you and loan to them?"[75] Years later she looked back fondly on this time:

> The best times were participating in routine work, a routine different every day. I helped type lists of negatives and felt proud of the finished stacks

and pleased to be part of such enthralled activity and contentment. Charis had the idea of organizing Edward's work; although he had made so many photographs of her she couldn't find a way to file inspiration.

My visits with Edward would pass in reading, eating by the fire, looking at photographs, listening to the radio, waking up too early, playing with the cats in the pine needles while Edward and Charis still slept. Waiting for the most routine of all, the ritual of Edward preparing the morning coffee in the old pot before going out to look at the world.[76]

It seemed that this happy and productive band rarely ventured beyond the immediate vicinity of the Carmel house or Point Lobos, but one day everybody went into Monterey; they wandered about looking at old gabled houses, and then on a lark they all went to a fortuneteller: "We all have our fortunes told by Doreen: Edward's, Charis, fame, lectures out-of-doors happiness—writing—Leon's.\ trips with Westons—writing kindness—likes home—great love—maybe meet someone to marry next year> me! Jean gone forever. Work—work. new people."[77] Doreen was right about many things—Edward and Charis would certainly enjoy a degree of fame—but her prediction concerning Jean was not. It may have seemed to Zohmah, or for that matter to Edward and Charis, that there was little chance that she would end up with Jean; there was relatively little contact between them at the time and he was rarely mentioned. But unbeknownst to Doreen—or Zohmah—the situation would soon change; within a few weeks she received a loving letter from Jean, along with a nice drawing. Nothing was resolved, but Jean was again on her mind.[78]

Zohmah, of course, was not the only visitor to Wildcat Hill that month. While she was there Brett came for a brief stay with his wife, Cicely, and daughter, Erica; Zohmah and Charis took care of Erica while Brett and Cicely went out to Point Lobos with Edward. A few days later Ansel Adams, who had played host to Edward and Charis in Yosemite not long before, paid a visit. Edward was looking forward to his coming, but as Zohmah recorded, his arrival was a little delayed: "With a last spurt we finish the numbering of the prints> Edward pleased as he is expecting Ansel Adams who doesnt arrive so as Charis & I were dressed up we feel partyish & drink & Edward tells us stories of his past & shows us pictures until late, exciting."[79]

The next day Adams finally arrived and Zohmah simply noted, "Ansel

Adams comes & we all have dinner & drinks & see Ansel's pictures."[80] The day after that, Sunday, Zohmah and Ansel were a bit sick—hungover, perhaps—but that did not prevent anyone from looking at more pictures. Adams was still around on Monday—Zohmah went for a ride with him that day—but soon after it would seem he departed, and so did Zohmah. The day she left Zohmah made a picture—a diagram, really—of "Maison Weston" that showed the basic layout of the house, along with many of the furnishings, in considerable detail (fig. 56). Zohmah's design was more elaborate than the simple diagram Charis had sent her earlier. It included not only the floor arrangement but also the walls, folded out in the manner of ancient Egyptian imagery; she even added color, a red sofa, red and black throw rugs and bedspread, and a good deal of blue: blue drawers, a blue desk, and blue doors and window frames.[81] As Zohmah later explained, Edward was shown spotting, and Charis was seated at his desk; a number of cats were present as well. She also indicated the entrance to Edward's darkroom and the drawers where he stored his prints. Nearby, Jean's *Gossip (Mestizas and Hammocks)* is shown hanging on the wall.[82]

Once again back in Los Angeles, Zohmah learned that Edward and Charis were planning another trip to Death Valley (their third and final trip), and she set about to provide them with "desert reading." Among other things she sent them copies of Wilkie Collins's *The Woman in White* and *The Moonstone*, as she had indicated she might while still in Carmel.[83] As Charis much later recalled, "Leon's presence meant we read aloud at night more often than usual, although it took little reading to put Edward to sleep. He used up his eyes on photography in the daytime and after dinner he was too tired to listen for long. When he and I did read it was generally adventurous accounts or stories—Robert Louis Stevenson's *The Wrecker* (a present from Leon), *The Woman in White* by Wilkie Collins, *Memoirs of a Texas Ranger*, and even true tales in crime magazines."[84]

After the Westons had been in Death Valley for close to two weeks Zohmah came and joined them. She drove there with a friend named Janey shortly after New Year's and first thing the next morning set out to find the Weston party at Texas Springs Camp; after spending the day "picnicing on the dunes & hiking up the narrow winding mosaic canyon," Janey went on to Las Vegas and Zohmah remained, spending the night with the Westons in their tent.[85]

The next day there was rain: "Mountains black & full of weather> Edward

photographs a rainbow & pools of sunrays."[86] As Zohmah's notes imply, Weston turned his attention to the sky, to a dramatic mixture of clouds and sun. Among the pictures he took that day was *Clouds, Death Valley* (fig. 36), in which light breaks through heavy black clouds that hover over the horizon.[87] The picture recalls Stieglitz's *Music #1* or even the much earlier *Gathering Storm*.

Weston had been interested in clouds for many years, initially inspired perhaps by Stieglitz. Most recently he had had success in Red Rock Canyon, where he had produced many wispy and delicate images, one of which Charlot had admired. But the current ones were somewhat different. For one thing, Weston tended to include the horizon, which imparted a pronounced sense of place largely absent in earlier examples. So too there is a greater concern with specific meteorological phenomenon—sun rays and rainbows and the like. As a result, the new, rather resplendent images are more dramatic and transcendent than the delicate, lyrical, calligraphic images of the year before.[88] Weston also took a picture of their campsite at Texas Springs, which, as Conger points out, would seem to be the only picture he took during the Guggenheim years that gives us any sense of their living arrangements. One of the tents may well be the one in which they all spent the night.[89]

The next day they rode up to Daylight Pass, where they encountered strong winds; after that they rode down to Badwater. That night they all had dinner at Furnace Creek Inn and sat through a speech about the "Redwood Empire" and kit boxes. Zohmah described the following day: "Everyone gets up singing 'Trees' & thinking about kit boxes> Warmer day, though first thing we ride up to Dante's View where there is snow> View breathtaking. Climb up a higher peak, thruw [through?] snow, breathe deep. See Death Valley. Lunch on a mud hill in 20 Mule Entrance\ Climb way up the Washes [?] & to tops of mud mountains> swim in the blue pool> Eat, read major Bell, & sleep by our evening fire>" On Sunday, January 8, they arose very early, packed the car, and drove back to Los Angeles. That night they all had dinner with Zohmah's friend Prudence, who played piano for them; Zohmah cut Edward's and Leon's hair.[90]

Before leaving Los Angeles Edward and Charis paid a visit to the MGM Studios, where Edward spent the day making pictures of dummies and elaborate staircases in the back lots. Some of these call to mind Atget's images of circus and carnival subjects, which Weston had singled out as among his favorites. After little more than a week in Los Angeles they returned to Carmel,

along with Leon. The day before their departure Zohmah dropped by; in her diary she reported that Edward was happy about his pictures.[91] It is not clear whether she was referring to the MGM pictures or the Death Valley imagery, or perhaps both, but in any case Weston had good reason to be pleased. Later Zohmah would speak of the MGM pictures in rather glowing terms: "Edward's pictures of MGM are more glamorous than the way the sets look in the movies. He has baroque curlicue steps with vistas of oil wells, and piles of staircases grouped together all leading up to the sky."[92] Charlot was more guarded in his judgment of the MGM pictures: he detected some surrealist leanings in these pictures, especially the one of mannequins (fig. 37)—which was partly set up, as Charis acknowledged.[93] For Charlot, it was in pictures like this that Weston began to wobble in his taste, and he attributed this straying off course to the influence of Charis. In his view, Edward was so smitten that he was willing to do anything to humor her.[94]

In 1938 Edward and Charis began to collaborate on a series of articles for the magazine *Camera Craft*, expounding Weston's views on photography. They were intended as a counterweight to the pictorialist photographer William Mortensen, whose views had already appeared in the magazine, at least by proxy. For a long time it was assumed that Edward wrote these articles on his own or largely on his own, but it has since been acknowledged that Charis did most of the actual writing, relying on previous statements by Weston as well as numerous conversations and informal interviews; Charis discussed this in some detail in *Through Another Lens*. Her goal, she explained, was "to make the articles sound exactly like Edward, but without the broad categorical statements found in his writing."[95]

In the first of the articles, "What Is a Purist," which appeared in January 1939, the authors responded to some of the misconceptions about straight photography that had been advanced by pictorialists like Paul Louis Hexter, Mortensen's friend; Hexter's recent article in *Camera Craft* was Edward and Charis's point of departure.[96] Surprisingly enough given his links to Group f/64, Weston viewed purism with a certain degree of suspicion. Far from being mechanical or dogmatic in his approach to the photographic medium—to exposure and development or to the making of negatives and prints—he permitted himself a good deal of latitude; for Weston, a certain degree of manipulation was acceptable. Moreover, some of his basic objectives with respect to artistic expression were not unlike those of the pictorialists—and

Weston seemed intent upon blurring the boundaries. In some respects it seemed almost as if he was edging toward pictorialism himself. Yet for all his protestations, Weston did not distance himself from purism entirely. In his view (as reported by Charis), there were photo-painters and photographers: "The basic difference between them is this: one group is striving to combine photography and painting in its processes and in its results; the other group uses only photographic means and is striving for purely photographic results."[97] While a certain degree of adjustment was possible, even desirable, there were important limits. Those who considered themselves true purists took fullest advantage of the basic properties of photography itself and — whatever slight changes they might make — avoided mixing in elements from other media.

The second *Camera Craft* article, which appeared a month after the first, focused on Weston's initial year as a Guggenheim fellow. It began with a discussion of what he termed "mass production": "I have long been aware of the potentialities for mass-production in photography — not only mass-production in duplication of prints, but mass-production in seeing. A Painter of prolific imagination might not be able to execute a hundreth of his ideas on canvas in a lifetime because of the time consumed by his recording process. But for the photographer seeing and recording are almost simultaneous. His output is limited only by his ability to see."[98]

Weston had already expressed in his daybooks how photography, in contrast to other media, fostered a heightened kind of seeing. He also had already mentioned mass production; in a short article in the *Magazine of Art* published in January 1939, he (and Charis) had characterized the Guggenheim experience as "a mass production year in seeing."[99] Now they went further, not only explaining the basic idea more fully but giving it a name. When Edward and Charis spoke of "mass production" in this context, they were perhaps being somewhat facetious — having a little fun at the expense of those who celebrated the mechanical nature of photography — but the basic principle involved was one that Weston took quite seriously and a matter about which he had started to think about even before he met Charis. Weston could not have anticipated the possibilities presented by current technology, but even his relatively cumbersome process of working with a view camera, in large format, had a distinct advantage over traditional media — provided the photographer had attained full technical mastery. Weston looked upon the Guggenheim grant as an opportunity to verify that proposition; the grant allowed him to work unimpaired, to mass-produce images, and although the fellowship had

not yet run its course (he was in the middle of the second year), he already looked upon the results with special favor.

Weston then went on the defensive, as if anticipating criticism from those who were expecting a literal document to result from the grant, a stereotypical record of California and the West—which, he explained, was not the objective. He had not photographed many of the most familiar monuments and scenes, nor were there many images of people. Nevertheless, the pictures were full of life. Indeed, Weston's intention was to photograph life in a most fundamental way, to reveal life through his subjects, whatever and wherever they might be: "I have tried to sublimate my subject matter, to reveal its significance and to reveal Life through it."[100] The remainder of the article dealt mostly with more practical concerns: his equipment, the food he and Charis ate, and some of the places to which they had traveled, including Lake Ediza in the High Sierra and Tenaya Lake, where Edward had photographed juniper trees. In these passages Charis's voice seems to come increasingly to the fore, and they anticipate some of the fuller accounts coming along in the next few years, like Charis's contribution to "Of the West" and the text of *California and the West*, which Charis wrote on her own.

At the end of February Zohmah again went to Carmel, travelling with Marie McCall. McCall rented a room near the Weston house and busied herself with her writing while Zohmah spent most of her time with Edward and Charis. As before, she helped them with a variety of projects, for as usual they had many balls in the air: not only did Zohmah work on captions for the *Westways* articles, but she also worked on some of the articles Edward and Charis were preparing for *Camera Craft*. They had already completed the two just discussed and were in the process of writing several more, starting with a discussion of lighting, followed by an article on photographic beauty.

When Charis spoke of her role in writing the *Camera Craft* articles she made no mention of Zohmah; indeed, she did not speak of Zohmah's visit at all. Nevertheless, as it turned out, Zohmah too played a key role in the creation of these articles: not only did she witness much of the brainstorming involved but she took down Edward's words in shorthand. She explained the process in a letter to Prue: "This letter started before dinner, and taking shorthand notes of a discussion on lighting for the next Camera Craft, Charis getting Edward to talk and I get it onto paper. Then the dishes and washing out some of my clothes and now I'm in bed."[101]

On subsequent evenings the process was repeated; the conversation shifted from lighting to photographic beauty and related matters. Afterward Zohmah would transcribe her notes and turn them over to Charis, who then transformed them into a finished text. In some cases it seems that Zohmah also typed the final draft.[102]

While work on the articles progressed, there were trips to the local library, where Zohmah did research for the *Westways* captions on the High Sierra and other places. There also were many diversions and distractions: Zohmah went on outings into town with Charis or Marie McCall, enjoyed crab at the wharf and long drives, read John Steinbeck's *In Dubious Battle*, saw a Western, and "listened to Gangsters on the Radio" with Edward.[103] A lot of time was also spent looking at pictures, including the MGM pictures and more recent photographs of junipers at Lake Tenaya. One day Zohmah's friend Lil Hobson came down from San Francisco and bought one of Weston's photographs. Then there was a visit from Johan Hagemeyer, "sad with failure."[104] Hagemeyer had applied for, but was not awarded, a Guggenheim Fellowship at about that time, which may explain his frame of mind.[105]

On March 22, as Charis was busy with the article on photographic beauty, Zohmah received a letter from Owen Plowe, Prue's husband and also an old friend. That letter, unfortunately now lost, precipitated a serious discussion that evening, which Zohmah recorded in her response to Owen. Her account provides a valuable glimpse into how artistic matters were discussed in the Weston household:

> Your discussion on art caused comment. I'll try to quote. Edward says, "not my conscious brain. A great artist gets beyond the point of striving, anymore than a driver of a car thinks about the mechanics, you just don't think. You see it and if it is right it is right and if it isn't —. You can't stop and put things into words."
>
> I shouldn't have started putting this into quotes. I'm not sure enough. Anyway he said, that he has no use for the over intellectual artist. Though that is a dangerous thing to say because who knows where intellect starts and if it isn't the same as emotion. Edward doesn't like theory and putting things down by rule.
>
> Each object, each picture, certainly has its own reasons and laws and you can't stop and think each time and formulate a new set of laws. From that point of view Piccasso's "jumping into the void" is o.k. Maybe Piccasso's whole article was alright.

Charis said, "Certainly isn't, through that throwing yourself into a void, a mystical state, but is not considering everything that has gone before that. Mystical being a much abused word."

Edward talked of William Blake in regard to mysticism; simply one that saw clearer than anyone else, not a person in a fog.

Edward, "For God's sake though I am certainly against any schools of expressionism."

Charis says that where your argument is to be criticized is wanting everything to fit into an even pattern, that it just can't be done, never does, and if you make it come out even it is because you have made a mistake.[106]

It is perhaps odd for a non-driver, as Weston was, to make an automobile analogy, but it is one he had made before, and his basic point about striving and technical mastery was important to him. Charlot had expressed essentially the same sentiments in his statement for the Increase Robinson Galleries announcement. Interestingly enough, Weston's analogy soon found its way into the article on lighting: "The photographer's first problem is to become complete master of his tools. And by complete master I don't mean just knowing their possibilities and being able to use them, I mean that their use shall become second nature to him, so that he no longer has to think about them, any more than an experienced driver has to think of the mechanical operations he performs in driving a car."[107]

Weston's distrust of theory was also of long standing. In "What Is a Purist," for example, he speaks in very similar terms. Although he stresses the importance of composition and pre-visualization, he makes it clear that good results are not a matter of following rules or formulas. He then goes on to say, "Again I am speaking only for myself when I say that my work is never intellectual. I never make a negative unless emotionally moved by my subject."[108]

In Zohmah's notes Weston refers to an article by Picasso, but in the statements by Picasso that Weston might have known (including two published by Armitage) there is no reference to leaping into the void, and it is unclear precisely what Weston had in mind.[109] Perhaps the phrase was something Owen Plowe said in his letter that prompted the discussion. Or perhaps it was Weston's phrase and he meant it in a general sense, referring to Picasso's fundamental break with the past. In any case, he seems to be saying that the creative process is more instinctive than intellectual, that the act of making a picture is a kind of leap into the void, a moment of release.

Charis apparently disagreed to some extent, although the nature of her objection is not entirely clear; it is hard to understand as Zohmah records it. But for Charis the idea of leaping into the void smacks of mysticism, and that made her uncomfortable; indeed, such a notion implies a mystical state of some sort, a trance or fog, which does not take into account a number of factors, such as the advanced preparation or state of readiness that is required. Weston hastened to clarify his point. He did not mean a person in a fog but rather a mystic like Blake, who sees things more clearly than anyone else. Charlot also had once spoken of a moment of clairvoyance, in a reference to Weston's work. Weston here seems to have more or less the same thing in mind.

The reference to Blake may come as a bit of a surprise, but in fact Weston had been interested in Blake for many years. Little more than a year after he left Mexico, for example, he spoke admiringly in his daybooks of Blake's illustrations for the book of Job: "A rare treat! A great artist, Blake! An hour with his engraving means more to me than a month of reading,—more spiritually,—for my eyes receive—and give—more directly, surely, than any other of my senses."[110] Later on, in a *Camera Craft* article, he again invoked Blake in connection with clarity of vision: "William Blake wrote: 'Man is led to believe a lie, when he sees with, not through the eye.'"[111] For Weston, photography enabled one to do precisely that, to see clearly through the eye, not just with it. To Weston, Blake had long represented someone who understood reality on the most basic level—not a mystic in the ordinary sense—and that is the view Weston comes back to in the remarks taken down by Zohmah. The mention of Blake in this context does not signal a growing interest in mysticism but rather echoes a longstanding conviction that art is about the real world.

Weston's condemnation of expressionism—"For God's sake though I am certainly against any schools of expressionism"—can be understood in similar terms. He had long spoken of photography as a means of creative expression; his own piece in the 1932 book of his photographs was titled "A Contemporary Means to Creative Expression."[112] But in statements such as these Weston was not speaking of expressionism as a movement or a style. What he had in mind was the expression of some inner reality, not self-expression in a more exaggerated or self-indulgent form. Once again he reveals his concern with recording the essence of things, with fundamental qualities, not passing moods or personal interpretations, which are either trivial or pretentious. When Weston disassociates himself from expressionism, he wishes to distance himself from the latter, not the former, and in doing so his views are very much akin to Charlot's.

Charis and Edward got married in Elk, she was confirmed at the Mission Dolores in San Francisco.[116] Three days later she saw the Westons—and now they were officially the Westons—again in Carmel; while there she heard about their recent adventures, including, of course, their marriage. She told them of her own marriage plans, which took them by surprise, although they were also glad; afterward they all went out dancing.[117]

Meanwhile, Jean, who was still on the East Coast, was finishing up his latest project, murals depicting the story of St. Bridget for a church in Pea-pack, New Jersey; once they were done he flew to California, on May 26. His plane was forced to land in Oakland instead of San Francisco because of fog, which caused some confusion and delay, but all that was quickly sorted out and Jean made his way into the city, where he and Zohmah were married the same day. Three days later, on May 29, Jean and Zohmah—the Charlots—traveled to Carmel for a brief stay; Zohmah noted in her diary: "warm ride to Carmel. Charis throws rice at us."[118] The next day they went to Edward's favorite spot: "To Point Lobos. Edward makes photographs of us. We walk the cypress trail."[119]

The pictures in question, which later came to be called *Honeymoon* or "the Honeymoon pictures," show Zohmah and Jean sleeping, or appearing to sleep, on the rocks. In one (fig. 38), the newlyweds are positioned at angles to one another, which echoes the arrangement of the rocks on which they are lying. Jean's head, partly covered by a floppy hat, rests against one of Zohmah's knees, and his right arm reaches around behind it. As Amy Conger put it, "the fairy-tale rock formations and the soft, opaque mist in the upper right corner contribute to the mood of the picture, which Weston framed with extraordinary care."[120] In the variant, the figures have shifted position slightly: Jean's arms are now crossed over his stomach and his hat now covers Zohmah's exposed knee (Zohmah was apparently somewhat sensitive about her knees), and there is more sea foam around the rock in the distance.

In certain respects the new portraits recall the double portrait Weston had taken in 1933, when Jean and Zohmah were last in Carmel together. Both pictures are among the most romantic pictures that Weston ever took, but the later ones seem less fraught and more relaxed. Jean and Zohmah are now clearly more comfortable with one another—and if the earlier double portrait showed Zohmah's subservience to Jean, as some have said, that is no longer the case here. In formal terms, *Honeymoon* reflects the general shift that took place in Weston's approach in the second half of the decade—that is to say,

the opening out that occurred in many of his pictures. The earlier portrait is close in and tightly composed, like the vegetables and many of the nudes of the early and mid-1930s. The *Honeymoon* pictures have more breathing room; although the images are carefully composed—indeed, the basic underlying structure is much the same—Weston takes a more distant vantage point and the emphasis on form is not as apparent.

Zohmah, much later, recalled how the pictures came about: "Jean and I went to stay with them on our honeymoon and were napping on the rocks on Point Lobos while Edward was prowling about carrying his big camera. When he later showed us just the perfect view he had focused on, it was us! This became one of his favorite pictures."[121] Weston himself, speaking specifically of the version in which Zohmah's knee is exposed, described the situation in similar terms: "A picture should not need explanation. I discovered the Charlots in this graceful and romantic posture, resting after a picnic lunch on Point Lobos. Call it a candid shot if you will."[122] Charis, however, had a different impression, and later claimed in a letter to Zohmah that the picture was not as candid as it seemed: "although lord knows you two look so sacked out that no one would imagine you were faking."[123] Charis might not have been present when the pictures were taken, but she nevertheless may have a point. The differences between the two versions go a little beyond the natural shifts that take place over the course of a nap and suggest that the subjects were not altogether unaware. Moreover, it seems almost as if special care had been taken to conceal Zohmah's knees, in consideration of her feelings on that score, and that would again suggest a collaboration between subjects and photographer. Conceivably, Weston came upon the scene much as it appears; it struck him as graceful and romantic, as he says, and as he proceeded to make the picture the Charlots became aware of his efforts. Some adjustments may have been made, spontaneously or at Weston's suggestion, but they were minor enough for him to regard the scene as essentially a found one rather than something he had set up from the start—candid in spirit if not in fact. In any case, these images must have appealed to Edward Steichen, because he would use one version (the one with Jean's hat on Zohmah's knee), in his *Family of Man* exhibition a little more than a decade later.

7

ATHENS, GEORGIA

Edward and Charis had officially been married almost two months when, on June 19, 1939, Charis's father, H. L. Wilson, passed away.[1] By that time the Charlots were in Iowa. After leaving Carmel they had headed south to Los Angeles and then on to Santa Fe and Taos, New Mexico. On June 16 they arrived in Iowa City, where Jean was to teach summer classes at the University of Iowa. Shortly after their arrival they received a batch of photographs from Edward, perhaps including *Honeymoon*, and on July 7 Zohmah, pining away for the cool Pacific, wrote Edward to thank him, in very effusive terms: "Both Jean and I have been going to write to you every day, but we both want to hug you more than to write to you. We just love you and we are so extra specially pleased with your pictures. THANKS is a very little word even as big as the typewriter makes it. Even as big as we think it for such a present."[2]

She also reported on their new experiences and in particular told of their encounter with Grant Wood, whom Jean had known for some time; Wood had probably been instrumental in bringing Charlot to Iowa. The two artists shared an interest in the development of local or "home-grown" art (as a newspaper clipping put it) in preference to imported European styles. Wood must have been a topic of conversation in Carmel, for in her letter Zohmah had no need to give his name, referring to him simply as "the Iowan Master": "We met the Iowan master. On his easel were three stages of a picture of a wheat field. The first one done from nature, then another erased [*sic*] and changed, then another with colors." It is not clear which work Zohmah was

165

referring to, but she was not entirely impressed; for Weston's benefit she commented on the work in photographic terms: "He didn't see his picture on the ground glass." She went on to speak of how Wood showed them a book of illustrations that she liked better and then added, "And his house is almost as entertaining and good as yours."[3]

Zohmah then turned to other matters; having read about H. L.'s death she tried to cheer Charis up. "Tell Charis, to try and make her smile, that while making a list for Jean's students, I typed under a picture of the Grand Canal, 'View of Venus.'" Charis had often expressed her amusement over Zohmah's malapropisms and misspellings; Zohmah was hoping that this latest example would lift her spirits. And a little further on, she added, "I didn't know until 'Time' today that Mr. Wilson named flappers. That is something." At the end of the letter she came back to the pictures Edward had sent them: "We showed your pictures to some people and they said we know Weston as an exponent of sharp focusing and slow exposure. So Jean wants me to ask you how you make the waves behave."[4]

Weston produced relatively few new pictures that summer. He was mostly preoccupied with his family and with printing the negatives from the Guggenheim trips, but he did photograph Maudelle Bass, a dancer who had modeled for Johan Hagemeyer, Diego Rivera, and Manual Alvarez Bravo, among others. In 1939 she was in Carmel to perform African dances, and Weston took the opportunity to make some new nudes.[5] The first sitting took place in July at Carmel; a second sitting took place at Oceano in late July and early August.[6] Soon after Weston returned again to Point Lobos, where he had photographed many times before. This time he concentrated on tide pools. One of the best-known examples shows kelp floating on the water; he also made a hallucinatory image of a dry tide pool with salt-encrusted algae.[7]

During the same period he produced several arrangements—as he himself referred to them—that featured, in various combinations, a lily, the remains of a wooden duck, and in some cases, curved pieces of carved wood—graceful arabesques, probably from a discarded chair or some other piece of furniture. Unlike the kelp and tide pool images, these photographs were carefully set up and in that respect recall *Shell and Rock—Arrangement* of 1931, to which some of his friends, like Ramiel, had taken exception.[8] The objects in question were moved about and moved again to produce different compositions, variations on a theme. In one the duck and lily are shown together, in another the head

of the duck is juxtaposed with the wooden arabesques, and in a third the wood and lily are covered over by a piece of broken glass, which almost creates a diamond-shaped picture within the picture, at the heart of the composition.[9]

In these changing combinations of flowers and junk, Weston seems to enjoy not only the formal beauty of the discarded objects, the intertwining curves, but also the odd, incongruous contrasts between the real and the artificial, between an actual flower, a wooden decoy, and kelp-like carvings. There is something almost comical about these improbable juxtapositions, but they are also rather poignant, even elegiac. These images are best understood, perhaps, in the context of surrealism, where such incongruities are common coin. So too they are strikingly similar to what Frederick Sommer was doing with chicken parts and the like—at roughly the same time—and Sommer's work has likewise been tied to surrealism, to the surrealist taste for the grotesque. Weston himself would have rejected such connections, but in this set of arrangements he seemed to be leaning, at least in part, in that direction.

The results of the Guggenheim trips were published in a series of articles in *Westways* starting in August 1937, and the money Edward and Charis received for the material was an important supplement to the Guggenheim grant. Each article concentrated on a particular region and included about half a dozen photographs by Edward, with captions and a brief text by Charis (for some of which Zohmah had done research during her visits to Carmel). Weston seems not to have taken these publications very seriously, but the layouts must have made him cringe, especially in the earliest articles. In some cases the pictures were artfully strewn across the page, like postcards or playing cards spread out on a table. Occasionally they overlapped one another, and in many cases the reproductions were quite small. The design of the later issues is less extreme—perhaps Edward and Charis had complained—but the presentation still does not do justice to Weston's work.[10]

The last collection appeared in the summer of 1939. It dealt with Monterey Bay and vicinity, including Point Lobos. Soon after, the *Westways* articles were collected in a slim volume, *Seeing California with Edward Weston*, which appeared at the end of the summer.[11] The book comprised twenty-one articles spanning roughly two years, and altogether there were 131 black-and-white photos (many more than would later appear in *California and the West*). It was the public's first comprehensive glimpse of what Weston had been up to during the Guggenheim years. By way of a preface there was also a brief article by Weston, reprinted from the *Magazine of Art* (January 1939), explaining his

project and procedures and touching on the question of mass production.[12] Although the context had now changed, Weston still saw the Guggenheim project in the same terms, as an experiment in "mass production" and as a demonstration of his theory.

The Charlots' Iowa sojourn was relatively brief. At the end of July they left and headed for New York City by way of Niagara Falls (for a more traditional honeymoon, perhaps); they arrived in the city on August 2. Soon afterward Jean's new book, *Art: From the Mayans to Disney*, was published. It included articles from the 1920s and 1930s on Mexican art, Posada, and pulquería paintings, as well as on Pintao and Orozco, some of which appeared in English translation for the first time; so too some of the more theoretical articles on cubism and surrealism were reprinted from *American Scholar*. In addition, there were essays on American artists, including Shore and Weston, as well as two recent essays on Disney and animation.

The article on Weston essentially combined two earlier efforts: Charlot took his essay from *The Art of Edward Weston* and, at the end, added his statement from the Increase Robinson Galleries announcement. There were only small changes, a phrase here, a sentence there; otherwise, the wording remained largely the same and so did the message. Charlot still valued most of all the directness of Weston's approach and his self-effacing attitude: "With a humbleness born of conviction, the artist distracts our attention from himself as spectacle, shifts it to nature as a spectacle."[13] Although written about work dating from the early thirties or earlier, Charlot's words were equally applicable to much of Weston's work of the later thirties—except perhaps for the arrangements.

Charlot reiterated some of the same ideas in his essay on Henrietta Shore, which follows the Weston piece in the new book. As before, he refers in particular to her self-effacement: "Her evolution of means achieves autonomy through a desire for self-effacement."[14] But near the end of the essay Charlot also speaks of the absence of anthropomorphism in her work. At the time it was not at all unusual for critics and other commentators to seek human references in modern art and photography, in images that were relatively abstract, but it was also common for artists to resist such associations. Stieglitz, for example, had expressed annoyance when viewers sought sexual imagery in his pictures of clouds, and O'Keeffe had felt same way about her paintings of flowers. So too Weston had always resisted sexual interpretations of his

pictures of shells and peppers; according to Charis, Edward had little patience for seeing the subject of a photograph as synonymous with something else, for what he called "double vision" or "seeing Lincoln's face in the clouds."[15] He was not interested in hidden symbols but aimed instead at showing the thing itself. Shore was of the same mind, as Charlot explained: "The world of Shore is made peculiar by an absence of anthropomorphic delusion. In this world of rocks, birds and flowers, man and man's moods play little part. Her trees need not ape human gestures to be significant, nor her flowers a corsage. Rather does she subject the few humans she portrays to laws of vegetable growth and mineral erosion."[16] Charlot could have said much the same thing about Weston.

The Shore article is accompanied by one of her lithographs (*Canadian Weed*, 1925). Charlot had apparently intended that the article on Weston be illustrated as well, but since there were no halftones in the book he attempted to make a line drawing of one of Weston's photographs; in that way, he thought, he would able to include something at least. Unsatisfied with the result, he quickly gave up and explained the situation, somewhat apologetically, to his friend: "I blushed at my attempting to line-draw your photograph, so that your article will go unillustrated in the book, no half-tones being included." On a more personal note, Charlot then added, "All happiness to you both and thanks for your own wishes for us both—California is [tear at edge of page] becoming very dear to me. I [the "I" is partly torn] dream of settling there and of giving piggy-back rides to my grand-children!"[17] As we shall see, Charlot would spend a bit more time in California but his dream of settling there would not be realized.

At the end of summer, as work continued on the Guggenheim project—Edward's pictures and Charis's text—and as preparations were being made for publication, Weston was approached to do an article on photography for the *Encyclopaedia Britannica*. He agreed, but on the condition that he could approach the topic his own way rather than simply revising the older entry by the British editor and pictorialist F. J. Mortimer, which had concentrated on printing processes, like Bromoil.[18] Weston wanted to start from scratch, giving his contribution a more American slant, and once the arrangements were made work got underway immediately. As before, Charis, it seems, did most if not all of the actual writing, although presumably the views expressed were Edward's; this time Zohmah was not involved. By November of that year,

after several months of concentrated effort, the writing was largely completed and the entry was sent off to the publisher.[19] The net result is quite revealing; although it reiterates some of the ideas presented in the earlier *Camera Craft* articles, it represents a more comprehensive discussion of the art of photography, with more historical context, than any of Weston's previous statements.

The entry begins by asserting photography's unique artistic potential and describing the development of the photographic art by those who sought to have photography recognized as an art form. In this Weston relied on the broad outline Beaumont Newhall offered in the history of photography he had recently published.[20] After describing the early technical evolution of the medium, Weston turns to what he calls "The Painter's Tradition" and, although he doesn't mention them by name at this point, he speaks first of all of photographers like Oscar Rejlander and Henry Peach Robinson, who were "content with swathing their models in flowing draperies, or creating genre studies with costumed figures and painted backgrounds, or combining parts of a variety of negatives into one composite print."[21] As Weston tells it, such efforts eventually led to the extremes of pictorialism, or what he describes as a kind of "photo-painting" in which the image is so altered that all traces of its photographic origins disappear. For Weston, here was a delicious irony: in an effort to demonstrate its artistic worth photography had denied its own existence.

Weston then credits Alfred Stieglitz, as leader of the Photo-Secession, with leading photography away from such absurdities; although Stieglitz and other members of the Photo-Secession accepted soft-focus lenses and the like, they "eschewed all manual interference with the camera's image as unphotographic." In other words, Stieglitz led the way toward a purer use of the medium in which photography's unique qualities were reasserted. But this sort of purism led to absurdities of its own when taken too far. Although he was certainly more of a purist than a pictorialist, Weston rejected the extremes on both sides, and a little further on, reiterating his 1939 *Camera Craft* article on purism, he states. "But there were heated debates over purist *vs.* pictorialist methods and a great deal of misunderstanding was fostered, first by the failure of both sides to define clearly the terms they employed, and second, by a tendency on the part of many photographers to mistake means for ends and consider the method of production more important than the product itself."[22]

This relatively balanced characterization of the opposition between purism

and pictorialism is somewhat surprising. After all, earlier in his career Weston had struggled to free himself from pictorialism, and he later joined forces with Adams and others to form Group f/64. Adams was especially vocal in his defense of purism and lost no opportunity to express his antipathy toward William Mortensen, who for many West Coast photographers, Weston included, represented pictorialism at its worst. Although Weston's attitude may have softened somewhat toward the end of the thirties, he still clearly identified himself as a purist, with only minor qualifications. In this context, given the vigorous debates of the past, the new discussion is quite tolerant; it reveals a degree of flexibility that not all of his f/64 associates would have shared.

But if Weston seems to be backing away from the most extreme positions held by photographers in his own circle, such as Adams, he is not embracing the artificiality of Mortensen or his forebears. After speaking of previsualization, he comes to the question of subject matter and upholds the principles of straight photography. In explaining his position, he comes back to Rejlander and Robinson, whom he contrasts with Mathew Brady, Alexander Gardner, and other photographers of the American Civil War. For Weston, the comparison brings out the artificiality of pictures like Rejlander's *Two Ways of Life* and Robinson's *Fading Away*: "Beside these photographs [by Brady, Gardner, et al.] the artistic efforts of Rejlander and Robinson appear self-conscious, stilted, and artificial. Their carefully posed and costumed figures look absurd and unreal."[23]

Newhall, in the first edition of *History of Photography*, had spoken of Rejlander and Robinson only briefly, in a matter-of-fact way; he was not a champion of their approach but did not condemn them. Weston, by contrast, is more openly judgmental here. He is likewise critical of some of his contemporaries, perhaps including Man Ray or even Moholy-Nagy, although he names no names: "But even today many photographers who attempt to use it as such still cling to the weak effects of photo-painting, while others imitate the work of abstract painters with 'shadowgraphs' (recording shapes, shadows, and sometimes a degree of texture by laying various objects on sensitized paper and then exposing it to light)."[24] Although he acknowledges the extremes of purism—especially with regard to technical matters like burning and dodging—he nevertheless defines the medium in relatively narrow terms.

The entry concludes with a statement that echoes some of Charlot's comments on Weston that had recently appeared, in modified form, in *Art: From the Mayans to Disney*. Likening the art of photography to Chinese brush

painting, Charlot had spoken of how hand and wrist give way to the mastery of the machine and how spiritual passion is revealed in a fraction of a second.[25] In a similar vein, Weston asserts here that, in the right skilled hands, visualization and realization are nearly simultaneous; he then goes on to explain how the combination of "keen perception" and technical mastery makes possible the sort of mass production of which he had spoken before: "Conception and execution so nearly coincide in this direct medium that an artist with unlimited vision can produce a tremendous volume of work without sacrifice of quality. But the camera demands for its successful use a trained eye, a sure, disciplined technique, keen perception, and swift creative judgement."[26] In the past Weston had spoken of mass production primarily in relation to the Guggenheim project, but now he applies it to the art of photography more generally, without referring to a specific project.

Weston's choice of illustrations is also revealing. The old *Britannica* entry had been illustrated with photographs mostly in the pictorialist tradition, including the work of Rudolph Koppitz and Alexander Keighley and a seascape by Mortimer himself; the only exceptions were portraits by Stieglitz and Steichen.[27] Weston, by contrast, emphasizes more modernist imagery: Stieglitz and Steichen are again included, but so are Strand and Sheeler. The West Coast is also well represented: Weston selected examples by Ansel Adams (*Barn, Cape Cod, Massachusetts*) and by his son Brett (*Sand Dunes, Oceano*), along with two of his own portraits (*Carma-Lita* and *Teddy*). Although Weston had been reluctant to use his own work (and the examples he did use were less prominent than most of the others), he nevertheless positions himself, in the broad history of the medium, as the culmination of a long struggle to define photography as an art. While acknowledging Stieglitz's historical significance, he implicitly places himself in the photographic vanguard, along with Brett and Ansel Adams.

As work got underway on the encyclopedia entry, Weston wrote the Charlots to tell them of the latest developments, and Zohmah, in one of her chatty letters, passed the news along to Prue. Not only did she mention that Edward had written to say that he had been asked to do the photographic section for the new *Encyclopedia Britannica*, but she also alerted her friend to Weston's upcoming retrospective at the Morgan Camera Shop in Hollywood. Then she added, "and he says the picture he took of me and Jean is included under title, 'Honeymoon'. Hope you get to show—and you might tell anyone interested."[28]

The retrospective exhibition to which Zohmah referred took place from November 1 to December 24, 1939, and comprised almost two hundred prints, starting with an early snow scene taken in Chicago in 1903 and ending with his most recent efforts. It also included numerous pictures from the Mexico years; shells, a pepper, rocks, and cypress; a variety of nudes from the thirties; and numerous portraits from the same period, including one of Jean from the 1933 visit to Carmel and another of Jean and Zohmah together. *Honeymoon* was probably featured among the post-Guggenheim images, at the end of the show, along with some of the Maudelle Bass pictures.[29] According to Gilbert Morgan, the show was well received and well attended—approximately two thousand people came to see it, but unfortunately, only one print out of the whole show was sold.[30] That must have been a serious disappointment, but perhaps it was not altogether surprising given the continuing economic difficulties of the time.

Zohmah made no mention of it in her letter, but Jean was again at work on the *Carmen* project that he had begun two years earlier. Most of the plates were done at this time, and a limited number of proofs were made of each subject. But it seems that, while the work was proceeding, Macy began to have second thoughts about what Charlot was doing and considered backing out of the deal altogether. Charlot later recalled, "Once he [Macy] phoned me and said, 'How is it coming?' I said, 'Well, it's going to be the most beautiful printing job in color lithographs ever done in the United States.' 'No, no,' he said, 'I don't mean that. I know the printing is good, but I'm worried about your *art*.'"[31] Macy's apparent skittishness here, his mercurial nature, presages the difficulties Weston and Armitage would encounter later on, but it seems that Macy's doubts were satisfied and the matter was resolved or at least set aside. By early January this phase of the project was complete.

A few weeks after the Morgan show came down, Weston's Guggenheim work was featured in a special section of the *U.S. Camera* annual for 1940: "Of the West: A Guggenheim Portrait." There were nineteen Weston photographs altogether, including *Dead Man, Colorado Desert*; *Grass and Sea, Big Sur*; *Yuma Nymph, Arizona*; *Golden Canyon, Death Valley*; and *Golden Circle Mine, Death Valley*. Most of them had not been published before: they had not appeared in the *Westways* articles, in *Seeing California with Edward Weston*, or anywhere else, and they provided a preview of *California and the West*, work for which was already underway.

"Of the West" was accompanied by a brief statement by Weston, which draws on several earlier discussions of his experiences during the Guggenheim years. He reiterates his theory of mass production and then goes on to speak of his technical procedures: "Almost all of these pictures are the result of one negative. (I made duplicates only when my subjects were fast-moving clouds, breaking waves, animals, etc.)."[32] Not long before Charlot had asked, partly in jest, about how Weston made waves behave; although perhaps not intended as such, this represents something of an answer.

After that Edward turns the discussion over to Charis ("the chauffeur-chronicler of the expedition, my wife"), and so begins the main text, which contains the germ of what would soon appear as *California and the West*. Her discussion covers both years of the grant, although she gives more attention to the first. Charis provides only a relatively brief summary, but her anecdotal style, her bemused approach to life, and her wry humor are already evident. There is little consideration of serious aesthetic concerns or technical challenges and more discussion of travel and adventures, which nicely complements the imagery. Charis had played a role in writing Weston's previous statements on photographing California, but here she speaks for herself, in the first person. Although she draws on material that had appeared before, Charis's own voice begins to emerge.

Weston's section takes up nearly twenty pages near the beginning of the volume. The rest of the annual is an interesting compilation, providing a revealing cross-section of photographic imagery from the period and including many familiar names. There are, for example, photographs by Ansel Adams and Willard Van Dyke as well as Brett Weston. Clarence John Laughlin is represented; so too there is a picture by Dorothea Lange, *Doorstep Document*, of someone asleep in a doorway. In a more commercial vein, there is an advertising photograph by Edward Steichen, made in Honolulu for the Matson Line, which shows a young woman against a background of lush foliage.[33]

The volume had probably gone to press only shortly after Hitler made his move on Poland in the fall of 1939, so no pictures of the invasion itself or related events are included. But the section on news photography begins with a brief text that refers to recent events and ends on a rather plaintive note, with a false hope:

The great news of the year became news after this issue of "U.S. Camera" went to press. Perhaps in a war-torn world it is just as well that these pictures

be of the life we live under the normal regime of American existence. It is not our intention to ignore anything that the camera does. And it is obvious that the camera becomes at once the great ally of truth and untruth, propaganda and news, when nations enter declared or undeclared war. Our hope, and wish, is that "U.S. Camera 1941" will be published in a world at peace. And though "U.S. Camera" has often carried pictures of strikes and internal strife, may it never be given any opportunity to picture America at war.[34]

Although most of the pictures give no real indication of it, war was on the horizon, and circumstances would soon make a mockery of the editor's plea.

In late 1939 or early 1940 Edward wrote a long letter to the Charlots (which has not survived), and he also sent along a copy of the *U.S. Camera* section, which Zohmah acknowledged soon after: "And thank you for sending the U.S. Camera section as I haven't had courage to go in a shop and ask to be allowed to look through it free. Jean had seen it at Brentanos book store. The reproductions seem good. Certainly lose much less than in most magazines."[35] Edward had perhaps expressed his concern with the quality of the reproductions, and Zohmah was attempting to reassure him. She also said she was enclosing two reviews, from the *Herald Tribune* and the *New York Times*, in case the Westons had not seen them.

Zohmah went on to recount rather momentous news. Just before Christmas, Jean had received his mobilization papers. His friend Paul Claudel had also been called up and was leaving for France. America was not yet in the war, but France was seriously threatened and the French were preparing for the German advance. Jean had been an artillery officer in World War I and, although he was almost forty-two years old, his services were once again required. According to Zohmah, Jean was supposed to be in France by March 22. He had already applied for U.S. citizenship by the time the mobilization papers arrived, but the process would not be finalized before the March deadline.

The situation was further complicated by the fact that Zohmah was expecting, which they had not mentioned to the Westons before; the baby—the Charlots' first child—was due in April. If they were going to leave the country, it was important to do so fairly quickly, while Zohmah could still travel; otherwise, she would be left behind and separated from Jean for an indeterminate amount of time. For Zohmah the uncertainty of the situation was

clearly distressing, but she was hopeful that Jean's return to France could be postponed, at least long enough for his U.S. citizenship to come through; that would make it easier for the Charlots to remain together in the United States.

Zohmah then continued her letter on a lighter note, and toward the end, she referred back to Weston's Los Angeles show at the Morgan Camera Shop. She had heard nice things about it, she said, and she added a humorous poem that Owen Plowe had written in response to it:

This free, wild world of visual things
It sure must be ashamed.
For it has always heretofor
Fled those who would have tamed
It, forced it into symmetry
And patterns, hung it framed.

But now for Edward Weston's eye
It meekly forms design,
Swings into balance, limns its forms
With contrapuntal lines,
Sits up and begs, leaps thru his lense,
Rolls over, lies supine.

For others it's still fractious, wild,
For him its sweet and trusting.
If you ask me, its been bequiled [beguiled],
And I think its disgusting.

The wild world of visual things—the subject of most photography—is likened, oddly enough, to a dog, a wild and fractious dog who behaves better for Weston and his camera than for others. How Weston—more of a cat lover than a dog person—responded is not known; Zohmah made no further comment on the matter. Then, after mentioning the recent Picasso show at the Museum of Modern Art in New York ("'everyone' loved the Picasso show too, too much"), she signed off with greetings to Charis and the cats: "Handshakes to all the cats. Love to the cara Charis and to you."[36]

Fortunately, Jean's military status was temporarily resolved in February, shortly after Zohmah's letter to the Westons, when he was appointed *officier du chiffre* with the French Commision d'Achat. He would work in a liaison

office in New York, taking orders for military supplies and equipment, and the danger of being separated from his expectant wife was averted.[37] Although he was able to remain in the United States, this was not a productive time for Charlot; he was so taken up with his military duties that he had no time for painting. Then, with the birth of the Charlots' first child, Ann, there were new family responsibilities. A little more than a week after the birth, Zohmah wrote to Edward and Charis from the hospital: "When I was writing to Charis I almost said the baby would probably get born on her [Charis's] birthday. However she waited until April 10th. Jean brought me to the hospital at 4:30 A.M. and wasn't even allowed upstairs with me. That was the worst part, being left alone in a dismal room."[38]

The baby was born several hours after Zohmah entered the hospital, at 8:05 a.m., but Jean did not find out until a little later: "Jean in the meantime went to the park to wait for proper visiting hours, of all things, which was 11:00 o'clock. By that time I had been put in a pleasant room and was getting really conscious from the ether. But as there was a large ice pack on my tummy, Jean didn't even know the baby was born. However I was just as amazed as he was when the nurse brought her in, she was so purple and her little face still kind of folded up. Jean thought she was beautiful right away."

A little further on, she said, "We will be pleased when we can introduce Ann Maria to you," and then she asked, with an implied wink, probably thinking that Charis was a Taurus and might know about such things, "What are the characteristics of Taurus?" Astrology was obviously a familiar topic for the two friends — there was no need to explain the reference — but Zohmah did not dwell on it, and she concluded by asking for news: "Hope the book is zooming along swell. Write us soon as you can news and gossip about the pictures you are taking." She signed off, "Lots of love from all the Charlots."

The Westons seem not to have responded right away; there are no further letters for many months, but in early June, almost two months after Ann was born (and a week before the Germans entered Paris), Jean was finally granted U.S. citizenship.[39] Soon after, he received a letter from his direct superior dismissing him from the French army; the office for which he had been working had, in effect, ceased to exist, and Jean's military status was fully resolved.[40]

During the spring of 1940 Weston had been only slightly more productive than Charlot. In February problems arose with *California and the West* when Tom Maloney, the editor, wanted to include some of Weston's earlier portraits,

an idea Weston resisted; then, in April, there were problems over reproductions for the encyclopedia article. All along, as Weston put out these little fires, the printing of the Guggenheim pictures continued, but he produced very little in the way of new images. Meanwhile, Charis was busy with the text for *California and the West*, expanding on what she had already written for the *U.S. Camera* annual earlier that year.[41]

In June 1940 Weston went to Yosemite, where he and Ansel Adams led a photographic workshop sponsored by *U.S. Camera*; Charis went along, and while there she continued to write, although she also spent some of her time ferrying Edward and the students from one location to another. One day, during a lesson in portraiture, Edward and Charis were photographed together by one of the students, a friend of Willard Van Dyke by the name of William Holgers. As Charis related, "On a morning when the subject was portrait photography he [Holgers] and several other students took pictures of Edward and me posed in front of a tree, but they insisted that Edward stand up and I sit next to him so I wouldn't be taller. This may have improved some of the pictures in an unexpected way—I'm sure it accounts for Edward's look of mild amusement."[42] In another shot the two of them press more closely together and look away toward the right with serious, pensive expressions. Long afterward, Charis would use the latter image for the dust jacket of her memoir, *Through Another Lens*.

After Edward and Charis returned to Carmel, Beaumont and Nancy Newhall came for a stay, along with Adams. The Newhalls had been in San Francisco to visit Adams and see the *Pageant of Photography*, an exhibition Adams had organized for the Golden Gate Exposition (which celebrated the completion of the bridge); it included a historical survey of photography as well as smaller group shows and individual sections, one of which was devoted to Weston.[43] After their stay in the city, Adams drove the Newhalls to Carmel, and Edward, who had been in San Francisco speaking to a group of photographers, came along for the ride. Edward had already been in contact with Beaumont Newhall for some time; he had been included in Newhall's ground-breaking exhibition on the history of photography in 1937 and the publications that stemmed from it, but this was the first time the two men had actually met, and it was Edward's introduction to Nancy Newhall. They would all soon become good friends.

When the group arrived in Carmel, they were welcomed by Charis, and later the newcomers were introduced to the host of cats, one of whom was

named Zohmah.[44] During his stay Beaumont made prints in Weston's dark-room, and when he saw them Weston expressed his surprise: he was puzzled that Newhall had not dodged any of them. Newhall had been assuming that purist standards precluded any sort of manipulation at all, including burning and dodging (i.e., how, during the printing process, light is selectively held back or intensified). Weston, however, was not as inflexible as his visitor imagined. He took Newhall back into the darkroom and gladly explained his dodging and burning techniques, which he regarded as a legitimate form of adjustment. As Charis later put it, "There is a real difference between burning and dodging to bring out more clearly what is on the negative and the kind of manipulations that Mortensen and his fellow Pictorialists did, and that added, removed, or significantly altered what was captured on the negative."[45]

Charis had completed about half of *California and the West* when the Newhalls came to visit, and she showed the unfinished text to them; she finished writing the book in the fall of 1940. By then Edward had also completed the printing—at least of the images required for the book—and both text and pictures were delivered to the publisher. Several years of hard work were finally over, and the Westons were obviously relieved, but they waited until the book actually appeared several months later before doing any real celebrating.[46]

In the summer of 1940 more trouble developed over the production of *Carmen*. On June 24, 1940 (while the Westons were in Yosemite), Macy wrote to Charlot expressing his dissatisfaction with Merle Armitage's design. Indeed, he seemed to be thinking of altering his original plan of action and dropping Armitage from the project, as he had almost done to Charlot not long before. Charlot responded, "There seems to be a jinx on the printing of 'Carmen.'"[47] Jean, together with Zohmah and Ann, was in Iowa at the time, so the matter was deferred until his return to New York. But Charlot must have been troubled by Macy's repeated changes of heart and was probably wondering whether the book would ever be published or if his artwork would be included or presented in a satisfactory way.

While in Iowa the Charlots renewed their friendship with Grant Wood, and at the end of their stay, on August 3, Wood took them to the train station; three days later they were back in New York.[48] The following month Charlot met again with Macy to talk about *Carmen*; it is not known what was said on that occasion.[49] Presumably the project was put back on track, but it is not

clear on what terms and whether Armitage, who was eventually pushed aside, was at that point still involved. In any case, the entire episode foreshadows the difficulties Weston would experience soon afterward in his dealings with Macy over *Leaves of Grass*.

That fall Charlot concentrated on a different theme, the Flight into Egypt (when the Holy Family fled to Egypt to avoid the slaughter of male infants ordained by King Herod). In October and November he did a number of paintings devoted to the subject. Although Charlot had represented the Flight into Egypt before, it had suddenly become more important to him.[50] Indeed, it was conceivably a reference to his own recent situation—to what was happening in Europe at the time, his military status, and the safety of his family. By this time all of continental Europe was under the control of Hitler; the Charlots might well have been trapped there had things gone a little differently, but Charlot had managed to shield his family from such dangers and they were all now relatively safe.[51] The Flight into Egypt clearly represents a comparable situation, and Charlot must have recognized the parallel.

At the end of November Zohmah reported to Prudence that Edward had written to say that his book *California and the West* was about to be published.[52] The letter itself did not survive, but in it Weston had apparently asked for snapshots of the Charlots and their new baby. Zohmah rushed to the drug store and had some developed, which she promptly mailed off with a letter. One of the photos showed Jean and Zohmah with Ann at the christening party; there was a close-up of Ann at five weeks and another at five months; and there was also a snapshot of Grant Wood holding Ann as they waited for the train at Iowa City, just before the Charlots departed for New York. Finally, there was one of Zohmah holding Ann, taken outside the zebra cage at the New York Zoo; on the back is written, "Nov. 5, 7 months, at N.Y. zoo, election day, has just voted for Milkie."

Ann may have voted for Milkie, but her parents voted for FDR. In the letter sent along with the snapshots, Zohmah reported, "Jean and I voted for Roosevelt. It took his third term for me to get up the courage to do so." This was Jean's first opportunity to vote in an American election, as he had only recently become a citizen, and apparently he had no hesitation about voting Democratic. Zohmah, on the other hand, had been reluctant to support the Democrats in the past, but with war on the horizon she decided to take the plunge. Edward had backed Roosevelt from the beginning.

In the same letter Zohmah explained that she and Jean had been trying to arrange to have Jean's sister, Odette, and her daughter, Arlette, leave occupied France and come to the United States. They were preparing affidavits to send to the consul in France and were frustrated by the slowness of the whole process. It had dragged on for so long that Odette was beginning to wonder whether it was sensible to proceed. Although eager to leave France, she had expressed concern about the developing tensions between Japan and the United States and whether these might interfere with their plans. Zohmah, however, was quick to dismiss such doubts: "We did have a recent letter though, saying do we think the Japanese situation will keep them from coming. Evidentally that is propaganda that we are so occupied, when really Japan is the one country we can boss a little." In hindsight, Zohmah's assessment was overly optimistic; while she recognized the dangerous situation in Europe, she, like many at the time, underestimated the Japanese threat.

In the same letter Zohmah reported that they watched the Macy's parade on Thanksgiving Day and enjoyed the Superman balloon, a recent addition to the lineup: "He was huge and fierce but kept losing his air. He had to be pulled down just where we were watching to have a limp foot blown up." She also mentioned how Jean had gone out and bought a seventeen-pound turkey for just the three of them. At the end, before signing off, she added a few words about Ann: "Ann, though, considers herself very busy about her mischief and just wishes we wouldn't frustrate her when she has so very much of it to do."[53]

California and the West finally appeared in November; it includes Charis's account of their adventures in California—and to a lesser extent in other western states—along with ninety-six pictures taken during their trips. The pictures are arranged in six groups of sixteen pages each, interspersed throughout the text. At the end are a map showing the places they visited and a short statement by Weston, as well as an explanation of the technical aspects of the photography. All in all, although the reproductions were somewhat of a disappointment, Edward and Charis were not entirely dissatisfied with the final result.[54]

Charis's narrative is nicely written, in the lively, anecdotal style that had begun to emerge in "Of the West," but it is much longer, more detailed, and more varied. She provides not only a close-up, intimate glimpse of a photographer at work during an important period in his career but also an engaging,

often wry account of the first year of their travels, starting with their initial trip to Death Valley with Cole; a brief summary of the second year appears as an epilogue. All along the way there are memorable stories: Charis describes photographing a dead man in the Colorado desert, a battle with mosquitoes at Lake Ediza, the fire in Ansel Adams's Yosemite darkroom, and many more episodes, including a visit to the Sommers in Prescott, Arizona.

In the fourth chapter Charis speaks of Zohmah and describes the trip to Red Rock Canyon in 1937. First, she introduces Zohmah to her readers: "June fourth we set out with a friend, Zohmah Day. (Her parents named her Dorothy but at an early age she decided to make up her own name, settled on Zohmah, and managed to keep it.)."[55] Then, having set the stage, she quotes at length from Zohmah's log, including the part about how Charis had exaggerated the threat of snakes. After that, as if called upon to defend her actions, Charis goes on to explain, "The remark about snakes was meant for a joke—I didn't know till later how ill-timed. But if Zohmah was as frightened as she afterward led others to believe, she concealed it well. Next morning, in her honor I'm certain, since it was the only bit of unfriendly wildlife we saw in two years' travel, I found a baby scorpion crushed under my sleeping bag."[56] Charis's narrative continues with the account of a visit with Zohmah to a petrified forest and subsequent adventures not involving Zohmah. Since the second year of the Guggenheim travels are not discussed at length in the book, the other trip Zohmah made with the Westons, to Death Valley, is not mentioned.

The pictures in *California and the West* represent only a sampling of the vast number of photographs taken during the Guggenheim trips; the range of subject matter, however, is considerable. There are burned-out cars, ruins, and a corpse, but there are also pictures of lakes and deserts, mountains and ocean, saguaro cactus, snow, and ice. Although most could be considered landscapes, there are also townscapes and interiors; some of the pictures are not unlike the work of RA/FSA photographers such as Walker Evans and others being done at about the same time: *Hot Coffee* and *Chief: Heggens Barn* both fall into that category.[57] One image, a steer's skull on a post (*Iron Springs Road/Arizona*), bears comparison with Arthur Rothstein's famous and controversial Dust Bowl–era photo of a skull on a background of parched land and perhaps raises some of the same issues. Near the end of the book are two pictures taken at MGM Studios, including the one of rubber dummies, partly set up by Charis, which anticipates in method and tone some of the backyard arrangements of subsequent years.

As Ansel Adams once noted, many of the pictures are quite different from Wilson's anecdotal text, less lighthearted in tone.[58] Many are quite serious: there are desolate landscapes and images of skulls and crumbling buildings. Some commentators have even detected a marked preoccupation with death and decay, as well as a growing sense of gloom—perhaps a reflection of the personal tensions that arose during the journey or even of Weston's age and physical condition, to say nothing of the growing threat of war.[59] But while some of the pictures can be understood in such terms, others—including the *Yuma Nymph*, *Hot Coffee*, and the rubber dummies—seem lighthearted and amusing; still others fall somewhere between these two extremes. In truth, it would seem that there is a considerable variety of attitudes and moods.

There is also a fairly broad range of styles: some of the pictures are close-up, relatively abstract imagery, such as *Burned Car/Mojave Desert*, *Juniper*, or *Potato Cellar/Lake Tahoe*; in images such as these we see a continuation of the aesthetic/modernist concerns of Weston's work from the late 1920s and early 1930s. But there are also open vistas, like *Ubehebe Crater/Death Valley* and *Embarcadero/San Francisco*, in which we find a more open, relaxed view than in much of Weston's previous work. Indeed, many of the pictures in *California and the West* reveal this new—or at least recent—tendency. As John Szarkowski has said, "Until the mid-1930s [Weston] tended to avoid the horizon, or use it as a beautiful line, a graphic obligato at the top of the taut, shallow space, almost in two dimensions. But by the late 1930s, when he was at the height of his powers, no space seemed to broad or deep for him."[60] Although some have regarded Weston's photographs of shells and peppers as "the classic center of his career," the work of the Guggenheim years is richer and more complex, a significant jump.[61] For Weston himself, they represented a high point, a summation of his art.[62]

In his statement at the end of *California and the West*, Weston restates once again his notion of mass production of images. The freedom of the Guggenheim years had allowed Weston to photograph with an abandon he had never really enjoyed before—not even during the Mexico years—and it therefore provided him with the opportunity, as he said, to test out his concept of mass production. The only question was whether he had succeeded, whether his theory was sound—and Weston's answer is essentially positive. Although there were a number of technical difficulties along the way, he was satisfied with his record and regarded his experiment in mass production to have been a success.[63]

His repeated insistence on "mass production" no doubt indicates how much he appreciated the opportunity to work with such freedom, unfettered by commercial obligations, and perhaps how much he missed that freedom after the fellowship ended. But there is more to it than that, for at the same time he asserts a special status for photography—almost a superiority when it comes to pure seeing. As he had asserted in his encyclopedia entry, a photographer can create more separate images in a given amount of time than most other visual artists; it is thereby possible to attain a heightened awareness and a more spontaneous expression. A painter or sculptor might labor for months or even years over a single image, a single invention; a photographer, on the other hand, can produce many more images in that same amount of time and thereby sharpen his or her vision to a greater extent. For Weston, *California and the West* was a demonstration of that fundamental advantage.

In November 1940 Weston went to Los Angeles to promote *California and the West*, and while there he went to the lot of Twentieth Century Fox, where he made a number of odd and amusing pictures. He had photographed at the MGM Studios the year before, with good results; Weston was obviously attracted to that kind of subject matter and was hoping to find more material. Once again his efforts were rewarded: he photographed broken-down sets and old buildings and took several intriguing pictures of a statue of a gunfighter with one hand missing but poised for action, standing near an empty gazebo. He tried several different angles and in each case conveyed the incongruity of the situation, the odd, almost surreal juxtapositions that sometimes occur on movie or circus lots. We are reminded of Atget, perhaps, and Walker Evans—both of whom were drawn to similar subjects.[64]

One of the most amusing photos—and perhaps the most suitable for Weston—was the picture of a storage lot with a number of bare and twisted trees, including one in the foreground that had fallen over.[65] At first glance it could almost be one of his recent landscape views of Point Lobos or elsewhere, except that the trees are all props and placed on bases. The image is, in effect, an imitation of a landscape, an imitation of the sort of picture Weston himself often produced, and he must have appreciated the irony of it. In any event, he was pleased with the studio shots he made that day: he exposed twelve negatives and kept them all. Soon after he wrote that these pictures were "tops" and belonged with his best.[66] Some of his admirers have

considered these images to be atypical of Weston, however, and to this day they have not been widely published or exhibited.

Back in Carmel he did more pictures at Point Lobos, including the classic *Kelp, China Cove, Point Lobos*, as well as pictures of gnarled cypresses along a rocky slope, such as *Cypress Grove, Point Lobos* (fig. 39), which recalls Charlot's lithograph of a cypress made in 1933 (fig. 26), when he visited Weston in Carmel.[67] Weston's photograph, however, is a more complex arrangement, less focused, less apparently unified, showing not one tree but several linked together, the twigs and branches creating intricate linear rhythms against a darkish background. This photograph is among Weston's most eloquent and moving works, and it makes a nice complement to the image of the tree storage lot.

In December 1940, after painting two more versions of the Flight into Egypt, along with other religious subjects, Charlot had a show at the Bonestell Gallery on East Fifty-seventh Street in New York City.[68] The show included the fourteen tondos (circular images) devoted to the Way of the Cross that he had been working on during the previous decade (which are now in St. Cyprian Church, River Grove, Illinois, near Chicago); there was also a portrait of Father Marie-Alain Couturier, who wrote the text for the show's announcement.[69] Later on Couturier would become quite well known for his role in bringing modern artists to liturgical art in France, encouraging artists like Matisse to undertake liturgical commissions. At the time of Charlot's exhibition, however, he was stranded in New York following the establishment of the Vichy regime in France and had spent a good deal of time with the Charlots; he often ate with them and even left his Dominican robes in their closet.[70]

In January of the following year, 1941, soon after the show came down, there was still more trouble about *Carmen*. Albert Carman, who had worked with Charlot on Hilaire Belloc's *Characters of the Reformation* (1936), had been selected to do the printing of the pictures, but at the last minute Macy refused to pay his price; Charlot and Carman, between themselves, referred to the situation as the "Affaire Macy."[71] Once again Charlot was probably wondering whether his *Carmen* project would ever be realized, but after several weeks Macy finally agreed to the deal, and the end was in sight. Preparations were soon underway for the final printing, which began the following month.[72]

A few days before that the Charlots had received a copy of *California and the West*. It is inscribed "For Jean, Zohmah and Ann Maria—this picture and

story book. With love and kisses from Edward & Charis."[73] Zohmah wrote back to acknowledge the present:

> We are so pleased to get your book. It came on Jean's birthday, which was a nice addition to such a wonderful gift. Jean has said a dozen times how well Charis writes. It is so convincing and amusing and makes one feel so confident in all the events. The adjectives are all mine, Jean just keeps remarking "Charis certainly writes well." He means too that not only is he interested but that he likes the sound.
>
> I was a little shocked to see how much better I liked Charis' writing than the part of mine that you put in. But I guess it is all right as an example of someone who remembers about snakes, the tenderfoot!
>
> The pictures are well reproduced. It is awfully pleasant to have them placed on the page so one needn't turn the book. There were a good number of the pictures too that I hadn't seen before which was an added thrill, along with seeing old favorites.[74]

Charis must have been quite pleased with this response. Many of the reviews of the book had neglected the text or passed over her role in the project, which understandably disturbed her, but that was not the case here. Jean and Zohmah were impressed not only with the photographs but with the text, with the book as a whole. Indeed, although they clearly admired the pictures, they—especially Jean—had more to say about the writing; if Jean had any reservations about Charis's influence on Edward's art, that is not recorded here. Some years later, after picking up the book again, Zohmah reiterated her admiration: "It really is a good book. . . . It made me remember all over again why I admired Charis. What good times she and Edward had on their trips."[75]

Just as one big project came to an end, another began: no sooner had work ended on *California and the West* than, in February 1941, Weston was commissioned to make photographic illustrations for a new, deluxe edition of Walt Whitman's *Leaves of Grass*. Ironically, the commission came from George Macy, for whom Charlot had done the *Carmen* pictures (which had yet to appear). Once again Merle Armitage was to be the designer, and he had at least some role in initiating the project, despite the difficulties he had been experiencing with Macy over the design of *Carmen*; apparently he was the one who suggested Weston's participation.[76] Although Macy's repeated use of

the word *illustration* gave him pause, Weston was excited at the opportunity to do another ambitious photographic project; he could again look forward to an extended period of uninterrupted work, travel, and relative freedom.[77]

Edward and Charis soon wrote the Charlots to tell them of their plans, and Zohmah passed the news along to Prue: "Edward is to illustrate 'Leaves of Grass' for the Ltd Edition Club & he & Charis have started through the South to go all over the U.S. photographing 'faces & places.' We will see them in N.Y. if they get here before we go to Georgia the latter part of August."[78] There seems to have been no mention of Jean's experience with Macy on the *Carmen* project, and if Zohmah (or Jean) was worried about how Macy might treat Weston or Armitage, she didn't say so; she was more focused on seeing the Westons again.

At about the same time Edward wrote to Beaumont and Nancy Newhall about his intentions, as Beaumont later reported in his monograph on Weston, *Supreme Instants*:

> This I should tell you; there will be no attempt to "illustrate," no symbolism except perhaps in a very broad sense, no effort to recapture Whitman's day. The reproductions, only 54, will have no titles, no captions. This leaves me great freedom—I can use anything from an airplane to a longshoreman. I do believe, with Guggenheim experience, I can & will do the best work of my life. Of course I will never please everyone with my America—wouldn't try to.[79]

Although Macy had apparently thought in terms of illustrations, Weston makes it clear that he is uncomfortable with the notion. While he had long admired *Leaves of Grass*, he was adamant that his pictures not be tied to the poem in any literal or symbolic sense; instead he hoped to represent a broad sweep of the country that would, in a general sense, parallel Whitman's poem. So too he was quite specific about there being no captions—although this is not exactly what came about.[80]

Whitman's poem has often been associated with a kind of nationalistic fervor, a celebration of the American spirit. This may have motivated Macy in choosing the poem for his latest effort; perhaps he considered his choice a timely one, an appropriate text at a time of national crisis, when the country was bracing for war. Weston did not make the same connection, however, and seems not to have conceived of this project in overtly political terms; nor did Charis.

While the Westons were making preparations for their Whitman trip, the Charlots—who were still in New York—were planning to move to Georgia. Jean had been named artist-in-residence at the University of Georgia at Athens, thanks in part to Lamar Dodd, the chair of the Art Department, who had been Charlot's student at the Art Students League in the early 1930s.[81] Now that he had been discharged from the French army and was an American citizen, Jean was free to accept the appointment, although it would mean having to give up some of the opportunities that went along with being in New York. By this time Jean had made many connections in the New York art world, and he was starting to have a good deal of success as an illustrator, but the new position represented greater stability; instead of part-time teaching assignments and freelance work, he would now have a full-time, relatively secure post. This must have been a welcome change for the Charlots, who had another child on the way.

Jean was not to take up his new post at Athens until the fall of 1941. In the meantime, he continued to teach at the Art Students League and the Brooklyn Museum, where he covered Giotto and Raphael, among other topics.[82] On April 13 their second child, John, was born, and he was baptized ten days later at St. Patrick's Cathedral by Father Couturier (Jacques Maritain was the godfather).[83] The same day, the edition printing of *Carmen* was finished. Despite the various disputes and difficulties that had held up production, after four years, the work was finally done and the book was about to appear.

Like all Limited Editions Club productions, the volume was a deluxe one. It had a gaudy—almost psychedelic—cloth cover, suggestive of gypsy silk, and was enclosed in a pale green slipcase. The paper was specially made for the project and suitably watermarked with "Carmen." There was an introductory essay by Konrad Bercovici, a noted authority on gypsy lore, followed by Mérimée's text, translated from the French by Mary Lloyd, along with Charlot's illustrations. According to the colophon, the book was planned and printed by Aldus Printers in New York, and the lithographs were printed by Albert Carman. Altogether there were fifteen hundred numbered copies, each signed by the artist. There is no mention of Armitage.[84]

Charlot's pictures, which illustrate many of the key moments in the story, are beautifully composed. *Window with Orange Vendor* is a good example (fig. 57).[85] Here, the verticals of the window bars are offset by the diagonal accents of the two figures, Carmen and the scarlet-coated officer; although they lean

in opposite directions, they are tied together by the sweeping curve of Carmen's dress, which is carefully balanced by her peacock-blue fan. The lines are delicate and fluid; they have a kind of gracefulness, an elegance, that sets them apart from the more boisterous, almost painterly images in the 1933 *Picture Book* (including *Malinche*). The colors—vibrant reds and yellows, greens and blues—are also remarkable; Charlot combines vivid, flat colors and blended pastel effects with great skill. Indeed, in this and other examples he raised the art of lithography to a new level; this edition of *Carmen* is now considered a masterpiece of fine printing and book art.[86]

In his introduction, Konrad Bercovici speaks of Mérimée and the authenticity of his tale, despite the fact that Mérimée's knowledge of the gypsies was based more on academic study than on personal contact; he also points out that the author did not fall prey to prevailing prejudices about gypsy sorcery and the like, but he makes no mention of the terrible things that were being done to gypsies in Germany and elsewhere.[87] How much was known of these atrocities at the time is unclear, but the matter was not addressed. Nor does Bercovici speak about the Spanish Civil War or its aftermath. If Charlot, or anyone else associated with the project, had been thinking of the war when the project began, it is not evident in the illustrations or the introduction.

The Westons set off on their Whitman travels full of excitement, but to some extent the expectation of war hung over the trip. The war in Europe had been going on for some time—France had fallen, and all of continental Europe was overrun by the Germans—and tensions with Japan were high. Roosevelt had already issued his proclamation of an unlimited national emergency; although preparations may not have been sufficient, the country was on alert. As Charis would later write, "we were traveling across a country that had been declared in a state of national emergency. Just the night before, we had listened to a radio broadcast of President Roosevelt making his Unlimited Emergency Proclamation. There was every likelihood that we would soon be at war."[88]

They started off in Arizona: after stopping at the Grand Canyon they headed for Phoenix, where they encountered a young Barry Goldwater and stayed with the Sommers for three days (in June 1941).[89] They proceeded to New Mexico, Texas, and Louisiana. By August they were in New Orleans, where they contacted the photographer Clarence John Laughlin. He invited them over to his house one evening and showed them a great deal of his work, most of which Edward considered precious and silly. The next day Laughlin

took them "up the Bayou" to see old plantation houses in Thibadoux, Belle Grove, and Woodlawn.[90]

On subsequent days their guides were local artists Bea and Don Prendergast, whom they had met at Laughlin's. The Prendergasts took them back to Belle Grove and Woodlawn as well as to a number of old New Orleans cemeteries that delighted Edward. Edward also used the Prendergasts' darkroom. Altogether the Westons spent several weeks with the Prendergasts—which Charis later recalled as a happy time—and they remained good friends in subsequent years.[91]

After New Orleans, the Westons headed to Tennessee in late August. In Monteagle they visited Charis' brother, Leon, who was working as a librarian at Highlander Folk School, a left-oriented institution dedicated to providing educational opportunities to Southern workers and the local community. One evening after dinner, Edward and Charis joined in a round of labor songs: "most of the songs being familiar, although I did not know 'Just like a tree that's planted by the water, we shall not be moved.' We sang 'Joe Hill,' [a song by Alfred Hayes and Earl Robinson] which they dragged out to lugubrious lengths."[92] In Nashville a short time later, they encountered the sculptor William Edmundson; Edward made several pictures of him and his works. Before leaving they selected one of his carvings for themselves, a stone dove, which Edward would later use in one of his photographs.[93] Then they headed north toward Ohio.

The Westons were still in Tennessee at the end of August when the Charlots left New York and headed for their new home in Athens, Georgia. On their way south they stopped off in Washington DC, where they (or at least Jean) visited the National Gallery of Art; Jean especially enjoyed a Nativity attributed to Fra Filippo Lippi.[94] While in the capital, Jean made arrangements with the Section of Fine Arts of the Public Buildings Administration to paint a mural in a post office in McDonough, Georgia, an area where cotton was produced and agricultural implements and overalls were manufactured.[95]

The Charlots arrived in Athens on September 2; once they were settled, Jean began a painting of the Nativity, which, like the Flight into Egypt, was becoming one of his favorite themes—perhaps again for personal reasons. This latest example was a free rendering of the Lippi he had just seen in Washington, and he referred to it as an "homage to Filippo Lippi."[96] He also painted more versions of the Flight into Egypt, taking interesting liberties

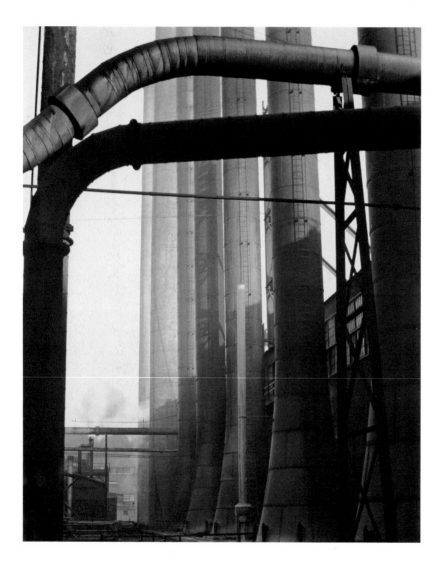

1. Edward Weston, *Pipes and Stacks: Armco, Middletown, Ohio*, 1922.
Collection Center for Creative Photography. © 1981 Arizona Board
of Regents.

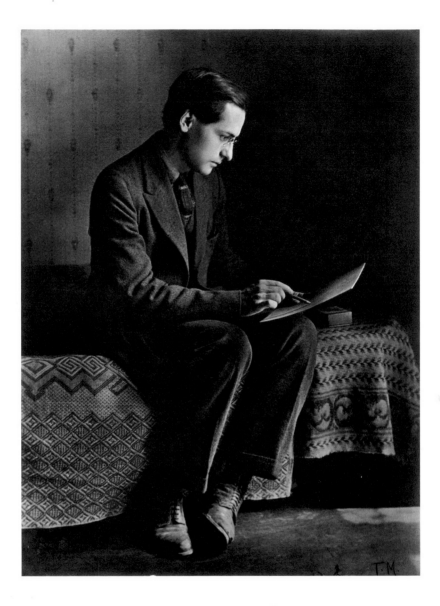

2. Tina Modotti, *Jean Charlot*, ca. 1924. Jean Charlot Collection, University of Hawai'i at Mānoa Library.

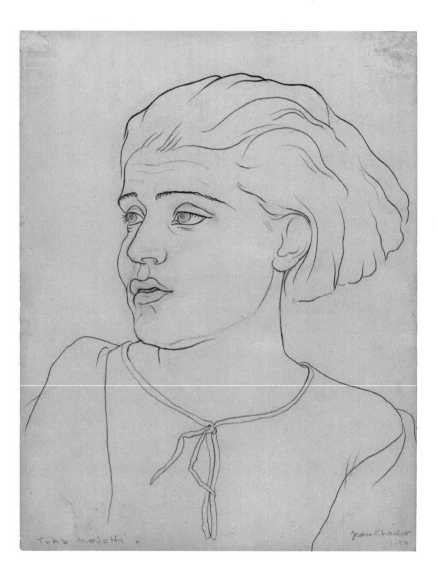

3. Jean Charlot, *Tina Modotti*, 1924. Jean Charlot Collection, University of Hawai'i at Mānoa Library. © The Jean Charlot Estate LLC. With the permission of the Jean Charlot Estate LLC.

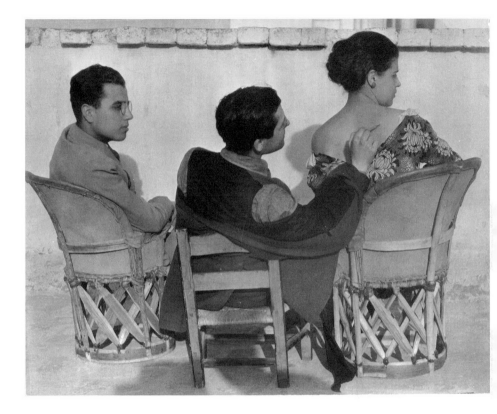

4. Edward Weston, *Federico Marín, Jean Charlot, and Tina Modotti,*
ca. 1924. © 1981 Arizona Board of Regents. Jean Charlot Collection,
University of Hawai'i at Mānoa Library.

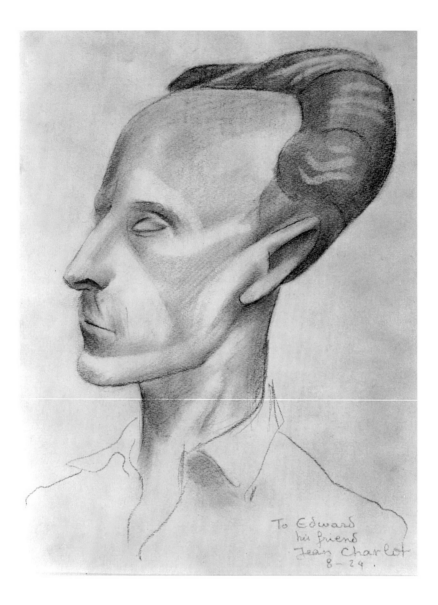

5. Jean Charlot, *Portrait of Edward Weston* (with inscription), 1924. Photo by Johan Hagemeyer. © The Jean Charlot Estate LLC. With the permission of the Jean Charlot Estate LLC. Collection Center for Creative Photography. © 1981 Arizona Board of Regents.

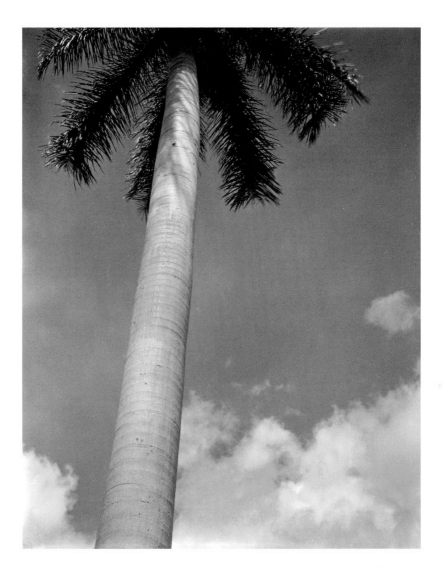

6. Edward Weston, *Palm, Cuernavaca,* 1924. Collection Center for Creative Photography. © 1981 Arizona Board of Regents.

7. Edward Weston, *Caballito de cuarenta centavos*, 1924. Collection
Center for Creative Photography. © 1981 Arizona Board of Regents.

8. Jean Charlot, *Temascal*, 1925. Jean Charlot Collection, University of Hawai'i at Mānoa Library. © The Jean Charlot Estate LLC. With the permission of the Jean Charlot Estate LLC.

9. Edward Weston, *El charrito*, 1926. © 1981 Arizona Board of
Regents. Jean Charlot Collection, University of Hawai'i at Mānoa
Library.

10. Edward Weston, *Jean Charlot*, 1926. © 1981 Arizona Board of Regents. Jean Charlot Collection, University of Hawai'i at Mānoa Library.

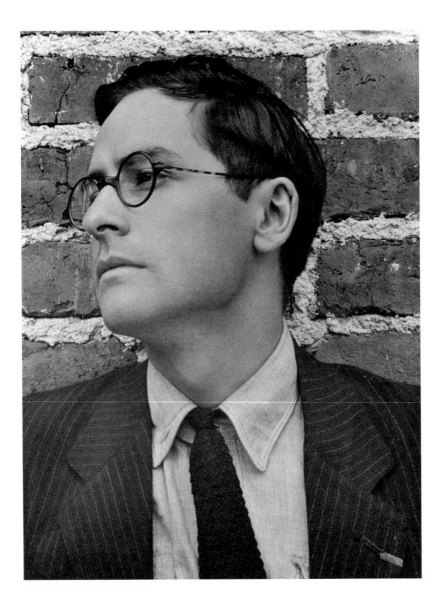

11. Edward Weston, *Jean Charlot* (close-up), 1926. Collection Center for Creative Photography. © 1981 Arizona Board of Regents.

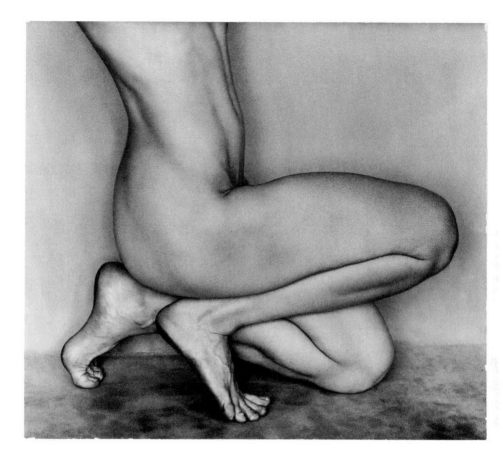

12. (*above*) Edward Weston, *Nude (Bertha, Glendale)*, 1927.
Collection Center for Creative Photography. © 1981 Arizona Board
of Regents.

13. (*right*) Photographer unknown, *Jean Charlot at Work*, ca. 1927.
Jean Charlot Collection, University of Hawai'i at Mānoa Library.

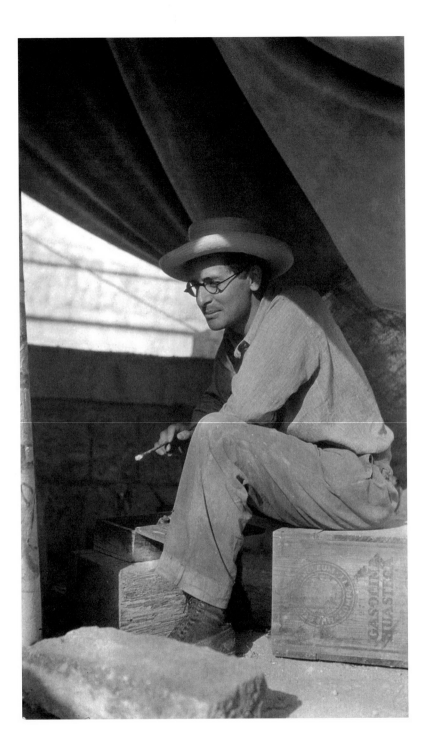

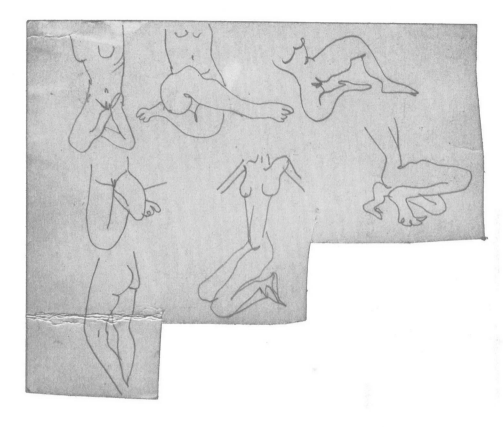

14. Jean Charlot, sketch of Weston photographs, 1927. From a
letter from Jean Charlot to Edward Weston, December 27, 1927,
Edward Weston Archive, Center for Creative Photography. © 1981
Arizona Board of Regents. © The Jean Charlot Estate LLC. With the
permission of the Jean Charlot Estate LLC.

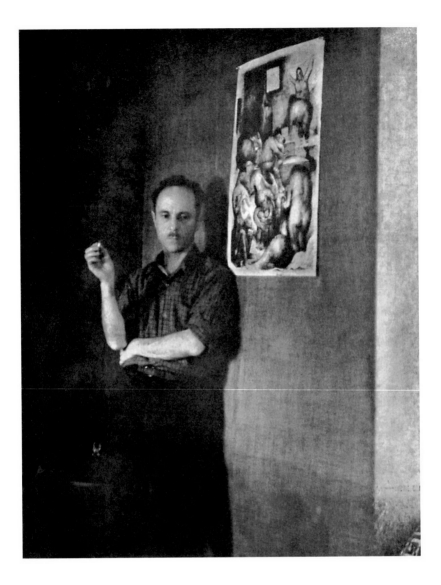

15. Fred R. Dapprich, *Edward Weston*, ca. 1928. Jean Charlot's
Temascal is in the background. From *American Annual of
Photography*, 1929.

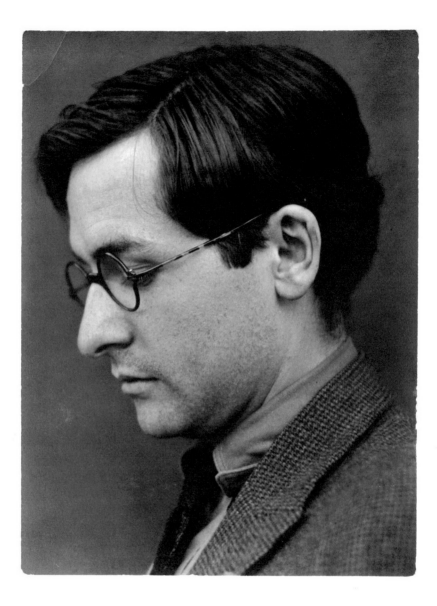

16. Tina Modotti, *Jean Charlot*, ca. 1928. Jean Charlot Collection, University of Hawai'i at Mānoa Library.

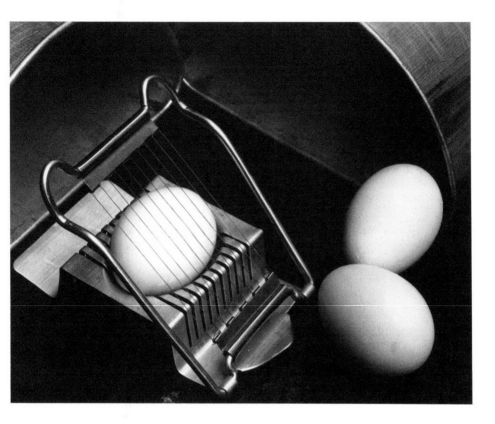

17. Edward Weston, *Eggs and Slicer*, 1930. Collection Center for
Creative Photography. © 1981 Arizona Board of Regents.

A girl lost among pyjamas, a hat, and a bottle of Vermouth.

18. Sergei Eisenstein, sketch of Zohmah Day and vermouth bottle, 1931. Jean Charlot Collection, University of Hawai'i at Mānoa Library.

19. Sergei Eisenstein / Gregori Alexandrov, *Zohmah Day*, 1931. Jean Charlot Collection, University of Hawai'i at Mānoa Library.

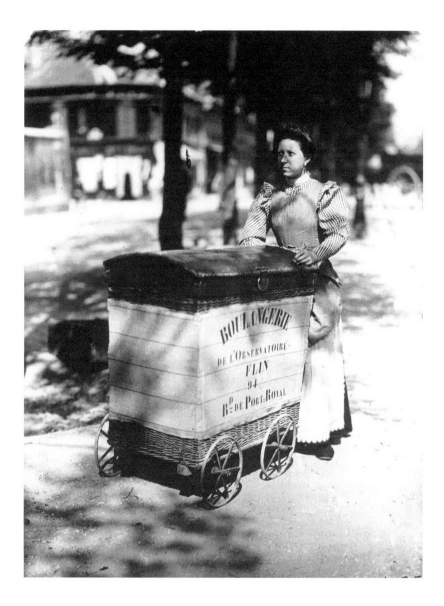

20. Eugene Atget, *La boulangère,* 1899–1900. Jean Charlot Collection, University of Hawai'i at Mānoa Library.

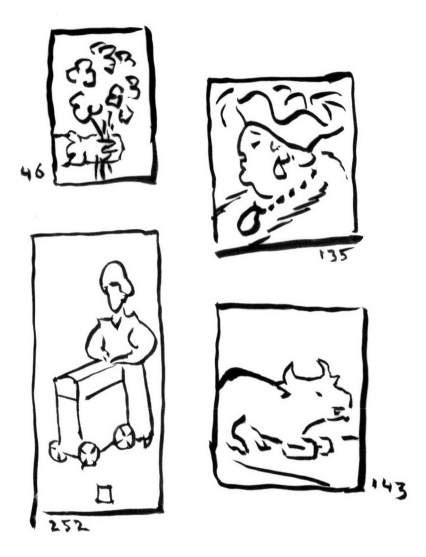

(*clockwise from top left*)

21. Jean Charlot, sketch of *Hand Holding Bouquet*, 1924.
22. Jean Charlot, sketch of *Lady with Hat*, 1926.
23. Jean Charlot, sketch of *Bull from Santa Cruz near Tonalá*, 1926.
24. Jean Charlot, sketch of *La grande boulangère. Hommage to Adget*,
1931. From Charlot's Checklist of Paintings, Jean Charlot Collection,
University of Hawai'i at Mānoa Library. © The Jean Charlot Estate
LLC. With the permission of the Jean Charlot Estate LLC.

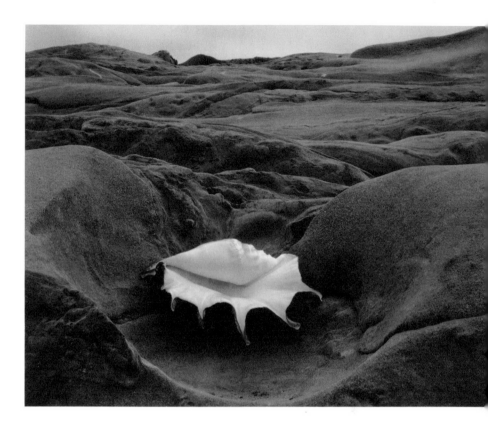

25. Edward Weston, *Shell and Rock—Arrangement*, 1931. Collection
Center for Creative Photography. © 1981 Arizona Board of Regents.

26. Jean Charlot, *Monterey Cypresses*, 1934. "Carmel 33" in the print refers to the original drawing. Jean Charlot Collection, University of Hawai'i at Mānoa Library. © The Jean Charlot Estate LLC. With the permission of the Jean Charlot Estate LLC.

27. Jean Charlot, *Weston in His Studio*, 1933. Jean Charlot Collection, University of Hawai'i at Mānoa Library. © The Jean Charlot Estate LLC. With the permission of the Jean Charlot Estate LLC.

28. Edward Weston, *Jean Charlot,* 1933. Collection Center for
Creative Photography. © 1981 Arizona Board of Regents. Jean
Charlot Collection, University of Hawai'i at Mānoa Library.

29. Edward Weston, *Zohmah Day*, 1933. Collection Center for
Creative Photography. © 1981 Arizona Board of Regents.

30. Edward Weston, *Jean Charlot and Zohmah Day*, 1933. © 1981 Arizona Board of Regents. Jean Charlot Collection, University of Hawai'i at Mānoa Library.

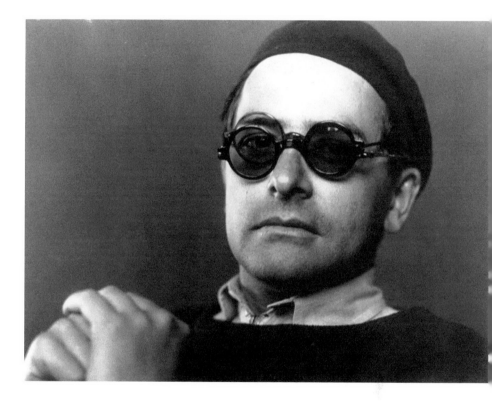

31. Sonya Noskowiak, *Jean Charlot*, 1933. Courtesy of Arthur F. Noskowiak. Jean Charlot Collection, University of Hawai'i at Mānoa Library.

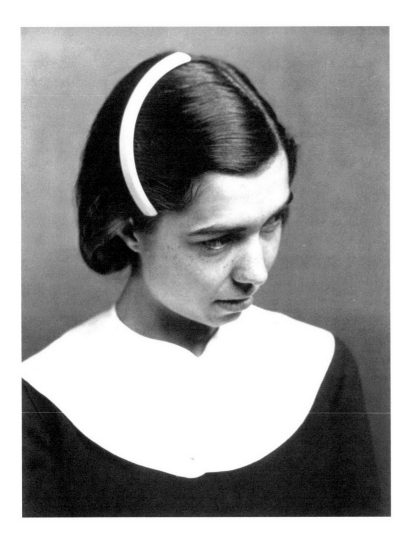

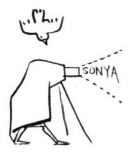

32. (*above*) Sonya Noskowiak, *Zohmah Day,* 1933.
Courtesy of Arthur F. Noskowiak. Jean Charlot
Collection, University of Hawai'i at Mānoa Library.

33. (*right*) Jean Charlot, sketch of Sonya photographing
and bird (letterhead for Sonya Noskowiak), 1933. Jean
Charlot Collection, University of Hawai'i at Mānoa
Library. © The Jean Charlot Estate LLC. With the
permission of the Jean Charlot Estate LLC.

34. Edward Weston, postcard to Zohmah Day, August 13, 1935. ©
1981 Arizona Board of Regents. Jean Charlot Collection, University
of Hawai'i at Mānoa Library.

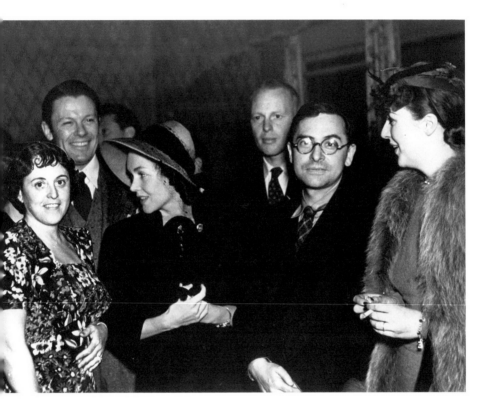

35. Photographer unknown, party at Beverly Hills Hotel, January 1938. In the center are Maureen O'Sullivan (with hat), John Farrow, and Jean Charlot; the other individuals' names are not known. Jean Charlot Collection, University of Hawai'i at Mānoa Library.

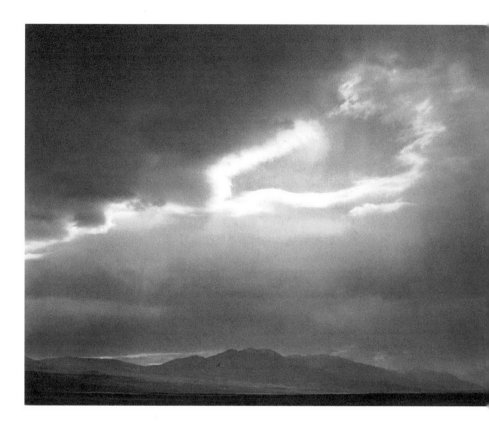

36. Edward Weston, *Clouds, Death Valley*, 1939. Collection Center for
Creative Photography. © 1981 Arizona Board of Regents.

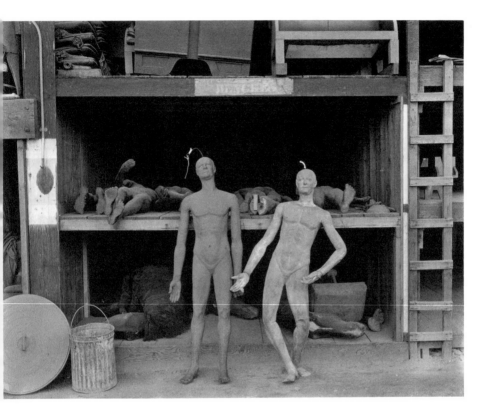

37. Edward Weston, MGM *Storage Lot,* 1939. Collection Center for
Creative Photography. © 1981 Arizona Board of Regents.

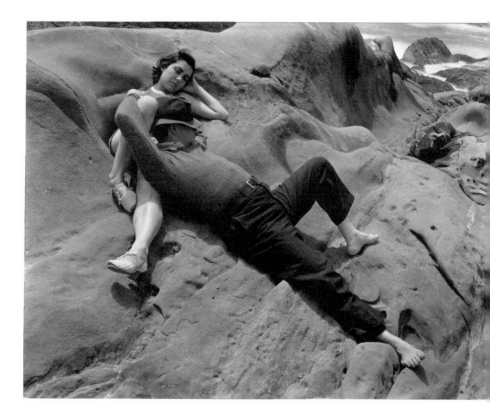

38. Edward Weston, *Honeymoon* [Jean and Zohmah Charlot], 1939.
Collection Center for Creative Photography. © 1981 Arizona Board
of Regents.

39. Edward Weston, *Cypress Grove, Point Lobos*, 1940. Collection
Center for Creative Photography. © 1981 Arizona Board of Regents.

40. Edward Weston, *Hunter Farm near Athens, Georgia*, 1941.
Collection Center for Creative Photography. © 1981 Arizona Board
of Regents.

41. Edward Weston, *Zohmah Charlot*, 1941. © 1981 Arizona Board of Regents. Jean Charlot Collection, University of Hawai'i at Mānoa Library.

42. Zohmah Charlot, *Edward Weston and Charis Wilson*, 1941. Jean Charlot Collection, University of Hawai'i at Mānoa Library. © The Jean Charlot Estate LLC. With the permission of the Jean Charlot Estate LLC.

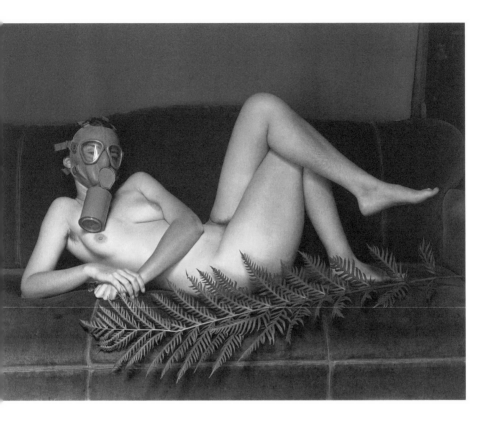

43. Edward Weston, *Civilian Defense*, 1942. Museum of Fine Arts,
Boston. © The Lane Collection. Photograph courtesy Museum of
Fine Arts, Boston. © 1981 Arizona Board of Regents.

44. Jean Charlot, *Ann and John Charlot*, 1942/1943. Handmade New
Year's card from Ann and John Charlot, Edward Weston Archive,
Center for Creative Photography. © 1981 Arizona Board of Regents.
© The Jean Charlot Estate LLC. With the permission of the Jean
Charlot Estate LLC.

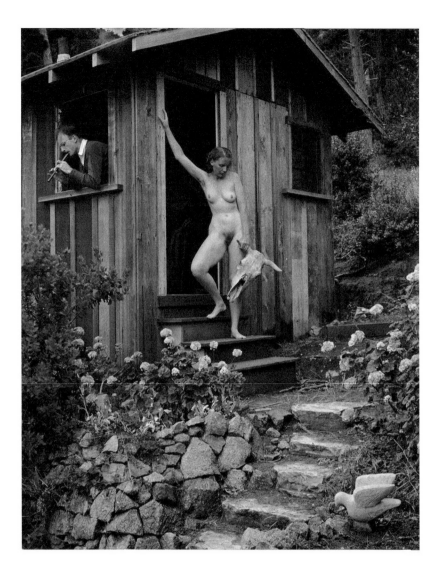

45. Edward Weston, *My Little Gray Home in the West*, 1943.
Collection Center for Creative Photography. © 1981 Arizona Board
of Regents.

46. Edward Weston, *Exposition of Dynamic Symmetry*, 1943.
Collection Center for Creative Photography. © 1981 Arizona Board
of Regents.

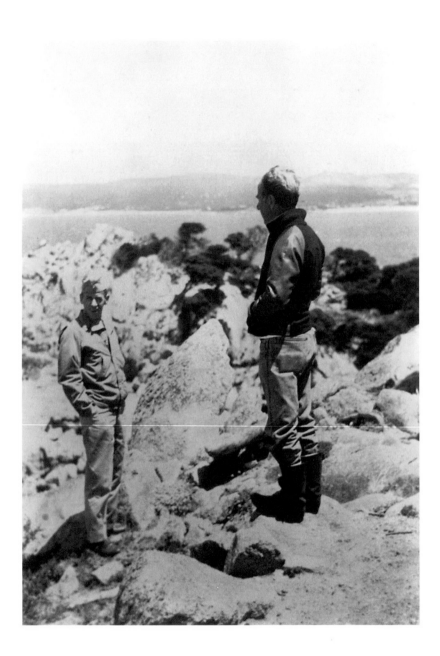

47. Photographer unknown, *Edward Weston and Roswell Ison*, 1944.
Jean Charlot Collection, University of Hawai'i at Mānoa Library.

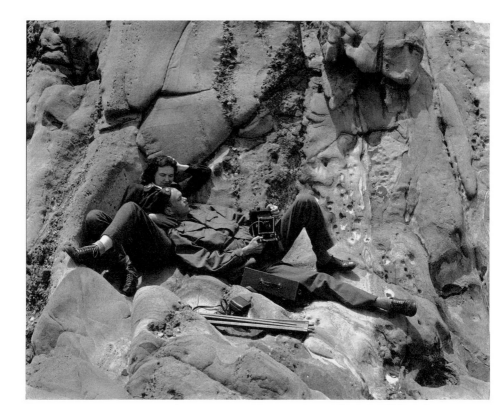

48. Edward Weston, *Beaumont and Nancy Newhall on the Rocks*, 1945.
Collection Center for Creative Photography. © 1981 Arizona Board
of Regents.

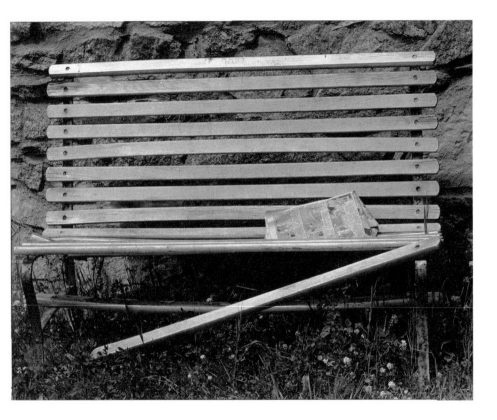

49. Edward Weston, *The Bench*, 1944. Collection Center for Creative
Photography. © 1981 Arizona Board of Regents.

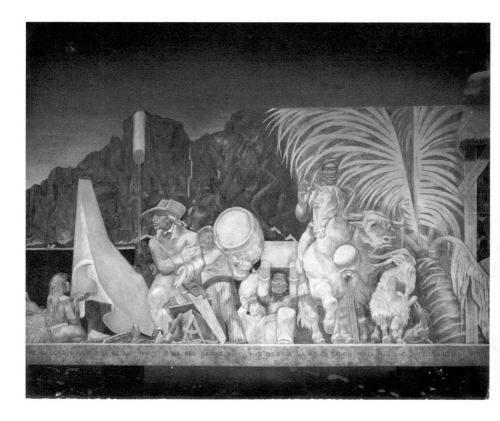

50. Jean Charlot, *Early Contacts of Hawai'i with the Outer World* (detail, central scene), 1951–52, First Hawaiian Bank, Waikiki Branch, Honolulu HI. © The Jean Charlot Estate LLC. With the permission of the Jean Charlot Estate LLC. Jean Charlot Collection, University of Hawai'i at Mānoa Library.

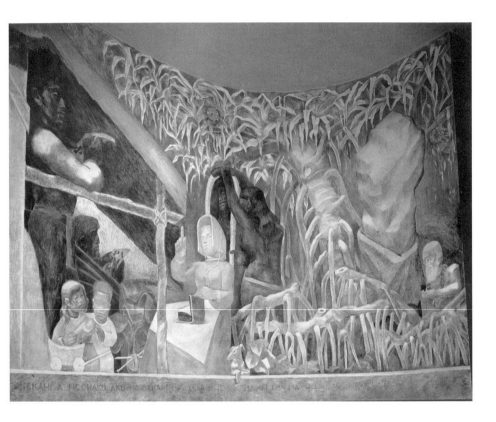

51. Jean Charlot, *Early Contacts of Hawai'i with the Outer World*
(detail, right side), 1951–52, First Hawaiian Bank, Waikiki Branch,
Honolulu HI. © The Jean Charlot Estate LLC. With the permission of
the Jean Charlot Estate LLC. Jean Charlot Collection, University of
Hawai'i at Mānoa Library.

52. Ansel Adams, *Jean Charlot*, 1959. © 2010 The Ansel Adams Publishing Rights Trust. Jean Charlot Collection, University of Hawai'i at Mānoa Library.

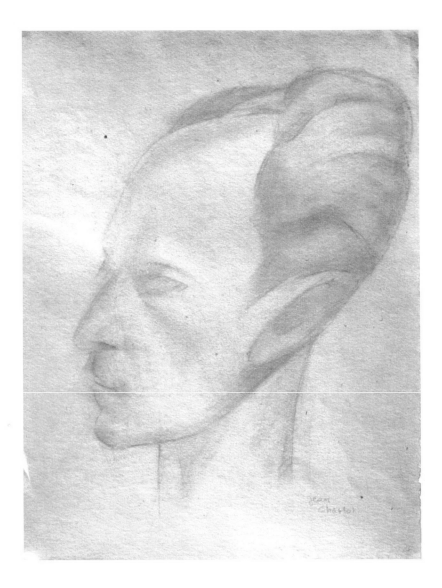

53. Jean Charlot, *Portrait of Edward Weston*, 1924. Photo by Joseph
F. Martin Jr., Collection of John Charlot. © The Jean Charlot Estate
LLC. With the permission of the Jean Charlot Estate LLC.

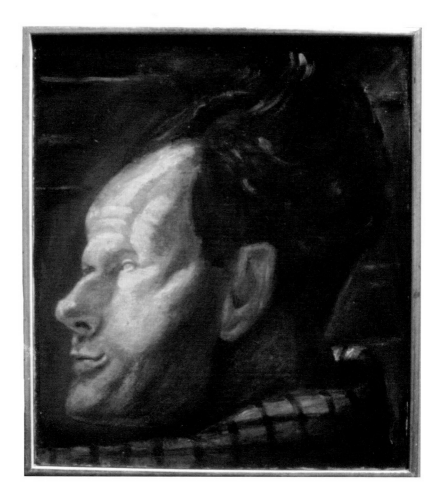

54. Jean Charlot, *Portrait of Sergei Eisenstein*, 1932. Photo by Joseph
F. Martin Jr., Collection of Martin Charlot. © The Jean Charlot
Estate LLC. With the permission of the Jean Charlot Estate LLC.

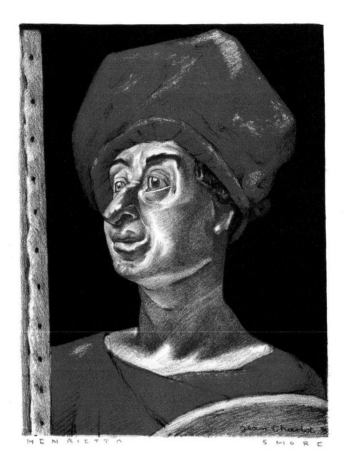

HENRIETTA SHORE

55. Jean Charlot, *Henrietta Shore*, 1933. Jean Charlot Collection,
University of Hawai'i at Mānoa Library. © The Jean Charlot Estate
LLC. With the permission of the Jean Charlot Estate LLC.

56. (*left*) Zohmah Day, "Maison Weston" (diagram), 1938. Jean Charlot
Collection, University of Hawai'i at Mānoa Library. © The Jean Charlot
Estate LLC. With the permission of the Jean Charlot Estate LLC.

57. (*above*) Jean Charlot, *Window with Orange Vendor*, 1941. Jean Charlot
Collection, University of Hawai'i at Mānoa Library. © The Jean Charlot
Estate LLC. With the permission of the Jean Charlot Estate LLC.

58. Jean Charlot, *Cortez Landing at Veracruz* (detail), 1943,
Journalism Building, University of Georgia, Athens GA. © The
Jean Charlot Estate LLC. With the permission of the Jean Charlot
Estate LLC. Jean Charlot Collection, University of Hawai'i at Mānoa
Library.

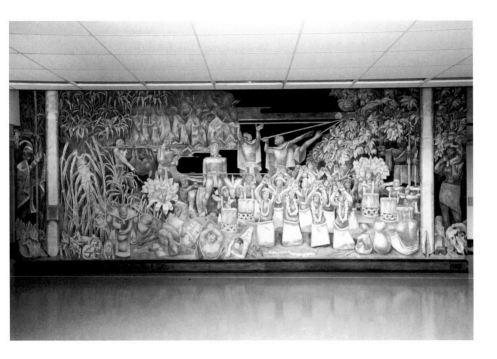

59. Jean Charlot, *Relation of Man and Nature in Old Hawai'i*, 1949,
Bachman Hall, University of Hawai'i at Mānoa, Honolulu HI. Photo
by R. David Beales, university photographer, University of Hawaii.
© The Jean Charlot Estate LLC. With the permission of the Jean
Charlot Estate LLC.

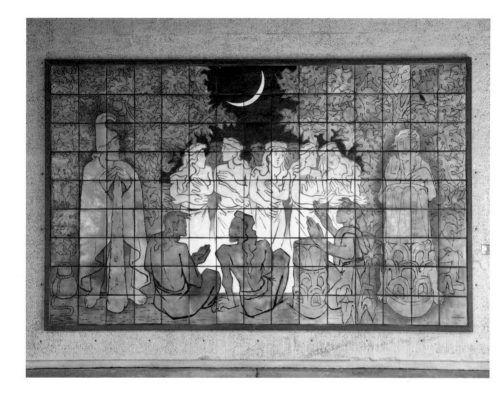

60. Jean Charlot, *Night Hula*, 1961, Saunders Hall, University of
Hawai'i at Mānoa, Honolulu HI. © The Jean Charlot Estate LLC.
With the permission of the Jean Charlot Estate LLC.

with traditional models: in one he included angels making tortillas, in another, angels washing diapers.[97] Soon after he turned his attention to the mural for the McDonough post office, and in early October he began work in earnest on the cartoon, the full-sized drawing used as a guide in the final painting process. In accordance with the postmaster's wishes, it depicted a cotton gin, with seed house and various gin hands.[98]

Having left New York without seeing the Westons, the Charlots were expecting to meet up with them in Athens, but by the time the Charlots were settled in the Westons were on their way to Ohio, then to Pennsylvania; by early October they were in New England and heading for New York City. Zohmah wrote to Prue and expressed her disappointment in a mock-exasperated tone: "The ratty Westons didn't stop to see us in Georgia." She added, with a touch of bitterness perhaps, "I wish I would take an example from them not to let things or people interfer [sic] with work."[99] But any disappointment or annoyance Zohmah might have felt would be short-lived: before the year was out Edward and Charis would visit them after all.

The Westons spent a good part of November in and around New York City. It was a time not only to see some of the sights—including Walt Whitman's birthplace on Long Island—but also to connect with old friends and acquaintances. They spent time with the Newhalls and visited Willard Van Dyke and his wife, Mary, who had moved to New York in the midthirties and had an apartment on Bank Street in Greenwich Village. They also saw Stieglitz and O'Keeffe at the gallery An American Place; it was the first time that Edward had seen Stieglitz since 1922, but according to Charis the visit was something of a disappointment ("it was unmemorable"). Stieglitz had nothing to say about Weston's photography, aside from a few remarks about the subject matter.[100] A few days later they were on the road again.

When the Japanese bombed Pearl Harbor, the Westons were in Wilmington, Delaware, planning out the rest of their trip. They immediately decided to go back to California as quickly as possible; Edward was especially impatient to get back. They took a southerly route, and along the way they stopped to visit the Charlots in Athens, Georgia; after several failed attempts, the four had finally connected again. It had been only two and a half years since they had seen each other last, but a good deal had changed in the meantime. The Charlots had two young children and were living in a new place. The Westons, on the other hand, had been on the road for many months, and as Charis

later revealed, they were beginning to have marital difficulties, problems that would eventually lead to their separation and divorce.[101] And of course, the country was at war.

According to Jean's diary, the Westons arrived in Athens on Saturday, December 13, 1941, in time for dinner.[102] Charis later recalled, "We arrived in Athens to be welcomed by Jean, Zohmah Ann Maria (eighteen months), and John Pierre (eight months). Jean and Zohmah took us to dinner at the home of their friend Frances Ison, with the select citizens of the city, including the De Wrenns, who invited us for tea the next afternoon."[103] The next day, Sunday, after mass, Jean took Edward to the Fine Arts Building to show him what he was working on. Preliminary work for the post office mural was continuing, and Jean had recently done a pen-and-wash study of the composition for the frescoes in the Fine Arts Building, representing the plastic (visual) arts, theater, and music. After that they went to visit Lamar Dodd, who took them for a drive; along the way they stopped at a cemetery in Athens, where Edward took photographs.[104]

In the afternoon, as arranged, they went to tea with the De Wrenns, but before they left Zohmah explained some of the local customs (as Charis recalled): "Zohmah explained the Athens Sunday-visiting rules: one could call on anyone but one could not stay more than fifteen minutes. She said that she and Charlot had been taking their ease in slippers and housecoats on their first Sunday in Athens when people they had never seen before entered unannounced, kid-gloved and hatted. Since then, she and Jean had learned to spend their Sundays 'making calls' to avoid being called upon."[105] While at the De Wrenns, Edward showed photographs, presumably some of the same ones Stieglitz had seen a few weeks earlier; after dark the Charlots and Westons roamed around Athens looking at Christmas lights.[106]

During the next two days, while Jean worked, the Westons spent much of their time with Frances Ison, who showed them the sights, as Charis related: "Frances Ison gave Edward a tour of homes with Corinthian and Doric columns, as well as the black church and an old slave's grave. 'Erected in memory of Fred Yarborough. Died Jan. 8, 1867 aged above 80 years. Former slave of the McKeans. Honest and Faithful.'"[107] It was probably on one of these excursions that Edward took photographs of Mr. Brown Jones, an African-American schoolteacher.[108] In addition, he took a photograph of the William H. Hunter farm near Athens, an expansive but carefully constructed landscape view (fig. 40).[109]

During the visit there was also an exhibition of Edward's photographs at the university, which Jean must have arranged; it went up on Wednesday, December 17.[110] To spread the word about this relatively impromptu event, Charis and Zohmah drafted a press release for the local paper:

> Athens is honored by the visit of Edward Weston. . . . His visit is two-fold: as he [and Mrs. Weston—crossed out] can renew his long friendship—dating from the days of the early 20s when he & Charlot were both part of the important artistic resurgence that came to be known as the mex. renasc.
>
> His main purpose in visiting Georgia is to discover the unheralded beauties which he prefers to official tourist sights. . . .
>
> Mr Weston has lent to Lamar Dodd head of the Univ. Art dept a collection of his prints. Some have never been shown before. They are exhibited for a few days in the Art Gallery of the F. A. Bldg; a rare opportunity for art lovers to see the work of this master in this most modern of mediums.[111]

In all likelihood the exhibition included many of the same photographs that Edward had just shown at the De Wrenns' tea party, but as Edward's would-be press agents indicated, some of them had never been exhibited before. There is no information as to what exactly was put on view or how Weston's work was received by the students at the university or the community at large. If the press release is to be believed, it would have been the shortest Weston exhibition on record, lasting only two days; scheduled as close to the holidays and the end of the semester as it was, it may have gone by largely unnoticed.

On Thursday, December 18, the day before the Westons left Athens, Charis' brother, Leon, arrived from Tennessee for a brief visit. Edward and Charis had last seen Leon a few months earlier when they stopped off at the Highlander School, but Zohmah had presumably not seen him since Carmel, several years before, so they must have had a good deal of catching up to do. Jean may have been meeting Leon for the first time, although he had probably heard a fair amount about him.

Sometime that same day Zohmah prevailed upon Edward to photograph Ann and John.[112] Edward was not thrilled with the idea of making baby pictures, but Zohmah was insistent and he reluctantly agreed; he took out his camera and set to work. It apparently took some doing, but Edward managed to make the children cooperate—perhaps with Zohmah's help; he pretended to cry in order to make Ann, who was being grumpy, smile. In the resulting portraits both Ann and John look remarkably attentive.[113]

It may have been on this occasion that Weston made photographs of Zohmah as well, wearing a scarf and looking a little disheveled. He had photographed Zohmah more than once before; in these new portraits she is shown at even closer range and more directly. By now Zohmah and Edward are old friends, and that is reflected in the images: they are frank and matter-of-fact, blunt and informal. Weston seems never to have printed any of them, but two were printed later by Dody Weston Thompson (Dody Warren), who was Edward's assistant in the late 1940s and became Brett's third wife. In one Zohmah appears momentarily lost in thought (fig. 41), and in another she turns her head slightly to the side and seems about to speak.[114]

The Westons and Leon left Athens on Friday, December 19, 1941, and continued south.[115] They had been invited to stay at the Isons' cabin on one of the Georgia Sea Islands, St. Simon's. Zohmah reported to Prudence, "The Westons have been here on their travels. We expect them for one more day, for Leon came here and met them and they have gone to Charleston, Savannah and southcoast and will stop on the way back for a night. It was nice to see them."[116] Along the way they stopped at Bonaventura Cemetery outside Savannah, where Edward took pictures. When they arrived at St. Simon's, Frances Ison took them around the island, and Edward took more photographs, including at least two images of the marshes of Glynn County.[117]

After several days in the Georgia Sea Islands, Edward, Charis, and Leon headed back to Athens to spend Christmas with the Charlots; they arrived on December 24, expecting to get some rest.[118] Early the next morning they were all rudely awakened by a loud noise, as Charis recalled, "In the pitch dark of Christmas morning Edward and I were startled awake by the sound of gunfire coming from all directions and steadily increasing in volume. It seemed impossible that the war had already reached American shores, but we stumbled out of bed in alarm. Before we could search for a safe refuge, Zohmah appeared in the doorway to reassure us. 'You can go back to sleep. It's not an invasion. Southerners don't celebrate July 4, because they think it's a Yankee holiday, so they save their firecrackers for Christmas.'"[119]

On Christmas day, after everyone had recovered from the trauma of the night before, they all ate turkey that Leon cooked.[120] After eating they played a game of some kind; Charis later came across the score sheet for it but could not recall what sort of game it was. She wrote to Zohmah, hoping she might remember: "What game were we playing in Dec 41, which Edward (as usual)

ducked out of, and you probably had to go nurse a baby (Ann was 18 mos, John 8 mos) (?) or change a diaper, etc."[121] Zohmah's response is not known.

There was also some political discussion: Leon voiced his opposition to the war and attempted to explain his unwillingness to answer the draft. More than a year later Zohmah recalled, "When he [Leon] was here a year ago Christmas he talked funny about why should workers work for this government and it would be just as good to have the Japanese win." She blamed it, at least partly, on the Highlander School: "He has been working for this workers school in Tenn., I suppose that is where he got these ideas and probably the reasons he gives himself for not answering the draft. Really, I just think he is crazy though not to report and give a reason, conscientious objector, I don't suppose not liking the government would be considered valid."[122]

Edward probably agreed with her to some extent, for later on he would write, "I think Leon is sincere, and knowing some of his background understand him, but I don't think that he has a leg to stand on, and I can't sympathize with his view point. If we had many who took Leon's direction the Japs would be camping on Wild Cat Hill, the Germans in Central Park."[123] Leon would later request conscientious objector status; the request was denied, and he eventually stood trial and was sent to prison.[124]

The Westons' visit to Athens was perfectly pleasant, but there was more than a little tension under the surface. Some months earlier Charis had fallen in love with another man, one of the Westons' hosts during their travels through New England (whom she never named). According to Charis, the romance never went beyond a few friendly kisses, but Edward became increasingly jealous and the resulting lack of harmony began to undermine their relationship. By the time they arrived in Athens, Charis had given up on any idea of straying; she remained committed to Edward, but their problems had not been completely resolved.[125] Meanwhile, to add to the strain, Jean and Charis did not hit it off entirely. Their distrust of each other may already have surfaced in California, but it seems to have solidified as a result of this renewed contact. Their reaction to each other was oddly parallel and apparently had to do with the way each of them treated their respective mates, or at least that is the way Charis recalled the situation:

> I was troubled all during our stay in Athens by what I saw as Charlot's efforts to make Zohmah more conventional, as well as by his insistence

that she be called by her given name, Dorothy, rather than the name she had given herself. He didn't want Zohmah to speak as irreverently as she used to in my company, and didn't want her to make fun of the people, their habits and traditions. In the latter respect, he was right, of course—but I was too much of a programmed rebel to go along with that. As far as I was concerned, Zohmah was a kindred spirit, the first woman my age whose company I really enjoyed, and he was trying to tame her. He also clearly disapproved of me.

I finally got to ask Zohmah about this when I visited her in Hawaii during the 1980s after Charlot had died. Did she know why he hadn't approved of me? "He thought you did too much talking for Edward and were always putting his ideas in your words," she said.[126]

Each felt the other was too controlling: Charis felt that Jean was making Zohmah into a conventional wife, and Jean felt that Charis was, in effect, putting words in her husband's mouth—in conversation and in the articles they wrote together. How accurate these assessments were, of course, is impossible to gauge, and nothing was said at the time, but in later years Charis acknowledged that Jean may have had a point, that she may indeed have done too much of the talking for Edward:

After some thought I realized that this charge was probably true. I was not aware of it at the time, but can see how easily it might have happened, particularly once I was in the habit of selecting and fine-tuning his words for the articles. It was only a small step to doing the same in conversation—his speech patterns seemed so limited in terms of what I knew could be wrung out of him when he was pinned down and forced out of his formulaic mode. It was the kind of overstepping boundaries that is easy to spot in other people's relationships but hard to recognize in one's own.[127]

Shortly before their departure Zohmah photographed Charis and Edward together against a brick wall, along one side of the Charlots' house. As in William Holgers's pictures, Edward had to appear taller than his wife, and Zohmah wrote about it as follows: "Edward accepted his subjects however they might be, but I asked him to stand a step above the taller Charis."[128] Charis had a similar recollection: "Zohmah wanted to have a picture of us to commemorate the visit, but like the Yosemite Forum students, she didn't want me to be seen as taller than Edward. We went around to the side yard of her house and she had Edward stand on a box while she did the honors."[129]

Zohmah's snapshots are more informal than Holgers's. In one, Edward, wearing a plaid shirt, stands with one hand in his pocket and the other around Charis; he seems untroubled about standing on a box and looks openly toward the camera. Charis, wearing a light sweater and slacks, places one hand on his chest, leans her head on his shoulder, and smiles slightly (fig. 42). If there were any tensions between them—if, as Charis would say later on, they had already begun to break down as a team—that is not apparent here. The photos show a good deal of affection.[130]

Later that same day, or perhaps early on the following day, Edward, Charis, and Leon said their good-byes to the Charlots and departed again. Their route took them first of all back to Tennessee; they made a brief stop at Highlander to drop off Leon and stopped in again to see the sculptor Edmondson. Then they headed home via Texas and New Mexico. Along the way Edward made a small number of photographs, but he and Charis were both increasingly impatient to get back; not only were they concerned about the fuel and tire shortages brought on by the war, but they had heard rumors of Japanese submarines off the coast of Carmel and other threats. So too they worried that Carmel and other parts of California might be evacuated even before they reached home. They had begun their trip under the threat of war, and now war was upon them.

8

MY LITTLE GRAY HOME
IN THE WEST

Edward and Charis arrived back in Carmel on January 20, 1942, having been away for eight months and traveled through twenty-four states; they found, to their dismay, that not one of the seventeen cats they had left behind still remained, but they were glad to be back, and there was a great deal of work to do.[1] Shortly after their return Edward wrote to the Prendergasts and reported on the pictures from the trip: "I have my negatives all enveloped and labeled, which means that I have seen them—every one! It was quite a new and thrilling experience, coming back to 700 neg's I had never seen. Now comes the grueling task of selecting 54 for 'Walt,' [*Leaves of Grass*] meeting an April 1st dead-line. As expected the N. Orleans photographs are tops."

Then Edward turned to the question of the war and, after discussing the draft status of each of his sons, reflected on his own predicament: "I have had to become fatalistic about the boys & myself for *that* matter; we are all in it in a big way, with no light ahead. Rather than be mixed up in local hysteria I shall probably see what I can do to help out in a photographic way—anything but dark-room work. Maybe I can get to be a captain or major. Airplain [*sic*] & ship spotting is a local possibility which either Charis or I could do, though I would not like to land a night shift." He went on to report—with a note of cynicism—that at the moment the situation in Carmel was relatively calm: "Actually everything is quiet around here, there hasn't even been a practice blackout since we returned; but you can never tell when some local yokel will decide to evacuate all of us along the coast—which would be just swell!"[2]

Weston was being facetious, of course; there was little danger that the entire population would be evacuated from the West Coast, but as it turns out his fears were not entirely misplaced. On February 19, 1942, FDR signed Executive Order 9066, which called for the evacuation of all persons of Japanese ancestry living in California, Oregon, or Washington—the majority of whom were U.S. citizens—and their immediate transfer to internment camps in various locations well away from the coast. Along with many others, Weston was outraged by this injustice, and he fired off a letter to the local newspaper in protest, demonstrating a level of involvement not usually associated with him. Indeed, Charis later described this as "one of his few overt political acts."[3] During the previous decade Edward had rarely involved himself in political activity, but Charis was undoubtedly underestimating the extent of his engagement.

As Edward and Charis were making their way back to California, Edward's old flame Tina Modotti died in Mexico quite unexpectedly and under somewhat mysterious circumstances. Edward had not heard from Tina since 1931, when she wrote to him from Moscow.[4] After many years in the USSR and Europe, including a long period in Spain during the Civil War, she had managed to return to Mexico in 1939, entering the country illegally; she took up residence in Mexico City, and there, on the morning of January 6, 1942, she died of an apparent heart attack in the back of a taxicab on her way home from a party. According to official accounts she died of heart failure, but almost immediately reports of foul play began to circulate, in the press and elsewhere. It was said that she had been poisoned with an undetectable substance that induced heart failure by Stalinist agents who wished to silence her. Apparently, Diego Rivera was among those who looked upon her death as some sort of sinister conspiracy and was outspoken about his suspicions—which have never been substantiated.[5]

Tina's funeral took place the day after her death. She was buried in a fifth-class cemetery plot in the Panteón de Dolores in Mexico City as a large crowd looked on. Her bier was draped with a cloth embellished with a hammer and sickle, and on top of it was a portrait that Weston had taken of her in Los Angeles about two decades earlier, in 1921, before they went to Mexico together.[6] Modotti's friends and admirers also held a memorial on February 23 at the Teatro de Pueblo; by that time Weston had learned of her death and supplied a brief statement for the occasion. He said simply, "Any superlative

employed to refer to Tina's character and beauty, would not be adequate. Thus I will limit myself to salute her memory."[7] Whether he realized it or not, several chapters of his life were coming to an end at once. Not only were his Whitman travels over but an important part of his early years, his time in Mexico, was gone as well.

Meanwhile, back in Athens, Charlot was once more busy on the McDonough post office mural. After having worked out the cartoon the previous fall, he spent the beginning of the new year doing the actual painting—in oil on canvas—in his studio; it was largely finished in February and then, presumably, set aside to dry.[8] Soon after work began again on the fresco for the Fine Arts Building at the University of Georgia. In April, after preparation of the wall surface was complete, he began the painting—true fresco in this case, not oil on canvas. The fresco comprises three sections. The first represents what Charlot referred to as the plastic arts; it shows a seated woman—"the Sybil"—surrounded by three artists: a painter (given the features of Lamar Dodd and based on one of Michelangelo's *ignudi* from the Sistine Chapel ceiling), a potter, and a sculptor. Charlot described his work as follows:

> the painter is seen working on a composition, a mathematical diagram rationalizing the proportions of man; the sculptor is seen attacking with hammer and chisel a piece of marble. Thus the painter symbolizes the conception of the work of art in the world of thought, while the sculptor symbolizes its execution in terms of material used. There is also the potter, and near him a potter's wheel of archaic type, a hint of future industrialization and machine-made art. The three artists cluster around a seated woman, "The Sybil," crowned with gold laurels and holding the plumb-line and square suggestive of the discipline and method that must reign even in the arts.[9]

Charlot's statement, like the painting itself, is indicative of the intellectual rigor of his approach to art. The emphasis is on mathematical order and proportion, on thought and discipline. Charlot had often spoken of art in such terms in the past, most notably perhaps in his Disney lectures. Indeed, in his writing and his own compositions he had long prized careful planning and geometric organization, which he regarded as the backbone of the visual arts. The fresco is an embodiment of this sort of thinking—a manifesto clothed in neoclassical garb.

The remaining two sections deal not with the visual arts but with the performing arts. The subject of the central section is theater, featuring two female figures holding masks, symbolizing Comedy and Tragedy; at the left are a mother and child (modeled on Zohmah and John) under the spell of the theatrical illusion. The final panel, on the right, deals with music. It includes a group of singers, reminiscent of the singers from Luca della Robbia's *cantoria* in Florence, who represent art and music as social activities; they are offset by a beautiful figure of a harpist, who embodies the more introverted, meditative aspect of musical pursuits. In these images too there is a strong sense of geometry, of measure and harmony.[10]

The Fine Arts Building frescoes were completed on May 1, and by that time the post office mural was dry and ready for installation. On May 11 Charlot and his assistants rolled up the canvas, and the next day they loaded it into a car and headed for McDonough; Frances Ison and another friend, Alan Kuzmicki, did the driving. That afternoon the mural was hoisted into place on the wall of the post office. Charlot had worked very hard to design the perspective with the painting's relatively high position in mind, and he was well pleased with the results: "Put in its intended position, WA1p63661 [the government's control number for the project] found its justification."[11]

Back in Carmel, complications had arisen with Weston's *Leaves of Grass* project. George Macy was not entirely satisfied with the photographs Weston had produced; he was concerned that they did not follow Whitman's text closely enough—that they did not illustrate the poems as fully or as literally as he had been expecting. To allay Macy's fears on that score, Charis found lines in *Leaves of Grass* that matched, or nearly matched, Weston's photographs and sent them along with the prints. Her goal was to demonstrate the affinity between the poet and the photographer; Macy was apparently convinced, as he accepted Weston's submissions.[12]

Difficulties then arose over payment, and to make matters worse, Macy also had misgivings about Armitage's design for the book; by this time Macy had decided to replace him, reneging on the original agreement.[13] Not surprisingly, Weston was furious, and he described some of his troubles to Beaumont Newhall:

To cap the climax, after accepting my "illustrations" with great enthusiasm, Macy tried to freeze out Armitage but M.A. wouldnt freeze, would

bring suit. I was, am, the innocent bystander, even had to write 3X for my 2nd installment which made me mad as hell which iritated Charis because she thinks nothing, nobody, is worth getting mad over and about. — but I love to get mad and feel surpressed or repressed (Zohmah Charlot would know the right word) if I can't fight or at least talk aloud to myself. I have to go way out among the pine trees where Charis can't hear me if I want to express myself.[14]

Despite all that the project eventually went forward, but without Armitage's participation. It must have seemed as if history was repeating itself. The same sort of difficulties Charlot had experienced during the publication of *Carmen* were happening again: Armitage and Macy were once more at odds. To his dismay, Weston was caught in the middle and understandably frustrated. To complicate the situation even further, personal tensions were slowly growing between Edward and Charis. The trouble that had started during the Whitman trip had not been alleviated with their return home. At this point the tensions remained largely under the surface, but they were nonetheless serious; the Westons' marriage was starting slowly to unravel.

Soon after, early in the summer of 1942, Don and Bea Prendergast came to California for an extended visit. The Prendergasts had been the Westons' guides in New Orleans during the Whitman trip the year before, but they had recently moved to Tucson, where Don was to start teaching art in the fall at the University of Arizona. They planned to spend the summer months in Carmel, and the Westons arranged for them to stay at a guest cottage—Charis called it Sea Gertie—just beyond Point Lobos. Bea Prendergast later wrote an affectionate account of her time there; she recalled how Edward divided his time between working in the darkroom, photographing, and other outdoor activities, like chopping wood.[15] Charis also recollected the visit fondly: "Don and Bea fit right into our lives at Wildcat Hill. They were great companions and we saw them almost daily. There was no distinction between hosts and guests—if they wanted to look at prints they got them out for themselves; they both photographed and worked in the darkroom with Edward; we prepared and ate meals at our place or theirs."[16]

While the Prendergasts were in Carmel, Weston made more photographs at Point Lobos. But in late August Weston wrote his son Neil that he had seen a sentry posted at the entrance.[17] If Weston's favorite stomping ground was

not yet completely closed off, it soon would be. Shortly afterward, guided in part by circumstance, his work turned in yet another direction; his methods started to change, as did his subjects and mood.

In late May the Charlots left Athens and headed for Berkeley, where Jean was slated to teach art history at the University of California during the summer session. Along the way they passed through New Orleans and then, in June, stopped in Los Angeles. While there they tried to arrange a visit with the Westons in Carmel, but something went wrong, for reasons that are not clear, and the visit never took place.[18] The episode seems to have stirred up some bad feeling, especially on the part of Charis and Jean, and it became a source of regret later on. Early the following year Zohmah reported to Prue, "Ann and John got a postcard from Charis! It is the first word we have had from her since Los Angeles. Edward writes a postcard every now and then. Jean still doesn't feel like writing. Our California trip was surely unfortunate from the point of view of many of our personal relationships."[19]

Obviously the trip was not a complete success in terms of long-standing friendships, but if their relationship with the Westons suffered somewhat that summer, the Charlots did manage to renew their acquaintance with a number of other people. One of them was Edward's old friend Jehanne Biétry Salinger, who had interviewed Jean on the occasion of his 1933 exhibition at Ansel Adams's gallery in San Francisco.[20] So too they dined with Dr. Eloesser; when she reported on the visit to Prudence, Zohmah identified him as "the doctor who made Jean faint when he cut a woman's breast off and who went to Spain for the Loyalists."[21]

One day at the very end of August or early in September, shortly before the Prendergasts left Carmel for Tucson, Charis brought home a gas mask that had been issued to her in her capacity as second in command of the local Aircraft Warning Service. Edward was reportedly fascinated by the sheer repulsiveness of the contraption, and when Charis modeled it for him, he reportedly said, "Let's make some nudes."[22] He quickly set to work and soon produced one of his most unusual pictures, which he initially called *Victory*; he later changed the name to *Civilian Defense*, which is how it is generally known today (fig. 43).[23] The picture shows Charis, wearing nothing but the mask, reclining on a sofa; alongside her, in the immediate foreground, there is a long fern that fills the lower part of the horizontal frame.[24] Weston had

never done anything quite like it, but he seems especially to have enjoyed the bizarre incongruity of the situation, as the sensual associations of the reclining nude clash with the horrifying character of the insect-like mask. The results are at once appealing and repellant, comical and unsettling, nightmarish and unreal.

Charis herself once explained how the picture came about and spoke of Weston's intentions; she rejected the idea that Weston was making any sort of political statement: "I don't doubt that he meant the images to be shocking, but I question the view that this represented any great leap of social consciousness on Edward's part. He greatly resented any infringements upon individual liberty, but he did not seek out messages."[25] Some years later, however, she spoke of the pictures in rather different terms; in an article in the *Boston Globe* she was quoted as saying, "people who call it a bad joke don't see it as it really is, as a pretty strong antiwar statement."[26]

Weston was not opposed to the war itself, but he did have specific concerns about how the war was being conducted. In this case, as Charis went on to explain, he was troubled that only military officers and other officials (like Charis) received the masks, while everyone else was left to fend for themselves; in the event of an attack, most people would be defenseless. For Weston that was unacceptable, unfair, and laughable, and the resulting pictures must be understood, at least in part, as an expression of his outrage. In that context the title *Civilian Defense* becomes especially ironic. Weston's photograph may have a somewhat surreal flavor; it can perhaps be understood in purely personal or sexual terms, but there is clearly a political dimension as well, satirically expressed. Some years earlier, in 1934, Weston had written to Adams affirming the relevance of his apparently apolitical images of rocks and the like, but now his imagery was becoming more explicitly and openly topical.

Civilian Defense represents a departure in another sense as well: it seems to be more carefully arranged and less spontaneous than many of his earlier nudes. Although many of his pictures—especially the nudes—had been set up to some degree, in this picture Weston ventures more deeply into what today might be called, following A. D. Coleman, the directorial mode.[27] Rather than being simply a nude, the picture is more of a tableau, the details of which are carefully arranged in order to achieve a particular effect or to enhance the meaning. Indeed, Weston comes precariously close here to the approach of nineteenth-century photographers like Rejlander and Robinson, an approach that he had roundly condemned earlier. It appears that his views had softened

considerably, circling back to the beginning of his career. By the same token, the use of titles was also a noteworthy change, a departure from Weston's recent practice, harking back to his earliest work; he had not used anything but straightforward descriptive titles since his pictorialist days.[28] Weston was clearly shifting gears, almost going into reverse—not only in spirit but also in method.

Toward the end of August the Charlots left Berkeley and returned to Athens. Soon after Jean began working on a study of mural painting in Mexico in the first half of the 1920s, which would culminate many years later in *The Mexican Mural Renaissance*. As the project got underway he contacted Edward, asking to see whatever Mexican material he might still have, in the hope that it would aid him in his research. Toward the end of the year Edward wrote back to say that he had not been able to find anything: "I spent several hours yesterday hunting our loft for mexican data for Jean. No luck. Worse, I know it *is* there. I'm sure that it was brought up from L.A. when Neil and I moved. I'm not giving up. I admit the loft is a mess with boxes of Leon's papers and books mixed with ours."

Edward went on to report that he would soon be sending along photographs; he did not specify which pictures, but he probably meant the ones he had taken in Athens the previous year, which had not yet been printed. Then he signed off: "Our love forever—Edward."[29] In the margin he added that *Leaves of Grass* would be out that month. There is no sign of any bitterness over the events of the previous summer; by now, whatever tension there may have been seems to have evaporated—at least as far as Edward was concerned.

The next day, after more searching in the attic, he wrote again with better news about the Mexican material: "Up in the attic again I saw a pink paper sticking out—it was one of the mexican broadsides. I found and will send when next we go in to shop, manifestos, 'El Machetes', 'Irradiador' and quite a group of photographs of early Charlots."[30] The photographs to which Weston referred may belong to the group that was made in the fall of 1926, although he gave no details. Weston then added that he did not expect to have the children's pictures finished in time to send along with the Mexican material and would attend to them shortly. A short time later Weston wrote again to say, once more, that he would soon make prints of the Charlot children. It seems that he had been having a little trouble making himself go into the

darkroom: "I have not printed in some weeks. When I start again the Char-lot children are first on list." Edward also informed Jean that he had been unable to find any more Mexican material; then, in closing, he mentioned that he had grown a "beautiful grey & red beard" and urged Jean to try one too.[31] It was beginning to sound as if the prints would be a long time coming, but soon after that Weston finally made it into the darkroom, produced the promised prints, and sent them off—about a year after they had been taken.[32]

Leaves of Grass finally came out toward the end of 1942, about a year after the United States entered World War II. It comprises two volumes in a slipcase; along with Whitman's text there is a short introduction about Whitman and his poetry by noted poet and critic Mark Van Doren and forty-nine photo-graphs by Weston, interspersed among the pages of text.[33] The book had all the makings of a fine work, but in the end it was something of a disappointment, especially with respect to the design. An obvious attempt was made to choose colors and textures that suggested grass and earth, in keeping with the title: the slipcase is brown, for example, and the cover of each volume is a bluish-green, with one of Weston's photographs—a depiction of grasses—used as a decorative motif. Perhaps the most unfortunate aspect of this conception, however, was the decision to tint the pages a pale and unattractive minty green, presumably to make the leaves of the book look grassy—as a result, Weston's pictures, which are not especially greenish in tone and have an ample white border, appear to be "tipped in" to the green pages. The pictures themselves are nicely reproduced, but the overall effect is very disagreeable.

To make matters worse, under each picture are two lines of Whitman's poem, which appear to be meant as captions or titles. Macy had used the selections Charis sent him in a way she—and Edward—had never intended. When she identified those lines, Charis had been trying to ally Macy's concerns about the suitability of Weston's imagery; she was merely pointing out the affinity between the text and the photographs. Charis was well aware that Weston did not want to illustrate Whitman's poetry in any literal way and was adamantly opposed to the use of captions. Macy, however, either failed to realize that or simply disregarded the photographer's wishes, further compromising the original conception.

Not surprisingly, Weston was not at all pleased with the result. He expressed his disappointment in a letter to Merle Armitage, who had long since been removed from the project and had no part in the final grassy design:

My reaction to W.W. [Walt Whitman] Book is quite definite: it stinks. I don't see how, if they had tried, a more undistinguished job could have been achieved. But it is really worse than that—and of course I am now thinking of my work, its presentation; the photographs look like paste-ins in an old scrap album. The green-tinted pages reach a new low in bad taste, almost kill any value my photographs have; this added to the wrong shape book for my work which is mostly horizontal, completes the unpretty picture. Thank the gods for one thing—the reproductions with a few exceptions are excellent. Those who persist will eventually be able to see my photographs. But when I think of what the book might have been————[34]

What is especially interesting about Weston's response is not his objection to the presentation—which is, after all, almost laughable—but the fact that he stands solidly behind the images themselves; he may have disavowed the publication, but he did not disavow the pictures, either individually or as a group, and he still believed that the original conception was sound, that his pictures and Whitman's poetry were a good match and in the right hands could have resulted in a much better book.

For some critics, the Whitman pictures lack the intensity or concentration of Weston's earlier efforts and seem more distant and impersonal, more literary, or even more picturesque, in a traditional sense.[35] Such criticism is sometimes overstated, but it is not without foundation. Although many of the images in *Leaves of Grass* are anticipated in *California and the West* and other earlier works, there is a noticeable change here in Weston's approach; the emphasis in the book is on relatively inclusive and more complex views. There are broad vistas of rolling hills and fields, pastures, canyons, and river valleys; so too there are many urban views, of train stations, harbors, and wharves. Weston had taken comparable views in the past—of the Embarcadero in San Francisco, for example—but now he applied the same approach to locations that he had not photographed before, including a number of northeastern cities (such as Cincinnati, Pittsburgh, and New York).

Although most of the pictures are landscapes, cityscapes, and industrial scenes, the book also includes a small number of relatively close-up, almost abstract images, such as the one of grass used for the cover and the frontispiece or the photograph of rocks, seaweed, and shells that accompanies "As I ebb'd with the Ocean of Life." Although they may bring to mind some of Weston's signature images from previous decades, even these examples are

more expansive than before; instead of emphasizing a single object, like a pepper or a cabbage, they seem more spread out, dispersed and un-centered. Comparable observations can be made about the portraits, a small number of which appear in the book. Here too Weston's approach has broadened considerably: unlike the portraits taken during the Mexican years, in which the head tends to fill the frame, the newer ones tend to include more of the figure and more of the surroundings—as, for example, in the opening plate of Dave Dillingham playing the banjo or in the photograph of Mr. and Mrs. W. P. Fry sitting on their porch in Burnet, Texas.[36] In their relative inclusiveness, such portraits bring Weston remarkably close to some of the documentary work of photographers like Walker Evans or even Margaret Bourke-White; so too they set the stage for the "portraits with backgrounds" of family members and close friends that Weston began to make the following year.

As Alan Trachtenberg has intimated, the relative distance in these new pictures, whether portraits or urban views, is perhaps best understood as an attempt to match the extensive reach of Whitman's poem. Once the project was underway Weston said as much to Macy, in very specific terms: "It is my feeling that the photographs worthy to go in an edition of Leaves of Grass are those that will present the same kind of broad, inclusive, summation of contemporary America that Whitman himself gave."[37] It was Weston's intention to create a visual equivalent of Whitman's sweeping view of the country, and as a result he favored wide, almost panoramic views. This might not apply to all the pictures taken on the Whitman trip, many of which grew out of the Guggenheim imagery, but it is certainly true of the selection included in Leaves of Grass—a selection for which Weston himself was at least partly responsible. Indeed, he chose those examples that brought him as close as possible to Whitman's comprehensive vision, and a more successfully designed book might have brought that out more effectively.[38]

At the end of the second volume of Leaves of Grass is a colophon. Predictably, there is no mention of Armitage; the book, it states, was prepared "at the shop of the Aldus Printers in New York, the plates having been made by Pioneer-Moos, the paper by Worthy, and the binding executed by Russell-Rutter." The colophon also states that Weston's photographs were made "in an extensive tour of Democratic America."[39] The emphasis on democracy here must have been Macy's way of asserting that the project was an appropriate wartime undertaking; in a small way he was striking a blow against America's undemocratic enemies. (And Weston, it seems, did not have a problem with that.)

At the end of 1942, just as *Leaves of Grass* appeared, Charlot had a show at the de Young Museum in San Francisco, where Weston and Group f/64 had exhibited a decade earlier.[40] It included a broad range of work: there were numerous oils from the Mexico years, a series on the Flight into Egypt, and the *Nativity* (homage to Filippo Lippi) that Charlot had done soon after his arrival in Athens the year before. So too there was a set of Stations of the Cross and many studies for the recently completed murals in Georgia, at the McDonough post office and the university (a few of which Weston may have seen during his visit to Athens).

In a review for the *San Francisco Chronicle*, art critic Alfred Frankenstein spoke favorably of the show and discussed the importance of Mexican sources, of Pre-Columbian sculpture and ancient codices, in Charlot's work. He also saw a good deal that led back to France and the western tradition. He mentioned Charlot's luminous color and spoke about his compositional abilities, about how every passage was carefully considered and no part of any picture was empty or meaningless—the mark of an important painter. Among all the work, Frankenstein was struck the most by the Mexico-related pictures and some of the religious subjects: "it is the Mexican pictures that tell most strongly. Particularly the smaller ones, the market place scenes, the mothers and children, and the Flight into Egypt series. This last is full of humorous, delightful incidents as if it had been done by a cartoonist, but the magic of tenderness and coloristic melody Charlot works in these canvases places them far beyond the class of works whose values lie in the first amusing contact."[41]

In conjunction with the show, Jehanne Biétry Salinger gave a lecture at the museum on Charlot's artwork and writings.[42] Salinger had written about Charlot when he last exhibited in the Bay Area, at Ansel Adams's Gallery, and now, presumably, she brought things up to date. But Charlot was recovering from appendicitis and did not make the trip to the West Coast as he had planned.[43] Although it stands to reason that Weston would have gone to see the exhibition, which was, after all, an important show and fairly close at hand, there is no mention of it in the surviving letters.

As the show was coming to an end, the Charlots sent Edward and Charis a New Year's card that was part thank-you note and part New Year's greeting from John and Ann. On the outside it featured a drawing by Jean showing the two children seated back to back, holding Edward's pictures of themselves, which they were thus, in effect, acknowledging (fig. 44). Inside, the message reads, "There are four of us now! Love and Happy New Year. Ann and John

Charlot."[44] The tensions that had developed over the summer had by then clearly dissipated.

In the early months of 1943 Weston began increasingly to make known his opinions on the issues of the day, writing letters to politicians and other public figures. During this period he followed current events very closely, in *Life* magazine and elsewhere, responding quickly—and with a good deal of sarcasm. He took exception, for example, to a speech made by Connecticut representative Clare Booth Luce on the floor of the House. Early in 1943 she had criticized Vice President Henry Wallace for advocating a global network of airways operated by a yet-to-be established United Nations; she called the vice president's scheme "Globaloney."[45] Weston, on the other hand, sided with Wallace and saw merit in his global outlook; he wrote to Representative Luce and told her she was "the glow-baloney-girl of the year."[46]

Weston also objected to the continued existence of the Dies Committee, a precursor to the House Un-American Activities Committee. The committee had been criticized not only for violating basic civil rights but also for devoting more attention to Communists than to Fascists—at a time when the country was at war with Germany and Italy, not the USSR. The critics, however, did not prevail, and in February a resolution in favor of keeping the committee alive passed overwhelmingly in the House. In this case Weston wrote to praise Bill Rogers, a new representative from California, for voting against it.[47]

At around the same time Weston even cancelled his subscription to *Life*, in response to an open letter that had recently appeared in the magazine. This was quite possibly "The Time Is Now: Are We Winning the War—or Are We Losing It?" in which the editors of *Life* argued that the war might become a protracted one and would not necessarily lead to the total military defeat of the enemy, especially if the Soviets were unwilling to drive straight on to Berlin.[48] Weston must have been offended by their overly pessimistic assessment of the war in general and the Soviets' role in particular. It seems he could not accept that the war would not end quickly and decisively; perhaps he even thought that *Life*'s editors, in pointing out the various ways in which things could go badly, were helping to bring about the wrong outcome and thereby undermining the war effort.

Early in March Weston summed up his recent letter-writing activity in a letter to Willard Van Dyke. He concluded by saying, "And believe me letters are noticed; I get quite a few answers, mostly from those I vilify! So perhaps

my time is not wasted."[49] Weston had, of course written on political matters before—in response to the internment of Japanese-Americans, for example—but as the war dragged on he devoted more energy to such endeavors and regarded his letter-writing as part of his contribution to the war effort, along with plane-spotting and maintaining a Victory Garden.

Early that spring the Charlots acquired their copy of *Leaves of Grass*, and Zohmah lost no time in writing to Edward about it; she began by making light of the use of green: "We are at last proud possessors of Leaves of Grass and think your contribution to it very beautiful. We understand that the Spanish bathroom nile green that adorns the margins of your plates may have gotten on your nerves but you may come to like them. They would match well the prints on pink paper that you will produce some day when you are tired of black and white." Then she turned to the volume's good qualities, and in particular, she spoke of how well Weston's pictures match the spirit and tone of the poem: "We do see an extraordinary kinship between Whitman and you and this is meant as a compliment." Without any prompting, the Charlots had clearly understood Edward's intentions, which were evident, at least to some degree, despite the overabundance of green.

On a different note, Zohmah also referred to an older work, the *Honeymoon* picture, which had just been published in the *U.S. Camera* annual for 1943; she wrote, jokingly, "We spend much time denying that we are the Charlots pictured in the Annual of Photography 1943, so as not to lose our job with the university that requires a dignified and neat appearance."[50] The annual was edited by Tom Maloney, with whom the Westons had worked—on *California and the West*, among other things—and the photography was judged by Edward Steichen (now a lieutenant commander in the U.S. Navy Reserve), who would later select a variant of this picture for the *Family of Man* exhibition. This time around, Weston's photograph was simply titled *Jean and Zohmah Charlot*.[51]

Zohmah made no mention of it, but Weston was also the subject of one of the pictures in the same volume; it was by a young California photographer named Glen Fishback and showed Weston at work, part of a series.[52] In addition, there were pictures by Dorothea Lange, Ansel Adams (a vertical version of *Moonrise near Hernandez, New Mexico*), and Wynn Bullock, among many others. Moreover, there was a small section in memory of frontier photographer W. H. Jackson, who had died not long before at the age of ninety-nine.[53] And naturally there was a good deal of war-related imagery. There was, for example,

a U.S. Navy photo of an explosion on the destroyer *Shaw* during the bombing of Pearl Harbor and an International News photo of a direct hit on the flight deck of the aircraft carrier *U.S.S. Yorktown* during the battle of Midway; so too there were photographs by Robert Capa and many others of the war in Europe.

In the April letter the Charlots reported on other matters as well. Ann and John, they wrote, were reading picture books, and they had already started going to school. Meanwhile, work on Jean's book about Mexican art was continuing, and Jean wanted to hang on to the material Edward had sent just a little longer, to have photostats made. Then the letter turned to cats and mice. It seems that the Charlots were having trouble with rodents: their house was inhabited by mice, which were driving them crazy, so they had asked around, hoping someone would give them a cat. Many people had responded, and the Charlots were expecting to receive quite a few felines. Knowing the Westons' interest in cats, they reported all this in the letter.[54]

Edward responded soon afterward and offered to send along some of their own cats: "Shall we express you a cat or two? We have one called 'Spottsylvania Jones' who is terrific." In the same letter he spoke of Ann and John: "I don't believe that Ann & John are 'now reading' — not even with such intellectual parents."[55] He went on to say that he was sending all of the negatives of Ann and John; he had printed a few of them but was obviously not interested in doing any more.[56] Then Edward turned again to *Leaves of Grass*: "This is the [green] ink Macy had me use for signing Leaves of Grass. I don't think that you should call yourself 'proud possessors' of same. I go around with bowed head. But I do appreciate the 'kinship between Whitman and you'. Wish you could see some of work that I did on the trip; it goes with my best."[57] Edward may have been displeased with the book, but he was clearly proud of the work he had done and happy with Jean and Zohmah's response.

Weston made no mention of his most recent work, of *Civilian Defense*, for example, or the circumstances that gave rise to it. Nevertheless, by this time the war was starting to affect their lives, and in the same letter he reported on war-related developments: "We are too busy. Have over 1000 sq. Ft. of V . . . [Victory]-garden going. It's down in front, in the flat before the drop to H'way. I am doing two nights a week in the Army Air Force. Ha ha! You thought me too old eh? Well I'm in the army all right, as ground observer. Charis is my boss, which irks me. But then I'm air-raid warden so can boss her when the time comes."[58]

Edward's tone is rather lighthearted; there is little indication of any serious

problem, but by this time, at least according to Charis, her relationship with Edward was becoming increasingly strained. There were no emotional scenes, but communication between them had broken down. We can only assume that when Edward spoke in his letter of being irked, he was not entirely joking.[59]

Soon after the Charlots sent Edward and Charis a copy of Anita Brenner's latest book, *The Wind that Swept Mexico*, which had just come out.[60] It recounted the history of the Mexican Revolution, including the years when Jean and Edward were in Mexico. The book was intended as a kind of photographic history of the period and featured a section of historical photographs selected by George Leighton. In his afterpiece Leighton mentions Weston as having had a studio in Mexico and speaks of how Tina Modotti had made one of the prints in the book, a photograph of Zapata, from an old negative by an unknown photographer. He also acknowledges the assistance of Walker Evans, who helped with the planning of the book and made a number of prints.[61]

Edward acknowledged the present (without mentioning the book by name) by postcard on June 15 and promised a real letter before long.[62] True to his word, toward the end of the summer he wrote again, a long letter this time, and mentioned the book more specifically: "I have thoroughly enjoyed 'Wind that Swept Mexico.'" He did not elaborate, but it seems to have led him to read more on the subject, for he added, "Have just got into Stuart Chase's 'Mexico', written a dozen years ago. Excellent."

In the same letter Edward detailed the latest news of his sons, who were going off to war in various capacities, and then he spoke at some length of his latest work:

> Despite war, or maybe because of it, I have done some new work— and quite different. Some of Titles: "My little grey Home in the West," "Exposition of Dynamic Symmetry", "Good Neighbor Policy", "What We Fight For". Lest you be misled by titles, I give you a hint or two; "What we F.F." is a still-life built up of such items as tooth brush, Ivory soap, Kotex, Life magazine, and "My Little Gray H. In the W" has added vitamins in the form of a nude woman, a skull, and a flute player. "Dyn. Sym." should be seen, can't be explained—not easily; but among other items it has 4 figures hanging from, or looking out of, as many many windows. Ho, Hum.[63]

Weston first described *What We Fight For*, a still life made up of a rather odd assortment of personal and household items. This of course was not the

first time that Weston had turned to still-life imagery as a means of sending messages or making statements—his *Masque* (or *Valentine*) of 1935 is perhaps the most pertinent precedent—but while his aesthetic strategy was a familiar one, his intentions were very different than before.[64] Instead of private, allusive meanings, he was now making a political or social statement, reflecting concerns and ideas already evident in *Civilian Defense*. In this case his target seems to be consumerism, or consumer culture, and as with *Civilian Defense*, the title here is to be taken with a grain of salt: while the consumer goods in the picture may represent the American way of life in the most superficial, materialistic sense, as conveyed, for example, in advertisements, that is clearly not what really matters, not what the war is really about. Indeed, a little later on, defending this and other recent pictures, Weston would say, "I need not say that 'What We Fight For' is *not* what I fight for."[65]

Weston's picture is perhaps best understood in conjunction with something he wrote at about the same time—a draft of a letter probably intended for one, or perhaps all, of his sons. The text is somewhat rambling, but Weston's initial intention was to clarify his position on the military draft. As he explained, he was not opposed to the draft, but at the same time he acknowledged that someone like Leon Wilson could object to killing on moral grounds without belonging to a religious group, as the law demanded; although he disagreed with Leon about the war, he felt that his brother-in-law was being treated unfairly. Leon's predicament, however, was only the point of departure for a discussion of even broader issues, about which he spoke in surprisingly savage political terms:

> The eternal internal mess we are in is caused by labor-capital conflict—two sides of the same rotten apple. The capitalists almost to the man are laboring men who—craftily, greedily—have grown from the ranks to power on one suspender. The capitalist knows the kind he came from too well—he will keep them down; while each laborer has hopes of rising to the height of some Soothing Syrup King.
>
> I am in very deep water, deeper than I should be, [I] hardly now where to swim next. Our peculiar American disease is a material one—almost everyone is out to at least keep up with the Joneses. Our aristocracy is one of money in place of intelligence, and money begets greed. . . .
>
> Why fight for Pepsi-Wunki = = *we* are not! We are fighting to keep out bigger bastards than our own; bastards perhaps more cruel and just

as stupid. And we are fighting on the homefront to keep our Pepsi-Wunki gang in line, keep them from winning the peace; or from compromising with their kind in Germany and Japan."[66]

Although Weston's picture *What We Fight For* contains no specific reference to Pepsi-Cola, it nevertheless would seem to be addressing similar issues. For Weston the war was not only against Germany and Japan but also against capitalist greed and materialism—a war that would continue even after the military conflict was finished. In taking such a position, Weston seems almost to be embracing the antiwar arguments that Leon and others espoused, but despite his concerns about the Pepsi-Wunki gang, Weston was not in fact calling the war effort into question. By the same token, *What We Fight For* is not a simple indictment of America's wartime policy. Indeed, when considered together with the letter, the picture quickly becomes a rather strong, almost cranky, statement about capitalist excesses and is more pointedly political than most of Weston's previous work. In the past Weston had avoided specific political content, direct or indirect, but here, in the middle of the war, Weston seems to be changing course. The war seems to have brought out the more political side of his nature, and this was starting to make itself felt in his photographic imagery as well, at least in certain cases.[67]

Not all of Weston's recent work was quite as political as *What We Fight For, Good Neighbor Policy,* or *Civilian Defense.* In his letter to the Charlots Weston also spoke of a picture, *My Little Grey Home in the West,* that seems to sound a more personal note (fig. 45). The image is not so much a still life as a figural composition; it features a nude Charis, against a doorway in a somewhat extravagant slouching pose, holding a steer skull. In the window at the upper left we see Leon playing a recorder, as if providing musical accompaniment, while in the lower right-hand corner there is a stone bird (the work of William Edmondson, which Edward and Charis must have picked up in Tennessee during the Whitman trip).[68]

The title in this case refers to an Irish song of the same name, which had been popular in England and Ireland during World War I and the years immediately following.[69] In the song the house is a humble refuge, somewhere to go when the day's work is done, where the singer will be warmly, even passionately, welcomed by a lover or spouse:

When the golden sun sinks in the hills
And the toil of a long day is o'er
Though the road may be long
To the lilt of a song
I forgot I was weary before

Far away where the blue shadows fall
I shall come to contentment and rest
And the toils of the day
They will all pass away
In my little grey home in the west

There are hands that will welcome me in
There are lips I am burning to kiss
There are two eyes that shine
Just because they are mine
And a thousand things other men miss

The song concludes on a more domestic note:

It's a corner of heaven itself
Though it's only a tumbledown nest
But with love blooming there
Sure no place could compare
With my little grey home in the west[70]

The song describes a humble but idyllic situation somewhat at odds with
the reality of Weston's now-faltering marriage. Wildcat Hill had once been
a happy place, and following Pearl Harbor Edward and Charis had been in
a hurry to return to Carmel—to protect their little home in the west—but
by the time they returned their relationship was no longer the idyllic one it
had been before, and their home in Carmel no longer represented the happy
nest described in the song. Edward and Charis were moving apart, and the
photograph seems to allude to these growing strains and the resulting unhap-
piness. In this context the little gray home in the west becomes the embodi-
ment of discord, not contentment or bliss; Weston invokes the sentimental
ideal celebrated in the song in order to turn it on its head, mocking his own
situation with considerable irony, even bitterness.[71]

The song to which Weston refers here had been popular in itself for quite

some time, even in the United States, but still closer to home, it had also been featured in a popular movie of 1938, a Jeanette McDonald and Nelson Eddy musical called *Sweethearts*. The movie concerns two young stars of the New York musical stage, the sweethearts of the title, who sing about the home they envision for themselves in California, a fantasy of domestic bliss. In pursuit of their romantic dream the young lovers set out for the West Coast, but before they can get there jealousy tears them apart and they go their separate ways. In the end, of course, they are reunited, and they presumably live happily ever after (although they return to New York and never make it to California as they had planned).[72] Weston might well have seen the film, which perhaps reminded him of the song, and he may have had both the film and the song in mind when making his photograph, or at least when devising the title. Indeed, he was perhaps taking aim not only at his own situation and how it contrasted with the film but also at the fluttering romanticism of the film and of Hollywood more generally. The slouching figure of Charis represents a telling contrast with the image of Jeanette McDonald, adding a further sardonic edge to the image.

Irony, or at least humor, is also the basis of the third photograph Weston described in his letter to the Charlots, another backyard setup, which he called *Exposition of Dynamic Symmetry* (fig. 46).[73] Edward did not explain the picture in his letter beyond saying that it included four figures hanging out of as many windows, but Charis later provided a fuller explanation, which moves us closer to understanding what is going on: "Another in this vein was Exposition of Dynamic Symmetry. This shows the back of Jean Kellogg's studio, with four figures in the windows: Neil holds a kettle, Leon dangles a doll, I am dressed only in a sweater and hold a lamp in my lap, Jean [Kellogg] stands with her palms against the screen. The picture is a spoof of a book on composition bearing a similar title."[74]

As Charis implies, the title in this case, *Exposition of Dynamic Symmetry*, refers to the work of the artist and illustrator Jay Hambidge, who had investigated the canons of proportion embedded in ancient art and architecture, particularly that of ancient Greece. He expounded his theories in a number of publications, starting in 1919.[75] For Hambidge the secret lay in something he called "dynamic symmetry," which represented a higher type of symmetry than the more commonplace, static variety based on ordinary geometric figures, like the square or the equilateral triangle. The building blocks of dynamic

symmetry, on the other hand, were what he termed dynamic rectangles, the most remarkable of which was the whirling square rectangle, or the golden rectangle; in golden rectangles the ratio between the sides is Phi (Φ) or the golden section (an irrational number, approximately 1.618 . . .). Such rectangles can be subdivided or extended in an infinite variety of ways to create further rectangles of similar proportions and pleasing rhythmical compositions, combining symmetry and asymmetry, as Hambidge demonstrated in his analysis of the shape of Greek temples and vases.

Hambidge died in 1924, but his theories had widespread influence. They were incorporated, for example, into Michel Jacobs's *Art of Composition*, published in 1926, and Matila Ghyka's *L'esthétique des proportions dans la nature et dans les arts*, which first appeared in France in 1927.[76] In the following decade there was a raft of publications rehashing and extending Hambidge's ideas, sometimes bound up with mystical ideas of various kinds, such as theosophy, Rosicrucianism, and the like. By the 1940s dynamic symmetry enjoyed considerable popularity among artists, architects, designers, and others.

Over the years a number of Weston's friends and acquaintances had shown an interest in dynamic symmetry or were at least familiar with it, in one form or another. Charlot, for one, probably first learned of Hambidge's theories in Ghyka's book, which he read soon after it appeared, while he was still in Mexico.[77] And he no doubt heard much more about Hambidge and dynamic symmetry after first moving to New York at the end of the 1920s; in those days Charlot spent a good deal of time with Orozco, who was very much interested in such ideas. Orozco, for his part, had frequented the salon of Mme Sikelianos, where he came to know Hambidge's widow, Mary, who, impressed with Orozco's grasp of dynamic symmetry, wanted him to help her carry on her late husband's work. In the end Orozco turned her down for fear it would interfere with his art making, but he continued to be interested in such ideas, and he relied heavily on the principles of dynamic symmetry in his frescoes for the New School for Social Research.[78] In this context it seems likely that Orozco shared his enthusiasms with Charlot; he had introduced Charlot into Mme Sikelianos's salon, where Charlot too had become a frequent visitor and had encountered Claude Bragdon, who also embraced dynamic symmetry.[79]

Charlot rarely mentioned Hambidge or dynamic symmetry specifically, but he did often speak of the golden section, an important component of such thinking; in his lectures to the Disney animators, *Pictures and Picture-making*, for example, he explains it in some detail. There he speaks of how, although it

is easy enough for anyone with a ruler and a compass to construct, this ratio is nevertheless difficult to understand fully. For Charlot the golden section was strangely compelling; it gave the thrill of both symmetry and asymmetry, and as a result, it was perhaps the most beautiful proportion in art. It also occurred with astonishing frequency in nature—in spiral shells, among other forms.[80] But Charlot stopped well short of embracing the quasi-mystical ideas often associated with the golden section or with dynamic symmetry more generally. However useful and mysterious such formulations might be, for Charlot they did not constitute a metaphysical system; nor, in themselves, did they provide the key to great art, past or present.

Another friend of Weston's, Jean Kellogg, a painter and printmaker, had developed an interest in Hambidge's *Elements of Dynamic Symmetry*. And it was her fascination with such theories that prompted Weston to make his parody.[81] Weston himself may have been attracted to these ideas earlier in his career, but by this point he no longer had much patience with the intricate geometry and extravagant claims of Hambidge and his followers, and so, in *Exposition of Dynamic Symmetry*, he set out "to poke fun at the formula boys" (presumably not including Charlot).[82] To that end he created a composition that is suggestive of some of Hambidge's diagrams, although not in any systematic way; the windows and other openings divide up the side of the building like dynamic rectangles. In the window at the upper left Jean Kellogg herself appears, looking a little as if she is trapped in the geometry of the studio and the image; however interested she may have been in Hambidge's theories, perhaps she did not take them all that seriously after all. The other figures add more absurdist notes to the photograph, further mocking the theorems to which the composition apparently refers.[83] Although the subject here is different, Weston's satirical strategy is much the same as in *My Little Gray Home in the West* (and it likewise looks forward in certain respects to more recent postmodern imagery).

The Charlots had spent the first part of September at Black Mountain College in North Carolina, at the invitation of Josef Albers. When they returned, Weston's letter about his new backyard setups was waiting for them, and their response was not long in coming. Zohmah, who was pregnant at the time, wrote most of it, and she first of all spoke again of *Leaves of Grass*: "Look at our Leaves of Grass book often and enjoy it very much (even if you do not)." She added that they had Westons hung all over their front room and liked

looking at them too. A little further on she reported on their trip to Black Mountain College and their encounter with Albers. Along the way she made a point of mentioning how Albers was also an admirer of Weston's work, which he had often seen at the Museum of Modern Art and elsewhere.

Zohmah also told Edward about Jean's latest project; as she explained, Jean was planning a new mural at the University of Georgia, for the Journalism Building, and unlike his earlier work in the Fine Arts Building, wartime themes appeared for the first time. Weston had touched on wartime concerns in *Civilian Defense;* now it was Charlot's turn. Although—given their setting in the Journalism Building—each scene understandably featured the exploits of journalists (writers, sketch artists, and a photographer), in each case they were engaged in the coverage of war, of invasion. As Zohmah related, "It is to be an invasion—parachute troups with green faces, one trooper with a typewriter, for the mural is to be in the journalism bldg. Another section is to show the invasion of Mexico with Montezuma's reporters painting their reports and Cortez posing his horse. My description comes from watching him draw a horse named Pearl at the farm of Black Mt. College!"

Zohmah also added news of the Isons, about whom Edward often inquired in his letters: "Frances got through camp and is now in New Jersey where her husband is completing all sorts of special training, they don't know whether [he is] to be stationed somewhere [as] an instructor or sent overseas."[84] At the end of the letter, Jean added a postscript. He indicated, first of all, that he was returning the Mexican sheets with thanks. And then he asked if Edward would consider sending his diary for the Mexican period, so that he could check it against his own or quote from it when appropriate. A few excerpts from Weston's daybooks had been published in the 1920s, in *Creative Art* and in the *Carmelite*, but when Jean made his request nothing else was accessible.[85] Edward had perhaps already considered publishing a fuller version, but nothing concrete had been done.[86] Jean's request seems to have started the ball rolling once again, and before long work was underway. It would still be many years, however, before the daybooks were published in the now-familiar version.

Jean also referred in passing to the mural Zohmah had just described. ("I am back to fresco painting which is nice, though thrills have gone with my young years!") And he concluded his note with a brief, rather laconic and plaintive comment about Weston's recent work (which Zohmah had not mentioned at all): "*Please*," he said, "dont become surrealist. Your letter gives me doubts."[87] Charlot had expressed his skepticism about surrealism in the past

on a number of occasions—and Weston seems to have shared his antipathy. But now it sounded as if Weston was moving away from the direct sort of seeing that Charlot had long admired and was cultivating precisely the sort of oddness usually associated with surrealism. Although Charlot had not yet actually seen the pictures in question, he was obviously a little concerned, yet hoping that Weston had not gone astray. Indeed, Jean's comment is not so much a criticism as a warning or a plea.

Some of Weston's other friends and admirers had similar concerns. Nancy Newhall, for one, also detected a surrealist tendency in Weston's latest efforts. Although she excluded *Dynamic Symmetry*, which she regarded as great fun (congratulating Charis on her "magnificent rump"), she was disturbed by Weston's apparent change of direction, which she attributed to the difficulties he was experiencing as a result of the war. In particular, she suspected that the new tendencies in Weston's work might have something to do with the fact that he had been denied access to Point Lobos.[88] Weston responded with a vigorous defense:

Sorry to have upset you (and Sibyl!) with my "back yard setups and their titles." You guess that the war has upset me. I don't think so, not more than the average dislocation. I am much more bothered by the antics of some Congressmen and -women, or by radio "commericals." As to Point Lobos, it has been open to the public for months, but I have had no desire to work there. No darling, don't try to pin pathology on me.

Your reaction follows a pattern which I should be used to by now. Everytime that I change subject matter, or viewpoint, a howl goes up from some Weston fans. An example: in the E.W. Book is a reproduction of "Shell & Rock—Arrangement"; my *closest* friend, Ramiel, never forgave me for putting it in the book because it was "not a Weston." Another example: when I sent some of my then new shell and vegetable photographs to Mexico, Diego asked if "Edward was sick." And finally (I could go on for pages) when I turned from shells, peppers, rocks—so called abstract forms—Merle Armitage called my new direction the "hearts & flowers" series.

So I am not exactly surprised to have you condemn (though I don't get your "Surrealist" classification; now Nancy!) work which will go down in history. "Victory" is one of the great photographs on which I will stake my reputation. I could go on, but you might think me defensive. I could explain my titles (I really had fun tacking them on *after* "creation") but

surely explanation would insult you; I need not say that "What We Fight For" is not what I fight for.[89]

When Weston had described his latest creations to the Charlots he specifically linked them to the war; now, in his response to Newhall, he framed the matter a little differently. He wished to downplay the effects of war, but he did not disguise his anger over certain recent developments—and there is no denying that Weston's work, surreal or otherwise, had taken a more political turn, at least with respect to the still lifes. Weston was offended by some of the propaganda associated with the war, by the behavior of the "Pepsi-Wunki Gang," and he reiterated that here in slightly different terms. He may not have been specifically addressing the inconveniences that war had caused him, his circumscribed situation, or even his concerns for his sons, but wartime conditions were nevertheless a central concern.

Not all of Weston's friends were quite as suspicious of Weston's new direction as Newhall and Charlot. A short time after responding to Nancy Newhall, Weston gave a print of *My Little Gray Home in the West* to Bea Prendergast as a Christmas present, and her reaction was more positive. Weston was clearly gratified, and he wrote to thank her for her "gorgeous response." He also used the occasion once again to respond to his attackers, especially Newhall, with whom he seems to have been truly miffed:

> Your gorgeous response to Xmas package came just when I needed to renew my faith in humankind, or to be more specific in certain heretofore admired friends. But that's not correct either—it's the *opinions* of these friends that I lost faith in. Now I am the last person in the world to expect *all* my "admirers" to like *all* my work *all* the time: but when they write and ask if you are upset by war, or upset because you can't go out on P. Lobos, or label you Surrealist (oh my God!) all because of new trends—then I almost threw up the sponge. One of these friends is a figure of some import in M. of M.A., N.Y.N.Y. You see I am so ashamed of, or for, her that I'll not use names. I wish I had your enthusiastic endorsement when I answered. It was difficult to answer too, because I never defend my work.[90]

Weston seemed genuinely shocked to be considered a surrealist, and surrealism remained anathema to him, despite his friendship with surrealistic photographers like Frederick Sommer and Clarence John Laughlin. The idea that his work might be considered in that context did not please him

at all—and he was not necessarily fooling himself, or at least not altogether. Certainly these setups include elements that could be linked to the work of various surrealist artists, but many of the new pictures are really more satirical than surreal. What unites most of them, more than anything else—whether they are political or personal, still lifes or figural compositions—is their bitter irony. They are remarkably caustic, not unlike the tone of some of his letters from the same period.

Most of Weston's hostility, feigned or otherwise, seems to have been directed toward Nancy Newhall, but Charlot could have been included as well, given that he too had raised the specter of surrealism. It is not clear when Charlot first saw these pictures, but he never did like them. Years later Jean continued to look upon them as a rather silly artistic misstep, which he blamed on Charis's influence.[91] In the case of these backyard setups, Jean felt that a besotted Edward simply did them to please his beloved—and lowered his artistic standards in the process. But Jean may have been letting his poor opinion of Charis cloud his judgment, for despite all the criticism, Weston seems to have been quite proud of this work. While at certain moments Charis exerted considerable influence on Edward, these pictures, made while their relationship was disintegrating, seem to have arisen as much from resentment as devotion. Charlot may not have taken that entirely into account.

In the fall of 1943, at least partly in response to Jean's request, Edward started working on the daybooks in earnest. As he reported to Jean, "Surprise! I am working on the Mexican Day Book. If I get it into shape that will go via express without setting afire other innocent packages, I will ship to you; but how soon is the question. You started something, but I'll need some cheering." After signing off, he added on the side of the card, "May take months!"[92] A little more than a month later he provided an update, reporting that he was still working on the daybooks, along with an upcoming show at the Museum of Modern Art in New York.[93]

Charlot, meanwhile, was continuing with his work on the murals in the Journalism Building. In early November he had gone to Fort Benning to study parachutists. One day he witnessed a mass landing; he was on the field as they landed and made notes. The next day he sketched the unpacking and mounting of a mortar and other activities. The day after that he returned to Athens and began work on the cartoon for the parachute fresco, which was completed before the end of the month, on November 20, 1943.[94] During

the same period Charlot also applied for a Guggenheim Fellowship, in order to pursue his study of the Mexican Mural Renaissance; Edward was one of his sponsors. Jean had been one of Weston's sponsors in 1936 when he had applied for the Guggenheim that led to the creation of *California and the West*; now it was Edward's turn to assist Jean.

At the end of the year Edward reported further about the daybooks: "My day book (Mex.) has been so well edited that it is in fragments or ribbons of paper. It can't go on to you until I find someone to type it." In the same postcard he also mentioned, "I recently had extreme pleasure of sponsoring Jean's application for a Guggenheim."[95] A few weeks later, just after New Year's, Edward sent a brief note along with some flowers (as he had often done in the past); in an almost humorous vein, he explained in a postscript, "Charis is now a mail-woman, she has taken over, as a patriotic duty, Route 1. Now she can get hold of my mail first (all the love letters from all my women)." In the same letter he added another postscript about the daybooks: "Day book copy ½ done. Charis hired a painter (*not* a house painter) to do the typing. You know what *that* means!"[96] Jean presumably understood and enjoyed Edward's little joke.

A week later, Edward sent yet another card; although progress was being made, one can detect a note of frustration on Edward's part about how slowly it was going: "Be of good cheer—Charis & stenog. working on Day B—twice a wk. It will be your xmas & Birthday present. *When? When? When?*" He also had some words of encouragement about the Guggenheim: "Fingers crossed for Guggenheim." Edward also managed to squeeze in a little news of family and friends, not all of it happy. Cole and his wife, Dorothy, were expecting a child, but Brett had entered the army. And a close friend, Ramiel McGehee, had passed away. Edward provided no details; he simply wrote on the side of the card, as a kind of postscript: "Ramiel died—."[97]

While work progressed—however fitfully—on the daybooks, Charlot remained busy on the frescoes for the Journalism Building. He had begun the actual painting of the frescoes, and as work continued, he sent a short letter—typed, not handwritten as was usual for him. He thanked Edward for the progress reports on the daybooks but expressed concern that in the editing process valuable information would get lost: "Let us hope that the censure will not cut out data that could be of interest to me. I do want to show in the book

the part you played and the influence you had in this episode and certainly your own words will be a valuable contribution."

Then Jean turned to his own work (repeating some of what Zohmah had already reported in an earlier letter): "I am busy too completing a very large fresco 66 ft. by 11 ft. in the Journalism Bldg., on the campus. Though the subject is journalism, I squeezed in a panel representing the Conquest of Mexico 'Indians [*sic*] scouts report to Montezuma America's first scoop: Cortez lands in Vera Cruz.'" He added, a little facetiously, perhaps: "This is the same subject than my 1922 fresco and age has mellowed me wonderfully, I now love the Indians *and* the Spaniards too." He then turned to the other panel, saying simply, "The other panel is of war reporters with a paratrooper outfit that I went to study at Fort Benning. I will send you photographs when ready." Jean also informed Edward that he would be going to Mexico before long to collect additional material for his book; he planned to take Zohmah and the children with him and wanted Edward to come too. Zohmah added a few words, telling Edward that the baby was expected in March and asking him about Cole and Dorothy. There was also a postscript about the Isons: "Frances and Roswell Ison are now stationed at Camp Kohler near Sacramento. War willing, I know they hope to see you."[98]

The journalism frescoes were completed on February 22, 1944, after thirty-five days of actual painting. As Charlot had said, the scene of Cortez landing at Veracruz in 1519 (fig. 58) harks back—at least in a general sense—to the fresco he had painted twenty-two years earlier in Mexico City, in the Preparatoria, but it is quite different from the earlier work in a number of ways. There is no violent action—the horror of battle is no longer an issue—and instead of the turbulent, swirling group of faceless aggressors dominating the right-hand side of the Preparatoria mural, the Spanish forces are now more individualized. Cortez is shown with a pensive expression, his hand resting gently on the arm of an Indian scribe (representing an early journalist). Although Charlot understood the brutality of the Spanish conquest, he seems also to have been thinking of the Spaniards in a more positive light. This ambivalence is not evident in the earlier fresco.[99]

So too the style has changed considerably. Although one can still detect the echoes of Uccello's battle scenes, so pronounced in the earlier version, the later work is less crowded and more measured. A profusion of circles has given way to a more balanced composition, anchored by a narrow pyramid

at the center. Piero della Francesca's frescoes in Arezzo come to mind, as does Raphael's *Expulsion of Heliodorus* and some of the work of Velázquez. But Charlot also incorporated motifs — most notably the woman kneading tortillas — from his own earlier paintings and prints.

The parachute scene is likewise a beautifully composed image, with a strong sense of geometry and a masterful foreshortening of the descending paratroopers. At the bottom left-hand corner of the fresco is a photographer who has just landed and has not yet unhooked his chute straps; with a small camera, he is taking pictures of the paratroopers as they come down. On the other side, a group of troopers unpack and mount a mortar; like most of this fresco, these figures are based on Charlot's observations at Fort Benning.

Charlot described the second scene as follows: "The conquest of America, in its day a bloody affair, brought Christianity to the new world. Today, against another background of turmoil and carnage, America frees Europe out of Festung Europa."[100] By this time the beachhead at Anzio had been secured and the Allies controlled most of southern Italy, which had officially been handed over to the Badoglio government. The invasion of Normandy was still several months away.

February and March were good months for Charlot. The Georgia frescoes were completed at the very end of February; less than a week later the Charlots' third child, Martin, was born. And soon after, in early April, Jean learned that he had been awarded a Guggenheim.[101] Upon learning the good news Edward wrote to congratulate him: "From Isons a letter with good news of your Guggenheim award. For many reasons we were rather low, so the news was most cheering." He added some nice words about Henry Allen Moe of the Guggenheim Foundation, with whom he had had much contact during his own Guggenheim years: "You will find Mr. Moe a grand person to deal with; he lets you alone, the Guggenheim policy — ."

The letter was written on April 22, 1944, the tenth anniversary of the start of Edward's relationship with Charis, presumably a happy occasion but, as Edward's opening line suggests, things had not been going well for them. Edward went on to explain: "Charis mother is *very* ill. I have developed a hernia. Brett is driving a truck in the army. Chandler's in the navy. Cole up for his physical. Neil still 4F. Charis drives U.S. mail. Leon in jail." The rapid-fire nature of this list in itself suggests how burdened by events Edward felt at this point. And as if that were not enough, work on the daybooks had

not been progressing as smoothly as planned: "The typist on Mexican day book's very slow. I'll try to hurry him."[102]

On the same day that he wrote this letter, Weston made his final entry in the daybooks. He had not written anything since 1934, the year he met Charis. Now, on the occasion of this special anniversary, he attempted to bring things up to date, summarizing what had happened to him in the previous ten years, after he had teamed up with Charis. He mentioned moving to Santa Monica, his Guggenheim Fellowship, and the resulting book, *California and the West*; he spoke also of his return to Carmel and, after that, the *Leaves of Grass* travels. Then, near the end, in the same gloomy mood reflected in the letter to the Charlots, Weston's thoughts turned to death: "Many deaths have saddened these last 10 years, but two were especially poignant to me—Tina and Ramiel. Tina returned to Mexico to die. Ramiel went to sleep in his little Redondo home, after a long painful struggle. Tina and Ramiel, always linked in my mind, always clasped to my heart."[103]

Weston did mention some good news, the birth of his granddaughter, Erica, but he concluded on another dark note, with news of his sister, who had suffered a stroke ("Something almost worse than death"). The gloomy news seemed to outweigh most everything else. Soon after Zohmah wrote to Prue, reporting on the latest developments and expressing her concern about Weston: "We had a letter from Edward sounding kind of blue."[104]

Several months later the Westons received a visit from Frances and Roswell Ison, then stationed at Camp Kohler in Sacramento. The visit seems to have taken place during the summer of 1944, and it is recorded in a few snapshots that the Isons later sent to the Charlots. One shows an outing at the beach, which included Brett, Jean Kellogg, Charis, Edward, and Frances, among others. Another shows Edward and Roswell standing on the rocks at Point Lobos; Roswell, in uniform, is looking off to the side with a slight smile; Edward stands higher up, his hands in the pockets of his jacket, looking over toward Roswell. We can't see Edward's face, but he seems entirely at ease, apparently unaware of the camera (fig. 47).[105]

By this time, in his own photographic work, Weston had begun to focus on cats, which represented a curious departure for him. He does not mention the cat pictures in any of his letters to the Charlots (even though, as we have seen, they shared an interest in felines); nevertheless, cats were becoming an increasingly important subject for him, displacing his more satirical imagery

of the last several years. The idea, it seems, originated with Charis, who wanted to write a book about cats that would go beyond the sentimental drivel often found in animal books. Edward was brought on board to do the illustrations—at Charis's urging—and the task soon became a challenge for him.[106] Despite any marital tensions, work was already underway by the summer of 1944, around the time the Isons came to visit, and at that point Weston wrote to his sister, "am all set to start a new epoch in my photo-life—emphasis on cats—Also Charis will start writing about cats—our cats—should be a best seller. No fancy cats allowed, just plan 'alley' cats—."[107] This collaboration would result, several years later, in *The Cats of Wildcat Hill*.[108] By that time, however, Charis and Edward were no longer together, and Weston's career as a photographer was coming to a close.

9

A CAT NAMED ZOHMAH

The spring semester of 1944 was the Charlots' last in Athens. Afterward they went to Black Mountain College in North Carolina, where they had been for a brief visit the previous year, but this time Jean remained there for the entire summer term, teaching drawing and painting. During their sojourn Jean also painted frescoes on two of the reinforced concrete pylons of the New Studies Building: one represented Inspiration and the other Study.[1] At the same time he wrote a synopsis for his book on the Mexican Mural Renaissance—which was to occupy more and more of his time in the coming years. Then, in the fall of 1944, the Charlots moved to Northampton, Massachusetts, where Jean had been named artist in residence at Smith College for the coming academic year.

While in Northampton they received the bad news that Roswell Ison had died, perhaps killed in action, at the end of September 1944. The Charlots wrote to Weston about it, and later that fall he responded, "Thanks for your letter with the sad news. I was truly moved. We had such a happy time with the Isons, so recently. Asi es la vida." Meanwhile, he explained, work on the daybooks had stalled: "Mexican Diary is at a standstill on acct no labor to hire. My regrets."[2]

By that time all four of Edward's sons were in the service: Brett was in the Army, Chandler and Cole in the Navy, and Neil in the Army Transport Service. Charis was planning to go to Washington DC to be with her sick mother, and Leon had been released from prison on parole. Meanwhile, Edward was still hoping to have a retrospective exhibition at the Museum of Modern Art in

New York the following year, although final negotiations were still underway; he anticipated that it would include as many as three hundred photographs, covering his entire career.

Speaking of politics, Edward went on to say that he and Charis had been electioneering for FDR. In late October he reported the same thing to Christel Gang ("we are busy electing Roosevelt!").[3] Weston was an ardent supporter of FDR; he had, in the past, been quite vocal about his political views, and that was even more the case for the 1944 presidential election season. In particular, he was outraged by FDR's opponent, Thomas Dewey, whose campaign claims Weston regarded as deceitful in the extreme. Indeed, shortly after writing to Christel he wrote to Dewey himself—all in upper case, for added emphasis—criticizing him for the way in which he was conducting his campaign:

I AM DESCENDED FROM REPUBLICANS WHOSE ANCESTORS SETTLED IN MAINE IN 1640 — VERY, VERY AMERICAN YOU SEE.

I HAD HOPED IN THIS FATEFUL YEAR THAT THE REPUBLICAN PARTY WOULD NOMINATE A MAN: THEY DID NOT.

YOU HAVE CARRIED ON A CHEAP, VULGAR CAMPAIGN; YOU HAVE MIS-LEAD — AND THUS LIED — BY QUOTING OTHERS IN PART; YOUR VOICE RINGS WITH THE INSINCERITY OF A PIOUS FRAUD.

YOUR ELECTION WOULD BE AN INTERNATIONAL CALAMITY; FOR THE SAKE OF THE UNITED NATIONS, THE UNITED STATES, MY FOUR SONS IN SERVICE, AND MY TWO GRANDCHILDREN, I PRAY THAT CALAMITY WILL BE AVERTED.[4]

The sharpness of his criticism is perhaps surprising, but the same strong feelings are evident in a letter he wrote on election day to his son Neil: "This is one of the most fateful days in American history. I am just about to go to the polls to vote for F. D. R., one of the greatest presidents we have had—perhaps the greatest considering the crises of the last decade which he so magnificently met. As for Dewey, it would be a national,—more, an international calamity if he were elected; his campaign has been one raucous round of lies and vilification; a nasty *little* man who has the *nerve* to speak of 'my opponent.' Enough!" The following day he proclaimed victory in the same letter, which he had not yet mailed; he was exultant: "'we' have won! Won a great victory. I hope the Republican Party will know enough to nominate a man of dignity next time instead of a small town D.A. like Dirty Dewey. I will never forgive that man for his campaign of lies."[5]

A few weeks later, in another letter to Neil, Edward reiterated those sentiments and then added, "In 1948—Wallace!"[6] Even as he rejoiced over FDR's victory he was looking ahead to the next presidential election; already, at this early stage, he clearly favored Henry Wallace, who would run on the Progressive Party ticket against Harry Truman (FDR's running mate in the election just concluded). We do not generally associate Weston with such partisan sentiments, but the war brought out these feelings more strongly than before. He paid very close attention to the war and national politics—which were, of course, inextricably linked, not only to each other but also to the fate of his sons.

Charlot was still trying to get a look at Weston's Mexican diaries—and he may well have despaired of ever seeing them—but sometime after the election work on them began again, and it was Zohmah who got things moving. As Edward had expected, Charis had gone to Washington to be with her sick mother, and work on the daybooks was at a standstill for lack of help. At this point Zohmah stepped in and arranged for a Los Angeles college student named Mary Kriger to work for Weston over the Christmas break. The plan was that she would stay with him in Carmel and continue the typing. Weston wrote to the Newhalls about the upcoming visit: "Have not been lonesome so far—no time; Merle here, and tomorrow Ansel arrives with a 'blind date', a girl, friend of Charlot, coming to type my Mex. Diary, stay here over holidays. Who will sleep where, and with whom, while Ansel is here, or after, is in the hands of Pagan Gods."[7]

Soon after she arrived with Adams, Kriger reported to Jean and Zohmah:

Dear Charlots: I am at Weston's as you can see from return address. Have been here for over a day now. All we do when we talk at all is talk about you, I hope you are feeling good and self conscious! Mostly talk of time you did something rediculous [sic] of course. Also he got out a painting of yours and hung it up, probably so I could tell you that you are still remembered. The painting was up in the attic. *Ha ha*. I have been typing assiduously all afternoon. Jean mentioned throughout MS as "that nice slim young boy". Sounds very unlike.[8]

Kriger stayed with Weston about a week and did only a modest amount of typing, but it was a start. Soon after Edward wrote to Jean to update him on the situation: "I am going through the finished—typing—part of Day Book—only about 5 months done—then ship express to you. Mary K—did

about 20 pages. I enjoyed her." He also reported that Charis was still in DC, on account of her mother's illness. Then he added, rather regretfully, "I love you all dearly, but all my writing time and energy goes to boys in service (all of them now)."[9] A little later he sent a postcard with what must have been unexpected but pleasant news: "Expressing Mex. Day Book (part ready) soon as get transport. To Carmel—LOVE E—."[10] It had been more than two years since Charlot had first asked about the diaries, but at last a portion, at least, was on its way. Although Charlot would have liked to see more, nothing further seems to have been done until Nancy Newhall occupied herself with the material several years later, and the daybooks were not published in their now familiar form until the 1960s. By that time the Charlots were no longer involved, but they had played an important role in the process, starting the ball rolling after years of neglect.

Meanwhile, in the early part of 1945 Charlot was hard at work on his study of the Mexican Mural Renaissance; at about this time he was completing a section on the artistic interconnections between Mexico and the United States, which included some discussion of Weston. Charlot had written about Weston before, but this was the first statement on Weston he had written in some time. In this case he focused on Weston's Mexican years and his contribution to the artistic developments of the time; in Charlot's view, Weston played a pivotal role: "It was the good fortune of Mexico," he wrote, "to be visited at a time when the plastic vocabulary of the [Mexican Mural] renaissance was still tender and amenable to suggestions, by Edward Weston, one of the authentic masters bred in the United States."[11]

When Weston arrived on the scene in 1923 the Mexican artists were under the spell of the European avant-garde—cubism, expressionism, and the like—and Weston's direct way of seeing, the objectivity of his photographic vision, led these muralists, including Charlot himself, away from some of those influences and toward a more representational and arguably more authentic approach, one rooted in their own surroundings and traditions: "He dealt with problems of substance, weight, tactile surfaces and biological thrusts which laid bare the roots of Mexican culture."[12]

At the same time, Mexico had an impact on Weston's photography; just as Weston helped redirect Mexican painting, Mexico helped him clarify his own vision, mature as an artist, and find his true roots: "Breughel needed to make the trip to Italy to know that his roots were north. The Americanism of

Weston grew its backbone in front of the hieroglyphs of another civilization. Magueyes, palm trees, pyramids, helped him shed, sooner than he would have otherwise, his esthetic adolescence. It was in front of a round smooth palm tree trunk in Cuernavaca that he realized the clean elegance of northern factory chimneys. Teotihuacan, with its steep skyward pyramidal ascent, taught him how to love his own country's skyscrapers."[13]

Charlot concluded his discussion with an incident involving Diego Rivera:

> While Rivera was painting "The Day of the Dead in the City" in the second court of the Ministry, we talked about Weston. I said that his work was precious for us in that it delineated the limitations of our craft and staked out optical plots forbidden forever to the brush. But Diego, rendering meanwhile a wood texture with the precise skill and speed of a sign painter, countered that in his opinion Weston did blaze a path to a better way of seeing, and as a corollary, of painting. It is with such humility at heart that Rivera painted with a brush in one hand and a Weston photograph in the other his self portrait in the staircase of the Ministry.[14]

Charlot refers here to the last panel of the frescoes on the stairway of the Ministry of Education (Secretaría de Educación), in which there is a self-portrait of Rivera—as an architect—based on a photograph by Weston. Not only did Weston's basic approach have an impact on Mexican artists like Rivera, but specific images became raw material as well.[15]

In mid-February, while Charlot was concentrating on his study of Mexican art, his book on the Georgia frescoes that had been in the works for a number of years finally came out. Designed by Charlot himself, it included a detailed account of the making of the pictures—the post office mural as well as those at the university—along with numerous detailed photographs taken by Eugene Payor, a member of the art faculty at the University of Georgia. Although almost all of the pictures are in black and white, the book is a fine record of one of Charlot's most ambitious and impressive projects up to that time—a work that warrants further study on many levels. Not surprisingly, Charlot immediately sent a copy to Weston, along with the discussion he'd been working on for his new book.

At the end of February 1945 Weston wrote back to acknowledge the material he had just received from Charlot: "Your book on Georgia frescoes here—and it's a thrilling experience! Thank you very much."[16] Then, after expressing

his wish to continue work on the daybooks (what Charlot had received by that time represented about one-quarter of the whole), Weston responded to Charlot's discussion of Mexico: "Jean, I was deeply moved, and felt quite humble I assure you, when I read your 'U.S. and the Renaissance' with my part in same. It gave me something to consider, until now unconsidered, about myself, my work." By this time Weston had received a good deal of praise and his historical importance had been well established, but Charlot's discussion offered a new perspective, and Weston had good reason to be gratified.

Edward then passed along some family news. After reporting on the whereabouts of his "soldier & sailor boy sons" he noted that Charis had returned from the East Coast; he again mentioned his upcoming retrospective at the Museum of Modern Art in New York and then added a postscript: "Latest photo. 'Nude & Blimp.'" Edward offered no further information, but he was referring to one of the pictures he took on a brief trip in January 1945 to Big Sur, where he and Charis visited their friend the lawyer Doug Short. *Nude and Blimp* was taken on his deck; Charis reclines, precariously near the edge, and looks off into the distance, where a blimp can be seen over the ocean.[17] In a general way, it recalls Weston's pictures of Tina Modotti on the azotea as well as the pictures of Charis in the sand dunes; in some ways it is a reprise of both. So too the combination of the nude figure with a blimp, with its wartime associations, reminds us of *Civilian Defense*, but the new picture is more open and airy, both humorous and ominous; the presence of the blimp adds a momentary, almost narrative quality not always found in Weston's nudes. A few years before Edward had written to Nancy Newhall that Charis had seen a blimp drop a depth charge; perhaps this new photograph refers back to that event in some way.[18] It also calls to mind Stieglitz's image of a dirigible or blimp in the clouds.

Edward wrote again about a month later concerning the daybooks: "This is just to say that I am going to bend every effort toward finding someone to type balance of Mex. Diary." Then he turned again to Jean's book about the Georgia frescoes, which by then he had looked at more closely: "The more I look over your Georgia murals the greater they become. Surely nothing of equal importance has been done in the U.S. Of course I have not seen everything! And I may be prejudiced!" He also had praise for the photographs, most of which were taken by Eugene Payor: "your photographer friend did an excellent job of difficult subject. My congratulations to Eugene Payor.

And to the other photographers!"[19] The additional photographers included Lamar Dodd and Zohmah, both of whom had taken pictures of Charlot and his assistants/students at work on the murals.[20]

Weston also praised Charlot's article on Posada that had recently appeared in the *Magazine of Art* and reported that his good friend Jean Kellogg wanted to study with Charlot.[21] Kellogg had already shown interest in the work of Jay Hambidge. Perhaps after looking with Weston at the photographs of Charlot's Georgia murals she realized—if she was not aware of it already—that Charlot was a kindred spirit, and given his emphasis on geometric structure she might have felt Charlot would be a good guide. Although Weston was not as interested in Hambidge or such theories, he clearly admired Charlot's work and was more than willing to encourage Kellogg in her endeavors.

In the same letter Weston touched on his own recent efforts, once again mentioning *Nude and Blimp*, telling Charlot, "My latest picture is called Winter Idyll; another 'Nude & a Blimp.' Just to make you curious."[22] *Winter Idyll*, like *Nude and Blimp*, was taken during the visit to Big Sur. It shows a nude Charis on a swing attached to an impressive oak tree, some distance away, set against the mist and sky; the ropes of the swing are partly twisted.[23] Charis later explained how the picture was made:

> People who believe that a photographer is "stuck with things as they are" may imagine that this tree is on a bluff. It appears that way because Edward arranged it so, by backing off until he had nearly the whole tree against the misty light above the ocean. He had me wind up the swing a few turns and be ready to stop on command as it unwound. On the third or fourth try he got what he wanted. "Pure Maxfield Parrish," he declared when the exposure was made. "Where else could you find such a scene in mid-January? We'll have to call it *Winter Idyll*."[24]

In citing Parrish Weston may have thinking of one of his advertisements for Djer-Kiss Cosmetics from 1916, which features a female figure in gauzy classical attire, seated on a swing and surrounded by flower blossoms and a landscape background.[25] In any case, the mist in Weston's image gives it a dreamy, even nostalgic quality that indeed calls Maxfield Parrish to mind and also harks back to Weston's earliest pictorial efforts. At the same time, however, it seems that Weston's intentions were not altogether serious: in a letter to Nancy Newhall he described *Winter Idyll*, along with *Nude and Blimp*, as "pure succotash."[26]

Jean wrote back to Edward about the new pictures; regrettably, his reply has disappeared, but he must have said something about how the titles of these new works made him think back to what Edward had done in his pictorialist days—to *Prologue to a Sad Spring*, for example (a hazy image in which Margrethe Mather looks away from the elaborate shadow of a tree on the side of a barn)—and in Edward's next communication, a postcard sent to Jean in Northampton, he confirmed Jean's suspicion: "Perhaps I have entered the last phase, back to my early seeing and titles. They *do* sound like 'a Sad Spring' (only my tongue may be wrapped around my back teeth)."[27] Weston was resorting not only to the same sort of titles but also to an earlier, more literary approach—only now in a less serious way. It was probably no accident that on the same trip to Big Sur Edward had made a nude of Charis standing against the wall of a cabin, which particularly recalls *Prologue to a Sad Spring*.[28] In all likelihood this too was done with tongue in cheek, although it seems more unsettling than humorous or satirical. Unlike the figure of Margrethe Mather in the earlier picture, most of Charis, even her head, embedded in the shadow of the tree, is obscured by darkness. It is one of the last pictures of Charis that Weston ever took.

FDR died on April 12, 1945. Given Weston's strong support of the president—he voted for him four times—it is not surprising that he took the news of FDR's death very hard. As he wrote to his son Neil, "After that came the shocking news of our President's death. I have been emotionally torn assunder for days. We never met, but he was my dear and personal friend. Millions must have felt as I do. The most important creative years of my life were spent under his administration. An era ends. Something died in me with FDRs passing." The next day, in the same letter, he added, "of course we go on fighting under a new chief—Truman's first address to his people augered well. He almost shouted 'unconditional surrender' which was the more dramatic because he lacks histrionic ability. We must back the man who has the most difficult job of filling FDR's shoes."[29]

The next month, on VE Day, he reiterated these ideas in another letter to Neil: "No one can take F.D.R.'s place; but his great work was done, he laid the ground, and I think Truman deserves all our support as a capable, honest man. But what a pity, that F.D.R. could not have shared the glory of victory. He may be listening in for all we know."[30] Although Weston had already expressed his support for Wallace, he was now, given the circumstances, willing to back

Truman—to whom he had even sent supportive letters. Nevertheless, he clearly had reservations and soon after, in another letter to Neil, he expressed his concern about recent developments: "Truman is O.K. I am quite convinced and back him with letters. But some of our State Dept *stinks*. I have asked for the removal of Dunn (Ass. Sec.) for pro-Fascist efforts to influence delegates at conference in favor of *Franco's* Spain. It was bad enough to let in Argentina."[31] Weston must be referring here to the San Francisco Conference at which the United Nations Charter was drawn up (it would be signed on June 26, 1945). Argentina, despite its Nazi sympathies, was included among the original member states; the status of Spain was still under discussion.[32] James C. Dunn was assistant secretary of state for European, Far Eastern, Near Eastern, and African affairs at the time; evidently he was pushing for the admission of Spain, to Weston's dismay.[33] Weston must have been following these events quite closely, and for him it was obviously unacceptable that, after the defeat of fascism in Germany and Italy, fascist Spain should be admitted to the new international organization. Weston had not been vocal about his opposition to Franco at the time of the Spanish Civil War, but by this point he did not hesitate to make his opinion known.

In early June 1945, while Edward was pondering world events, Beaumont and Nancy Newhall came for a visit. Beaumont, who had been serving in the Air Force as a photographic intelligence officer, was on leave and had recently returned from Europe; he and Nancy had decided to spend some time in California. Ansel Adams invited them to Yosemite, and after that they stopped in Carmel to visit Edward and Charis. The Newhalls had been to Carmel together before the war, in 1940, when the two couples met in person for the first time; now they were old friends and Nancy and Edward were already collaborating on his New York retrospective, scheduled for the following year.

While the Newhalls were at Wildcat Hill Weston took a picture of them lying on the rocks, which is known as *Furlough (The Newhalls)*. Beaumont, in uniform, is shown with Nancy snuggled up against him; some photographic equipment is close at hand. It is a kind of reprise of the *Honeymoon* picture of Jean and Zohmah, but with more humorously suggestive undercurrents. Its sexual implications are fairly overt, and as Amy Conger has noted, "Surely, neither the Westons nor the Newhalls could have failed to notice the Freudian way the tripod rested between Beaumont's legs and the film box between Nancy's legs, as well as the vulvar lips of the foreground rocks."[34] Indeed,

the existence of an altogether different version (fig. 48), in which Beaumont, holding a camera, leans against Nancy—and which looks even more like the *Honeymoon* picture—suggests a certain amount of premeditation.[35] The reference to the earlier picture of the Charlots must have been deliberate—a kind of inside joke.

By the time the Newhalls left Carmel the Charlots were on their way to Mexico for Jean's Guggenheim-funded research on the Mexican Mural Renaissance. In Mexico Jean and Zohmah reconnected with many old friends and acquaintances, including Luz Jiménez, who had been a model for Weston, Charlot, and Modotti as well as many other artists. It was not long before she joined the Charlot household. As Zohmah later explained to Prue, Luz "was Jean's model when he first came to Mexico and she has been much painted and sculpted. Jean stood godfather for her child, Concha, and comadre-compadre being a close relationship they have always written, even when Jean is in the States. When she knew we were coming to Mexico she quit her job modeling at the Academy to come and help us."[36]

The Charlots' return to Mexico was also an opportunity for Weston, indirectly, to catch up on developments there. He wrote to Jean and Zohmah in Mexico later the same summer to bring them up to date. Although no further typing had been done on the daybooks, he had already been thinking in terms of publication; he had promised the work to Duell, Sloan, and Pearce, who were publishing other Weston material. Meanwhile, he was "getting off" his New York show and expecting to undergo the first of several hernia operations ("going South to get my side sewed"). He reported that his son Neil had become second mate and navigator. Then Edward asked, "Do you hear any details of Tina's death? Was it at all irregular?"[37]

Edward had known about Tina's death for some time; he had supplied a brief statement saluting her memory for a memorial held in Mexico. So too in one of the final entries in his daybooks, from 1944, he had spoken briefly and regretfully about Tina' passing. At the time he had written nothing about the questionable circumstances, but he obviously had a sense that all was not right. No doubt he had heard rumors and knew of Rivera's suspicions; now, more than three years after her death, he was still wondering. Edward had recently been immersed in preparing for his own retrospective at the Museum of Modern Art, which would include pictures of Tina. It stands to reason that she was on his mind during this time, and he must have been hoping that

Jean, being in Mexico and in contact with old friends and acquaintances like Rivera, Orozco, and Luz—to all of whom Edward sent his regards—might be able to tell him something more.

It was Zohmah who wrote back, toward the end of the summer (Jean was away in Guadalajara):

> Jean says he feels too much like Rip Van Winkle not to love everyone from the old days in Mexico, even Paca [Frances Toor] (though this is unbelievable). But anyway I am slowly giving the greetings you sent. Luz was very pleased that you remembered her.
>
> I asked Luz about Tina and all she knew was Diego's story which was of course lurid, and incorrect.
>
> The best account was from Mrs. Xavier Guerrero who seems to have been a very close friend of Tina's. She says she was at a party and left the house with friends, very merry. The friends wanted to take her home but she laughed and said she could get home in a libre, and said goodnight. She got the libre and must have been taken sick even before getting into the car as she told the driver to take her to the general hospital as quickly as possible and died on the way. Clarite Guerrero says she doesn't think she meant to go to the hospital, but as she lived across the street from the hospital and feeling ill, gave that as the easiest direction. She says everyone packed the "church" for the funeral, that it was a wonderful demonstration of the devotion people felt for her. She says the tomb is beautiful with a line carving of her head and part of a poem that was written for her. I'll try to go and take a snapshot. Clarite says that they wrote to Xavier, who was in Chile at the time, to ask his advice and he had made this same suggestion, that was already carried out. There was a retrospective exhibit of her photographs.[38]

Edward's reaction to this report is not known; he does not mention it again in subsequent correspondence with the Charlots. But recent studies have more or less accepted this account, and no contradictory information has been unearthed in recent years. It is not entirely clear from Clarite Guerrero's account or those of others whether Tina intended to go to the hospital or simply wanted to go home, but whatever happened, happened quickly, before she had gotten very far. Realizing that his passenger was seriously ill, the cab driver took her first to the General Hospital, which did not take emergencies, and then to another hospital, the Cruz Verte. By that time she

was already dead. The official cause of death was cardiac arrest.[39] It is only natural that questions would be raised, but despite the suspicions of Rivera and others, no real evidence of foul play has been revealed.[40]

The war in the Pacific ended in August 1945, soon after the bombings of Hiroshima and Nagasaki. On VJ Day Weston described his reaction to Neil, who was stationed with the U.S. Army Water Transport Division in San Francisco: "Writing about the Jap surrender is impossible. What can one say? I just sat by the radio & cried my eyes out for you and all the others. But now for the big fight, for the Peace. We can't let the Fascists get on top again—and I mean again in the U.S."[41] Later he was to write, "Peace? The home front looks more like war than ever— and dont blame labor!"[42] Weston continued to support Truman, but he was also quite critical of what he regarded as fascist tendencies—this time not only in international affairs but on the home front as well. It is not clear what specifically he had in mind, but once again he shows a degree of political concern that goes beyond wartime worries or party politics. Such statements reveal leftward-leaning political convictions that are deeply felt—and rather militant, for this is not a simple observation or opinion but a call to action.

Back in the 1920s, in Mexico, Weston may not have been as active politically as many of his companions, most notably Tina Modotti; indeed, his stance at that time seemed relatively apolitical. But if that was the case in his earlier years, it was certainly no longer true.

Soon after, Edward's relationship with Charis, which had begun in 1934, came to a close. On November 15, after most of the work on the Museum of Modern Art exhibition was done, Charis and Edward separated. Edward wrote to the Newhalls about the breakup: "You will never again have coffee with Charis and Edward on Wild Cat Hill. We are divorcing. . . . I guess our separation will come as a surprise, even a shock, to some of our friends, most of them. But we began to break down as a team as far back as the Whitman trip. We have had almost 12 years together, most of them of much beauty. I think the fault can be divided 50-50."[43]

It was Nancy Newhall who responded: "The news was not altogether unexpected, at least by me, and yet it was a shock. Beau brought it home to me, and neither of us could settle down to anything the rest of the day. And yet the actual separation from Charis seemed to us the best possible thing for

you both. Charis may now actually focus her abilities; she may have needed such a catalyst, it seems to me. And you, darling, are free once again. Hail to the new work! Flight from women seems always to agree with you. You do ever more wonderful things."[44]

The Charlots were in Mexico and did not hear about the separation for several months. It seems that they heard the news not from Edward or Charis but from Frances Ison, to whom Edward must have written. She in turn wrote the Charlots in Mexico, and Zohmah related the news to Prue: "Another divorce! Is Edwards and Charis! This news from Frances Ison who says she thought Charis seemed very restless when she visited them last year at Carmel." A little further on she added, "Hope he doesn't care too much. I wonder what will happen to their house."[45] Oddly, there is nothing more. It is certainly possible that Edward was in contact with the Charlots at some point during this difficult time; he may have written to Jean or Zohmah or they may have reached out to him, but if so, none of this correspondence has been preserved. It is also possible that Charis and Zohmah were in touch with each other—the two of them had once been quite close—but if anything like that happened, there is no record; perhaps the tensions of more recent years stood in the way.

Weston's show at the Museum of Modern Art opened in February 1946, shortly before his sixtieth birthday. Although Weston felt it was not large enough to represent his achievements adequately, it was the largest show of Weston photographs in his lifetime and the largest one-man show that had ever been held at the museum. A retrospective, it included a broad range of Weston's pictures. There were pictures from the Mexico years; there were shells and peppers, nudes and sand dunes, as well as pictures from the Guggenheim years, the Whitman trip, and more recent work. All in all it comprised 267 prints, less than initially anticipated but still many more than previous shows had included; among the prints was the *Honeymoon* picture of the Charlots on the rocks (Zohmah and Jean Charlot, Point Lobos, 1939) (fig. 38).[46]

The accompanying catalogue was slim, especially by current standards (and it did not include a checklist of the exhibition). Only twenty-four of the pictures were reproduced, but among them was the ubiquitous *Honeymoon* picture, which appeared opposite one of the images of Maudelle Bass taken the same year. It also included an essay by Nancy Newhall summarizing Weston's career and development. Speaking of his Mexico years, she quoted

from Charlot's piece on Weston and Mexico, which had not yet been published and which Weston must have made known to her. Further on, speaking of Weston's return to Carmel and Point Lobos after his Guggenheim travels, she referred obliquely to the *Honeymoon* image: "The stream of visitors began again. Weston photographed them more and more with the 8 × 10, sunning on the rocks [the Charlots], against his house, among the ferns and flowers of his garden [Maudelle Bass]."

Newhall also covered Weston's more recent work, a sampling of which had been included in the show. She did not shy away completely from the cats or the backyard setups (some of which she had questioned): "Lobos was occupied by the Army. Security regulations and gas rationing confined Weston to his backyard. Here he began photographing a beloved tribe of cats. Capturing their sinuous independence with an 8 × 10 produced an amusing series—a formidable photographic achievement. With the robust humor and love of the grotesque that have always characterized his work, he also began producing a series of startling combinations—old shoes, nudes, flowers, gas masks, toothbrushes, houses—with satiric titles such as *What We Fight For*, *Civilian Defense*, and *Exposition of Dynamic Symmetry*." She concluded her essay with Weston's description of himself as "a prolific, mass-production, omnivorous seeker."[47] Obviously, for Weston, the notion of mass-produced seeing, which he had discussed a number of times in the past, going back to the Guggenheim years, still had merit.

Weston, with financial assistance from Merle Armitage, went to New York to attend the opening.[48] According to Beaumont Newhall Edward went to the museum almost every day to meet his public and ate his meager lunch there in the galleries.[49] Not surprisingly, the exhibition was well received and attracted large crowds. By the end Weston had received many orders for prints.[50] Unfortunately, the Charlots were not able to see the show as they were still in Mexico, but Armitage later wrote to Jean, telling him of the show's "amazing success. Nearly 3000 [300?] prints were displayed, the reviews were remarkable, the crowds were record breaking, and he sold nearly $2,700 worth of prints . . . very helpful at this particular time, for as you know, Edward and Charis are separating, and Edward will probably have to build a new home at some as yet undecided location." Armitage then added a note by hand, telling Jean that Edward "has just had an operation for a hernia which has been troubling him for years—is recovering rapidly!"[51]

Edward too reported to the Charlots on recent developments: "I'm out of

hospital over a month now. Feeling fair in most respects. Have lovely hemstitching on my person." Somehow he had heard that Zohmah was expecting again, and he commented on that: "And Z—is going to surprise us again! Great! With Dr. Charlot as pappa." He then told them that he was "desparately [sic] trying to print up 108 sales from my N.Y. show, working against odds of poor, or unobtainable paper, old (25 yrs. some) negatives." He reported that Brett and his daughter Erica were there with him and that soon Cole and his wife, Dorothy, would replace them, adding a little ruefully, "Substitutes for a wife."[52] Before signing off he apologized for the shaky handwriting; writing was difficult for him, he explained, with the implication that he was weak from the operation. He gave no indication of more serious health problems, and he did not say anything about where he planned to live; although he was sick, Weston now had to make a new beginning.

In April, a few months after Weston's show, Beaumont Newhall left the Museum of Modern Art; he had been displaced by Edward Steichen, who had a very different vision of the role of photography, in the modern world and at the museum, and of exhibition design. Weston, like Ansel Adams, was very displeased and regarded Newhall's departure as the end of an era. Somewhat dramatically, he wrote, "But now the curtain goes down, so far as I am concerned with photography at the M. of M.A. With the resignation of Beaumont Newhall as Curator, and the taking over by others unfitted to carry on the established policy, my interest ends—."[53]

Not long after Newhall left the museum, Alfred Stieglitz passed away, in August 1946. Weston had had an ambivalent attitude toward Stieglitz for many years, after their less than satisfactory encounter in 1922. Weston had also seen Stieglitz when he and Charis passed through New York City during the Whitman trip in 1941, but it is not clear whether he saw Stieglitz again in 1946 or whether Stieglitz came to see Weston's retrospective. Neither Armitage nor Weston mentioned anything about Stieglitz in their letters; perhaps he was already too ill to participate. Soon after his passing, Weston wrote to Adams, "One can't weep over the passing of a life as rich as Stieglitz. Ave! Vale! I hope St. Peter gives him a rip roaring welcome."[54]

Some months later, in the fall, Jean wrote to Edward to announce the birth of their fourth child, Peter Francis. Referring to Armitage's recent letter, he also mentioned "gorgeous private reports of your New York show, even as to its

financial success. The newspapers, Time Mag, etc. seemed rather inadequate to us, and the foreword to your catalogue not too comprehensive of your craft and aims."[55] Meanwhile, Jean went on to say, work on his Mexico book was nearing completion, and he asked if Edward would provide photographs; among the pictures he requested was a portrait of Diego Rivera looking sad. Edward responded soon afterward, offering his congratulations on the new arrival: "Your joyous news came yesterday. Now you have caught up to me. May all go well with you." Weston had had four sons, and now, as he said, the Charlots too had four children. As to the photographs Jean requested, Edward was only too happy to oblige, where possible. And then he wrote in the margin, a little wistfully perhaps, that he wished Jean and Zohmah could have seen the New York show.[56]

Weston made no mention of it in his letter to the Charlots, but he had been approached by the Eastman Kodak Company in mid-August about the possibility of doing some work in color, and toward the end of the year he took up the challenge. Although most of his life had been devoted to black-and-white photography and he was an acknowledged master in that area, he seemed to enjoy working in color. If nothing else it freed him from having to print, which he was no longer really able to do because of his health. As might be expected the money was good, too, and eventually it made possible the purchase of Wildcat Hill from Charis.

Not surprisingly, he made some of his first color pictures at Point Lobos, broad views of the water and the rocks. He also photographed at the Monterey waterfront, which, although relatively close at hand, had not interested him before; he must have chosen it at least in part because of the colorful building facades. A number of these initial efforts were included in a three-page Kodak advertisement that appeared in several photography magazines the following year.[57] Kodak touted Weston's artistic credentials—his Guggenheim grant and the exhibition at the Museum of Modern Art—in order to establish the legitimacy of working in color. Stieglitz might not have approved, but Weston was not concerned.

Early the following year Charlot wrote from Coyoacán, where his family planned to spend the rest of their stay in Mexico. He reported that he was now working on the final chapter of his book, "in which I quote from your beautiful Day Book."[58] The chapter in question ("Mexico and the United

States") was a revision of the piece Nancy Newhall had quoted in the cata-
logue for Weston's New York show.[59] In the revised version, Charlot spoke
of Rivera's self-portrait on the staircase of the Ministry of Education (the
Secretaría): "Stylistically it blends north and south of the Rio Grande, for it
owes as much to the lens of Edward Weston as to the painter's brush."[60] He
then went on to quote passages from Weston's daybook—at that point still
unpublished—that describe how the photo of Rivera on which the painter
based his self-portrait came to be made.[61] Charlot must have thought that,
after all the trouble taken over the typing, Weston would be pleased to hear
that his diary was being put to good use.

In the same letter Jean went on to say that they had heard from Frances
Ison that Edward was buying Wildcat Hill, and he expressed his desire to
make another visit; the Charlots had not seen Edward since the Whitman trip.
Further on Jean also asked if Edward might be able to help him find a teaching
job for the following year; his two years in Mexico on the Guggenheim were
about over, and he was worried about the future, as might be expected. He
then related an encounter with Rivera: "To recontact friends here gave me a
sharp idea of the time elapsed. When went to visit Diego on his scaffold (he
is painting at the Palacio Nacional) I called 'Diego!' and he turned around
and said 'Your hair is all white,' and when he opened his mouth to say that I
saw that most of his teeth were missing."

Jean renewed his request for pictures; he was especially interested in the
portrait of Galván, the magueys, the Cuernavaca palm tree, and Diego's head.
Then he turned things over to Zohmah, who had been assisting him on the
book, typing the chapter Jean had just mentioned. She too spoke of the diaries,
telling Edward that she "enjoyed so much typing from your Day Book today.
If we ever get to California, with better communication possible, I would like
very much to type the whole of the book for you in readiness of publication."
Before signing off she too expressed her regret that the Guggenheim period
was coming to an end and appealed to Edward for advice: "How did you ever
reconvert from being a Guggenheim? With the Guggenheim up in June we
are beginning to wonder how it is done!"[62]

Edward was happy to hear from the Charlots and wrote back soon after:
"A great event, a letter from the Charlots!" He was ready to send Jean the
prints he wanted and glad that his daybooks were being put to good use, but
he was a little apologetic about the quality and tone of his writing: "After all
these years of lying around and expurgating, it seems a bit stale. Also too many

exclamation points!" He also confirmed that he was buying Wildcat Hill, which was possible, he said, because of the color work he was doing for Kodak: "Surprised? Color really pays. I spent 3 pleasant mornings on Pt. Lobos and received 1750.00. Now I'm doing a job for Standard Oil—one transparency, 300.00. If one could only get enough of such paying work. I have shouldered a heavy indebtidness [*sic*] for one of my age with an inclination to slow up."

Edward commiserated with the Charlots about making the transition from the Guggenheim. Although he was more than willing to do what he could, he was not really in a position to be of much help: "I have slight communion with academic powers, Jean, but if I hear or think of a possibility, I'll move all I can. Reconverting from Guggenheim is not easy."[63] At the end of the letter he reported that Charis had remarried—someone he didn't know, named Noel Harris—and offered them his blessings. Charis had met Harris soon after she and Edward had separated; they were married in December 1946, the day after her divorce from Edward was granted.[64]

Edward also added that he was expecting to have another hernia operation in the near future; the prospect obviously upset him, but he maintained a sense of humor about his condition: "I don't disintegrate gracefully," he said. After receiving this letter Zohmah wrote to Prudence, "Edward writes that he is buying Wildcat Hill from Charis and that she is married again. From his handwriting he seems very shaken."[65] Zohmah was familiar with Edwards' handwriting, which was usually sprawling and fluid, even florid, and written across the horizontal page. But by this time the page was vertical and his writing was becoming a little shaky. Although Zohmah attributed the shakiness to emotional distress, it was instead an early indication of Weston's Parkinson's disease, of which the Charlots were not yet aware.

Soon after Edward sent along the prints Charlot had requested, and Jean acknowledged them in a letter: "You are a darling to send so many nice photographs and they will greatly help to raise the quality of my illustrations. The only thing is that you sent me the wrong Rivera for my purpose. I enclose a tracing of Diego's self portrait on the Ministry stairway, which in turn is a faithful copy of your photograph. I wanted to publish them side by side."[66] Eventually the mistake was rectified, and years later when Charlot's book was finally published, Rivera's self-portrait was shown together with Weston's photograph, as Charlot intended.[67]

Unfortunately, Charlot's book had recently been turned down by one

publisher, as Jean duly informed Edward, but he was undaunted and planned to send it elsewhere. Not wanting to dwell on himself, however, or on bad news, Jean quickly went on to speak of Edward's recent endeavors. First he touched on Weston's color work ("I hope that with your color photographs that you will soon be the owner of your own house") and then told him, "All our friends are making jokes concerning the naked negress who watches the Charlots on their honeymoon in your New York catalogue."

At that point Zohmah took over the letter-writing duties. She expressed her continuing concern about the future: Jean had an offer at Chouinard's for the summer, but she wasn't sure whether it was worth taking or where they would go after that. Then she told Weston that "Jean was going through Anita Brenner's files yesterday which had just arrived from New York and came on all the photographs you and Tina did for the prospective Folk Art book, why didn't it ever materialize—maybe this is a good time."[68] Zohmah was referring to the pictures that Weston and Modotti had done for *Idols behind Altars*, only a small number of which had been included in Brenner's book. Perhaps they had planned to do something more; unfortunately, nothing seems ever to have come of it.

As it turned out Jean did accept the job at the Chouinard School of Art for the summer of 1947. In the fall they moved to Colorado, where Jean had gotten a post as resident director of the School of Art at the Colorado Springs Fine Art Center—which must have seemed a welcome opportunity after the post-Guggenheim anxieties. Jean and Zohmah arrived in Colorado Springs in September, and while she unpacked, Zohmah came upon their copy of *California and the West*, which started her reminiscing about old times, as she explained in a letter to Prue: "The one nice thing to see again were our books I began to read the Weston's "California and the West". . . . It really is a good book, have you read it? I'll try to get you a copy if you haven't. It made me remember all over again why I admired Charis. What good times she and Edward had on their trips."[69]

Around the same time Weston was visiting old haunts to make new pictures, this time in color. Willard Van Dyke was making a film on Weston for the United States Information Agency, called *The Photographer*. In the process of making the film, Van Dyke and his crew took Weston to a number of locations at which he had worked in the past, including Oceano and Death Valley. The idea was to show him in action, as if making some of the black-and-white pictures for which he was already known. Weston explained what happened in a brief article:

He wanted me to trace my steps through Death Valley, Lake Tenaya, The Big Sur, and other places I have worked a lot. And he urged me really to work, offering the strong backs of his assistants to lug my 8 × 10 anywhere. I didn't want to do again what I had done in black-in-white, so I took along nothing but color film. I wanted to think exclusively in color. As in black-and-white one learns to forget color, so in color one must forget the black-and-white forms. In spite of my early successes, I still didn't know much about the technique, so I just followed the printed instructions. I never made more than one exposure—unless of course there is a high wind or some moving object.[70]

Not surprisingly, many of the pictures reprise earlier black-and-white images, but they are not entirely the same. Despite his dwindling physical strength, Weston's visual intelligence remained strong. It is hard now to judge his color work, since the color materials have deteriorated more than the black-and-white ones. So too the reproductions made for the magazine spread represent a different standard than modern-day color reproductions, and they may have faded as well. Nevertheless, his color photography represents an important departure for Weston—one that, unfortunately, he did not have time to explore as fully as he (or we) might have liked.

Although Weston was no longer as productive as in the past, 1947 saw the publication of two more books of his photographs. Even after the Westons separated, their book about the cats in and around their home in Carmel continued to go forward, and by the end of the year *The Cats of Wildcat Hill* appeared. Edward had taken many pictures of the cats, mostly in 1944 and 1945, but in the end the book included only eighteen photographs, along with Charis's lively and detailed account of the cats' behavior, adventures, and foibles. As in their previous collaborations, image and text were intended to complement each other, but the theme now was clearly different, less grand. It was originally intended as an unsentimental—sometimes even horrifying—look at real animals, but at the publisher's insistence it became lighter and more entertaining.[71]

The pictures have been all but disregarded by Weston fans and serious critics. Ben Maddow, for example, in his biography, dismisses them as in bad taste, a wrong turn. David Travis, in a more recent book on Weston's late work, discusses them only briefly, emphasizing the technical challenge

of taking all of the photos with an 8 × 10 view camera.[72] Admittedly these pictures are not among Weston's most important works; one may have to be a cat lover to appreciate them fully, and it is hard not to see some of them as raw material for a calendar. Nevertheless, *The Cats of Wildcat Hill* does include some rather striking images, including the one used for the dust jacket (and frontispiece), which shows a large group of somewhat spooky cats on the steps in front of the house. Nancy Newhall once characterized this photo as "absolutely the best picture of pussies I've ever seen."[73] Also included is a broad view of Wildcat Hill, which shows Charis perched on the roof of the house, reading, in the company of two of the cats; the ocean can be seen through the trees in the background. So too there is a prematurely postmodern and horribly cute image of a cat named Joseph standing in a picture frame set against the bushes.[74]

The text is somewhat more engaging—bordering on obsessive—with an extensive cast of feline characters whose activities are described in rather anthropomorphic terms. Among the many cats Charis introduces in the book is one named Zohmah, a silver tabby named "for a friend"; she was born around the time the Charlots were married and Weston made the *Honeymoon* picture of 1939. In the cat world Zohmah had a brother named Gourmy, who had once made a hearty meal of a rat, and a sister named Fraidy; the three of them are shown in one of Weston's photographs, curled up together in a basket. Zohmah, it seems, became Charis's favorite of the three, and she confesses to having spoiled Zohmah with extra treats and attention. A little further on Charis speaks of the feline Zohmah's romantic involvement with an ugly tomcat called Needles, who lived nearby; for a few days she refused to come home, even for meals, to the consternation of Edward and Charis. Charis then provides a detailed, blow-by-blow account of the birth of Zohmah's first batch of kittens, followed by a picture of Zohmah and her offspring.[75] Zohmah and her relatives are by no means the only characters in the book, but Charis's detailed recounting of their behavior is indicative of her approach and the tone of the book—which ultimately is more about cats than photography.

Fifty Photographs, the second Weston book published in 1947, was a very different sort of project. It arose, at least to some extent, as an effort by Merle Armitage to help raise money for Weston, who was struggling, financially and otherwise, in the wake of his divorce; it was designed by Armitage and printed by Lynton Kistler, who had worked with Charlot on numerous occasions.[76]

Rather than combining pictures and text devoted to a single theme, as was the case with *The Cats of Wildcat Hill*, *Fifty Photographs* was an anthology, a fine collection of some of Weston's favorite pictures—generally those that had not been circulated widely or published previously.

Merle and Edward together selected the images, which encompass a full range of subjects, including landscapes, nudes, still lifes, and portraits, with preference given to more recent work. There is only one picture from the Mexican period, a portrait of Dr. Atl; there is only one image of shells, and one pepper. There are several early images of Point Lobos but also many later ones, including *Cypress and Stone Crop, Point Lobos*, taken in 1946. Most of the pictures in the book are from the Guggenheim years and the Whitman trip. There are a number of views that were not included in *California and the West*—for example, one of Death Valley from the late 1930s—along with a view of Eel River Ranch and one of the pictures taken at the MGM storage lot in 1939. So too there are a number of the pictures taken for *Leaves of Grass* but never submitted or else rejected by Macy, including a view of Boulder Dam and pictures from New Orleans cemeteries, as well as portraits of the sculptor William Edmundson and Mr. Brown Jones of Georgia (taken when Edward and Charis were visiting the Charlots in Athens). These pictures set the stage for the portraits with backgrounds taken in the midforties, a number of which are included: all of Edward's sons are represented, and there is a striking portrait of Elsa Armitage, Merle's wife, taken in 1945. Interestingly, there are only three pictures of Charis, all of them nudes (the only nudes in the book), including one taken in 1943, just four years prior to the book's publication, called *Springtime*. It is noteworthy, perhaps, that in each of them Charis's face is hidden.[77]

The book begins with prefatory essays by Armitage, Robinson Jeffers, and Donald Baer; there is also an afterward by Weston, in which he sounds some familiar themes. He speaks of his technique and of pre-visualization and then goes on to say, "I do not know any formal rules of composition, nor do I recognize any boundaries to subject matter. Subject matter is everywhere: it may be an old shoe, a cloud, or my own backyard. Whatever it is, its inherent qualities supply the rules of composition for that particular subject, within the scope of the medium."[78] There is a combative flavor to these remarks, as if Weston were still fending off earlier criticism of his choice of subject matter. And once again he voices his disdain for compositional rules. As we have seen, Charlot's approach was somewhat different; Weston and Charlot had long ago agreed to disagree on this point.

Toward the end of the year, after settling into their new home in Colorado, the Charlots decided to send Weston a book of photographs by William Henry Jackson, who had died not long before. Jackson was best known for his pictures of Yellowstone National Park, but he also did a great deal of work in Colorado—which seems to be one of the reasons behind the gift. Although Jackson was not included in the first two editions of Newhall's history of photography, Weston would certainly have been familiar with his work, at least to some extent. Jackson's imagery had been included in a show at the Museum of Modern Art, "Photographs of the Civil War and the American Frontier" in 1942, about which Weston had heard, and Jackson was also featured soon after his death in the *U.S. Camera* annual of 1943, which also included Weston's *Honeymoon* picture and a feature on Weston himself.[79] Perhaps the Charlots also had that in mind when they decided to send the book to Weston. In any event, when Weston received the book he did not have the Charlots' new address, so he sent a postcard to the bookstore from which the Jackson book had been mailed, hoping the Charlots would get it anyway—remarkably enough, they did. Soon after Zohmah explained the situation to Prudence: "We sent Edward a book about Jackson, a photographer who worked in Colorado for about 90 years. The book store mailed it, and later when I went by there was a postcard from Edward saying if would send him our address he would send us 'Cats of Wildcat Hill.' Doesn't that sound exciting. I've been awaiting eagerly his new book 'by' Armitage, but I didn't know there was one about the cats."[80]

A few days later Jean wrote to Edward from Colorado Springs with their new address. He again commented briefly about the 1946 catalogue: "The catalogue of your show was slim, if fine, but the Charlots were not amused when Nancy Newhall, page 10, refers to them as 'the stream of visitors'." He also mentioned that, while in Los Angeles the previous summer, they saw proofs of the Armitage book, which they had ordered. Then Jean went on to speak of a little show he was planning: "just now I am arranging the prints of yours that we own to make a small show at the Fountain Valley School where I teach one day a week. The younger generation prefers photographs to handmade pictures, and I don't mind as long as they are your pictures."[81] The show went up early the following year, on January 20, 1948, and was taken down almost a month later.[82] Nothing more is known about that exhibition, but over the years the Charlots had amassed a good collection of Westons, so it must have been of considerable interest. It anticipates another such show, much later, at the Honolulu Academy of Arts.[83]

As promised, Edward soon sent along a copy of *The Cats of Wildcat Hill*. He inscribed it to the younger Charlots, possibly as a Christmas present: "From Keddsy / To Ann, John, Martin, Peter, / With many a purr and miow. / 12-25-'47."[84] Keddsy was the name of another of the cats in the book, a would-be Persian who was obtained from the animal shelter in 1942. Her paws looked like white tennis shoes, or Keds, which is how she came to be called Keddsy. Edward apparently thought that "her face fitted the popular concept of an Irish washerwoman type," and at one point in the book Keddsy is described as both tough and sweet, as well as "a born ruler." At the end of the book, in a kind of postscript, Charis describes how Keddsy kills and eats a gopher.[85] But why Edward chose the persona of Keddsy when inscribing the book is not clear.

The Charlots' reaction to *Fifty Photographs* is not recorded (and it is not clear when exactly they received their copy), but they responded favorably to the cat pictures—which must have brought back pleasant memories, especially for Zohmah, of past visits to Carmel. Although the Charlots' response has not survived, it seems to have included a drawing by Jean of a cat named Weston—an oblique reference, perhaps, to Zohmah the cat. Edward wrote in return saying that he was glad the book was well received and telling Jean, "I sure liked the drawing which illustrated your pleasure? A cat named 'Weston'? I have one named 'Eddypuss Complex.'" He also spoke of how much he enjoyed the Jackson book ("The book you sent on Jackson is being thoroughly enjoyed. Thanks for such a fine gift") and then related some news: "Willard Van Dyke just completed a documentary film on my life & work for the U.S. State Dept. We went to my old haunts, Death Valley, Tenaya, Oceano, Pt. Lobos. A crew of five took 3 months. I am photographing almost entirely in color!" The Charlots already knew of Weston's color work but had not yet heard anything about the film. Edward did not offer any further details; he did not say whether he had seen any of the film yet or what he thought. He then brought the letter to a close on a somewhat apologetic note: "And I have a bad tic in my right side which makes writing difficult."[86] Edward had not yet been diagnosed with Parkinson's disease, or at least had not made it known, but the disease had obviously taken hold and was already limiting his letter writing. That did not prevent him from adding that Charis, with whom he was still in touch, was expecting.

It was not long afterward, on February 20, 1948, that Edward wrote to his son Chandler with the bad news that he had Parkinson's disease.[87] At about the

same time he also informed Merle Armitage, who responded sympathetically: "Sorry to hear about the other hernia, but just refuse to believe that there is some disease that the doctors have given a name to, and which is incurable."[88] Although Zohmah had already noted Edward's shaky handwriting, it is not clear when and how the Charlots came to know the exact nature of Weston's affliction.

Some months later Zohmah wrote in a letter now lost to tell Edward, among other things, that she and Jean were buying a house. She also must have expressed a desire to buy more Weston photographs as soon as they had more money, for in his reply Weston told her, "Don't wait until you are 'richer' for the new Weston photographs." Then he added, rather wistfully, "The last few years have been barren, but you have not seen the Whitman trip yet. Or have you? And of course you have not seen my color!"[89] Edward had perhaps forgotten that the Charlots had seen *Leaves of Grass*, at least, and had written him about it, but he was right that they had not yet seen any of his color work—except, perhaps, in magazines. In any case, Weston was not happy with his lack of productivity, which was, of course, due to his declining health. It was probably soon after that Weston made his last photograph, a final image of Point Lobos.[90]

In her letter Zohmah must have asked to hear more about the film Van Dyke had made; she and Jean were probably hoping to be able to see it. Edward explained, "The doc. film by Willard is for foreign release, 'The Voice of America.' I expect to have a copy." Zohmah, still not knowing that Edward had been diagnosed with Parkinson's, must also have expressed her concerns about Edward's health, and he was not altogether forthright with her—or, perhaps, with himself. He more or less skirted the issue by saying, "I think I'm on the mend (except for a new hernia!) After 3 poor years."[91] And then he added that Charis had given birth to an eight-pound girl.

Although he had somewhat grudgingly supported Truman since the death of FDR, Weston continued to be interested in Wallace. In 1946 he had sent a card or letter to Wallace and received an acknowledgment.[92] By 1948, as the presidential campaign heated up, Weston had become increasingly involved with the Progressive Party—especially since his son Cole was running for Congress on the Progressive ticket. As he wrote to his old friend Christel Gang, "There is but one choice for President—*Henry A. Wallace!*"[93] And then again, several months later, "Wallace is of course my man. Who else is possible! The

pretender Truman, or the pipsqueak, Dewey. Cole, Dorothy and Chan went to the Progressive Convention."[94] Evidently Edward himself did not attend the convention, but sometime during the campaign he traveled to San Francisco to photograph Wallace. Afterward he reported to Chandler that his session with Wallace had been "a flop."[95] Cole, however, recalled the situation a little differently: "One photographic subject he enjoyed immensely in 1948 was Henry Wallace, then running for President as the Independent Progressive Party candidate. I was on Wallace's ticket, running for Congress. Though he had a reputation for being apolitical, Dad delighted in the race." According to Cole, Weston's involvement with Wallace and the Progressive Party put a strain on his friendship with Merle Armitage, who was more conservative than Edward (Cole described Merle as "a devout right-winger").[96] It also brought him into contact once again with Charis and, at least indirectly, with Paul Strand, both of whom were Wallace supporters. At Strand's request Weston provided pictures for an auction on behalf of the Progressive Party.[97] As it turned out, Cole lost the election (as, of course, did Wallace), but Weston's involvement in the campaign is indicative not only of his loyalty to his son but also of his continuing interest in politics more generally. But in the coming years, as the Parkinson's progressed, Weston's political engagement seems to have subsided along with his photographic activity.

10

CARMEL AND HAWAI'I

After only a few years in Colorado the Charlots decided to move on. Jean had become increasingly displeased with the administration of the Fine Arts Center, and at the end of April 1949 he abruptly resigned his post, an action that sparked a protest from students who wanted him to remain.[1] Soon after, he accepted a job at the University of Hawai'i. He had been invited to paint a mural, on a subject to be determined, in the administration building then under construction (now Bachman Hall); the mural was to be a gift of the classes of 1949, 1950, 1951, and 1952. He was also given a position on the art faculty for the summer.[2] Once the arrangements were finalized the Charlots sold their house in Colorado Springs and put most of their belongings in storage, and the whole family moved to Honolulu—where they expected to stay only a short time. As it turned out, they remained there permanently.

On the way to their new home Jean and Zohmah, along with the children, paid a visit to Edward in Carmel, stopping off first in San Francisco. In advance of the trip Zohmah wrote to Prue to invite her and Owen along: "We expect to be in S.F. on the afternoon of the 5th and maybe spend the 6th driving down to Carmel and back (why not come and do that with us)."[3] Late in the day on June 4, 1949, they boarded the train (the *Zephyr*) in Denver; they rode in the observation car, which Jean referred to in his diary as the "bubble."[4] They arrived in San Francisco on Sunday, June 5, and the following morning they called Edward to arrange a visit.[5] As it turned out, the Plowes were

unable to join them, but on Tuesday, June 7, the Charlots left San Francisco and headed for Carmel; when they arrived not only was Edward on hand to receive them, but Brett, Neil, and Cole were all present as well. It was the first time Jean and Zohmah had been to Carmel since 1939 (and the first time they had seen Edward since 1941, when the Westons stopped in Athens during the Whitman trip). It must have been a happy moment.

Viewing photographs was always an important part of any visit to Wildcat Hill, and no sooner had the Charlots arrived than Edward brought them into the house to show them his recent work, including the color images. In his diary Jean commented, "beautiful color photography and later work" but did not elaborate.[6] Edward had kept Jean apprised of his latest endeavors during the war and in the years that followed, but how much the Charlots had actually seen, aside from what had been published in books and elsewhere, is not altogether clear; they undoubtedly had a good deal of catching up to do. Edward may have shown them the pictures from the Whitman trip and the backyard setups as well as more recent portraits, landscapes, and nudes, but it seems Jean was especially taken with the color work. If he had any reservations about the backyard setups, Jean kept his views to himself.

That night the Charlots slept at Brett's house, and the following morning Jean and Zohmah looked at Brett's work (a set of sand-dune photographs) while the children played with a horse.[7] After a trip to the market in town—which struck Charlot as phonier than he had remembered—they went to the beach for a picnic, and the children went wading. Afterward Weston showed more pictures, this time the ones he was preparing for a show in England, a one-man show that ended up in the U.S. Embassy gallery in London.[8] This perhaps provided an opportunity to revisit older work from previous decades and no doubt sparked a discussion of old times, of earlier encounters and experiences.

Later that same day they paid a visit to the home of the Kelloggs, where Charlot admired the view. Later on there was a farewell dinner at a Chinese restaurant in Monterey, and then, after all the good-byes, Cole drove the Charlots to Salinas, where they caught the night train to Los Angeles. There they spent several days visiting family and friends, including the Plowes.[9] Late on Sunday, June 12, 1949, they left Los Angeles and flew to Honolulu, arriving the following morning; they were welcomed by Ben Norris, chair of the Art Department, and Father Kennedy, the priest who had married them in San Francisco ten years before.[10]

Almost immediately after their arrival Jean got to work planning his new mural, and he met with his fresco class for the first time. Several weeks later he wrote Edward to say how much he had enjoyed the visit to Carmel: "It was grand seeing you again after so long." And then, reiterating what he had said in his diary, he told Edward, "your new color work is beautiful." Now that they were in Hawai'i, Jean reported, Zohmah and the kids were spending their afternoons at Waikīkī, while he was cooking up ideas for the new mural project: "I'm boning up on Hawaiian history for the mural I am to paint; bless them, they cooked *poï*, by mashing the pulp of taro on a stone platter, very like in Mexico they knead dough for tortillas. So the subject of the mural will be *poï* making." At the bottom of the page Jean drew a cartoon showing himself at work on a mural while reclining in a hammock at the beach; nearby are five pairs of legs — obviously belonging to Zohmah and the children — sticking up out of the waves.

At this point Zohmah took over and reiterated Jean's sentiments about the Carmel trip: "That was a wonderful time you gave us in Carmel. The best of all was just seeing you. We miss you always and every place. And I was so happy to see Brett and Erica. To talk with him and get better acquainted. I guess it is you and Prudence of all my friends I feel the most lonesome for." She also mentioned Jean's intensive research into all things Hawaiian in preparation for the new mural, and then she went on to speak of food: "We pick mangoes, and papayas are 10 cents a pound, the cheapest food, and coconuts fall off the trees, through very hard to open. We point away at the skins and shells for hours and then drink up the milk and eat the coconut in a few minutes."[11] Like Jean, Zohmah obviously enjoyed reporting on these new and, to them, exotic experiences.

Although the Parkinson's disease was slowing him down and he was no longer making black-and-white photographs, Weston devoted the summer to a number of projects. To begin with, he was preparing another one-man show, a major retrospective that he expected would be held in Paris later on in the year, in the autumn.[12] It was being organized by Le Groupe des XV, a French photographic society formed soon after the end of World War II that was dedicated not only to the promotion of French photography but also to photographic technique and the beauty of the fine print. Le Groupe des XV included Emmanuel Sougez, Willy Ronis, Robert Doisneau, and a dozen others. They represented a range of approaches and methods — from

reportage to fashion—but for some, especially the older members of the group like Sougez and Daniel Masclet who were strongly committed to a purist aesthetic, Weston was an important forerunner and Group f/64 a useful model.[13]

In addition to working on the Paris show, Edward was collaborating with Cole on a story for *Life* magazine about cotton, which involved periodic trips to the San Joaquin Valley. While work proceeded on these two projects Edward found time to write to the Charlots. He acknowledged their recent letter (and the illustration) and also spoke of their visit, telling them, "Seeing you-all was a great treat. What a family!" He was especially gratified by Jean's response to his color work: "It gave me a needed lift to hear that you liked my color. As long as E.K Co. furnishes film, I'll go ahead!" In addition, Weston expressed interest in the mangoes, which reminded him of earlier times: "My mouth waters when you speak of mangoes. Imagine picking them! I almost lived on tropical fruits in Mexico." Then he turned to his most recent activities: "Cole and I are busy with the cotton job for 'Life' magazine. Go to San Joaquin Valley every few weeks. Hot there. And I am busy selecting my Paris show to open this autumn, auspices group XV."[14] He closed by wishing Jean good luck with his murals.

During the month of August, as the planning of Charlot's mural continued, the project was announced in the local newspaper (although the actual painting would not begin for several more months). Already the theme had been amplified; instead of poi-making, as he had jokingly indicated to Weston, it had become the collaboration between people and nature in the islands and would include a range of traditional activities. In the article, Charlot's thinking is explained, "The subject matter . . . suggested itself soon after his arrival here in June when he was strongly impressed with the unusually close relationship between man and nature in Hawai'i, in spite of the many changes wrought by the various cultures which have supplanted the early Polynesians."[15] Charlot had not been in Hawai'i very long, but he had already grasped some of the basic historical issues, and as preparations went forward he sought out advice about traditional Hawaiian culture from leading local authorities, including Mary Kawena Pukui of the Bishop Museum and Mrs. John H. Wilson (Aunt Jennie Wilson), who was the wife of the mayor of Honolulu and had danced for King Kalākaua.[16]

Meanwhile, Zohmah had taken notice of Edward's comments about the

mangoes and wanted to send him some of the fruit directly from Hawai'i, but realizing that agricultural restrictions made this impossible, she settled on an alternate plan. Sending a check to Prue in Los Angeles, Zohmah asked her, if possible, to buy some mangoes there in her neighborhood and send them on to Edward, along with some unsalted almonds or shelled walnuts.[17] As it turned out, Prue was unable to come up with any mangoes, but she did send some other kinds of fruit, along with some nuts, in the Charlots' name. When Weston received the package, which had been sent from Los Angeles, not Honolulu, he was somewhat confused, thinking that the Charlots had returned to the mainland. In his next letter he inquired about the situation: "Your wonderful package arrived. I could not believe my eyes when I noted the address, and then opened to the magnificent contents! Thank you dear friends, *mil gracias*. But I thought you were in Hawaii; it seems as though you left Wild Cat Hill just a few weeks ago. Are you back for good? And where next?"

Weston then spoke again of his Paris exhibition, apparently forgetting that he had mentioned it in his last letter. Although the show had originally been scheduled for the fall, it seems that it had now been pushed back to early the following year, and Weston was still in the midst of selecting the prints and packing them: "News: I am having my first big 'one-man' exhibition in Paris. I am shipping it by the 1st Nov. But I think show will open in Jan. at galerie 'Kodak,' Place Vendôm. Will hang 125 photographs. Auspices 'group XV,' something like our American 'group f64.'"[18] He then asked if the Charlots knew of anyone in Paris, or if they had any suggestions concerning the show.

Edward made no mention of it, but shortly before he wrote his letter, Mary Kriger, who several years earlier had done some of the typing of the daybooks, stopped in Carmel to visit him; she brought along a friend named Alfred Starr. Weston showed them his color work, and they may have discussed the progress that had been made on the daybooks, which by then the Newhalls had taken in hand. So too they must have talked a good deal about the Charlots, as Edward and Mary had done during Kriger's previous stay. Afterward both guests wrote to the Charlots to report on their visit.[19]

Zohmah responded to Edward's letter almost immediately, explaining about the package of fruit and nuts. She then added the exciting news that Jean had been asked to stay on at the University of Hawai'i indefinitely. Meanwhile, she reported, he was now hard at work on the mural, the painting of which

had begun about ten days earlier.[20] She promised to send photographs when it was completed. She also mentioned the letters from Mary Kriger and Alfred Starr and made a point of saying how much they had both enjoyed seeing Edward's color pictures.

Then Zohmah turned to the Paris show: "It is wonderful to have an exhibit sent from U.S. to Paris of which we can be proud. Jean says he wants to write the Claudels [Paul Claudel and family] to be sure and see it. I don't think anyone will need reminding, all Paris will be there. I'll write to Jean's sister." She couldn't refrain from asking, "Will 'Honeymoon' be included, so I can tell her to look for us?"[21] In response to Edward's request for ideas, Zohmah suggested that he include his various books—and by this time there were quite a few, including the 1932 monograph *California and the West* and the more recent *Fifty Photographs*—in the exhibition.

After he had finished preparing the Paris show, Weston wrote again: "Sent off my Paris show: 125 photos from 1922–1948. Best show yet. Will let you know opening date & data." And then, since Zohmah had asked, he added, "'Honeymoon' included—of course." After that he reported that he was a grandfather again, referring to Neil's new son. ("I am grandpa once more—and to a boy! Boys seem to predominate in the Westons."[22]) He also enclosed an excerpt from *Life* magazine, without further comment or explanation. The Charlots' response has been lost, but they sent along some papayas as well as a book for Edward's new grandson, perhaps as a Christmas present. The book in question was probably one of the picture books that Charlot had done with Margaret Wise Brown: *Two Little Trains* had been published in 1949 and *A Child's Good Night Book*, which had first appeared in 1943, was about to be reissued in a larger format.[23] Although rarely mentioned in his letters to Weston, Charlot had long been involved with the creation of picture books. Not long before he had illustrated a book by Anita Brenner, *The Boy Who Could Do Anything*, based on Nahuatl stories recounted by Luz Jiménez; whether Weston ever received or had the opportunity to see a copy is not recorded, but it seems likely.[24] In the coming years Charlot would collaborate again with both Brenner and Brown.

Edward acknowledged the fruit and the book, briefly but effusively, soon afterward, "What a wonderful present! And how thoughtful! This is just to say the Papayas arrived in fine shape. I'm panting until they ripen. Then I'll report on the eating. Did we have papayas in Mexico? I don't recall." He

added a few words about the book and his grandson, who now had a name: "I had a hurried glance at a beautiful book to 'Edward's grandson.' I shall borrow it! I hope Mark writes you. He can smile."[25]

As promised, Weston wrote again after he had had a chance to sample the papayas and reported that they had all ripened perfectly and were delicious. And as he said he would, he gave more particulars about the Paris exhibition, which was now slated to open on January 23 at Maison Kodak, Place Vendôme. He went on to speak of another project, a new book of his pictures, *My Camera on Point Lobos*, which was scheduled to come out later that year: "My 'Point Lobos' book is about on the press. Will send you one when finished. Virginia Adams is subsidizing it."[26] The project had been set in motion by Ansel and Virginia Adams, and it was modeled on Ansel's own *My Camera in Yosemite Valley*, which had been published the year before. To make sure Weston got something out of it financially, Virginia generously advanced him one thousand dollars from her personal funds.[27] It was an opportunity to collect a group of pictures taken over many years at one of Weston's favorite spots.

Meanwhile, in late November 1949 Charlot finished his mural of old Hawai'i (fig. 59), which had taken almost two months. Early the next year it was unveiled with considerable fanfare. As promised, the Charlots sent Weston a newspaper clipping, including a photo of the whole mural to give him at least some idea of its basic subject and appearance. As the news account makes clear, Charlot's mural shows a moment just before the arrival of Captain Cook, as a traditional feast unfolds. At the left men carry in a pig, while in the foreground one figure digs the imu (the pit in which the pig will be cooked) and another pounds poi. On the right we see drummers and other musicians, along with hula dancers beginning a dance in honor of the dead; behind them stand a small group of spearmen, whose spears help to tie the composition together, as do the carefully rendered native plants, including taro, ti, a lauhala tree, and a breadfruit tree. In the distance, at the center, there is a flattened-out view of Kealakekua Bay, and on the horizon, Cook's ship approaching. It had been Charlot's intention from the start to celebrate traditional culture and to convey an authentic, vital connection with the land, threatened by subsequent developments. The small but ominous presence of Cook's ship in the distance signals the coming changes and gives the image not only a temporal specificity but also a poignant political dimension that is sometimes overlooked.[28]

Weston's Paris show had not yet closed when he wrote to the Charlots about it once again: "Paris show a big success, according to all reports. Some 10,000 saw it at galerie Kodak, and then it was moved to the American Embassy. I have a bushel of press notices, which I'll have Jean Kellogg read to me."[29] This was the second time within a year that Weston's work was exhibited at an American Embassy abroad. His London show the previous year had been transferred to the American Embassy from its original location, and now, in Paris, a similar arrangement had been made. Although it may not have been planned initially, this move from the Kodak gallery to the embassy is one more indication that Weston's work was looked upon favorably by the U.S. government and promoted in postwar Europe—even though Weston had refused to resign from the Photo League (a progressive group of photographers in New York) when it had been placed on the attorney general's list of subversive organizations. In this context it is significant that Willard Van Dyke's film *The Photographer*, which had likewise been sponsored by the government, was shown at the American Embassy in conjunction with the show. Like certain brands of modernism, including some of the abstract painting being produced at the time, Weston's work represented an impressive but relatively harmless alternative to the socialist realism promoted by the USSR at the time. It demonstrated the openness of American society, its commitment to the arts, and its cultural riches—but unlike the work of many members of the Photo League, it did not raise any uncomfortable social questions and did not pose any serious challenge to the American self-image.

In the same letter Weston reported on how his new book was progressing: "Pt. Lobos book out in May. Expect one. Reproductions (30) the best yet. Included are excerpts from my day-book of that period."[30] He then turned his attention to Jean's new fresco. He acknowledged the newspaper clipping with a picture of the new work—which, he said, looked gorgeous—adding, "Soon he will circle the globe!" Charlot already had murals in Mexico, Georgia, and elsewhere in the continental United States, and now he was adding Hawai'i (at the time a U.S. territory) to the list. Before long there would be more examples, in Hawai'i and on the mainland; although Weston would not live to see it, Charlot would eventually work in Fiji as well.

Weston's new book, *My Camera on Point Lobos*, must have come out soon after, and it was most impressive. Many of the photographs had not been published before, and they were beautifully reproduced, as Edward had predicted,

surpassing earlier books and setting a new, high standard. There are thirty images altogether, and although they are not arranged chronologically, many phases of his career are represented. There are examples of the concentrated imagery from the end of the 1920s and early 1930s, pictures of tree trunks, eroded rocks, and kelp; so too there are broader views of rocky shorelines and cypress groves from the Guggenheim and Whitman years as well as the complex imagery from the years immediately after World War II when Weston could again photograph in the area, including *Eroded Rocks, South Shore*, taken in 1948, an enigmatic image of scattered rocks embedded in the sand, reputedly the last photograph he ever took. One picture includes a bird, some distance away, perched on a rock, but otherwise there are few signs of life. The *Honeymoon* picture, taken on the rocks at Point Lobos, is not included.[31]

Alan Trachtenberg once likened Weston's last picture, *Eroded Rocks, South Shore*, to Stieglitz's Equivalents.[32] While that image may have been as close as Weston ever came to making an Equivalent in the fullest sense, the concept could well be applied to many other pictures in the book as well—or even to the book as a whole, which helps to explain its strange power. In superficial terms, the pictures hang together because they were all taken in the same place, but it was never Weston's intention, when he was taking the pictures or when he was putting the book together, to provide a complete documentary record of Point Lobos. Instead, the pictures transcend the particularities of the location and communicate on a more intangible level. Whether close-up views or more distant vistas, the images flow into one another in an almost fugal or symphonic way, as one form flows into another. Undulating rock erosion gives way to twisted cypress and then to foaming surf at China Cove; cypress roots are transformed into piles of kelp, lichen, and sand. Taken together, they represent a complex response to a particular location, this magnificent part of the California coast, but also something more profound and mysterious.

In addition to the pictures, the book includes an introductory text by Dody Warren (later Dody Weston Thompson), mostly about the history of Point Lobos and the nature of the place; selections from the daybooks are presented at the end of the book, following the images. Weston had originally intended to include an up-to-date statement, but after turning to the daybooks to refresh his memory on certain specifics he decided they would be more appropriate and revealing. Although the passages in *My Camera on Point Lobos* cover only a few years (1929–32), they represent the largest selection of the daybooks published up to that time, and they remind us of Weston's earlier thinking,

invoked Blake in the excerpts he quoted from the daybooks, he did not make extravagant claims about the mystical meanings of his imagery or emphasize their spiritual content. Nevertheless, there is a transcendent aspect to this book, an almost mystical reverberation that is as undeniable as it is elusive. The juxtaposition of images, the sequential arrangement, seems to bring that out, linking forms and meanings in suggestive, evocative ways. Partly as a result of these interconnections, *My Camera on Point Lobos* is Weston's most coherent book and perhaps the most satisfying collection produced in his lifetime.

In the spring Zohmah made a trip to the island of Hawai'i, and upon her return she wrote again to Edward. She reported on her recent adventures and told him, "We are so happy your Paris show was so well appreciated, but then we knew that it would be. Jean would like to see the French clippings sometime. We haven't heard from Claudel, but Jean's sister Odette writes about seeing the exhibit." Then she quoted Odette, who after several unsuccessful attempts had seen the exhibit with a friend, Carol, at the American Embassy; she was clearly impressed:

> For the 4th time I went to see Weston's exhibition (for 1st time they don't know (it was in January) at Kodak what I will say [what I was talking about]; the 2nd time at Kodak the exhibition was not beginning; the 3rd time, at Kodak, the shop was not open; the 4th time at Kodak, the exhibition was finished). And for 5th time at the Embassy Documentation Exhibition I went with Carol. He is a great photographer. What marvellous things we saw, and first we see you tenderly pressed upon Jean, it was easy to know you, suddenly I say "Carol those are Jean's toes!" Carol laughs, we look at the program, it was just [correct]; Jean's toes (not the title) with you on a California beach.[37]

Odette was, of course, referring to the *Honeymoon* picture, which Zohmah did not feel the need to identify.

In the same letter, Zohmah went on to speak of recent developments back in Hawai'i. She described her inter-island trip ("Honolulu is fun, but Hawaii is really fascinating and mysterious"); she mentioned that Jean had painted another small mural and that she herself was enjoying her ceramics class.[38] She then turned to the latest visitors to the islands. Mrs. Chouinard, for example, had been in Hawai'i for vacation, and the Charlots had seen her

a couple of times during her stay; meanwhile, the painter Millard Sheets, whom Jean knew from the Chouinard School of Art, had likewise been in town for a few days and was planning to come back soon. Zohmah also made a point of saying how much they were looking forward to seeing the Point Lobos book, which had not yet arrived.

Charlot spent the summer in California, on his own, but he did not see Weston. He started in San Francisco and went to Palo Alto to make arrangements—which later fell through—with Stanford University Press for the publication of his book on the Mexican Mural Renaissance. He would have liked to continue on to Carmel, and perhaps he had originally intended to do so, but he was on such a tight schedule that he could not make it. He then returned briefly to San Francisco, and two days later he was in Los Angeles; soon after he continued on to San Diego, where he was to teach at San Diego State College and at the Summer Art Institute of the Fine Arts Society at the Fine Arts Gallery, Balboa Park.[39] There is no indication that he was in contact with Weston during that time, by letter or by phone. He returned to Hawai'i in early September, once again taking up his teaching duties at the University of Hawai'i.

A short time later his latest book, *Art-Making from Mexico to China*, appeared. This new volume was a collection of twenty-seven essays and articles on various topics—a kind of sequel to *Art: From the Mayans to Disney*. Among other studies, it included a review of a new edition of Matila Ghyka's *Geometry of Art and Life* (from the *Magazine of Art*, 1947), in which Charlot reasserts the importance of basic geometric relationships to the visual arts. There were many articles on Mexican art, including the one on José Guadalupe Posada that Weston had seen and admired in the *Magazine of Art*. In addition, there were discussions of Orozco, Guerrero, and Tamayo, as well as a review of Huyningen Huene's *Mexican Heritage*, a book of photographs of Mexico—but there was no discussion of Weston's work, in Mexico or elsewhere.

Art-Making from Mexico to China also contained several studies of liturgical art, an important concern for Charlot. In one of them, "Catholic Art, Its Quandaries" (1940), Charlot speaks of the interconnectedness of things: "Thus it may not be accident, as Delacroix remarks in his Journals, that the cracks to be observed in dried mud have a shape and logic similar to the formation of tree trunks and branches. It must mean something, for example, this insistence on the sphere—spherical cells, spherical eye, spherical planets. Or

this relation of a pine branch lovingly mimicking the outline of Mount Saint Victoire, miles away as observed by Cézanne."[40] Charlot makes no specific reference to Weston, but the sentiments expressed here are not unrelated to Weston's remarks about the resemblance among natural forms included in *My Camera on Point Lobos*. Weston understood such resemblances in relatively empirical, even secular terms. Charlot's argument, on the other hand, grew out of a deep religious faith—and the context here is completely different—but his position is analogous to Weston's. In the most basic sense, leaving aside specific religious beliefs or mathematical terminology, Weston and Charlot were more in agreement on such matters than it might at first appear.

All of the essays in the book had been previously published, except for one on Chinese brush painting focusing on the art of Tseng Yu-Ho (Betty Ecke), whose work Charlot had gotten to know after joining the University of Hawai'i faculty. Here he brings out the instinctive, almost automatic, aspect of brush painting. Western art is, in Charlot's eyes, often tied to reason and based on carefully measured lines. Brush painting, by contrast, is a process beyond reason, which can be considered a kind of spiritual disrobing, revealing the harmony between the painter and the universe. Charlot is talking here about drawing and painting, not photography, but the language he employs is not unlike what he had once said about Weston and his photographs. In the early 1930s, when Charlot supplied a short statement for Weston's exhibition at the Increase Robinson Galleries, he had invoked Chinese painting in connection with photography. For Charlot, Weston's approach to photography, and to nature, could be likened, in its directness, to brush painting or calligraphy. Although Charlot now focuses more specifically on Chinese painting itself and makes no mention of photography, his words could again be applied to Weston, in effect amplifying his earlier statements.

Soon after the Charlots received a copy of *My Camera on Point Lobos*; it was inscribed, "To Jean & Zohmah & all the little Charlots with all my love. Edward." Jean wrote to Edward to express his appreciation: "Your Carmel book reached us. It is admirable both as to commission and as to omission. We enjoyed not seeing us on our honeymoon spralled on the rocks of Point Lobos; and we enjoyed seeing all the other plates old and new." And then he added, referring to Weston's final photograph, "I am glad you included the most mysterious one, that you said was a demonstration made for your class, of unassuming pebbles."

Jean also told of his visit to Stanford, apologizing for not having had time to visit Carmel, and then he mentioned the new book, *Art-Making from Mexico to China*, which he promised to send as soon as he received his copies. So too he asked Edward to send him more Mexican documentation; now that his book had been accepted for publication, Jean was turning his attention back to his Mexican days, and since much of his own Mexican material had been put in storage back in Colorado he was turning to other sources. Edward had already offered—probably when the Charlots last visited Carmel, in the summer of 1949—to give Jean whatever newspapers and broadsides he might still have, and Jean, hoping that this would help fill in some of the gaps, took him up on the offer.

At that point Jean signed off, and Zohmah, in a postscript, added, "We are happy to have the Carmel book to look at." Then, referring to Hawai'i, she remarked, "How different are these Islands. Wish we had a chance to see these accordion pleated mountains through your eyes."[41] Edward, of course, never had the opportunity to visit Hawai'i or to photograph there, but his son Brett took up the challenge and later spent a considerable amount of time in the islands.

In early December 1950, in response to Jean's request, Edward sent off a package of Mexican material and followed it up with a letter in which he explained, "Last week I mailed the newspapers of so many years ago; they include the famous manifesto, the protest by the extranjeros, and several 'El Machetes.' Keep them or turn them over to some historical society, maybe the 'United States National Museum.' They certainly have historical value." He did not mention it, but he also sent along a copy of the pamphlet accompanying Willard Van Dyke's film *The Photographer*, which by then had been shown in Paris and was starting to circulate to other locations.

In the same letter Edward told of the arrival of Jean's new book, which caused a "wild scramble by those who wanted to be first. I lost to Dody! You appear to be up to your standard—which very high. Yours are the only (almost) ones* (*I mean books on art) that I can read with eagerness, profit & pleasure."[42] Although Edward had not yet delved into Jean's latest collection, he would find a good deal of material to which he could relate.

Back in the summer of 1950, Charlot had been approached about the possibility of doing a mural for the new Waikīkī branch of the Bishop National Bank

of Hawaii at Honolulu (now First Hawaiian Bank); the letter of agreement was signed in January of the following year.[43] The subject would be the early contacts between Hawai'i and the West (*Early Contacts of Hawaii with the Outer World*), a kind of sequel to the mural at the University of Hawai'i, which had shown life in the islands prior to Cook's arrival. The new bank mural was to deal with subsequent events, after the westerners came, including one of the visits of the Russian ship *Rurik* to Hawai'i in the early nineteenth century.[44]

As the initial arrangements were being worked out with the bank, Jean wrote again to Edward and acknowledged both the brochure on the film and the Mexican material. The pamphlet made him curious to see the film, and he wanted to obtain a copy for the university or the Honolulu Academy of Arts; to that end, he asked Edward whom he might contact about it. Then, turning to the Mexican material, he quipped, "It seems to me a little mouse got it since I saw it last as there were holes in the newspaper."[45] He then echoed Weston's desire that the material should go to a public institution, as he felt the same way about his own Mexican materials. Weston's material is perhaps among the many examples now in the Jean Charlot Collection at the University of Hawai'i.

Charlot also reported on his latest mural project: "I am starting another mural on a Hawaiian subject. The subject matter is wonderful though perhaps too pictorial. It is nice to be back to fresco on a large scale after a few years of relative idleness." He then spoke of his summer plans to paint yet another fresco in Arizona, on a Native American subject yet to be determined. And in the same letter, Jean went on to ask Edward about his latest photographs. Jean knew from earlier letters that Edward had not been especially productive of late, but perhaps he had not yet realized that Weston had not taken any photographs since 1948—or perhaps, sensing that such might be the case, he was trying to goad his friend into action.

Jean closed his letter by recounting a recent incident involving, of all people, Edward Steichen: "The other day I met a navy officer in full uniform and shook hands coldly with the proper attitude towards the military. They told me later that he was Colonel Steichen on a mission to photograph things in Korea." Charlot said nothing more, but he certainly knew that Weston had mixed feelings about Steichen; he must have thought Weston would be amused to hear about this odd encounter. For further comic relief, he enclosed a rather curious snapshot, in color, showing Jean and Zohmah standing in front of their house. Jean, who is scowling, appears in a loose-fitting, checked

mu'umu'u, which almost looks like a smock, while Zohmah, smiling, is wearing a more attractive purple mu'umu'u and a yellow 'ilima lei.[46]

Weston responded quickly but briefly—almost telegraphically—with a kind of list, written on a postcard: "Your portrait in full color superb," he said. Then, in response to Charlot's inquiry about the film, he advised him to write Willard Van Dyke and gave him the address in New York City. Then he congratulated Charlot about the new fresco ("Cheers for new fresco!") and added a rueful comment about his own work: "—my latest work? I have not made any, not for 3 years. Maybe I'm through."[47] Weston was beginning to realize that he had already taken his last picture.

A short time later, Edward went to Yosemite to visit Ansel Adams. When he returned he wrote to Jean and Zohmah to acknowledge a Valentine's Day package he had received in the meantime, with candy, jelly, a Posada, and a family snapshot, among other things. At the same time, he reported on the recent trip: "Stayed with Ansel Adams in Yosemite and had a stimulating time; music, books, photography, local—and magnificent—landscape."[48] He would have liked to write more, he said, but could not, because writing was difficult for him. And indeed, the handwriting is an obvious sign of his illness; it was becoming increasingly shaky and cramped, and this would continue to be the case, slowly worsening, in the coming years. Looking through the letters from this period, it is saddening to see the gradual but steady deterioration.

Weston did not mention it, but at around this time preparations had begun, with the help of Brett, Cole, and Dody Warren, as well as Morley and Frances Baer, for what would become the *Fiftieth Anniversary Portfolio*. It was to be a portfolio of twelve Weston photographs, one hundred copies of which would be made available to subscribers at one hundred dollars each. By this time Weston was no longer able to make the prints himself, but he selected the images—a challenge in itself—and carefully supervised the printing.[49]

In addition to his teaching duties, Charlot devoted a good deal of time during the spring of 1951 to doing research and making sketches in preparation for the Bishop National Bank mural. He was assisted in this effort by local artist Juliette May Fraser and again advised by Mary Kawena Pukui, along with Samuel H. Elbert, with whom he had been taking Hawaiian language classes at the University of Hawai'i. The painting would not begin until the fall. In the meantime the Charlots went off to Arizona, where Jean painted the

fresco on the main stairway wall in the Administration Building of Arizona State College (now Arizona State University) in Tempe.[50] On the way back to Hawai'i, Jean, Zohmah, and the children all paid Weston a visit in Carmel.

They arrived in Monterey by bus on the morning of Saturday, September 15, and after breakfast at a drive-in and a stroll around the town Brett came to get them, taking them first to a motel near the mission and then to Wildcat Hill, where Edward, somewhat frail and stiff, was on hand to greet them. Zohmah captured Jean and Edward on film shaking hands warmly, over and over.[51] As with the previous visit, looking at pictures was almost the first thing to happen, and Edward showed the Charlots some of his work, including prints for the fiftieth anniversary portfolio then in preparation. Afterward Dody took the visitors to the beach, where Brett joined them again and the children played on the rocks; while they were relaxing in the sun, Zohmah captured Dody vamping for the camera. Then the Charlots spent a few hours with the Kelloggs, and Jean Kellogg showed her guests some of her recent etchings.[52]

Sometime during the day, Martin, the Charlots' third child, injured his wrist—perhaps it happened while playing on the rocks that afternoon—and that night he began having trouble with it, keeping his parents awake. The following morning they made a trip to a doctor in Monterey, and after an x-ray revealed a fracture, he was given a cast; once that was taken care of they all went to Brett's ranch, not far away, and looked at some of Brett's photographs. The Charlots had been following Brett's work, too, for quite some time, and this was an opportunity to see his most recent efforts. They also spent some time at Garrapata Creek, where Cole had started a trout farm (after he had given up portraiture, in the wake of his run for Congress). The rest of the afternoon was devoted to fishing, and that evening there was a party in the Kelloggs' garden.[53] Zohmah caught some of the proceedings on film, including a momentary glimpse of Edward mugging for the camera and a shot of Jean Kellogg's mother, looking stolid and well dressed, more formal than the rest.[54]

The following morning they had breakfast in Carmel, where they saw Millard Sheets again; Sheets, they learned, had bought land on the island of Hawai'i, in Kona. A little later in the day, after a trip to Monterey where Martin saw the doctor again, they went to back to Brett's ranch and then to Cole's trout farm once more: that night they had fresh trout for dinner, with Edward and others.[55] On their final day, after a farewell phone call to

Edward, they had lunch with Brett and Dody at a Mexican restaurant.[56] Dody brought along a note from Edward, who had decided not to join them (not feeling up to the trip, or perhaps not wanting to prolong the good-byes): "This is farewell—for awhile. I thought to ride with you to Salinas—but feel it's too far."[57] As it turned out, Brett drove them as far as Monterey, where they caught the bus to Salinas, and from Salinas they took the train to San Francisco. Two days later they boarded the *President Cleveland* for the trip back to Hawai'i, where they arrived five days later.[58]

Before they left Edward presented the Charlots with new prints of the pictures of the children and Zohmah that he had taken on his visit to Athens with Charis ten years earlier.[59] So too they were given their choice of one of Edward's more recent works, in fulfillment of a pledge. Much earlier Edward had given Zohmah a coupon good for one Weston photograph, and although she had not brought it with her to Carmel, she took this occasion to redeem it. She chose *The Bench* (fig. 49), taken in 1944, which is a close-up view of a wooden bench with one slat askew; on the seat we can see the funny papers, featuring Maggy and Jiggs, left behind by the last person to sit there.[60] The Charlots reciprocated in a rather unusual way: they presented Edward not with another picture but with a piece of furniture. At some point during the visit they had expressed a desire to get a present for Edward; Dody told them that what he needed was a chair, and that was what they gave him. It was delivered to Wildcat Hill sometime later, once the visitors had departed.[61]

Edward wrote to the Charlots in Hawai'i shortly after their visit to say how much the experience had meant to him. He had been hesitant to have them come, as he explained: "You will never know how near I was to wiring you not to come up—not for my sake, but for yours. I did not feel equal to having you see me as was, and as is. But how glad I am that we did get together, despite me!" He was especially moved by the gift of the chair: "But you were far too generous with your hard earned cash. Perhaps I should not even mention this, but the last item of a new chair, broke me down, and I must say, very simply, thank you." He also reported that work was proceeding slowly on the fiftieth anniversary portfolio, which he expected to be completed later that fall. And then he signed off, with special warmth: "You-all have a wonderful family; give them all my love—and oceans to you dear friends—Edward."[62]

It was Zohmah who responded, after a few weeks; she too spoke, at some length, of how important the visit was to her, and to Jean:

Being in Carmel is such a pleasure for me for the moment itself and also for the memories the place brings of so many other happy times. I don't suppose you will ever know what a specially important person you are to my life.

Anyway it was wonderful to be there, and thank you all for giving us such a good time. We loved meeting the darling Dody, although it seemed more like seeing an old friend.

Jean has said again and again how splendidly your sons have grown up, and how proud you must be that they are all so independent and capable, living on their own efforts and ideas, not a white collar worker among them, which is certainly a refreshing novelty.

I am so slow in writing, even after getting your letter! But somehow I expect words to say how much we feel about seeing you and they just don't.

Zohmah also wrote about the home movies she had shot during the visit and how pleased she was with the result: "Yesterday we got the movie film that I had taken in Carmel. It really turned out pretty good. . . . Especially the party at the Kellogs' came out well. Tell Mrs. Kellog that I caught your famous profile, and the expression you made when you turned and saw I was taking your picture. Also I got a good picture of Mrs. Kellog." Then she turned to the pictures Edward had given them: "The pictures printed from the negatives you gave me made Jean about faint with delight. For a moment he thought I had discovered a new genius, that I had just had them taken. I had to tell him that they were by our same genius, Edward. We like these so much that we would surely like to make proofs of all of them, if you ever run across the others you made at the same time." As for *The Bench*, she said that they had hung it on their bedroom wall, and she closed with a quip about the work on Jean's bank mural: "As the bank is in operation he is a little nervous about dropping plaster on the money being passed back and forth beneath him."[63]

The *Fiftieth Anniversary Portfolio* was completed by the end of the year. Of the twelve prints included, a few were from Weston's early years (the earliest was his portrait of Lupe Marín from 1924), but for the most part they were relatively recent, from the later 1930s and the 1940s.[64] Many of them had been included in *Fifty Photographs*, but a small number had not been included in any of his major publications. In a brief accompanying statement, Weston spoke of the selection process. To reduce a lifetime of photography to twelve

images was clearly impossible, he explained, so after careful consideration he decided to emphasize more recent work, from the last fifteen years, while providing a representative sample of the subjects to which he had devoted the most attention over the years.[65] Whether he succeeded is another question, for although the individual pictures are, of course, beautiful, the collection seems scattered. It lacks the obvious cohesion of *My Camera on Point Lobos* and does not have the range of *Fifty Photographs*. But that was perhaps inevitable.

Charlot's bank mural was completed in February 1952, and the final result was quite elaborate, comprising a number of interconnected incidents. At the center is a scene devoted to barter—an appropriate choice for a bank—including exchanges of a feathered cape and helmet for metal tools and nails and Hawaiian pigs for California cattle and goats (fig. 50). To the left, King Kamehameha I, in European attire, is shown receiving Captain Otto von Kotzebue, the leader of a Russian imperial expedition, while Louis Choris, the expedition artist, draws the king's portrait (one of the few portraits of Kamehameha I made from life). This scene is complemented on the opposite side with a depiction of King Kamehameha II printing his own name, using a printing press newly introduced to the islands. At either end are scenes in which old and new are juxtaposed: at the far left the making of kapa (bark cloth) is contrasted with the spinning and sewing of the first mu'umu'u, while at the far right a missionary teacher and her native Hawaiian students are shown alongside a diminutive kahuna (priest/sorcerer) and his akua (god/spirit) stone, almost hidden among the plants; this last representative of traditional culture seems to have been pushed aside, displaced by missionary activities (fig. 51). Contact with the outside world may have brought certain benefits, but Charlot was not unaware of the costs.[66]

On the evening of February 20 opening festivities were held at the bank, and some five hundred people attended.[67] For the occasion, the bank issued a brochure with a picture of the entire mural, a description of the subject and the technique, and a brief summary of Charlot's career. The Charlots quickly sent a copy to Weston. Edward had not yet responded to Zohmah's last letter, about the Carmel visit, but this new missive finally prompted him to write. He told them both, first of all, that their copy of the *Fiftieth Anniversary Portfolio* would be mailed soon and then commented on the brochure, which he had just received: "The folder on Jean's bank mural looks to be one of Jean's greatest works. Sure wish I could see it, and you."

He then apologized, rather sadly, for not having written sooner: "Your last letter, Z-, has been on my desk four months! It seems as though those I care for most get treated the worst. It is a beautiful letter which I shall treasure. I can't begin to answer it—to many complications with hands & feet & brain. There is so much to tell, just to talk about nothing would be something!"[68] Clearly, writing had become more and more difficult for him, but that did not prevent him from adding bad news about Cole's trout farm: storms had destroyed ninety percent of it, and many fish, the fruit of two years' work, were unfortunately lost. As promised, the Charlots received their inscribed copy of the *Fiftieth Anniversary Portfolio* soon after, and they quickly acknowledged it, without going into detail. ("We received our beautiful Portfolio and appreciated the wonderful dedication.") Zohmah also hastened to reassure Edward about his letter writing: "And thank you for your very dear letter. We don't need to hear from you to love you so don't worry about writing."[69] She then expressed her concern about the trout farm; she was well aware of how much time and energy had been put into the project. What she did not know, at least not at the time, was that the destruction of the farm would prompt Cole to return to photography.

President Truman had ordered U.S. forces into Korea after Seoul was captured by the Communists on June 29, 1950, and the war was still raging on during the fall of 1952, when Dwight Eisenhower was elected president. Meanwhile, the Photo League, which had been placed on the attorney general's list of subversive organizations and as a result had had trouble making ends meet, disbanded in 1951.[70] Although Weston had been quite vocal about political developments during World War II and in the years immediately following, that seems no longer to have been the case as these events unfolded in the 1950s. We don't know what Weston might have said to his friends or family in private conversations at the time, but he was not as openly engaged as he had been during the previous decade. There is no indication of any electioneering during the 1952 presidential election campaign, for example, nor any political letter writing—either to praise or to criticize—on Weston's part. Just as his photographic activity waned at this time, so did his political engagement.

Nevertheless, Weston was not completely idle; in the second half of 1952 an anonymous donor put up six thousand dollars to fund the printing of a substantial number of his images, intended to represent the best work of his entire career.[71] Edward, of course, was no longer able to do the printing

himself, so Brett took on the task, and by early 1953 he was devoting several days a week to the job. Despite his condition, Weston supervised the undertaking and kept a close watch on the quality of the prints. In the end, over eight hundred images were printed, in multiple copies—not quite as many as originally planned but certainly an impressive number. They are generally referred to as the "Project Prints."[72]

The Charlots didn't hear from Edward again for almost a year, but in June 1953 he wrote, with a rather unusual opening: "Surprise to Jean & Zohmah—a letter from me, Edward: You may be in Michigan or Minnesota for all I know, it has been so long since I have written you, or you me." He was leading a sequestered life, he explained, rarely leaving Wildcat Hill, but, he added, "there is activity here." And then he explained about the printing project: "Brett, under my direct supervision is printing 8 prints each from 1000 of my selected negatives, destination—those libraries, museums, art galleries or just people, who want a Weston collection before it is too late. There will be a minimum, I guess not less than 50 to the order. So, I'm kept busy. Something had to be done!" If Edward was hoping that Jean and Zohmah might be able to help him find a home for some of the prints, he didn't say so, and after asking for Charlot family news, he signed off: "Love from Edward to his beloved friends."[73]

As soon as Edward's letter arrived, Zohmah wrote back, with great affection, and in response to his request for news, she filled him in on what they were all doing. They, of course, were still in Hawai'i, and Jean was busy teaching summer school, including a course on the history of mural painting; he had also been planning a new fresco at the university. The fresco in question was *Commencement*, on the second floor of the Administration Building (Bachman Hall) at the University of Hawai'i; it shows graduation day at the university, with family and friends presenting lei to the new graduates. When finished, it would complete the decoration of the lobby, where Charlot had already painted *The Relation of Man and Nature in Old Hawai'i*.[74] Zohmah added that Jean had also done another children's book with Anita Brenner; she promised to send along a copy for Edward's grandchildren.[75]

Meanwhile, Zohmah reported, the children had grown a great deal since Edward had seen them, and the Charlots were now hoping to move out of their current dwelling, in faculty housing, which was becoming overcrowded: "Our house is crowded not only with the children getting bigger and bigger

but with three mynah birds and a rooster. I remember your tame rooster! Or rather hearing you tell about him."[76] As for Zohmah herself, she informed Edward that she had learned to drive; so too, she added, in a rather bemused tone, she had recently been psychoanalyzed and ended up becoming the godmother to the analyst's baby.

Weston's letter-writing activity had slowed down considerably, and he did not write again for many months. When he did, in March of the following year, he spoke again of the Print Project, which was still underway, and he added another bit of news: "The latest item in my life: I have been invited by Northwestern University to receive the degree of Doctor of Fine Arts, 'to recognize your distinguished accomplishments.' I feel quite honored."[77] Weston had never shown much interest in formal education and had rarely involved himself in the academic side of photography; unlike Charlot, he had managed to get along without spending a great deal of time teaching, but he could not help but be pleased with this new honor.

The Charlots didn't respond for some time, but during the summer, Zohmah, who more and more had taken over the family correspondence, wrote to "Dearest Doctor Weston" congratulating him on his latest honor. And she reported that they had recently seen *The Photographer*: "The other night the movie of you and your work was shown at the public library. Jean and I went with such eagerness, and we thought the picture excellent but it made us homesick to be with you too. I was especially nostalgic about the desert pictures." No doubt Zohmah was thinking again of her trips with Edward and Charis during the Guggenheim years. Turning to other news, she reported that although Jean had no new fresco projects in the works, their life was nevertheless quite hectic, with day-to-day activities, social engagements, and visitors to the islands—including Josef and Anni Albers, whom they had gotten to know at Black Mountain College some years ago; Josef was teaching at the university that summer. In the same context, she expressed her hope that Brett might come to Hawai'i one day, adding rather prophetically, "I know he would like the scenes here for his camera."[78]

Weston responded six months later to report—as outrageous as it may seem now—that his honorary degree had fallen through: "My degree from N.W. University did not materialize. I accepted, but when they heard that I could not be there in person and be seen in cap and gown I was ruled out! Think what they missed." He went on to say that he was glad Jean and Zohmah

had seen *The Photographer*, adding, "I look on it as a personal greeting [to] my friends."[79] He also noted that the film had been shown at the American Embassy in Paris, in conjunction with his exhibition there in 1950.

It was Jean who answered, very soon afterward. Making light of the honorary degree, he included a little drawing of a figure in a cap a gown and said, "I give you a degree right here." Then he went on to speak of his own situation, opening up more than he had for a long time as he expressed his frustration about how teaching was taking him away from making art. He had been doing some painting, mostly of Hawaiian subjects, but not as much as he would have liked. Meanwhile, he went on to say, he was studying petroglyphs: "One of our nice Hawaiian activities is hunt among the rocks for ancient petro-glyphs, pictures scratched long ago, usually of dogs and men. I have learned [?] to love them—They teach me how to peak [?] feeling in simplicity." To give Edward a better idea of what he was talking about he provided a small drawing of petroglyphs of two human figures and a dog. Clearly Charlot was very taken with Hawaiian culture, and in many ways his response to Hawai'i was comparable to his reaction to Mexico. Indeed, almost from the moment he arrived in the islands he embraced local imagery, as he himself acknowledged: "I paint Hawaiian subject[s], mostly drummers = war drums and hula drums." At this point he added a drawing of a drummer and a pahu drum; then, overgeneralizing more than a little, he linked Hawai'i and Mexico: "Hawaiians are as beautiful as Mexicans, but more extroverted."[80]

Turning to other matters, Charlot mentioned that he was trying his hand at acting ("For a change, I took to acting in a French comedy, the role of a swindler"), and with an implied chuckle he added that he was complimented mostly for his French accent, which of course was his own.[81] Jean also spoke at some length about the children, two of whom (John and Martin) were also doing some acting, in school plays. In closing, he turned again to Weston and his pictures: "How much we would like to be with you this Christmas. It was nice seeing your film and nice too from time to time to look at your photo-graphs!" He then wished Edward a happy Christmas and signed off. It may have been the last time that Edward would hear directly from his old friend.

The following summer the Charlots went to South Bend, Indiana, where Jean taught summer classes at Notre Dame. Jean had taken a leave of absence from the University of Hawai'i, and in August they moved to New York City, where

they spent the next nine months. They seem not to have been in touch with Weston during their first months on the East Coast, but at Christmas they sent him a copy of the latest book that Charlot had illustrated, *Our Lady of Guadalupe*, by Helen Rand Parish.[82] Edward wrote back soon after to acknowledge his Christmas present: "Wonder where I am? Can't blame you! What is left of me is living at the same old 'Wild Cat Hill,' and wondering what you are doing in the wilds of N. York. I got your Xmas greeting & the delightful book all about our 'Lady of Guadalupe.' I like especially your autograph in the front."

Edward then turned to his own situation, which was increasingly difficult and uncomfortable: "When I get to tell my story of the last ten years it is so uninspired that I cant go on writing—hence no letters. My latest episode was that of having my teeth out, every one of them! My three hernia operations did not cause me as much grief & woe. But you can see why I don't write you. I am fast becoming a hypochondriach. Enough."[83] His frustration at this juncture is understandable, to say the least, and one wonders what he really meant when he said "enough."

Despite his difficulties, Edward reported that he had become a great-grandfather and then added a few more words about his family—his sons, his grandchildren, and even his cats. As the letter continues, Weston's handwriting becomes more and more strained, the last lines slanting downward a good deal. Given the difficulty he was obviously having with his writing by that time, it was a relatively long letter; Weston must have been trying very hard to communicate. It was the last letter the Charlots ever received from him.

Still in New York, Zohmah wrote back some time later. Jean, she reported, was about to leave for Des Moines to do a mural and then on to South Bend, where he was going to be teaching again during the summer. Meanwhile, Zohmah and the children were to remain in New York until the end of the school year, and she hoped that they would all come through California on the way back to Hawai'i toward the end of the summer.[84] They had not seen Edward for close to five years.

In the same letter Zohmah also had a good deal to say about the *Family of Man* exhibition, which was getting a lot of attention at the time. The show included over 500 works by 273 photographers, but Steichen had included only one picture by Weston in the exhibition—and interestingly enough, it was the *Honeymoon* portrait of the Charlots, or at least a variant of it (the one in which Zohmah's knee is covered with Jean's hat). Given Weston's displeasure with

the Museum of Modern Art in the wake of Newhall's resignation, it is note-worthy that he even allowed the picture to be included. For some reason he had acceded to the museum's request; perhaps the years, or his present condition, had softened his attitude. In any event, Steichen must have liked the tender, romantic mood of the photograph; such qualities were relatively uncommon in Weston's imagery, but they clearly fit in with Steichen's grand plan.[85]

By the time the Charlots had arrived in New York the previous fall the *Family of Man* exhibition had already closed, but it was still causing consider-able stir; the exhibition was traveling to various locations around the world, including Japan (under the auspices of the United States Information Agency). The accompanying book also was attracting a good deal of attention, and the Charlots could not help but take notice, as Zohmah explained:

> We see ourselves all over New York in bookstore windows. And yesterday I had a letter from Japan from which I will quote a paragraph: "Last week they opened the 'Family of Man' exhibition here in Tokyo, and it was crowded to the rafters—and there was Jean and Zohmah, in the Edward Weston photo—right up there on the wall where everyone could see it—as a matter of fact your picture had also been used on the display advertising posters—I tried but was unable to acquire a copy." Poor me, with my ugly knees, that you my dear dear friend have managed to show to all the world, in your so appallingly popular picture.

This picture, in one version or another, had appeared many times—in books and exhibitions—over the years, and it became a kind of ongoing link between Weston and the Charlots, ever since it was first taken more than fifteen years before. No doubt it brought back happy memories every time it appeared, and Edward must have relished Zohmah's response to the latest incarnation of his now-famous image; certainly Zohmah must have been hoping as much. In the rest of her letter Zohmah reported on current developments and in particular on the abstract painting dominating New York museums and gal-leries, which was making Jean feel pleasantly old-fashioned. At the end she provided news of family and of mutual friends, and she once again expressed her great affection for her old friend, Edward: "So much love, most loved friend. We long to see you."[86]

As it turned out, the Charlots did not make it to Carmel again; by the end of August they were back in Hawai'i, without having seen their old friend as they

had hoped. After their return home they were swept up in their old routines. They continued to send Christmas cards to Edward, as they done for a long time, but there is no record of any other communication. On the morning of New Year's Day 1958 Weston passed away. That afternoon the Charlots received a telegram from Jean Kellogg announcing his death: "Edward died early this morning releasing his great spirit."[87] Jean noted his friend's death in his diary, without further comment ("telegram = death Edward!").[88] Jean rarely marked such events in his diary, but in this instance he felt the need. An enduring and important friendship had come to an end.[89]

from a window beyond the frame on the left. The slight distortion (resulting from the use of a wide-angle lens) as well as the lighting contribute to the almost mystical air of the image. Adams later said of the portrait: "It's one of my favorites. It is not a real 'likeness,' but one that says a lot to me about the person."[5]

Adams left the islands soon afterward and following his return to California wrote to the Charlots; he apologized for his abrupt departure and thanked Jean for having introduced him to Father McDonald. He also expressed his satisfaction with the portrait of Jean and jokingly wrote, "I hasten to tell you that in case you are concerned I do not charge extra for making my subjects look like an El Greco head! I am quite nuts about the portrait I made of Jean." Perhaps Jean had mentioned El Greco when Ansel first showed him the proof; in any event, Adams liked the effect. In the same letter, Adams mentioned a gift that he had just received from Brett Weston, "a very fine little primitive from Mexico which Edward bought a long time ago and cherished. I am touched to have such a memento."[6] Adams did not give any further details, but he could have been referring to one of the juguetes or figures that Weston and Charlot had enjoyed together during the first years of their friendship.

When the book appeared Charlot's portrait was included (slightly cropped on the right side), accompanied by a caption that read, "Painter, teacher, actor, Jean Charlot is an internationally known artist who possesses the many abilities of the Renaissance man."[7] The book also included an image of Reverend McDonald seated in front of St. Sylvester's Church in Kīlauea, Kaua'i.[8] There is no mention of it, but two years before Charlot had painted fourteen fresco panels surrounding the altar of that church, depicting the *Way of the Cross*.

Adams and Charlot saw each other again in the fall of the same year when the Charlots stopped in San Francisco on their way back to Hawai'i from New York City. Adams met them at the airport and took them back to his place, where they stayed; that night they had dinner together.[9] A few days later the travelers boarded a ship to return to Honolulu, but the Charlots saw Adams again the following year, in November in New York.[10] It was perhaps then that Adams took several Polaroids of Charlot in the apartment of Earl Stendahl, Charlot's longtime dealer. In one example Jean, with a knowing smile and wearing dark clothing, is shown seated, leaning on the arm of a chair in relatively spare surroundings (fig. 52). This portrait is a little less formal than the one taken in Hawaii (and El Greco is no longer an issue). Adams also photographed Zohmah and Peter Charlot on the same occasion.[11]

Hawai'i became a state in 1959. The years that followed were productive ones for Charlot: not only was he busy teaching at the University of Hawai'i, but he also produced a great deal of artwork—oils, prints and murals—as well as writings of various kinds. In 1961 he created the ceramic-tile mural *Night Hula* (fig. 60), and the following year he traveled to Fiji, where he began work on frescoes in the church of St. Francis Xavier in Naiserelagi, in the Province of Ra.[12] The work in Fiji was completed the following year, and soon after his book on the Mexican muralists in the 1920s, *The Mexican Mural Renaissance*, was finally published.[13] He had had some trouble finding the right publisher, but it was eventually accepted by Yale University Press. Charlot had intended to include a discussion of Weston's influence on Mexican art, but because of space limitations most of that section was dropped; nevertheless, Charlot spoke of Weston at several points and quoted from the daybooks (parts of which Weston had sent him years before). Charlot's book is an impressive blend of personal experience and art-historical documentation, and to this day it remains an important source of information on Mexican art during a crucial period. The same year that he completed the Fiji frescoes and *The Mexican Mural Renaissance* appeared, Charlot published three original plays he had written on Hawaiian themes.[14]

Jean had written to Edward about the mural he had done in the early 1950s for the Bishop National Bank of Hawaii at Honolulu, *Early Contacts of Hawaii with the Outer World*. It was an impressive achievement. Unfortunately, it was all but destroyed when the bank building was demolished in 1966; the mural was cut into small, easel-sized panels, which were auctioned off for the benefit of a community theater. The present whereabouts of most of the pieces are unknown, although two sections are currently on view in the Charlot house in Kāhala, now owned by the University of Hawai'i.[15] Soon after the first mural was removed, Charlot painted another version in the new Waikīkī branch of the bank (at 2181 Kalākaua Avenue). For the images to fit the new setting, the original design had to be modified somewhat: the kapa scene was revised and expanded to include a canoe bringing a high chief back from an official visit to Captain Cook. The changes also extended the time frame of the events represented.[16]

Charlot retired from the University of Hawai'i in 1966, but in the years that followed he continued to produce paintings, books, and more. In 1971 a collection of Orozco's letters to Charlot appeared, with appendices by Charlot.[17] The following year a two-volume collection of Charlot's essays

came out. It included the piece on Weston that had first appeared in 1939 in *Art: From the Mayans to Disney*; this time it was illustrated with an ink version of Charlot's portrait of Weston from 1924 as well as his depiction of Weston in his studio from 1933.[18] That was followed by another collection of lithographs, *Picture Book II: 32 Original Lithographs and Captions*, modeled on the one that had appeared in the 1930s (*Picture Book: Thirty-two Original Lithographs*), which Weston had greatly admired.[19] The same year Charlot painted an extensive mural at Leeward Community College in Pearl City, *The Relation of Man and Nature in Old Hawaii*, a reprise of one of his first murals in Hawai'i (also entitled *The Relation of Man and Nature in Old Hawaii*, at Bachman Hall at the University of Hawai'i at Mānoa), about which Jean had written to Edward more than once.[20] The new mural was, as John Charlot has stated, "his last monumental depiction of Hawaiian culture."[21] Soon after, Jean completed a series of ceramic-tile murals for the United Public Workers building on School Street in Honolulu (completed in 1975); Zohmah appeared prominently in one of the panels.[22]

Shortly before the School Street murals were finally finished, Charlot was diagnosed with prostate cancer, and he was already undergoing treatment when Dody (Weston) Thompson, whom the Charlots had first met in Carmel in 1951, came to Honolulu. She was researching a book on Weston's portraits and interviewed Jean in conjunction with that project; Zohmah and John Charlot also participated. In the interview Jean had some rather critical things to say about Charis and her influence on Edward; he also spoke of the subjects of some of Weston's portraits from the Mexico years: Galván, Nahui Olín, Dr. Atl, and Rosa Covarrubias.[23] Afterward, Zohmah reported on the visit to Ansel Adams and his wife, Virginia, with whom the Charlots had remained in touch: "She [Dody] really brought the special atmosphere of our Weston days with her, and it was a joy to speak of photographs and 'old times' with her. She didn't remember us, as [we] were only part of the many who came to Carmel, but we had a vivid mind picture, and also scenes caught on our 8 mm. camera, of what was our last time with Edward."[24] In the same letter Zohmah spoke of how the curator of photography at the Bishop Museum, Lynn Davis (now head of the Preservation Department, Hamilton Library, University of Hawai'i at Mānoa), had been putting their collection of Weston prints in order (and encouraging the Charlots to preserve them in a more archival fashion). Zohmah made no mention of Jean's health problems and spoke instead of how busy he was painting and writing.

In 1976, following Dody's visit, a catalogue raisonné of Charlot's prints came out, after many years of work; compiled by Peter Morse, it brought together a lifetime of achievement by a prolific printmaker, starting with his early woodcuts made in France and Germany and ending with a self-portrait (an etching) from 1975.[25] In the ensuing years, Charlot did a few projects for the Maryknoll School in Honolulu, including a fresco, *Christ and the Samaritan Woman at the Well*, which was completed in September 1978 with the assistance of his son Martin. Jean Charlot died on March 20, 1979.

After Jean's death Zohmah took a trip to California, including a stop in Carmel. In anticipation of the trip, Ansel Adams sent her a short note, saying, "It was WONDERFUL to hear from you. Unless I am celled [*sic*] east on a professional job I shall be here to greet you. Virginia will be here positively." And before signing off he added, rather emphatically, "LOOK FORWARD TO YOUR VISIT!!!!"[26] Around the same time Brett Weston, who had been in contact with the Charlots quite often during the 1970s, also sent a card saying that he expected to see Zohmah in Carmel, but if he missed her there he would see her in Hawai'i, where he was spending much of his time.[27] Zohmah had not heard from Charis for many years, but she too wrote to say that she would be on hand at the Adams's and was hoping that she and Zohmah could spend more time together, either before or after that.[28] It is not entirely clear who else may have come to see Zohmah in Carmel, but in addition to the Adamses and Charis she saw Jehanne Salinger and various Westons, perhaps including Brett. The visit must have been a bittersweet experience: although it was obviously overshadowed by her recent loss and colored by distant memories, it was a good opportunity for Zohmah to reconnect with old friends, some of whom she had not seen for many years.

In particular, the trip seems to have rekindled her friendship with Charis, and after Zohmah's return to Hawaii they wrote to one another quite frequently. Moreover, in the fall of 1982 Charis came to Honolulu and visited Zohmah; they must have enjoyed talking over old times, exchanging memories of the thirties and forties. One of the matters they discussed was Jean's attitude toward Charis. With the exception of the interview with Dody, Jean had rarely expressed his feelings about Charis in any explicit way, but Charis had clearly sensed a degree of disapproval and asked Zohmah about it. As Charis later reported, Zohmah explained to her that Jean had thought that she did too much of the talking for Edward and was always putting words in his mouth.[29] After considering Zohmah's response, Charis acknowledged

that there may have been some truth to Jean's assessment, although she had not been aware of it at the time.[30] In any event, Zohmah and Charis obviously had some rather frank discussions, and after Charis returned to the mainland she wrote, "Dear Zohmah, I miss you! I so enjoyed being with you and peeling back the layers of in-between life to find so much remains of the people we were."[31]

Over the years the Charlots had acquired quite a few Weston prints, and in the fall of 1984 the Honolulu Academy of Arts held an exhibition of their collection, curated by Van Deren Coke. It included images from the Mexico years, such as a number of pulquería pictures, as well as portraits of Jean and Zohmah, separately or together, from their visit to Carmel in 1933. So too there were quite a few images from the Guggenheim years, including two views of Death Valley. For the catalogue, Zohmah wrote a short piece describing her visits to the Weston household over the course of the thirties. Speaking of Charis, she wrote, "I liked Charis, and she seemed not to mind my coming. But she swayed Edward to think of me as comical. I had to get used to someone else admiring him with an even warmer love than mine." She also spoke of the *Honeymoon* picture, describing how Weston had taken it without their knowing he was photographing them and how it had become one of his favorites. Then she added, "So my knees were not only photographed, but published in The Family [of] Man, and in not one copy of the best-selling book did they improve."[32]

Charis received a copy of the catalogue at the end of the year and wrote Zohmah in response to some of her comments:

> I do think it was unfair of you to make readers curious about Z's knees, and then fail to come through with any evidence! (Only fair to let viewers decide for themselves.) It's an interesting notion that I made Edward see you as comical but it doesn't set off any buzzers of truth for me. I don't think I ever changed E's view of anyone; I don't think either of us thought of you as comical. For me you were not only a great original, but the first woman I ever felt a truly warm friendship for. It was always my idea, if I ever made any $$$, to finance a trip around the world for you so I could follow along and record what happened. It was obvious to me that you would have remarkable adventures just from being the person you were.[33]

The trip Charis had in mind never transpired, but Zohmah did travel extensively. Meanwhile, Charis continued to communicate with Zohmah

in the years that followed. She kept Zohmah posted on her movements and provided her with news about the Westons. So too she updated Zohmah on the memoir that she was writing about her years with Weston and occasionally asked her for clarification on certain points, especially with regard to the visit to Athens. Charis worked on the book for many years, and it finally appeared in 1998.[34] It is an invaluable source of information on an important phase of Weston's career, and the Charlots are mentioned in a variety of contexts. Zohmah would have been interested to read Charis's account of their time together, especially during the Guggenheim years and beyond. Unfortunately, by the time the book appeared Zohmah had suffered several strokes and was unable to read it or enjoy it fully. But John Charlot movingly described her response in a letter to Charis: "Your book arrived with the affectionate dedication to mom. She smiled happily the moment she saw the cover and understood very well what it was about. I went through the photos with her, especially the ones of her and pop, and she was clearly happy to see them. You made her a wonderful present."[35]

On September 2, 2000, at the age of ninety, Zohmah passed away. Charis passed away in 2009, at the age of ninety-five.

At Zohmah's funeral service, at the Star of the Sea Church in Kāhala, one of Weston's photographs of her, taken in 1933, was on display at the center of the sanctuary. Like Jean, Zohmah had played a significant role in Edward's life, and in Charis's; the portrait not only helped make her presence felt at the service but also served as a posthumous salute to an old friend.

APPENDIX

"Edward and Mexico" by Jean Charlot

It was the good fortune of Mexico to be visited, in 1923, at a time when the plastic vocabulary of the mural renaissance was still tender and amenable to suggestions, by Edward Weston, one of the authentic masters bred in the United States.

Edward helped us unravel the web of Paris-bred scruples that slowed our effort. The mural artist of the twenties needed to revise drastically contemporary relative estimates of subjective and objective if he were to champion objectivity in paint at a time when the best informed critical opinion, indeed the best gifted artists, praised only subjectivity. The example of the old masters should have been sufficient. They had validly solved similar problems of uniting nature and esthetic investigations, but had done so in a society different from ours. Our acutely contemporary social consciousness would have felt ill at ease—in period clothes, as it were—if it had relied on their example exclusively.

Weston's camera produced art though it lacked all elements listed by contemporary critics as ingredients of art. The camera eye was incapacitated for subjective vision, devoid of a passion that distorts the model, showed no inclination toward escapism, had no means of leaving out of the picture even an iota of the physical world. Weston's photographs illustrated in terms of today the belief in the validity of representational art that the seventeenth century academies had upheld. Looking at these photographs cleansed objectivity of its Victorian connotations. The problems of geometric bulk that the

293

Mexican muralists had worked on, under the spell of cubism and of Aztec carvings, appeared superficial compared to Weston's approach. He dealt with problems of substance, weight, tactile surfaces and biological thrusts which laid bare the roots of Mexican culture.

This pragmatic estimate, based on our local needs of the nineteen-twenties, does not constitute a rounded judgment of Weston's art. He had not come to Mexico to help us out of our subjective-objective impasse, but to work. Breughel needed to make the trip to Italy to know that his roots were north. The Americanism of Weston grew its backbone in front of the hieroglyphs of another civilization. Magueyes, palm trees, pyramids, helped him shed, sooner than he would have otherwise, his esthetic adolescence. It was in front of a round smooth palm tree trunk in Cuernavaca that he realized the clean elegance of northern factory chimneys. Teotihuacan, with its steep skyward pyramidal ascent, taught him how to love his own country's skyscrapers.

While Rivera was painting "The Day of the Dead in the City" in the second court of the Ministry, we talked about Weston. I said that his work was precious for us in that it delineated the limitations of our craft and staked out optical plots forbidden forever to the brush. But Diego, rendering meanwhile a wood texture with the precise skill and speed of a sign painter, countered that in his opinion Weston did blaze a path to a better way of seeing, and as a corollary, of painting. It is with such humility at heart that Rivera had painted with a brush in one hand and a Weston photograph in the other his self portrait in the staircase of the Ministry.

NOTES

ABBREVIATIONS

CW = Charis Wilson
EW = Edward Weston
JC = Jean Charlot
PP = Prudence Perry, later Prudence Plowe
TM = Tina Modotti
WVD = Willard Van Dyke
ZDC = Zohmah Day (born Dorothy Day), later Zohmah Charlot

CCP = Center for Creative Photography, University of Arizona, Tucson AZ
 AAA/CCP = Ansel Adams Archives
 BZC/CCP = Bea Zuckerman Collection
 CGC/CCP = Christel Gang Collection
 EWA/CCP = Edward Weston Archives
 EW/JHC/CCP = Edward Weston/Johan Hagemeyer Collection
 NN/BNC/CCP = Nancy Newhall/Beaumont Newhall Collection
 WVDA/CCP = Willard Van Dyke Archives
JCC = Jean Charlot Collection, Hamilton Library, University of Hawai'i at Mānoa, Honolulu HI

AC = Amy Conger, *Edward Weston: Photographs from the Collection of the Center for Creative Photography*. Conger assigns a number, including a year, to each photograph (e.g., #1473/1939). Those numbers are used herein for ease of identification; in most cases the reference is to the photograph, but in some cases the reference is to the text accompanying the photograph.

DB = Edward Weston, *The Daybooks.*

JC checklist = Jean Charlot, Checklist of Paintings, JCC. The checklist is sometimes referred to as the Painting Catalog. Where photographs of Charlot's paintings are not available, sketches from the checklist are used as illustrations.

JC diaries = Diaries of Jean Charlot, JCC.

ZDC diaries = Diaries of Zohmah Day Charlot, JCC.

PREFACE

1. The Jean Charlot Collection, Hamilton Library, University of Hawai'i at Mānoa, was established in October 1981, two years after the artist's death on March 20, 1979, at the age of eighty-one. It opened to the public in 1983. The Collection houses, among other things, a master set of Charlot's prints, numerous drawings, files of correspondence and clippings, and his personal library, as well as work by many other artists. See Bronwen Solyom, "About the Jean Charlot Collection" (unpublished manuscript, JCC, September 2006). See also the JCC website at http://libweb.hawaii. edu. Weston's papers as well as a large collection of his photographs are housed at the Center for Creative Photography at the University of Arizona in Tucson. See Stark, *Edward Weston Papers*; Myers, *Guide to Archival Materials*; and Rule and Solomon, *Original Sources.*

2. Charlot, speaking in 1971, quoted in Morse, *Jean Charlot's Prints*, xvii.

3. Morse, *Jean Charlot's Prints*, xvii; Peter Morse to John Charlot, September 16, 1982, JCC. The Aimé Paris system was devised in the early nineteenth century by a French lawyer named Aimé Paris (1798–1866) and later modified by others, including Emile Duployé. It was popular not only in France but also in Belgium, Holland, and Switzerland. Glatte, *Shorthand Systems of the World*, 25. Morse's surmise was recently confirmed by Dorothy Roberts, an expert on stenography who, after examining samples from Charlot's diaries, opined that the system was either the Aimé Paris system or the Duployé system (a variation of Aimé Paris) or possibly a combination of the two. Dorothy Roberts to John Charlot, March 5, 2007, JCC. (The JCC's efforts to find someone who can transcribe the diaries are complicated by the fact that Charlot wrote not only in French but also in Spanish and English.)

4. Conger, *Edward Weston in Mexico*, 16.

5. AC.

6. Coke, *Charlot Collection of Weston Photographs.*

7. Coke, *Charlot Collection of Weston Photographs*, 6.

8. Wilson, *Through Another Lens.*

9. Weaver, "Curves of Art."

10. Furth, "Starting Life Anew." Quinn also touches on Charlot in "'Universal Rhythms.'"

1. On Weston's early years, see Danly and Naef, *Edward Weston in Los Angeles*; Stebbins, "'Already Changing'"; and Warren, *Margrethe Mather and Edward Weston*.

2. AC, #85/1922 (*Steel: Armco, Middletown, Ohio*) and #86/1922 (*Pipes and Stacks: Armco, Middletown, Ohio*).

3. DB, 1:2–7.

4. On Luz, see Karttunen, *Between Worlds*, 192–214; *Luz Jiménez, símbolo;* Villanueva, "Doña Luz"; and John Charlot, "Jean Charlot y Luz Jiménez."

5. On Brenner, see Glusker, *Anita Brenner*. See also Glusker's edition of Brenner's journals, *Avant-Garde Art and Artists in Mexico;* unfortunately, this book did not appear until the present volume was already in press, so I was unable to take it into account except in a few instances.

1. CABALLITO DE CUARENTA CENTAVOS

1. DB, 1:20–21, 25–27.

2. The pictures of Mather included AC, #92/1923. One of the images of Elisa Guerrero is reproduced in Conger, *Edward Weston in Mexico*, fig. 3. The picture of Chandler, *Chandler* (on a cowshed wall), is AC, #103/1923.

3. DB, 1:25–26.

4. The guestbook for the exhibition includes Charlot's signature on p. 11. Scrapbook D, Mexico, EWA/CCP.

5. DB, 1:34. Weston does not furnish any specific information about the woodcut he received.

6. JC diaries, November 29, 1923.

7. Modotti, *Portrait of Jean Charlot* (seated on chest, hands together) (JCCTM6), JCC. Usually dated ca. 1923. Judging from Charlot's diaries, which cannot be deciphered completely, he visited the Weston-Modotti household only a few times in late 1923, so it is possible that the photograph was not made until January of 1924 or slightly later. The JCC has another print of the same image, originally from the collection of Zohmah Charlot.

8. DB, 1:41.

9. A related image, *Smoke-Stacks or Steel: Armco, Middletown, Ohio* (AC, #85/1922), would soon appear on the cover of *Irradiador* 3 (1924). Weston gave Charlot a print of *Pipes and Stacks* in 1924, which he inscribed "for Charlot with much appreciation in many ways—Edward Weston—Mexico 1924." Lynn Davis, "Description of [Weston] Photographs," December 1980 (1980.32), JCC. It is not among the Weston prints auctioned in 1988; present whereabouts unknown.

10. DB, 1:43.

11. Modotti, *Portrait of Jean Charlot* (seated, with pencil and sketch pad), 24

x 18 cm, signed "TM" (JCCTM22), JCC. The date of this image is uncertain; it has been dated anywhere from 1923 to 1926 but seems to have been done a little later than JCCTM6 (see note 7). There is also an oddly cropped print of the same image in the JCC (JCCTM5), which includes only Charlot's head, part of his upper body, and his left arm. Modotti also enlarged another negative from the same sitting to create a close-up variant. In this case, Charlot is looking up and away—perhaps seeking inspiration; the effect is quite different from the fuller view. Modotti, *Portrait of Jean Charlot* (right profile), 23½ x 18½ cm (JCCTM1), JCC. The print is signed "Tina Modotti—" in ink on the bottom right; on the back is written, in pencil in Charlot's hand, "Tina Modotti 1924."

12. Charlot, *Tina Modotti*, pencil on paper, 29 x 22.5 cm, JCC. The drawing is dated "1-24." Charlot did another drawing of Tina soon after. It shows Tina wearing the same sort of blouse as before but turned toward the right. It was in the collection of Zohmah Charlot; it is dated "2-24." Charlot did still another related drawing of Tina, now in the collection of the Museum of Modern Art in New York: Charlot, *Tina Modotti*, 1924, crayon on paper, 15 x 11⅛ in. It is reproduced in Cancil, *Latin American Spirit*, 38, fig. 19. No date is evident in the reproduction, but there is an inscription on the lower right: "Para Abe / Jean."

13. Charlot, "Martinez Pintao, Sculptor," 99.

14. DB, 1:44.

15. Weston, *Pintao*, 1924, Lane Collection, Museum of Fine Arts, Boston.

16. DB, 1:49.

17. DB, 1:49.

18. DB, 1:54.

19. DB, 1:55.

20. DB, 1:54–55.

21. AC, p. 10. Another version of the same scene is reproduced in *Nahui Olín*, 76, cat. 131. According to Amy Conger, Weston himself took this variant. Conger, note to author, November 2007.

22. Unfortunately, no pictures from this sitting are known, nor is Charlot's sketch of Modotti.

23. DB, 1:55.

24. DB, 1:57.

25. DB, 1:56; Ann Axtell Morris, *Digging in Yucatan*, 207, speaks of Charlot's boxing prowess.

26. DB, 1:61.

27. DB, 1:62.

28. Weston, *Federico Marín, Jean Charlot, and Tina Modotti on the Azotea*, Mexico, 1924, JCCEW6, JCC; reproduced in Lowe, *Tina Modotti: Photographs*, 22, fig. 10, where it is dated ca. 1924–26.

29. DB, 1:63; Conger, *Edward Weston in Mexico*, 16–17.

30. DB, 1:62.

31. DB, 1:66.

32. DB, 1:72.

33. DB, 1:72.

34. DB, 1:79.

35. DB, 1:80.

36. DB, 1:82.

37. DB, 1:85.

38. DB, 1:86.

39. DB, 1:87–88. One portrait—with a rustic scene as backdrop—is in the JCC. The J. Paul Getty Museum has another copy of the rustic scene; EWA/CCP has another of these cabinet cards—the one in a church setting.

40. Charlot, *Portrait of Edward Weston*, 1924, red chalk on paper, 12¾ × 9⅞ in., collection of John Charlot. Charlot later made an ink tracing of this version, which is in the JCC.

41. According to Amy Conger, Weston gave the drawing to his son Neil, who later sold it. Conger, note to author, November 2007. The present whereabouts of this version are unknown, but it was photographed by Johan Hagemeyer; a print is in EWA/CCP.

42. DB, 1:90; AC, #135/1924.

43. DB, 1:91.

44. DB, 1:91.

45. DB, 1:93.

46. Conger, "Edward Weston's Early Photography," vol. 5, figs. 24/59 and 24/59a. See also Furth, "Starting Life Anew," 212n71.

47. DB, 1:93, 99.

48. DB, 1:94.

49. AC, #139/1924.

50. DB, 1:94.

51. DB, 1:95.

52. DB, 1:99.

53. Aztec Land Gallery, October 15–31, 1924; Conger, *Edward Weston in Mexico*, 30–34.

54. DB, 1:98.

55. DB, 1:99.

56. Charis Wilson, describing this exchange, seems perhaps to have understood Charlot's intentions more clearly than Weston: "In the *Daybooks* I had read his [Weston's] admonitions to artist Jean Charlot . . . I thought Edward had missed the point of Charlot's interest by ignoring the word 'appear.' Charlot had seen him at work and certainly knew he didn't stop to calculate. I think his question, like mine,

was how did Edward see, understand, and decide in that swift glance that preceded exposure?" *Through Another Lens*, 96.

57. DB, 1:99.

58. DB, 1:99.

59. Charlot, *Toy Horse*, November 1924, JC checklist, #61; it is listed as having been in the collection of Frances Flynn Paine until sold at auction.

60. DB, 1:100–101.

61. Koprivitza and Pulido, *México en la obra de Charlot*, 167, 174, 188; John Charlot, note to author, October 2007.

62. DB, 1:101.

63. DB, 1:102.

64. Weston, "Personal Recollections of Charlot in Mexico"; copy in JC clippings file, 1912–47, 78, JCC.

65. DB, 1:103.

66. According to the listing of Jean's work prepared by Jean and Zohmah Charlot, *Jean Charlot: Books, Portfolios, Writings, Murals*, *Danza de los listones* (Dance of the ribbons) was destroyed in 1924. In Charlot's account of the destruction of his fresco, however, he seems to say it took place sometime after January 1925. *Mexican Mural Renaissance*, 278–79. The two surviving murals are *Lavanderas* (Women washing), and *Cargadores* (Burden bearers); he also painted nine shields in the second court of the Secretaría in the fall of 1923.

67. DB, 1:103.

68. DB, 1:104.

69. DB, 1:104.

70. DB, 1:105.

71. DB, 1:106.

72. DB, 1:129.

73. DB, 1:107; AC, #152/1924.

74. DB, 1:109.

75. DB, 1:109.

76. Charlot, *Hand Holding Bouquet*, May 1924, 14 × 10¾ in., JC checklist, #46. Weston lent it to an exhibition in Carmel in 1931; at some point later, perhaps upon Weston's death, it came into the possession of his son Neil. In 1976 it was given over to Bernard Lewin, a Los Angeles art dealer; its present whereabouts are unknown.

77. DB, 1:109.

78. DB, 1:109; *Bomba en Tacubaya*, AC, #105/1923; *Lupe*, AC, #110/1923; *Circus Tent*, AC, #116/1924; *Hands against Kimono*, AC, #117/1924; *Caballito*, AC, #139/1924; "*Two Bodies*" may have been *Pajaritos*, AC, #152/1024.

79. DB, 1:110.

80. John Charlot, note to author, October 2007.

81. DB, 1:110.

1. DB, 1:113–14.

2. Maddow, *Edward Weston: His Life*, 125–31; AC, #168/1925; Stark, *Letters from Modotti to Weston*, 30.

3. AC, #168/1925, #169/1925. It is not clear whether the pictures were taken at this time or the following summer, when Weston was back in Los Angeles.

4. Stark, *Letters from Modotti to Weston*, 29.

5. JC to EW, March 27, 1925, CCP.

6. AC, p. 13.

7. AC, #179/1925 (from scrapbook D, 44); the show ran until September 6.

8. DB, 1:128.

9. Siqueiros, "Una transcendental labor fotográfica," quoted in translation in DB, 1:129. Siqueiros was actually speaking of both Modotti and Weston, and the passage more properly reads as follows: "Weston and Modotti create TRUE PHOTOGRAPHIC BEAUTY. Material qualities of things and of objects they portray could not be more EXACT: What is rough is rough; what is smooth, smooth; what is flesh, alive; stone, hard." Trans. Amy Conger in Newhall and Conger, *Edward Weston Omnibus*, 19.

10. DB, 1:129.

11. DB, 1:127.

12. DB, 1:127–28.

13. DB, 1:129.

14. DB, 1:125, 129; according to Charlot's diary, he saw Weston on the evening of September 12, 1925; Weston is also mentioned on September 2, 1925. JC diaries.

15. Charlot, *Church Patio*, Cuernavaca, June 1925, JC checklist, #95.

16. Charlot, *Tree, Spherical, and House* (*The Round Tree*), July 1925, JC checklist, #102; Charlot, *Arches and Mountains*, Cuernavaca, June 1925, JC checklist, #92 (he was in Cuernavaca June 4–9). The JC checklist shows it as having been in the possession of Edward Weston, then Neil Weston, and then Los Angeles art dealer B. Lewin; its present whereabouts are unknown.

17. DB, 1:130. Furth rightly points out that Weston's description of Charlot's picture calls to mind his own *Arcos, Oaxaca*, taken the following year. Furth, "Starting Life Anew," 212n70.

18. DB, 1:130.

19. DB, 1:129.

20. Charlot, *Mexican Mural Renaissance*, 298.

21. Brenner, *Idols behind Altars*, 304.

22. Charlot, *Temascal*, 1925 (litho on stone, transfer from paper, 28 × 22 in.), reproduced in Morse, *Jean Charlot's Prints*, no. 69.

23. Morse, *Jean Charlot's Prints*, no. 69.

24. Weaver, "Charlot's Repertory of Motifs," 77, suggests that the bathers in the

foreground are suggestive of the cleansing power of baptism and as a result also refer to the Resurrection. The following month, in November, Charlot made a painted version of the same theme but without the window view and crosses (JC checklist, #117).

25. Charlot, *Great Nude, Chalma I*, 1925, JC checklist, #115; reproduced in Koprivitza and Pulido, *México en la obra de Charlot*, cat. 30.

26. For a discussion of Charlot's nudes, see Jensen, "Jean Charlot: The Nude."

27. DB, 1:132–33; AC, #183/1925 or #184/1925.

28. DB, 1:136–35; AC, #186/1925.

29. DB, 1:138.

30. DB, 1:147–48.

31. Conger, *Edward Weston in Mexico*, fig. 21.

32. DB, 1:139.

33. The Pan-American Exhibition was held in early 1926, although it may have opened at the end of 1925. DB, 1:141.

34. DB, 1:139.

35. DB, 2:11.

36. DB, 1:139.

37. Anita Brenner, journal entry, December 2, 1925, quoted in Glusker, *Anita Brenner*, 42.

38. DB, 1:139.

39. DB, 1:141.

40. Charlot, *Temascal*, November 1925, JC checklist, #117; *Pintao, with Bowler*, November 1925, JC checklist, #118; *Portrait of Anita Brenner*, December 1925, JC checklist, #120b.

41. DB, 1:143.

42. Karttunen, *Between Worlds*, 195.

43. DB, 1:147.

44. DB, 1:147.

45. Flores, "*Estridentismo*," 32–35.

46. Karen Thompson, "Jean Charlot: Artist and Scholar"; McVicker, "El pintor convertido."

47. Charnay, *Ancient Cities*. On Charnay, see Davis, *Désiré Charnay*.

48. Charlot set down his recollections of Charnay in a letter to Keith Davis dated October 20, 1977, a copy of which is in the JCC. One of Charnay's portfolios is also now in the JCC, as is the toy whistle.

49. Charlot, *Mexican Mural Renaissance*, 179–80.

50. *Jean Charlot and Mexican Archaeology*, an exhibit curated by Bronwen Solyom, Hamilton Library, University of Hawai'i at Mānoa, June 2006. The exhibit included an English translation, by Bertha Boom, of Charlot's letter to the Bibliothèque Nationale dated November 17, 1914. See also Martínez H., "Jean Charlot y La Coleccion Goupil."

51. DB, 1:149.

52. DB, 1:150.

53. DB, 1:152.

54. DB, 1:152.

55. Hooks, *Tina Modotti*, 119.

56. DB, 1:152–53.

57. DB, 1:156, 158, 159; AC, pp. 15–16; Conger, *Edward Weston in Mexico*, 47–48.

58. JC to EW, undated (probably April 1926), EWA/CCP.

59. His contributions included "Aesthetics of Indian Dances," *Mexican Folkways* (September 1925), reprinted in Charlot, *Art: From the Mayans to Disney*, 48–56. See also Morse, *Jean Charlot's Prints*, 40, cat. 67. For a discussion of *Mexican Folkways*, see Cuevas-Wolf, "Indigenous Cultures," 120–67.

60. JC to EW, undated (probably April 1926), EWA/CCP.

61. DB, 1:158–59.

62. JC to EW, undated (probably mid/late April 1926), EWA/CCP.

63. DB, 1:160.

64. Weston, "Photography."

65. Conger, *Edward Weston in Mexico*, 65–69.

66. Modotti, *Convent of Tepotzolán (Stairs through Arches)*, 1924.

67. Charlot, *Arches and Mountains*, Cuernavaca, June 1925, JC checklist, #92. For a comparison of Modotti's image and Weston's, see Furth, "Starting Life Anew."

68. Charlot, *Church Patio*, Cuernavaca, June 1925 (listed in Koprivitza and Pulido, *México en la obra de Charlot*, as in the Charlot family's possession).

69. DB, 1:182.

70. DB, 1:183.

71. Charlot, *Mexican Mural Renaissance*, 31; DB, 1:189; Brenner, *Idols behind Altars*, frontispiece.

72. Charlot, *Mexican Mural Renaissance*, 31.

73. Conger, *Edward Weston in Mexico*, 60.

74. DB, 1:188.

75. Charlot, *Builder on Ladder, Yucatán*, 1926, JC checklist, #124; reproduced in Brenner, *Idols behind Altars*, plate 102.

76. Charlot, *Great Malinches I*, 1926, JC checklist, #131.

77. DB, 1:188.

78. Charlot, *Lady with Hat*, August 1926, 32 × 23 in., JC checklist, #135, where it is listed as in the collection of John Charlot and Martin Charlot; reproduced in color in *Jean Charlot: A Retrospective*, 123.

79. AC, #462/1926. Brenner, *Idols behind Altars*, 338 (note to plate 29); John Charlot, "Pintor y Escritor," 46, 60n78. In the end, Brenner did not include Weston's photograph in the book and instead used a drawing of the same statuette by Charlot.

The drawing is similar to Weston's photograph, but the sculpture is seen from a lower vantage point. Brenner, *Idols behind Altars*, plate 29; Charlot also made a number of paintings of the same statuette, including *Tortillera* (¾ to right), JC checklist, #166, and *Tortillera* (3/4 to left), JC checklist, #167, both from October 1929. The statuette itself is now in the JCC.

80. AC, #528/1926, #529/1926, #530/1926. On September 27, 1926, Brenner noted in her diary that Weston had photographed some of Charlot's work. AC, #528/1926.

81. DB, 1:161; Rivera, "Mexican Painting."

82. DB, 1:193.

83. AC, #385/1926; Brenner, *Idols behind Altars*, fig. 48.

84. DB, 1:193.

85. Charlot, "Pulqueria Paintings," in Charlot, *Art: From the Mayans to Disney*, 65–66. According to John Charlot, "Pintor y Escritor," 2, Charlot was active in the publication of *Forma*.

86. Weston, "Los daguerreotipos."

87. DB, 1:201.

88. DB, 1:201.

89. AC, #404/1926.

90. DB, 1:201.

91. JCCEW, JCC; JCCEW2 (1980.24), JCC, on the verso of which is a drawing of a vase of flowers on a tabletop (on the body of the vase: "For Z"); JCCEW31, JCC (matted together with JCCEW32 and JCCEW33).

92. JCCEW32, JCC; Koprivitza and Pulido, *México en la obra de Charlot*, 91; and JCCEW33, JCC. JCCEW32 and JCCEW33 are matted together with one of the portraits taken against the low wall (JCCEW31).

93. From an old scrapbook now in a box labeled "Edward Weston, unmatted prints, original negs, copy negs," JCC. On the back there is a small Charlot drawing, which shows a putto holding a plaque that reads, "For Zohmah."

94. AC, #430/1926. JCC has two prints of this image, one of which is a small print, roughly the same size as the rest of the portraits from this session (9½ × 7 cm), JCCEW7 (1980.23), JCC. The other, which is relatively large (23 × 17½ cm), is JCCEW1; on the verso, in an unknown hand, "Edward Weston/Mexico 1926."

95. DB, 1:202. The painting in question cannot be identified with certainty, but it could be *Tree, Spherical, and House* (*The Round Tree*), July 1925, JC checklist, #102, which is recorded as having been in the possession of Edward Weston.

96. DB, 1:202.

97. Charlot, *Bull from Santa Cruz near Tonalá*, December 1926, JC checklist, #143; Brenner, *Avant-Garde Art and Artists in Mexico*, 23.

98. Coke, *Charlot Collection of Weston Photographs*, cat. 8 (*Bull from the Town of Santa Cruz near Tonalá*). It was sold at auction in 1988: Photographs (including

property in the collection of Mrs. Jean Charlot), November 1 and 2, 1988, Sotheby's, New York, lot 561. Reproduced in Conger, *Edward Weston in Mexico*, fig. 13 (*Mexican Toys: Bull, Pig, Horse, and Plate*, 1925, San Francisco Museum of Modern Art).

99. The painting was once owned by Brenner.

3. BACK IN CALIFORNIA

1. DB, 2:5.

2. On Henrietta Shore, see *Henrietta Shore, A Retrospective Exhibition*; Aikin, "Henrietta Shore and Edward Weston"; Armitage, *Henrietta Shore*.

3. DB, 2:5.

4. Quoted in DB, 2:6.

5. JC to EW, probably late February or early March 1927, EWA/CCP.

6. AC, #536/1927.

7. DB, 2:11.

8. Glusker, *Anita Brenner*, 62; Brenner, *Avant-Garde Art and Artists in Mexico*, 381–405.

9. Reproduced in Koprivitza and Pulido, *México en la obra de Charlot*, 86, where it is dated ca. 1926; the photographer is unknown.

10. Reproduced in Koprivitza and Pulido, *México en la obra de Charlot*, 59.

11. Some of these were included in the exhibit *Jean Charlot and Mexican Archaeology*, curated by Bronwen Solyom, Hamilton Library, University of Hawai'i at Mānoa, June 2006. See also McVicker, "El pintor convertido"; Ann Axtell Morris, *Digging in Yucatan*, 174, 246–47.

12. DB, 2:12.

13. Although Weston makes no mention of it, some of his shell pictures are remarkably similar to what Steichen had done some years before. See Weaver, "Curves of Art," 87.

14. DB, 2:17.

15. DB, 2:18.

16. DB, 2:20.

17. DB, 2:20.

18. Armitage, *Henrietta Shore*, 9–12; Charlot, "Henrietta Shore."

19. DB, 2:12.

20. DB, 2:24.

21. DB, 2:24.

22. DB, 2:24.

23. DB, 2:24–25.

24. DB, 2:25.

25. TM to EW, June 25, 1927, in Stark, *Letters from Modotti to Weston*, 51–52 (letter 27.4).

26. TM to EW, July 4, 1927, in Stark, *Letters from Modotti to Weston*, 53 (letter 27.5).

27. TM to EW, July 7, 1927, in Stark, *Letters from Modotti to Weston*, 54 (letter 27.6).

28. DB, 2:32.

29. JC to EW, August 15, 1927, EWA/CCP.

30. JC to EW, August 15, 1927, EWA/CCP.

31. DB, 2:36.

32. DB, 2:37.

33. Henrietta Shore to EW, September 11, 1927, EWA/CCP.

34. Henrietta Shore to EW, October 15, 1927, EWA/CCP.

35. JC to EW, October 20, 1927, EWA/CCP. Charlot's sketch is of Weston's photograph of a shell and an olla (AC, #548/1927), which Shore found delightful.

36. JC to EW, October 20, 1927, EWA/CCP.

37. Henrietta Shore to EW, October 24, 1927, EWA/CCP.

38. Henrietta Shore to EW, November 3, 1927, EWA/CCP.

39. Glusker, *Anita Brenner*, 54, argues that the religious differences were indeed an obstacle to their relationship; Zohmah Charlot was under the same impression. But John Charlot suggests, based on a close reading of Charlot's letters to Brenner, that may not have been the case. John Charlot, "Jean Charlot: Life and Work," vol. 2, "Mexico," unpublished draft, 2007. Cf. Brenner, *Avant-Garde Art and Artists in Mexico,* 685–87.

40. DB, 2:39. *Edward Weston / Brett Weston,* Los Angeles Museum, October 4–November 2, 1927.

41. Weston, "Statement," in *Edward Weston / Brett Weston Photographs.*

42. DB, 2:40.

43. JC to EW, November 14, 1927, EWA/CCP. John Charlot suggests that the writer in question might be Léon Bloy. John Charlot, note to author, October 2007.

44. JC to EW, November 14, 1927, EWA/CCP.

45. Henrietta Shore to EW, November 16, 1927, EWA/CCP.

46. JC to EW, November 17, 1927, EWA/CCP.

47. Henrietta Shore to EW, November 24, 1927, EWA/CCP, quoted in *Henrietta Shore, A Retrospective Exhibition,* 27.

48. DB, 2:43.

49. JC to EW, December 27, 1927, EWA/CCP; Weston seems not to have received it until early the following year, when he makes a note of it in his daybook on January 12, 1928 (DB, 2:43).

50. Draft of obituary in Frances Flynn Paine correspondence, JCC.

51. Mary Flynn Fierro to JC, March 11, 1963, JCC.

52. JC to EW, December 27, 1927, EWA/CCP.

53. Mme Charlot to EW, December 27, 1927, EWA/CCP.

54. *Mexican Art,* The Art Center, 65 E. 56th St., New York NY, January 19–February 14, 1928.

55. Charlot, *The Great Malinches* (exhibited as *Fiesta*), JC checklist, #131; *Temascal I* (exhibited as *The Bath*), JC checklist, #117.

56. *Creative Art* (February 1928), in JC clippings file, JCC.

57. José Clemente Orozco to Mrs. A. Charlot Goupil, February 22, 1928, in Orozco, *Artist in New York*, 33–36.

58. José Clemente Orozco to JC, February 23, 1928, in Orozco, *Artist in New York*, 37.

59. According to Armitage, he and Weston first met in 1920 at a party given by Arthur Millier, but that date is unlikely. Armitage describes it as shortly before Weston left for Mexico with Brett, which was in 1925 — or if Armitage was thinking of Weston's first trip to Mexico, with Chandler, it was in 1923. Since Armitage speaks of Weston being at a transitional stage in his work at that point and about his being away for three years, it was probably the 1923 trip with Chandler. Armitage, *Accent on Life*, 237–38.

60. DB, 2:50–51.

61. DB, 2:52.

62. JC to EW, April 20 [?], 1928, EWA/CCP. (The date was added later; Weston speaks of it in his daybook entry for April 17, 1928.)

63. DB, 2:54.

64. The circumstances surrounding the making of this photograph are unknown. It was probably taken in 1928, and it was published in the *American Annual of Photography* 43 (1929): 118 (copyright 1928). My thanks to Amy Conger for bringing this image to my attention.

65. DB, 2:54–55.

66. Weston, "From My Day Book."

67. Quoted at DB, 2:64.

68. Review by Jehanne Salinger, *San Francisco Examiner*, July 22, 1928 (Scrapbook C), EWA/CCP.

69. "Jehanne Bietry-Salinger Carlson, Memories of Edward Weston: A Conversation with Linda Bellon-Fisher" (January 22, 1986), *Friends of Photography Newsletter*, JCC.

70. DB, 2:79. On Eloesser, see Herrera, *Frida: A Biography*, 120–22.

71. TM to EW, September 18, 1928, EWA/CCP; Stark, *Letters from Modotti to Weston*, 56 (letter 28.3).

72. JC to EW, undated (September 1928), EWA/CCP.

73. Charlot, foreword to Orozco, *Artist in New York*, 18.

74. JCCTM8, JCC.

75. The other portraits from this session are JCCTM9, JCCTM11, JCCTM13, JCCTM14, and JCCTM15, JCC. All the prints are small and appear to have been taken with a Graflex.

76. Charlot, foreword to Orozco, *Artist in New York*, 20.

77. Morse, *Jean Charlot's Prints*, 51.

78. Morris, Charlot, and Morris, *Temple of the Warriors*.

79. Charlot, foreword to Orozco, *Artist in New York*, 21–22.

80. Reed, *Mexican Muralists*, 70.

81. DB, 2:79.

82. DB, 2:80.

83. DB, 2:83–92, 96–98, 100. The photographs of A. have not been pinpointed.

84. DB, 2:83–84, 87, 89.

85. DB, 2:88–89.

86. DB, 2:91.

87. DB, 2:98.

88. EW to Johan Hagemeyer, November 23, 1927, EW/JHC/CCP. Although dated in Weston's hand, this letter seems to refer to the same episode that, according to the daybooks (DB, 2:98), occurred more than a year later.

89. DB, 2:102–3; AC, p. 23. Weston seemed initially to think he was responsible for all of the work of American photographers, but as it turned out he was charged only with collecting the work of West Coast photographers; Edward Steichen organized the East Coast material, while László Moholy-Nagy collected the material from Europe. See also Karlt Steinorth, "Die internationale Werkbundausstellung 'Film und Foto' und Ihre Organisatoren," in Stotz, *Internationale Ausstellung.*

90. DB, 2:108.

91. Charlot, foreword to Orozco, *Artist in New York*, 22.

92. JC to EW, March 29, 1929, EWA/CCP. The article to which Charlot refers is Weston, "From My Day Book."

93. AC, #559/1929.

94. DB, 2:114, 116.

95. DB, 2:118.

96. AC, #714/1933; *Sonya Noskowiak Archive*; Heyman, *Seeing Straight*, 153.

97. Reed, *Mexican Muralists*, 70.

98. Charlot, *Henrietta Shore*, May 1929, 20 x 24 in., JC checklist, #159.

99. JC checklist, #160–64.

100. JC to EW, June 20, 1929, EWA/CCP.

101. Whelan, *Alfred Stieglitz*, 498–99.

102. JC to EW, June 20, 1929, EWA/CCP.

103. Weston, "Amerika und Fotografie."

104. AC, #571/1929, #574/1929.

105. DB, 2:136, 138; AC, p. 23.

106. Brenner, *Idols behind Altars*, 304, 309.

107. Brenner, *Idols behind Altars*, frontispiece, plates 3, 11, 42–43, 45, 47–48.

108. Brenner, *Idols behind Altars*, plate 88; cf. Manjarrez, *Tina Modotti y el muralismo mexicano*, e.g., plate 51, where the same image is dated 1927–28.

109. According to Conger, *Edward Weston in Mexico*, 51, Weston wrote to Brenner

on October 28, 1929, to acknowledge the complimentary copy of *Idols behind Altars* that she had recently sent him. Brenner also sent a copy to Modotti.

110. JC to EW, undated (probably fall 1929), EWA/CCP. Brenner later wrote Weston to give him the news and spoke of how upset Charlot was, about how he thought his life was ruined. Anita Brenner to EW, February 22, 1930, EWA/CCP.

4. AT THE HACIENDA

1. Charlot, *Exhibition of Mexican Paintings*, Art Students League, 215 West 57th Street, New York NY, January 13–25, 1930.

2. Brenner, foreword to *Jean Charlot;* copy in JC clippings file, 1912–47, JCC.

3. *An Exhibition of Work of 46 Painters and Sculptors under 35 Years of Age*, Museum of Modern Art, New York NY, March 1930; *Exhibition of Modern Mexican Art*, Harvard Society for Contemporary Art, Cambridge MA, March 21–April 12, 1930.

4. AC, #571/1929, #574/1929, #584/1930; Coke, *Charlot Collection of Weston Photographs*, cat. 10–12.

5. JC to EW, postmarked April 11, 1930, EWA/CCP.

6. Glusker, *Anita Brenner*, 9, 132.

7. TM to EW, February 25, 1930, and March 9, 1930, EWA/CCP; Stark, *Letters from Modotti to Weston*, 69–71 (letters 30.1, 30.2).

8. TM to EW, April 14, 1930, EWA/CCP; Stark, *Letters from Modotti to Weston*, 71–73 (letter 30.3).

9. JC to EW, undated (probably late April or early May 1930), EWA/CCP.

10. John Charlot, "Jean Charlot: Life and Work," vol. 1, chap. 7.

11. JC to EW, undated (probably late April or early May 1930), EWA/CCP.

12. Abbott, "Eugène Atget."

13. JC to EW, undated (probably late April or early May 1930), EWA/CCP.

14. Reed, *Orozco*, 133. For a discussion of Alma Reed and the Delphic Studios, see also Anreus, *Orozco in Gringoland*, 26–46.

15. DB, 2:168; AC, #594/1930.

16. AC, #596/1930, mentions Stuart Davis as well as Man Ray and Duchamp.

17. DB, 2:168–69.

18. EW to Newhalls, January 14, 1944, Newhall Collection, Santa Fe NM, quoted in AC, p. 24.

19. DB, 2:177; AC, p. 24.

20. DB, 2:178.

21. DB, 2:181.

22. DB, 2:186.

23. Delphic Studios, New York NY, October 15–31, 1930. Exhibition checklist, Scrapbook A, EWA/CCP; see also DB, 2:188, 189.

24. [Statement], *San Franciscan* 5, no. 2 (December 1930): 23; reprinted in Bunnell, *Edward Weston on Photography*, 62–63.

25. JC to EW, October 17, 1930, EWA/CCP.

26. DB, 2:191.

27. DB, 2:195.

28. Vickery, Atkins and Toorey Gallery, San Francisco CA, December 1–20, 1930.

29. DB, 2:198.

30. Hurlburt, *Mexican Muralists*, 98–122; Herrera, *Frida: A Biography*, 116–20; Lee, *Painting on the Left*.

31. DB, 2:198–99. The pictures he took that day include AC, #619/1930, #620/1930, #621/1930.

32. DB, 2:199.

33. Herrera, *Frida: A Biography*, 120–22, fig. 21.

34. DB, 2:199.

35. AC, #619/1930.

36. *Atget: Photographe de Paris*.

37. DB, 2:200.

38. DB, 2:201.

39. For a good discussion of Weston's response to Atget, see Szarkowski, "Understandings of Atget," 19–21. Some years later, in a letter to Willard Van Dyke, Weston gave a slightly less positive assessment of Atget and his work, drawing a sharper distinction between Atget's approach and his own: "Atget was a great documentary photographer but is misclassed as anything else. The emotion derived from his work is largely that of connotations from subject matter. . . . I have a deep respect for Atget; he did a certain work well. I am doing something quite different." EW to WVD, April 18, 1938, WVDA/CCP; Calmes, *Letters between Weston and Van Dyke*, 35. Interestingly, Charlot thought that Atget was not French and thus more sensitive to Paris sights. John Charlot, note to author, October 2007.

40. Hooks, *Tina Modotti*, 207–14; Albers, *Shadows, Fire, Snow*, 239–60.

41. TM to EW, January 12, 1931, EWA/CCP; Stark, *Letters from Modotti to Weston*, 75–77 (letter 31.1).

42. Hooks, *Tina Modotti*, 219–21; Argenteri, *Tina Modotti*, 151.

43. Stark, *Letters from Modotti to Weston*, 75.

44. "Charlot Exhibit," *Carmelite*, February 5, 1931, in JC clippings file, 1912–47, 75, JCC. The exhibition continued until the middle of March.

45. Weston, "Personal Recollections of Charlot in Mexico."

46. JC to EW, undated (ca. February 1931), EWA/CCP.

47. JC to Odette Charlot, undated, JCC. My thanks to John Charlot for bringing this to my attention.

48. DB, 2:210–11.

49. *Jean Charlot: Paintings 1927–1931*, John Levy Galleries, New York NY, April 1–18, 1931.

50. Henry McBride, "Jean Charlot's Work Is Shown in the John Levy Galleries:

Painter Very Much in the Present Fashion, but Whether He Is Much More a Question," *New York Sun*, April 4, 1931, in JC clippings file, 1912–47, 88, JCC.

51. Ralph Flynt, "Jean Charlot: Levy Galleries," *Art News* (April 4, 1931), in JC clippings file, 1912–47, 90, JCC. The name of the author is not given in the article itself but is noted in pencil.

52. Edward Alden Jewell, "Modernism at Levy Galleries," *New York Times*, April 1, 1931, in JC clippings file, 1912–47, 93, JCC.

53. Frances Carter, "Zohmah Charlot," unpublished article, 1984, JCC; Marie Wasnock, biographical sketch in "Zohmah Charlot Diaries 1922–1994, Finding Aid," 2006, JCC.

54. Zohmah Charlot, *Mexican Memories*, 39, JCC.

55. *Jean Charlot: Watercolors and Drawings*, John Becker Gallery, 520 Madison Ave, New York NY, May 8–31, 1931.

56. Claudel, "Jean Charlot," 1–2, 5–6.

57. Zohmah Charlot, *Mexican Memories*, 17–18.

58. Zohmah Charlot, *Mexican Memories*, 25–26.

59. Zohmah Charlot, *Mexican Memories*, 27–31.

60. Zohmah Charlot, *Mexican Memories*, 33.

61. Zohmah Charlot, *Mexican Memories*, 32.

62. Zohmah Charlot, *Mexican Memories*, 32, 36; ZDC to PP, June 8, 1931, JCC.

63. The drawing is reproduced in Zohmah Charlot, *Mexican Memories*, near the end. Above the figure is written, "A girl lost among pajamas, a hat and a bottle of Vermuth [*sic*]."

64. The drawing is reproduced on the cover of *Mele: The International Poetry Letter* 27, no. 84 (1991).

65. Zohmah Charlot, *Mexican Memories*, 36–37.

66. The photo is reproduced in Christie and Taylor, *Eisenstein Rediscovered*, 21, fig. 5; in the caption Zohmah is incorrectly identified as Lina Boytler. My thanks to John Charlot and Oksana Bulgakowa for bringing this to my attention.

67. These photographs (JCCGA1, JCCGA2) are now in the JCC.

68. ZDC to PP, June 8, 1931, JCC.

69. JC diaries, June 8, 1931.

70. Leyda and Voynow, *Eisenstein at Work*, 61; Bordwell, *Cinema of Eisenstein*, 19.

71. Goodwin, *Eisenstein, Cinema, and History*, 132; Barna, *Eisenstein*, 106.

72. For a discussion of Eisenstein's unfinished film, see Leyda and Voynow, *Eisenstein at Work*, 60–73. See also Goodwin, *Eisenstein, Cinema, and History*, 129–38; and Karetnikova and Steinmetz, *Mexico According to Eisenstein*.

73. "Sandunga" was filmed in January and February 1931. Leyda and Voynow, *Eisenstein at Work*, 154. Charlot was also an extra in one sequence. John Charlot, note to author, October 2007, citing Martin Charlot.

74. JC diaries, June 9, 1931.

75. Sergei Eisenstein to JC, telegram, June 12, 1931, JCC; JC diaries, June 12, 17, 1931.

76. Seton, *Sergei M. Eisenstein*, 213–14, 216, citing letters from Charlot to the author dated March 1950 and April 1, 1950.

77. JC diaries, June 6, July 7, 1931.

78. Emily Edwards would later write *Painted Walls of Mexico*.

79. Zohmah Charlot, *Mexican Memories*, 39.

80. Zohmah Charlot, *Mexican Memories*, 41–43, 44–45, 46–66; JC checklist, #232, 236, 238, 240.

81. The photograph, taken on August 6, 1931, is reproduced in Herrera, *Frida Kahlo: The Paintings*, 57.

82. Kirstein, "Jean Charlot."

83. John Charlot, "Jean Charlot: Life and Work," vol. 1, chap. 8. Charlot may have acquired the print from the Weyhe Gallery, which had exhibited Atget's work the previous year, or more likely he bought it from Julien Levy's gallery in New York; Levy co-owned Abbott's collection of Atget's work. That photograph is now in the JCC, and on the verso is written "'Collection Bérénice Abbott,' New York City." On Atget's photograph, see Szarkowski and Hambourg, *Work of Atget*, vol. 4, plate 20.

84. JC checklist, #248, 249, 250, 252.

85. John Charlot, "Jean Charlot: Life and Work," vol. 1, chap. 3.

86. AC, #655/1931.

87. DB, 2:226.

88. DB, 2:226.

89. De Young Museum, San Francisco CA, November 17, 1931–; DB, 2:232.

90. Ansel Adams, "Photography."

91. EW to Ansel Adams, January 28, 1932, AAA/CCP, reprinted in Alinder and Stillman, *Ansel Adams: Letters*, 49–50.

92. ZDC to PP, November 3 and December 3, 1931, JCC; JC diaries, November 3, 1931.

93. ZDC to PP, December 1931, JCC.

94. ZDC to PP, November 13, 1931, JCC.

95. ZDC to PP, undated (probably February 1932), JCC.

96. Barna, *Eisenstein*, 183; Leyda and Voynow, *Eisenstein at Work*, 154.

97. JC checklist, #257-58, 263-66.

98. ZDC to PP, February 13, 1932, JCC.

99. *Exhibition of Photographs / Edward Weston*, Delphic Studios, New York NY, February 29–March 13, 1932 (a copy of the catalogue/checklist is in EWA/CCP); DB, 2:246.

100. DB, 2:246; Weston, [Statement], in *Photographs / Edward Weston*.

101. *Experimental Cinema* 4 (1932).

102. Seton, *Sergei M. Eisenstein*, 170–71; AC, #534/1927.

103. *Experimental Cinema* 3 (1931): 4.

104. DB, 2:247. In some cases the softness of the images seems to have been a deliberate choice; see Leyda and Voynow, *Eisenstein at Work*, 67.

105. DB, 2:254.

106. JC diaries, April 17–19, 1932; *Portrait of Eisenstein* (April 1932), JC checklist, #285, now in the collection of Martin Charlot.

107. Barna, *Eisenstein*, 183.

108. Albers, *Shadows, Fire, Snow*, 263–64.

109. A part of Eisenstein's material (mostly from the "Maguey" episode) was used to make *Thunder over Mexico*, which had little to do with the director's original intentions; it came out in 1933. The following year (1934) another film, *Death Day*, was made from the footage originally intended for the epilogue. In subsequent years still other films, long and short, were made from the surviving footage. Barna, *Eisenstein*, 183–84. In 1979 Grigory Alexandrov and Nikita Orlov attempted to reconstruct the film, relying on Eisenstein's notes and sketches; this version was later reissued on DVD (Kino International Corp., 2001).

110. DB, 2:256.

111. DB, 2:258.

112. DB, 2:262.

113. JC checklist, #292-96.

114. Jensen, "Jean Charlot: The Nude," 71–72.

115. Charlot, *Nude* (painter's hand in foreground), 1932, JC checklist, #296. Charlot had seen and admired a show of Matisse's work about six months before, but it is not clear whether any drawings of this sort were included. On Matisse's drawings, see Barr, *Matisse*, 250, 251.

116. JC to EW, July 1932, EWA/CCP.

117. Claudel, *Jean Charlot*.

5. VISITING CARMEL

1. DB, 2:261.

2. JC to EW, July 1932, EWA/CCP (copy in JCC).

3. DB, 2:263.

4. DB, 2:264, 265.

5. Armitage, *Art of Edward Weston*. The double portrait of Rivera and Kahlo (AC, #619/1930) is plate 16.

6. Charlot, "An Estimate," 4.

7. Charlot, "An Estimate," 5.

8. Weston, "A Contemporary Means to Creative Expression," in Bunnell, *Edward Weston on Photography*, 68.

9. Ansel Adams, review of *The Art of Edward Weston*, in Newhall and Conger, *Edward Weston Omnibus*, 51.

10. EW to Ansel Adams, postmarked June 9, 1933, AAA/CCP, quoted in Newhall and Conger, *Edward Weston Omnibus*, 50.

11. DB, 2:266–67.

12. EW to Ramiel McGehee, December 1932; he says much the same thing in his daybooks, DB, 2:266–67.

13. JC to EW, February 18, 1933, EWA/CCP.

14. Weston later gave Zohmah a copy, which is now in the JCC; it has brief inscriptions by Weston, Lynton Kistler (who did the printing), and Merle Armitage.

15. On Chouinard and the Chouinard School, see Perine, *Chouinard*. In the 1970s the Chouinard School of the Arts (which was by then called the Chouinard Art Institute) was absorbed into the California Institute of the Arts (Cal Arts).

16. JC to EW, February 18, 1933, EWA/CCP.

17. JC to EW, April 24, 1933, EWA/CCP.

18. JC to EW, June 30, 1933, EWA/CCP.

19. JC checklist, #326-27. Both of these pictures were acquired by Weston, probably as presents.

20. The Chicago show took place in June 1933. Another show was held in Los Angeles, in July, at the Stendahl Galleries. The Denny-Watrous show occurred in August.

21. JC to EW, April 30, 1933, EWA/CCP.

22. The painting, *Retrato de Zohmah Day*, 1932 (private collection, USA) is reproduced in *Retrato de una década*, no. 52. According to John Charlot, notes to author, September 2000 and October 2007, Zohmah was going to pay for it in installments, but Siqueiros sold it because he needed the money right away.

23. JC to EW, July 9, 1933, EWA/CCP.

24. JC to EW, late July / early August 1933, EWA/CCP. On July 31, 1933, Weston wrote to Willard Van Dyke that Charlot was arriving on Sunday and would give a talk about contemporary Mexican art at the opening of his exhibition. EW to WVD, July 31, 1933, WVDA/CCP; Calmes, *Letters between Weston and Van Dyke*, no. 24.

25. Quoted in Morse, *Jean Charlot's Prints*, 78.

26. DB, 2:265.

27. Armitage, *Henrietta Shore*, 11.

28. Charlot, "Henrietta Shore," 177.

29. Coke, *Charlot Collection of Weston Photographs*, 8.

30. Coke, *Charlot Collection of Weston Photographs*, 8.

31. JC diaries, August 5–29, 1933, .

32. JC diaries, August 17, 1933; Morse, *Jean Charlot's Prints*, 131.

33. Cf. Henrietta Shore, *Cypress Trees*, ca. 1930, colored pencil on paper, reproduced in *Henrietta Shore, A Retrospective Exhibition*, fig. 14.

34. The drawing (a pencil sketch) is now in the JCC. The JCC also has an ink drawing of the same composition, which is the same in most respects as the pencil sketch, although a few details are slightly simplified; it is reproduced in Charlot, *Artist on Art* 1:175.

35. "Visiting Artist Has Narrow Escape in Fall," *Carmel Sun*, August 31, 1933. The accident actually occurred on August 17; see JC diaries, August 17, 1933.

36. JCCEW19, JCC; Weston, "Thirty-Five Years of Portraiture,"459.

37. Weston made a variant of this image and several related poses, including one in which Charlot is shown leaning against the back of a straight chair, again lost in thought. Here, too, the broken glasses add a wry note to an otherwise serious picture. JCCEW8, JCCEW9, JCCEW16, JCCEW24, JCC. Several variants are reproduced in *Edward Weston: Life Work*, plates 91–93.

38. Weston, "Thirty-Five Years of Portraiture," 455.

39. ZDC to PP, August 3 [?], 1933, JCC. The date is not fully legible, but it must be later than August 3, for Jean and Zohmah had not yet arrived in Carmel by then; in all likelihood, the letter is from the end of August.

40. JCCEW27, JCC.

41. Robert Adams, *Why People Photograph*, 65. Charis Wilson was probably referring to this image when she wrote to Zohmah saying, "The sexist hogwash runs on in a stream of nonsense, doesn't it? The tenderness evident in the 4 x 5 of you and Jean must be invisible to those who make it a subservience demonstration." CW to ZDC, March 20, 1985, JCC.

42. There are also a number of variants in which we can see Zohmah's face, which alters the mood somewhat. See, for example, Coke, *Charlot Collection of Weston Photographs*, 21, cat. 22; JCCEW11, JCC.

43. These photographs are also illustrated in *Sonya Noskowiak Archive*, 76:009:117, 76:009:097. Noskowiak also photographed Charlot in 1938. One example is *Sonya Noskowiak Archive*, 76:009:007; a print of the same image is also in the JCC (JCCSN14).

44. John Charlot, note to author, September 2000.

45. The JCC has quite a few of Noskowiak's portraits of Zohmah from 1933 and 1938; one of them, from 1938, is illustrated in *Sonya Noskowiak Archive*, 76:009:008.

46. Mary Street Alinder, *Ansel Adams*, 112–13. Much of the correspondence between Adams and Charlot concerning the show is now in the AAA/CCP.

47. EW to WVD, August 15, 1933, WVDA/CCP; Calmes, *Letters between Weston and Van Dyke*, no. 26; Enyeart, *Willard Van Dyke*, 72–74.

48. DB, 2:276.

49. ZDC to PP, undated, but possibly August 1933, on EW stationery, JCC.

50. Increase Robinson Galleries, announcement for *Edward Weston: 100 Photographs*, September 16–October 14, 1933.

51. Bunnell, *Edward Weston on Photography*, 59; Weston made the statement in 1930.

52. EW to WVD, ca. September 8, 1933, WVDA/CCP; Calmes, *Letters between Weston and Van Dyke*, no. 28.

53. Charlot, *Art: From the Mayans to Disney*, 171–72.

54. JC diaries, August 30, 1933. It is not entirely clear whether Noskowiak went along on this trip; she was having a show at the Denny-Watrous Gallery at almost the same time and may have had to remain behind; Zohmah may have stayed in Carmel as well.

55. JC diaries, August 31, 1933. The Group f/64 show ran from September 1 to 16. Calmes, *Letters between Weston and Van Dyke*, 56, no. 35.

56. JC diaries, September 1, 1933.

57. Jehanne Biétry Salinger, "Jean Charlot: Artiste Franco-Mexicain à San Francisco," *Courrier du Pacifique*, September 6, 1933 (translation mine). At the end of the interview Salinger asked Charlot when he would paint a fresco in the United States; he responded, "aussitôt que l'on m'offrira un mur et qu'on m'y invitera" (as soon as I'm offered a wall and asked to paint it).

58. Soon after she wrote Weston to express her appreciation, and Weston wrote back, "I appreciated your letter, deeply. I am glad you liked Jean's portrait. The day he left I made several more, which in different ways are equally good. His is a rare person, —one whom I feel very close to. A fine artist with a brilliant and subtle mind, and keen humor. There is no charge for the print sent. I was glad to do it for your purpose." EW to Jehanne Biétry Salinger, September 13, 1933 (copy in JCC).

59. WVD to EW, September 8, 1933, EWA/CCP; Calmes, *Letters between Weston and Van Dyke*, 20, no. 27.

60. JC diaries, September 2, 5, 1933.

61. DB, 2:275–76.

62. DB, 2:278–79.

63. JC diaries, September 8, 1933; Karen Thompson, "Jean Charlot: Artist and Scholar," 19.

64. Jehanne Biétry Salinger, *Courrier du Pacifique*, September 22, 1933.

65. Ansel Adams to JC, October 7, 1933, AAA/CCP. By contrast, Weston sold four pictures from his show at the Increase Robinson Galleries, for which he received a check for $36.67; Increase Robinson to EW, September 15, 1933, EWA/CCP.

66. JC checklist, #347 (*Los Posadas. Feliz Navidad* [Mexican Christmas], 1933).

67. JC checklist, #340, 330, 321, 334, 355, 351.

68. The Oakland show included JC checklist, #336, 345, 352, 355, 359, 361, all of which had already been shown in San Francisco. Many of the paintings in both shows were eventually sold through Charlot's dealer in Los Angeles, the Stendahl Art Galleries.

69. EW to JC, undated (fall 1933), JCC.

70. ZDC to EW, September 12, 1933, EWA/CCP (copy in JCC).

71. EW to ZDC, November 1, 1933, JCC (signature missing).

72. Charlot, *Picture Book*. According to John Charlot, note to author, September 2000, Charlot was originally supposed to do the text, but then it seems Claudel offered to take part. Charlot also worked out the design, although on the colophon page it states that the format was designed by Merle Armitage. The book was printed at the plant of Will A. Kistler; the type was handset by Lynton R. Kistler, who signed the colophon page along with Charlot and Armitage.

73. Morse, *Jean Charlot's Prints*, 130 (letterheads, #225, Sonya photographing and bird, 1933).

74. Sonya Noskowiak to ZDC, January 3, 1934, JCC.

75. See Kothari, *Uday Shankar*.

76. EW to WVD, December 28, 1933, WVDA/CCP; Calmes, *Letters between Weston and Van Dyke*, 21, no. 31.

77. JC diaries, February 10, 1934.

78. ZDC diaries, March 26, 1934.

79. EW to ZDC, undated, JCC.

80. Back in Carmel, Weston wrote in his daybooks on April 20, 1934, of two romantic adventures in Los Angeles, one of which was never consummated. DB, 2:282. There is no specific mention of Zohmah. Zohmah later showed Edward's letter to her son John, telling him how funny it was and how Edward continued to charm her in a clownlike way, which she liked. But she never posed nude for him because she didn't trust him not to make advances. John Charlot, note to author, September 2000.

81. Wilson, *Through Another Lens*, 17–33.

82. ZDC diaries, April 11–18, 1934. Charlot mentions Rivera's fresco in JC diaries, April 16, 1934.

83. ZDC to PP, May 17, 1934, JCC.

84. ZDC to PP, June 21, 1934, JCC.

85. ZDC to PP, June 21, 1934, JCC.

86. The book on which Zohmah worked was Paul Brunton, *A Hermit in the Himalayas* (New York: E. P. Dutton, 1937).

87. ZDC to PP, July 19, 1934, JCC.

88. Holroyd, *Augustus John*, 553. In January 1935, shortly after Zohmah left England, Henry John died in what appeared to be a cliff-climbing/swimming accident while on a trip to Cornwall; his father believed that he had committed suicide, but that was never ascertained. Tom Burns—for whom the suicide theory was completely out of the question—attended the funeral. John, *Autobiography*, 239; cf. Burns, *Use of Memory*, 21–22. Zohmah, who liked Henry very much, thought that he might have committed suicide, but she wasn't sure; in any case, she felt very bad about his death. John Charlot, note to author, September 2000.

89. ZDC to EW (postcard), July 18, 1934 (postmark is difficult to make out), EWA/CCP.

90. EW to ZDC, undated (probably early 1935), JCC.

91. Del Rio, *Sun*. On Charlot's picture books, see Nancy Morris, "Jean Charlot's Book Illustrations."

92. The project received preliminary approval from the Art Commission of the City of New York in May 1934, and Charlot began work in earnest in August. It was completed the next May. Shortly afterward the director of the school objected to one part of it, a seated classical figure holding out two crowns; it was deemed obscene because the knees were open. After Charlot completed a copy of the offending figure on May 16, 1935 (JC checklist, #385), that part of the mural was destroyed and redone by someone else, keeping some of the reclining figures on the side. The mural (modifications and all) probably was not dedicated until early the following year, and it is generally dated 1936. It was restored in 1995.

93. Charlot, "Art, Quick or Slow," 147, 149.

94. Quoted in Epstein, *Epstein*, 146.

95. ZDC diaries, March 14, 1935.

96. ZDC to PP, April 17, 1935, JCC.

97. ZDC to PP, April 26, 1935, JCC. Zohmah wrote an extended account of her trip to England, which was never published. She covered many of the same events that she described in her diary and in her letters to Prudence, but she changed everyone's names to protect their identities. She included, for example, a brief description of her visit to Epstein (dubbed "the sculptor"). She spoke of his collection of modern pictures and ancient sculpture but made no specific mention of Mexican art or of Weston or Charlot. ZDC, unpublished manuscript on trip to England, 62, JCC.

98. EW to ZDC, undated (spring 1935), JCC.

99. These developments are discussed in Wilson, *Through Another Lens*, 58–59. There is a discrepancy between Wilson's account and other sources regarding the date of Weston's departure. Conger says that Weston left Carmel in June, not January; she calls attention to articles published in the *Carmel Cymbal* in April dedicated to Weston and lamenting his departure. AC, p. 27.

100. Cane, *Artist in Each of Us*; Mary Wallace, "On Jean Charlot and the Florence Cane School in 1935," interview with John Charlot, recorded in Hawai'i, May 2, 1984 (audio recording), JCC.

101. JC diaries, spring 1935.

102. St. Cyprian church, River Grove, Illinois. The set comprised fourteen paintings, the last of which was completed in August 1938. See JC checklist, #386, 391, 402–3, 426–29, 432–35, 573–74. He also designed four lithographs on the same theme with the idea of making a full series, which was never realized. *Four Stations of the Cross*, 1934; see Morse, *Jean Charlot's Prints*, 140, cat. 235–38. See also Weaver, "Charlot's Repertory of Motifs," 81–82.

103. JC checklist, #394.

104. ZDC diaries, May 30–June 11, 1935.

105. John Charlot, note to author, October 2007.

6. THE HONEYMOON PICTURE

1. ZDC diaries, July 4, 1935.

2. EW to ZDC, August 13, 1935, JCC; EW to ZDC, undated, JCC (postcard, with no postmark or address, probably mailed in an envelope now lost, which must have been written before August 27, 1935, when Charis joined Edward in Los Angeles).

3. ZDC diaries, February 8, 1936.

4. ZDC diaries, February 10, 1936. In the diary it just says, "Money from J." I am assuming that means Jean.

5. EW to ZDC, undated (ca. February 24, 1936), JCC. This is probably the letter that belongs to the small envelope—empty except for some dried flowers—postmarked February 24, 1936, and addressed to Zohmah Day, 732 Heliotrope Dr., Los Angeles.

6. ZDC diaries, February 24, 25, 1936.

7. CW to ZDC, December 17, 1984, JCC.

8. Belloc, *Characters of the Reformation.*

9. Charlot, "The Critic."

10. Charlot, *Art: From the Mayans to Disney*, 122.

11. Charlot, *Art: From the Mayans to Disney*, 132. See also Morse, *Jean Charlot's Prints*, 88–89, where Charlot speaks of art for the people and how he favored the Images d'Épinal or the work of Posada over Bonnard, Vuillard, or Denis.

12. Anita Brenner, "Giorgio de Chirico: Dreams of Destruction," *Brooklyn Daily Eagle*, November 24, 1935, quoted in Glusker, *Anita Brenner*, 183–84.

13. John Charlot, "Formation of the Artist," 44–45.

14. EW to Ansel Adams, February 3, 1934, AAA/CCP, reproduced in Stark, *Edward Weston Papers*, 10–12. Weston's letter was written in response to a letter from Adams, November 29, 1934, EWA/CCP. Both Adams's letter and Weston's response are reprinted in Alinder and Stillman, *Ansel Adams: Letters*, 74–78.

15. Szarkowski, *Photography until Now*, 239.

16. Bunnell, *Edward Weston on Photography*, 78.

17. Wilson, *Through Another Lens*, 107–14.

18. ZDC diaries, December 6, 9, 10, 1936.

19. EW to ZDC, undated (December 1936), JCC.

20. Wilson, *Through Another Lens*, 170.

21. ZDC diaries, January 16, 1937. The visitor is identified only as an artist; in the following entry—which is crossed out for some reason—Sommer is named. On Sommer, see Lyons and Cox, *Art of Frederick Sommer.*

22. The amended proposal is dated February 4, 1937; it is reprinted in Bunnell, *Edward Weston on Photography*, 78–80, quote at 79.

23. Quinn and Stebbins, *Weston's Westons: California and the West*, 16 (Stebbins), 20 (Quinn).

24. Bunnell, *Edward Weston on Photography*, 55, 56.

25. Armitage, *Henrietta Shore*, 3.

26. EW to ZDC, undated, JCC (postcard, date obliterated, but perhaps January 26, 1937).

27. ZDC diaries, January 30, 1937.

28. ZDC diaries, March 7, 1937.

29. ZDC diaries, March 28, 1937.

30. ZDC to PP, undated (April 1937), JCC.

31. *American Photographer: Edward Weston*, Nierendorf Gallery, New York NY, March 30–April 18, 1937.

32. JC to EW, April 18, 1937, EWA/CCP.

33. AC, e.g., #944/1936 or #948/1936; perhaps #960/1936; probably #959/1936.

34. EW to ZDC (postcard), June 1, 1937, JCC.

35. Wilson, *Through Another Lens*, 120–21; Spaulding, "Bright Power," 39.

36. ZDC to PP, June 3, 1937, JCC.

37. ZDC, log of trip to Red Rock Canyon, typescript, 1937, JCC; quoted (with minor corrections) in Wilson, *Through Another Lens*, 131.

38. ZDC, log of trip to Red Rock Canyon; quoted in Weston and Wilson, *California and the West*, revised ed., 16.

39. Weston and Wilson, *California and the West*, revised ed., 16.

40. Wilson, *Through Another Lens*, 132.

41. Weston and Wilson, *California and the West*, revised ed., 27.

42. ZDC, log of trip to Red Rock Canyon, quoted in Wilson, *Through Another Lens*, 132–33.

43. Weston, *Seeing California*, 25; Wilson, *Through Another Lens*, 134; the picture is AC, #1015/1937.

44. Weston, *Seeing California*, 24.

45. Weston and Wilson, *California and the West*, revised ed., 27.

46. Wilson, *Through Another Lens*, 133.

47. Weston and Wilson, *California and the West*, revised ed., 72; ZDC diaries, June 6, 1937.

48. San Francisco Museum of Art, September 24–October 30, 1937.

49. ZDC diaries, November 24, 1937.

50. Wilson, *Through Another Lens*, 293.

51. ZDC diaries, November 27, 1937.

52. ZDC diaries, November 28, 1937.

53. ZDC diaries, December 1, 1937.

54. See Morse, *Jean Charlot's Prints*, 215; Nancy Morris, "Jean Charlot's Book Illustrations," 89–90.

55. Doering, *Jacques Maritain*, 102–25.

56. Marie McCall, "Memories of Jean Charlot," unpublished manuscript, JCC; the book of poetry was Helene Mullins, *The Mirrored Walls* (New York: Twayne, 1970).

57. Stendahl Ambassador Galleries, February 7–19, 1938.

58. Charlot, *Art: From the Mayans to Disney*, 225–26.

59. Charlot, *Art: From the Mayans to Disney*, 235.See also Weaver, "Curves of Art."

60. Charlot, *Art: From the Mayans to Disney*, 244.

61. Wilson, *Through Another Lens*, 178.

62. JC diaries, April 3, 1938.

63. ZDC diaries, April 3, 1938.

64. ZDC diaries, April 30–May 15, 1938; JC diaries, April 30–May 15, 1938.

65. ZDC diaries, May 15, 1938.

66. See chronology of Guggenheim trips in AC, pp. 82–83.

67. Charlot, *Pictures and Picture Making*. There were eight lectures in all, starting on April 12, 1938; the last one was given on June 7, 1938.

68. JC checklist, #547-65.

69. Reprinted in Charlot, *Art: From the Mayans to Disney*, 193–220.

70. August 1938, JC checklist, #573-74.

71. ZDC diaries, June 13–21, 1938.

72. EW and CW to ZDC, August 13, 1938, JCC. (Zohmah's address is now Edgemont, not Compton; the letter seems to be in Charis's hand.)

73. JC checklist, #527; AC, #1032/1937 (*Legs in Hammock, Laguna*).

74. CW to ZDC, September 1, 1938, JCC.

75. ZDC to PP, undated (October 1938), JCC.

76. Coke, *Charlot Collection of Weston Photographs*, 12.

77. ZDC diaries, November 2, 1938.

78. ZDC diaries, November 15, 1938.

79. ZDC diaries, November 11, 1938.

80. ZDC diaries, November 12, 1938.

81. ZDC diaries, November 16, 1938.

82. Zohmah describes one version of the picture, a watercolor, in Zohmah Charlot, "In Weston's World," 10. The original drawing (with added color), which was done on November 16, 1938, is now in the JCC.

83. ZDC diaries, December 15, 1938.

84. Wilson, *Through Another Lens*, 205.

85. ZDC diaries, January 4, 1939.

86. ZDC diaries, January 5, 1939.

87. AC, #1421/1939.

88. Charlot's reaction to these pictures in not known, but one of them ended up in the Charlot Collection. Coke, *Charlot Collection of Weston Photographs*, 35, no. 40; AC, #1415/1939.

89. AC, #1413/1939.

90. ZDC diaries, January 6, 7, 8, 1939.

91. ZDC diaries, January 15, 1939.

92. ZDC to PP, February 27, 1939, JCC.

93. AC, #1440/1939. Weston and Wilson, "Of the West"; Weston and Wilson, *California and the West,* revised ed., 121.

94. John Charlot, conversation with the author, spring 1998.

95. Wilson, *Through Another Lens,* 190–92. See also Bunnell, *Edward Weston on Photography,* xviii–xx; AC, p. 32.

96. Weston, "What Is a Purist?"

97. Weston, "What is a Purist?," 8; Bunnell, *Edward Weston on Photography,* 86.

98. Weston, "Photographing California."

99. Weston, "My Photographs of California."

100. DB, 2:168–69; Weston, "Photographing California," part 1, 56; Bunnell, *Edward Weston on Photography,* 88.

101. ZDC to PP, February 27, 1939, JCC.

102. ZDC to PP, March 1, 1939, JCC.

103. ZDC diaries, March 2, 1939.

104. ZDC diaries, March 14, 1939.

105. Lorenz, "Johan Hagemeyer," 19.

106. ZDC to Owen Plowe, March 22, 1939, JCC.

107. Bunnell, *Edward Weston on Photography,* 98.

108. Bunnell, *Edward Weston on Photography,* 86.

109. Picasso, *Picasso: Two Statements.*

110. DB, 2:45.

111. Weston, "Photography Not Pictorial," in Bunnell, *Edward Weston on Photography,* 57.

112. Armitage, *Art of Edward Weston,* 7–8.

113. Wilson, *Through Another Lens,* 189.

114. ZDC diaries, March 27–29, 1939.

115. ZDC diaries, April 5, 1939; JC checklist, #383.

116. ZDC diaries, April 22–23, 1939.

117. ZDC diaries, April 26–27, 1939.

118. ZDC diaries, May 29, 1939.

119. ZDC diaries, May 30, 1939.

120. AC, #1473/1939. Conger reports that Zohmah, in a phone conversation in 1989, recalled that the picture was taken around May 29, 1939.

121. Zohmah Charlot, "In Weston's World," 9.

122. Quoted in Maloney, *U.S. Camera: 1943,* 96, where the picture, simply titled *Jean and Zohmah Charlot,* was reproduced. The photo judge was Lt. Comdr. Edward

Steichen, U.S.N.R. The accompanying caption also adds some technical data: "This picture was made with an 8 × 10" view camera with a 12" Turner Reich lens. Mr. Weston did not keep a record of his exposure data but says: 'It is obviously stopped down to at least f/90, and probably had a full second exposure on Isopan film.' This contact print was made on Haloid glossy paper. Weston composes his pictures, before an exposure, and prints full size of negative."

123. CW to ZDC, August 8, 1982, JCC. Anne Hammond and Mike Weaver point out the similarity between Weston's photograph and Picasso's drawing *Le repos des moissoneurs I*, 1919, in the Sammlung Oskar Reinhart, Winterthur, Switzerland. Note to author, January 2009.

7. ATHENS, GEORGIA

1. Wilson, *Through Another Lens*, 209–10.
2. ZDC to EW, July 7, 1939, EWA/CCP.
3. ZDC to EW, July 7, 1939, EWA/CCP. The following fall, after Charlot had left Iowa, there was an exhibition of his work, and on October 26, 1939, Wood gave a gallery talk about it. "Grant Wood to Lecture," *Iowa City Press Citizen*, October 25, 1939, in JC scrapbooks, JCC.
4. ZDC to EW, July 7, 1939, EWA/CCP.
5. Stebbins, *Weston's Westons: Portraits and Nudes*; AC, #1476/1939.
6. Wilson, *Weston: Nudes*, 14; Stebbins, *Weston's Westons: Portraits and Nudes*, 34.
7. AC, #1490/1939, 1493/1939.
8. AC, #655/1931.
9. Weston would later refer to this last example, *Lily and Rubbish*, as one of his "best arrangements," and he would insist that it be included in his 1946 retrospective at the Museum of Modern Art in New York. AC, #1497/1939; the other two are #1496/1939 and #1498/1939.
10. Wilson, *Through Another Lens*, 134.
11. Weston, "Seeing California With Edward Weston."
12. Weston, *Seeing California*, 6.
13. Charlot, *Art: From the Mayans to Disney*, 169. Charlot's essay on Weston was reprinted in *California Arts and Architecture* (April 1940): 20.
14. Charlot, *Art: From the Mayans to Disney*, 177.
15. Charis Wilson on Edward Weston, audiotape of public lecture at Asilomar, summer 1981, JCC—CT29, JCC. Weston expressed comparable views in a letter to Ansel Adams; see Alinder and Stillman, *Ansel Adams: Letters*, 49.
16. Charlot, *Art: From the Mayans to Disney*, 170.
17. JC to EW, undated (summer 1939), EWA/CCP.
18. Wilson, *Through Another Lens*, 213–14; Mortimer, "Photographic Art."
19. Wilson, *Through Another Lens*, 213–14; Weston, "Photographic Art."

20. Beaumont Newhall, *Photography*. As Peter Bunnell points out, Weston would have been familiar with Newhall's history of photography by this time. Bunnell, *Edward Weston on Photography*, xxi.

21. Bunnell, *Edward Weston on Photography*, 127.

22. Bunnell, *Edward Weston on Photography*, 128.

23. Bunnell, *Edward Weston on Photography*, 132.

24. Bunnell, *Edward Weston on Photography*, 133.

25. Charlot, *Art: From the Mayans to Disney*, 172.

26. Bunnell, *Edward Weston on Photography*, 134; see also Charlot, *Art: From the Mayans to Disney*, 172.

27. Mortimer, "Photographic Art," plates 1–4. In the thirteenth edition of the *Encyclopaedia Britannica*, A. Horsley Hinton's entry, "Pictorial Photography," was accompanied by the work of H. P. Robinson, James Craig Annan, D. O. Hill, and Hinton himself (plates 1–3).

28. ZDC to PP, October 9, 1939, JCC; the letter from Weston to the Charlots to which she refers is lost.

29. There is a list of the prints in the Morgan show, a copy of a consignment sheet, in the EWA/CCP. The version of the honeymoon picture is the one that would later be included in the *Family of Man* exhibition (PO39-CH-2).

30. Gilbert Morgan to EW, December 17, 1939, EWA/CCP.

31. Morse, *Jean Charlot's Prints*, 216.

32. Weston and Wilson, "Of the West," in Bunnell, *Edward Weston on Photography*, 114.

33. Maloney, *U.S. Camera: 1940*, 69, 124, 165, 169, 186–87.

34. Maloney, *U.S. Camera: 1940*, 197.

35. ZDC to EW, January 22, 1940, EWA/CCP.

36. ZDC to EW, January 22, 1940, EWA/CCP. The exhibition to which Zohmah referred was *Picasso: Forty Years of His Art*, November 15, 1939–January 7, 1940, organized by Alfred Barr. It featured 344 works (*Guernica* included). A version of the show traveled to San Francisco.

37. JC checklist, beginning of the section on 1940. Karen Thompson speaks of how he worked "in a NY liaison office taking orders for military equipment." "Jean Charlot: Artist and Scholar," 21.

38. ZDC to EW and CW, April 19, 1940, EWA/CCP. Zohmah was a little confused about Charis's birthday, as was Charis herself. Zohmah probably thought Charis was born on April 9, although Charis was actually born in May. At the time Charis believed that her birthday was May 9, but as it turns out she was actually born on May 5, while her brother, Leon, was born on the ninth. Zohmah's prediction was therefore a little misplaced, although she did not know it at the time.

39. Certificate of Naturalization No. 4770013, June 7, 1940, JCC.

40. French Army Air Commission [signature illegible] to JC, July 18, 1940, JCC.

41. Wilson, *Through Another Lens*, 211–12.

42. Wilson, *Through Another Lens*, 220.

43. Spaulding, *Ansel Adams*, 172–75.

44. Wilson, *Through Another Lens*, 223–24.

45. Wilson, *Through Another Lens*, 225.

46. Wilson, *Through Another Lens*, 225.

47. JC to George Macy, June 28, 1940, quoted in Morse, *Jean Charlot's Prints*, 218.

48. JC diaries, August 3, 6, 1940.

49. JC diaries, September 20, 1940.

50. JC checklist, #630-33.

51. According to John Charlot, Jean made a vow to Saint Anne de Beaupré that he would make a pilgrimage to her shrine in Canada if he was spared from the war. The Charlot family made that pilgrimage in the early 1950s. John Charlot, note to author, October 2007.

52. ZDC to PP, November 26, 1940, JCC.

53. ZDC to EW, November 26, 1940, EWA/CCP (with snapshots).

54. Wilson, *Through Another Lens*, 225–26.

55. Weston and Wilson, *California and the West*, 50 (1940 ed.), 69 (revised ed.).

56. Weston and Wilson, *California and the West*, 51 (1940 ed.), 70 (revised ed.).

57. Grundberg, "Edward Weston's Late Landscapes," 97.

58. Alinder and Stillman, *Ansel Adams: Letters*, 129.

59. Grundberg, "Edward Weston's Late Landscapes," 97–98; Lowe, "Late Landscapes," 181.

60. Szarkowski, *American Landscapes*, quoted in Grundberg, "Edward Westons's Late Landscapes," 94.

61. Maddow, *Edward Weston: His Life*, 255; cf. Szarkowski, "Edward Weston's Later Work," 159.

62. Wilson, *Through Another Lens*, 212.

63. Weston and Wilson, *California and the West*, 127 (1940 ed.), 188 (revised ed.).

64. AC, #1516/1940–#1525/1940.

65. AC, #1524/1940.

66. EW to Beaumont Newhall and Nancy Newhall, December 24, 1940, NN/BNC/CCP, quoted in AC, #1516/1940.

67. AC, #1530/1940, #1537/1940.

68. JC checklist, #640, 643; Jean Charlot, *Religious Paintings, Including The Way of the Cross*, Bonestell Gallery, New York, December 19, 1940–January 4, 1941.

69. JC checklist, #637.

70. Jean Charlot, interview by John Charlot, JCC: interview 10 (October 10, 1970), 8; interview 20 (November 28, 1970), 5.

71. JC diaries, January 23, 1941, quoted in Morse, *Jean Charlot's Prints*, 218.

72. JC diaries, March 10, 1941, quoted in Morse, *Jean Charlot's Prints*, 218.

73. That copy is in the JCC. All except "& Charis" (which was added by Charis) is in Edward's hand.

74. ZDC to EW and CW, March 9, 1941, EWA/CCP.

75. ZDC (from Colorado Springs) to PP, September 24, 1947, JCC.

76. Wilson, *Through Another Lens*, 229; Susan Danly, "'Literally Photographed,'" 55–56.

77. Edward and Charis planned on making a related book of their own—along the lines of what they had done together in *California and the West*—from the results of their upcoming travels. Weston mentioned this in a 1944 entry in his daybooks (DB, 2:287), but unfortunately the project was never realized. Wilson's account of their travels in *Through Another Lens* (229–98) is as close as we get. See also Danly, "'Literally Photographed,'" 56–79.

78. ZDC to PP, April 1941, JCC.

79. EW to Beaumont Newhall and Nancy Newhall, April 28, 1941, NN/BNC/CCP, quoted in Beaumont Newhall, *Supreme Instants*, 41.

80. Weston himself had a long association with the poem. In the 1920s he is known to have owned a copy of *Leaves of Grass*, in which he sometimes hid money. Before leaving for Mexico in 1923, he left a check for 135 dollars—payment for some lenses he had sold—inside it; it was intended as a reserve fund to fall back upon in case things did not work out for him in Mexico. In 1925 he wrote to Flora Weston and asked her to retrieve it for him. EW to Flora Weston, undated (from 1925, from San Francisco), EWA/CCP.

81. Charlot, *Charlot Murals in Georgia*, 19.

82. JC diaries, spring 1941.

83. JC diaries, April 13, 23, 1941; JC scrapbooks, Family, 1940s and early 1950s, JCC.

84. Mérimée, *Carmen*.

85. Charlot, *Window with Orange Vendor*, 1941, JCC; reproduced in Mérimée, *Carmen*, 107.

86. Nancy Morris, "Jean Charlot's Book Illustrations."

87. Bercovici, introduction to Mérimée, *Carmen*, 7–15.

88. Wilson, *Through Another Lens*, 235.

89. Wilson has described the visit with Goldwater (Wilson, *Through Another Lens*, 238–39), but she did not discuss the visit with the Sommers, which is mentioned in AC, #1562/1941.

90. Wilson, *Through Another Lens*, 256–58; Ullrich-Zuckerman, "With Edward Weston," 3. According to Ullrich-Zuckerman, they spent the first evening looking only at Laughlin's work; Weston did not get a chance to show any of his. According to Charis (Wilson, *Through Another Lens*, 256–58), Laughlin showed them a good deal of

his work, which Weston regarded as "goobledygook." Charis later wrote to Zohmah, "So Clarence is one of those people who lives in a fantasy land full time, and he has adjusted the past to suit himself. You have only to look at his pictures to understand that Edward would not have had much time for him." cw to zdc, August 8, 1982, jcc.

91. Wilson, *Through Another Lens*, 257–60, 316–17; Ullrich-Zuckerman, "With Edward Weston," 3–4; and Charis Wilson on Edward Weston, audiotape of public lecture at Asilomar (summer 1981), jcc—ct29, jcc.

92. Wilson, *Through Another Lens*, 265.

93. Wilson, *Through Another Lens*, 268–70.

94. The nativity is reproduced in Shapley, *Catalogue of Italian Paintings*, 1:265–66, cat. 390; 2:plate 181. According to Shapley, the panel is probably by a pupil or follower of Lippi. Ruda, *Fra Filippo Lippi*, 378–79, cat. 12, ascribes it to Lippi himself, as do Boskovits and Brown, *Italian Paintings*, 406–9 (1939.1.279).

95. Charlot, *Charlot Murals in Georgia*, 42.

96. jc checklist, #658, *Nativity*, inscribed "Homage to Filippo Lippi" (begun September 16, 1941).

97. *Rest on the Flight*, with angels making tortillas, jc checklist, #663; *Rest on the Flight into Egypt*, with angels washing diapers, jc checklist, #664). Here the personal associations seem especially strong, albeit lighthearted.

98. Charlot, *Charlot Murals in Georgia*, 42–66.

99. zdc to pp, October 21, 1941, jcc.

100. Wilson, *Through Another Lens*, 289–90; according to Charis, O'Keeffe's views echoed those of Stieglitz.

101. Wilson, *Through Another Lens*, 280–81, 290.

102. jc diaries, December 13, 1941.

103. Wilson, *Through Another Lens*, 293.

104. jc diaries, December 14, 1941; ac, #1684/1941.

105. Wilson, *Through Another Lens*, 293.

106. jc diaries, December 14, 1941.

107. Wilson, *Through Another Lens*, 294.

108. ac, #1685/1941.

109. ac, #1686/1941.

110. jc diaries, December 17, 1941. They planned out and hung the show on that day.

111. cw to zdc, September 9, 1985, jcc: "This looks as though I—or we—wrote a press release for local newsp—Do you remember?"

112. jc diaries, December 18, 1941; zdc diaries, December 18, 1941.

113. John Charlot, conversation with the author, summer 2004, and email to the author, May 25, 2007.

114. jccew14 and jccew15, jcc. The box containing the negatives, which is now

in the JCC, has writing on it in what looks like Weston's hand, suggesting that there were also pictures of Leon and/or Jean, but if there were any such pictures, they have not been located.

115. JC diaries, December 18, 1941.

116. ZDC to PP, Monday, undated (December 1941), JCC.

117. Wilson, *Through Another Lens*, 294; AC, #1687/1941 (*Marshes of Glynn, Sea Islands, Georgia*).

118. JC diaries, December 24, 1941.

119. Wilson, *Through Another Lens*, 295.

120. JC diaries, December 24–25, 1941.

121. CW to ZDC, August 31–September 3, 1985, JCC.

122. ZDC to PP, March 15, 1943, JCC.

123. EW to Nancy Newhall and Beaumont Newhall, July 13, 1943 (photocopy), NN/BNC/CCP.

124. Wilson, *Through Another Lens*, 267, 334.

125. Wilson, *Through Another Lens*, 280–81.

126. Wilson, *Through Another Lens*, 293.

127. Wilson, *Through Another Lens*, 293–94.

128. Coke, *Charlot Collection of Weston Photographs*, 10.

129. Wilson, *Through Another Lens*, 295.

130. There is another one of the two of them together in a somewhat more awkward position, a kind of spontaneous off moment. Zohmah also photographed Weston alone against the same wall, from slightly below, standing with his hands on his hips.

8. MY LITTLE GRAY HOME IN THE WEST

1. Wilson, *Through Another Lens*, 297–98.

2. EW and CW to Bea and Don Prendergast, February 11, 1942, BZC/CCP.

3. Wilson, *Through Another Lens*, 314.

4. TM to EW, January 12, 1931, EWA/CCP; Stark, *Letters from Modotti to Weston*, 75–76 (letter 31.1). At the top of the letter Weston wrote, "Tina's last letter to me."

5. Hooks, *Tina Modotti*, 253.

6. Albers, *Shadows, Fire, Snow*, 332; a photograph of her bier is reproduced in Constantine, *Tina Modotti*, 187.

7. *Tina Modotti* (Mexico City, 1942), 20, quoted in Argenteri, *Tina Modotti*, 202.

8. Charlot, *Charlot Murals in Georgia*, 47.

9. Charlot, *Charlot Murals in Georgia*, 79.

10. Charlot, *Charlot Murals in Georgia*, 91, 113.

11. Charlot, *Charlot Murals in Georgia*, 46–47.

12. Wilson, *Through Another Lens*, 311; Bullard, "Weston in Louisiana," 15.

13. Bullard, "Weston in Louisiana," 15; Wilson, *Through Another Lens*, 299–303.

14. EW to Beaumont Newhall, June 5, 1942 (photocopy), NN/BNC/CCP; quoted, in part, in Maddow, *Edward Weston: His Life*, 221.

15. Ullrich-Zuckerman, "With Edward Weston," 6.

16. Wilson, *Through Another Lens*, 317.

17. EW to Neil Weston, August 27, 1942, EWA/CCP.

18. JC diaries, June 15, 1942.

19. ZDC to PP, January 18, 1943, JCC.

20. JC diaries, July 8, 17, 1942 (and subsequent days).

21. ZDC to PP, August 12, 1942, JCC.

22. Wilson, *Weston: Nudes*, 15.

23. Weston, *Civilian Defense*, 1942; gelatin silver print, 19.4 × 24.4 cm (7⅝ × 9⅝ in.), Lane Collection, Museum of Fine Arts, Boston. The Boston print is inscribed on verso of mount, "Victory [crossed out]/Edward Weston/Civilian Defense/1942."

24. On the same occasion Weston made a second, vertical version of essentially the same subject, also known as *Civilian Defense* (or *Civilian Defense II*). AC, #1695/1942.

25. Wilson, *Weston: Nudes*, 15.

26. Christine Ternin, "Weston's Model Looks Back," *Boston Globe*, undated. Charis sent a copy of the article to Zohmah; although the clipping (now in the JCC) does not include a date, the article appeared at the time of the exhibition *Weston's Westons: Portraits and Nudes*, Museum of Fine Arts, Boston, December 1989–March 1990.

27. Coleman, "Directorial Mode." See also Coleman, "Image in Question."

28. Stebbins points this out in *Weston's Westons: Portraits and Nudes*, 36.

29. EW to JC and ZDC, November 3, 1942, JCC.

30. EW to JC, November 4, [1942], JCC.

31. EW and CW to JC and ZDC, undated (probably late November or December 1942; "1942?" handwritten on verso), JCC. The letter is written in green ink, which Weston received from Macy around the time *Leaves of Grass* came out, in late 1942 or shortly thereafter.

32. JCCEW12 and JCCEW13, JCC; they are signed and dated: "EW 1941." There is a second print of the portrait of John Charlot, which was made later by Dody Weston Thompson, in the JCC; it is not numbered.

33. Whitman, *Leaves of Grass*.

34. EW to Merle Armitage, December 29, 1942, Harry Ransom Humanities Resource Center, University of Texas, Austin, cited in AC, p. 37.

35. Trachtenberg, "Edward Weston's America," 106–7; Trachtenberg, "Final Years," 288–89; Danly, "'Literally Photographed,'" 64.

36. Danly, "'Literally Photographed,'" 77, identifies the subject of the first image as Dave Dillingham, an old Texas fiddler turned banjo player.

37. EW to George Macy, August 15, 1941, Huntington Collection, quoted in AC, p. 35; Trachtenberg, "Edward Weston's America," 103–15; Trachtenberg, "Final Years," 291–93; Danly, "'Literally Photographed,'" 78–79.

38. According to Conger, Weston submitted seventy-two or seventy-three pictures, about one-tenth of the total, from which Macy made the final selection. AC, p. 36.

39. Whitman, *Leaves of Grass*, 2:colophon.

40. *Paintings and Drawings by Jean Charlot*, M. H. de Young Memorial Museum, Golden Gate Park, San Francisco, November 20–December 31, 1942, from an announcement in JC clippings file, 1912–47, JCC.

41. Alfred Frankenstein, "The Paintings of Charlot Suggest Christmas," *San Francisco Chronicle*, November 29, 1942, 33.

42. Jehanne Biétry Salinger, "Jean Charlot, Scholar and Artist," M. H. de Young Memorial Museum, Golden Gate Park, San Francisco, Sunday, December 6, 1942, from an announcement in JC clippings file, 1912–47, JCC.

43. JC diaries, November 15, 16, 1942.

44. JC and ZDC to EW and CW, undated (probably late 1942 or early 1943), EWA/CCP.

45. *Life*, February 22, 1943, 19–23. I have relied largely on references furnished in Calmes, *Letters between Weston and Van Dyke*, 60. See also Peeler, *Illuminating Mind*, 267.

46. EW to WVD, March 8, 1943, WVDA/CCP; Calmes, *Letters between Weston and Van Dyke*, 40–41.

47. Calmes, *Letters between Weston and Van Dyke*, 60.

48. "The Time Is Now: Are We Winning the War—or Are We Losing It?" *Life*, February 15, 1943, 30–34.

49. EW to WVD, March 8, 1943, WVDA/CCP; Calmes, *Letters between Weston and Van Dyke*, 40–41.

50. ZDC and JC to EW and CW, April 15, 1943, EWA/CCP.

51. Maloney, *U.S. Camera: 1943*, 96. This is the same version as AC, #1473/1939, but not the version that Steichen would later select for the *Family of Man* exhibition.

52. Glen Fishback, *Edward Weston in Action*, reproduced in Maloney, *U.S. Camera: 1943*, 220.

53. "In Memory of W. H. Jackson, 1843–1942," in Maloney, *U.S. Camera: 1943*, 189–92.

54. ZDC and JC to EW and CW, April 15, 1943, EWA/CCP.

55. EW to JC and ZDC, undated (after April 15, 1943), JCC.

56. Soon after she received the negatives Zohmah wrote to Prudence, "Edward sent us the negatives of the children. Wish I knew someone to print them nicely for me. Sonia would be good, but don't feel I can ask." ZDC to PP, May 26, 1943, JCC. The negatives are now in the JCC.

57. EW to JC and ZDC, undated (after April 15, 1943), JCC.

58. Wilson, *Through Another Lens*, 324–25, speaks of how the garden was mostly her doing, and she was puzzled as to why Weston claimed credit for it.

59. Wilson, *Through Another Lens*, 323–26.

60. Brenner, *Wind That Swept Mexico*.

61. Brenner, *Wind That Swept Mexico*, 292. Although there is no mention of it in the book, Evans may have also helped with the sequencing of the images; that was something with which he had considerable experience. See Andrews, "Sequential Arrangement."

62. EW and CW to JC and ZDC, June 21, 1943, JCC.

63. EW and CW to JC and ZDC (actually written by EW), undated (before September 16, 1943, when ZDC and JC respond), JCC.

64. *Masque* is reproduced in Wilson, *Through Another Lens*, fig. 20, and in Maddow, *Edward Weston: His Life*, 210 (where it is called *Valentine*).

65. EW to Nancy Newhall, quoted in Maddow, *Edward Weston: His Life*, 221 (he gives no date).

66. Draft on newsprint (in green ink), with no heading or date (outgoing political letters, 1944–45), EWA/CCP (but probably from 1943, when Weston was using the green ink he had received from Macy).

67. A similar approach is evident in *Good Neighbor Policy*, which Edward also mentioned in his letter to the Charlots (although he did not describe it). Like *What We Fight For*, it includes soda—a six-pack of Dr. Pepper rather than a bottle of Pepsi—and in this case the reference is apparently to Claude Pepper, a senator from Florida who at the time was a member of the Foreign Relations Committee and a supporter of FDR's Good Neighbor policy. See AC, #1721/1943.

68. AC, #1723/1943. Weston did not mention it to Charlot, but he made another version of the subject in which Charis holds, in one hand, both a cigarette and a sign that reads "Edward Weston Photographer." In her other hand she holds a half-eaten apple rather than a skull (AC, #1722/1943).

69. Wilson, *Through Another Lens*, 342.

70. "My Little Grey Home in the West," traditional, as performed by Jimmy O'Byrne, *Le Mór Ghrá*, Rego Irish Records and Tapes, Garden City NY, 1998, track 12.

71. Near the end of *Through Another Lens* (343–44), Wilson speaks of *My Little Gray Home in the West* (in this case, the version with the sign, not the skull). She sees herself as an Eve-like figure, about to be banished from Eden, holding a sign like a fig leaf to cover her shame; she sees the surroundings as a mosaic, a summation of her years with Weston: their tryst at the beginning, their romantic ideas of settling down together after the Guggenheim travels, the mixed emotions of the Whitman trip (represented by the sculpture), and the growing separation between them. The implication in her discussion is that the picture shows her on the brink of separation, about to break away from Weston's world, which had been Edenic at the start.

72. Jeannette MacDonald and Nelson Eddy in Victor Herbert's *Sweethearts*, directed by W. S. Van Dyke II (Hollywood: Metro-Goldwyn-Mayer, 1938).

73. AC, #1724/1943.

74. Wilson, *Through Another Lens*, 332.

75. Hambidge's initial explanation of Dynamic Symmetry, in the form of monthly lessons, appeared in the magazine *The Diagonal* in the winter of 1919–20; the lessons were published together in slightly modified form two years after his death, as Hambidge, *Elements of Dynamic Symmetry*. His ideas were also expounded in Hambidge, *Dynamic Symmetry: The Greek Vase*; Hambidge, *Parthenon*; and Hambidge, *Practical Applications*.

76. Jacobs, *Art of Composition*; Ghyka, *L'esthétique des proportions*.

77. Charlot, *Art-Making*, 23–27.

78. Orozco, *Autobiography*, 143–50; Reed, *Orozco*, 204–8.

79. Charlot, foreword to Orozco, *Artist in New York*, 21–22; Reed, *Mexican Muralists*, 69–70.

80. Charlot, *Pictures and Picture-Making*, lecture 3; Weaver, "Curves of Art." Weaver speaks of the influence of Theodore A. Cook, author of *The Curves of Life* (London: Crown, 1914).

81. AC, #1724/1943.

82. EW to Stanley Duggan, about December 1945, George Eastman House, quoted in Stebbins, *Weston's Westons: Portraits and Nudes*, 36.

83. For a variant of this image, see Stebbins, Quinn, and Furth, *Edward Weston*, plate 136.

84. ZDC (and JC) to EW, September 16, 1943, EWA/CCP. On these frescoes, see Charlot, *Charlot Murals in Georgia*, 130–41, 179–80, and accompanying plates.

85. Weston, "From My Day Book"; Weston, "Mexican Days."

86. In the 1920s Christel Gang typed up portions of the daybooks after taking dictation from Weston; he later destroyed some of that material. Pauli, "Weston and Gang." According to Wilson, *Through Another Lens*, 321, Ramiel McGehee did some of the typing as well.

87. ZDC (and JC) to EW, September 16, 1943, EWA/CCP.

88. Nancy Newhall to EW, December 22, 1943, NN/BNC/CCP, quoted in AC, #1722/1943.

89. EW to Nancy Newhall, quoted in Maddow, *Edward Weston: His Life*, 220–21 (he gives no date).

90. EW to Prendergasts, January 14, 1944, BZC/CCP.

91. Jean Charlot, Zohmah Charlot, and John Charlot, interview by Dody (Weston) Thompson, August 18, 1975, transcript, 4, JCC.

92. EW to JC, October 5, 1943 (postcard), JCC.

93. EW to JC and ZDC, November 10, 1943 (postcard), JCC.

94. Charlot, *Charlot Murals in Georgia*, 135.

95. EW and CW to ZDC and JC (postcard), December 16, 1943, JCC.

96. EW to JC and ZDC, January 3, 1944, JCC.

97. EW to JC and ZDC, January 10, 1944 (postcard), JCC.

98. JC (with postscript by ZDC) to EW, January 29, 1944, EWA/CCP.

99. Charlot, *Charlot Murals in Georgia*, 140–41. On the earlier fresco, see John Charlot, "El primer fresco."

100. Charlot, *Charlot Murals in Georgia*, 179.

101. Charlot received the Guggenheim letter on April 3, 1944. JC diaries, April 3, 1944.

102. EW to JC and ZDC, April 22, 1944, JCC.

103. DB, 2:287.

104. ZDC to PP, May 8, 1944, JCC.

105. These snapshots are now in the JCC (in a scrapbook in the vault, in the box that includes materials from 1944).

106. Wilson, *Through Another Lens*, 328–29.

107. EW to May Weston Seaman, July 27, 1944, in Foley, *Weston's Gifts*, 59, quoted in AC, #1736/1944.

108. Weston and Wilson, *Cats of Wildcat Hill*.

9. A CAT NAMED ZOHMAH

1. Harris, *Arts at Black Mountain College*, 96.

2. EW to ZDC and JC, undated (probably fall 1944), JCC.

3. EW to Christel Gang (postcard), postmarked October 25, 1944, CGC/CCP.

4. EW to Gov. Thomas E. Dewey, October 30, 1944, EWA/CCP.

5. EW to Neil Weston, November 7–8, 1944, EWA/CCP.

6. EW to Neil Weston, November 27, 1944, EWA/CCP.

7. EW to Nancy Newhall, January 27, 1945, NN/BNC/CCP (Weston/Newhall photocopies, January 1945–December 1945).

8. Mary Kriger postcard, quoted in ZDC to PP, January 18, 1945, JCC. Oddly, this card is dated before Weston's letter to Nancy Newhall, even though it refers to events that presumably had not yet happened when Weston wrote to Newhall.

9. EW to JC, undated (but must be early 1945), JCC. Zohmah later bemoaned the fact that Kriger had done only twenty pages in the week that she was there: "Wish I could figure out a way to get the typing done. If only Mary Kriger had been more useful! 20 pages in a week didn't seem enough to suggest she try again." ZDC to EW, August 23, 1945, EWA/CCP.

10. EW to JC and ZDC, January 12, 1945, JCC.

11. Charlot, "The United States and the Renaissance," unpublished chapter, 557, "Mexican Mural Renaissance-Chapters Not Used" folder, JCC; it was apparently intended first as appendix 3 and then later as the final chapter (chap. 25). This section of Charlot's text was dropped at the suggestion of Yale University Press when the book was finally published. It appears that Charlot later extracted the material on Weston

with the intention of making it into a separate article, "Edward and Mexico," which remained unpublished until now. John Charlot, conversation with author, summer 2005; see the appendix to this book, "Edward and Mexico," by Jean Charlot.

12. Charlot, "United States and Renaissance," 559.

13. Charlot, "United States and Renaissance," 559–60.

14. Charlot, "United States and Renaissance," 560.

15. Speaking of Orozco and Rivera, Charlot later said that they "lived the rest of their lives copying their photographed portraits by Weston. They couldn't see themselves differently from what Weston had seen." Dody Weston Thompson, "Edward Weston: A Memoir and a Summation," 212.

16. EW to JC, February 28, 1945, JCC.

17. AC, #1773/1945.

18. EW to Nancy Newhall, May 11, 1943, NN/BNC/CCP.

19. EW to JC, March 22, 1945, JCC.

20. Zohmah passed some of this along to Prudence—about Weston's praise for Charlot's Georgia murals and about the photographs: "Poor Eugene gave the rest of us FULL credit as he didn't want to [be] blamed for our snapshots, even though he had to work very hard over the printing to get anything good enough out of the negatives." In the same letter she also reported on Leon: "Speaking of the Weston tribe, imagine my surprise on getting home from the grocery store the other day to find a note from Leon Wilson and Carolyn, evidently a brand new bride and groom. . . . They [the babysitters] reported her [Carolyn] as being very pretty, but what amused me and Jean was that she is a Wac, which don't you think, is an amusing wife for a consciencious [conscientious] objector. She is Smith graduate which is why they were here." ZDC to PP, March 30, 1945, JCC.

21. Charlot, "José Guadalupe Posada."

22. EW to JC, March 22, 1945, JCC.

23. AC, #1772/1945.

24. Wilson, *Weston: Nudes*, 16, quoted in AC, #1772/1945.

25. The ad is reproduced in Gilbert and Levin, *Make Believe World of Maxfield Parrish*, 45.

26. EW to Nancy Newhall, March 1945, NN/BNC/CCP, quoted in AC, #1772/1945.

27. EW to JC, April 27, 1945, JCC.

28. AC, #52/1920.

29. EW to Neil Weston, April 16–17, 1945, EWA/CCP.

30. EW to Neil Weston, May 8, 1945, EWA/CCP.

31. EW to Neil Weston, June 18, 1945, EWA/CCP.

32. "An Oral History Account of the Founding of the United Nations," Yale University, United Nations Studies at Yale (UNSY), certifying authority Jean Krasno, last modified May 8, 2000, copy in author's possession.

33. U.S. Department of State, "Principal Officers of the Department of State: Assistant Secretaries of State for European, Far Eastern, Near Eastern, and African Affairs," 1944–46, http://www.state.gov/www/about_state/history/officers.html, accessed July 9, 2003.

34. AC, #1776/1945.

35. AC, #1777/1945.

36. ZDC to PP, ca. Christmas 1945, JCC.

37. EW to ZDC and JC, undated (shortly before August 23, 1945), JCC.

38. ZDC to EW, August 23, 1945, EWA/CCP.

39. Argenteri, *Tina Modotti*, 195.

40. On the circumstances of Modotti's death, see Argenteri, *Tina Modotti*, 195–202.

41. EW to Neil Weston, September 4, 1945, EWA/CCP.

42. EW to Neil Weston, October 9, 1945, EWA/CCP.

43. EW to Newhalls, November 16, 1945, NN/BNC/CCP, quoted in AC, p. 41.

44. Nancy Newhall to EW, November 20, 1945, EWA/CCP.

45. ZDC to PP, January 30, 1946, JCC.

46. Beaumont Newhall, *Supreme Instants*, 42.

47. Nancy Newhall, *Photographs of Edward Weston*, 7, 10.

48. AC, p. 41.

49. Beaumont Newhall, *Focus*, 144.

50. AC, p. 42; Beaumont Newhall, *Supreme Instants*, 42.

51. Merle Armitage to JC, May 18, 1946, JCC.

52. EW to JC, ZDC, and "Frances" (presumably Ison), undated (probably early June 1946), JCC.

53. EW to Stephen C. Clark, April 1, 1946, quoted in AC, p. 42.

54. EW to Ansel Adams, July 22, 1946, AAA/CCP.

55. JC to EW, September 23, 1946, JCC.

56. EW to JC and ZDC, undated (probably October 1946), JCC.

57. The ad is reproduced in Pitts, *Edward Weston: Color Photography*, 14–15.

58. JC and ZDC to EW, January 28, 1947, EWA/CCP.

59. This would become chapter 23 ("Exit Vasconcelos, Enter Puig") of the final version of *Mexican Mural Renaissance* (294–303).

60. Charlot, *Mexican Mural Renaissance*, 298.

61. DB, 1:103–5 (November 15, 24, 1924). There are very slight discrepancies, barely worth mentioning, between what Charlot quoted and what appears in the published version of the daybooks.

62. JC and ZDC to EW, January 28, 1947, EWA/CCP.

63. EW to JC and ZDC, undated (marked "1946?" in pencil on reverse, but must be after January 28, 1947), JCC.

64. Wilson, *Through Another Lens*, 352–54.

65. ZDC to PP, undated (marked "Feb. 1939?" in pencil on reverse, but must be later, perhaps February 1947), JCC.

66. JC and ZDC to EW, March 23, 1947, EWA/CCP.

67. Charlot, *Mexican Mural Renaissance*, 298 and figs. 47a, 47b.

68. JC and ZDC to EW, March 23, 1947, EWA/CCP.

69. ZDC to PP, September 24, 1947, JCC.

70. Weston, "Color as Form." See also Enyeart, *Willard Van Dyke*, 245–49.

71. Weston and Wilson, *Cats of Wildcat Hill*; Wilson, *Through Another Lens*, 329.

72. Maddow, *Edward Weston: His Life and Photographs*, 269; Travis, *Weston: Last Years*, 43.

73. EW to Nancy Newhall, January 14–15, 1944, NN/BNC/CCP, quoted in AC, #1731/1944.

74. Weston and Wilson, *Cats of Wildcat Hill*, 5, 73; AC, #1712/1942, #1790/1945.

75. Weston and Wilson, *Cats of Wildcat Hill*, 9, 13, 15–18, 49.

76. AC, p. 43.

77. Weston, *Fifty Photographs*, plates 19, 20, 21.

78. Weston, afterword to Weston, *Fifty Photographs;* reprinted in Bunnell, *Edward Weston on Photography*, 148–49.

79. Beaumont Newhall, *Focus*, 67–68; Maloney, *U.S. Camera: 1943.*

80. ZDC to PP, December 20, 1947, JCC. There are two copies of *Fifty Photographs* in the JCC. One (#1017) is inscribed, "To my dear friends / Jean & Zohmah / with all my love / Edward." There is no date, but the inscription, in a relatively steady hand, was probably written around the time the book first came out. The second copy (#1344) was inscribed later, with shakier handwriting: "To Jean & Zohmah /—until we meet dear / friends, with all my / love—Edward 1951!" (He first wrote "1952" but then crossed out the "2" and added a "1").

81. JC and ZDC to EW, December 22, 1947, JCC.

82. JC diaries, January 20, February 17, 1948.

83. *The Charlot Collection of Edward Weston Photographs,* Honolulu Academy of Arts, September 13–October 28, 1984; there had also been an exhibition of Weston photographs at the Academy in 1947.

84. It was received on January 2, 1948. JC diaries, January 2, 1948.

85. Weston and Wilson, *Cats of Wildcat Hill*, 23, 26, 86.

86. EW to JC and ZDC, undated (probably early 1948), JCC.

87. EW to Chandler Weston, February 20, 1948, EWA/CCP.

88. Merle Armitage to EW, March 3, 1948, EWA/CCP.

89. EW to ZDC, undated (1948), JCC.

90. AC, #1826/1948.

91. EW to ZDC, undated (1948), JCC.

92. There is a card from Wallace in EWA/CCP acknowledging Weston's support; it is from 1946.

93. EW to Christel Gang, postmarked May 3, 1948, CGC/CCP.

94. EW to Christel Gang, undated (August 1948), CGC/CCP.

95. EW to Chandler Weston, May 21, 1948, EWA/CCP, quoted in Peeler, *Illuminating Mind*, 270.

96. Cole Weston, afterword to Maddow, *Edward Weston: His Life and Photographs*, 287.

97. Paul Strand to EW, October 1, 1948, EWA/CCP.

10. CARMEL AND HAWAI'I

1. "Art Center Students Cheer Jean Charlot, Dig for Facts," *Colorado Springs Free Press*, May 3, 1949, and related stories, in JC clippings file, 1947–1959, JCC.

2. The basic offer is described in the *Honolulu Advertiser*, April 28, 1949, when it was approved by the University of Hawai'i Board of Regents; Charlot noted in his diary that he had accepted the Hawai'i job. JC diaries, May 19, 1949.

3. ZDC to PP, May 27, 1949, JCC.

4. JC diaries, June 4, 1949.

5. JC diaries, June 5, 6, 1949.

6. JC diaries, June 7, 1949.

7. JC diaries, June 7, 1949.

8. According to Amy Conger, the Focal Press show in London was transferred to the U.S. Embassy gallery. AC, p. 63 (appendix C, "Exhibitions").

9. JC diaries, June 8, 1949, et seq.

10. JC diaries, June 12, 13, 1949.

11. JC and ZDC to EW, July 11, 1949, EWA/CCP. Jean wrote the first part of the letter at the beginning of July; Zohmah continued it about a week later, when the letter is dated.

12. It is listed as spring 1949 in AC, p. 63; judging from Weston's updates, it seems not to have opened until early the following year.

13. On Le Groupe des XV, see de Thézy, *Paris 1950*, 12.

14. EW to JC and ZDC, August 6, 1949, JCC.

15. *Honolulu Advertiser*, August 15, 1949.

16. JC diaries, August 2, 4, 1949; Betty Wilson, "Charlot's Mural Termed Beautiful Piece of Work," *Honolulu Star-Bulletin*, November 9, 1949, 14. For an important discussion of this fresco and Charlot's approach to Hawaiian culture more generally, see John Charlot, "Charlot and Classical Hawaiian Culture."

17. ZDC to PP, October 1, 1949, JCC.

18. EW to JC and ZDC, October 21, 1949, JCC.

19. ZDC to EW, October 27, 1949, EWA/CCP. The letters from Kriger and Starr are not in the JCC.

20. The actual painting began October 17 and continued until November 25; Charlot was assisted by two students, Richard Lucier and Raymond Brose.

21. ZDC to EW, October 27, 1949, EWA/CCP.

22. EW to ZDC and JC, undated (probably November or December 1949), JCC.

23. Brown, *Two Little Trains*; Brown, *Child's Good Night Book*.

24. Brenner, *Boy Who Could Do Anything*.

25. EW to JC and ZDC, undated (probably late 1949 or early 1950), JCC.

26. EW to JC and ZDC, January 19, 1950, JCC.

27. AC, p. 43.

28. Barbara Dorsam, "Mural Presented to University," *Honolulu Advertiser*, January 21, 1950, in JC clippings file, 1947–59, 527, JCC; Walter R. Johnson, "Hawaii: In Fresco," *Aloha* (February–April 1950): 16–22.

29. EW to ZDC and JC, March 31, 1950, JCC.

30. EW to ZDC and JC, March 31, 1950, JCC.

31. Weston, *My Camera on Point Lobos*.

32. Trachtenberg, "Final Years," 288.

33. Weston, *My Camera on Point Lobos*, 78 (quoting from his daybook entry for August 14, 1931; emphasis in original).

34. Weston, *My Camera on Point Lobos*, 78 (quoting his daybook entry for October 1, 1931).

35. Weston, *My Camera on Point Lobos*, unnumbered last page (A. A., "A Note on the Photographs").

36. Hammond, *Ansel Adams: Divine Performance*.

37. ZDC to EW, June 14, 1950, EWA/CCP.

38. The mural to which Zohmah referred was probably *Hawaiian Drummers*, portable fresco mural, 4 × 6 ft., May 5, 1950, originally in the John Young house, Honolulu, Hawai'i, and now in the office of Dr. Percival Chee, Kukui Plaza, Honolulu, Hawai'i.

39. JC diaries, July 24–September 1, 1950.

40. Charlot, "Catholic Art."

41. JC and ZDC to EW, October 31, 1950, EWA/CCP.

42. EW to JC and ZDC, December 5 (no year, but must be 1950), JCC.

43. Letter of agreement from Carl E. Hanson, president, Bishop National Bank of Hawaii at Honolulu, to JC, January 22, 1951, JCC. Charlot signed it the following day. The Bishop National Bank of Hawaii at Honolulu became the Bishop National Bank of Hawaii, then First National Bank of Hawaii, and later First Hawaiian Bank.

44. Memo by Ben Norris, February 28, 1951, JCC.

45. JC to EW, January 20, 1951, EWA/CCP.

46. Photographer unknown, *Jean Charlot and Zohmah*, Honolulu, 1951, EWA/CCP; another print is in the JCC, in a scrapbook.

47. Postcard from EW to JC, January 26, 1951, JCC.

48. EW to JC and ZDC, February 23 (no year, but probably 1951), JCC. It is not clear what Weston is referring to when he speaks of a Posada, but Charlot may have

sent him one of the prints from the 1947 portfolio Posada, *100 Woodcuts*, for which Charlot had written the foreword. It included proofs from original woodblocks—small vignettes or portraits—in the possession of the Vanegas Arroyo firm.

49. AC, p. 43.

50. Charlot, *Hopi Snake Dance. Preparing Anti-Venom Serum*, Administration Building, Arizona State College (now Arizona State University), Tempe, Arizona, June 27–July 20, 1951.

51. "Charlot Family through the Years," home movie, JCC-AF4, transferred to videotape, VF-54, JCC.

52. JC diaries, September 15, 1951.

53. JC diaries, September 15, 1951.

54. "Charlot Family through the Years."

55. JC diaries, September 17, 1951.

56. JC diaries, September 18, 1951.

57. EW to JC and ZDC, undated (but perhaps September 18, 1951), JCC.

58. JC diaries, September 18, 20, 25, 1951.

59. These probably include the picture of John Charlot printed by Dody Weston Thompson now in the JCC. It is not clear how Weston came to have the negatives again, since he had already turned them over to the Charlots (in 1943). Perhaps Zohmah or Jean brought them along on the trip. If so, the same negatives were soon returned to the Charlots (and are now in the JCC).

60. AC, #1744/1944 (where it is titled *Comics, Elliot Point*).

61. Jean Charlot, Zohmah Charlot, and John Charlot, interview by Dody (Weston) Thompson, August 18, 1975, transcript, JCC.

62. EW to JC and ZDC, undated (but probably late September 1951), JCC.

63. ZDC to EW, October 23, 1951, EWA/CCP.

64. Weston, *Fiftieth Anniversary Portfolio*.

65. Weston, "Fiftieth Anniversary Portfolio," in Bunnell, *Edward Weston on Photography*, 151.

66. Waikiki Branch of First National Bank of Hawaii (now First Hawaiian Bank), *Jean Charlot's Fresco Mural: Early Cultural Exchanges between Hawaii and the Outer World*, brochure, undated, JCC.

67. JC diaries, February 20, 1952.

68. EW to ZDC and JC, February 28, 1952, JCC.

69. ZDC to EW, March 22, 1952, EWA/CCP. The Charlots' copy of the portfolio is inscribed, "To my dear friends Jean and Zohmah with all my love, Edward—1952."

70. On the demise of the Photo League, see Bezner, *Photography and Politics*; Tucker, "Photo League."

71. The anonymous donor may have been Ansel Adams's friend Richard (Dick) McGraw, heir to the McGraw Edison fortune. Anne Hammond, note to author, January 11, 2009.

72. AC, p. 43. As Conger indicates, the only complete set, comprising 832 prints, is at the University of California at Santa Cruz, but many of the Project Prints are at CCP as well.

73. EW to JC and ZDC, June 5, 1953, JCC.

74. The painting was done in the fall of 1953; it was funded by an anonymous donor (Nesta Obermer) through the Watamull Foundation.

75. Brenner, *Hero by Mistake.*

76. ZDC to EW, July 14, 1953, EWA/CCP.

77. EW to JC and ZDC, March 7, 1954, JCC.

78. ZDC to EW, July 6, 1954, EWA/CCP.

79. EW to JC and ZDC, December 4, 1954, JCC.

80. JC to EW, undated (but must be December 1954), EWA/CCP.

81. The play, presented by the Honolulu Community Theater, was *My Three Angels,* by Sam and Bella Spewack; it opened at the Ruger Theater on December 1, 1954. Charlot played Joseph, a humanitarian French convict (no. 3011).

82. Parish, *Our Lady of Guadalupe.*

83. EW to ZDC and JC, undated (probably early 1956), JCC.

84. ZDC to EW, April 11, 1956, EWA/CCP.

85. *Family of Man,* 131.

86. ZDC to EW, April 11, 1956, EWA/CCP.

87. Jean Kellogg to the Charlots, telegram, January 1, 1958, JCC.

88. JC diaries, January 1, 1958.

89. John Charlot recalls that his parents were very quiet and somber that day. When he asked them what was wrong, they told him Edward had died and reminded him of their stay with Weston in Carmel. John Charlot, note to author, October 2007.

CODA

1. On Adams's work in Hawai'i, see Hammond, "Ansel Adams and Hawaiian Landscape."

2. JC diaries, April 21, 22, 1958.

3. *Compassionate Christ,* fresco, 10 × 7 ft., January 27–February 3, 1958; *Way of the Cross,* fourteen ceramic-tile panels, each 3 × 2 ft., 1958, St. Catherine's Church, Kapa'a, Kaua'i.

4. JC diaries, April 25, 1958.

5. James Alinder, *Ansel Adams,* 51.

6. Ansel Adams to JC and ZDC, May 2, 1958, JCC.

7. Adams and Joesting, *Islands of Hawaii,* fig. 41.

8. Adams and Joesting, *Islands of Hawaii,* fig. 86.

9. JC diaries, September 2, 1958.

10. JC diaries, November 15, 1959.

11. JC scrapbooks, June 1959–January 1962, box 1, JCC.

12. *Night Hula*, ceramic tile mural, 9 × 15 ft., Tradewind Apartments, Waikīkī, Honolulu, Hawai'i, October 1961 (technician: Isami Enomoto), now installed at Saunders Hall, University of Hawai'i at Mānoa; *Black Christ and Worshipers* (main altar), *St. Joseph's Workshop; The Annunciation* (side altars), 10 × 12 ft., St. Francis Xavier Church, Naiserelagi, Province of Ra, Fiji, December 24, 1962–January 4, 1963). On Charlot's work in Fiji, see Klarr, "Painting Paradise."

13. Charlot, *Mexican Mural Renaissance*.

14. Charlot, *Three Plays*.

15. A list of the original purchasers of the various pieces is included in the JC checklist for 1966.

16. *Early Contacts of Hawaii with the Outer World*, fresco mural in two sections, 9 x 98 ft. (all together), First National Bank of Hawaii (now First Hawaiian Bank), Waikīkī Branch, August 9–November 26, 1966. Unfortunately, this new version, too, has since been severely compromised. In 2007, during a renovation of the branch office, the larger panel was cut into three sections and then reinstalled in two sections. Bank officials initially intended to cut out a significant portion from the center of the larger panel and remove it from the bank altogether, which would have destroyed the visual and narrative integrity of the work; they were eventually persuaded to keep the entire mural together, but the main panel of Charlot's fresco was cut apart, rearranged, and reinstalled in a smaller space, ruining the flowing sculptural sweep of the original arrangement.

17. Orozco, *Artist in New York*.

18. Charlot, *Artist on Art*, 171–76.

19. Charlot, *Picture Book II*.

20. *The Relation of Man and Nature in Old Hawaii*, fresco mural, 23 x 104 ft. (overall), Leeward Community College, Pearl City, O'ahu, Hawai'i (February 14–May 17, 1974).

21. John Charlot, "Charlot and Classical Hawaiian Culture," 78–80.

22. *On Strike at the Capitol; Refuse Collectors; Hospital Laundry; The Strike in Nuuanu; Road and Board of Water Supply Workers; Cafeteria Workers and Custodians*, ceramic tile murals, United Public Workers Building, School Street, Honolulu, Hawai'i, July 1970, November 1971, October 1972, August 1973, June 1974, and May 1975 (technician: Isami Enomoto).

23. Jean Charlot, Zohmah Charlot, and John Charlot, interview by Dody (Weston) Thompson, August 18, 1975, transcript, JCC.

24. ZDC to Ansel and Virginia Adams, January 3, 1976, AAA/CCP.

25. Morse, *Jean Charlot's Prints*.

26. Ansel Adams to ZDC, September 22, 1979, JCC.

27. Brett Weston to ZDC, September 26, 1979, JCC.

28. CW to ZDC, October 5, 1979, JCC.

29. Wilson, *Through Another Lens*, 293.

30. Wilson, *Through Another Lens*, 293–94.

31. CW to ZDC, February 14, 1983, JCC.

32. Zohmah Charlot, "In Weston's World," 10.

33. CW to ZDC, December 17, 1984, JCC. Zohmah would later sell some of her Weston prints at auction (Sotheby's Photographs, New York, November 1 and 2, 1988, lots 545–63); Charis had offered some advice on that score in some of her letters. One of the pictures included in the sale, *Eel River Ranch*, 1937, is inscribed by the photographer, "Edward loves Zohmah on December 18th, 1938 (other days too)." Lot 556; AC, #1155/1937.

34. Wilson, *Through Another Lens*.

35. John Charlot to CW, March 1, 1999. My thanks to John Charlot for having shared his letter with me.

BIBLIOGRAPHY

FURTHER READING

For basic biographical information on Jean Charlot, a good place to begin is Anita Brenner's *Idols behind Altars*; Charlot himself wrote about his role in the Mexican Mural Renaissance in *The Mexican Mural Renaissance, 1920–1925*. Charlot's writings on art are collected in a number of volumes, including *An Artist on Art*, and his writings in Spanish and French are published on the website of the Jean Charlot Foundation, at http://www.jeancharlot.org. See also Prithwish Neogy and Francis Haar, *Artists of Hawaii*, vol. 1, with an introduction by Jean Charlot, and the exhibition catalog *Jean Charlot: Paintings, Drawings, and Prints*, with essays by Lester C. Walker Jr., John Charlot, Laurence Schmeckebier, Lamar Dodd, and Jean Charlot.

Of fundamental importance is Peter Morse's catalogue raisonné, *Jean Charlot's Prints*. In 1968 Jean and Zohmah prepared a listing of Charlot's major works in *Jean Charlot: Books, Portfolios, Writings, Murals*, which was revised in 1975 and again in 1986, with the help of Peter Morse; it includes a selected bibliography of works on the artist.

In 1990 the University of Hawai'i Art Gallery held a retrospective exhibition of Charlot's work, organized by its director, Tom Klobe; the catalog for the exhibition, *Jean Charlot: A Retrospective*, includes an overview of Charlot's life and career by Karen Thompson ("Jean Charlot: Artist and Scholar") and essays by John Charlot, James Jensen, Mike Weaver, and Nancy J. Morris. Four years later another comprehensive exhibition of Charlot's work was held in Mexico City, which then traveled to other locations in Mexico; the exhibition catalog (*México en lo obra de Jean Charlot*, edited by Milena Koprivitza and Blance Garduño Pulido) reprints some of the essays from the University of Hawai'i catalog and includes additional material by José Luis Martínez H., Donald McVicker, Milena Koprivitza, Mario Rendón Lozano, and

343

others. More recently, Tatiana Flores speaks of Charlot at some length in her dissertation, "*Estridentismo* in Mexico City, 1921–1924." Meanwhile, Caroline Klarr has written an illuminating study of Charlot's Fiji frescos in "Painting Paradise for a Post-colonial Pacific"; it is posted at http://www.jeancharlot.org/onJC/books.

John Charlot, the artist's son and one of the contributors to the catalogs just cited, has written many other important articles about his father covering various aspects of his achievement; see, for example, John Charlot, "Jean Charlot's First Fresco," available at http://www.jeancharlot.org/onJC/writings. He is currently working on a rigorously documented, monumental biography of his father, which is part academic study and part personal memoir. Thus far he has completed a very extensive section on Charlot's early years in Europe before he moved to Mexico: John Charlot, "Jean Charlot: Life and Work," vol. 1, "The French Period," available at http://www.jeancharlot.org/onJC/books/. Although incomplete, this biography already broadens our understanding of the artist considerably and is an invaluable resource. More recently, John Charlot has written about his father's activity as an art historian in an as-yet-unpublished monograph, "'Pintor y escritor yo mismo': Jean Charlot as Historian of Mexican Art." For additional information on Charlot in Mexico and beyond, see also Susannah Joel Glusker, *Anita Brenner: A Mind of Her Own*, Glusker's edition of Brenner's Journals, *Avant-Garde Art and Artists in Mexico*, and Susan Vogel, *Becoming Pablo O'Higgins*.

On Edward Weston, the obvious starting point is his diaries (*The Daybooks*), which cover his years in Mexico and the period immediately following, after he returned to California. Subsequent discussions of Weston's life and work, including this one, have drawn extensively on them. Another oft-cited account, which itself relies heavily on the daybooks, is Ben Maddow's biography, first published in 1973 as *Edward Weston: Fifty Years*. Maddow tends to dwell on the sections that describe the photographer's sexual adventures, and he focuses on the darker aspects of Weston's musings. In Maddow's account, Weston's jealousies, regrets, money troubles, and moments of depression overshadow the joy and satisfaction he derived from his personal relationships and his photographic work. For a related view see Janet Malcom, *Diana and Nikon: Essays on Photography*, 9–25.

In more recent years Weston's work has been studied in greater depth, and a more nuanced and detailed picture has emerged. An important step was taken by Amy Conger, whose dissertation, "Edward Weston's Early Photography: 1903–1926," includes a catalogue raisonné of Weston's early work in California and Mexico, prior to 1927. Part of this material was published in conjunction with an exhibition in San Francisco on Weston's years in Mexico. See Conger, *Edward Weston in Mexico: 1923–1926*. Another helpful resource is *Edward Weston on Photography*; a collection of Weston's writings on photography edited by Peter Bunnell, it includes a number of pieces discussed

here. See also Beaumont Newhall and Amy Conger, eds., *Edward Weston Omnibus: A Critical Anthology*, which brings together a wide range of writings about Weston, including an essay by Charlot and a memoir by Dody Weston Thompson, Weston's assistant in the 1940s and later his daughter-in-law. Charlot's essay was later reprinted in *The Charlot Collection of Edward Weston Photographs*, edited by Van Deren Coke, which also included an essay by Zohmah Charlot.

Not surprisingly, 1986, the centennial of Weston's birth, was a banner year for Weston studies. From among the works that appeared at that time, see Susan Danly and Weston J. Naef, *Edward Weston in Los Angeles*; Amy Conger, "Edward Weston: A Preface to the Carmel Years" and "Edward Weston: The Monterey Photographic Tradition"; and Terrence Pitts, *Edward Weston: Color Photography*, with short pieces by Weston himself and by Nancy Newhall, both reprinted from *Modern Photography* (December 1953). Another publication celebrating the centennial is *EW 100*, edited by Peter Bunnell and David Featherstone, which contains important essays by Amy Conger, Alan Trachtenberg, Charis Wilson, and others. The same year Beaumont Newhall curated an exhibition that offered an overview of Weston's photography drawn from the collection of the Center for Creative Photography in Tucson, one of the largest collections of Weston's prints. In his essay for the book that accompanied the exhibition (Newhall, *Supreme Instants*), Newhall focused primarily on Weston's stylistic development and technique but in addition provided some personal recollections of the photographer. The Center for Creative Photography has also published useful collections of letters, such as *The Letters between Edward Weston and Willard Van Dyke*, edited by Leslie Squyres Calmes. Additional letters are included in *Laughing Eyes: A Book of Letters between Edward and Cole Weston, 1923–1946*, edited by Paulette Weston.

One of the most essential sources for any rigorous study of Weston's work is Amy Conger's *Edward Weston: Photographs from the Collection of the Center for Creative Photography*. It is a detailed catalog of the Weston photographs at the Center. Although focused on a single collection (and inevitably incomplete), it is the closest to a full catalogue raisonné of Weston's work throughout his career that we are likely to have in the foreseeable future, and it has put Weston studies on a much more solid footing. It also includes a useful and reliable biography, more balanced than Maddow's, as well as an extensive bibliography and other data. Another essential source is Charis Wilson's *Through Another Lens*. An important account of Wilson's years with Weston and a window on a significant phase of Weston's life, it provides a great deal of useful detail and explanations not available otherwise (including material on Zohmah Charlot) on which I have relied. Wilson calls Maddow's portrayal of Weston into question. For further insights on Weston, see also Wilson's *Edward Weston: Nudes*.

In recent years an increasing number of studies have focused on particular phases or aspects of Weston's career, mostly in conjunction with exhibitions. In particular, over

the course of the 1990s the Boston Museum of Fine Arts issued a series of volumes based on exhibitions organized by subject categories and drawn from the collection of William H. Lane and Saundra B. Lane (another extensive collection of Weston's work, comprising about two thousand prints). The volumes include a number of noteworthy essays on various aspects of Weston's career. The first covered Weston's portraits and nudes (Theodore E. Stebbins Jr., *Weston's Westons: Portraits and Nudes*). The second focused on his landscape work, especially during the Guggenheim years, and included a foreword by Charis Wilson (Karen E. Quinn and Theodore E. Stebbins Jr., *Weston's Westons: California and the West*). The culminating volume in the series was devoted to Weston's relation to modernism in his early work, in the work he did in Mexico, and later on (Theodore E. Stebbins Jr., Karen Quinn, and Leslie Furth, *Edward Weston: Photography and Modernism*). In this context, mention should also be made of *Edward Weston: Forms of Passion*, edited by Gilles Mora, which is an overview of Weston's imagery that also includes instructive essays on various phases of Weston's career by Gilles Mora, Terence Pitts, Trudy Wilner Stack, Theodore E. Stebbins Jr., and Alan Trachtenberg.

More recent overviews of Weston's career include: *Edward Weston, 1886–1958*, edited by Manfred Heiting, with an essay by Terence Pitts and a personal portrait by Ansel Adams; and David P. Peeler, *The Illuminating Mind in American Photography*. Peeler combines his account of Weston—a kind of intellectual biography, which includes new and useful material—with discussions of Alfred Stieglitz, Paul Strand, and Ansel Adams and devotes considerable attention to the links among them. In the late 1990s and early 2000s several noteworthy Weston exhibitions were held and resulted in significant publications, including Beth Gates Warren's study of Weston's association with Margrethe Mather (*Margrethe Mather and Edward Weston: A Passionate Collaboration*); David Travis's book on Weston's late work (*Edward Weston: The Last Years in Carmel*); and Jennifer A. Watts's *Edward Weston: A Legacy*. The latter work centered on pictures from the Huntington Library's collection, selected by Weston himself in the 1940s, mostly from the Guggenheim years; in addition to an introduction by Watts, the book includes essays by Jonathan Spaulding (on the Guggenheim project), Susan Danly (on the *Leaves of Grass* photographs), and Jessica Todd Smith (on an unpublished book of Weston's nudes assembled by Nancy Newhall in the 1950s). See also *Edward Weston's Book of Nudes*, edited by Brett Abbott.

Another useful collection is *Edward Weston: Life Work*, which accompanied a traveling exhibition and includes a brief biographical essay by Sarah M. Lowe and a revised version of Dody Weston Thompson's memoir, originally published in 1970. Like Charis Wilson, Thompson takes issue with Maddow's characterization of Weston. Similarly, in a volume published in conjunction with an exhibition organized by the Dayton Art Institute, Alexander Lee Nyerges, like Wilson and Thompson, sought to revise past misconceptions about Weston's life and character and emphasized his

family life (*Edward Weston: A Photographer's Love of Life*); the exhibition centered on the collection of John W. and Dede Longstreth, most of which originally belonged to Weston's sister, May Weston Seaman. Still more recently, Amy Conger has argued against the notion that Weston was obsessed with sex and photographed nudes more than any other subject (*Edward Weston: The Form of the Nude*). For interesting commentary on Weston's work, see also *In Focus: Edward Weston, Photographs from the J. Paul Getty Museum*.

Tina Modotti, who figures prominently in the first part of this story, has likewise received a good deal of attention in recent years, and Weston — or at least his Mexican period — is frequently considered in that context as well. In some cases Charlot is also mentioned, if only in passing. See especially Mildred Constantine, *Tina Modotti: A Fragile Life*; Margaret Hooks, *Tina Modotti: Photographer and Revolutionary*; Sarah M. Lowe, *Tina Modotti: Photographs*; Patricia Albers, *Shadows, Fire, Snow: The Life of Tina Modotti*; Letizia Argenteri, *Tina Modotti: Between Art and Revolution*; and Sarah M. Lowe, *Tina Modotti and Edward Weston: The Mexico Years. The Letters from Tina Modotti to Edward Weston*, edited by Amy Stark, is a remarkable collection and an important resource. In addition, see Riccardo Toffoletti, ed., *Tina Modotti: Una vita nella storia*, which contains many useful essays, including one by Amy Conger, "Tina Modotti: Una metodologia, una proposta, e una lettera d'amore perduta" [Tina Modotti: A methodology, a proposal, and a lost love letter], that sheds light on her own study of Weston, rooted as it is in Renaissance examples. James L. Enyeart's *Willard Van Dyke: Changing the World through Photography and Film* includes much valuable information on Weston and his world from the perspective of another artist who played a part in Weston's story.

SELECTED SOURCES

Abbott, Bernice. "Eugène Atget." *Creative Art* 5, no. 3 (September 1929): 651–56.

Abbott, Brett, ed. *Edward Weston's Book of Nudes*. Based on an unpublished book compiled by Nancy Newhall and Edward Weston. Los Angeles: J. Paul Getty Museum; Tucson: Center for Creative Photography and University of Arizona, 2007.

Adams, Ansel. "Photography." *The Fortnightly* 1 (December 18, 1931): 21–22. Reprinted in Newhall and Conger, eds., *Edward Weston Omnibus*, 45–47.

———. Review of *The Art of Edward Weston*, edited by Merle Armitage. *Creative Art* 12 (May 1933): 386–87. Reprinted in Newhall and Conger, eds., *Edward Weston Omnibus*, 50–51.

Adams, Ansel, and Edward Joesting. *The Islands of Hawaii*. Honolulu: Bishop National Bank of Hawaii, 1958.

Adams, Robert. *Why People Photograph*. New York: Aperture, 1994.

Aikin, Roger. "Henrietta Shore and Edward Weston." *American Art* 6 (1992): 43–61.

Albers, Patricia. *Shadows, Fire, Snow: The Life of Tina Modotti.* New York: Clarkson Potter, 1999.

Alinder, James. *Ansel Adams: 50 Years of Portraits.* Untitled 16. Carmel CA: Friends of Photography, 1978.

Alinder, Mary Street. *Ansel Adams: A Biography.* New York: Henry Holt, 1996.

Alinder, Mary Street, and Andrea Gray Stillman, eds. *Ansel Adams: Letters 1916–1984.* Boston: Little, Brown, 2001.

Andrews, Lew. "The Sequential Arrangement of Walker Evans's *American Photographs.*" *History of Photography* 18, no. 3 (Autumn 1994): 264–71.

Anreus, Alejandro. *Orozco in Gringoland: The Years in New York.* Albuquerque: University of New Mexico Press, 2001.

Argenteri, Letizia. *Tina Modotti: Between Art and Revolution.* New Haven: Yale University Press, 2003.

Armitage, Merle. *Accent on Life.* Ames: Iowa State University Press, 1965.

———, ed. *The Art of Edward Weston.* New York: E. Weyhe, 1932.

———, ed. *Henrietta Shore.* With essays by Edward Weston and Reginald Poland and a frontispiece by Jean Charlot. New York: E. Weyhe, 1933.

Atget: Photographe de Paris. With an introduction by Pierre Mac Orlan. Paris: Henri Jonquières; New York: E. Weyhe, 1930. Also published as *Eugène Atget: Lichtbilder.* With an introduction by Camille Recht. Leipzig: Henri Jonquières, 1930.

Barna, Yon. *Eisenstein.* Bloomington: Indiana University Press, 1973.

Barr, Alfred H., Jr. *Matisse: His Art and His Public.* New York: Museum of Modern Art, 1951.

Beals, Carleton. *Glass Houses.* Philadelphia: Lippincott, 1938.

———. *House in Mexico.* New York: Hastings House, 1958.

Belloc, Hilaire. *Characters of the Reformation.* New York: Sheed and Ward, 1936.

Bezner, Lili Corbus. *Photography and Politics in America: From the New Deal into the Cold War.* Baltimore: Johns Hopkins University Press, 1999.

Bordwell, David. *The Cinema of Eisenstein.* Cambridge MA: Harvard University Press, 1993.

Boskovits, Miklós, and David Alan Brown. *Italian Paintings of the Fifteenth Century.* Washington DC: National Gallery of Art, 2003.

Bragdon, Claude. *The Frozen Fountain: Being Essays on Architecture and the Art of Design in Space.* New York: Alfred A. Knopf, 1932.

Brenner, Anita. *Avant-Garde Art and Artists in Mexico: Anita Brenner's Journals of the Roaring Twenties.* Edited by Susannah Joel Glusker, with a foreword by Carlos Monsiváis. Austin: University of Texas Press, 2010.

———. *The Boy Who Could Do Anything, and Other Mexican Folk Tales.* With illustrations by Jean Charlot. New York: William R. Scott, 1942. Rev. ed., Hamden CT: Linnet Books, 1992.

———. Foreword to *Jean Charlot: Exhibition of Mexican Paintings*. New York: Art Students League, 1930.

———. *A Hero by Mistake*. With illustrations by Jean Charlot. New York: William R. Scott, 1953.

———. *Idols behind Altars*. New York: Payson and Clarke, 1929.

———. *The Wind That Swept Mexico: The History of the Mexican Revolution 1910–1942*. With 184 historical photographs assembled by George R. Leighton. New York: Harper and Brothers, 1943.

Britton, John. *Carleton Beals: A Radical Journalist in Latin America*. Albuquerque: University of New Mexico Press, 1987.

Brown, Margaret Wise. *A Child's Good Night Book*. With illustrations by Jean Charlot. New York: William R. Scott, 1950. Rev. ed., New York: Harper Collins, 1992.

———. *Two Little Trains*. With illustrations by Jean Charlot. New York: William R. Scott, 1949.

Bullard, E. John. "Edward Weston in Louisiana." In *Edward Weston and Clarence John Laughlin: An Introduction to the Third World of Photography*, 11–18. New Orleans: New Orleans Museum of Art, 1982.

Bunnell, Peter, ed. *Edward Weston on Photography*. Salt Lake City: Peregrine Smith Books, 1983.

Bunnell, Peter, and David Featherstone, eds. *EW 100: Centennial Essays in Honor of Edward Weston*. Untitled 41. Carmel CA: Friends of Photography, 1986.

Burns, Tom. *The Use of Memory: Publishing and Further Pursuits*. London: Sheed and Ward, 1993.

Calmes, Leslie Squyres, ed. *The Letters between Edward Weston and Willard Van Dyke*. The Archive 30. Tucson: Center for Creative Photography, University of Arizona, 1981.

Cancil, Luis R., ed. *Latin American Spirit: Art and Artists in the United States, 1920–1970*. New York: Bronx Museum of the Arts / Harry N. Abrams, 1988.

Cane, Florence. *The Artist in Each of Us*. New York: Pantheon Books, 1951. Rev. ed., Craftsbury Common VT: Art Therapy Publications, 1983.

Charlot, Jean. *Art: From the Mayans to Disney*. New York: Sheed and Ward, 1939.

———. *An Artist on Art: Collected Essays of Jean Charlot*. Honolulu: University of Hawai'i Press, 1972.

———. *Art-Making from Mexico to China*. New York: Sheed and Ward, 1950.

———. "Art, Quick or Slow." *Magazine of Art* (November 1934). Reprinted in Charlot, *Art: From the Mayans to Disney*, 143–50.

———. "Catholic Art, Its Quandaries." In Charlot, *Art-Making*, 264–65.

———. *Charlot Murals in Georgia*. With an introduction by Lamar Dodd. Athens: University of Georgia Press, 1945.

———. *Choris and Kamehameha*. Honolulu: Bishop Museum Press, 1958.

————. "The Critic, the Artist, and the Problems of Representation." *American Scholar* (Spring 1937), 131–44. Reprinted in Charlot, *Art: From the Mayans to Disney*, 117–42.

————. "Cubism R.I.P." *American Scholar* (Winter 1938–39). Reprinted in Charlot, *Art: From the Mayans to Disney*, 193–220.

————. "An Estimate and a Tribute to Weston from a Painter." In Armitage, ed., *Art of Edward Weston*, 4.

————. "Henrietta Shore." In Charlot, *Art: From the Mayans to Disney*, 174–79.

————. "José Guadalupe Posada: Printmaker to the Mexican People." *The Magazine of Art* (January 1945). Reprinted in Charlot, *Art-Making*, 65–80.

————. "Martinez Pintao, Sculptor." *El democrata* (August 5, 1923). Reprinted in English as "Martinez Pintao" in Charlot, *Art: From the Mayans to Disney*, 94–99.

————. *Mexican Art and the Academy of San Carlos, 1785–1915*. Austin: University of Texas Press, 1962.

————. *The Mexican Mural Renaissance 1920–1925*. New Haven: Yale University Press, 1963.

————. *Picture Book: Thirty-Two Original Lithographs*. With inscriptions by Paul Claudel, translated into English by Elise Cavanna. New York: J. Becker, 1933.

————. *Picture Book II: 32 Original Lithographs and Captions*. Los Angeles: Zeitlin and Ver Brugge, 1973.

————. *Pictures and Picture Making: A Series of Lectures*. Mimeograph, Disney Studios, Hollywood, 1938. Copy in Jean Charlot Collection, Hamilton Library, University of Hawai'i at Mānoa, Honolulu HI.

————. "Pulqueria Paintings." *Forma* 1:1 (October 1926). Reprinted in Charlot, *Art: From the Mayans to Disney*, 62–66.

————. *Three Plays of Ancient Hawaii*. Honolulu: University of Hawai'i Press, 1963.

Charlot, Jean, and Zohmah Charlot. *Jean Charlot: Books, Portfolios, Writings, Murals*. Revised with the help of Peter Morse. Honolulu: Privately published, 1986.

Charlot, John. "The Formation of the Artist: Jean Charlot's French Period." In *Jean Charlot: A Retrospective*, 34–57.

————. "Jean Charlot: Life and Work." Vol. 1, "The French Period." Unpublished draft, 2006. http://www.jeancharlot.org/onJC/books/.

————. "Jean Charlot and Classical Hawaiian Culture." *Journal of Pacific History* 41, no. 1 (June 2006): 61–80.

————. "Jean Charlot and Local Cultures." *Georgia Museum of Art Bulletin* 2, no. 2 (Fall 1976): 26–35.

————. "Jean Charlot y Luz Jiménez." *Parteaguas: Revista del Instituto Cultural de Aguascalientes* 2, no. 8 (Spring 2007): 83–100. English original available at http://www.jeancharlot.org/onJC/writings/JohnCharlotOnJean.

————. "'Pintor y escritor yo mismo': Jean Charlot as Historian of Mexican Art." Unpublished, 2006.

———. "El primer fresco de Jean Charlot: *La masacre en el Templo Mayor*." In *Memoria Congreso Internacional de Muralismo: San Ildefonso, cuna del Muralismo Mexicano; Reflexiones historiográficas y artísticas*, 243–79. Mexico City: Antiguo Colegio de San Ildefonso, 1999. English original available at http://www.jeancharlot.org/onJC/writings/JohnCharlotOnJean.

Charlot, Zohmah. "In Weston's World." In Coke, ed., *Charlot Collection of Weston Photographs*, 8–14.

———. *Mexican Memories*, ed. Ronn Ronck. Honolulu: Privately published, 1989. Rev. ed., 1993.

Charnay, Désiré. *Ancient Cities of the New World*. London: Chapman and Hall, 1887.

Christie, Ian, and Richard Taylor. *Eisenstein Rediscovered*. London: Routledge, 1993.

Claudel, Paul. *Jean Charlot*. Paris: Nouvelle Revue Française, 1932.

———. "Jean Charlot." In *Jean Charlot, Watercolors and Drawings*, 1–6. New York: John Becker Gallery, 1931.

Coke, Van Deren, ed. *The Charlot Collection of Edward Weston Photographs*. With essays by Jean Charlot and Zohmah Charlot. Honolulu: Honolulu Academy of Arts, 1984.

Coleman, A. D. "Conspicuous by His Absence: Concerning the Mysterious Disappearance of William Mortensen." In *Depth of Field: Essays on Photography, Mass Media, and Lens Culture*, 91–112. Albuquerque: University of New Mexico Press, 1998.

———. "The Directorial Mode: Notes toward a Definition." *Artforum* 15, no. 1 (September 1976): 55–61. Reprinted in Coleman, *Light Readings: A Photography Critic's Writings, 1968–1978*, 246–57. New York: Oxford University Press, 1979; Albuquerque: University of New Mexico Press, 1998.

———. "The Image in Question: Further Notes on the Directorial Mode." In *Depth of Field: Essays on Photography, Mass Media, and Lens Culture*, 53–61. Albuquerque: University of New Mexico Press, 1998.

Conger, Amy. *Edward Weston: The Form of the Nude*. New York: Phaidon, 2005.

———. *Edward Weston: Photographs from the Collection of the Center for Creative Photography*. Tucson: Center for Creative Photography and University of Arizona, 1992.

———. "Edward Weston: A Preface to the Carmel Years" and "Edward Weston: The Monterey Photographic Tradition." In *Monterey Photographic Tradition: The Weston Years*, 5–55.

———. *Edward Weston in Mexico: 1923–1926*. Albuquerque: University of New Mexico Press, 1983.

———. "Edward Weston's Early Photography: 1903–1926." PhD diss., University of New Mexico, 1982.

———. "Tina Modotti: Una metodologia, una proposta, una lettera d'amore perduta" [Tina Modotti: A methodology, a proposal, and a lost love letter]. In Toffoletti, ed., *Tina Modotti*, 271–304.

———. "Tina Modotti and Edward Weston: A Reevaluation of Their Photography." In Bunnell and Featherstone, eds., *EW 100*, 70–71.

Constantine, Mildred. *Tina Modotti: A Fragile Life*. 1983. Reprint, San Francisco: Chronicle Books, 1993.

Cuevas-Wolf, Cristina. "Indigenous Cultures, Leftist Politics, and Photography in Mexico from 1921 to 1940." PhD diss., Northwestern University, 1997.

Danly, Susan. "'Literally Photographed': Edward Weston and Walt Whitman's *Leaves of Grass*." In Watts, ed., *Edward Weston*, 55–81.

Danly, Susan, and Weston J. Naef. *Edward Weston in Los Angeles*. San Marino CA: Huntington Library and Art Gallery; Malibu CA: J. Paul Getty Museum, 1986.

Davis, Keith F. *Désiré Charnay, Expeditionary Photographer*. Albuquerque: University of New Mexico Press, 1981.

———. "Edward Weston in Context." In *Edward Weston: One Hundred Photographs from the Nelson-Atkins Museum of Art and the Hallmark Photographic Collection*, 62–65. Kansas City: Rockhill Nelson Trust, 1982.

Del Rio, Amelia Martinez. *The Sun, the Moon, and a Rabbit*. With illustrations by Jean Charlot. New York: Sheed and Ward, 1935.

de Thézy, Mare, with Marcel Bovis and Catherine Floc'hlay. *Paris 1950 / photographié par le Groupe des XV*. Paris: Bibliothèque historique de la ville de Paris, 1982.

Doering, Bernard E. *Jacques Maritain and the French Catholic Intellectuals*. Notre Dame IN: University of Notre Dame Press, 1983.

Edwards, Edward B. *Dynamarhythmic Design: A Book of Structural Pattern*. New York: Century Company, 1932.

Edwards, Emily. *Painted Walls of Mexico: From Prehistoric Times until Today*. With photographs by Manuel Alvarez Bravo and a foreword by Jean Charlot. Austin: University of Texas Press, 1966.

Edward Weston: Life Work. Photographs from the collection of Judith G. Hochberg and Michael P. Mattis; with essays by Sarah M. Lowe and Dody Weston Thompson. Revere PA: Lodima Press, 2003.

Edward Weston and Clarence John Laughlin: An Introduction to the Third World of Photography. New Orleans: New Orleans Museum of Art, 1982.

Ehrlich, Susan, ed. *Pacific Dreams: Currents of Surrealism and Fantasy in California Art, 1934–1957*. Los Angeles: Armand Hammer Museum and University of California, 1995.

Enyeart, James L. *Willard Van Dyke: Changing the World through Photography and Film*. Albuquerque: University of New Mexico Press, 2008.

Epstein, Jacob. *Epstein: An Autobiography*. London: Vista Books, 1963.

The Family of Man: The Photographic Exhibition Created by Edward Steichen for the Museum of Modern Art. New York: Simon and Schuster, 1955.

Flores, Tatiana. "*Estridentismo* in Mexico City, 1921–1924: Dialogues between Mexican Avant-Garde Art and Literature." PhD diss., Columbia University, 2003.

Foley, Kathy. *Edward Weston's Gifts to His Sister.* Dayton OH: Dayton Art Institute, 1978.

Furth, Leslie. "Starting Life Anew: Mexico, 1923–1926." In Stebbins, Quinn, and Furth, ed., *Edward Weston*, 25–56.

Ghyka, Matila. *L'esthétique des proportions dans la nature et dans les arts.* Paris: Gallimard, 1927. Published in English as *The Geometry of Art and Life.* New York: Sheed and Ward, 1926; repr., New York: Dover, 1977.

Gilbert, Alma, and Sue Levin. *The Make Believe World of Maxfield Parrish.* San Francisco: Pomegranate Artbooks, 1990.

Glatte, H. *Shorthand Systems of the World: A Concise Historical and Technical Review.* New York: Philosophical Library, 1959.

Glusker, Susannah Joel. *Anita Brenner: A Mind of Her Own.* Austin: University of Texas Press, 1998.

Goodwin, James. *Eisenstein, Cinema, and History.* Urbana: University of Illinois Press, 1993.

Grundberg, Andy. "Edward Weston's Late Landscapes." In Bunnell and Featherstone, eds., *EW 100*, 93–101.

Hambidge, Jay. *Dynamic Symmetry: The Greek Vase.* New Haven: Yale University Press, 1920.

———. *The Elements of Dynamic Symmetry.* New York: Brentano's, 1926. Reprint, New York: Dover, 1967.

———. *The Parthenon and Other Greek Temples: Their Dynamic Symmetry.* New Haven: Yale University Press, 1924.

———. *Practical Applications of Dynamic Symmetry*, ed. Mary C. Hambidge. New Haven: Yale University Press, 1932.

Hammond, Anne. *Ansel Adams: Divine Performance.* New Haven: Yale University Press, 2002.

———. "Ansel Adams and Hawaiian Landscape." In *History of Photography* 26, no. 1 (Spring 2002): 42–46.

Harris, Mary Emma. *The Arts at Black Mountain College.* Cambridge MA: MIT Press, 1987.

Heiting, Manfred, ed. *Edward Weston, 1886–1958.* With an essay by Terence Pitts and a personal portrait by Ansel Adams. Cologne: Taschen, 1999.

Henrietta Shore, A Retrospective Exhibition: 1900–1963. With essays by Roger Aikin and Richard Lorenz. Monterey CA: Monterey Peninsula Museum of Art, 1986.

Herrera, Hayden. *Frida: A Biography of Frida Kahlo.* New York: Harper and Row, 1983.

———. *Frida Kahlo: The Paintings.* New York: Harper Collins, 1993.

Heyman, Therese, ed. *Seeing Straight: The f.64 Revolution in Photography.* Oakland: Oakland Museum, 1992.

Hinton, A. Horsley. "Pictorial Photography." In *Encyclopaedia Britannica*, 13th ed., 1926.

Holroyd, Michael. *Augustus John: A Biography*. New York: Holt, Rinehart and Winston, 1975.

Hooks, Margaret. *Tina Modotti: Photographer and Revolutionary*. San Francisco: Pandora / Harper Collins, 1993.

Hurlburt, Laurance P. *The Mexican Muralists in the United States*. Albuquerque: University of New Mexico Press, 1989.

In Focus: Edward Weston, Photographs from the J. Paul Getty Museum. Los Angeles: J. Paul Getty Museum, 2005.

Jacobs, Michael. *The Art of Composition: A Simple Application of Dynamic Symmetry*. Garden City NY: Doubleday, Page, 1926.

Jean Charlot: Paintings, Drawings, and Prints. Exhibition catalog, with essays by Lester C. Walker Jr., John Charlot, Laurence Schmeckebier, Lamar Dodd, and Jean Charlot. Athens: Georgia Museum of Art, 1976.

Jean Charlot: A Retrospective. Edited by Thomas Klobe. Honolulu: University of Hawai'i Art Gallery, 1990. Available online at http://www.jeancharlot.org/onJC/books/.

Jensen, James. "Jean Charlot: The Nude Figure." In *Jean Charlot: A Retrospective*, 64–73.

John, Augustus. *Autobiography*. London: Cape, 1975.

Karetnikova, Inga, and Leon Steinmetz. *Mexico According to Eisenstein*. Albuquerque: University of New Mexico Press, 1991.

Karttunen, Frances E. *Between Worlds: Interpreters, Guides, and Survivors*. New Brunswick NJ: Rutgers University Press, 1994.

Katz, Vincent, ed. *Black Mountain College: Experiment in Art*. Cambridge MA: MIT Press, 2003.

Kirstein, Lincoln. "Jean Charlot." *Creative Art* 9, no. 4 (October 1931): 306–11.

Klarr, Caroline. "Painting Paradise for a Post-colonial Pacific: The Fijian Frescoes of Jean Charlot." PhD diss., Florida State University, 2005.

Koprivitza, Milena, and Blanca Garduño Pulido, eds. *México en la obra de Jean Charlot*. Mexico City: Instituto Nacional de Bellas Artes, 1994.

Kothari, Sunil, ed. *Uday Shankar: A Photo-Biography*. New Delhi: Mohan Khokar, 1983.

Lee, Anthony. *Painting on the Left: Diego Rivera, Radical Politics, and San Francisco's Public Murals*. Berkeley: University of California Press, 1999.

Leyda, Jay, and Zina Voynow. *Eisenstein at Work*. New York: Pantheon Books / Museum of Modern Art, 1982.

Lorenz, Richard. "Johan Hagemeyer: A Lifetime of Camera Portraits." In *Johan Hagemeyer*, 5–21. The Archive 16. Tucson: Center for Creative Photography and University of Arizona, 1986.

Lowe, Sarah M. "Late Landscapes." In *Edward Weston: Life Work*, 181–84.

———. *Tina Modotti: Photographs*. Philadelphia: Philadelphia Museum of Art / New York: Harry N. Abrams, 1995.

————. *Tina Modotti and Edward Weston: The Mexico Years.* London: Barbican Art Gallery; New York: Merrell, 2004.

Luz Jiménez, símbolo de un pueblo milenario, 1897–1965. Mexico City: Consejo Nacional para la Cultura y las Artes, Instituto Nacional de Bellas Artes, Museo Casa Estudio Diego Rivera y Frida Kahlo, Mexic-Arte Museum, 2000.

Lyons, Naomi, and Jeremy Cox, eds. *The Art of Frederick Sommer: Photography, Drawing, Collage.* With an essay by Keith F. Davis. New Haven: Yale University Press / Frederick and Frances Sommer Foundation, 2005.

Maddow, Ben. *Edward Weston: Fifty Years.* Millerton NY: Aperture, 1973. Rev. ed., with an afterword by Cole Weston, *Edward Weston: His Life and Photographs.* Millerton NY: Aperture, 1979. Paperback ed., with a new afterword by the author, *Edward Weston: His Life.* New York: Aperture, 1989.

Malcolm, Janet. *Diana and Nikon: Essays on Photography.* New York: Aperture, 1997.

Maloney, T. J., ed. *U.S. Camera: 1940.* New York: Random House, 1939.

Maloney, T. J., ed. *U.S. Camera: 1943.* New York: Duell, Sloan and Pearce, 1942.

Manjarrez, Maricela González Cruz. *Tina Modotti y el muralismo mexicano.* Mexico City: Universidad Nacional Autónoma de México, Instituto de Investigaciones Estéticas, 1999.

Martínez H., José Luis. "Jean Charlot y La Coleccion Boturini-Aubin-Goupil." In Koprivitza and Pulido, eds., *México en la obra de Charlot,* 38–43.

McVicker, David. "El pintor convertido en arqueólogo." In Koprivitza and Pulido, eds., *Mexico en la obra de Jean Charlot,* 58–72.

Mérimée, Prosper. *Carmen.* Translated by Mary Lloyd. Illustrated by Jean Charlot. New York: Limited Editions Club, 1941.

Modotti y Weston: Mexicanidad. A Coruña, Spain: Fundación Pedro Barrié de la Maza; Rochester NY: George Eastman House, 1998.

The Monterey Photographic Tradition: The Weston Years. Monterey CA: Monterey Peninsula Museum of Art, 1986.

Mora, Gilles, ed. *Edward Weston: Forms of Passion.* New York: Harry N. Abrams, 1995.

Morris, Ann Axtell. *Digging in Yucatan.* With decorations by Jean Charlot. New York: Doubleday, 1940.

Morris, Earl H., Jean Charlot, and Ann Axtell Morris. *The Temple of the Warriors at Chichén Itzá, Yucatán.* 2 vols. Washington DC: Carnegie Institute, 1931.

Morris, Nancy. "Jean Charlot's Book Illustrations." In *Jean Charlot: A Retrospective,* 86–97.

Morse, Peter. *Jean Charlot's Prints: A Catalogue Raisonné.* Honolulu: University of Hawai'i Press and the Jean Charlot Foundation, 1976.

Mortimer, F. J. "Photographic Art." In *Encyclopaedia Britannica,* 14th ed., 1929.

Myers, Roger. *Guide to Archival Materials of the Center for Creative Photography.* Tucson: Center for Creative Photography and University of Arizona, 1986.

Nahui Olín: Una mujer de los tiempos modernos. Mexico City: Museo Estudio Diego Rivera, 1992.

Neff, Emily Ballew. *The Modern West: American Landscapes 1980–1950.* With an essay by Barry Lopez. New Haven: Yale University Press / Houston: Museum of Fine Arts, 2006.

Neogy, Prithwish, and Francis Haar. *Artists of Hawaii.* With an introduction by Jean Charlot. Honolulu: State Foundation on Culture and the Arts and University of Hawai'i Press, 1974.

Newhall, Beaumont. *Focus: Memoirs of a Life in Photography.* Boston: Little, Brown, 1993.

————. *Photography: A Short Critical History.* New York: Museum of Modern Art, 1938.

————. *Supreme Instants: The Photography of Edward Weston.* Boston: Little, Brown / Tucson: Center for Creative Photography and University of Arizona, 1986.

Newhall, Beaumont, and Amy Conger, eds. *Edward Weston Omnibus: A Critical Anthology.* Salt Lake City: Peregrine Smith, 1984.

Newhall, Nancy. *The Photographs of Edward Weston.* New York: Museum of Modern Art, 1946.

Nyerges, Alexander Lee. *Edward Weston: A Photographer's Love of Life.* Dayton, OH: Dayton Art Institute, 2004.

Orozco, José Clemente. *The Artist in New York: Letters to Jean Charlot and Unpublished Writings, 1925–1929.* Austin: University of Texas Press, 1974.

————. *An Autobiography.* Translated by Robert C. Stephenson Introduction by John Palmer Leeper. Austin: University of Texas Press, 1962.

Parish, Helen Rand. *Our Lady of Guadalupe.* New York: Viking Press, 1955.

Pauli, Lori. "Edward Weston and Christel Gang: Silent Communion." *History of Photography* 19, no. 3 (Autumn 1995): 263–68.

Peeler, David P. *The Illuminating Mind in American Photography: Stieglitz, Strand, Weston, Adams.* Rochester NY: University of Rochester Press, 2001.

————. "Power, Autonomy and Weston's Imagery: A Balancing Act." *History of Photography* 15, no. 3 (Autumn 1991): 194–202.

Perine, Robert. *Chouinard: An Art Vision Betrayed; The Story of the Chouinard Art Institute, 1921–1972.* Encinitas CA: Artra, 1985.

Picasso, Pablo. *Picasso: Two Statements.* With a comment by Merle Armitage. New York: Merle Armitage, 1936.

Pitts, Terrence. *Edward Weston: Color Photography.* With short pieces by Edward Weston and Nancy Newhall reprinted from *Modern Photography* (December 1953). Tucson: Center for Creative Photography and University of Arizona, 1986.

Posada, José Guadalupe. *100 Woodcuts / Grabados en madera.* With a foreword by Jean Charlot. Mexico City: Arsacio Vanegas Arroyo; Colorado Springs CO: Taylor Museum, 1947.

Quinn, Karen E. "'Universal Rhythms': Edward Weston and Modernism after 1927." In Stebbins, Quinn, and Furth, *Edward Weston*, 81–103.

Quinn, Karen E., and Theodore E. Stebbins Jr. *Weston's Westons: California and the West.* Boston: Museum of Fine Arts; New York: Bullfinch Press / Little, Brown, 1994.

Raeburn, John. *A Staggering Revolution: A Cultural History of Thirties Photography.* Urbana: University of Illinois Press, 2006.

Reed, Alma. *The Mexican Muralists.* New York: Crown, 1960.

———. *Orozco.* New York: Oxford University Press, 1956.

Retrato de una década, 1930–1940: David Alfaro Siqueiros. Mexico City: Museo Nacional de Arte, 1996.

Rivera, Diego. "Mexican Painting: Pulquerías." *Mexican Folkways* 2 (June–July 1926): 6–15.

Robinson, Ione. *A Wall to Paint On.* New York: Dutton, 1946.

Roth, Paul. *Weston and Surrealism.* Tucson: Center for Creative Photography and University of Arizona, 1990.

Ruda, Jeffrey. *Fra Filippo Lippi: Life and Work.* London: Phaidon, 1993.

Rule, Amy, and Nancy Solomon, eds. *Original Sources: Art and Archives at the Center for Creative Photography.* Tucson: Center for Creative Photography and University of Arizona, 2002.

Seton, Marie. *Sergei M. Eisenstein: A Biography.* London: Bodley Head, 1952.

Shapley, Fern Rusk. *Catalogue of Italian Paintings.* Washington DC: National Gallery of Art, 1979.

Siqueros, David Alfaro. "Una transcendental labor fotográfica: La exposición Weston-Modotti." *El informador* (Guadalajara), September 5, 1925. Translated by Amy Conger as "A Transcendental Photographic Work: The Weston-Modotti Exhibition." In Newhall and Conger, eds., *Edward Weston Omnibus*, 19–20.

Sonya Noskowiak Archive. Compiled by Donna Bender, Jan Stevenson, and Terence R. Pitts. Guide Series 5. Tucson: Center for Creative Photography and University of Arizona, 1982.

Spaulding, Jonathan. *Ansel Adams and the American Landscape.* Berkeley: University of California Press, 1995.

———. "Bright Power, Dark Peace: Edward Weston's California." In Watts, ed., *Edward Weston*, 29–53.

Stark, Amy, ed. *Edward Weston Papers.* Guide Series 13. Tucson: Center for Creative Photography and University of Arizona, 1986.

———, ed. *The Letters from Tina Modotti to Edward Weston.* The Archive 22. Tucson: Center for Creative Photography and University of Arizona, 1986.

Stebbins, Theodore E., Jr. "'Already Changing': Weston's Early Work." In Stebbins, Quinn, and Furth, *Edward Weston*, 1–15.

———. *Weston's Westons: Portraits and Nudes.* Boston: Museum of Fine Arts; New York: Bullfinch Press / Little, Brown, 1989.

Stebbins, Theodore E., Jr., Karen Quinn, and Leslie Furth. *Edward Weston: Photography and Modernism*. Boston: Museum of Fine Arts; New York: Bullfinch Press / Little, Brown, 1999.

Stotz, Gustaf, ed. *Internationale Ausstellung des Deutschen Werkbudes Film und Foto Stuttgart 1929*. Stuttgart: Des Deutschen Werkbunds, 1929; Deutsche Verlags-Anstalt, 1979.

Szarkowski, John. *American Landscapes*. New York: Museum of Modern Art, 1981.

———. "Edward Weston's Later Work." In Newhall and Conger, eds., *Edward Weston Omnibus*, 158–59.

———. *Photography until Now*. New York: Museum of Modern Art / Boston: Bullfinch Press, 1989.

———. "Understandings of Atget." In Szarkowski and Hambourg, *Work of Atget*.

Szarkowski, John, and Maria Morris Hambourg, eds. *The Work of Atget*. Vol. 4, *Modern Times*. New York: Museum of Modern Art, 1985.

Teague, Walter Dorwin. *Design This Day: The Technique of Order in the Machine Age*. New York: Harcourt Brace, 1940.

Thompson, Dody Weston. "Edward Weston." *Malahat Review* (University of Victoria, British Columbia) 14 (April 1970): 39–80. Reprinted in Newhall and Conger, eds., *Edward Weston Omnibus*, 132–51. Expanded version, "Edward Weston: A Memoir and a Summation," in *Edward Weston: Life Work*, 207–41.

Thompson, Karen. "Jean Charlot: Artist and Scholar." In *Jean Charlot: A Retrospective*, 15–17.

Toffoletti, Riccardo, ed. *Tina Modotti: Una vita nella storia*. Atti del convengno internazionale di studi. Udine, Italy: Comitato Tina Modotti / Edizioni Arti Grafiche Friulane, 1995.

Trachtenberg, Alan. "Edward Weston's America: The Leaves of Grass Project." In Bunnell and Featherstone, eds., *EW 100*, 103–15.

———. "The Final Years." In Mora, ed., *Edward Weston*, 288–94.

Travis, David. *Edward Weston: The Last Years in Carmel*. Chicago: Art Institute of Chicago, 2003.

Tucker, Anne Wilkes. "The Photo League: A Center for Documentary Photography." In *This Was the Photo League: Compassion and the Camera from the Depression to the Cold War*, edited by Anne Wilkes Tucker, Claire Cass, and Stephen Daiter, 17–18. Chicago: Stephen Daiter Gallery / Houston: John Cleary Gallery, 2001.

Ullrich-Zuckerman, Bea. "With Edward Weston." *Photo Metro* 5, no. 43 (October 1986).

Villanueva, Jesús. "Doña Luz: Inspiration and Image of a National Culture." *Voices of Mexico* 41 (October–December 1997): 19–24.

Vogel, Susan. *Becoming Pablo O'Higgins*. San Francisco: Pince-Nez Press, 2010.

Warren, Beth Gates. *Margrethe Mather and Edward Weston: A Passionate Collaboration*. Santa Barbara CA: Santa Barbara Museum of Art, 2001.

Watts, Jennifer A., ed. *Edward Weston: A Legacy*. San Marino CA: Huntington Library; London: Merrell, 2003.

Weaver, Mike. "Curves of Art." In Bunnell and Featherstone, eds., *EW 100*, 81–91.

——. "Jean Charlot's Repertory of Motifs." In *Jean Charlot: A Retrospective*.

Weston, Brett. *Hawaii: Fifty Photographs*. Carmel CA: Photography West Graphics, 1992.

Weston, Cole. *Cole Weston: At Home and Abroad*. New York, Aperture, 1998.

——. *Cole Weston: Fifty Years*. With an introduction by Cole Weston and an afterword by R. H. Cravens. Salt Lake City: Peregrine Smith Books, 1991.

Weston, Edward. "Amerika und Fotografie." In Stotz, ed., *International Ausstellung*, 13–14. [A German translation of all but the last two paragraphs of Weston's original English-language manuscript, now in the Edward Weston Archives at the Center for Creative Photography, University of Arizona, Tucson.] English-language original in Bunnell, ed., *Edward Weston on Photography*, 55–56.

——. "Color as Form." *Modern Photography* (December 1953): 54. Reprinted in Pitts, *Edward Weston*, 25–26.

——. "A Contemporary Means to Creative Expression." In Armitage, ed., *Art of Edward Weston*, 7. Reprinted in Bunnell, ed., *Edward Weston on Photography*, 68–69.

——. "Los daguerreotipos." *Forma* 1, no. 1 (October 1926): 7. English translation in Bunnell, ed., *Edward Weston on Photography*, 44.

——. *The Daybooks*. Vol. 1, *Mexico,* and Vol. 2, *California,* edited by Nancy Newhall. Rochester NY: George Eastman House, 1961. Reprint, New York: Horizon Press, 1966; Millerton NY: Aperture, 1973.

——. *Fiftieth Anniversary Portfolio, 1902–1952*. Carmel Highlands CA: Edward Weston / San Francisco, Grabhorn Press, 1951.

——. *Fifty Photographs: Edward Weston*. Edited by Merle Armitage. New York: Duell, Sloan and Pearce, 1947.

——. "From My Day Book." *Creative Art* 3, no. 2 (August 1928): xxix–xxxvi. Reprinted in Bunnell, ed., *Edward Weston on Photography*, 48–52.

——. "Mexican Days." *Carmelite,* August 7, 1929.

——. *My Camera on Point Lobos*. New York: Houghton Mifflin / Yosemite National Park, 1950. Reprint, New York: Da Capo Press, 1968.

——. "My Photographs of California." *Magazine of Art* 32, no. 1 (January 1939): 32. Reprinted in Bunnell, ed., *Edward Weston on Photography*, 81–82.

——. "Personal Recollections of Charlot in Mexico." *Carmelite.* February 12, 1931, 6.

——. "Photographic Art." In *Encyclopaedia Britannica*, 14th ed., 1941. Reprinted in Bunnell, ed., *Edward Weston on Photography*, 126–34.

——. "Photographing California." Pts. 1 and 2. *Camera Craft* 46, no. 2 (February 1939): 56–64; 46, no. 3 (March 1939): 99–105. Reprinted in Bunnell, ed., *Edward Weston on Photography*, 88–96.

————. "Photography." *Mexican Life* 2, no. 4 (June 1926): 16–17. Reprinted in Bunnell, ed., *Edward Weston on Photography*, 45.

————. "Photography Not Pictorial." *Camera Craft* 37, no. 7 (July 1930): 313–20. Reprinted in Bunnell, ed., *Edward Weston on Photography*, 57–60.

————. *Seeing California with Edward Weston.* N.p.: *Westways* and the Automobile Club of California, 1939.

————. "Seeing California with Edward Weston: Monterey Bay and Vicinity," *Westways* 31, no. 7 (July 1939). Reprinted in *Seeing California with Edward Weston*, 48–49.

————. "Statement." In *Edward Weston / Brett Weston Photographs.* Los Angeles: Los Angeles Museum, 1927. Reprinted in Bunnell, ed., *Edward Weston on Photography*, 46.

————. [Statement.] *The San Franciscan* 5, no. 2 (December 1930): 23. Reprinted in Bunnell, ed., *Edward Weston on Photography*, 62–63.

————. [Statement.] In *Photographs / Edward Weston.* New York: Delphic Studios, 1932. Reprinted in Bunnell, ed., *Edward Weston on Photography*, 70.

————. [Statement.] In Weston, *Fiftieth Anniversary Portfolio.* Reprinted in Bunnell, ed., *Edward Weston on Photography*, 151.

————. "Thirty-Five Years of Portraiture." Pt. 2. *Camera Craft* 46, no. 10 (October 1939): 449–60. Reprinted in Bunnell, ed., *Edward Weston on Photography*, 103–13.

————. "What Is a Purist?" *Camera Craft* 46, no. 1 (January 1939): 3–9. Reprinted in Bunnell, ed., *Edward Weston on Photography*, 83–87.

Weston, Edward, and Charis Wilson. *California and the West.* New York: Duell, Sloan and Pearce, 1940. Rev. ed., with a new foreword by Charis Wilson and 64 rather than 96 photographs. Millerton NY: Aperture, 1978.

————. *The Cats of Wildcat Hill.* New York: Duell, Sloan and Pearce, 1947.

————. "Of the West: A Guggenheim Portrait." In *U.S. Camera: 1940*, edited by T. J. Maloney, 37–55. New York: Random House, 1939. Reprinted in Bunnell, ed., *Edward Weston on Photography*, 114.

Weston, Paulette, ed. *Laughing Eyes: A Book of Letters between Edward and Cole Weston, 1923–1946.* Carmel CA: Carmel Publishing Company, n.d. [1999?].

Whelan, Richard. *Alfred Stieglitz: A Biography.* Boston: Little, Brown, 1995.

Whitman, Walt. *Leaves of Grass.* 2 vols. With an introduction by Mark Van Doren and photographs by Edward Weston. New York: Limited Editions Club, 1942.

Wilson, Charis. *Edward Weston: Nudes.* Millerton NY: Aperture, 1977.

————. "Weston's Eye." In *EW 100*, 121.

Wilson, Charis, with Wendy Madar. *Through Another Lens: My Years with Edward Weston.* New York: North Point Press / Farrar, Strauss and Giroux, 1998.

ILLUSTRATION CREDITS

INDEX

Goldschmidt, Alfons, 10, 11
Goldwater, Barry, 189
Gómez Robelo, Ricardo, 1
Goupil, Eugène, 30
Goupil, Louis, 30
Goya, Francisco, 93, 94
Le Groupe des XV, 259–60
Group f/64, 117, 118, 120, 171, 260, 316n55
Grünewald, Matthias, 132
Guadalajara, Mex., 8–9, 23–24, 36–37
Guerrero, Clarite, 241
Guerrero, Elisa, 1
gypsies, 189

Hagemeyer, Johan, 21, 67, 69, 159
Hambidge, Jay, 65, 218–19, 220, 237, 332n75
Hambidge, Mary, 65, 219
Hammond, Anne, xxii, 323n123, 338n36, 339n71, 340n1
Harris, Noel, 248
Harvard Society for Contemporary Art, 75
Hawai'i, 257, 260, 263, 268–70, 272, 276; becomes state, 287; Charlot move to, 282–83
A Hermit in the Himalayas (Brunton), 151
Hernández Galván, Manuel, 2, 36; portrait by Weston of, 5, 41, 58, 71
Hertz, Alfred, 67
Hexter, Paul Louis, 156
Hickey, Thomas W., 67
Highlander Folk School, 190
History of Photography (Newhall), 171
Hobson, Lil, 159
Hoch, Hannah, 71
Holgers, William, 178
Hoover, Herbert, 67

Hound and Horn, 113
Huene, Huyningen, 268
Hughes, Richard, 152

Idols behind Altars (Brenner), xxviii, 32, 35–38, 73–74, 249
impressionism, 72; Charlot on, 137, 150–51
Increase Robinson Galleries (Chicago), xxix, 111, 118–19, 121–22, 316n65
In Dubious Battle (Steinbeck), 159
infinity, 53–54
Ingres, Jean Auguste Dominique, 150
International Red Aid, 85
Ison, Frances, 192, 194, 202, 221, 228, 243, 247
Ison, Roswell, 228, 231, F47
Ivins, William, Jr., 99

Jackson, William Henry, 212, 253
Jacobs, Michel, 219
Japanese American internment, 200, 212
Jean Charlot (Charlot), 105
Jeffers, Robinson, 80, 114, 252
Jeffers, Uno, 114
Jensen, James, xix
Jewell, Edward Alden, 88
Jiménez González, Julia (Luciana, Luz), xxvii–xxviii, 262; modeling for Charlot and Weston by, xxviii, xxxi, 25, 26
Joesting, Edward, 285
John, Augustus, 128
John, Henry "Elffin," 128, 317n88
John Becker Gallery (New York), 89
John Levy Gallery (New York), 88–89, 93

Kahlo, Frida, 62, 82, 83, 93

Modotti, Mercedes, 27
Modotti, Tina, 28, 32, 44, 89; background, xxvi; Charlot and, 63, 64; Charlot drawing of, xxxi, 3, F3; death of, 200, 228, 240–42; deported from Mexico, 76; left-wing political involvement, 24, 49, 51, 85, 242; letter to Weston, 62; and Mella, 64, 68; photo exhibitions by, 16, 23–24; photos by, 2, 3, 35, 73, 74, 214, 297n7; photos by Weston of, xxxi, 1, 5, 6; visit to Eisenstein, 102; with Weston in Mexico, 1–20; Weston message for funeral of, 200–201; Weston relationship with, xxvi, 16, 20, 42; on Weston's photos, 48–49; works, photographic: *Jean Charlot* (1924), 3, 64, 297–98n11, F2; *Jean Charlot* (1928), 64, F16
Moe, Henry Allen, 141, 227
Moholy-Nagy, László, 171, 308n89
The Moonstone (Collins), 154
Morgan, Gilbert, 173
Morley, Sylvanus G., 30, 33, 34, 44
Morris, Earl and Ann, 69
Morse, Peter, xvii, 289
Mortensen, William, 96, 98, 156, 171, 179
Mortimer, F. J., 169, 172
Mullins, Helene, 147–48
Museum of Modern Art (New York), 57, 224, 245
Museum of Modern Art (New York) exhibitions: *An Exhibition of Work of 46 Painters and Sculptors under 35 Years of Age* (1930), 75; *Family of Man* (1955), xxx, 281–82; Matisse (1931), 99; "Photographs of the Civil War and the American

Frontier" (1942), 253; Picasso (1939–40), 176, 324n36; Weston retrospective (1946), 243–44
My Camera on Point Lobos (Weston), 263, 264–67, 269
mysticism, 160, 161; Charlot on, 65, 148

Naidu, Madame Saronjini, 65
National Gallery of Art (Washington DC), 190
National Museum of Anthropology (Mexico City), 5
Neutra, Richard, 68
Newhall, Beaumont, 170, 178, 179, 239, 245; *History of Photography*, 171; *Supreme Instants*, 187
Newhall, Nancy, 178, 222, 234, 239, 247, 251; on Weston career, 243–44; on Weston divorce, 242–43
New Orleans LA, 189–90
New York Sun, 88
New York Times, 88
Nierendorf, Karl, 139, 142
Nierendorf Gallery (New York), 142
Norris, Ben, 258
Northwestern University, 279
Norville, George, 66
Noskowiak, Sonya, 132, 316n54; and Charlot and Zohmah, xxix, 114, 124–25, 150; Weston relationship with, 69–70, 127; works, photographic: *Jean Charlot*, 117, 315n43, F31; *Zohmah Day*, 117, 315n45, F32

O'Higgins, Pablo, 92, 93, 102
O'Keeffe, Georgia, 19, 191
Olín, Nahui, 2, 16, 17, 51, 61; portrait by Weston of, 5, 41, 76

Orlov, Nikita, 313n109
Orozco, José Clemente, 57, 60, 63,
70, 77; and Charlot, 58–59, 63–64,
71, 79, 219, 287; Charlot on, 130,
334n15; and dynamic symmetry,
219; portrait of Weston by, 80; and
surrealism, 79, 81; visit to Weston
by, 79; Weston on, 45, 87–88; on
Weston's photos, 49–50
Orozco Romero, Carlo, 24
O'Sullivan, Maureen, 148, F35
Our Lady of Guadalupe (Parish), 281
Ouspensky, P. D., 52, 54
Outerbridge, Paul, 96

Pacheco, Máximo, 8, 44, 45
Paine, Frances Flynn, 57–58, 60, 88,
89, 93
The Painted Veil (film), 131
Pan-American Exhibition (Los
Angeles, 1925), 27, 28, 45
Parish, Helen Rand, 281
Parrish, Maxfield, 237
Payor, Eugene, 235, 236, 334n20
Pearl Harbor, 191
Peintres Nouveaux, 105
Pflueger, Timothy, 83, 119–20
Phipps, Sallie, 127–28
The Photographer (film), 249–50, 254,
264, 270, 279–80
Photo League, 264, 277
Picasso, Pablo, 7, 29, 159, 160, 176,
324n36
pictorialism, 179; Weston's opposition
to, 55, 71–72, 101, 108, 156–57, 171
Pierro della Francesca, xxviii, 150, 227
Pintao, Manuel Martínez, xxviii, 3–5,
28, 53; portrait by Charlot of, 28
Plowe, Owen, 159–60, 176
Point Lobos CA, 69, 95, 115, 185,
203–4

Poland, Reginald, 141
Pontormo, 132
Posada, José Guadalupe, 168, 268, 272,
338–39n48
Prendergast, Bea and Don, 190, 203,
223
pre-visualization, 47, 72, 160
Public Works of Art Project (PWAP),
125–26
Pukui, Mary Kawena, 260, 272
purism, 71–72, 78–79, 96, 156–57, 171

Qué viva México! (Eisenstein), 90, 93,
100, 311n73, 313n109; Eisenstein
conception of, 92; unraveling of
project, 101–2
Quintanilla, Pepe, 16

Raphael, 150; *Expulsion of Heliodorus*,
227
realism: Ansel Adams and, 96–97;
socialist, 264; Weston and, 5, 27, 51,
78–79, 81
Red Rock Canyon (NV), 143, 144, 145,
155, 182
Reed, Alma, 65–66, 77, 79
Rejlander, Oscar, 170, 171, 205
Renger-Patzsch, Albert, 78
Revista de revistas (journal), 45
Revueltas, Fermín, 8
Rivera, Diego, 22, 27, 33; and Charlot,
xxvii, xxviii, 36, 93, 235, 247, 294;
Charlot on, 120, 247, 334n15; on
Modotti death, 200, 240, 242;
photos by Weston of, 17–18, 58,
82, 83, 108; Shore on, 57; use of
Russian motifs by, 63; and Weston,
xxviii, 2, 3, 24, 36, 38, 82–83;
Weston on, 17, 25, 35, 45; on
Weston's photography, 15, 28, 29,
40, 48, 49, 235, 294

Rivera, Lupe, 2, 5, 15, 22
Roberts, Dorothy, 296n3
Robinson, Henry Peach, 170, 171, 205
Robinson, Ione, 89, 90, 92, 93
Rodin, Auguste, 98
Rogers, Bill, 211
Ronis, Willy, 259
Roosevelt, Franklin D., 180, 189, 200,
 232, 238
Rosicrucianism, 219
Rothstein, Arthur, 182
Rubens, Peter Paul, 93–94
Ruggles of Red Gap (Wilson), 132

Sala, Monna, 2, 6, 12, 13, 27, 29, 48
Sala, Rafael, 2, 4, 6, 12, 27, 29; works
 exhibited, 8, 16
Saldivar, Julio, 90
Salinger, Jehanne Biétry, 289; and
 Charlot, 120, 122, 204, 210,
 316n57; and Weston, 61–62, 120,
 150, 316n58
Sanborn, Bob, 110
San Francisco Chronicle, 210
San Francisco Evening News, 66
San Francisco Examiner, 61, 122
San Francisco Museum of Art, 146
Santayo, Matias, 61
Sargent, John Singer, 94
sculpture: photography compared to,
 81, 82, 184; as symbolism, 97–98
Search in Secret India (Brunton), 128
Seeing California with Edward Weston
 (Weston), 145, 167–68
Sesshu, 130
Shankar, Uday, 125
Shan-Kar Dancers, 125
Sheeler, Charles, 71, 108, 139, 172
Sheets, Millard, 268
Shore, Henrietta, 59, 141; and Charlot,

44, 54, 60, 114, 115; Charlot on,
 56, 63, 168, 169; Charlot portrait
 by, 57; portrait by Charlot of, 63,
 70, 112, F55; and Weston, 43–44,
 45–46, 52, 56–57, 112, 162; Weston
 on, 52–53, 113; Weston portrait by,
 56–57; on Weston's work, 46
Short, Doug, 236
Sikelianos, Madame, 65, 77, 219
Simonson, Lee, 61
Sinclair, Upton, 101, 102
Siqueiros, David Alfaro, 45, 110;
 portrait of Zohmah Day by, 111–
 12, 314n22; on Weston-Modotti
 exhibition, 23–24, 300n9
Smith, Al, 67
Smith College, 231
socialist realism, 264
Sommer, Frederick, 140, 141, 167, 223
Sougez, Emmanuel, 259, 260
Soyer, Raphael, 132
Spanish Civil War, 147, 189, 239
Stackpole, Ralph, 82
Stanton, William P., 67
Starr, Alfred, 261, 262
Steffens, Lincoln, 108, 114
Steffens, Peter, 104
Steichen, Edward, 71, 174, 308n89;
 Charlot and, 271; and Museum of
 Modern Art, 245, 281–82; Weston
 and, 97, 164, 172, 212
Steinbeck, John, 159
Stendahl, Earl, 286
Stevenson, Robert Louis, 152, 154
Stieglitz, Alfred, 29, 97, 168, 172;
 Charlot view of, 60, 61, 69, 70, 77;
 criticisms of Weston's work by, 47,
 48; death of, 245; Weston meetings
 with, xxvi, 191; Weston's works
 likened to, 19, 139, 155, 236, 265;

Weston view of, 9–10, 70, 170, 172, 245
storytelling, 137, 148
Strand, Paul, 22, 71, 97, 172, 256
Sturtevant, Roger, 71
The Sun, the Moon, and a Rabbit (Martinez Del Rio), 129
Supreme Instants (Newhall), 187
surrealism, 85, 137; Charlot and, xxxi, 76, 81, 82, 137, 148, 221–22; Weston and, xxxi, 80–81, 149, 167, 222, 223–24
Sweethearts (musical), 218
symbolism: Charlot on, 81; Weston on, 53, 97–98, 141, 266
Syndicate of Technical Workers, Painters, and Sculptors, 11
Szarkowski, John, 139, 183

Taylor, Paul, 141
Teixidor, Felipe, 16
Tennessee, 190
Teresa of Avila, 92–93
Tertium Organum (Ouspensky), 52
Tetlapayac, Mex., 90, 92
Thompson, Dody Weston, 194, 265, 270, 272, 288, 339n59
Through Another Lens (Wilson), 156, 178, 291
Thunder over Mexico (film), 125, 313n109
The Tiger's Coat (film), xxvi
Tisse, Edouard, 90, 93
Tonalá, Mex., 24, 36
Toor, Frances, 10, 27, 33, 38, 303n59
Trachtenberg, Alan, 209, 265
Travis, David, 250–51
Trotsky, Leon, 103, 104
Truman, Harry, 233, 238–39, 242, 255, 277

Tseng Yu-Ho (Betty Ecke), 269
Turnbull, Roberto "Tito," 13
Two Little Trains (Brown), 262

Uccello, Paolo, xxviii
University of California at Berkeley, 204
University of California at Los Angeles, 43
University of Georgia, 188, 193
University of Hawai'i, 257, 287, 337n2
University of Iowa, 165
U.S. Camera, 173–75, 212–13, 253

Van Doren, Mark, 207
Van Dyke, Mary, 191
Van Dyke, Wanda, 121
Van Dyke, Willard, 118, 119, 120, 121, 174, 191, 211; *The Photographer* film by, 249–50, 254, 264, 270
Van Dyke Gallery (Oakland), 122, 316n68
Van Gogh, Vincent, 72, 84, 130
Velázquez, Diego, 227
Vickery, Atkins, and Toorey Gallery (San Francisco), 82

Wallace, Henry, 211, 233, 238, 255–56
Wardell, Bertha, 44
Warren, Dody. *See* Thompson, Dody Weston
Wasserman, Jakob, 9
Weaver, Mike, xix, xxii, 323n123
Weston, Brett (son), xxv, 55–56, 69, 231, 289; and Ansel Adams, 286; assistance to father with work, 272, 278; in Mexico with father, 23, 24; moving in with father, 66, 132; as photographer, 43, 71, 100, 172, 174, 228; visits to and from father, 142, 153, 245, 258

Weston, Chandler (son), xxv, xxvi, 11,
21, 118, 142, 231
Weston, Cole (son), xxv, 52, 132, 231,
245, 258; as photographer, 143, 260,
272, 277; political involvement of,
256
Weston, Edward: biographical
information and background, xxv–
xxvi; Charlot visits to in Carmel,
xxix, xxx, 113–21, 152–54, 257–59,
273–74, 275; daybooks of, xvi, xxx–
xxxi, 61, 221, 224–25, 228, 233–34,
240, 247–48, 332n86; death of, xvi,
283, 340n89; exchange of artwork
with Charlot, 18–19, 41, 143,
151, 165, 274; film about, 249–50,
254, 264, 270, 279–80; financial
struggles of, 11–12, 32, 135, 251;
first meeting with Charis, 127; first
meeting with Charlot, xv, 2; as
grandfather and great-grandfather,
228, 262, 281; Guggenheim
fellowship of, 139, 141, 142, 146,
149, 157–58, 168; help to and from
Charlot, 56, 110–11, 118; marriage
to Charis, 162; in Mexico, xv–xxix,
1–20, 23–41; Parkinson's disease
of, xxxi, 245, 248, 254–55, 272;
photo by Dapprich of, 61, 307n64,
F15; photo with Rosell Ison, 228,
F47; portraits by Charlot of, 12,
299nn40–41, F5, F53; and religion,
10; tensions and breakup with
Charis, 191–92, 195, 203, 213–14,
217, 227, 242–43; visit to Charlots
in Athens GA, 191–92, 194–97;
on women in art, 43; work for
Calif. Public Works of Art Project,
125–26; work for *Westways*, 143–46;
work for WPA Federal Arts Project,

132, 135; Zohmah Day attraction
to, 126–27
Weston, Edward, artistry of: and
abstraction, 5, 27, 31, 50–51,
73, 97–98, 208–9; aesthetic
radicalism of, 11, 103, 104, 138–39;
arrangement and manipulation in,
95, 96, 205; and Atget, 83–85, 97,
130, 155, 184, 310n39; Augustus
John opinion of, 128; broadening
vistas and imagery, 183, 208–9;
Charlot appreciation of, xxix,
7, 15, 50–52, 75, 80, 81, 108–9,
119, 142–43, 168, 234, 258, 259,
293–94; critics on, 61, 116, 121;
distrust of theory, 159, 160, 252;
and eroticism, 50, 116, 168–69;
and formalism, 138, 139, 140;
honesty of photography, xxvii, 55,
71–72, 108; influence of Mexico
on, xxvi–xxvii, 22, 234–35; mass
production theory of photography,
78, 157, 168, 174, 183–84, 244;
and modernism, xxvii, 101, 104,
172, 183, 264; opposition to
pictorialism, 55, 71–72, 101, 108,
156–57, 171; on photography
as revelation, 100, 109, 141,
161; on photography-painting
relationship, 34–35, 86, 157, 170,
184; and purism, 71–72, 78–79, 96,
156–57, 170–71; and realism, 5,
27, 51, 78–79, 81; on relativity and
interconnectedness, 141, 149, 269;
on social role of art, 87, 88, 103–4;
and spontaneity, 4, 50, 160, 205;
and Stieglitz, xxvi, 9–10, 19, 70,
139, 155, 170, 172, 236, 245, 265;
and surrealism, xxxi, 80–81, 149,
167, 222, 223–24; on symbolism

and representation, 13, 97–98, 141, 266; technical mastery in photography, 160, 172; techniques and procedures, 101, 174, 179; on transcendent and infinite, 53, 54, 98, 141, 149; views and motifs shared with Charlot, 36, 149; visualization and execution, 46–47, 72, 160, 172; work in color, 246, 248, 249, 250, 254, 258, 259

Weston, Edward, exhibitions by: at Aztec Land Gallery (1923), 1–2; at Aztec Land Gallery (1924), 15–16; at Bonestell Gallery (1940), 185; at Delphic Studios (1930), 79, 80; at Delphic Studios (1932), 99–100, 312n99; at Denny-Watrous Gallery (1931), 86; at de Young Museum (1931), 96; at East West Gallery in Western Women's Club (1928), 61; at El Café de Nadie (Mexico City) (1924), 8; *Film und Foto* (1929), 71; at Guadalajara (1924), 8–9; at Guadalajara (1925), 23–24; at Honolulu Academy of Arts (1984), 253, 290, 336n83; at Increase Robinson Galleries (1933), xxix, 118–19, 121–22, 316n65; at Japanese Club (1925), 23; at Le Groupe des XV (Paris) (1949), 259–60, 261, 262, 264, 337n12; at Los Angeles Museum (1927), 55; at Morgan Camera Shop (1939), 172–73; at Museum of Modern Art (1946), 243–44; at Nierendorf Gallery (1937), 142; at Palacio Minería (1924), 16, 17; at San Francisco Museum of Art (1937), 146; at University of California at Los Angeles (1927), 43; at

University of Georgia (1941), 193; at U.S. Embassy Gallery, London (1949), 258, 337n8; at Vickery, Atkins, and Toorey Gallery (1930), 82

Weston, Edward, photo subject matter of, 47, 104; cats, 228–29, 244, 250–51; clouds, 155, 169; dancing legs, 50–51, 52, 58, F14; landscapes, 114–15, 138, 182, 208; Mexican toys, 25, 31, 32, 39; movie sets, 155–56, 184–85, F37; nudes, 6–7, 44, 46, 127, 138; portraits, 5, 41, 66, 67; pulquería paintings, 37–39; rocks and trees, 95, 97, 145; shells, 45–46, 50, 52, 61; vegetables and fruit, 46, 57, 61, 79–80, 81, 97

Weston, Edward, political views of, 87, 88, 209; on anticommunist investigations and witch-hunt, 211, 264; on communism, 11, 102–3; on Herbert Hoover victory, 67; opposition to Japanese American internment, 200, 212; on Spanish Civil War, 147, 238–39; subsiding of political engagement, 256, 272; support for Roosevelt, 180, 232–33; support for Wallace, 233, 255–56; on Truman, 238–39, 242; on World War II conduct, 199, 205, 211, 213, 216, 222–23

Weston, Edward, relationships and affairs of, 317n80; with "A," 66; with Charis Wilson, 127, 162, 191–92, 203, 213–14, 227, 242–43; with Margrethe Mather, xxv; marriage to Flora, xxv, 132, 162; with Miriam Lerner, 21; with Sonya Noskawiak, 69–70, 127; with Tina Modotti, xxvi, 16, 20, 42; with "X," 32